TURNERS AND BURNERS

THE UNIVERSITY OF NORTH CAROLINA PRESS

CHAPEL HILL AND LONDON

The Fred W. Morrison Series in Southern Studies

TURNERS & BURNERS

THE FOLK POTTERS OF NORTH CAROLINA

BY CHARLES G. ZUG III

Library of Congress Cataloging-in-Publication Data

Zug, Charles G.

 Turners and burners.

 (The Fred W. Morrison series in Southern studies)

 Bibliography: p.

 Includes index.

 1. Pottery, American—North Carolina. 2. Pottery—
19th century—North Carolina. 3. Pottery—20th century—
North Carolina. 4. Folk art—North Carolina. I. Title.

NK4025.N8Z82 1986 738′.09756 86-1456

ISBN 0-8078-1704-X

For Dot and Walter,

Irene and Burl

I was hauling wood, grinding clay, beating those cinders, help putting the kiln of ware in, help taking one out, carrying it out to dry, and all that stuff, you know. They was always a job. You go around a potter's shop, you had a job. You didn't lay down under a shade tree.

—Enoch W. Reinhardt
 Henry, N.C., 1978

CONTENTS

PREFACE

It all began in the spring of 1969, shortly after I moved to Chapel Hill to teach at the University of North Carolina. My colleague in the Curriculum in Folklore, Daniel Patterson, proposed an excursion to a fiddler's convention at the local school in Star, Montgomery County. On the way down, he added, why not stop at "the potteries," as the music wouldn't get underway until evening? At the time, I had no idea what he meant. I recalled eating and drinking out of some smooth, green mugs and bowls at his house and hearing something about "frogskin" and "Ben Owen" and "Jugtown." But as exotic as they sounded to me then, these names soon merged with numerous others as Dan introduced me to the history and culture of my new state. Moreover, having lived in Pennsylvania and New England, I had never encountered any truly indigenous potteries of the sort that would have caught my interest.

The shops that we visited that day were scattered along a fifteen-mile stretch of roads in the southeastern Piedmont—the Seagrove Pottery on Route 220 just north of Seagrove, Randolph County; J. B. Cole's Pottery in the very northeast corner of Montgomery County; the Joe Owen Pottery, the Old Plank Road Pottery, the M. L. Owens Pottery (now the Owens Pottery), and the Jugtown Pottery off Route 705 in northwest Moore County; and, about ten miles to the south, the Teague Pottery on Route 24/27 just below Robbins. All seven appeared to have been created by the same hand, each a series of weathered log or frame buildings sprawling among the tall, shaggy pines common to the region. Inside were simple displays of tablewares—bowls, dishes, plates, mugs, pitchers, candlesticks—as well as vases, urns, planters, lamp bases, birdhouses, and jugs, most glazed in bright hues and rich textures. The potters were there, too—grinding clay and working on their wheels and loading the kilns. I found them remarkably open and unpretentious. In fact, they seemed almost eager to interrupt their work just to talk—perhaps to explain how the wares were produced or to relate their family histories. And they willingly referred us to the other nearby potteries, valuable assistance to an outsider in a region where advertising is almost nonexistent and the winding, unmarked country roads all look the same.

That first encounter with the potteries was important to me, though a full five years would pass before I began to take an active, scholarly interest in them. Other sporadic visits followed, and I slowly sensed that there was

something special about these worn, cluttered buildings and the unassuming, friendly people inside them. Admittedly they were not folk potteries. Though there were numerous forms and glazes that harkened back to earlier North Carolina traditions, many were of modern provenance, and the equipment used in their manufacture included relatively recent innovations such as mechanical pug mills, electric wheels, and downdraft kilns fired with oil. At the same time, these were not studio or art potteries, nor could they be classified as industries in any sense of the word.

Even more puzzling to me were the intangible qualities of the shops—qualities that only emerged gradually and increased the difficulties of classification. Most apparent of these is the pervasive family orientation. All seven shops are owned or operated by Aumans, Coles, Cravens, Owens, and Teagues, who have worked together and carefully nurtured the skills of "turning" and "burning"—the local terms for throwing and firing—through numerous generations. And reinforcing these clay clans, as they might be called, is the deep sense of place. Many of these "modern" potteries have been operating at the same location for the better part of half a century, and some of the families—most notably the Coles and Cravens—appear to have settled in this region to make pottery as early as the eighteenth century. Finally, there is the potters' historical self-consciousness, their awareness of their forebears and the venerable craft that they have maintained. This is not the false charm of nostalgia, nor is it a calculated form of appeal to their customers. It is a genuine sense of the past that gives pride and purpose and guidance to the present.

As I began to travel about the state, I discovered that there were other potteries outside this core area that were no less deeply rooted in the North Carolina clay. In Lee County, some twenty miles to the east of Robbins, I found the Cole Pottery on Route 1/15/501, on the north edge of Sanford. Established by the late A. R. Cole, who moved out of rural Randolph County in 1934, it is now operated by his daughters Neolia and Celia. Until 1978 Walter Owens maintained the Pine State Pottery, just seven miles west of Sanford on Route 42. Founded in 1924 as the North State Pottery, this shop lasted fifty-four years and only closed as age and illness prevented Walter from getting to his wheel. In the western Piedmont, the Outen family ran their Matthews Pottery at Matthews, Mecklenburg County, from 1922 to 1978. Originally they turned traditional forms on their treadle wheels and burned them in a groundhog kiln, but in later years they shifted to a more automated technology and produced massive volumes of molded flowerpots. Even farther west, just south of Asheville, two shops owned by the Brown family continue to prosper. The original was established about 1923 at Arden, Buncombe County, by Davis and Javan Brown, fifth-generation potters from Georgia; today Brown's Pottery is headed by Davis's grandsons, Charles and Robert. And just a few miles to the east, at Skyland, is Evan's Pottery, opened in 1965 by Javan's son Evan J. Brown, Jr. Finally, at the hamlet of

Henry, in the northwest corner of Lincoln County, is the shop of Burlon B. Craig, the last folk potter in North Carolina.

I did not meet Burl until 1977, but for some time before that I had heard reports that there was an "old-time" potter still at work somewhere in the Catawba Valley. These rumors turned out to be truer than I ever could have hoped. I can still recall that cold, clear January evening when I drove into Irene and Burl Craig's yard and saw the old frame shop, the huge groundhog kiln, and the shed full of alkaline-glazed stoneware. It was like looking through an open window directly into the past. A potter for over half a century, Burl has made few concessions to modernity. He digs his clay by hand from the bottomland on the South Fork of the Catawba River and hauls it back to his shop to weather. Next, he grinds it to the proper consistency in his pug mill, though he now powers the mill with his tractor instead of the once ubiquitous mule. Inside his shop—which he purchased, along with his kiln, from an earlier potter named Harvey Reinhardt—he turns a variety of traditional forms on his treadle wheel, pumping the flywheel pedal with his left foot as he pulls up the clay walls with his hands. To produce his alkaline glazes, he crushes glass bottles—or, less frequently, cinders from the old iron furnaces in Lincoln County—in a homemade, water-powered, trip-hammer mill that sits in a creek branch behind his pasture. Then he combines the glass, now the consistency of flour, with wood ashes, clay, and water, and grinds the resulting solution in a hand-powered, stone glaze mill, a miniature of the old grist mills that were once so common. Finally, he burns his wares in a long groundhog kiln, a task that requires ten hours of close attention and hard labor, not to mention the 2½ cords of four-foot pine slabs needed to mature the wares. Until the last decade, Burl sold most of his wares to local customers or hardware stores. Now the bulk of his output goes to collectors who value the early forms and glazes, or dealers who sometimes recycle his products as "old" pottery.

Burl is the single remaining link between the potteries of today, represented by the numerous shops that stretch from Sanford to Asheville, and a heritage of folk pottery that extends back in time for two centuries. From at least the middle of the eighteenth century through the second quarter of the twentieth, the folk potter in North Carolina produced millions of gallons of earthen- and stonewares in sturdy, simple, indispensable forms such as jars and jugs, milk crocks and churns, pitchers and dishes, chamberpots and chicken waterers, ring jugs and flowerpots. His repertory was limited—he made what he knew was useful and would sell readily to a rural, self-sufficient people. This was entirely a men's world, one that was filled with long hours of arduous, repetitive labor. The bulk of his raw materials the potter gathered locally at little or no expense. He dug the clay from ponds and river bottoms and concocted the glazes from lead, salt, wood ashes, iron slag, or discarded glass. His technology was time-tested, efficient, and homemade. He constructed all of his tools himself, from the treadle wheel

on which he turned his pots to the groundhog kiln in which he burned them. Working with his family and friends, he produced wares that were intentionally utilitarian, but that, on occasion, invoked a powerful aesthetic response through their bold, bulbous forms and natural, flowing glazes.

Today the folk potter is an anachronism, a largely vanished type of craftsman, yet many of his creations survive and are now much admired for their inherent strength and beauty. But this was not always so. The people who originally purchased his wares took them for granted, just as we scarcely notice the mason jars, tin cans, milk cartons, or molded flowerpots that we use each day. Moreover neither the potters nor their contemporaries felt any need to document the craft; it was just too commonplace, too much a part of daily life, to be worthy of notice. While this lack of interest is understandable, it is not acceptable for us to share it. In the course of my research, I have identified some five hundred folk potters in North Carolina, and there are certainly others whose work will remain forever anonymous. This is a surprisingly large figure; surely, such an extensive craft—and art—tradition merits attention on the basis of numbers alone. And while the true folk tradition survives only in the work of Burlon Craig, what of the dozen or so potteries, worked by members of the old families, that have evolved directly out of the folk tradition? This, too, is a surprisingly large figure—I can think of no other state today that possesses such an active and extensive ceramic heritage, one that is entirely continuous. This book is an attempt to understand both our past and our present, both the now largely vanished world of the folk potter and the continuing achievements of his descendants. It is a tribute that is long overdue.

Not until 1974, fully half a decade after my initial acquaintance with the potteries, did I make the plunge and begin documenting the craft. My interest had grown steadily, but the catalyst needed to get me going was a visit to Chapel Hill by John Burrison, an old friend and former classmate at the University of Pennsylvania, who was already deep into research on the folk pottery of Georgia. His recently published *Brothers in Clay: The Story of Georgia Folk Pottery* is the first comprehensive ceramic history of a southern state. John gave a public lecture at the University of North Carolina, and his color slides of the old shops and the richly textured traditional forms stirred my imagination and enthusiasm. As if to cap his performance, he presented me with a green, popeyed face jug made by Lanier Meaders, a potter from the hill country of north Georgia. This was my first acquisition—many others were soon to follow—and I was on my way.

Right from the start, I encountered some unexpected obstacles. Accustomed to the usual methods of literary research, I instinctively headed for the library, assuming that my first task would be to tally up the resources and assemble a bibliography. But I found little of direct use. True, there were substantial volumes on American pottery, notably the classic works of Edwin Atlee Barber, John Spargo, John Ramsay, and Lura Woodside Watkins,

as well as more recent, lavishly illustrated studies by Donald Blake Webster, Harold F. Guilland, and Cornelius Osgood. But these proved of limited value, for two reasons. First, these scholars tended to pursue an object-oriented approach; that is, they treated each pot as an independent entity, usually emphasizing its particular form or decoration or history. What seemed lacking to me, particularly after I had witnessed the living tradition in North Carolina, was a deeper cultural emphasis that considered the specific uses of the various forms, the processes of the craft, and the aims and attitudes of the potters. Above all, there was no unified, regional emphasis, one that explored the essential importance and meanings of the pottery in the lives of the people who made and used it.

A second omission, one that seemed much more serious at the time, was a marked disregard for the products of the southern potter. Clearly these authors preferred the more familiar, elaborately decorated earthenware and stoneware of New England, the mid-Atlantic region, and, to a lesser extent, the Midwest. Repeatedly, they lamented the lack of written records, the isolation, the primitive methods, and the relentlessly utilitarian nature of the southern tradition. I did find two books, however, that appeared very relevant and promising: John Bivins's *The Moravian Potters in North Carolina* and Jean Crawford's *Jugtown Pottery: History and Design*. The former is a thorough reconstruction of the achievement of the Moravian potters, who flourished in the eighteenth and early nineteenth centuries, the latter a slim volume on the most famous of the twentieth-century potteries. Both proved useful in delineating developments at the beginning and end of the folk tradition, but neither gave more than passing notice to the huge numbers of farmer-potters who plied their trade across the state for some two centuries.

To compensate for this lack of written information, I took John Burrison's counsel and opted for a broad, interdisciplinary approach, employing all the tools of the folklorist. Instead of at the library, most of the work had to be done in the field. And here I found it an advantage to be working on southern pottery because of the tenacity of the old folk tradition. Not only did I discover that an immense number of pots waited to be documented, but I also found dozens of potters, former potters, and members of potters' families who could recall the old craft in remarkable detail. Two people who provided critical advice and direction at this point were Dorothy and Walter Auman, owners of the Seagrove Pottery and the Seagrove Potters Museum (the museum was recently purchased by the Mint Museum of Charlotte, but a basic collection of pottery will remain in Seagrove). A member of the Cole family, one of the oldest and largest pottery "dynasties" in the state, Dot had already carried out extensive research on the potters of the eastern Piedmont. In fact, she had purchased her own microfilm reader and had spent many long evenings—after spending the day at her wheel—poring over census records. Both she and Walter encouraged my interest, generously shared their deep-rooted knowledge of the craft, and allowed me to examine

and photograph the artifacts in their museum, which is a more graphic testimony to the potters of North Carolina than any book can ever be.

In this way, I began using my camera to catalog systematically all the old pots that were signed, dated, or identifiable in some respect. At the same time, I located old kiln and shop sites, examining the "waster dumps" of broken shards and recording the remaining equipment: clay mills, treadle wheels, kilns, and the like. And with my tape recorder—the tool that most sharply distinguishes the folklorist from the art historian or anthropologist who is interested in ceramics—I proceeded to collect the reminiscences of many who were familiar with the craft.

Even today there are many scholars who distrust oral histories. Carefully transcribed interviews, however, provide one of our richest resources for uncovering the past. Most assuredly, memory can be a fickle ally, subject to all types of distortions. I have been told, for example, that all pottery with blue (cobalt) decoration was made by the Indians; that groundhog kilns were 75′ and 100′ long (16′ to 20′ is the norm); and that some potters thought nothing of turning five hundred gallons of ware every day (eighty to one hundred would constitute a full day's work). Other informants have understandably slanted their accounts towards members of their families or their areas. But lapses in memory, family pride, and regional patriotism are all part of human nature, and the distortions they cause are easily checked and verified. The cardinal virtue of such interviews is that they provide a view of the potter's world from the *inside*: his terminology, his interests, his values. Accordingly, wherever possible, I have let the potters speak for themselves, and they have done so with remarkable articulacy.

All transcriptions of the interviews are verbatim, except that I have occasionally removed common pauses or stall phrases ("uh," "you know") when a speaker employed them in abundance. In most cases I have also standardized the spelling. Each of us uses some form of dialect, and there is little purpose in tormenting the reader with a series of Joel Chandler Harris style deliveries. At no point have I attempted to splice separate tapes or even sections of the same interview. All quotations are carefully documented, and ellipses clearly indicate omitted materials. Eventually all of these recordings will be stored in the Folklore Archives of the University of North Carolina in the remodeled Wilson Library, where they will be available to interested scholars. Although I have made full use of these tapes, much remains for the researcher interested in the traditional craft of pottery or the history and culture of North Carolina.

In short, what began as a dearth of information gradually became an excess. Admittedly, many gaps yet remain—on the genealogical level alone there are enough entanglements and puzzles to provide someone so inclined with a lifetime's work. And there will always be those who can say, "Well, you left out my great-grandfather," or "I have a jug initialed 'C.G.Z.' that you overlooked." For any such omissions, misjudgments, or errors I can

only apologize. I feel confident that I have listed a good 90 percent of the folk potters, and in any research project the time comes when one has to stop and put it all down on paper. Moreover, the numerous photographs (old as well as new), census and estate records, wills, account books, and, above all, tape transcriptions, have enabled me to go somewhat beyond the usual ceramic history by providing a fuller portrait of the craft, the people involved, and the meanings of the pottery to rural North Carolinians.

Indeed, without a full consideration of the cultural context, it becomes all too easy both to romanticize and to depreciate the achievements of the folk potter. Scholars and collectors concerned with aesthetics tend to seek out the rare, the atypical, the presentation piece, and to praise the old potters as artists—men who transmuted raw earth and fire into unique forms of great beauty. In reality the folk potter spent long hours digging and hauling and turning and burning endless loads of "mud," as he modestly referred to his clay, in order to supplement an often meager income derived from the land. His wares were familiar and everyday—not innovative or unusual—because they were shaped through generations of use for specific functions, such as pickling beans or preparing butter or storing brandy. This does not mean that his work was without artistic potential. But his craft was first and foremost a business, a cottage industry or miniature production line, designed to supply useful implements to the surrounding communities and states.

No less invalid is the opposing attitude that his output and technology were "crude" or "primitive," mere second-rate imitations of superior commercial or artistic operations. Such condescending judgments spring from an elitist perspective that fails to comprehend the autonomy of the folk potter's work. As a true jack-of-all-trades, he had to master a wide range of skills, from selecting and preparing the appropriate raw materials to selling the finished product. Moreover he was not even a full-time craftsman; farming and other occupations—sawmilling, blacksmithing, even teaching or the ministry—were no less important to him than making pottery. As my research progressed, I came to admire both the complexity and the overwhelming logic of the folk potter's operations and aims. Perhaps he was no scientist or technician, but he approached his work in a direct, pragmatic manner and displayed an admirable competence in all he did. It is essential, then, to view the realities of his world with openness and understanding.

More than a century and a half ago, Englishman Simeon Shaw completed his *History of the Staffordshire Potteries*, in which he drew much of his information from "the Reminiscences of many aged Persons, who had witnessed the time and manner in which the Art of Pottery had attained much of its importance." Even then Shaw proudly recognized that he had rescued "from Oblivion much of these Materials, which probably would have been irretrieveably lost, thro' the demise of several since the Memoranda were first obtained, and the indifference or listlessness of others rapidly ap-

proaching the bourne which bounds the confines of the Eternal World."[1] For my own part, I share with Simeon Shaw the same enthusiasm and sense of urgency and pride in having performed a similar service. Sadly, many of our old masters—Javan Brown, Ben Owen, and Enoch Reinhardt, just to mention three of my favorites—have passed on to Shaw's Eternal World since I began this project. But much of their wisdom remains with us in untransmuted form, both in this history of the North Carolina potters and in the living craft that continues to flourish in many parts of the state. In recent years, in fact, the number of potters descended from the old families has actually increased. Ben Owen's son and grandson, Wade and Ben, have reopened the old shop on Route 705. Not far up the road is Laura Teague Moore's Potluck Pottery, situated at the homeplace of her grandfather, John Wesley Teague. Vernon Owens has purchased the Jugtown Pottery, where he is assisted by his brother Bobby. And a short distance to the east, in Sanford, General Foister Cole has returned from South Carolina and built a second shop near the original Cole Pottery. Were they to return today, the old turners and burners would no doubt view the work of their descendants—a varied array of smaller, brightly colored, more decorative forms—with some degree of amusement and scorn. Such toys and fancy wares were not part of their repertory. But there is no question they would be pleased at the vitality and prosperity of the tradition they once worked so hard to establish and maintain.[2]

ACKNOWLEDGMENTS

My major resource in writing this account of the folk potters has been people, not manuscripts or journals or books. For more than a decade, I have crossed and recrossed the state, driving the equivalent of several trips around the world and encountering numerous North Carolinians who have generously shared their knowledge of the old craft of pottery. Scholars, archivists, curators, collectors, antiques dealers—and most of all, the potters, their families, and friends—could not have been more considerate in response to my requests for information. Let me illustrate.

During the winter of 1977, I was doing research along the western border of Catawba and Lincoln Counties, the center of alkaline-glazed stoneware production. One chilly afternoon I knocked on the door of a farmhouse owned by the descendant of one of the prominent local potters. The couple inside was watching the soaps, but they quickly admitted me and turned off the set when they heard of my interests. Two hours later I left with genealogical information on the family, photographs of pottery still in their possession, a list of other neighbors to interview, and a large jar of homemade pickles. As we walked off the porch, the husband laughed and said, "You know, when we saw you drive in, we thought you were one of those college kids peddling magazine subscriptions. I was planning to get rid of you in a hurry!" Perhaps the pickles were an added bonus, but the time and material assistance given by this couple typify my fieldwork experience.

I know that mere lists of names are insufficient repayment for all the help I received, but I want to attempt to acknowledge all who have contributed to this book. Hopefully the study that follows will provide a better reward. First, I thank the readers of the original manuscript—Dorothy and Walter Auman, John Burrison, and Georgeanna Greer. They are the pioneer scholars in southern pottery; they greatly improved the quality of the final product and, in fact, offered continuous assistance while I was doing the fieldwork and writing. Numerous other ceramic historians contributed valuable leads or advice, notably Cinda Baldwin, Joey Brackner, Terry and Stephen Ferrell, Susan Myers, Arlene Palmer Schwind, Robert Sayers, Nancy Sweezy, and Hank Willett.

After I commenced this project over a decade ago, I gradually discovered numerous institutions across the state that contained important pottery or historical records, or in some cases both. All of the following organizations and individuals shared their holdings with me in the most courteous and

generous manner: the Ackland Art Museum, University of North Carolina at Chapel Hill (Evan Turner and Innis Shoemaker); the Catawba County Historical Association, Newton (Sidney Halma); the Friends Historical Collection, Guilford College (Damon Hickey); the Greensboro Historical Museum (William Moore); the Mint Museum, Charlotte (Milton J. Bloch, Daisy Bridges, and Stu Schwartz); the Museum of Early Southern Decorative Arts, Winston-Salem (Frank Horton, Brad Rauschenberg, Luke Beckerdite, and John Bivins); the North Carolina Room, University of North Carolina (Alice and Jerry Cotten); the North Carolina State Archives, Raleigh; the Pack Memorial Library, Asheville; the Randolph County Public Library, Asheboro (Charlesanna Fox and Carolyn Hager); the Seagrove Potters Museum (Dorothy and Walter Auman); the Southern Historical Collection, University of North Carolina; the Southern Stars Chapter No. 477, United Daughters of the Confederacy, Lincolnton; and the William R. Perkins Library, Duke University (William R. Erwin, Jr.).

Old pottery is a passion among North Carolinians; at times it seems there is a collector in every city, town, and hamlet. Among those who have willingly allowed me to examine and photograph their pots are: John and June Allcott, Nancy Conover, Cece Conway, Allen and Barry Huffman, Bill Ivey, Hurdle Lea, Rodney Leftwich, Ralph and Judy Newsome, Isabel Thomas, Mary Emma Thomas, Ann and William Trotter, and Reid Voss. Perhaps the late Roddy Cline of Lincolnton best exemplifies the virtues of the North Carolina collector: an extreme zeal for discovering new pots and potters; an extensive knowledge of the craft and its place in his region; a generosity in sharing his treasures; and, above all, a deep love for the lustrous, dark alkaline glazes made by the local potters, from Daniel Seagle to Burlon Craig.

Where there are collectors, there must be dealers. In most cases, at least in North Carolina, the two roles are inseparable; almost everyone who runs a business retains a small personal collection and finds it agonizing to part with fine examples, no matter what the profit. Among the antiques dealers who have contributed in all sorts of ways to this undertaking are: Mr. and Mrs. L. C. Beckerdite, Mary Frances Berrier, Tom and Cindy Edwards, Edd and Peggy Elkins, Gray Ezzard, Ron and Gwen Griffin, Robert and Jimmie Hodgins, Clint Lindley, Paul Lloyd, Larry Loman, Thurman Maness, Katherine McFarland, Carl and Deeta Pace, Doug and Jane Penland, Mr. and Mrs. Owen B. Reid, Ben Rood, Quincy and Betty Scarborough, Mr. and Mrs. A. H. Stuart, and John Wilson. Special thanks go to Howard Smith, who has made many important discoveries and who continues to pursue research all over the Southeast.

Finally, and most important of all, there are the almost innumerable individuals who either worked in a potter's shop or observed at firsthand the potter's world. To the fifty-five persons cited in the interviews, who made direct contributions to the text, I want to add: Mrs. Herman Barnes, Asa

Blackburn, Tom Blackburn, Forrest Brackett, Charles Brown, Mr. and Mrs. Evan Brown, Robert Brown, Neolia Cole, Elbert Craven, F. Duval Craven, Robert Craven, James Creech, Alma Duncan, Elmer Duncan, Malcolm Duncan, Grace Fleming, Virginia Forrest, Daniel Garner, Walter Gay, Nell Cole Graves, Martha Meaders Griggs, Mrs. Albert Hartsoe, Doug and Karen Helms, Bob Hilton, Howard Hinshaw, Mary Huffman, Della Ritchie Lingerfelt, Becky Melton, Mrs. Virgil Mosteller, Bobby Owens, Boyd Owens, Vernon Owens, Walter Owens, Charlie Phillips, Mr. and Mrs. Dan Phillips, Mr. and Mrs. L. O. Searcy (who gave me the pickles), Mrs. Kenneth Shuford, and Earl Weaver. If I have overlooked anyone, I can only apologize; all improved the accuracy and helped to flesh out the human dimensions of this study.

For photographic assistance I thank Dan Ellison, Roger Manley, and Jim Wise, all expert photographers and former students in the Curriculum in Folklore. In addition, the staff of the UNC Photo Lab very skillfully printed—and occasionally reprinted—many of the black and white photographs. For financial assistance I am indebted to the University of North Carolina for a Kenan Leave during the spring semester of 1977 and also to the University Research Council for several grants that helped to defray expenses. I also want to acknowledge an extremely generous three-year grant from the National Endowment for the Humanities that provided the funds for extensive travel as well as photographic supplies and tapes. I should add that the findings and conclusions presented here do not necessarily represent the views of the Endowment.

My children, Geordie and Eliza, have grown up in a home full of churns, jars, milk crocks, and face jugs, and to my knowledge have never broken a single one. I imagine that as youngsters, they assumed that these were normal domestic furnishings; they must have wondered why their friends didn't have any. Today they have their own small collections of North Carolina pots and patiently continue to tolerate their father's strange obsession.

Finally, I want to dedicate this book to four North Carolina potters—Dot and Walter Auman, and Irene and Burl Craig. Without their patience and insights and generosity, I could not have written it. I hope that it illustrates their heritage as they would wish to see it.

North Carolina Pottery Centers

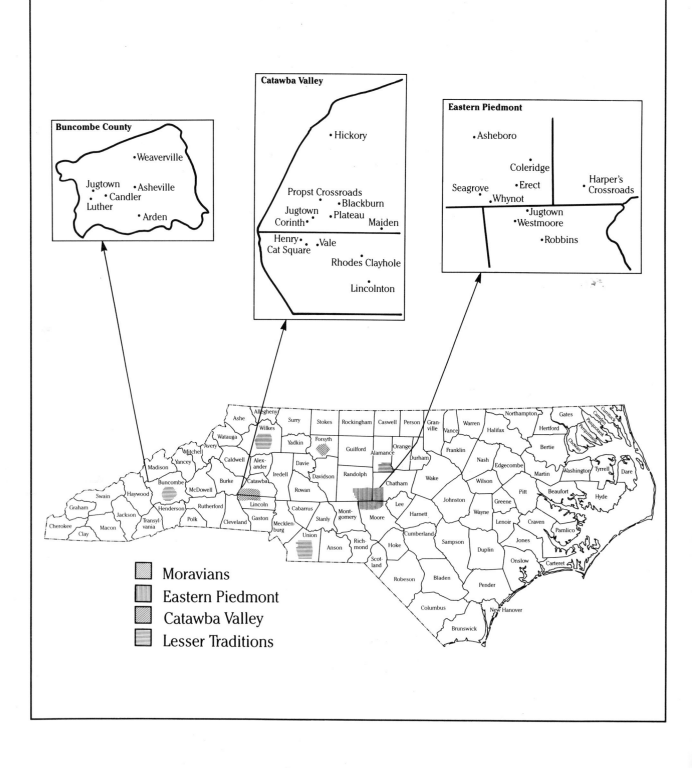

Buncombe County

- Weaverville
- Jugtown
- Asheville
- Candler
- Luther
- Arden

Catawba Valley

- Hickory
- Propst Crossroads
- Blackburn
- Jugtown
- Plateau
- Corinth
- Maiden
- Henry
- Vale
- Cat Square
- Rhodes Clayhole
- Lincolnton

Eastern Piedmont

- Asheboro
- Coleridge
- Seagrove
- Erect
- Harper's Crossroads
- Whynot
- Jugtown
- Westmoore
- Robbins

Moravians
Eastern Piedmont
Catawba Valley
Lesser Traditions

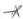

PART ONE. HISTORY

1

THE AGE OF EARTHENWARE

Virtually all of the folk potters in North Carolina have resided in the Piedmont. While this finding may appear surprising or illogical, it is buttressed by solid historical and geological facts. According to migration patterns, the earliest potter should have worked in the Albemarle region of the Coastal Plain, as Englishmen from Virginia settled this area during the second half of the seventeenth century. Not far to the north, potters were already at their wheels at a number of sites near Jamestown, Virginia.[1] However, there is no evidence that any potter ever inhabited this northeast corner of the state. In fact, other than several nineteenth-century shops in the vicinity of Fayetteville, the entire Coastal Plain is devoid of potteries.

Certainly the lack of first-rate clays was a deterrent. To the east of the fall line, which divides the Piedmont from the Coastal Plain, there are no primary (or residual) clays. There are adequate deposits of sedimentary clays for stoneware, particularly along the Cape Fear River south of Fayetteville, but they contain sand and organic material and are inferior to those of the Piedmont.[2] More important, the plantation economy and active commerce with England, the West Indies, and the Northeast must have further discouraged potters from setting up in this region. Large quantities of naval stores, foodstuffs, lumber, and tobacco were exported and exchanged for a variety of manufactured goods, including all types of tin, pewter, glass, and ceramic utensils.[3] In short the lack of quality clays, combined with the easy access to foreign markets, made the pottery business in the Coastal Plain an unattractive gamble.

The Mountain region of the state fared slightly better in terms of numbers of potters, but overall the tradition there was still small and widely scattered. This fact contradicts the frequent assertion that folk artifacts—log buildings, quilts, ballads—are found only in the mountains. The folklorist discussing his or her fieldwork in North Carolina is invariably greeted with, "Oh, you must go to the mountains all the time!" Whatever the reasons for this romantic attitude, the truth is that all three regions of the state are rich in traditional culture. The Mountains are even deficient in some respects: there the wildfowl decoy carver was conspicuously absent, and, for very compelling reasons, there were few potters as well. Settlement in the west began only toward the end of the eighteenth century; the population was sparse and transportation extremely difficult. Moreover, in the second half

of the nineteenth century, potters from Lincoln and Catawba counties established a thriving market in the Mountains. The greatest number of potters lived in Buncombe County, and the most notable shop was the one above Candler—at Jugtown, as the region was called—operated from the 1840s to the 1940s by members of the Stone and Penland families. Most of the Mountain potteries were established no earlier than the middle of the nineteenth century, and the potters came in from established ceramic communities in South Carolina, Georgia, and the Catawba Valley of North Carolina.

The potters of the Coastal Plain and the Mountains constituted less than 10 percent of the total in North Carolina. It was in the Piedmont that their numbers swelled, and there the earthenware and stoneware traditions reached their fullest development. Heavy settlement of the area began during the second quarter of the eighteenth century and produced a region very distinct in character from the Coastal Plain. "There were fundamental differences between East and West—in geography, national stocks, religion, social life, and economy. The East was settled largely by English and by Scottish Highlanders; its plantation economy was based on slave labor and aristocratic ideals. . . . The commercial outlets of the East were largely with England, the West Indies, New England, and, to a lesser extent, with Virginia and Charleston. The backcountry trade contacts were more difficult and fewer, being largely restricted to overland trade with Pennsylvania, Virginia, and South Carolina."[4] An abundance of fine clays, a rapidly expanding population, an economy dominated by small, self-sufficient farms, and a relative isolation from outside markets created ideal conditions for the folk potter.

Until the second quarter of the nineteenth century, earthenware was the predominant type of pottery in North Carolina. Produced from an ocher-colored surface clay containing considerable quantities of iron and other impurities, earthenware is fired to a relatively low temperature of 1800°F. To make it watertight, the potters coated it with a lead glaze, normally consisting of: a lead flux; a silica source such as sand, flint, or quartz; and other additives including clay, water, and coloring oxides. The resulting pieces possess warm, earthy tones of yellow, orange, pumpkin, rust, and brown, though when fired in a reduced (oxygen deficient) kiln atmosphere they may take on an olive green cast. Because it was so brittle, little of the early earthenware has survived.

Without question, the dominant craftsmen in the Piedmont in the latter half of the eighteenth century were the Moravians. In 1753 they commenced building a settlement called Bethabara on the north side of what is now Winston-Salem, and just two years later a German-born potter named Gottfried Aust (1722–1788) arrived from Bethlehem, Pennsylvania. Aust and his successors were highly skilled potters. In the words of John Bivins, Jr., who has written the definitive study of their achievement, they were "master potters whose quality and scope of workmanship was virtually unparalleled

in the entire country during the period."[5] Their slip-decorated earthenwares are the equal of any produced in Pennsylvania or New England, and their experiments with the sophisticated English creamware and stoneware and, later, German faience, reveal a surprising open-mindedness and awareness of fashionable tastes. With their penchant for innovation, they cannot be labeled "folk" potters; in fact, few other potters anywhere in eighteenth-century America were so conversant with contemporary European ceramic developments.

Even more remarkable, these developments occurred in what was then a dangerous, unsettled, frontier region. Indian attacks were a frightening reality, and the Moravians knew how isolated and vulnerable their small settlements were. On 5 July 1756, just a month before Aust burned his first full kiln of ware, the inhabitants of Bethabara convened to discuss the Indian problem. "It was decided to protect our houses with palisades, and make them safe before the enemy should invade our tract or attack us, for if the settlers were all going to retreat we would be the last left on the frontier, and the first to be attacked."[6] In one respect, this precarious situation proved an advantage for the potter: there was an enormous need for his products. On 15 June 1761, "people gathered from 50 and 60 miles away to buy pottery, but many came in vain, as the supply was exhausted by noon." Enterprising merchants from other areas began placing orders; on 12 November 1762, "John Moore, a store-keeper from the Catawba River, came to get a wagon-load of pottery." Even in 1770, fifteen years after Aust's arrival, the demand had not slackened. On 21 May in Bethabara, "there was an unusual concourse of visitors, some coming sixty or eighty miles, to buy milk crocks and pans in our pottery. They bought the entire stock, not one piece was left; many could only get half they wanted, and others, who came too late, could find none. They were promised more next week."[7] The following year Aust moved to the newly constructed town of Salem, where he continued to prosper. On 25 May 1773, the members of the Aufseher Collegium, the governing body for Moravian businesses, reported that "although the Tavern shows only a small profit, and the Tannery has a deficit of something like £40:, we can thank the Lord for His blessing on the Store and the Pottery."[8]

Much yet remains to be learned about the Moravians, but an abundance of historical records and extensive archeological research have enabled John Bivins to produce a remarkably detailed account of their pottery. Accordingly the Moravian potters will receive only passing mention in this study. It does not appear that they exercised a significant influence on the much larger body of folk potters that was developing simultaneously across the Piedmont. Their numbers remained small—Bivins suggests that there were six master potters, as well as perhaps two dozen journeymen, apprentices, and general workers.[9] Moreover, the wares they produced, the technology they employed, and the highly regulated community in which they lived were very different from that of the rural farmer-potters. Finally, the

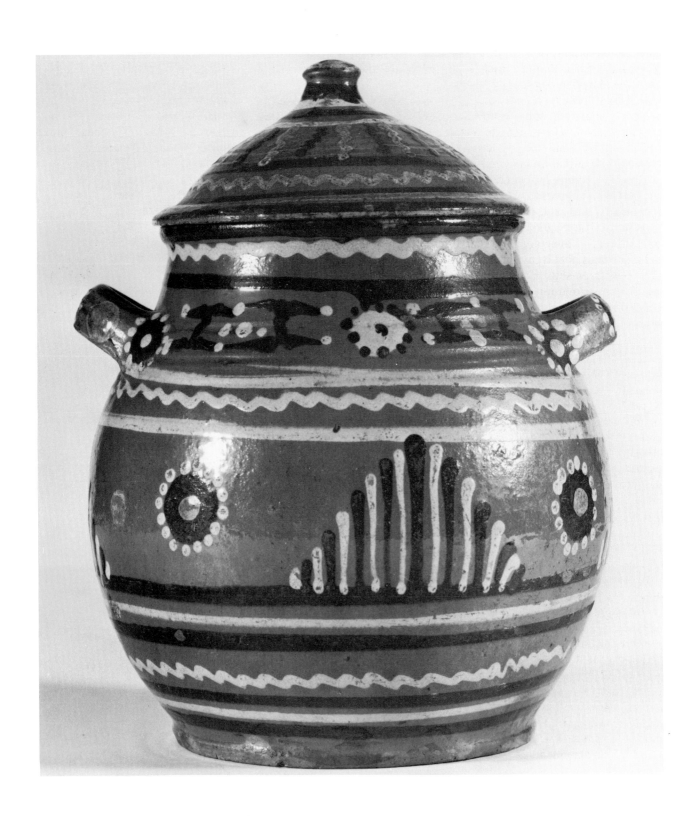

quintessential Moravian tradition faded in the 1820s with the retirement of the second master, Rudolf Christ (1750–1833), and the general acculturation of the Moravian community.

Aside from the experiments in creamware, stoneware, and faience, the characteristic product of the Moravian potters was lead-glazed earthenware. Gottfried Aust—who was born in Silesia and later apprenticed to Andreas Dober in the Moravian town of Herrnhut, Germany—brought directly to rural North Carolina a mature knowledge of German pottery. Under his tutelage the Moravian potters produced a wide range of forms, including "bottles, jugs, jars, drinking vessels, bowls, pans, pots, lighting devices, miscellaneous forms, and pressed ware." No less striking was their emphasis on decoration: "The potters in Wachovia considered slip-decorated ware a standard item in their everyday production."[10] The Moravians first bisque fired their wares, that is, fired them once before glazing. Then they applied a variety of colored slips under a lead glaze, set the pots back in the kiln, and fired them a second time. Sometimes they coated the entire surface with a light or dark slip base, or engobe, and then trailed on elaborate geometrical or floral designs, often in three or four contrasting colors (fig. 1-2). Other specialties were press-molded wares such as stove tiles or bundt pans—both characteristic German forms—and a series of bottles in the shapes of various animals. While such decorated pieces appear to have been remarkably plentiful, the bulk of the output consisted of utilitarian forms such as the graceful, high-necked storage jar in figure 1-3.

In comparison with the Moravians, the North Carolina folk potters—who first produced earthenware and, later, stoneware—exhibit a limited repertory of forms, the most common being jars, jugs, churns, milk crocks, pitchers, and baking dishes. Other than pipes, they produced no molded wares, and conscious attempts at decoration were both infrequent and restrained. Moreover, there is no evidence that they bisque fired their pots; this would have involved an unnecessary expenditure of time, labor, and resources. Instead they applied their glazes directly to the greenware and then burned the pottery only once.

A superficial review of the technology suggests other critical differences. Where the Moravian potters employed a kick wheel (fig. 5-6), their counterparts in the countryside seem to have preferred the treadle wheel (although it is by no means certain when this type was introduced). In addition, the Moravians did not use a pug mill to grind their clay "until well into the nineteenth century." Instead they "all seem to have been contented to either use the clay as it came from the ground, or to wash it." Finally, there is the problem of the Moravian kilns. Little archeological data is available at present, but John Bivins suggests that "there is every indication that they were of the updraft type commonly called a 'beehive' because of their shape." However, in 1793 Rudolf Christ constructed a "'secondary'" kiln whose "'length and width from the outside would amount to eight feet,'" and which he planned to use for "'several sorts of pottery which do not burn

Figure 1-1
Lead-glazed earthenware jar, late eighteenth century, attributed to Rudolf Christ, Forsyth County. H 7½". White, green, and brown slip decoration over the red clay body. Courtesy of Old Salem Restoration, Winston-Salem, N.C.

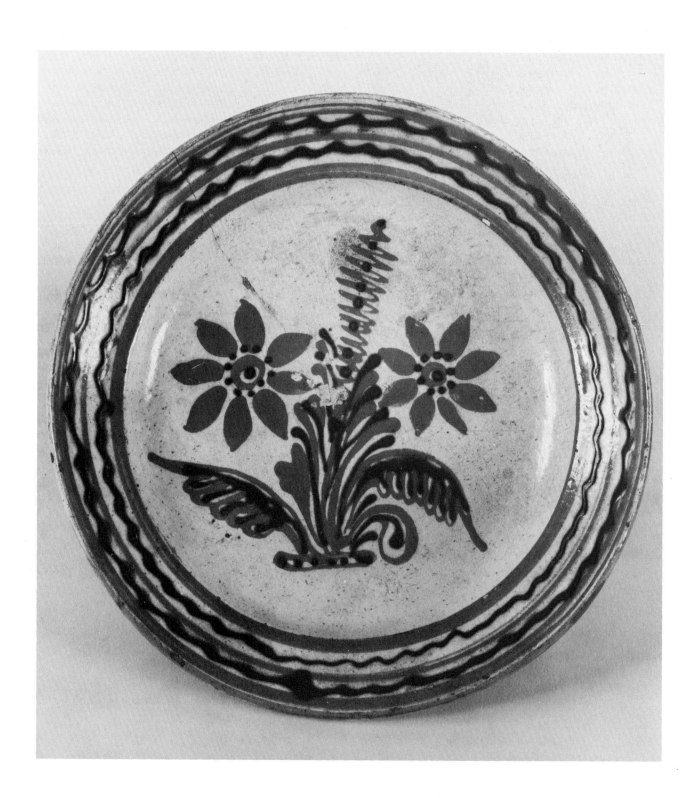

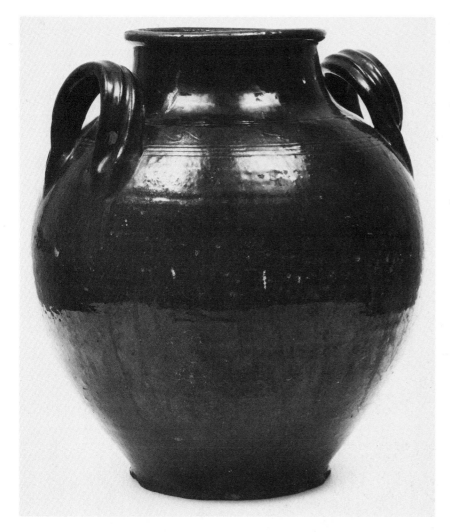

Figure 1-2
Lead-glazed earthenware plate, second half of the eighteenth century, attributed to Gottfried Aust, Forsyth County. H 2½", D 11¾". Orange and green slip decoration over a white engobe. Courtesy of Old Salem Restoration, Winston-Salem, N.C.

Figure 1-3
Lead-glazed earthenware storage jar, late eighteenth century, Forsyth County. H 13¾". The deep purple-brown hue suggests that the potter added manganese dioxide to his glaze. Courtesy of Old Salem Restoration, Winston-Salem, N.C.

hard enough in the usual potter oven.'"[11] The dimensions and the function cited here allow the possibility that this may have been a small rectangular kiln of the type widely used in Germany for making stoneware. In any case, there is no hard evidence of any ancestor to the long, low groundhog kiln that came into use in the early nineteenth century. Little is known about the equipment used by the potters who worked outside of Salem in the eighteenth century, but it is clear that the technology of their successors did not come from the Moravians.

Even the few Moravian potters who continued at their craft into the second half of the nineteenth century remained deeply faithful to their heritage. The 1850 Census of Manufactures for Forsyth County indicates that Henry

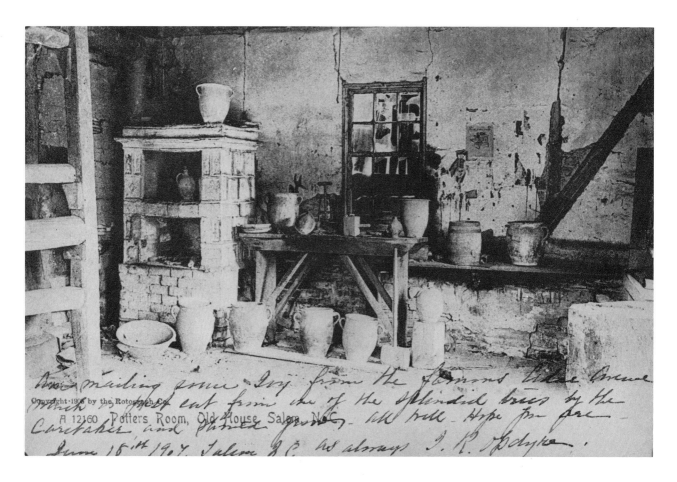

Figure 1-4
Interior of the Henry Schaffner–
Daniel Krause pottery shop in Sa-
lem, Forsyth County, during the late
nineteenth century. Courtesy of Old
Salem Restoration, Winston-Salem,
N.C.

Schaffner (1798–1877) and John Butner (1778–1857) were still producing "earthenware." By contrast, the folk potters, such as William N. Craven of Randolph County, were all now engaged in "stoneware making." A postcard published in 1905 provides graphic evidence of the ultimate isolation and tenacity of the Moravian practices (fig. 1-4). It illustrates the interior of the last pottery in Salem and clearly shows stove tiles, a basin, jugs, and a series of jars with vertical strap handles—all anachronistic earthenware forms that could as easily have been made over one hundred years earlier. In no way could this scene be mistaken for the shop of any of the dozens of stoneware potters who were active across the Piedmont and in the Mountains at precisely the same period.

No less distinctive was the rigidly controlled craft community within which the Moravian potters worked. "The Moravians were quick to realize that a stable foundation for a new settlement was an active and diversified craft system. The output of trades in a new town would ensure income for

the community through trade, thus insuring the continuance of the missionary program."[12] Because it played such an important economic role in the proselytizing activities of the Brethren, the pottery was owned and carefully regulated by the congregation. Moreover, the potter was a full-time craftsman, and the craft was perpetuated by the guild system, with its formal ranks of master, journeyman, and apprentice. This closed, tightly ordered system effectively sustained the Moravian values through the first seventy-five years of the settlement. The folk potters, on the other hand, worked under very different sociocultural conditions. Their shops were owned by families or individual entrepreneurs; they were part-time craftsmen who worked equally hard at farming, sawmilling, wagoning, and dozens of other occupations; and their craft was perpetuated within the family or among neighbors by a more informal oral tradition and on-the-job training.

With the acculturation of the German population in North Carolina, the Moravian pottery declined in both quality and quantity. The signs of change are clear enough. In 1821 Rudolf Christ, the only potter whose skills and output matched that of Aust, retired and relinquished the pottery to the improvident John Holland (1781–1843). By 1822 the annual inventories were no longer in German; they were now "written wholly in English."[13] And finally, in 1829, the Aufseher Collegium closed its books and leased the pottery to Holland. From this time on, the potters ran private businesses and worked on in relative obscurity until the beginning of the twentieth century. Thus, the dissolution of the Moravian ethnic community brought to an early end one of the most remarkable ceramic traditions in the United States.

It is ironic that we know more about the pranks and mischievous behavior of the unruly Moravian apprentices than we do about the lives of such prolific potters as the Cravens of Randolph and Moore Counties or the Seagles of Lincoln County. The Moravian fathers took a keen interest in the energetic young boys who snitched pots to trade for gingerbread or knives, or who coaxed their pets into shops full of fragile greenware.[14] Regrettably, the Moravians did not keep track of their neighbors as they did their own kind; therefore, there was no one present to record the activities of such rural masters as John A. Craven or Daniel Seagle. For the most part, the well-studied achievements of the Moravians have tended to obscure the work of many other potters, of both German and British ancestry, who were also producing earthenwares in the Piedmont in the eighteenth and early nineteenth centuries. Unfortunately very little pottery has survived that can reliably be attributed to a particular potter, place, or period. Unlike the later stonewares, the earthenware was rarely marked or signed, and it exhibits much less variety in form, glaze, and texture. Still, sufficient information has surfaced to permit some insight into the major historical and regional developments that mark the beginning of the North Carolina folk pottery tradition.

The earliest recorded potter in the state was a German named Johannes Adam, who emigrated from Pennsylvania and purchased one of the first lots

in Salisbury, Rowan County, in May 1755. This was a full six months before Gottfried Aust reached Bethabara. With the influx of settlers from the north, Salisbury grew rapidly. By 1762 there were more than 150 people in the township, enough to require "a candlemaker, a doctor, two lawyers, a potter, three hatters, an Indian trader, a weaver, a tailor, a tanner, a butcher, two merchants and a wagon maker."[15] Situated at the junction of several roads, the most important of which was the Great Philadelphia Wagon Road out of Pennsylvania and Virginia, Salisbury developed into an important trading center. Not a single piece of Adam's pottery has been identified, but there is tangible evidence for another early potter. In 1774 Thomas Andrews, a thirty-five-year-old English potter, embarked from London on the Carolina Packet with the stated intention of "going to settle."[16] Andrews located in Chatham County, where, in 1779, he composed a will directing that "my Kill now in the Possession of William Dunken be Sold Imediately after my Decease to the Highest Bidder and the Money arising from the Sale to be applied to the payment of my Just Debts." Presumably the kiln itself was not sold, but rather the finished earthenwares inside it. Many years ago, a farmer from Chatham County named Mr. Whitehead uncovered a small green flask in one of his fields and presented it to Charles C. Cole. Although it is badly damaged, it bears the inscription "Thos. Andrews 1784." Cole simply dropped it in a bureau drawer, but many years later his daughter, Dorothy Auman, recognized that it was made either by the above Andrews or his son Thomas, who received from his father "two Hundred acres of land to Include the Plantation whereon I now live."[17]

A similar document reveals that potters were also active a short distance to the south, in Mecklenburg County. In his will, dated 28 March 1797, Philip Miller wrote that "I will and Bequeth to My Son James Miller the Plantation and all utentials belonging to a plantation, My horse Sadle and bridle, the Potthouse and Kiln-house and whatever Stok may be to the fore. . . . And [I] Hereby further add to this will by way of Codesil that one kill of potters ware that Has not been mentioned In the above will I order to Imploy sum sutable person to Burn sd kill and all my Just Debts to be paid out of it."[18] Miller had been a potter for at least fourteen years, for he is mentioned in the estate records of David Flough, also of Mecklenburg County. From 1783 to 1792, Flough purchased varying quantities of earthenware from Miller, ranging in value from £0.5.0 to £1.3.0 per year. Flough partially repaid his debt by "pading Two Sadles," "Covering Sadle with my Leather," and exchanging bushels of wheat and corn, but at his death he still owed Miller £2.4.4.[19] Although there are interesting details here—the early use of the Southern term "burn," instead of fire, and the barter between the two men—the lack of additional information limits the value of such historical documents. What forms, for example, did Flough purchase? What were their sizes or prices? Were any of them decorated or marked in a particular way? Furthermore, an examination of James Miller's will provides no evidence that he carried on his father's craft.

For most of the early earthenware potters, the records provide little more than names and dates—just a few tantalizing traces of a potter's lifework. Sometimes the census does offer a bit more. For example, the 1820 Census of Manufactures for North Carolina cites David Mauney as a "Potter, In Crockery," in Rutherford County. With capital of thirty-six dollars invested, he used three thousand pounds of clay, one male employee, and one mold and furnace to produce "Crocks & Pots of Earthen Ware," with "Sale of articles Tolerable good." The Mauneys were early settlers in this region, but nothing more is known about this craftsman. There is, however, one important resource that suggests the geographical distribution of the earliest potters. A sufficient number of indentures of apprenticeship have survived to show that numerous potters were spread across the Piedmont by the beginning of the nineteenth century. These forms were issued by the county courts and served to outline the essential responsibilities of both parties involved. Typically, the young apprentice promised to "faithfully serve" until he was twenty-one and to "behave as a good and faithful servant towards his said master." The latter, in return, agreed to provide proper food, lodging, and apparel and, most importantly, to teach "the art & mystery of a potter." In North Carolina most of these documents were issued between the Revolution and the Civil War. Only a tiny fraction of them pertained to pottery; the predominant occupation for boys was "farmer," and for girls, "spinstress." In short, these "apprenticeships" were not the formal documents associated with the guild system, for in the majority of cases no true craft was taught. In effect, they were a convenient means of removing orphans from the care of the county and providing cheap labor for rural families with few or no children.

Table 1 is derived from James H. Craig's *The Arts and Crafts in North Carolina, 1699–1840* and, with the exception of Henry Barroth, includes only those potters outside the Moravian tradition. As brief as it appears to be, this list of seventeen potters (not counting Barroth) and nineteen apprentices partially illuminates an otherwise dark period. First, the number is quite impressive, and there can be little doubt that these figures represent only a fraction of the total. In most cases the folk potter did not formalize an apprenticeship with a document; he simply took on members of his family or neighbors as assistants or coworkers. A similar situation obtained in eighteenth-century Staffordshire, where "the majority of work-people were not formally apprenticed. Those who did enter into a full-term apprenticeship seem to have had the prospect of becoming master-potters." In general, however, "training, both for skilled and unskilled processes, could have taken place within the pottery without a formal apprenticeship."[20] Most of the apprentices listed in Table 1 are specifically designated as "orphans," indicating that these documents existed for the primary purpose of finding them a home. Even more significant is the marked separation between potters of British name in the eastern Piedmont (Orange, Guilford, and Randolph counties) and those of German extraction to the west (Rowan,

Iredell, and Lincoln counties). This regional division became more pronounced after the first quarter of the nineteenth century, as the potters multiplied in number and shifted to the production of stoneware. By 1850 Randolph County was the center of the salt-glazed stoneware tradition, while Lincoln County was firmly established as the nucleus for the production of alkaline-glazed stoneware.

Aside from the flask signed "Thos. Andrews 1784," the only other hard evidence of earthenware production—outside the Moravian tradition—during the eighteenth century comes from the so-called Mount Shepherd Pottery, which was located about eight miles to the northwest of Asheboro, in Randolph County. When earthenware shards were discovered at this remote location in 1968, potters Dorothy and Walter Auman immediately recognized their importance and proceeded to organize and fund a study of the site. The main excavations took place during the summers of 1974 and 1975 under the leadership of archeologist Alain C. Outlaw, who recovered numerous shards and artifacts, located the foundations of a potter's shop and other structures, and uncovered the complete base of a circular updraft kiln. Although additional research and analysis is needed, the evidence suggests that the pottery was active during the last quarter of the eighteenth century and that several potters worked there. In fact, the clay mortar in the kiln walls contains wasters—fragments of previously fired pots—clearly revealing that this is not the original kiln.[21]

A recent historical study by L. McKay Whatley leaves little doubt that one of the potters at Mount Shepherd was Philip Jacob Meyer (1771–1801), a former apprentice under Gottfried Aust at Salem.[22] Like so many of Aust's underlings, Meyer was an obstreperous young man, who ultimately proved so defiant that the Collegium officially banished him from the Moravian community in 1789. Through an extended study of the Randolph County land records, Whatley established that Meyer owned the land on which the pottery was located at least as early as October 1793.[23] The shards recovered by Outlaw—including "stove tile, smoking pipe, utilitarian earthenware, and decorated slipware production"—confirm the presence of a Moravian potter.[24] Specifically the forms include press-molded pipes and stove tiles (albeit decorated with very un-Moravian military motifs), polychrome plates and dishes, a delicate, English-style teacup, and numerous cream pots. Other marks of a Moravian hand are the extruded handles, double-rim bowls, price marks on the bottoms of pots, and bisque firing. Finally, the glazes include a sophisticated English "Whieldon" type (requiring manganese and copper oxides) as well as elaborate red and green slip designs (including close copies of Aust's seedpod and frond motifs) over a white engobe.[25]

That Jacob Meyer extended the Moravian tradition into eastern Randolph County before the close of the eighteenth century seems indisputable. And he was by no means the first to leave the Salem area. On 25 March 1774,

TABLE 1

Indentures of Apprenticeship

Master	Apprentice (Age)	Date
Orange County		
John Bullock	Moses Newby (16)	31 Aug 1798
Guilford County		
Barnet Waggoner	Martin Summerz	21 Feb 1792
Thomas Beard	Elliot Dison (5)	22 Aug 1810
Randolph County		
Peter Dick	Isaac Beeson (18)	5 Nov 1806
William Dennis	George Newby (12)	3 May 1813
Henry Wadkins	Joseph Wadkins (10)	5 Feb 1821
Rowan County		
Henry Barroth	Thomas Passinger (12)	May 1777
George M. Murr	Joseph Bowen (10)	5 May 1797
George Murr	Jacob Winsler (17)	8 May 1798
Benedict Mull	Jacob Kelsipack (6)	6 Feb 1809
Thomas Passinger	George Freedle	16 Aug 1824
Iredell County		
Georg Davidson	Cornelius Craise	4 Feb 1794
Surry County		
Seth Jones	Thomas Dillard	13 Feb 1806
Mecklenburg County		
William Goodwin	Matthew Ormand (7)	25 Jan 1802
Lincoln County		
Andrew Yont	Christopher Long Cryer	17 Apr 1816
Andrew Yont	Joel Matthews (17)	18 Jul 1816
Jacob Thernbury	William Redman (10)	21 Apr 1818
John Pope	William Pope (9)	19 Jan 1819
Daniel Seagle	Daniel Holly (16)	23 Apr 1828

Source: Craig, *Arts and Crafts*, pp. 88–93.

another discontented Aust apprentice named John Heinrich Beroth headed southwest and settled in Salisbury.[26] His name appears in Anglicized form on the above tabulation of indentures, which indicates that he took twelve-year-old Thomas Passinger as his apprentice in May 1777. Given the sub-

Figure 1-5
Lead-glazed earthenware jar, second quarter of the nineteenth century, Henry Watkins, Guilford or Randolph County. H 7⅜", C 23⅞".
Signed in script: "Henry Watkins."
Courtesy of Old Salem Restoration, Winston-Salem, N.C.

stantial number of potters present in Salisbury (including the original Johannes Adam) and the fact that Passinger himself took an apprentice nearly half a century later, there is good reason to believe that the wares of Rowan County must have exhibited some Moravian influence. But no identifiable pieces survive to document this possibility.

What little reliable evidence survives from the wheels of the earthenware potters outside of Wachovia suggests that meandering individuals like Meyer and Beroth did not transplant the essential forms, glazes, and techniques of the Moravian masters. By contrast, the work of the rural potters appears very limited in range and highly restrained in decoration. Of the seventeen "masters" in Table 1, only two have left signed pieces—Henry Watkins and Daniel Seagle. Watkins was born about 1798 in Randolph County, the son of Quakers William and Lydia Watkins. His apprentice, the Joseph Wadkins listed above, was almost certainly his younger brother, as William's will of 1816 lists a son of the same name.[27] Henry apparently moved to southern Guilford County in 1837 to join the Center Monthly Meeting and to work as a potter, but by 1860 he had returned to Randolph County where the census records his occupation as a "Miller."[28] Figure 1-5 shows a squat, bulbous jar coated with a smooth, brownish-green lead glaze and signed in flamboyant script on the bottom "Henry Watkins." The prominent foot and elongated, gently curving neck typify the earlier earthenware forms and are not seen in the subsequent stonewares. In fact, in both respects Watkins's jar bears a general resemblance to the larger Moravian jar illustrated earlier in the chapter (fig. 1-3). More characteristic of the North Carolina tradition, however, are the closely attached, pulled lug handles. Moravian jars normally had vertical strap handles; moreover, the protruding pair on the large jar appear to have been extruded. Even more common are the incised bands on the shoulder that are deftly located so as to break up the surface of the jar. Such decoration—whether multiple rings or one or more "sine waves" enclosed by rings—could be quickly applied with a pointed object, such as the edge of the potter's chip, a coggle wheel, or even his fingernail. The main consideration here was speed: each band required but a single rotation of the headblock, a matter of only a few seconds. To the skilled potter such embellishment becomes almost a reflex action, the final touch before applying the handles and cutting the form off the wheel. While assuredly found in other ceramic traditions, these incised bands are extremely common on both the North Carolina earthenware and the later stonewares, and they constitute the major type of ornamentation in the folk pottery. As well as enhancing the visual appeal of the pot, they sometimes constituted a sort of signature for a particular potter.

A contemporary of Henry Watkins whose precise identity yet remains a mystery is the J. C. Cox who produced the lead-glazed jar and baking dish in plate 1. The Coxes were numerous in Randolph County, and the name also abounds in Quaker records, complicating the search for the potter. This jar

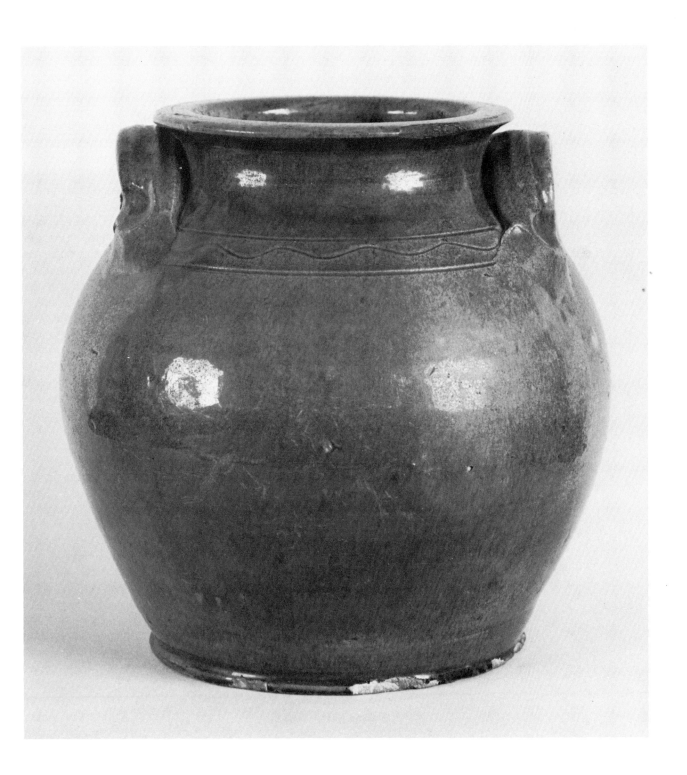

is slightly larger than the one turned by Watkins but is quite similar in form. However, the foot has disappeared, and the potter has been more sparing in the use of his glaze. Lead was expensive and by no means easy to obtain; consequently, the potter often coated only the interior and the area around the handles, to increase their adhesion to the walls of the pot. Again, the handles have been pulled in the potter's hands, but this time they are attached to the walls of the pot along their full length, the standard practice with the later stoneware. The neat thumbprints at the terminals add a degree of aesthetic appeal but are also practical—they indicate that the potter firmly worked the slab into the wall. The dish also exhibits an early form, with its deep central well, wide and nearly horizontal rim, and concave outer wall. Over time the baking dish lost its curvilinearity and gradually evolved into a simple, flat-bottomed, straight-walled container.

Based on the surviving forms, the jar and the baking dish appear to have been the most common products of the North Carolina earthenware potters. However, they also turned out jugs, pitchers, bowls, flowerpots, and, less frequently, plates, colanders, chamberpots, lamps, and kegs. Churns are conspicuously absent; no doubt a few were made, but it would appear that the potters and their clientele recognized that the fragile earthenware body was ill-suited for the vigorous stroking and pounding required to make butter. All of these products will be discussed more fully in the later chapters on form and function.

In general the earthenware vessels seem diminutive when compared with the later stonewares. Most have capacities of one gallon or less, whereas the far stronger stoneware containers in common use held up to five gallons, and not infrequently went as high as ten and fifteen gallons. Perhaps because they were smaller, the earthenwares appear to have been intended primarily for food preparation and consumption—that is, for use in the house—while the main function of stoneware was storage. Figure 1-6 illustrates a small, covered jar, perhaps a sugar container, together with a cream pitcher that likely came from the same hand. Both have prominent feet, indicating a relatively early date of production, as well as the familiar incising. The reduced size and attention to appearance suggest that this pair was intended for display and use at the table at family meals.

Earthenware production persisted through the second quarter of the nineteenth century, but thereafter the only two earthenware forms that the potters continued to make in significant quantity were the baking dish and the flowerpot. The former remained in demand because, with its porous body, it proved an ideal cooking vessel. The high-fired stonewares, by contrast, although far stronger and more vitreous, were less likely to withstand thermal shock and could crack when heated or cooled too rapidly. The subsequent decline in the quality of form and decoration of the earthenware is aptly illustrated by two dishes made by Solomon Loy and his grandson Albert (plate 2, fig. 1-7). Solomon was born about 1805, just early enough to have

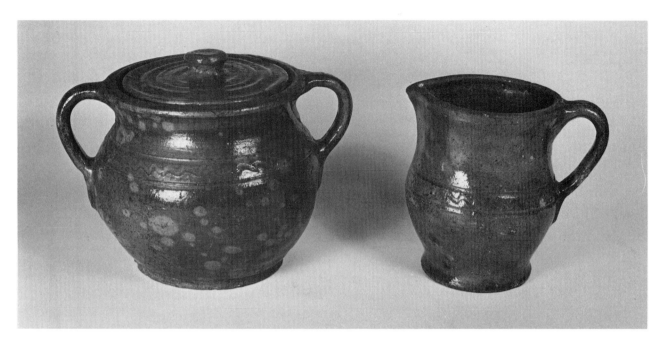

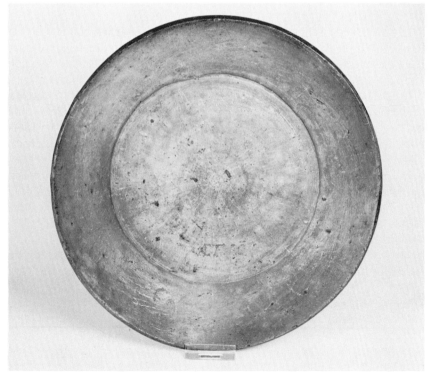

Figure 1-6
Lead-glazed earthenware sugar jar and cream pitcher, first half of the nineteenth century, eastern Piedmont. Jar: H 6", C 23⅜". Collection of Ralph and Judy Newsome. Pitcher: H 5⅞", C 16". Collection of the Ackland Art Museum, University of North Carolina at Chapel Hill, gift of Mr. and Mrs. Charles G. Zug III.

Figure 1-7
Lead-glazed earthenware dish, ca. 1925, Albert F. Loy, Alamance County. H 1⅞", D 10¹⁵/₁₆". Stamp: "A. F. Loy." Collection of Mr. and Mrs. William W. Ivey.

been trained by someone skilled in the full techniques of earthenware production. Although all other pieces that bear his name are salt-glazed stonewares, he has left this one flamboyant masterpiece in the earlier fabric. Like J. C. Cox's dish, his is skillfully turned, with a concave exterior wall, carefully squared rim, and well-formed interior. While he lacked the sophisticated control of an Aust or a Christ, Loy was clearly familiar with slip-trailing and created an exuberant pattern of triangles and bands to frame his name in the center. Where Aust might have employed a white engobe to set off a design in three colors, Loy has used just two, rust and white, against the deep orange of the clay under the lead glaze.

Although decidedly less elaborate than the works of the Moravians, Solomon Loy's dish represents one of the most complex examples of the North Carolina potter's folk art. In fact, it is the only one from this tradition that bears the potter's signature in slip, and was likely intended as a presentation piece for family or friends. More commonly, the local potters trailed a single color against the natural, warm tones of the clay body, usually in the familiar rings or sine waves that took little time to apply (fig. 1-8). Less frequently he sponged or spattered on a thin slip containing a coloring oxide. The dish in figure 1-9 (it is unsigned but was purchased by the Museum of Early Southern Decorative Arts together with the previously discussed jar by Henry Watkins) is a pumpkin color with a green wash containing copper oxide. The pattern is a random one, created in part by centrifugal force (on the spinning headblock) and in part by gravity (as the slip ran while the dish was set in a vertical position). Extremely rare are pictorial designs such as the oak leaf painted in iron or manganese slip on the shoulder of the jug in figure 1-10 or the leafy patterns on the dish in plate 2.

Most of the earthenware, of course, had no embellishment whatsoever, a sharp contrast to the Moravian output. And by the middle of the nineteenth century, the art of slip decoration had become irrelevant, as the potters shifted to stoneware. Dishes and like vessels made after this time are best characterized by the work of Solomon's grandson Albert, who was born about 1874 and worked in Alamance County into the second quarter of this century. Like his father, John, Albert was a stoneware potter. In contrast to his grandfather's ornate creation, his baking dish is heavy, straight-walled, hastily turned, and purely utilitarian. For Albert, earthenware was merely a sideline, a matter of burning an odd groundhog kiln full of dishes and flowerpots, and perhaps an occasional bowl or teapot, to satisfy his customers.

While there is ample evidence for an early and continuous earthenware tradition in the eastern half of the Piedmont, few wares exist to document a similar development in the west. Not a single piece can be attributed to the early cluster of potters at Salisbury, but good fortune has preserved two signed forms from Lincoln County. The first is a one-gallon, lead-glazed jug made by Daniel Seagle (plate 3), one of the masters listed on the tabulation

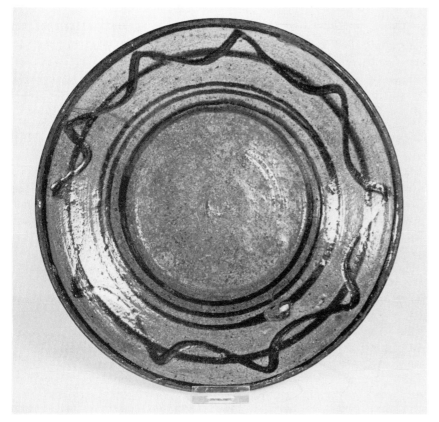

Figure 1-8
Lead-glazed earthenware dish, late eighteenth century, eastern Piedmont. H 2⅛″, D 10⅛″. Trailed black slip. Collection of Mr. and Mrs. William W. Ivey.

of apprentice indentures. The pronounced ovoid form, extended, flanged neck, and well-formed foot all bespeak an early date. The jug is further decorated with two sets of coggled bands of diminutive diamonds on both the upper and lower shoulders, and there are two small Maltese crosses—or perhaps they are fylfots—flanking the familiar stamp "DS." Next to the jug in the photograph is a small coffee jar, a very thin-walled piece with a domed lid, concave shoulder, and incised belly, which has descended through the family and could also have been made by Seagle. It is noteworthy that the indenture of 1820, with which he took Daniel Holly into his business, specifies that the latter was to be an "apprentice to the earthenware maker's trade."[29] Like Solomon Loy, Seagle began as an earthenware potter, but the dozens of magnificent forms in alkaline-glazed stoneware that bear his initials better represent his true lifework. Soon after he took on Holly, he must have turned to stoneware. The jug and jar above bear no resemblance to his later output, which is considerable. And all of the surviving wares stamped "DHOLLY" are also in alkaline-glazed stoneware.

Figure 1-9
Lead-glazed earthenware dish, early nineteenth century, Guilford or Randolph County. H 5/16", D 12 1/2". Copper green wash. Courtesy of Old Salem Restoration, Winston-Salem, N.C.

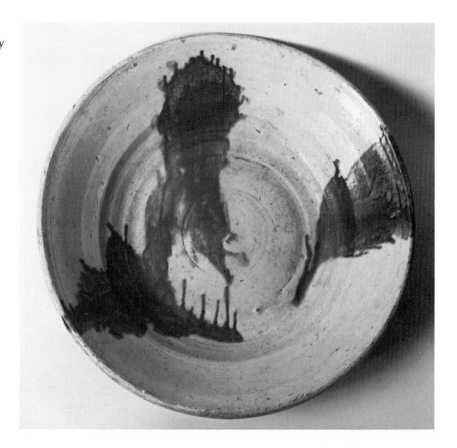

According to the census of 1850, Seagle's immediate neighbor at Vale, in northwest Lincoln County, was David Hartzog. Although his name does not appear in the indentures, Hartzog was also a prolific potter who, like Seagle, is best known for his stonewares. However, he, too, produced some earthenware: the small barrel or keg in figure 1-11 is marked around the belly "DAVIDHARTZOGHIꙄMAKE." On either side of the applied bunghole are lightly incised sine waves within rings, and the glaze has a deep purple-red hue, suggesting the addition of iron or manganese. While no slip-decorated wares have been discovered from this region, Seagle's jug and Hartzog's barrel demonstrate a mature knowledge of the use of the lead glaze. But aside from these two pieces, no other earthenwares can be reliably attributed to the Catawba Valley. In fact, it is highly unusual today to find *any* earthenwares in Lincoln or Catawba counties, either in the homes of the older families or for sale in shops or markets.

One reason for this dearth is the later date of settlement of the western Piedmont. This fact is reflected in the indentures for Lincoln County, which

run from 1816 to 1828, a time range considerably later than that spanning the indentures for the eastern counties. In other words, the craft was established in the west during the final decades of the earthenware tradition; men like Seagle and Hartzog, perhaps the seminal potters of the Catawba Valley, quickly converted to the new stoneware and trained their sons and daughters in the new medium. A second explanation lies in the clay body used with the alkaline glaze. When burned to maturity, it turns anywhere from a buff to a reddish purple and possesses a rough and porous texture. Because it is rarely so tight and vitreous as the stoneware of the eastern Piedmont, it manifests some of the qualities of an earthenware clay and can be used for cooking. A reasonable number of alkaline-glazed stoneware baking dishes and beanpots have survived, and it is said that milk crocks were also used for this purpose. Thus, it appears that once the transition to stoneware was made, the potters of the Catawba Valley saw no reason to continue producing a sideline of earthenware vessels for food preparation or consumption.

Although the ceramic and historical evidence remains limited, it is clear that the main period of earthenware production in North Carolina extended from the 1750s through perhaps the 1830s or 1840s. Compared to developments in the northeastern United States, this time span is rather late. Earthenware potters were among the earliest settlers in Virginia and Massachusetts, and by the mid-seventeenth century they were producing a variety of useful forms such as "storage jars, jugs, pitchers, bowls, cups, mugs, porringers and milk pans."[30] During the eighteenth century their numbers increased dramatically, particularly due to the influx of German potters in the mid-Atlantic region, and "American earthenware reached its height as a beautiful, if humble, art form."[31] However, by the time of the Revolutionary War, production had begun to taper off. One reason was the danger of lead poisoning from the glazes. An article in the *Pennsylvania Mercury*, dated 4 February 1785, cautioned that "the best of Lead-glazing is esteemed unwholesome, by observing people. The Mischievous effects of it fall chiefly on the country people, and the poor everywhere. Even when it is firm enough, so as not to scale off, it is yet imperceptibly eaten away by every acid matter: and mixing with the drinks and meats of the people, becomes a slow but sure poison, chiefly affecting the nerves, that enfeeble the consititution, and produce paleness, tremors, gripes, palsies, &c, sometimes to whole families."[32]

Perhaps the "observing people" in the larger towns and cities of the northeastern and mid-Atlantic states were aware of such catalogs of disease and decay, but not so the "country people," who continued to use the noxious lead glazes on a daily basis. However, by the early nineteenth century, warnings of the potential health hazards involved had worked their way down into the Southeast. One particularly graphic account, written for a Nashville newspaper in 1817, explained that earthenware

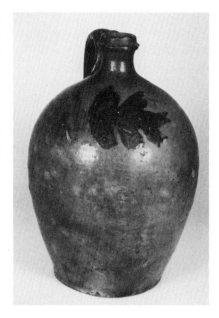

Figure 1-10
Lead-glazed earthenware jug, first half of the nineteenth century, eastern Piedmont. H 11⅛", C 24½", 1 gal. Oak leaf in brushed brown slip on shoulder. Collection of Mr. and Mrs. William W. Ivey.

Figure 1-11
Lead-glazed earthenware barrel,
second quarter of the nineteenth
century, David Hartzog, Vale, Lin-
coln County. L 7", C 18⅛". Stamp:
"DAVIDHARTZOGHIꙄMAKE." Collec-
tion of Dr. and Mrs. Allen W.
Huffman.

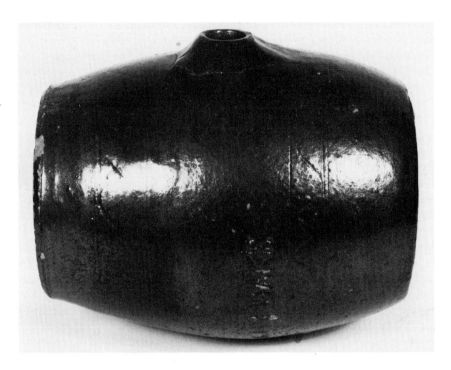

is generally made from clay that contains a . . . larger quantity of lead in its glaze than ought to be used in order that it may run with a trifling heat, and therefore is soon corroded by lard, butter, oil, salt, honey, acids, preserves, &c. which articles become mixed with the glaze, and frequently proves injurious to the health of those who use them. Two persons (the very next neighbors to the writer of this) were sometime ago taken very suddenly and violently ill, with pains in the bowels—a Doctor was immediately sent for, and on enquiring what they had last eaten, was informed, 'Bacon and Cabbage, with a little vinegar'—he then enquired for some of the latter article, when an earthen jug was handed to him; he soon discovered that it had been thickly glazed and but slightly burnt, and its contents become an ascetite of lead, which every Physician knows is a tolerably strong poison.[33]

Concurrent with the growing knowledge of the lethal nature of lead was another development that contributed to the decline of earthenware: the emergence of the stoneware industry in the United States. By the late eighteenth century, large deposits of stoneware clays had been discovered, notably in New Jersey and New York, and the public was eager to purchase the new salt-glazed jugs, jars, and pitchers. Stoneware has several advantages over earthenware. Because it is fired to a much higher temperature, it is far more durable and vitreous. Moreover, stoneware is easier to clean and

nontoxic, as no lead is used in the glazing. In the opinion of the correspondent cited above, "for the common purposes of life, and for cheapness, durability, and health, no kind can surpass it—in all these qualifications it is equal to the best porcelain."[34]

Such changes in taste and technology were slow in coming to the North Carolina folk potter. Although the Coastal Plain was being settled when earthenware production was at its zenith, the lack of good clays and, most importantly, the cash-crop economy that necessitated extensive commerce with outside markets, seem to have worked against the establishment of local potteries. The major growth of the Piedmont, on the other hand, did not occur until the second half of the eighteenth century. By this time, earthenware production was declining in the North, and so the local tradition arose late and was somewhat attenuated. The critical "generation gap" occurred during the second quarter of the nineteenth century. Potters born near the beginning of the century, like Solomon Loy or Daniel Seagle, were competent in both earthenware and stoneware. But those born about 1825 and thereafter—including Solomon's and Daniel's sons John M. Loy and J. Franklin Seagle—made almost all stoneware. Only in the eastern half of the Piedmont did the potters maintain a small sideline of earthenwares into the twentieth century.

Overall, very little earthenware was ever produced in any of the states to the south and west of North Carolina. There stoneware was the predominant type of pottery, due largely to the relatively late settlement of those regions. Within this well-defined southern ceramic region—best delimited by the occurrence of the alkaline glaze, which is found from North Carolina south to Florida and west to Texas—only North Carolina exhibits an extensive earthenware tradition. The Moravians, of course, were the star performers, but as a small, closely regulated religious and craft community, they represent something of an anomaly. Their influence was not extensive, and the brilliance of their achievement has obscured the work of the other early potters in the state. There were ever-increasing numbers of turners outside of Wachovia. As early as 1789, one of the leaders of the Moravian community lamented that "more potter shops are being built in the neighborhood, and while they make little good ware it hurts our market, and it is a wonder that our pottery has been able to maintain itself."[35] Just how many there were by this time it is impossible to say, but this chapter lists or discusses more than forty, and that figure does not include members of such large and prolific early families as the Coles and Cravens. Given the lack of historical data and archeological research and the informal nature of the folk tradition, the number of earthenware potters could well approach one hundred. But even this total is small compared to the next group of potters, who developed a new and characteristically southern stoneware with distinctive regional qualities and a rich variety of forms and glazes.

2

THE EMERGENCE OF STONEWARE
THE SALT GLAZE

It is generally accepted that the salt glaze first appeared in Germany, possibly as early as the fourteenth century, and most certainly by the fifteenth. From Germany the technique spread gradually across Europe and finally into England, where in 1671 John Dwight of Fulham (now a section of London) obtained the first patent to produce salt-glazed stoneware. Both the German and English products were exported to the American colonies in huge quantities, and thus it was not until the early eighteenth century that a native stoneware industry began to develop in the mid-Atlantic region. One of the earliest potters was Johan Willem Crolius, a German immigrant who arrived in Manhattan in 1718. Others include Johannes Remmi (Remmey) in Manhattan; Anthony Duché, a Huguenot who emigrated to Philadelphia from England; and the "poor potter" of Yorktown, Virginia, whose wares exhibit both German and English influence.[1]

As might be expected, the Moravians appear to have produced the first salt-glazed stoneware in North Carolina. An itinerant English potter, William Ellis of Hanley, appeared in Salem in 1773, and in May of the following year "made a successful 'burning' of Queensware, and one of stoneware, so that the process was 'fairly understood here.'" The precise nature of this stoneware remains unknown; John Bivins speculates that it "more than likely was of the white salt-glazed variety then declining in popularity in England."[2] The young Rudolf Christ was particularly interested in new types of pottery, and by 1795 he had successfully burned a kilnful of gray, salt-glazed stoneware. Apparently he used this experiment to develop a sideline to his earthenware, for the inventories after 1800 list "stone" jugs, mugs, crocks, and chamberpots.[3] However, the output remained very small, and the bulk of these forms continued to be made in lead-glazed earthenware.

Outside the Moravian community, the lack of precise documentation makes it impossible to pinpoint the first stoneware potter. However, the surviving wares, associated names and dates, and oral tradition all suggest that stoneware was first produced during the initial quarter of the nineteenth century. This was a full century after Crolius arrived in New York, but the time lag is understandable, given the very gradual growth of the stoneware industry in the North and the comparatively late development of the southern Piedmont. Among the likely candidates for early stoneware producers are Gurdon Robins and Company of Fayetteville, Cumberland County; Benja-

min Beard of Guilford County; one of the Cravens or Coles in Randolph County; or, somewhat less likely, a Seagle or Hartsoe in Lincoln County. What is eminently clear is that stoneware production expanded rapidly during the second quarter of the nineteenth century, and by 1850 two concentrated centers had emerged. The larger one was located in the eastern Piedmont, in an area that included the southeastern quarter of Randolph County, the northern edge of Moore County, and southwestern Chatham County. Here numerous potters, most of them of British stock, produced salt-glazed stoneware as well as small quantities of earthenware. About one hundred miles due west, along the western end of the common border of Lincoln and Catawba counties, was a slightly smaller body of potters, almost all of German descent, who were burning a distinctly different alkaline-glazed stoneware. Both of these centers—hereafter referred to as the "eastern Piedmont" and the "Catawba Valley"—grew out of the earlier earthenware traditions; together they form the nuclei for the two major types of traditional stoneware in North Carolina.

The earliest dated stoneware producer was the firm of Gurdon Robins and Company, which was established by 1820 in Fayetteville, in the southwestern corner of the Coastal Plain. Located at the upper end of the navigable portion of the Cape Fear River, the town was an important commercial center in the early nineteenth century, an ideal location for an ambitious businessman. The 1820 Census of Manufactures indicates that the company was quite substantial. Four men and six boys, working with three wheels and one kiln, used 200 tons of clay, 100 bushels of salt, and 120 cords of wood to produce five thousand dollars worth of salt-glazed stoneware. Robins apparently planned to conduct his business on the broadest possible scale, as he advertised his wares at wholesale prices:

POTS.	JUGS.		
6 Gallon	6 do	$12	per dozen
5 do	5 do	11	do
4 do	4 do	9.50	do
3 do	3 do	7.50	do
2 do	2 do	5	do
1 do	1 do	3	do
½ do	½ do	2	do
¼ do	¼ do	1.50	do
⅛ do	⅛ do	1	do

Also available were "'Pitchers, Mugs, Churns, Kegs, Chambers—Fountain and Common Inkstands (equal to Glass).'"[4]

Recent sleuthing by Fayetteville historian Quincy Scarborough has shed considerable light on this early operation. "During the early decades of the nineteenth century," he observes, "Fayetteville developed strong ties with the lower Connecticut Valley." Among the many immigrants was merchant Gur-

Figure 2-1
Salt-glazed stoneware jug, ca. 1820,
attributed to Edward Webster, Fay-
etteville, Cumberland County.
H 16¼", C 33", 3 gal. Stamped:
"Gurdon Robins / & Co. / Fayette-
ville." Collection of Quincy and
Samuel Scarborough.

don Robins of Hartford, who by 1816 had established a store in partnership with his brother-in-law Timothy Savage. The two men advertised " 'a general assortment of Dry goods, Groceries and Hardware,' " including imported ceramic utensils. On 18 June 1818, for example, they offered " '50 crates and hogheads [*sic*] of crockery and glass ware.' "[5] Many of these goods were carried west and sold in the Piedmont of North Carolina. Apparently the market was strong, and so the two men decided to make their own pottery instead of importing it.

Capital they had, but they required a skilled potter to direct their operation. Not surprisingly, they looked north rather than west and enticed Edward Webster of Hartford "to move to Fayetteville in 1819 to assist with constructing the kiln and the new stoneware factory."[6] Edward was a member of a prominent family of potters in Hartford that made stoneware from 1810 to 1867.[7] By 1820 his younger brother Timothy may have joined him in Fayetteville, and about 1828 a third brother, Chester, also arrived.[8] Although the indicated output was extremely large, few pots have survived that can be attributed to the firm. Figure 2-1 illustrates a three-gallon, salt-glazed jug that is stamped on the shoulder opposite the handle "Gurdon Robins / & Co. / Fayetteville / III." Grouped around the base are examples of kiln furniture that Scarborough recovered from the site in 1982. Most likely the ware was stacked in a large upright kiln—a circular scar made by one of the crude clay props or spacers is readily visible on the shoulder. The jug itself is very different from the later North Carolina stonewares and represents a direct transplant from the Connecticut tradition. Most characteristic are the pronounced foot, the long, corded neck, and the thick handle attached almost horizontally into the side of the neck. In addition, the exterior was covered with a dark iron wash, a practice then common in the Northeast and England. Finally, the interiors of these wares were coated with a slip glaze, because in this type of kiln the salt vapors could not enter the pots. In the low, unstacked groundhog kilns later used by the North Carolina stoneware potters, this additional operation was unnecessary.

For all its promise, the pottery did not prosper. "By the fall of 1823, Robins' business failed and he returned to Hartford." Edward Webster apparently ran the pottery into the 1830s and proceeded to stamp some of his wares with his own name (fig. 2-2). The jug shown here is similar to the previously illustrated one, even to the point of bearing the same "Fayetteville" stamp. The eventual demise of the shop was in part due to the economic panic of 1837, but in a broader sense it was probably attributable to the ready availability of all classes of imported wares.[9] Wealthy merchants or planters in the Coastal Plain placed special orders for the finest English pottery of the time, while others could afford the more utilitarian forms.[10] A field survey by the Museum of Early Southern Decorative Arts (MESDA) in Winston-Salem, North Carolina, has uncovered numerous pieces of early English and American stoneware in this region. Figure 2-3 shows a late

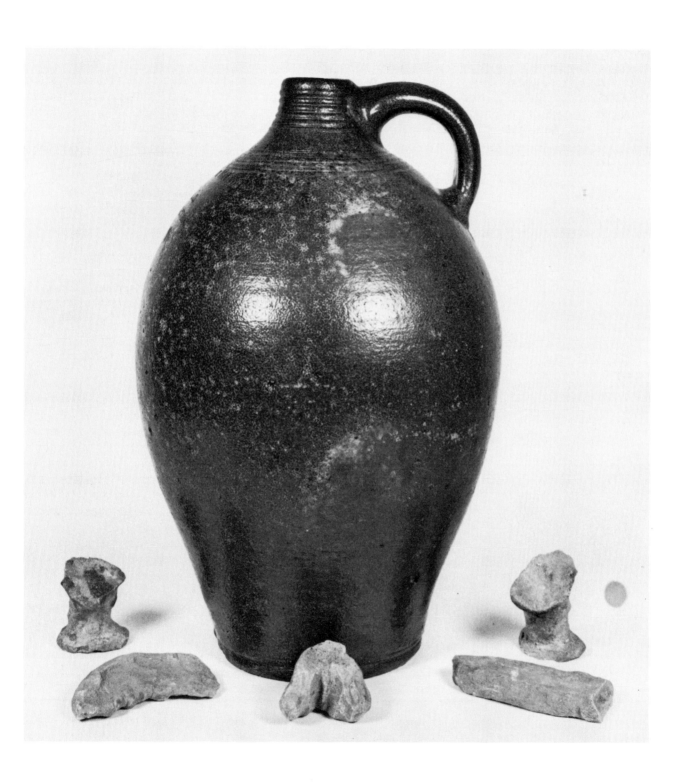

Figure 2-2
Salt-glazed stoneware jug, ca. 1825, Edward Webster, Fayetteville, Cumberland County. H 12⅛", C 25¾", 1 gal. Stamped: "EDWARD WEBSTER / Fayetteville." Collection of the Mint Museum, Charlotte, N.C.

eighteenth-century English jug, glazed with salt over a coating of brown iron wash, which was found at the Cupola House in Edenton. In turn, figure 2-4 illustrates an American product, a jar with trailed cobalt decoration made about 1860 at the Somerset Potters' Works in Pottersville, Massachusetts, and located by the MESDA research team in Halifax County. Such imported

Figure 2-3
Stoneware jug, salt glaze over iron wash, late eighteenth century, England. H 19⅝". Courtesy of the Museum of Early Southern Decorative Arts, Winston-Salem, N.C.

wares were common throughout the Coastal Plain, and their abundance is reflected in the early port records. A few sample entries for "Port Brunswick," a general designator for the towns of Brunswick and Wilmington on the lower Cape Fear River, attest to the quantity and diversity of the imports:

Date	Ship	Origin	Cargo
22 Apr 1785	Ship Ann	Cork	2 creats of Earthen Ware
10 May 1785	Brig Nancy & Jean	Glasgow	36 juggs
23 Jun 1785	Brig Jessie	Liverpool	83 large Stone Juggs 81 Small do
16 Nov 1785	Schooner Speedwell	Boston	a quantity of Earthenware
16 Nov 1785	Sloop Sally	Rhode Island	23 Stone jugs
5 Dec 1785	Sloop Nancy & Polly	Philadelphia	6 creats earthen ware
30 Jan 1786	Schooner Willing Maid	New York	10 Crates Earthen ware
30 Jan 1786	Brig Polly	St Astetia	1 Hhd queens ware

Earthenware and stoneware, both British and American, predominate, but there are also a significant number of listings for Queensware (creamware), the highly refined white earthenware developed by Josiah Wedgwood and others in Staffordshire in the mid-eighteenth century. The hogshead of Queensware cited above likely came from one of the western English ports via the Caribbean island of St. Eustatius.[11]

There is little question that it was this intense foreign competition that spurred Gurdon Robins to establish his company in the first place. In advertising the opening of his " 'New Establishment' " and offering " 'at Wholesale, at reduced prices, a large and universal assortment of Ware,' " he affirmed the benefits of patronizing a local potter: " 'Among the advantages which will result to those who favour us with their custom in preference to purchasing abroad, are,—they will have all sound ware—they will save the freight, which is considerable—they will also save commissions and exchange, and will not be obliged to take as large an assortment as when they purchase their year's stock abroad—and, lastly, they will be encouraging a Domestic Manufactory.' "[12] Robins's arguments are convincing. By all odds his firm should have flourished as a supplier to retailers in both the Coastal Plain and the Piedmont, but it did not. Perhaps the prices were excessive for such homegrown, utilitarian products. The listing of his wares and prices indicated that the wholesale rates ranged from seventeen cents per gallon for a six-gallon jug to a whopping sixty-seven cents per gallon for the ⅛-gallon size. While comparable data for other North Carolina potters at this time is nonexistent, potters working from the mid-century on charged a *retail* rate of only ten to fifteen cents per gallon. Whatever the reason—cost, quality, management, tastes—Gurdon Robins and Company proved unable to compete with the rich variety of imported earthenware, stoneware, and creamware flowing up the Cape Fear River.

Figure 2-4
Salt-glazed stoneware jar, ca. 1860,
Somerset Potters' Works, Pottersville,
Ma. H 8½". Stamped: "SOMERSET
POTTERS' WORKS." Trailed cobalt
decoration. Courtesy of the Museum
of Early Southern Decorative Arts,
Winston-Salem, N.C.

Conceivably Gurdon Robins's real mistake was that he attempted to oper-
ate a pottery in the Coastal Plain in the first place. History shows that
remarkably few potters ever attempted to work in this region. As early as
1709, John Lawson, an explorer and surveyor of the Carolinas, had found

Figure 2-5
Edgar Allen Poe of Fayetteville.
Courtesy of the Museum of Early
Southern Decorative Arts, Winston-
Salem, N.C.

Figure 2-6
Salt-glazed stoneware butter jar, ca.
1890, E. A. Poe and Company, Fay-
etteville, Cumberland County. H
8½", D 9½", 2 gal. Stamped: "POE &
CO." Courtesy of the Museum of
Early Southern Decorative Arts, Win-
ston-Salem, N.C.

that "Good Bricks and Tiles are made, and several sorts of useful Earths, as Bole, Fullers-Earth, Oaker, and Tobacco-pipe-Clay, in great plenty; Earths for the Potters Trade."[13] His observations suggest that a few earthenware potters must have worked in the eastern part of the state during the eighteenth century. Commerce was not yet extensive, and the poorer classes would have required cheap containers for dairy products, meats, fruits, and vegetables. But careful research has failed to locate any such early craftsmen. One other tantalizing piece of evidence occurs in a 1796 letter from John Gray Blount, a prominent merchant, to Peter Schermerhorn of New York. "This will be delivered to you by Captain Smith by whom I send a kegg of Potters Clay or Fullers Earth of which there is in the neighborhood of this place an abundance on a piece of Land now for sale and as the value of the Land much depends on the Value of this Clay, I have taken the liberty of troubling you with the inquiry, Whether it is of such quality as to make it Valuable, please to enquire what the Clay is fit for and what worth per Ton deld. in New York Should it not answer to send there in time of peace when freight is low, it may answer to set up a Pottery here."[14] What happened to the clay is not known; very likely the New York potter judged it harshly, and the undertaking was abandoned. Blount was a perceptive businessman, and, unlike Gurdon Robins, he must have recognized that a pottery shop in his area constituted a very shaky investment.

The only other pottery of significant size in the Coastal Plain was E. A. Poe and Company, which was established in Fayetteville in 1880. Together with Z. F. Newton and, later, W. J. Tolar, Edgar Allen Poe ran a brick company that grew rapidly and remained in operation for more than half a century. By 1889 the firm was advertising the "Best Brick Manufactured South of Philadelphia" and boasted a "Capacity [of] 20,000 Per Day."[15] Just eight years later a pamphlet extolling the virtues of living and working in this region cited "Poe & Co., makers of building and paving brick of the finest quality, and of draining and sewer tiling, and pottery and earthenware."[16] From all indications, the pottery was a sideline to Poe's main business and was discontinued about 1898 when demand fell off. The clay came from "Poe's Bottom," a swampy area at the foot of Cool Spring Street, and the firm sold a variety of traditional forms glazed with salt or Albany slip. The wares were stamped "POE & CO." during the partnership and later, "E. A. POE" or "E. A. POE / FAYETTEVILLE.NC." Forms such as the butter jar in figure 2-6, with its flat lid, wide ear handles, and gallon capacity applied with a toothed coggle wheel, all betray a Moore County origin. Like his predecessor Gurdon Robins, Poe had to reach outside the area to find skilled turners. But at this late date he did not have to go to Connecticut; instead he imported William Henry Hancock and Manley William Owen from northern Moore County.[17]

While the rise and fall of Gurdon Robins's early enterprise in Fayetteville constitutes an important chapter in the development of North Carolina pottery, the subsequent saga of the Webster family is no less significant. For

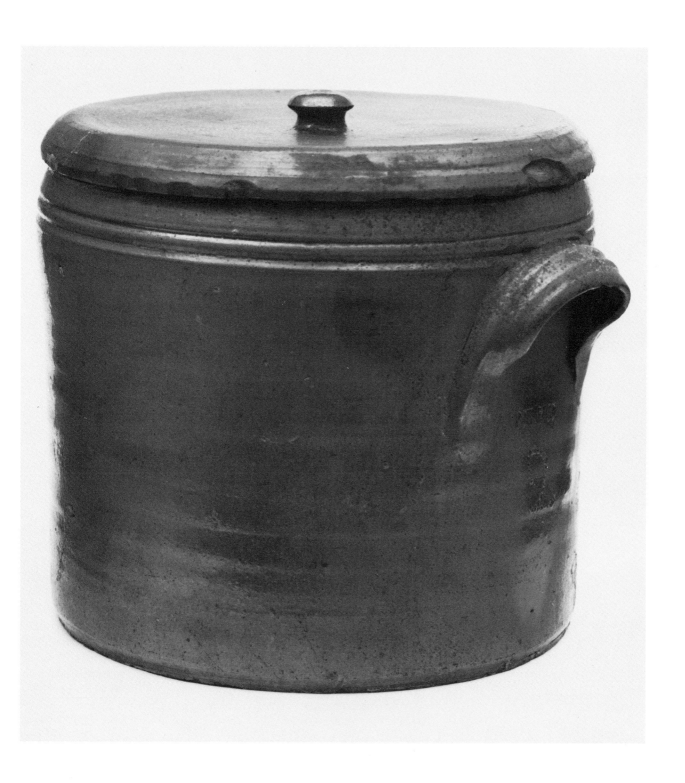

Figure 2-7
Salt-glazed stoneware jar and pitcher, attributed to Chester Webster, Randolph County. Jar: third quarter of the nineteenth century. H 11¾", C 20⅛". Incised bird and fish. Collection of Ralph and Judy Newsome. Pitcher: 1879. H 12⅞", C 26", 1½ gal. Incised bird, fish, flowers, and date. Collection of the Museum of Early Southern Decorative Arts, Winston-Salem, N.C.

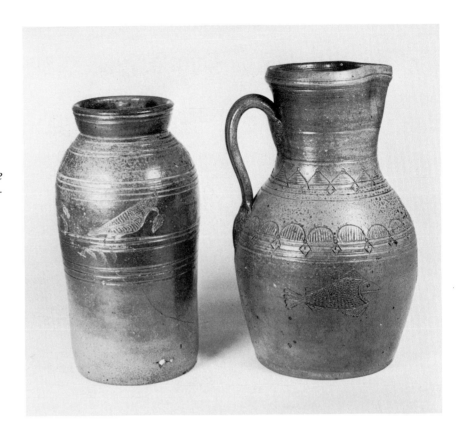

years, collectors have admired the work of the "Bird and Fish Potter" (fig. 2-7), who produced salt-glazed stoneware jars, jugs, pitchers, and even an inkwell and a keg. Remarkably, not a single one of these more than two dozen pieces is signed, though nine are dated, from 1842 to 1879. Variously covered with birds, fish, flowers, trees, branches, Masonic emblems, and geometric embellishments, this very consistent body of wares represents the only extensive tradition of pictorial incising in southern pottery. Birds and fish were, of course, common motifs on northern stoneware; in fact, Donald Blake Webster finds that "far more bird designs were produced than all other animal forms combined." The earliest decorations in the North were incised and often highlighted with cobalt; by the mid-nineteenth century, however, most were painted on with a slipcup or brush, a much faster method that was in keeping with the growth of large stoneware factories. In all, these North Carolina examples are as skillfully and elaborately executed as any of the examples in Webster's broad survey, *Decorated Stoneware Pottery of North America*.[18]

One early clue to the identity of the artist who made these wares was provided by Jean Crawford's 1964 study of the Jugtown Pottery, in which she

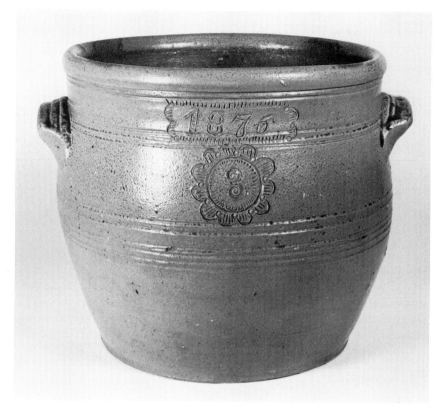

Figure 2-8
Salt-glazed stoneware jar, 1876, attributed to Chester Webster, Randolph County. H 9⅞″, C 35⅞″, 3 gal. Incised date and flower containing gallonage. Collection of the Mint Museum, Charlotte, N.C.

cites a letter—presumably sent to Jacques and Juliana Busbee—that describes the unusual work of Chester Webster. The unknown writer characterizes his work as "'distinctly Flemish—my pitcher is ornamented with childish drawings of birds and flowers, with scalloped bands and handle decorated at its juncture with the pitcher.'"[19] This is a very apt description of the large pitcher in figure 2-7, which now resides in the Museum of Early Southern Decorative Arts. More recently Quincy Scarborough has proven beyond all reasonable doubt that Chester Webster was the primary potter-artist who created these unusual pieces. Scarborough found a few incised shards at the site of the Robins shop in Fayetteville, some with cobalt blue markings that show portions of a leaf and also possibly an eagle with a shield. At the pottery of Bartlet Yancy Craven near Coleridge, Randolph County, where Chester worked as a journeyman turner, Scarborough found other fragments that correlate in general form and motif with other "Bird and Fish" pots.[20] The precise contribution made by Chester's brothers, Edward and Timothy, remains unclear, particularly as the former moved to South Carolina in 1838, but both of them may also have contributed to this tradition.

Close examination of these wares reveals a gradual acculturation into the

North Carolina tradition. The large jug in plate 4, with its handsome, zipper-mouthed fish, was probably made about the same time as the keg, dated 1846, that is illustrated in figure 11-14. Both are a very dark brown, suggesting that an iron wash was still being applied under the salt glaze. Later wares lack the wash and tend to be much lighter in color; some are a very pale gray. This jug form also differs from the previous examples by Edward Webster (figs. 2-1, 2-2). It exhibits a somewhat slimmer, more balanced ovoid shape and lacks the pronounced foot, reeded neck, and horizontal handle attachment used earlier. In short, it is beginning to look much more like a North Carolina jug than a Connecticut one. There also appears to be a gradual simplification in the incised designs. The fish on the large pitcher dated 1879 has straight rather than u-shaped scales, less elaborate detailing on the head and fins, and a straight rather than upcurved tail (fig. 2-9). In like manner, the heart-shaped wings and feathering on the birds become progressively straighter and less complex. What is illustrated here, then, in Scarborough's words, is "the assimilation of New England forms and decorative techniques by a Back Country district whose pottery industry had already been well established. Almost fifty years after incised decoration disappeared from Connecticut stoneware, at least one North Carolina potter still found ready market for such whimsey."[21] It appears that Chester's efforts did not go unnoticed. At least one other local potter, Elijah K. Moffitt of Randolph County, incised what appears to be a somewhat scrawny sucker on the belly of one of his jugs (fig. 2-10). His work lacks the sophisticated technique of Chester Webster, but Moffitt was still proud enough to emblazon his name above his creation.

When the Websters left Fayetteville and headed west, they may have recognized that prospects for potters were much more promising in the Piedmont. Chester and Timothy very wisely settled in Randolph County, which was already the center of a burgeoning stoneware industry. Perhaps the earliest signed salt-glazed stoneware from the Piedmont is the small jar stamped "BENJAMIN BEARD / GUILFORD COUNTY," illustrated in figure 2-11. The dark brown coloration results from the heavy iron content of the clay—or possibly an iron wash such as used by the Websters—and the unusual handles (one is missing) were formed by doubling over a pulled strap of clay and applying the ends to the shoulders. In fact, both the handles and the form of this jar—if that is what it is—are unique in the North Carolina tradition. Beard was born in 1775 and died in 1841, a time span that suggests that this piece could have been made in the very early nineteenth century.[22] Like E. A. Poe, Beard ran a brickyard and probably operated the pottery as a sideline. There is no evidence that he himself was a turner, and so it is very difficult to assess this unusual vessel.

Beard was a member of the extensive Quaker community in southern Guilford and northern Randolph counties, and was likely a relative of potter Thomas Beard, who took Elliot Dison as his apprentice in 1809 (see Table 1,

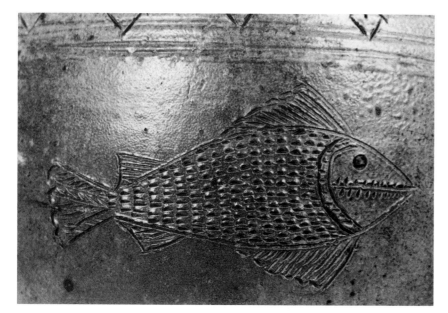

Figure 2-9
Incised fish on pitcher in figure 2-7
(detail).

Indentures of Apprenticeship, in Chapter 1). Thomas was married to Elizabeth Dicks, the sister of Peter Dicks of Randolph County, who also took an apprentice in 1806. Theirs was an influential family in the region, and in fact the town of Randleman in northern Randolph County was originally called Dicks "for Peter Dicks who built a grist mill here approx. 1830."[23] In turn, the mother of Peter's apprentice, Isaac Beeson, was Margaret Hoggatt (also spelled Hockett), quite possibly the aunt of potter Mahlon Hoggatt, a leader among the Quakers known for " 'a depth of Spiritual discernment that often created a sensation in the meeting. He was called a Prophet. He often told what had occurred or would occur in a short time when it was very evident that he could not have known before rising to his feet.' "[24] Others in this Quaker group include William Dennis, who took a black apprentice named George Newby in Randolph County in 1813; the previously mentioned earthenware potters Henry and Joseph Watkins; and possibly J. C. Cox. In all, these Quaker potters appear to have been prominent citizens with close relationships due to intermarriage and their religious activities at the monthly meetings. Because they were at work quite early—from the late eighteenth century into the early nineteenth—they burned both earthenware and stoneware, but the dearth of signed pieces makes it impossible to appraise their influence on the succeeding generations.

However, the true center for the salt-glazed stoneware tradition of the eastern Piedmont lies, not in Guilford County, but in the southeast quadrant of Randolph. There the two predominant families have been the Cravens

Figure 2-10
Salt-glazed stoneware jug, second half of the nineteenth century, Elijah K. Moffitt, Randolph County. H 14³⁄₈″, C 25¹⁄₄″, 2 gal. Signed in script: "E K. Moffitt / NC." Incised fish. Collection of Mr. and Mrs. Hurdle Lea.

Figure 2-11
Salt-glazed stoneware jar, early
nineteenth century, Benjamin Beard,
Guilford County. H 9⁹/₁₆", C 22⁷/₈".
Stamped: "BENJAMIN BEARD /
GUILFORD COUNTY / NC." Collec-
tion of Mrs. Nancy C. Conover.

and the Coles. Each has made pottery for perhaps two hundred years, through some nine generations, and continues right to the present day. The activities of the first three generations of both families remain obscure, and there are no wares that can be definitely attributed to any of the early potters. However, the fourth generation was born around 1800, at precisely the right time to pioneer the development of the new stonewares. Their lives and achievements, as well as those of the succeeding generations, can be documented in detail, and they provide a rich portrait of the growth of a regional craft, as well as demonstrating the importance of family as the organizing unit.

Oral tradition, reinforced by numerous magazine articles, avers that Peter Craven was the original potter in this area. For example, in 1929 Jacques Busbee, who with his wife Juliana founded the Jugtown Pottery in northern Moore County, asserted that "about 1740 two English potters from the Staffordshire district settled in the section where the Jugtown pottery now operates. Moravian and German potters settled in the western section of the state considerably later. These Staffordshire men made the necessary domestic articles that, in those pioneer days, could not be bought, for their craft was directed by the urge of dire necessity."[25] More recently, another director of Jugtown has reaffirmed that "pottery making on the Piedmont plateau of central North Carolina has been a continuous craft since 1740, when records show that Peter Craven, potter, paid taxes. Undoubtedly tax assessment was sketchy at that time and easily avoided, so it is possible that potters were at their wheels there even earlier."[26] In actuality, the Germans and Moravians appear to have been the first potters in the Piedmont; the Staffordshire connection is tenuous and unproven; and no tax receipt exists to verify Peter's work as a potter. But such regional patriotism and the desire to validate the historical roots underlying the Jugtown Pottery are understandable enough, and there may well be a grain of truth in these assertions.

In fact, there *was* a Peter Craven, although he arrived some twenty years later than specified above. Mildred Craven Galloway, genealogist for the family, has located an early land grant to Peter from Lord Granville, dated 1761, as well as a deed of 1764, which states that Craven purchased 197 acres on the Deep River in southeastern Randolph County. In addition, Galloway explains that "our Peter Craven came from an area in New Jersey sometime before 1744, at which date he is named in a road survey of early Augusta County, Virginia. By 1753, he is listed in the community of Big Lick (later Roanoke), on the Roanoke River, Virginia. . . . The area of southern New Jersey—Salem County—is the birthplace of our Peter Craven. The area is noted for glass manufacture—and probably pottery manufacture in colonial days."[27] Thus, it appears that the Craven family migrated from England during the early eighteenth century and then gradually moved south. Peter's entry date of about 1760 is consistent with general historical patterns of migration. "During the French and Indian War (1754–63) many people

moved from Virginia to North Carolina because of French and Indian attacks in 'The Valley,' and because of the eagerness of dissenters to escape taxes for the Anglican Church. This migration was accelerated at the close of the war."[28]

That Peter was not a believer in excess taxation is clearly illustrated by his active participation in the Regulator Movement in North Carolina, which was formed in 1768 to protest a corrupt and overbearing tax system. As one of the leaders, he is frequently cited in the legal records of the period. For example, a deposition of 9 October 1770 avers that on 24 September Peter Craven and others entered Hillsborough "armed with Wooden Cudgels or Cow Skin Whips wherewith they assaulted and beat John Williams Esquire. . . . Soon after they had run to surround the Court House He [Judge Henderson] saw them return beating and pursuing Col. Edmund Fanning till He took Shelter in the Store of Messre. Johnston and Thackston which they instantly beset, demolished the Windows, and threw Dirt and Stones or Brick Bats into the House in Order to force Him hence; That they also beat several other Gentlemen on the same Day." For his efforts, Peter was one of many cited "as being enemies to his Majestys Person and Government and to the liberty, happiness and tranquility of his good and faithful subjects of the Province" by a Grand Jury at New Bern on 15 March 1771.[29] Fortunately, Peter was never punished for his violent actions. However, several thousand of his fellow Regulators left the state, and six were hanged after the climactic Battle of Alamance in 1771.

At the present time—hypothetical tax records or pieces of ware notwithstanding—there is no tangible evidence that Peter Craven was a potter. The personal inventory of his son Thomas, who died in 1817, does contain the tantalizing entry "turning tools and lathe."[30] However, this item is sandwiched amidst a crosscut saw, adzes, jack planes, and augers, almost certainly indicating that it was a woodworker's lathe, not a potter's wheel and its associated equipment. But with Thomas's son John, the craft of pottery clearly emerges. The inventory of his property, sold after his death in 1832, includes "1 poters wheel and crank" that fetched a mere 50 cents.[31] Combined with a persistent oral tradition, as well as the fact that John's brothers Solomon and Thomas and their children were all in the craft, this documentary evidence allows at least a reasonable possibility that Peter and his son Thomas could have been potters. By the fourth generation, the number of potters multiplies to the point that only a family tree—an abbreviated one for the known potters—can do justice to the range of the family's activities (fig. 2-12).

Not all of the Cravens chose to remain in North Carolina. Perhaps because of the growing local competition, many carried their craft into other southern states. Peter's grandson Thomas left North Carolina with his family in the late 1820s. "Thomas's sons John, Tinsley, and William moved to Henderson County, Tennessee, in 1829, and Thomas and a fourth son, Ba-

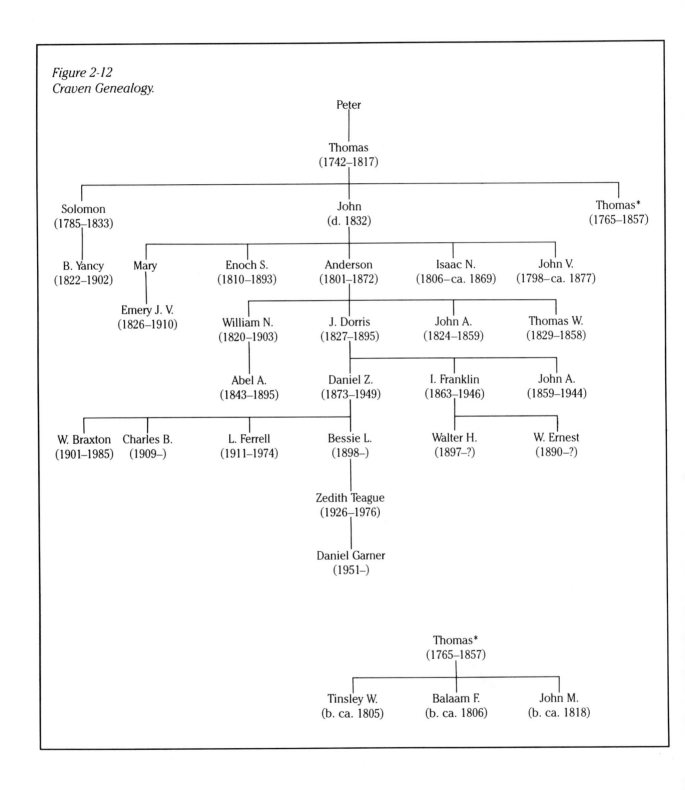

Figure 2-12
Craven Genealogy.

laam, were in Clarke County, Georgia in 1830 (1830 U.S. Census, Clarke County, Georgia). By 1840 Thomas and Balaam had joined the other Cravens in Henderson County. An additional generation of potters appeared in 1850 when Tinsley's sons, Malcolm and Thomas E. Craven, were listed as potters."[32] These six potters—William is never so identified but may have been a seventh—worked in at least three different sites and produced salt-glazed stoneware as well as tobacco pipes and animal figurines.

Three other members of the fourth generation—Thomas W. (who was not a potter), John V., and Isaac N.—also left the state during the 1820s but headed in a more southerly direction into Georgia. John and Isaac were among the pioneer potters of the Mossy Creek District in White County, where members of the Meaders family still make alkaline-glazed stoneware today. Unlike their North Carolina relatives, the Georgia Cravens used an alkaline glaze, and in fact become known for their "iron sand" glaze, which possesses "a lustrous black or red-brown" due to the addition of an iron-bearing sand. Today John's great-great-great-grandson Billy Joe Craven runs the Craven Pottery near Gillsville, a huge, modern operation that sells planters, strawberry pots, concrete lawn ornaments, imported Italian pots, and even a few "old-time" churns glazed with Albany slip.[33] Finally, William Nicholas of the fifth generation (plate 5) worked in Randolph County until about 1857, when he headed west to Missouri. During the 1860s he recrossed the Mississippi and settled in Jackson County, Illinois—most likely to escape the ravages of the Civil War—but by 1870 he had returned to southeastern Missouri. At Poplar Bluff in Butler County he discovered a fine, white stoneware clay and so established the Craven Manufacturing Company, in which he was assisted by his son Abel.[34]

Despite the wide dispersal of so many members of the family, enough Cravens remained in North Carolina to take a leading role among the potters of the eastern Piedmont. Enoch produced a substantial number of well-formed jugs and jars, marked "E. S. CRAVEN" in bold, half-inch letters, and usually decorated with one or more bands made by a toothed coggle wheel (fig. 2-13). In 1833 he married Susannah Hayes and very likely trained James and Eli Hayes—the numerous pieces stamped "J. M. HAYS" are very similar in form and decoration. Finally, Enoch's work also resembles that of his nephew Emery John Vandevere Craven. The two lived near each other in the Reed Creek section of Randolph County in 1860, and it appears that Emery adopted his uncle's neat, thumb-printed handles, abbreviated jar rims, and decorative coggle banding on the shoulders of his pots.

Enoch's brother Anderson, who was both a preacher and a potter, married Elizabeth Fox, a member of another prominent family of potters, and they produced four sons whose work represents the full maturity of the folk tradition. With its evenly turned form, arching strap handles, and dense coating of flyash—or concentrated salt—the large five-gallon jug by John A. Craven (fig. 2-14) is a ceramic masterpiece. All four of Anderson's sons

Figure 2-13
*Salt-glazed stoneware jars, second
half of the nineteenth century. Left:
Enoch Craven, Randolph County.
H 8⁷⁄₈″, C 20¼″. Stamped:
"E.S.CRAVEN." Right: James Hayes,
Randolph County. H 9³⁄₈″, C 18⁷⁄₈″.
Stamped: "J.M.HAYS."*

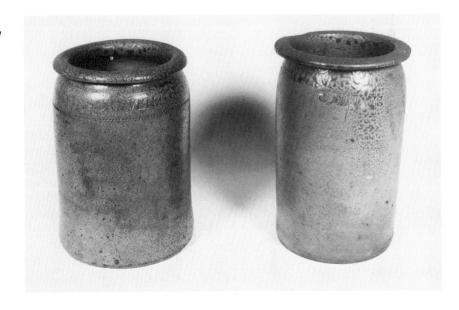

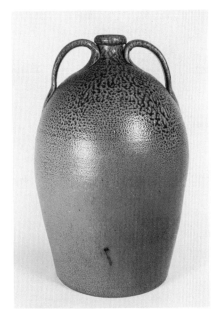

Figure 2-14
*Salt-glazed stoneware jug, ca. 1850,
John A. Craven, Randolph County.
H 19¾″, C 40⁹⁄₁₆″, 5 gal. Stamped:
"J.A.C." Collection of Mary Frances
Berrier.*

made occasional use of cobalt, a commonplace practice in northern shops at this time but a rarity in the South. Figure 2-15 shows a lidded butter jar by Thomas W. Craven, with cobalt bands brushed around the side and top and cobalt filling to accentuate the impressed Masonic emblems and potter's mark. The very restrained, geometrical treatment typifies the North Carolina tradition. Cobalt oxide was expensive and hard to obtain, and the competition did not warrant such additional aesthetic flourishes. Even more rare— in fact, almost nonexistent—were pictorial designs in cobalt, such as Thomas's (sumac? pecan?) "tree" that he painted on both sides of a tall, ten-gallon jug (fig. 2-16). His execution may appear somewhat hasty or crude in comparison to the elaborate flora or fauna so frequently encountered on the stonewares of New England or the mid-Atlantic region. But in the northern shops—which, by the mid-nineteenth century, were becoming factories, in the true sense of the word—the decorator was frequently a specialist, who did nothing but paint or trail designs on pots made by others. By contrast, the Cravens and their fellow potters were complete craftsmen who did everything from digging the clay to burning and selling the wares. Hence, such artistic touches were rare and represented only a small part of their broad competence.

Of the four brothers, only Dorris Craven still remained in the eastern Piedmont in 1860; William had moved to Missouri, and Thomas and John had both died prematurely, the former before he reached the age of thirty. However, this loss was at least partially offset by the industry and influence of Dorris. In terms of signed pieces, he was easily the most prolific of all North Carolina potters, and he appears to have been the dominant force in establishing the craft in Moore County.

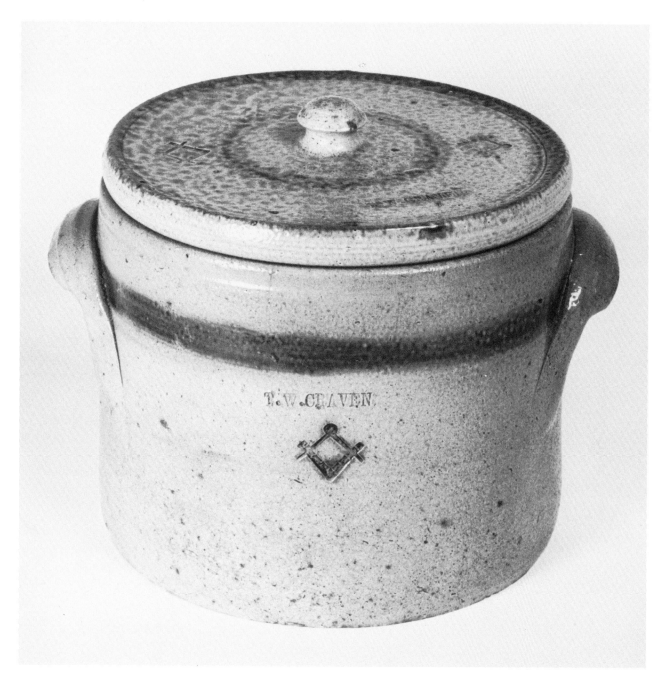

Figure 2-15
Salt-glazed stoneware butter jar, ca. 1855, Thomas W. Craven, Randolph County. H 6³/₁₆", C 28⅛". Stamped: "T. W. CRAVEN." Stamped Masonic emblems (compass and square) *with cobalt bands and infill. Collection of Ralph and Judy Newsome.*

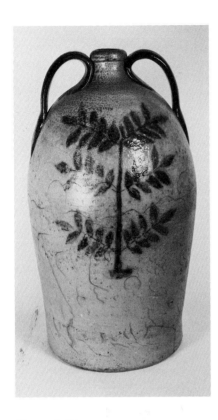

Figure 2-16
Salt-glazed stoneware jug, ca. 1855,
Thomas W. Craven, Randolph
County. H 21⅞", C 39⅜", 10 gal.
Stamped: "T. W. CRAVEN." Painted
cobalt tree on both sides and cobalt
edging on the handles. Collection of
Ralph and Judy Newsome.

Why Dorris chose to leave Randolph County during the late 1850s is somewhat of a mystery. Family tradition allows that some Cravens were against slavery and left because of the growing tensions that would soon culminate in war. Dorris's younger brother Thomas probably accompanied him—a few surviving pots are stamped "JD & T.W.CRAVEN"—and William headed for Missouri at the same time. There may also have been more compelling economic reasons for Dorris's migration. The 1850 census for Moore County lists carpenters, blacksmiths, wheelwrights, tailors, millers, hatters, gunsmiths, even a basketmaker—but not a single potter. Moreover, with the completion of the Fayetteville and Western, a plank road running across Moore County from the Moravian communities of Bethania and Salem in the northwest to Fayetteville in the southeast, the area was ripe for commercial expansion, and distant markets were now much more accessible. Dorris must have recognized the opportunities for a young potter, and he set up shop at a site about three miles west of the current Jugtown Pottery. In the 1860 census he is listed as a "Mannufactor of Stoneware" and is the only potter so designated for the county.

Clearly his business flourished. The Census of Manufactures for 1860 records that he was employing three men to process sixty thousand pounds of clay, sixteen bushels of salt, and twenty cords of wood into six thousand gallons of "jugs, churns, crocks & pitchers" valued at six hundred dollars. By 1870 four workers, active during seven months of the year, were producing eight hundred dollars worth of pottery. Among those working for him at this time were his immediate neighbors, William Henry Hancock and William Henry Luck, both of whom stated in the census that they were "Working in Potter Shop." Hancock went to work for E. A. Poe in Fayetteville around 1880 and later (1896–1903) ran his own pottery near Four Oaks in Johnston County.[35] In addition to occasionally stamping his own name, Hancock sometimes "signed" his wares with a band of impressed triangles around the shoulder (fig. 2-17). Another likely disciple of Craven was Benjamin Franklin Owen, who in 1870 lived just four houses away from Dorris. A fourth was young William Henry Chrisco, who went to live with Dorris at age thirteen or fourteen for a monthly wage of eight dollars. Chrisco later constructed his own pottery just south of the Craven site and turned ware into the 1930s, when he was almost eighty years old.[36] In 1969 his log shop was dismantled and hauled off to the Smithsonian Institution, where one day it may become a permanent exhibit.

Dorris also taught the craft to his own children, notably his sons Isaac and Daniel, who later established their own potteries nearby and who represent the last generation of folk potters. Illustrated in figure 2-18 is Daniel's shop as it appeared about 1915. In the foreground are salt-glazed storage jars and milk crocks, the two most popular utilitarian forms in the folk tradition at that time. The final three generations of the family—most particularly Daniel's sons, Charles and Ferrell—played an active role in the

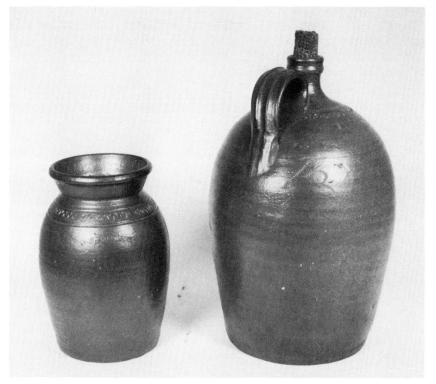

Figure 2-17
Salt-glazed stoneware jar and jug, fourth quarter of the nineteenth century, William H. Hancock, Moore or Johnston County. Jar: H 8¼", C 19". Stamped: "W.H.HANCOCK." Collection of Mrs. Nancy C. Conover. Jug: H 12⅞", C 26⅝", 1½ gal. Stamped: "W.H.HANCOCK." Collection of Mr. and Mrs. Hurdle Lea.

development of the new forms, glazes, and technology that transformed the old craft. Today the Teague Pottery at Robbins—although temporarily closed—is operated by Daniel Garner, who is Peter Craven's great-great-great-great-great-great-grandson.

This brief account of the Craven family suggests an unusual adherence to a single craft, but the story of the Coles is remarkably similar. Once again, only a genealogical outline can convey the size and duration of the family's industry (fig. 2-19). Because a lengthy history of the Coles is available elsewhere, the ensuing discussion will highlight only the major phases of their history and their impact on the pottery traditions of the eastern Piedmont.[37]

Like the Cravens, the Coles trace their ancestry to England. Although no firm links can be proved, potters of this surname were recorded in England and Wales. Mary Cole of Woolstanton, Staffordshire, married William Adams, an "Earth potter," on 12 September 1771. Subsequently Mary's younger brother, Caleb, and her husband formed the firm of Caleb Cole and Company, which operated into the early years of the nineteenth century.[38] One decade earlier, on 19 September 1764, a William Coles obtained a lease to erect the first pottery in Swansea, Wales. Although not a potter himself, Coles directed a successful business that produced utilitarian earthenwares

Figure 2-18
The pottery shop of Daniel Z. Craven, ca. 1915, Moore County. Courtesy of the North Carolina Division of Archives and History, Raleigh, N.C.

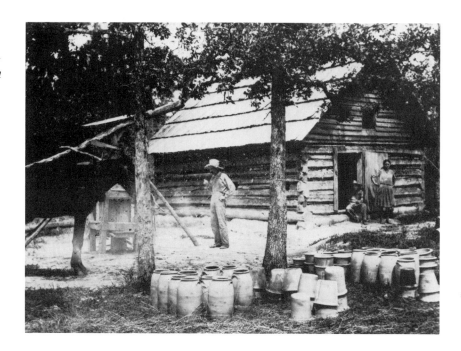

for domestic use—"such crocks as bread pans, pitchers and baking dishes [that] would find a ready market in the town and its vicinity"—as well as more sophisticated creamware and stoneware forms. His son John remained a partner until 1799, and the business continued until 1870.[39]

For early generations of the Coles in the New World the records are scarce. An entry in *The Records of the Virginia Company of London* lists a John Cole and a William Cole, who disembarked at Jamestown on 4 December 1619, from the ship *Margaret* out of Bristol.[40] No occupations for the men are cited, but whatever their craft or trade, the Coles were early arrivals in the South. Like the Cravens, they probably migrated south into North Carolina during the middle of the eighteenth century, but there is no hard data to prove that William, Stephen, or Mark (fig. 2-19) were potters. In fact, a persistent problem in studying all the Coles is that they rarely signed their pottery. Moreover, it is said that they habitually informed the census taker that they were farmers rather than potters, even when they owned only a mule, a cow, and a vegetable garden.

In the middle three generations (fig. 2-20), however, there was an explosion of activity; as with the Cravens, this expansion coincided with the growth of the stoneware tradition in the nineteenth century. Michael moved to Tennessee, where a number of Coles are reported to have made salt-glazed stoneware in White and Putnam counties.[41] Raphard—or Rafe, as he was known—lived near the present community of Whynot in southeastern Randolph County. There he raised a large family in his log house, which was

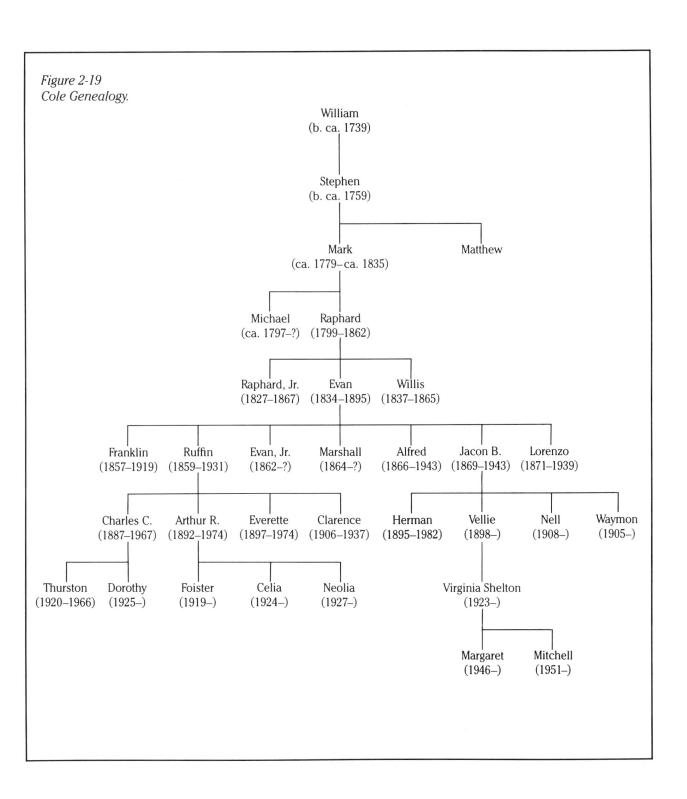

Figure 2-19
Cole Genealogy.

Figure 2-20
Three generations of Cole potters: from left to right, Ruffin, Raphard, and Evan. Courtesy of Walter and Dorothy Auman.

still standing as late as 1939, surrounded by the foundations of his outbuildings: a barn, springhouse, and smokehouse. Some two hundred yards east of the house was a rectangular depression in the ground measuring approximately 20′ by 8′. According to the late Charles C. Cole, a great-grandson, this was Rafe's groundhog kiln, one of the earliest in the area. Of Rafe's seven children, three sons followed the potter's craft—Raphard, Jr., Evan, and Willis. In addition, several of his daughters married potters; Elizabeth, in fact, married two: first Thomas W. Craven and, later, Enoch Garner.

Much like his contemporary, Dorris Craven, Evan Cole played the pivotal role in his family's fortunes during the second half of the nineteenth century. He married Sarah Jane Luck in 1854, and they produced seven active potters. With the assistance of these sons, his father-in-law William Luck, his son-in-law Henry Luck (who also worked with Dorris Craven), and a neighbor named John Chrisco, Evan operated what was probably the largest pottery shop in the region. Ironically, the cream-colored stoneware bottle in figure 2-21 is the only marked piece that appears to have survived. Evan's sons represent the last generation to make the traditional utilitarian forms. After their father's death in 1895, they pursued a variety of new opportuni-

ties: Franklin set up his own shop north of Seagrove and engaged Ruffin as a turner; Evan, Jr., and Marshall joined a turpentine distillery; Alfred went into the lumbering business; and Jacon and Lorenzo (Wren) hired out as journeymen at other established shops. Jacon later opened his own pottery, but Wren remained a journeyman all of his life. Figure 5-2 shows him leaning in the doorway of Baxter Welch's shop at Harper's Crossroads, Chatham County, where he was the chief turner. The last three generations of Coles, descendants of Ruffin and Jacon, played a critical and innovative role in transforming the old folk tradition during the 1920s and 1930s. Today members of the family operate the Seagrove Pottery in Seagrove; J. B. Cole's Pottery in Montgomery County; and the Cole Pottery (Neolia and Celia) and Cole Pottery (Foister), both of which are located in Sanford.

While the Cravens and Coles dominate the history of pottery in the eastern Piedmont, several other families deserve consideration for their special achievements. One exception to the general rule of British ancestry is the Fox (originally Fuchs) family, Pennsylvania Germans who migrated from Bucks County to Chatham County about 1779 (fig. 2-23).[42] None of Jacob Fox's work survives, but a substantial number of pieces by Nicholas and Himer are extant, distinguished by their perfect form, even glaze, neat thumb-printed handles, and, most particularly, by their decorative incised bands (fig. 2-24). In fact, the term "Fox jug" crept into the local potters' jargon to describe these exemplary pieces, and later potters such as Ben Owen admired and made copies of them. As established craftsmen, Jacob and his progeny trained other potters in Chatham County, notably John and Henry Vestal and Nathaniel H. Dixon. "Family hearsay" in the Dixon family asserts that "Nath" was paid wages of four dollars per month and soon became too proficient for his own good. "He was bound out to Jack Fox to work around the potter shop. . . . And he got to do a little turning pottery, and he caught right on to it. And Jack Fox seen he was going to learn the pottery trade, and he fired him! Afraid he was going to take his business! And when he quit he knowed enough about it."[43] Nath Dixon did prove an apt student, though his control of form and the decorative cording does not match that of his remarkably skilled mentors (fig. 2-25). He never did put the Foxes out of business. He died in 1863 while trying to enlist in the Confederate army. Daniel Fox kept the Chatham County pottery going until the mid-1880s.

Not all of the pottery families in the eastern Piedmont were in business as early as the Cravens, Coles, and Foxes. The majority took up the craft in the second half of the nineteenth century, when stoneware production was peaking, and most made pottery for only one or two generations. Among the relative "late-comers" who have continued as potters to the present are the Teagues and the Owens of Moore County.

Like so many others in this region, the Teagues got their start in the business under Dorris Craven (fig. 2-26). John Wesley was apprenticed to

Figure 2-21
Salt-glazed stoneware bottle, ca. 1880, Cole and Company, Randolph County. H 9¹/₁₆″, C 13⅛″. Stamped: "COLE & Co." Collection of the Mint Museum, Charlotte, N.C.

Figure 2-22
Potters Walter and Dorothy (Cole)
Auman, owners of the Seagrove Pottery and Seagrove Potters Museum,
1975. Courtesy of Walter and Dorothy Auman.

Craven at the age of nine; he later worked for Henry Chrisco and then established his own shop on Route 705, just north of the present community of Westmoore. James G. Teague lives at the old site and recalls that his father was virtually a full-time potter; he did very little farming. With Alex Teague and journeymen Rufus Owen and Frank Moody doing much of the turning, John produced earthenware and stoneware and wagoned his products to customers in North and South Carolina, sometimes wholesaling it for as little as four cents per gallon. His wife, Lucy Chrisco Teague, attempted to run the pottery after her husband's death in 1916, but most of the sons wandered off to other jobs.[44] However, three worked as potters for much of their lives: Charles was the first turner at the Jugtown Pottery; James had his own shop and also worked for others, including a stint at the Fulper Pottery in New Jersey; and Bryan established the Teague Pottery just south of Robbins about 1928. Bryan married Bessie Lee Craven, one of Dorris's granddaughters, and in recent years her brother Charlie turned many of the larger forms sold at the pottery. In 1979 Laura Teague Moore, James's daughter, opened the Pot Luck Pottery with her husband Wayne on Route 705, just across the road from the site of her grandfather John's long vanished shop.

Along with the Coles, the most active family in the pottery business in this century has been the Owens (originally Owen, but James H. added an "s" to the name for his branch of the family). It is not clear just how far back the

Jacob (Jack)
(1775–1851)

Atlas Davis mr. Anna Margaret Nicholas Elizabeth mr. Anderson Craven
(1797–1858)

William T. James M. Himer Daniel G.
(1840–1924) (1836–1919) (1826–1909) (1845–1915)

Levi T.
(1868–1936)

Figure 2-23
Fox Genealogy.

craft goes in this family (fig. 2-28). Benjamin Franklin (Frank) lived just four houses away from Dorris Craven in 1870 and may well have worked in Craven's shop, though the census labels him a farmer. There are a few surviving pieces stamped "J. J. OWEN," indicating that Frank's uncle James was in the business. On the other hand, Melvin L. Owens holds that Frank's son James H. was the first potter in the family. He adds that, at the age of seventeen, Jim Owen learned to turn from Paschal Marable in Randolph County. He later returned to his homeplace in Moore County—adjacent to the present Joe Owen Pottery on Route 705—and taught his father and brothers. Jim worked at many locations in Randolph and Chatham Counties before settling down, about 1910, at the current site of the Owens Pottery.[45] Rufus also hired out as a journeyman before establishing his own shop, and oral tradition affirms that it was a "'brilliant orange glaze pie plate'" of his that initially inspired the Busbees to found the Jugtown Pottery.[46]

Whereas the first generations of Owens produced utilitarian wares, the children of Rufus and Jim played key roles in developing and maintaining two of the best-known modern potteries. Jonah Owen was the first turner at the North State Pottery, which opened near Sanford about 1924. He left just two years later, but his brother Walter took his place and, lacking the wanderlust of other members of the family, remained at the pottery for thirty-five years. With the death of owner Henry Cooper in 1959, Walter inherited the plant, rechristened it the Pine State Pottery, and operated it for another

Figure 2-24
Salt-glazed stoneware jar and jug,
second quarter of the nineteenth
century, Nicholas Fox, Chatham
County. Jar: H 8", C 25⅞". Jug:
H 7¾", C 16½". Both stamped:
"N.FOX." Collection of Mr. and Mrs.
William W. Ivey.

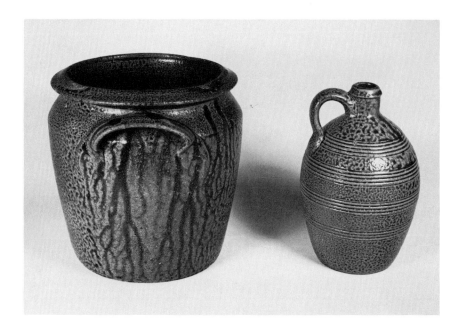

Figure 2-25
Salt-glazed stoneware jugs, ca.
1860, Chatham County. Left: Himer
Fox. H 14¼", C 27³/₁₆", 2 gal.
Stamped: "H. FOX." Collection of
Cecelia Conway. Right: Nathaniel
Dixon. H 11⅝", C 23⁹/₁₆", 1 gal.
Stamped: "N H DIXON." Collection
of Mrs. Nancy C. Conover.

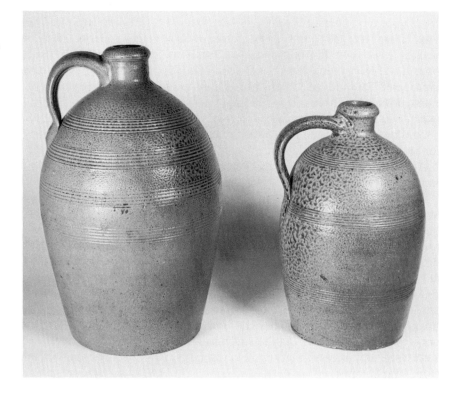

*Figure 2-26
Teague Genealogy.*

nineteen years.[47] Perhaps the Jugtown Pottery owes the greatest debt to the Owens. Rufus's pie dish provided the Busbees with their incentive, and his brother Jim helped to construct the first shop. But the key figure was Rufus's son, Ben, who went to work for the Busbees at the age of eighteen. Like his cousin Walter, Ben possessed all the skills of the potter, having been honed on the folk tradition, yet he was also young enough to be receptive to new ideas, forms, and glazes. Today, Jugtown is owned by Melvin's son, Vernon, who is assisted by his brother Bobby. Almost next door is the old family shop; Boyd now directs operations and calls on his father and sister Nancy for much of the turning. And in late 1982 Ben Owen's son Wade and grandson Ben reopened the Old Plank Road Pottery that had been closed down for more than a decade.

This brief account of the potter families of Randolph, Chatham, and Moore counties only hints at the full extent of the tradition. In an area approximately twenty-five miles square, some two hundred potters have produced lead-glazed earthenware and salt-glazed stoneware. In addition to the Cravens, Coles, Foxes, Teagues, Owens, and others mentioned above, any complete account should also add the Aumans, Browers, Garners, McCoys, McNeills, Moffitts, Moodys, Spencers, Suggs, Wrenns, and Yows, and even this list includes only the larger, more prominent families. Without question, this compact, well-defined area produced the largest number of potters in North Carolina. But there were several other significant clusters or satellite groups that also merit attention as part of the larger salt-glazed stoneware tradition.

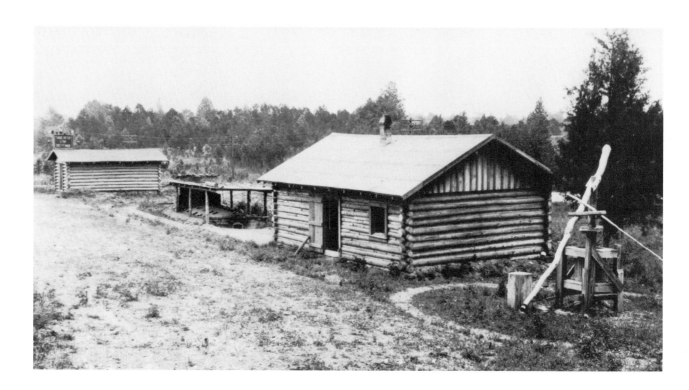

Figure 2-27
The Teague Pottery near Robbins,
Moore County, ca. 1930. From left to
right are the sales cabin (a feature
not seen on the older potteries), the
groundhog kiln, the shop, and the
mule-powered clay mill. Courtesy of
the Teague family.

One such cluster occurred in what is now southern Alamance County, below the small, rural village of Snow Camp, first settled in the mid-eighteenth century by Quakers from Pennsylvania and New Jersey.[48] About half of the potters who worked here were members of the Loy family, who made ware for at least a century (fig. 2-30). In addition to these names, a John Loy (b. ca. 1809) and a Jeremiah Loy (b. ca. 1818) are also recorded as potters in the census; they were likely brothers or close relatives of William and Solomon. Moreover, John R. Glenn was living with Solomon Loy in 1850 and 1860, and by the latter date he is designated as a potter. Also important were J. Thomas Boggs and his son Timothy, who were active throughout the second half of the nineteenth century. William Long probably worked with Thomas Boggs—the two potters lived only two houses apart in 1860—and around the turn of the century Joseph H. Vincent took over the Boggs shop after the death of his brother-in-law Timothy. Vincent and his sons, Cesco and Turner, later built their own shop and made ware into the 1930s. Other twentieth-century potters were Lester Thompson and R. Bascom Keller, who lived on the northern edge of Chatham County and who continued turning into the 1940s.[49]

Although situated adjacent to Chatham and Randolph counties, the Alamance potters constitute a distinctive, self-contained tradition. Some earth-

Figure 2-28
Owen Genealogy.

enware has survived, the most notable piece being the elaborate, slip-decorated dish on which Solomon Loy boldly trailed his name (plate 2); Solomon's grandson Albert continued producing lead-glazed earthenware bowls (fig. 11-1) and other forms well into the twentieth century. But the bulk of the output was salt-glazed stoneware, and here, too, Solomon proved extremely versatile, occasionally using slip or cobalt for decoration. As shown in figure 2-32, the local stonewares possess a number of distinctive characteristics: a light gray to cream-colored body, indicating clays relatively free of iron; thick, dark drippings of salt; and wide, pale green,

Figure 2-29
Salt-glazed stoneware pitcher, sec-
ond half of the nineteenth century,
Manley W. Owens, Moore County.
H 8⅜", C 21¹³/₁₆". Stamped:
"MW.OWENS." Collection of Mr. and
Mrs. William W. Ivey.

Figure 2-30
Loy Genealogy.

crackled flows down the sides. Normally these glassy patches result from
melting bricks in the arch of the kiln, but on the jug illustrated here they
appear to be deliberate. Very likely the potter, a Loy or a Boggs, placed
shards of window glass across the handle or spout after he set the piece in
the kiln. Similar effects are evident on the fruit jar in figure 2-33, though here
the wide patches are unintentional, as part of the archbrick is clearly visible
on the side. Whether accidental or deliberate, these green, glassy flows are
quite common on the Alamance wares. In addition, this type of preserve jar,
with the sloping shoulders and high neck, is indigenous to the area, as are
the smoothly pulled strap handles and thick flanges at the tops of the spouts
on the two jugs.

During the twentieth century, a few of the Alamance and Chatham potters
used Albany slip as a substitute for the salt glaze. Of these, most commonly
found today are the wares of Bascom Keller, who emigrated from Hardeman
County, Tennessee, and settled in northern Chatham County about 1917.[50]
His wares have a dark brown to reddish purple hue, usually show a single
incised band on the upper belly or shoulder, and chip quite readily, as he
employed a pale orange earthenware clay body (plate 10).

Figure 2-31
Potter Albert Loy relaxing in his slatback chair, Alamance County, ca. 1940. Courtesy of Robert and Jimmie Hodgins.

Figure 2-32
Salt-glazed stoneware jug and pitcher, second half of the nineteenth century, Alamance County. Jug: H 12¾″, C 22¾″, 1½ gal. Pitcher: H 10⅛″, C 23⅛″, 1 gal. Collection of Robert and Jimmie Hodgins.

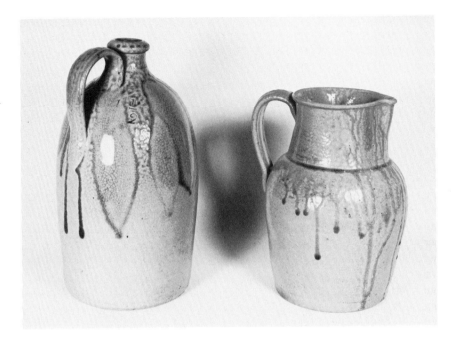

Figure 2-33
Salt-glazed stoneware preserve jar and jug, second half of the nineteenth century, Alamance County. Jar: Timothy Boggs. H 11³⁄₁₆″, C 21³⁄₁₆″. Stamped: "TB." Jug: J. Thomas Boggs. H 12½″, C 25⁵⁄₁₆″. Stamped: "J T BOGGꙄ/ꟽC" and signed in script: "Sylvester." Collection of Robert and Jimmie Hodgins.

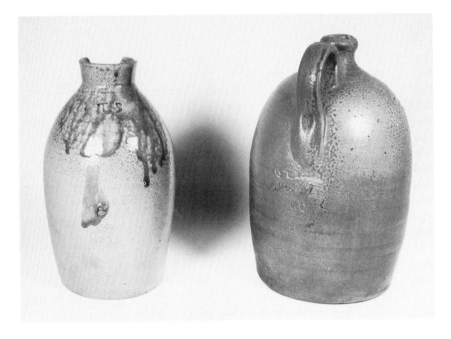

Wilkes County is best known for its moonshine, a product that, at least in the days before the glass fruit jar, literally demanded the art of the potter. But the county was mountainous and sparsely populated, and so there were only about five shops, all dating from the 1870s or later. The earliest potters employed a salt glaze, but where they acquired their craft remains unclear. According to one local historian, Samuel E. Sebastian, John and Mary Ballard moved into the region from Iredell County in 1858 to avoid an outbreak of typhoid fever.[51] Their son, W. W. Ballard, established potteries at Dockery and later at Hays; shards from the latter site show that he also used Albany slip. His brother, C. C. Ballard, was apparently working there as well; there is a small jug stamped "C. C. BALLARD / HAYS / N.C." in the Seagrove Potters Museum. Two miles east of Hays was a shop operated by Reverend Eli Sebastian, a Baptist minister, who very likely learned to turn from the Ballards. A miniature salt-glazed jug remains in the family and is signed, in script, "Eli Sebastian / May the 1st 1886." One of Eli's full-size products, a two-gallon whiskey jug, no doubt, is illustrated in figure 2-34. Typical of the wares of this area, the jug has a light brownish cast, due to the iron leached out of the clay body by the sodium flux. Local oral tradition also suggests that there was a potter named "Dockery," after whom the present community was named, but no wares or historical records exist to affirm this possibility.[52]

By the second half of the nineteenth century, potters from the Catawba Valley were wagoning their wares into Alexander and Wilkes counties. Thus it is not surprising that two potters from Catawba County, Bulo Jackson Kennedy and his brother, Dave, decided to build a shop in Wilkesboro when they discovered that good stoneware clays were available locally. Their father, the Reverend Julius A. Kennedy, was a Methodist minister in Cleveland and Catawba counties, and there is a strong possibility that he was also a potter, as a number of alkaline-glazed pieces stamped "JAK" are extant. Dave did not remain in Wilkesboro for long, but B. J. established a large and thriving business—it came to be known as the Kennedy Pottery—that operated from 1895 to 1968. B. J. first produced alkaline-glazed utilitarian wares, with the help of Catawba Valley potters such as Ernest Auburn Hilton and Poley Carp Hartsoe. Later he used salt, Albany slip, and Bristol glazes, hiring potters from as far away as Georgia (McGruder Bishop, Bill Gordy, Javan and Willy Brown) and even Texas (Guy and Lon Dougherty).

The Kennedys catered to the local moonshine trade. B. J.'s son, Ray, recalls that "this used to be a terrible country for moonshiners here. And, federal officers in there one day, and he was making five gallon jugs. One of them said to this fellow working, says, 'Have you ever given it a thought about this stuff you're making, these jugs, what goes in 'em?' He says, 'Yes, I have, quite a bit. Every one I turn out, I wonder where this one is going to be buried!' "[53]

Demand for the traditional forms fell off during the 1920s, and so the

Figure 2-34
Salt-glazed stoneware jug, ca. 1880,
Eli Sebastian, Wilkes County.
H 13⅞", C 28¾", 2 gal. Stamped:
"ELI. SEBASTIAN."

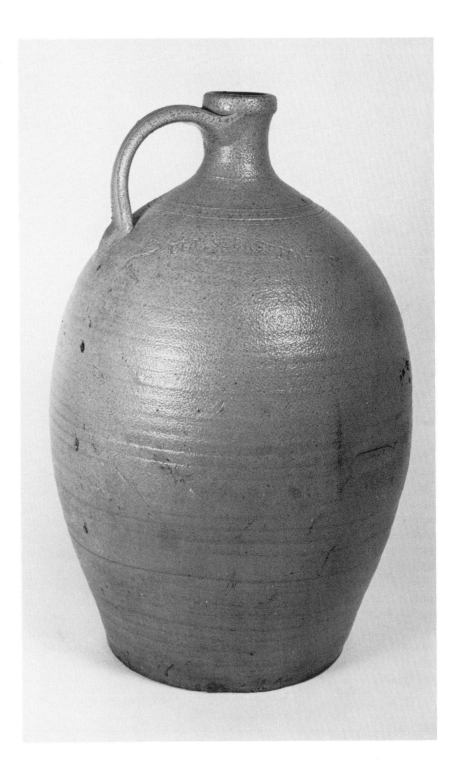

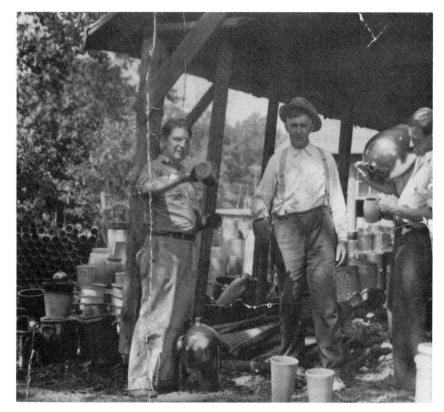

Figure 2-35
The Kennedy Pottery, Wilkesboro, ca. 1925. Bulo (center) and his oldest son Claude (left) hold beer mugs. Numerous other forms are visible, including jugs, jars, churns, milk crocks, flowerpots, and florist's vases. Courtesy of Ray A. Kennedy.

Kennedys turned increasingly to tourist items and flowerpots. B. J.'s sons Claude, George, and Ray joined the business, and during its last thirty years the Kennedy Pottery produced only machine-made flowerpots, in volumes as high as forty to fifty thousand per week. Perhaps the last potter to locate in Wilkes County was the above-mentioned McGruder (Mack) Bishop, who settled briefly at Ronda, and who stamped his slip-glazed wares "McG. BISHOP / ROИDA / И.C."

Union County lies on the border of South Carolina, immediately to the southeast of Charlotte. Near the crossroads hamlet of Altan, seven miles due south of the county seat of Monroe, a small community of about a dozen potters worked from at least 1850 to the end of World War II. Like Wilkes County, this appears to have been a transition area, where a variety of glazes was used. One colorful local account even suggests that the tradition was initiated by an Indian:

> Thomas Gay also owned a Pottery Manufacturing Business in his younger days. He was the first person to make pottery in Union County and the way he got into it was just by chance.

One day there was an Indian stopped at Thomas Gay's store; . . . as he needed some help with his work, he hired the Indian. One day he told my grandfather that he knew how to make pottery; and that he had seen what looked like good pottery clay on his land. The Indian said if grandfather would get the machinery, he would teach him how to make it, and put him in business. So they bought the equipment; and he turned out to be a good potter, and was in success from the start.[54]

This tale of the Indian origins of a pottery is by no means unusual; a similar account exists to explain the beginnings of the much larger Catawba Valley tradition, and the story is also heard in at least one other southern state.[55] In Alabama, "Falkner family folklore has it that their family learned the pottery craft from the Cherokees in North Carolina, the initial home of the Falkners in America."[56] While appealing in terms of historical and cultural continuity, such explanatory legends have little basis in fact. Native American pottery was made without a wheel, glazes, or high-fired kilns. Unless the Indian had worked within the Euro-American technology, he could not have taught Thomas Gay or the Seagles or the Falkners the secrets of making stoneware.

Instead, it is highly probable that the Union County tradition originated shortly before the mid-nineteenth century, with the influx of settlers from South Carolina. The earliest recorded potter in the county was George W. Hance of South Carolina. In the 1850 census of Union County he was listed as living with Thomas Vincent, a wagoner, and Murphey Usery, a laborer; ten years later Usery was also designated a potter. Hance remained in Union County for at least a decade, and in 1860 was probably working with another potter named Hugh Starnes. The aforementioned Gay family arrived in the Altan area during the 1850s. Thomas and his brother Isaac were both potters, and later two of Thomas's children, George C. and Thomas N., continued the business. Whether the Gays learned the craft in South Carolina or after their arrival in Union County is unknown, but in 1860 Isaac was living quite close to Hance and Starnes. Thomas Gay married Mary Broom in 1857 and almost certainly trained his brother-in-law Nimrod Broom. Nimrod's son James C.—or "Jug Jim," as he came to be known—was the last traditional potter in Union County; old age finally forced him to close his shop in 1946.[57] Nimrod also most likely taught his son's brother-in-law, William Franklin Outen, a member of another South Carolina family that entered the area about 1860. Outen worked for a time with Jug Jim and had his own shop as well; a number of pieces stamped "W. F. Outen / Monroe / NC." are extant (fig. 2-36). After working for some time in South Carolina as a potter, brickmaker, and farmer, he established a pottery at Matthews, Mecklenburg County, in 1922. His sons Rufus and Gordon were also potters, and until 1978 Gordon's son Kenneth operated the Matthews Pottery, a major producer of flowerpots.[58]

The predominant glaze used by the Gays, Brooms, and Outens was salt; a small, wide-mouthed jar signed in script "I gay," as well as a one-gallon jug

Figure 2-36
Salt-glazed stoneware jug, ca. 1900,
William F. Outen, Union County.
H 12¼", C 20¹³/₁₆", 1 gal. Stamped:
"W. F. Outen / Monroe / NC." Collec-
tion of Mrs. Nancy C. Conover.

Figure 2-37
Salt-glazed stoneware jar and jug,
second half of the nineteenth cen-
tury, Isaac Gay, Altan, Union County.
Jar: H 9¼", C 24⅝", 1 gal. Signed in
script: "I gay." Jug: H 12¹⁵/₁₆",
C 22¼", 1 gal. Signed in script: "gay."
Collection of Robert and Jimmie
Hodgins.

signed "gay," are shown in figure 2-37. Isaac's large, vertical signature is distinctive, and at least one piece of his work with a brown alkaline glaze has been reported. It is also said that Jug Jim Broome (who, early in the century, added an "e" to the family name) and Frank Outen experimented with several types of glass glazes, suggesting a possible variant of the alkaline glaze, but there is no way to verify the ingredients used. In later years both potters also made heavy use of Albany slip and the Bristol glaze, just as the Kennedys had done in Wilkesboro. These two rather late, marginal groups of potters in Wilkes and Union counties define the westernmost limits of the salt glaze in North Carolina. An imaginary line drawn across the Piedmont, from Wilkes in the north to Union in the south, marks a transi-

tional zone, a liminal area in which the two major stoneware glazes come together. To the east of this corridor, only the salt glaze is found, the main concentration of potters being in Randolph, Chatham, and Moore counties, with a number of smaller, ancillary groups in outlying counties. To the west of the corridor, the potters relied exclusively on the alkaline glaze.

Within the larger southern region, North Carolina possessed the most vital and extensive salt-glazing tradition. Further south, the salt glaze appeared only sporadically. It was used in the later nineteenth century in the Atlanta and Jugtown (Upson and Pike counties) areas of Georgia; in western Alabama, where it was introduced by the Cribbs family from Ohio in the 1820s; and in some parts of Mississippi. To the north, the Virginia potters used only the salt glaze, but their work is easily distinguishable from that of their North Carolina counterparts. Virginia stoneware is heavier and more cylindrical; possesses an even, dark gray hue; and is frequently decorated with abstract or floral designs painted on with cobalt. It appears that North Carolina was a ceramic "border state." The use of the salt glaze in the upper South represented a continuation of the northern tradition, but across the Virginia-North Carolina border, major changes took place. Cobalt decoration virtually disappeared; the groundhog kiln came into use; and the more typical southern forms such as the large, bulbous storage jar, the syrup and whiskey jugs, and the milk crock abruptly appeared in large numbers. With these alterations came the alkaline glaze, which best delineates the native southern tradition.

3

THE SOUTHERN
STONEWARE TRADITION
THE ALKALINE GLAZE

In the late eighteenth and the nineteenth centuries, salt was the predominant glaze used on American stoneware in all areas except the Southeast. Here, in the very early nineteenth century, a distinctly different regional type evolved, which has come to be called the alkaline glaze. Depending on the ingredients, which are far more variable than those used in the salt glaze, this glaze is normally green or brown and forms a lustrous coating, often with thick veins or rivulets flowing down the walls of the pots. The adjective "alkaline" refers to the flux, the substance that lowers the melting point of the glaze to the proper level. The potters used either lime or wood ashes, two economical and readily available sources containing compounds of calcium, sodium, and potassium. For the silica source, which provides the glass for the body of the glaze, southern potters drew on clay, sand, quartz, feldspar, iron cinders, or glass. Thus, a typical alkaline glaze might consist of sifted ashes, powdered glass, water, and clay, all ground to a smooth consistency in a stone mill.

While the alkaline glaze appears at first to be of comparatively recent vintage, it is in fact an ancient type that predates the salt glaze by well over a millennium. The stoneware potters of the Han Dynasty (206 B.C.–220 A.D.) developed the high-fired kiln and glazes that were "gray-green or brown, rather cloudy, and with a tendency to run and to accentuate surface variations. The experienced potter will recognize the surface quality of these glazes as being derived from wood ash. It seems quite sure that these earliest of stoneware glazes were made from ash, probably from the ash collected from the fire mouths of the kilns. The brown-green color results from iron in the glaze fired in a reducing atmosphere. Very similar glazes may be made by mixing hardwood ash and common red clay in about equal proportions."[1] This description is no less apt for the southern alkaline glaze. In fact, some of the large, bulbous jars made in China, and later in Korea and Japan as well, bear an uncanny resemblance to the creations of Daniel Seagle and others from the Catawba Valley. Subsequently the Chinese potters greatly refined these early glazes and used them on both stoneware and porcelain, skillfully controlling them to attain a rich variety of textures and colors.

That the alkaline glaze used in many parts of the Orient is identical to that of the American South is unquestionable. But, because it is not part of the European ceramic heritage, how did the glaze become known to the rural potters of the Carolinas in the early nineteenth century? There is no single, satisfactory answer to this question, but there are a number of intriguing possibilities.

Ceramic historian Georgeanna Greer has suggested that a knowledge of Chinese practices may have been transmitted to America via England, where many potters were eager to duplicate the much-admired Chinese porcelains.[2] An extended description of Chinese manufacturing techniques —which included glazes compounded of lime, plant ash, *petuntse* (feldspar), and water—appears in two letters written in 1712 and 1722 by a French Jesuit missionary named Père d'Entrecolles. These letters were published in both French and English during the 1730s.[3] One interested English reader was William Cookworthy, a Quaker minister and apothecary who studied the Jesuit's accounts and subsequently produced "the first true hard paste porcelain manufactured in England using clay and stone from Cornwall."[4] Cookworthy duplicated the Chinese formula by experimenting with local materials. By 1758 he was able to report that " 'my problems with the glazing are being resolved. 'Tis best to make the glaze from the ground moorstone [feldspathic rock, equivalent to *petuntse*] with some of the china earth [kaolin], some lime and fern ash.' "[5]

Cookworthy's experiments were devoted to the production of sophisticated porcelains, not utilitarian stoneware. Thus, it was his general identification of lime and ash as appropriate fluxes for a high-fired glaze—not his specific formula—that would have proved useful to the southern potters. Greer cites several individuals who might have served as carriers for this information.[6] First, there was Richard Champion of Bristol, Cookworthy's close friend and later partner, who lived in Camden, South Carolina, from 1784 until his death in 1791. Certainly he understood Cookworthy's discoveries as well as anyone, but there is, as yet, no evidence that he made any pottery during his years in South Carolina. A second potential source was Staffordshire potter John Bartlam, who, in 1771, advertised that his " 'Pottery and China Manufactory' " in Charleston made " 'Queensware, equal to any imported.' "[7] In the same year, an unnamed potter from Bartlam's establishment visited Gottfried Aust at Salem and instructed him in the manufacture of Queensware, a decorative white earthenware that is coated with a lead glaze. Two years later another potter from the same shop, William Ellis of Staffordshire, also arrived at Salem. His influence proved much more extensive. He directed the production of both Queensware and stoneware and thus established a line of " 'fine pottery' " that was to be continued by Rudolf Christ.[8] Once again, however, though the latest English techniques were employed, there is no evidence of an alkaline glaze at Salem. Stanley South, who directed the archeological investigations at both Bethabara and Salem,

has asserted that the stoneware fragments found at Salem—made in 1774 by Ellis, and from 1795 to 1798 by Christ—are covered with an alkaline glaze. However, subsequent tests have shown that the "glossy lead-like glaze" on the shards was indeed lead.[9] As John Bivins explains, Ellis's kiln apparently overheated; "the lead glaze held up surprisingly well in this over-firing, although the greens turned a dark olive color rather than their normal, bright, translucent hue."[10] Thus, the excess heat so transformed the colors and texture of the lead glaze that the veteran South was led to surmise that here at last was the source of the southern alkaline glaze.

Recently John Burrison has offered a more direct approach to the alkaline puzzle by suggesting that one of the early potters in the South might have sought out "literature like the d'Entrecolles letters with an eye to applying new techniques as potential solutions to problems. Key figures in such a process may well have been potting members of the Landrum family, which by 1773 had moved, by way of Virginia and North Carolina, into the Edgefield District of western South Carolina." Burrison specifically cites "Abner Landrum (1780–1859), a physician, scientific farmer, and newspaper publisher," as a possible candidate for this important role. Landrum is said to have established the first shop in the region around 1810, and the fact "that he named his sons after great names in Old World decorative pottery—Wedgwood, Palissey and Manises—is indicative of his wide-ranging ceramic knowledge."[11] Clearly a well-educated and enterprising shopowner like Landrum could have uncovered some account of the Chinese practices by the early nineteenth century. And it is certainly curious that the rural potters of White County, Georgia, have persisted in terming the local ash glaze a "Shanghai" glaze.[12]

While this Chinese-English connection seems promising, there are several other possibilities. Men such as Cookworthy and Champion were obsessed with the creation of porcelain, but others were exploring the alkaline glaze for a more practical reason: to replace the poisonous lead glaze. Two American accounts published in 1801—one in Philadelphia and one in Baltimore—well illustrate the increasing desire for a lead substitute. In *Essays and Notes on Husbandry and Rural Affairs*, John Beale Bordley observed that "lead requiring but little fuel to melt it, is the cheapest or earliest material for producing common glazing. It is therefore imposed on the inattentive people of the country, who buy the ware without knowing its bad qualities, or without caring for them." As an alternative, Bordley continued, "our own country abounds in materials for producing the most perfect, durable and wholesome glazing. These materials are *wood-ashes* and *sand*."[13] The second article, published in the *Baltimore American and Daily Advertiser*, offers a somewhat more complex formula. "Professor Fuchs lately read to the Academy of useful science of Erfurt [Germany], a treatise on the composition of varnish for pottery without lead. He says the following is the result of a long series of experiments;—Melt one ounce pounded

glass, one ounce of free stone [probably sandstone or limestone], one and a half ounce of borax, two drams of salt, and half an ounce of tobacco pipe earth together; keep them in fusion about a quarter of an hour. Let the pots be plaistered over with this matter well ground."[14]

Although the folk potter did not use fritted glazes (that is, glazes that were pre-melted, allowed to cool, and then ground into powder), most of the ingredients here are familiar enough. The main flux is sodium (salt and borax), as well as considerable calcium if the limestone is used, and the silica sources are glass, pipe clay (kaolin), and, perhaps, sandstone. The importance of these two admittedly obscure commentaries is their evidence that the quest for a humble alkaline substitute for lead glazing was widespread by the early nineteenth century, at precisely the same time that the southern potters were turning to stoneware. Surely other such treatises were available in books, periodicals, and newspapers, meaning that an Abner Landrum or a Daniel Seagle did not have to rely on foreign sources for new methods and techniques.

Finally, there was another traditional industry that might well have contributed to the development of the native alkaline glaze. During the latter half of the eighteenth century, there were a number of German-run glasshouses in the mid-Atlantic region, the most prominent names being Wistar (New Jersey), Stiegel (Pennsylvania), and Amelung (Maryland). Had one of the early potters observed or worked at a glasshouse before heading south down the Great Wagon Road, he would have encountered the following materials:

(1) sand (silica source)
(2) ashes (the alkaline flux)
(3) lime (both a flux and a stabilizer)
(4) broken glass or "cullet"

These ingredients were heated in large clay pots, meaning that a potter was directly involved in the operation. Moreover, the batch was melted in a long, low furnace that bears some resemblance to a groundhog kiln. English glassmakers converted to coal in the early seventeenth century, but the Germans continued to fuel their ovens with large logs cut from coniferous timbers until well into the nineteenth century.[15]

In short, traditional glassmaking manifests a number of striking parallels to the production of alkaline-glazed stoneware in North Carolina: the use of wood ashes as the primary flux; the addition of broken glass (which the North Carolina potter employed both in the glaze and as a decorative effect); the long kiln fired at one end; and the preference for pine as a fuel (it was the only wood used in the Catawba Valley). Georgeanna Greer has asserted that "all of the presently known early potters using the alkaline glaze in the Carolinas and Georgia were of English descent," but this is not true for North Carolina.[16] In fact, the potters of the Catawba Valley were

almost exclusively German, with names like Dietz, Hartzog, Hefner, Helton, Leonard, Propst, Reinhardt, Rudisall, Seagle, Shufford, Speagle, and Weaver at the heart of the tradition. Conceivably, then, there could have been a German connection as well as an English one in North Carolina, with the related craft of glassmaking as the source of inspiration for the new glazing techniques.

Whatever the specific origins or transmission of the alkaline glaze, current research pinpoints two early centers for its evolution in the Southeast: the Edgefield District of South Carolina and the Catawba Valley of North Carolina. Eventually, the glaze spread throughout the Southeast, but the early wares, as well as archeological and historical investigations, leave little doubt that it all began in the Carolinas.

The old Edgefield District of South Carolina—which encompassed present-day Edgefield as well as parts of Aiken and Greenwood counties—lay on the west-central border of the state, just across the Savannah River from Augusta, Georgia. Here, from perhaps 1810 until the end of the century, a moderate number of potters, both black and white, produced alkaline-glazed stoneware. Prominent figures included Abner Landrum, who is credited with establishing the first pottery in the district, and his brothers Amos and John; Amos's son-in-law, Collin B. Rhodes, and John's son-in-law, Lewis J. Miles; a slave named Dave, who worked for Abner Landrum and Lewis Miles and produced huge storage jars inscribed with amusing verses; and Thomas M. Chandler, who, along with Rhodes, played an important role in the profusion of slip-decorated pieces made from about 1840 to 1853.[17]

Several features sharply distinguish the Edgefield tradition from that of the Catawba Valley. First, the important families in the former area were of British stock. The Landrums, for example, are believed to have migrated from Aberdeenshire, Scotland, to Essex County, Virginia, during the late seventeenth century.[18] Moreover, the important families were large landholders and had numerous business interests. Collin Rhodes "owned a sawmill and gristmill, as well as a pottery. When he sold his 'Piney Woods' plantation in 1853 it contained 2700 acres."[19] Lewis Miles's plantation, "Stony Bluff," was even larger, comprising four thousand acres in 1850.[20] Slaves constituted an important part of the work force, and some became very competent potters. As well as the usual utilitarian wares, they produced a number of face vessels, usually in the form of small jugs or cups.[21]

The stoneware clays in the region contained unusually large quantities of sedimentary kaolin, which often produced a very hard and vitreous body. The accompanying glazes were "usually composed of kaolin or 'chalk,' wood ashes or lime and silica sand."[22] At times the relative purity of the clay used in both body and glaze produced a smooth, pale, translucent gray or lime green that resembles a Chinese celadon. Most pieces, however, exhibit shades of brown or darker green due to the iron content in the clays. In addition, the Edgefield wares tend to be thicker-walled and noticeably

Figure 3-1
Alkaline-glazed stoneware jar, ca.
1840, Edgefield District, S.C. H 14³⁄₄",
C 37¹⁄₈", 4 gal.

heavier than their Catawba Valley counterparts, most likely because of the kaolin and a longer firing period; Stephen and Terry Ferrell have even suggested that some of the ware "could be classified as porcelanous stoneware."[23] The basic forms such as jugs or jars are generally similar to those of the Catawba Valley, but there are several subtle distinctions. Lug handles are comparatively long and thin on the Edgefield jars; jug necks often show a protruding single or double flange; and the gallon capacity is frequently indicated with a series of short, vertical lines or small, incised circles, rather than numerals.

Ultimately the most reliable distinguishing characteristic of the Edgefield pottery is its decoration. Unlike other southern utilitarian wares, a substantial number of jugs, jars, pitchers, and bowls exhibit elaborate, well-executed designs in dark (iron-bearing) and light (kaolin) slips. "In the Edgefield District, slip trailing was used in a somewhat different way than traditional slip decoration. Instead of being used on flat pieces and dishes, it was intricately applied to vertical surfaces of large storage jars and jugs. Decoration presented another technical problem: preservation of the decoration during the application of the liquid glaze. To accomplish this the pots were bisque fired in the kiln to make permanent the clay decoration. This process was unusual for the period, as nearly all ware was single-fired for economy of money, time and labor."[24] In fact recent archeological research has indicated that the wares were probably not bisque fired; rather, the pieces that were believed to have been in a bisque state were indeed fully glazed and had probably been underfired in a cool area of the kiln. Moreover, Burlon Craig of Lincoln County has recently experimented with similar slip decorations under his alkaline glaze, and he has had no problem maturing them with a single firing.

Whatever the precise technique used on the Edgefield wares, the common embellishments were swags, tassels, curlicues, and other abstract flourishes; floral patterns; and elaborately concocted numbers and names (for the gallonage and maker). Occasionally there were more realistic depictions such as "flowers, birds, snakes, Negroes, and ladies in hoop skirts." Many may have been drawn by women: in the 1850 Census of Manufactures Collin Rhodes "stated that he valued his male help at $10 per month and his female help at $15 per month."[25] The large, strap-handled jug in figure 3-2 was made at the Phoenix Factory about 1840 and exhibits a typical coloration and decorative technique. The smooth body is predominantly olive green to brown, while the bib around the shoulder is outlined in trailed kaolin slip and filled in with a thinner, dark brown iron slip.

It may be tempting to regard the Edgefield tradition as a variation on the cobalt-decorated stoneware made in the northern United States, but the forms, glazes, and decorations belie such a connection. A more plausible inspiration may be the folk pottery of England. In particular, John Burrison has observed that "this seems to represent a transferral of Old World earth-

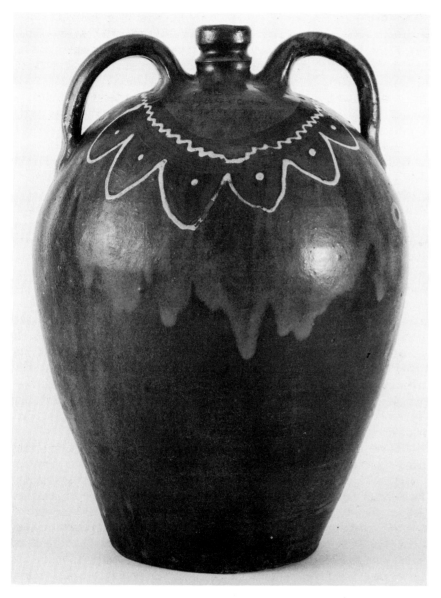

Figure 3-2
Alkaline-glazed stoneware jug,
ca. 1840, Phoenix Factory (Collin
Rhodes and Thomas Chandler),
Eureka, S.C. H 16⅝". Stamped:
"PHOENIX / FACTORY / ED SC" with
an "L" on the reverse side. Trailed
white kaolin and painted brown
iron slip decoration. Courtesy of Old
Salem Restoration, Winston-Salem,
N.C.

enware techniques to southern stoneware."[26] Another source of design could have been the ornate Spencerian penmanship that was so popular in nineteenth-century American schools. The owners of the Edgefield potteries were literate, educated individuals and might well have inspired their decorators with illustrations from broadsides or handwriting manuals.

A more immediate problem than the source of the decorations is the

relationship between the Edgefield potters and those in the Catawba Valley of North Carolina. Here again there appear to be more differences than similarities. The potters of the Catawba Valley were of German ancestry; they migrated south from Pennsylvania and established modest farms throughout the western Piedmont. There were never any plantations in this region. In 1850, for example, the census indicates that potter Daniel Seagle lived on a farm of 327 acres with a cash value of $825. On his 65 acres of improved land he raised corn, oats, hay, Irish potatoes, and sweet potatoes, and he maintained a modest number of horses, mules, milk cows, cattle, and swine valued at $240. In the same year, slaves constituted slightly over one-quarter of the population of Lincoln County; the Seagles had one female slave, aged nineteen, in their household. More to the point, there is no evidence that any black potters worked in the Catawba Valley. In fact, only one is known to have used the alkaline glaze anywhere in the state, and that was in Iredell County at the beginning of the twentieth century.

In addition to these socioeconomic contrasts, the stoneware clays dug from the South Fork of the Catawba River were saturated with iron, rutile, and other impurities; they produced dark colors and highly variable textures. Perhaps because of the inherently unpredictable nature of the clays and glazes, slip decoration was never employed. One indigenous technique of embellishment that developed in the second quarter of the nineteenth century—apparently in the Seagle and Hartzog families—consisted of balancing shards of window glass over the mouths, necks, handles, and ends of the wares as they were being set in the kiln (fig. 3-3). During the burn, the glass melted and flowed in milky white and pale blue streaks down the walls of the pots. In essence a kind of overglaze, and one that may have been intended to strengthen the handles, the glass stripes provided a dramatic contrast to the alkaline glaze, which, because of its thickness and dark color, often obscured markings or attempted decoration under the glaze.

Although the existing evidence provides no specific links between the Edgefield District and the Catawba Valley, there is one curious historical connection between the two regions. The Landrum family—that is, the father, uncles, and grandfather of the previously mentioned Abner, Amos, and John—resided in what is now west-central Chatham County, North Carolina, during the third quarter of the eighteenth century. John Landrum left Orange County, Virginia, with his six sons—John, Jr., Charles, Reuben, Samuel, Benjamin, and Joseph—and obtained a land grant from Lord Granville, dated 28 August 1754, for 640 acres.[27] Today the Chatham County map issued by the North Carolina Department of Transportation still shows "Landrum Creek," which runs in a southeasterly direction and empties into the Rocky River about midway between Siler City and Pittsboro. The family's migration in itself is not particularly remarkable, but a number of documents stemming from the Regulator Movement tenuously link the Landrums with other North Carolina pottery families. For example, Regulators' Adver-

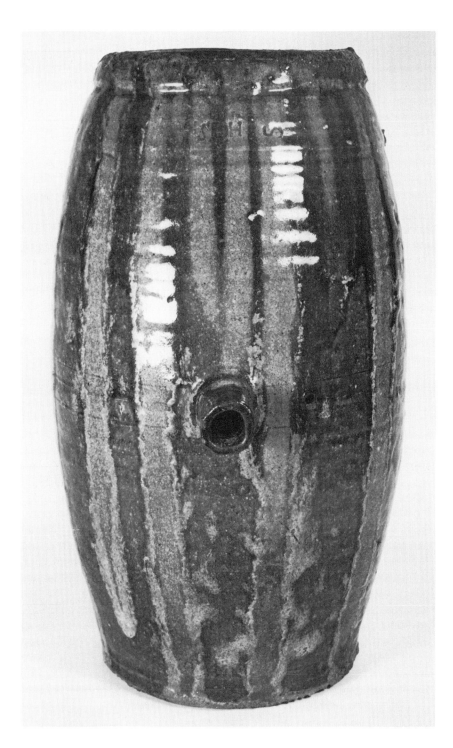

Figure 3-3
Alkaline-glazed stoneware barrel, ca. 1890, Sylvanus L. Hartsoe, Catawba County. H 19", C 35¼", 5 gal. Stamped: "SLH." Decorated with glass streaks. Collection of Mr. and Mrs. Olen T. Hartsoe.

tisement No. 9, which appeared in late April or early May 1768, protested the "larger Fees for recording Deeds than any of the adjacent Counties and many other Fees more than the Law allows," and included the following names in its lengthy list of petitioners: Peter Craven and his sons Thomas, Peter, and Joseph; Philip Hartzo; and Charles Landron and Reuben Landrum.[28] As mentioned in chapter 2, Peter Craven was one of the leaders of the movement and was in constant trouble with the authorities. Philip Hartzo was very likely a progenitor of the Hartsoe family of Lincoln County, which was one of the earliest to produce alkaline-glazed stoneware. Several other documents also connect the three families. John Philip Hartso and Peter Craven are cited together in a 29 September 1768 indictment "for a rout," and again in a 29 October 1768 letter from the sheriff of Orange County to Governor Tryon.[29] Moreover, Craven and Reuben Landrum are named several times for "Riot" on a list presented to the grand jury at New Bern on 11 March 1771. The accompanying presentment declares them "unthinking and deluded People, . . . under the influence and direction of several Wicked, Seditious, Evil Designing and disaffected Persons."[30]

The repeated appearance of these names does not prove that Peter Craven, Reuben Landrum, and John Philip Hartso were close friends, nor should it suggest that they discussed or made pottery together. Given their energetic commitment to "Seditious, Evil Designing" during these years, they may have found little time for the craft. But the fact that they participated together in this very dangerous and important historical event does allow the possibility, however remote, that there were later communications between the families. Landrum genealogist Joel P. Shedd suggests that the "harsh suppression of the movement without taking any remedial action had disastrous consequences, as it caused the wholesale departure of settlers from the misgoverned province. Perhaps this is why the Landrums left Chatham County shortly before the Revolutionary War."[31] Samuel Landrum appears to have headed south about 1775. Of his potter sons, only John (b. 1765) was born in North Carolina; Amos (b. 1780) and, most important, Abner (b. 1785) were born after the family was settled in the Edgefield District.[32] Because Peter Craven's descendants remained in the eastern Piedmont and made salt-glazed stoneware, the crucial connection would have been between the Landrum and Hartsoe families, probably during the early nineteenth century, when the first stoneware was being produced. There is no historical evidence to document such a tie, but the signatures on a number of pieces made by David Hartzog are somewhat similar to those of Collin Rhodes and Thomas Chandler. In addition to the earthenware barrel discussed in chapter 1 (fig. 1-11), several alkaline-glazed stoneware jugs are stamped "DAVIDHARTZOGHI2MAKE," which is akin to the "C. Rhodes Maker" and "Chandler Maker" employed by the South Carolina potters. Moreover, the two-gallon jug in figure 3-4 is decorated with numerous incised bands and sine waves; milky white runs of glass from the top and

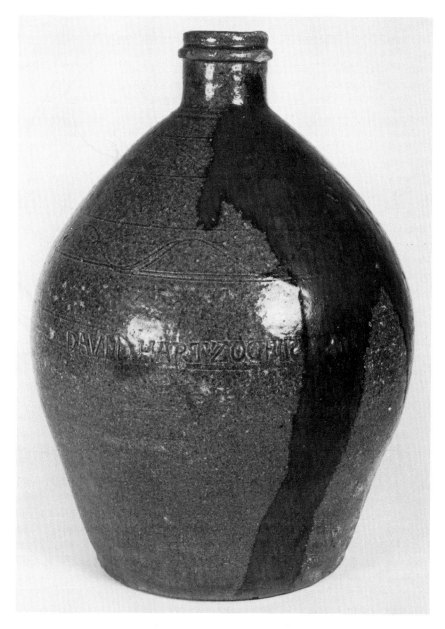

Figure 3-4
Alkaline-glazed stoneware jug, second quarter of the nineteenth century, David Hartzog, Vale, Lincoln County. H 12⅞", C 30", 2 gal. Stamped: "DAVID-HARTZOGHR.MAKE." Decorated with glass streaks from the handle and iron slip. Collection of Mr. and Mrs. Allen W. Huffman.

bottom of the handle; and a wide, reddish-purple flow running from the neck to the base on one side. The first two embellishments are clearly intentional and are a familiar part of the Catawba Valley tradition, but the third remains a mystery. Was it an unexpected dripping from a melted arch brick? The color, consistency, and random pattern suggest that this is a

plausible answer, but the size of the flow is far larger than usually encountered. Alternatively, might Hartzog have been experimenting with an iron wash or slip in the manner of the Edgefield potters? The incising and glass runs leave no doubt that he was intentionally decorating his jug, but the iron slip—if that is what it is—seems totally uncontrolled. Perhaps he even balanced a chunk of iron rock, limonite or hematite, on the shoulder and then let nature take its course. In any event, Hartzog's signature and, to a lesser extent, this unusual "decoration" are suggestive, but they do not provide a firm link between the two counties.

Largely on account of the striking decorative qualities of the Edgefield wares, contemporary ceramic historians have generally favored this region as the birthplace of the southern alkaline glaze. However, it is important to recall that slip decoration only "flourished for a relatively short time during mid-century."[33] In other words, it was not part of the formative stage of the craft. Still, the force of history does suggest that alkaline-glazed stoneware was first produced in this area. Abner Landrum may have established his pottery in the village of Pottersville as early as 1810; his shop, along with another run by his brother John, appears on an 1817 map of the Edgefield District. And in 1826, Robert Mills offered the following praise of Abner's achievement: " 'This village is altogether supported by the manufacture of stoneware, carried on by this gentleman; and which, by his own discoveries, is made much stronger, better, and cheaper than any European or American ware of the same kind.' "[34] Finally, a piece of Edgefield alkaline-glazed stoneware dated 1825 has recently been acquired by a South Carolina collector.

As documented in chapter 1, there is little question that the North Carolina pottery tradition is the older of the two. German potters moved into the western Piedmont during the second half of the eighteenth century, and the number of indentures of apprenticeship for Lincoln County in the early decades of the nineteenth century suggests the craft was by then well established. However, it would appear that these potters were still making earthenware while Landrum was developing his "stronger, better" stoneware. Specifically, it will be recalled that Daniel Seagle took Daniel Holly into his business in 1828 as an "apprentice to the earthenware maker's trade." And there are no dated pieces for the Seagles or Hartsoes to pinpoint the early use of an alkaline glaze here. Thus, until new pots or records appear, the best hypothesis is that some as yet unknown Edgefield potter introduced the new alkaline glazes to the Catawba Valley during the 1830s, possibly through the Hartsoe family, and that from then on the two traditions evolved independently.

Like the eastern Piedmont with its Peter Craven, the Catawba Valley possesses an archetypal potter whose achievements are shrouded in the mists of oral tradition. A newspaper article of 1938 offers the following chronicle:

E. A. Hilton, owner and operator of the Hilton Pottery at Marion, claims that the first Jugtown in North Carolina was a section about eight miles square in Catawba and Lincoln Counties. In this compara- tively small area . . . about 42 potters have plied their trade, beginning with Jake Weaver and continuing to the present.

Pioneer pottery maker of Catawba county and the founder of the Jugtown settlement in this section, Jake Weaver, who has been dead over 100 years, is said to have been the direct cause of pottery-making becoming such an important industry in this state.

Weaver came to this country from Germany, according to Mr. Hilton, who has been making pottery for the past 52 years. Whether Weaver's secret color formula for pottery was learned in that country or whether he found it by experimenting with native materials in Catawba county is not known, but he died without revealing the formula.

Mr. Hilton, who has been referred to as the Dean of North Carolina potters, was the first man after Jake Weaver in the Western part of the state to use color in making pottery.[35]

And so goes a typical version of the legend of Jacob Weaver, a story that was repeated over and over again in newspaper articles in the 1920s and 1930s. Invariably the narrator is Ernest Auburn Hilton, who learned his craft by making traditional alkaline-glazed stoneware with his family in Catawba County. Like his contemporaries among the Coles, Cravens, Owens, and Teagues in the eastern Piedmont, "Auby" Hilton moved gradually away from the utilitarian forms and became famous for more artistic wares decorated with cobalt, dogwood flowers, or painted rural scenes. As the most promi- nent potter from his region during the second quarter of this century, Hilton became the public spokesman for the Catawba Valley tradition and so pro- ceeded to voice its "history." In part, he was defending his heritage against the assertions of Jacques and Juliana Busbee, founders of the Jugtown Pottery in Moore County. To advertise their wares, the Busbees had written or encouraged dozens of interviews and articles in which they proclaimed Peter Craven as the first North Carolina potter, and asserted the primacy of the "Staffordshire" potters of the eastern Piedmont. Hilton reacted energeti- cally to these claims, and thus the tale of the "German" Jacob Weaver owes as much to Hilton's particular situation and era as it does to the facts of history.

To substantiate the "secret color formula" of Jacob Weaver, Hilton owned and displayed the handsome, lead-glazed earthenware plate that is illus- trated in figure 1-2. Although the plate is now recognized as the work of Moravian Gottfried Aust, Hilton insisted that it was made by his German predecessor; on the back of the plate is the pencilled notation, presumably by Hilton, "Made by / Jake Weaver / one of North Carolinas / first potters." In the same interview cited above, Hilton also reported finding a piece that

was " 'striped kinda like a Georgia watermelon' " that was made by Weaver.[36] This sounds very much like alkaline-glazed stoneware, in particular a pot with glass runs down the sides (see fig. 3-3).

Despite the lack of evidence, it would be presumptuous to dismiss Hilton's assertions as mere propaganda. In fact, there *was* a Jacob Weaver living on the Jacob Fork in southern Catawba County in the late eighteenth century. His will, dated 5 April 1788, indicates that he was a "Schoolmaster" and also a farmer; he owned considerable land and left his "working tools & implements of Husbandry" to his younger son, Jacob, Jr.[37] He apparently died in the following year, because his inventory is dated 3 August 1789.[38] Unfortunately, neither of these documents, nor subsequent ones concerning his sons (Jacob, Conrad) or grandsons (Ephraim, Solomon, Jacob) provide any details to indicate that there were any potters in the family. However, William M. Weaver and his son, Pinkney Lester Weaver, later ran shops at Blackburn and Plateau and could have been descendants of Jacob. And it is interesting that there were a substantial number of Weaver potters in both Pennsylvania and Tennessee.[39]

Whether one of these Jake Weavers was the patriarch or not, Hilton was entirely correct that numerous potters—in fact, several times his estimate of 42—worked along the west end of the common border between Lincoln and Catawba counties. The length of this area is indeed only eight miles, extending roughly from Henry and Vale in the southwest to the hamlets of Propst Crossroads and Blackburn in the northeast. This section was the original Jugtown of North Carolina. From 1874 to 1906 a post office with this name operated right in the center of the district. Today the entire region is commonly referred to as Jugtown, though in terms of historical development it is divided into three distinct sections.

The first potters appear to have settled at the southwest end, in Lincoln County, during the late eighteenth century. The next major cluster appeared about the time of the Civil War in southern Catawba County, near the present community of Corinth in Bandy's Township. The establishment of the Jugtown post office (originally spelled Jug Town) here in 1874 provides a clear sign that the center of the industry had moved into Catawba County. Finally, a third group of potters developed, after the Civil War, at the northeast end of the region between Propst Crossroads and Blackburn in Jacob's Fork Township. Potters moved back and forth very freely, of course, and there were a significant number of potters around Henry in the twentieth century, but in general the tradition seems to have originated in Lincoln County and gradually edged north and east. All three subsections are roughly equidistant from the potters' main clay source, the Rhodes claypit, which was located on the South Fork of the Catawba River some four miles north of Lincolnton.

Among the prominent early families were the Seagles (Siegel, Seigle) and Hartsoes (Hartzog, Hartzoch), who lived along Howard's Creek, just west of the Trinity Lutheran Church at Vale. Daniel Seagle is the earliest potter to

whom marked pieces of alkaline-glazed stoneware can reliably be attributed. He was either a prolific potter or he signed an unusually large percentage of his wares, for many survive, ranging from one-quart preserve jars to rotund fifteen-gallon storage jars. As the wares in plate 7 reveal, Seagle set a high standard for his peers. His forms are characteristically evenly turned, thin walled, bulbous, and enhanced by large, carefully pulled handles and well-melted green or brown glazes.

Seagle's parents were Adam and Eva (Lohr) Seagle, appropriate names to herald the beginning of a new tradition. Adam appears to have entered Lincoln County between 1790 and 1800, no doubt after making the long trek south from Philadelphia. An "Adam Siegel" landed in Philadelphia in 1774 on the ship Sally from Rotterdam, but there is no certainty that this is the same individual.[40] In addition the census records that Eva was born in Pennsylvania. There is the possibility that Adam was a potter—family tradition very tentatively allows that he might have made the coffee jar illustrated in plate 3—but his will and estate records offer no corroborating evidence. Daniel, however, most certainly made lead-glazed earthenware before turning to alkaline-glazed stoneware. By 1850 he had a well-established business. The Census of Manufactures indicates a capital investment of four hundred dollars; three employees produced six thousand gallons of ware valued at five hundred dollars. At least four potters were trained by him: his son James Franklin Seagle; his son-in-law John Goodman; Isaac Lefevers, who lived with the family; and his apprentice Daniel Holly. Surviving marked wares by all four embody Daniel's high craftsmanship. Although the later forms are somewhat smaller and less bulbous than Daniel's, they are often recognizable for their very thin walls, evenly applied glazes, carefully pulled strap and ear handles, and incised grooves cut into the jug necks.

Franklin and his brother-in-law, John Goodman, took over the shop after Daniel's death and ran it into the late 1890s. The Census of Manufactures for 1880 records a capital investment of one thousand dollars and an annual output worth nine hundred dollars. It was a full-time operation: the pottery operated for ten hours per day, twelve months per year, and during peak periods it employed as many as ten workers. Frank Seagle was apparently the last turner in the family; at his estate sale in 1892, potter Kelly Ritchie purchased his "Turning lay" for fifty cents, and Nelson Bass carried off the remaining "Raw ware" to his kiln for only forty-five cents. Thomas Seagle did purchase his father's "Clay mill" for thirty cents but probably never used it;[41] he had been primarily employed as the wagoner.[42]

Living right next door to the Seagles in 1850 was the family of David Hartzog, whose descendants continued to make pottery until the middle of the twentieth century (fig. 3-5). Patriarch David turned both earthenware and stoneware, stamping his handiwork with his flamboyant "DAVIDHARTZOGHI꘎MAKE." There are also a number of pots stamped "DH," and herein lies a problem. These could be either from the hand of

Figure 3-5
Hartsoe Genealogy.

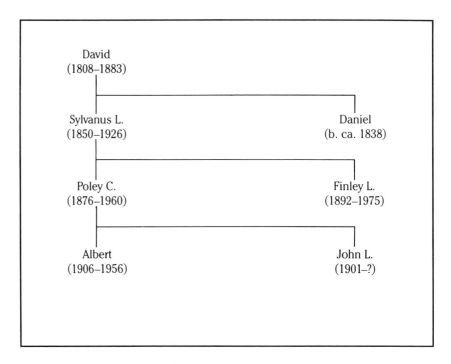

David or his son Daniel, about whom little is known except that he continued to work in the same area until the end of the nineteenth century.[43]

In terms of marked pieces, Sylvanus Leander Hartsoe ranks with Daniel Seagle as one of the most prolific potters of the Catawba Valley. Sylvanus worked first in Lincoln County and then moved up into Catawba near the Jugtown post office. What may be his masterpiece is illustrated in figure 3-3: a green, five-gallon brandy barrel with pale streaks of glass running down the sides. Sylvanus set the barrel in the kiln on one end and then heaped up a mound of broken glass on the top, which is now coated with a thick, translucent layer of solid green glass. Sylvanus also turned at least one other barrel, this one in a plain brown alkaline glaze, which is inscribed "August 25, 1898." Olen T. Hartsoe recalls that it was given to his Uncle Finley, who made ware as a boy but never pursued the business. One other characteristic of Sylvanus's work is the appearance of rich flows of blue fringed with milky white on the surface of his pots. This phenomenon is caused by rutile (titanium dioxide), which occurs naturally in the clays of the region. While occasionally found in the work of other potters, such as Burlon Craig, it is common enough in Sylvanus's wares to suggest that he may have deliberately sought such clays to produce this striking effect.

The third generation of Hartsoes is best represented by Sylvanus's son, Poley Carp, who stayed at his wheel until he was over eighty. Poley worked for years as a journeyman throughout the Catawba Valley at shops run by

Tom Phillips, the Hiltons, Luther Seth Ritchie, and Enoch and Harvey Reinhardt. He even turned at a pottery in South Carolina and boarded at the Kennedy Pottery in Wilkesboro. About 1926 he settled in the Little Mountain section of Catawba County, some five miles west of Maiden, and worked, with the help of his family, until 1957. During the early 1950s, his shop burned down, but he moved into a small house nearby and continued turning. Two of his sons, John and Albert, also briefly made wares but turned to other occupations. Poley was one of the last potters in the Catawba Valley—only Burlon Craig has continued longer—and to the end of his lengthy career he continued using the alkaline glaze and the associated traditional technology.[44]

Along with the Seagle contingent and the Hartsoes, other potters at work in the vicinity of Vale during the mid-nineteenth century included John Alrand, Jeremiah Clemer, Daniel Haynes, James M. Page, Thomas Ritchie, Noah Shufford, and Alexander Stamey. Like Daniel Seagle and David Hartzog, Haynes, Page, and Seagle's former apprentice, Daniel Holly, are all listed in the 1850 Census of Manufactures for Lincoln County, all five shops recording an output of five hundred dollars worth of "crocks." No potteries from Catawba County are listed in this census, but by the 1870s the largest body of potters was in Bandy's Township in the southwest corner of the county. Appropriately, the Jugtown post office was administered from 1875 to 1897 by potters Amon L. Johnson and his son Wade. Wade's brothers, Joseph and Harvey, also made ware in the area before establishing a shop in South Carolina, as did their cousin Eli before heading north into Virginia.

Three other prominent families located in Bandy's Township during the latter nineteenth century were the Ritchies, Propsts, and Reinhardts. The Ritchies (Richie, Ritchey, Ritchy) appear to have been the largest family of potters in the Catawba Valley, but so far it has been difficult to unscramble their genealogy (fig. 3-7). Moses—again an apt name for the head of a dynasty—started out in Lincoln County, but he and his three sons soon moved north into Catawba. Other than Thomas and his son Luther Seth, members of the family rarely bothered to mark their wares. A rare cooler decorated with glass runs, made by Thomas, is illustrated in figure 3-8. In 1850 he was still living in Lincoln County not far from the Seagles, from whom he may have acquired this decorative technique as well as the habit of stamping his initials ("TR") on the lug handles instead of the shoulder. His son Robert built his shop just up the hill from his father, not far south of the Jugtown post office, and is shown with his co-workers, Jim Lynn and Bob Canipe, in figure 3-9. Another son, who came to be known as "Uncle Seth," ran a shop at Blackburn until his death in 1940; he was the last of this large clan to make pottery.

In contrast to that of the ubiquitous Ritchies, the Propst genealogy is a model of simplicity (fig. 3-10). Family tradition affirms that Jacob was the first potter, but from whom he learned the craft remains a mystery. His shop

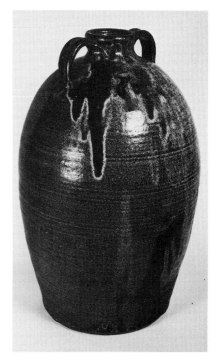

Figure 3-6
Alkaline-glazed molasses jug, last quarter of the nineteenth century, attributed to Sylvanus L. Hartsoe, Catawba County. H 16⅛", C 33¼", 4 gal. Collection of Mary Frances Berrier.

Figure 3-7
Ritchie Genealogy.

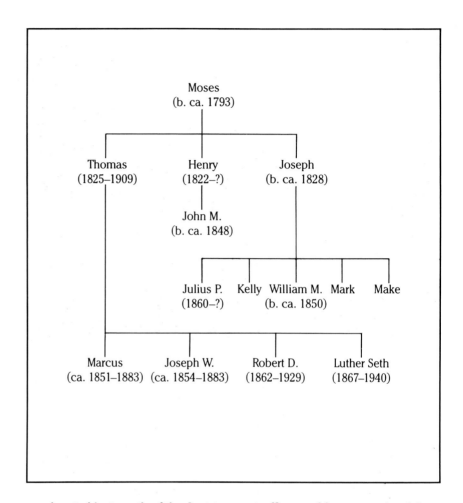

Moses
(b. ca. 1793)

Thomas Henry Joseph
(1825–1909) (1822–?) (b. ca. 1828)

John M.
(b. ca. 1848)

Julius P. Kelly William M. Mark Make
(1860–?) (b. ca. 1850)

Marcus Joseph W. Robert D. Luther Seth
(ca. 1851–1883) (ca. 1854–1883) (1862–1929) (1867–1940)

was located just south of the Jugtown post office, and he was assisted there by his cousin Daniel and his son Sam. After Jake's death, Sam worked as a turner for Lawrence Leonard near Cat Square, Lincoln County; went into partnership with his brother-in-law, Jim Lynn; and finally erected his own pottery at Henry. Sam was regarded as one of the most skilled turners in the region, and the careful symmetry of his forms justifies this reputation (fig. 3-11). Unlike most folk potters, he worked full-time at the craft; farming was definitely not one of his interests. As his daughter Hazeline reminisces, "the only thing my Daddy ever done in the field was plant his watermelon patch." In later years he was assisted by his family, particularly his son Floyd, who by the age of eight was turning smaller, decorative wares such as the baskets and pinch bottles that sold well in the growing tourist market. With the help of oldtimers Will Bass and Jule Ritchie, Floyd kept the pottery going until 1937, when he moved to California.[45]

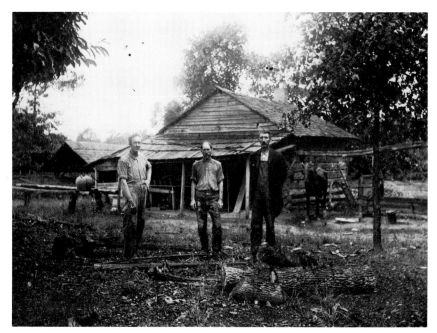

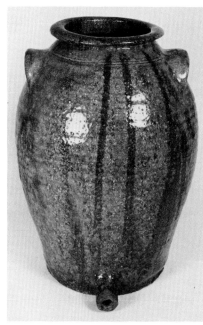

Like so many North Carolina potters, the Propsts either made their own tools or managed to acquire ones used by earlier potters in the region. Money and resources were never abundant; it was always more efficient to recycle old materials. Even their sturdy log shop (fig. 3-12) was a hand-me-down from their neighbors, the Reinhardts; many decades earlier it had been used by the Reinhardt patriarch, Ambrose. In addition to the main family outlined in the genealogy (fig. 3-13), a distant relative named Logan Reinhardt (1852–1936) ran a shop just south of Propst Crossroads until 1908. Unlike the six potters in figure 3-13, Logan was not a turner and so hired Joe Stamey, Poley Hartsoe, and George Baker to turn for him.

Ambrose's shop was located in Catawba County just north of the Lincoln County line, and later his two sons ran their pottery just across the road from his home. Young Enoch and Harvey (fig. 3-14) worked for their father and uncle, along with their cousin Hugh, but it was not until about 1932 that they went into business together in Henry. Harvey had been working for his neighbor, Jim Lynn, and then persuaded Enoch to open a shop with him. Generally Harvey turned the large, utilitarian pieces, Enoch, the smaller tourist items; much of their output was stamped "REINHARDT BROS / VALE, N.C." About 1936 Harvey erected his own shop and kiln—which are still used today by Burlon Craig—and the two brothers ran separate businesses until 1942, when Harvey went to work at a shipyard in Wilmington, North Carolina. Enoch burned the last Reinhardt wares in the summer of 1946,

Figure 3-8
Alkaline-glazed stoneware cooler, third quarter of the nineteenth century, Thomas Ritchie, Catawba County. H 11¹¹/₁₆", C 27¹/₄". Stamped: "TR." Decorated with glass streaks. Collection of Roddy Cline.

Figure 3-9
The pottery shop of Robert Ritchie (r.), located near Jugtown, Catawba County, ca. 1914. The groundhog kiln and woodshed are on the far left; a treadle wheel is set up under the shed roof behind journeymen Jim Lynn (l.) and Robert Canipe (c.); and the clay mill is to the right of the log shop. Courtesy of Clara Ritchie Wiggs.

Figure 3-10
Propst Genealogy.

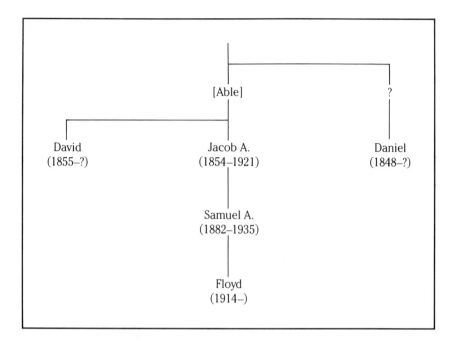

[Able] ?

David Jacob A. Daniel
(1855–?) (1854–1921) (1848–?)

 Samuel A.
 (1882–1935)

 Floyd
 (1914–)

Figure 3-11
Alkaline-glazed stoneware jar and
jug, ca. 1920, Samuel Propst, Henry,
Lincoln County. Jar: H 15 1/8",
C 35 1/4", 4 gal. Jug: H 16 1/2", C 37 5/8",
5 gal. Collection of Hazeline Propst
Rhodes.

after persuading his new neighbor, Burlon Craig, to turn enough large pieces to fill his kiln.[46]

The third major subregion in the Catawba Valley was at the northeast end of the district in Jacob's Fork Township, Catawba County. Here the most prominent family was the Hiltons (earlier spelled Helton), headed by John Wesley Helton, who established a shop after returning from the Civil War (fig. 3-15). A photograph of Helton appears in George W. Hahn's *The Catawba Soldier of the Civil War*, along with the following account: "John W. Helton, a member of Company E. 72nd Regiment of Junior Reserves, enlisted with the seventeen year old boys, and was, with nearly all of them, captured at Kinston, N.C., December 25th, 1864. He remained in prison until April or May, 1865. He became a farmer after the war, and also engaged in the manufacture of jugs."[47] Just what or who induced the retired soldier to manufacture jugs remains unclear, but by the turn of the century this area was saturated with Hilton potters.

In all, there appear to have been at least half a dozen Hilton potteries, and members of the family worked as journeymen in distant counties as well. Three of John Wesley's daughters married potters Spurgeon Childers, Uncle Seth Ritchie, and Junius W. Cobb. Three shops were located along Route 10 just east of Propst Crossroads: John Wesley's, Rufus's, and the Hilton Pottery Company, established by John's three sons in about 1918 (fig. 3-16). In addition, George Hilton and Seth Ritchie made ware at Harmony and Houstonville, Iredell County, and they employed Curtis Hilton as their main turner. As the demand for traditional wares waned after World War I, Auby Hilton took the leading role in creating more decorative art and table ware, not only at Propst Crossroads but also at Oyama, just east of Hickory, and Pleasant Gardens, in McDowell County.[48]

Further east of Hilton country along Route 10 is the hamlet of Blackburn, which was named after another family of potters that included brothers Henry and Cornelius ("Nealy") Blackburn and Henry's son Walter (fig. 3-17). And there were numerous other potteries between Propst Crossroads and Blackburn operated by Spurgeon Childers, Newton Leatherman, Tom Phillips, Seth Ritchie, Peter Sharpe, Robert Speagle, William Weaver (who also served with John Helton in the ill-fated 72nd Regiment), and Colin Yoder.[49]

Altogether, there were fewer potters in the Catawba Valley—perhaps 130 as compared with about 200 for the eastern Piedmont—but the narrow, eight-mile section along the border of Lincoln and Catawba counties was much smaller and more densely packed with shops than were Randolph, Chatham, and Moore. Moreover, the traditional potters continued much later in the Catawba Valley. As late as the 1920s and 1930s, at least thirteen shops were still producing large quantities of utilitarian, alkaline-glazed stoneware. Even more remarkable, Burlon Craig of Henry continues today to burn about four kilnfuls of ware per year, using the old shop and kiln built by the Reinhardts during the late 1930s (fig. 3-18). More than fifty years ago,

Figure 3-12
The Propst family's pottery shop,
Henry, Lincoln County, ca. 1930.
Courtesy of Hazeline Propst Rhodes.

Figure 3-13
Reinhardt Genealogy.

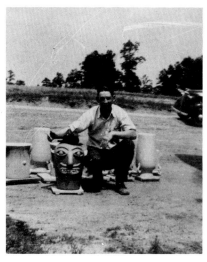

Figure 3-14
Harvey Reinhardt and friend outside
his pottery shop (now owned by
Burlon Craig), Henry, Lincoln
County, late 1930s. Courtesy of
James and Irene Gates.

Figure 3-15
Hilton Genealogy.

Burl learned to turn from his neighbor Jim Lynn (fig. 3-9), who in turn had acquired his skills at Lawrence Leonard's shop. The 1870 census for Lincoln County indicates that Lawrence's father, twenty-year-old John F. Leonard, lived only a few houses away from Frank Seagle and John Goodman. If, as is most likely, John Leonard learned his craft from *his* neighbors, then the link between Daniel Seagle at one end and Burlon Craig at the other is complete. Burl is the last of a long, long line of folk potters in the Catawba Valley.

Outside of the Catawba Valley, small quantities of alkaline-glazed stoneware were produced at several other locations in the western Piedmont and also in the Mountains. The most important of these satellite traditions lay

Figure 3-16
The Hilton Pottery Company just east of Propst Crossroads, Catawba County, ca. 1922. Standing from left to right behind the drying flowerpots are Claude, John Wesley, and Shufford. Courtesy of the North Carolina Division of Archives and History, Raleigh, N.C.

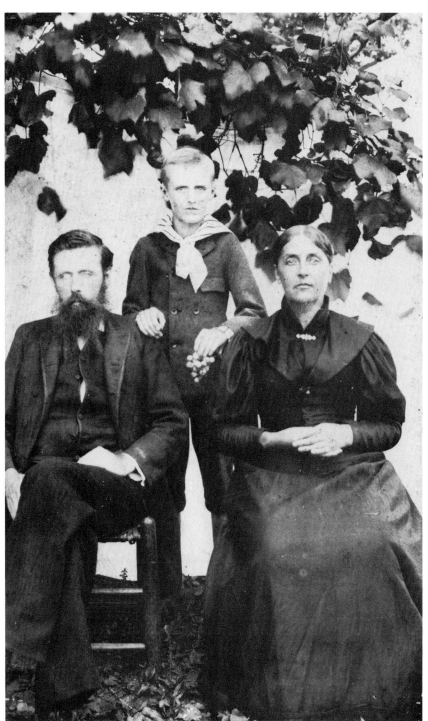

Figure 3-17
Henry and Caroline Blackburn with their son Walter, Blackburn, Catawba County, ca. 1900. Courtesy of Asa and Thomas Blackburn.

just west of Asheville in Buncombe County, where members of the Stone and Penland families made pottery for at least one hundred years. In fact the area just above Interstate 40, north of present-day Luther and Candler, was once known as Jugtown and is still so designated on current county maps issued by the North Carolina Department of Transportation. There are several different versions of the founding of the first pottery there, but it seems clear that the Penland family played the central role (fig. 3-19). One account of the Penland Pottery, published in 1930, affirms that "it has been handed down through six generations of Penlands[;] at present it is owned and operated by W. M. Penland. Ninety-nine years ago the great-grandfather of the present potter, he too a William Penland, left a section of England famous for its earthenware. . . . He sought a spot in America similarly endowed by nature. This he found in western North Carolina. He settled in Candler, and in 1831 the first jug was fashioned at the Penland Pottery. Mr. Penland was not himself a potter. The first potter he employed was a Mr. Matthews: the second, a Mr. Stone."[50] This account differs in many respects

Figure 3-18
Burlon Craig's groundhog kiln and woodshed, with the clay mill and shop directly behind it, Henry, Lincoln County.

Figure 3-19
Penland Genealogy.

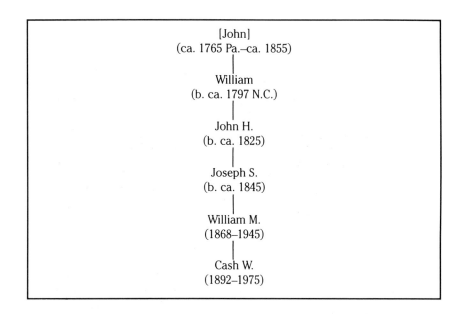

[John]
(ca. 1765 Pa.–ca. 1855)

William
(b. ca. 1797 N.C.)

John H.
(b. ca. 1825)

Joseph S.
(b. ca. 1845)

William M.
(1868–1945)

Cash W.
(1892–1975)

from another version that had appeared four years earlier. "'Just anybody can't make pottery,' William Penland says. It was his great-grandfather who went into business with E. W. Stone in South Carolina in 1836 to learn the trade. Stone had learned it from Chandler, who might be given the title of the first Anglo-American potter, and the designs and patterns have been changed very little as time has passed. Leaving South Carolina the original firm of Stone and Penland settled near Candler, where the clay looked good, and where enough iron ore could be found to make the glaze solution." This article also notes that the Penlands "have burned their pottery in the same place" for seventy-five years, indicating a founding date of about 1851.[51]

No doubt these two accounts are a mixture of fact and fancy, but there is sufficient agreement to construct a reasonably plausible chronicle of the establishment of this Jugtown. The English connection can be dismissed; very likely it evolved over the years to validate the Buncombe County tradition, just like the assertions of a Staffordshire origin for the potters of the eastern Piedmont. Instead, it appears that the alkaline-glazed pottery of this region is an offshoot of the Edgefield District of South Carolina. The key figure is Edward W. Stone, who arrived from South Carolina probably in 1843 or 1844.[52] Stone had earlier operated a pottery in the Edgefield District, where in 1841 he was sued by the State of South Carolina. A brief notice in the *Edgefield Advertiser* states: "Will be sold on Monday the 16th of August (inst.) at the Pottery on the Martintown Road, one lot of Jugs, Jars, etc. Terms cash."[53] Whether Stone was ever in business with William Penland in South Carolina remains unproven, but there must have been some connection that

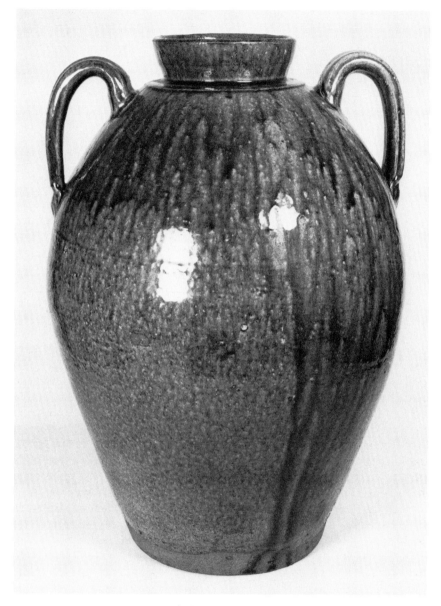

Figure 3-20
Alkaline-glazed stoneware jug,
fourth quarter of the nineteenth cen-
tury, James Henry Stone, Candler,
Buncombe County. H 18⅞″, C 42⅝″,
5 gal. Stamp: "J. H. STONE." Collec-
tion of Doug and Jane Penland.

brought him to Buncombe County at this time. Most likely, Stone contrib-
uted the potter's skills and Penland, the capital and land to set up the new
shop.

There was also an Isaac R. Matthews from South Carolina living near
Stone and the Penlands in 1850. Although he is listed in the census as a
"Laborer," he may have been the potter named "Mr. Matthews" cited above.

Figure 3-21
William Marion Penland standing in the doorway of his shop at Candler, Buncombe County, ca. 1925. Courtesy of Walter and Dorothy Auman.

Figure 3-22
A selection of wares made by Oscar Louis Bachelder at Luther, Buncombe County, ca. 1925. The two on the left have unglazed rustic surfaces; those on the right are coated with Albany slip. Courtesy of the North Carolina Division of Archives and History, Raleigh, N.C.

Moreover, the "Chandler" who supposedly taught Stone is almost certainly the Thomas Chandler of the Edgefield District discussed earlier. Chandler was active as a potter from 1838 through 1850 and then died somewhere in North Carolina in 1854. Two other potters from South Carolina also resided in the immediate area and almost certainly worked for the shop: Francis Devlin and William Rhodes. Again, both of these surnames are found among the potters in the Edgefield District.[54]

Presumably, then, the Penland-Stone pottery was established in the 1840s with Edward Stone as the turner. However, the first Penland formally listed as a potter is Joseph Sylvester; he and James Henry Stone, Edward's son, ran the shop together into the twentieth century. William Marion Penland married Henry's daughter Emma, and he and his descendants continued to produce stoneware until about 1945. Apparently the success of the Penland-Stone enterprise encouraged other families to erect shops in the area. Benjamin Robert Trull built his during the very late nineteenth century and was assisted by his sons, William and James Otis, who did most of the turning. Benjamin sold the ware from his wagon and on one occasion may have ranged as far west as Texas. "He went down there with a load [of pottery] and selling a cancer remedy, and he got chills and fever down there and like to died before he got back. Had to leave his horses and everything—he had a whole drove of horses that he was bringing back. And he had to leave all of them and just come back, and he never was well after that, and went down, and got out of the shop business."[55]

About 1905, when the Trulls went out of business, James D. Rutherford put up a large pottery nearby and operated it for another ten years or so. He built a twenty-foot waterwheel in the west fork of the Webb Branch and used it to power his three potter's wheels. As he was not a turner, he hired others to work for him, including his son-in-law J. O. Trull, W. M. Penland, Robert Anderson, Albert Fulbright from South Carolina, and Oscar Louis Bachelder.[56] Like the Penlands and Trulls, Rutherford used an alkaline glaze containing both glass and crushed iron rock. This combination produces a mottled orange-brown and black that is very distinct from the alkaline glaze of the Catawba Valley. However, as Albany slip became available, the Rutherfords and Penlands soon abandoned the old glaze.

One potter in this region who partially transcended the utilitarian tradition was the aforementioned O. L. Bachelder. A journeyman potter who worked for over forty years in twenty-eight states and territories and even in Canada, Bachelder entered Buncombe County in 1911 and turned for a time for James B. Rutherford. In 1914 he founded his own shop at Luther, in partnership with Robert F. Gudger. Eventually Gudger left the business, and Bachelder adopted the name Omar Khayyam Pottery to emphasize a growing line of art wares. His forms did not deviate widely from the folk tradition but were distinguished by their rich, dark coatings of Albany slip (some-

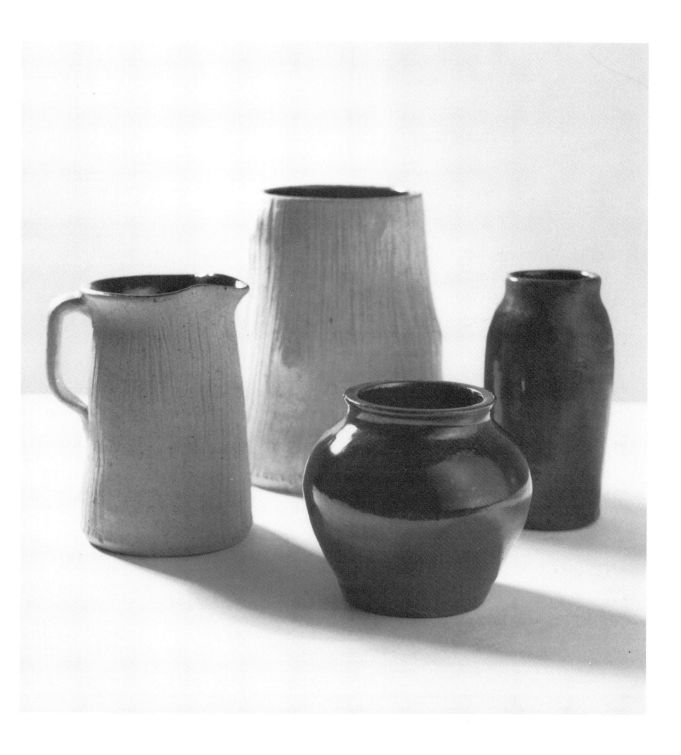

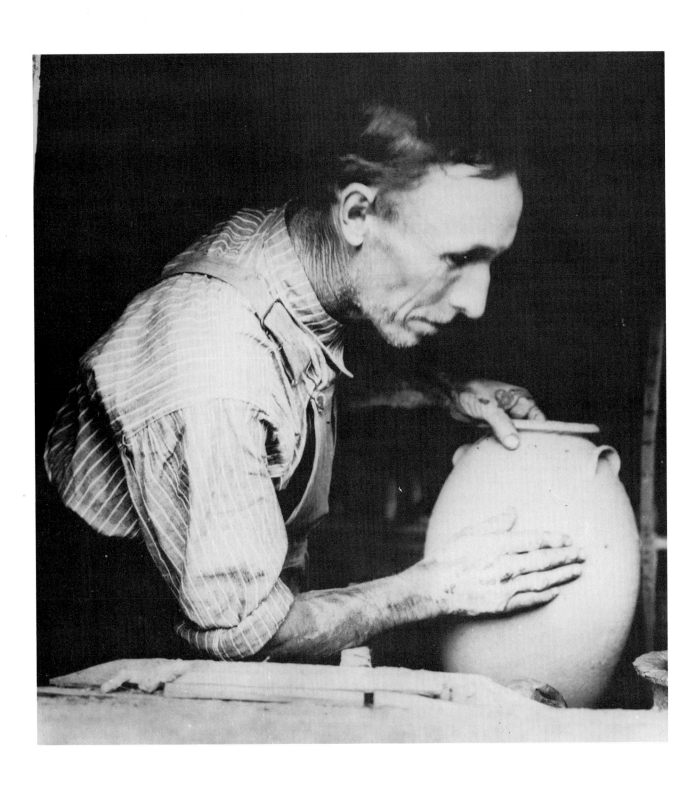

times combined with ashes, cobalt, or manganese) or their unglazed, tan exteriors textured to simulate wood (fig. 3-22). Bachelder probably influenced the neighboring Penlands to make slip-glazed vases and similar rustic wares, and he eventually achieved a national reputation as an art potter. Certainly he was one of the earliest potters in North Carolina to make art wares out of the utilitarian tradition.[57]

There were also a number of potteries in and around Weaverville, nine miles to the north of Asheville. James R. Cheek ran a shop from the late nineteenth century until perhaps 1910. His grandson Lester recalls that the main turner was a "Mr. Stone," no doubt Henry Stone.[58] The shards at the site reveal an alkaline glaze identical to that made by the Stones and Penlands, indicating that this was an offshoot of the Jugtown potteries. An "M. Shuford" is also listed as running a "Pottery Works" at Weaverville in the 1890s; possibly he was a migrant from the Catawba Valley.[59] Finally, just before the turn of this century George and David Donkel established a pottery along Reem's Creek to the east of Weaverville. The Donkels were originally from Williamsport, Pennsylvania, but their parents moved to the Catawba Valley, where the two brothers learned to make pottery. Local tradition affirms that they were peddling wares in Weaverville and decided to settle because of the abundant local clay. David soon turned to farming, but George continued to make alkaline-glazed stoneware until about 1940, assisted in later years by Talman Kermit Cole. The stamp used by the Donkel brothers is certainly one of the least modest in North Carolina; as illustrated in figure 3-24, it bluntly declares: "D.&D. / THE. BEST."

Outside of Buncombe County, there are only scattered references to potters, most of them relatively late arrivals. For example, the Population Census lists a Jeremiah C. Martin, from South Carolina, in Yancey County in 1850; a Samuel D. Harper, from Tennessee, in Macon County in 1850; and Michael Austin (Georgia) and Arthur Webb (Tennessee), who lived next to each other at Wolf Creek, Cherokee County, in 1860. Even as late as 1923, the Brown family migrated north out of Georgia and built a pottery at Arden, just south of Asheville. Although raised on traditional alkaline and salt glazes in their home state, the Browns used mostly Albany slip, Bristol, and commercial glazes at their new location and increasingly moved away from churns, pitchers, and jars toward casseroles, horticultural wares, and tourist items. Today, Brown's Pottery at Arden and Evan's Pottery at nearby Skyland are the sole survivors of the old folk tradition in the Mountain region of North Carolina.[60]

The history of the development of folk pottery in North Carolina thus falls into well-marked temporal and spatial patterns. The formative period occurred from 1755 to 1825, as potters of German and British origin filtered into the Piedmont, the majority arriving with tens of thousands of other immigrants via the Great Wagon Road through the Valley of Virginia. These early craftsmen supplied much-needed lead-glazed earthenwares to isolated

Figure 3-23
George Donkel with a characteristic ovoid jar at his shop just east of Weaverville, Buncombe County, ca. 1914. Photograph by William A. Barnhill. Courtesy of the Library of Congress.

Figure 3-24
Alkaline-glazed stoneware inkwell,
a rare form, made ca. 1900 by Dave
or George Donkel, near Weaverville,
Buncombe County. H 3⅜", D 3⅞".
Stamped: "D.&D. / THE. BEST." Col-
lection of Talman K. Cole.

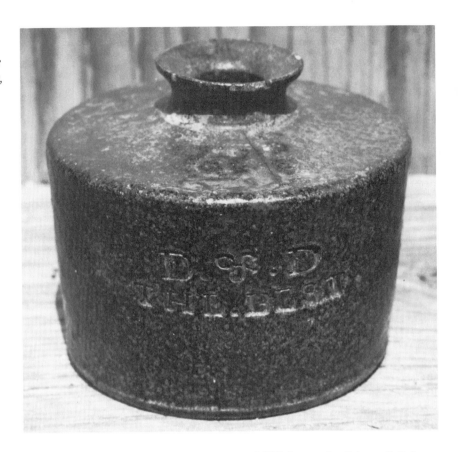

farms as well as to the growing towns of Hillsborough, Salem, Salisbury, Charlotte, and Lincolnton. Given the frontier conditions that prevailed, the pottery was utilitarian and unembellished, and little has survived that can be reliably attributed to specific potters. The one striking exception was the elaborate slip-decorated and molded ware fashioned by the Moravians, who comprised a distinctive community in the center of Forsyth County. Virtually all of the production occurred in the Piedmont, a region characterized by small, self-sufficient farms. Although the Coastal Plain was initially settled almost a century earlier, the lack of good clays and the heavy competition from foreign markets discouraged local potters from setting up shop.

The next seventy-five years, from 1825 to 1900, constituted the great age of stoneware. During this era potters multiplied across the Piedmont and spilled into the Mountains as well. Stoneware rapidly displaced earthenware as the primary product, although earthenware baking dishes, flowerpots, and lesser forms remained an important sideline in the east. By 1850 two large, highly concentrated stoneware centers had evolved: the salt glaze tradition of the eastern Piedmont—including Randolph, Chatham, and

Moore counties—which was fostered by potters of British origin; and the German-dominated alkaline glaze of the Catawba Valley counties of Lincoln and Catawba. Each center appears to have developed from an early cluster of earthenware potters, notably in Randolph and Lincoln counties respectively; together these two compact areas produced half of the folk potters in North Carolina. Smaller clusters of potters appeared in outlying counties, but the division between the salt and alkaline glazes remained very precise, with a transitional zone extending from Wilkes County in the north to Union County in the South.

The ascendancy of stoneware also heralded the rise of a number of important families, two of which—the Cravens and Coles—appear to have remained in the craft for two centuries. Others, such as the Foxes, Teagues, Owens, Seagles, Hartsoes, Ritchies, and Penlands persisted a mere one hundred years. Moreover, the growth of the craft within individual families in the nineteenth century shows some remarkable similarities:

Figure 3-25
Brown's Pottery, Arden, Buncombe County.

Cole: Raphard (1799–1862) / Evan (1834–1895)
Craven: Anderson (1801–1872) / Dorris (1827–1895)
Fox: Nicholas (1797–1858) / Himer (1826–1909)
Hartsoe: David (1808–1883) / Sylvanus (1850–1926)
Seagle: Daniel (c. 1800–1867) / Franklin (1829–1892)

Excepting Sylvanus Hartsoe, who was something of a latecomer, the dates for these important father-son combinations are almost identical. In each instance, they represent the first and second generations to make stoneware. The fathers were all active during the crucial second quarter of the century, from 1825 to 1850, and the sons were even more fortunate to be working in the second half of the nineteenth century, during the period of maximum output and the full flourishing of the folk tradition.

The final years, from 1900 to 1940, constituted an era of decline and transition. Even before the turn of the new century, diverse forces were combining to undermine the demand for the utilitarian pottery: the availability of cheap metal, glass, and whiteware containers; the growth of large dairies and markets; and improved methods of transportation and refrigeration. Next followed Prohibition, World War I, the Depression, and World War II, each of which further weakened the old craft. However, each of the major regions was affected by these events in different ways.

In the eastern Piedmont, only a few of the old potters remained in business after World War I. But during the 1920s and 1930s, a remarkable period of innovation occurred, as a number of potters altered their products, technology, and marketing practices to appeal to a new and diversified middle-class clientele. A full account of this striking renewal will be given in chapter 13; its success is embodied in the potteries operated by the Auman, Cole, Owens, and Teague families that still flourish in this region.

By contrast, the production of traditional alkaline-glazed stoneware in the

Catawba Valley remained largely unabated until World War II. After its eventual decline, however, no similar revitalization occurred here, and today only a single figure remains: Burlon Craig, the last folk potter in the state. Further west, the Penlands closed down around 1945, but two potteries operated by the Brown family south of Asheville are very much in business. Like the families in the east, the Browns adapted to changing tastes and demands and successfully weathered the decline of the folk tradition. In their varying ways, all of these potteries embody a tenacious, deep-rooted ceramic heritage. But beyond the flow of history, they are also valuable for the insights they provide into the now largely vanished folk technology.

PART TWO. TECHNOLOGY

4

CLAYS

Clay is one of the most versatile materials known to man. It is soft, flexible, plastic, almost infinitely variable in its natural state. "It can be modeled, pounded, flattened, rolled, pinched, coiled, pressed, thrown on the wheel, cast into molds, scored, shredded, pierced, stamped, extruded, cut, or spun."[1] And yet when fired to maturity, it becomes extremely durable, harder than many metals. This "mud," as the potters refer to it, is abundant, easy to locate, and cheap. But when it is burned with fire, it undergoes an irreversible transformation and assumes a new utility, beauty, and value. Frequently, the end product of the potter's work totally belies its common origins.

Clays of varying compositions are continually created by the weathering of the earth's crust. Geologists like to classify clays into two categories based on this process of formation: residual or primary, and sedimentary or secondary clays. The former type consists of "clays which have been formed on the site of their parent rocks and have not been transported, either by water, wind, or glacier."[2] Because these clays have experienced relatively little movement, they tend to be coarse-grained, nonplastic, and free of impurities. Kaolin, the pure, white-burning clay used for porcelains, falls into this group. Sedimentary clays, on the other hand, have been carried from their original site, most commonly by streams and rivers. Eventually, the "coarse sediments are dropped and the finer materials are carried into the valley and deposited as flood-plain and terrace clays in quieter water."[3] Because of this extensive action, the particles—microscopic plates or flakes —are relatively small in size, and the clay therefore possesses good plasticity. However, due to the long journey, such clays contain considerable impurities in the form of rocks and carbonaceous matter. Most of the clays used by the folk potters were sedimentary and were dug from pits along stream and river bottoms.

North Carolina has been blessed with a particularly rich supply of clays. "There is hardly a community in the State that does not contain clay of some use, however limited it may be. Residual clays are limited to the Piedmont and Mountain regions of the State. River-bottom or flood-plain clays of varying quality and quantity occur along streams in the Mountains, Piedmont, and Coastal Plain."[4] And not only the potters have taken advantage of these abundant natural resources. Since 1962 North Carolina has been the leading producer of bricks in the United States, most of them now made from shale, a compacted form of sedimentary clay found in the Piedmont. Moreover, the

state ranks first in the commercial production of residual kaolin, from a large number of mines in the Mountain region. While the folk potters never tapped this particular clay source, the most renowned of all English potters did so more than 200 years ago.

In 1767 Josiah Wedgwood sent Thomas Griffiths to America to obtain a load of Cherokee clay, or *unaker*, as it was referred to by the Indians.[5] Always the aggressive, far-sighted entrepreneur, he even contemplated securing a monopoly on these valuable deposits. The following year, he confided to a friend that a "Patent, or Exclusive Property in the Cherokees, is business enough of it self to sollicit and prosecute in the best manner."[6] However, he soon recognized that governmental red tape, as well as the need to keep the project secret, precluded such a course, and so he dispatched Griffiths as his private agent. Despite the numerous obstacles to the undertaking—not the least of which was the reluctance of the Cherokee owners—Griffiths successfully dug five tons of high-grade kaolin out of a pit several miles north of Franklin in present-day Macon County and hauled it by packhorse and ship back to England. Despite the fine quality of the clay—Wedgwood declared it superior to the native Cornish clays—there were no further expeditions.[7] In Wedgwood's words, "what with the difficulties in procuring leave from the natives to dig for it, and a long and heavy land carriage on horseback by the Indian traders at just what rates they please to charge, there was no hope of any future supply upon such terms as could be complied with by any manufactory."[8] The tale of Josiah Wedgwood and the Cherokee clay constitutes another chapter in Europe's continuing attempts to replicate Chinese porcelains. But this one shipment did not go to waste; Wedgwood used the *unaker* for his delicate Jasper wares, perhaps the most famous of all his products.[9]

Kaolin, however, was not part of the stock of the folk potter. It was expensive and often difficult to obtain (all of the North Carolina deposits were in the distant mountains); it required numerous additives to achieve proper plasticity and strength; and even with additional fluxes to lower the melting point, it had to be fired at very high temperatures. Kaolin thus became part of the more sophisticated artistic or commercial tradition. The basic clay types used by the folk potter were earthenware and stoneware, two humbler but more serviceable relatives of kaolin.

At a minimum, all clays contain large amounts of silica, alumina, and water. The differences in their compositions lie in the ratios of these three main ingredients, as well as the quantities of other materials contained in the clay body. A chemical analysis of the average composition of the surface of the earth and the three primary clay types is provided in Table 2. Clearly earthenware clays differ relatively little from ordinary earth. On the other hand, stoneware clay and kaolin show an increasing "purity," as the percentages of iron and other oxides fall off markedly, and the amount of alumina and water climbs. Ideally, the perfect kaolin would consist of only silica,

TABLE 2

The Composition of Clays

	Earth[a]	Earthenware[a] Clay	Stoneware[b] Clay	Kaolin[c]
SiO_2	59.14	57.02	57.08	45.56
Al_2O_3	15.34	19.15	26.11	38.65
Fe_2O_3	6.88	6.70	4.64	.41
MgO	3.49	3.08	.16	.08
CaO	5.08	4.26	.20	.05
Na_2O	3.84	2.38	} 1.42	.55
K_2O	3.13	2.03		.80
TiO_2	1.05	.91		.10
H_2O	1.15	3.45	8.52	13.90

Sources: a. Rhodes, *Clay and Glazes*, p. 6.
 b. Ries, *Clay Deposits*, p. 78.
 c. Ries, Bayley, et al., *High-Grade Clays*, p. 25.

alumina, and water—this would be the mineral kaolinite—but in reality some impurities are always present. Ultimately there is an infinite range of ceramic possibilities in the spectrum suggested above. That is, there is no single "stoneware clay," but a variety of clay bodies under this general classification, some of them tending more toward the redware end of the spectrum, others toward the kaolin end. For example, the stoneware bodies of the Catawba Valley tend to be less dense and vitreous than those from the eastern Piedmont. And some of the wares from the Edgefield District of South Carolina probably lie between stoneware and porcelain on the above scale, as the clays used contained high proportions of sedimentary kaolin.

Geologist J. L. Stuckey suggests that the "physical properties of importance in controlling the value of clays include (1) plasticity, (2) strength, (3) shrinkage, (4) color, and (5) fusibility."[10] For the folk potter, the plasticity and strength of his clay body were of primary concern, and he employed a number of common terms to designate these qualities. Highly plastic clays were "fat" or "tough," as opposed to those that were "lean" or "short." The former tended to be fine-grained and relatively free of nonplastic materials; the latter contained coarser clay particles and also substantial sand or flint. Often the potter had to combine both types in order to balance plasticity with strength. Clyde Chrisco recalls that "we'd mix it. You could take the kind that wouldn't work by itself—you've got to experiment with it, you know. . . . Michfield [clay from Randolph County] burnt mighty good but it was short—didn't turn good. You'd get a little tough clay to mix with it,

made it work better."[11] In other words, a more plastic clay was added so that the potter could turn his jars and churns on the wheel. Without the proper plasticity, the clay would crack and pull apart as the potter attempted to shape it.

On the other hand, it was often necessary to strengthen an already plastic clay. As Burl Craig describes it: "A real tough clay—what I call tough—won't stand up in making big stuff. It'll wobble. And you have to put some short clay, or some other clay that will stand up good, to go with it."[12] In effect, the nonplastic matter strengthens the walls of the pot and prevents warping or shearing. One of the best sources for short clay was the Rhodes claypit in Lincoln County, which was used by most of the potters of the Catawba Valley. In Ernest Hilton's words, " 'potters find this clay not a very fine clay, but it is liked by them for its strength, it being unusually long and stout [short] and can be spun exceedingly thin.' "[13] It is not uncommon to find lightweight, five-gallon jugs from this region with walls no more than ¼″ in thickness. But the rotund storage jars by Daniel Seagle—with capacities of ten, twelve, and fifteen gallons—provide even more impressive testimony to the truth of Hilton's remarks. That the curved walls did not shear on the wheel and the huge greenware forms did not break during glazing or loading in the kiln provide striking proof of the strength of this clay. The Rhodes clay was the potter's ideal, as it was ready to use without any additions. Perhaps the highest praise comes from the late Enoch Reinhardt, who once declared, "I don't know what you called it, but it looked good enough to eat when you took it out."[14]

A third problem for the potter was shrinkage, which occurred first after the pot was turned and later in the kiln. "Drying is greatly facilitated by the presence in the clay of any sort of nonplastic particles. Such particles tend to take up much less water than clay and . . . also furnish open pores or channels through which moisture can escape toward the surface."[15] Thus, shrinkage was directly related to plasticity: the clay could not be too fine-grained or free of sand, flint, and the like. Otherwise the water would escape unevenly, and sections of the piece might warp and crack. Each piece that "air cracked" while drying meant a loss of income for the turner. At the end of the day, the potter deducted the wares with cracked rims or bottoms or broken handles before reckoning his output. Likewise, excessive shrinking in the kiln meant further damage or an improper glaze fit. Clearly other factors were present here—the potter's ability to turn walls of even thickness, or the rate of firing of the kiln—but it was important to select or mix a clay that would dry and fire properly. However, this does not appear to have been a significant problem for the traditional potter. And when an unexpected crack appeared in a finished piece, he sometimes found ways to reclaim it. "Sometimes," explains Bascom Craven, "maybe a crock had a crack in the bottom. Just lay a piece of glass in there and put it down and burn it again. And it'd just seal it up, that glass, it melted that glass, you know." In effect, the technique was just like soldering.[16]

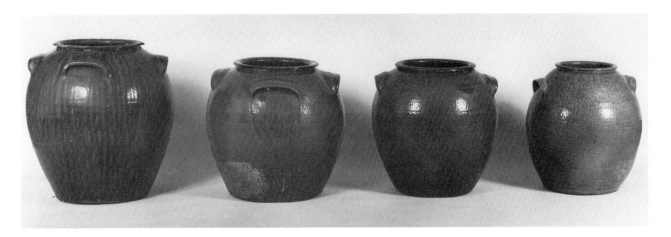

The achievement of a particular color was relatively unimportant, as is evident from the wide range of natural hues found in North Carolina pottery. For the industrial potter or artist, color is critical—even a tiny percentage of iron can contaminate the pure whiteness of a porcelain epergne. The folk potter, however, was primarily concerned with utility, not decoration; what few attempts he made to manipulate color were largely accomplished with the glazes, not the clay body. The iron in the clay is the primary coloring agent, but the precise tone produced depends on many factors—most importantly, the type of glaze and the conditions of the firing. Normally, earthenwares range from yellow to orange to reddish brown; salt-glazed stoneware is gray but often possesses a brown or greenish shading; and alkaline-glazed stoneware is characteristically brown or green.

There appear to be few instances where the color of the clay body was deemed particularly important. About the turn of this century, Franklin Cole dreamed one night "of a large mass of white clay, and the next day he went off in search of his vision. Incredibly, he discovered a large body of white-burning stoneware clay on a farm just north of Seagrove, and he soon traded his land for that valuable deposit."[17] The cream-colored stoneware that resulted from this source became very popular—buyers requested it because it was cleaner looking and somewhat resembled commercial whitewares—and the "Auman Pond" or "Michfield clay," as it was later called, was used by many potters in the region. About 1930 the Propsts and Reinhardts in Lincoln County began making a kind of agate or "swirl" ware by combining light and dark clays to produce an attractive striped body. This new pottery sold very well, particularly in the growing tourist market, and forced the potters to take extra pains to locate clays with contrasting hues. On several occasions they even drove one hundred miles east to Seagrove to obtain their white clay from the Auman Pond. But such examples occurred rather late in the tradition and were clear exceptions to the rule. For the most part, the folk potter accepted the colors that nature provided for him.

Figure 4-1
A lineup of behemoths: four alkaline-glazed stoneware storage jars by Daniel Seagle, Vale, Lincoln County, rated (from left to right) at 15, 15, 10, and 10 gallons. The one at the extreme left is probably closer to 20 gallons. Courtesy of the Museum of Early Southern Decorative Arts, Winston-Salem, N.C.

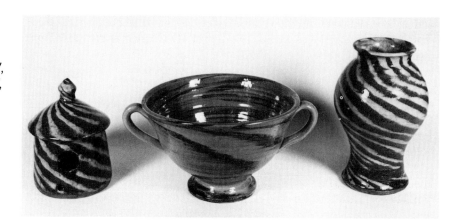

Figure 4-2
Alkaline-glazed swirl ware, old and new. Birdhouse: 1981, Burlon Craig, Henry, Lincoln County. H 7⅝", C 18⅜". Stamp: "B. B. CRAIG / VALE, N. C." Bowl: ca. 1930, attributed to Shufford Hilton, Catawba County. H 6¹⁵⁄₁₆", D 11⅛". Vase: 1981, Burlon Craig, Henry, Lincoln County. H 10⅜", C 21¼". Stamp: "B. B. CRAIG / VALE, N. C."

Fusibility, Stuckey's fifth criterion, relates to the burning of the ware in the kiln. Ideally a pot should be heated to its fusion point, when the clay body begins to vitrify. "The more fusible impurities of the clay may melt into small beads of glass. These liquid beads of melted material soak into the surrounding area, binding the particles together like a glue, and act like a solvent in promoting further fusion."[18] Obviously, the potter needed to stop the firing process once the wares reached maturity; if the process continued, the potter ended up with a twisted, useless form, or even a murky puddle of glass on the kiln floor. Because each clay was a unique blend of minerals, he learned through experience when the fusion point—actually a temperature range—had been reached.

In general, the greater number of impurities like iron, the lower the melting point. Thus, an earthenware may mature at about 1,800°F, stoneware at 2,300°F, and porcelain at perhaps 2,600°F. If necessary the fusion point of a clay could be raised by adding nonplastic materials such as sand or flint or even a short clay. Enoch Reinhardt recalled a "blue clay" in Lincoln County that "was tough—it wouldn't work well by itself, nor it wouldn't stand up under fire by itself." In other words, the clay was too plastic and had too low a maturation temperature. His solution? "You could mix it, say a third or a fourth, with the Rhodes [clay], and it made it work fine, you know, it made it more pliable and it would stand up good and it would burn good."[19] In thus blending it with a short clay, Enoch simultaneously improved the quality of his clay body on three counts: plasticity, strength, and fusibility. Very likely, he also decreased the shrinkage of the original blue clay.

A somewhat related problem was blistering, which could be caused by excess water, overly thick walls, a too rapid heating of the kiln, or the use of an improper clay body in the first place. Burl Craig once tried a fine-grained clay that he dug on the Catawba River in the eastern part of Catawba County. "I went over there and got a load of it, and used some of it by itself. I had churns in there with blisters on them, bubbles come out on them big as the

end of your finger." Although pieces such as the milk crock in figure 4-3 remained watertight and hence functional, their unattractive appearance discouraged would-be buyers. To allow the trapped water or gases to escape from within the walls of the pot, Burl saw two options. One was to place these wares in a cooler part of the kiln. "Naturally, it's overheating your clay. In a kiln like I got, you always overheat some of it. The trick is to have some clay that'll stand it, you know, stand the heat. And so I used it, used that and went back and got more, and it was good clay. But I didn't put it down in the hottest part of the kiln, and it worked fine." The alternative strategy was to add "real fine sand. I put some in some of that clay I got over at Catawba." In effect, Burl created a shorter clay, but this produced another problem. "You can feel that sand in turning. I don't care where you get it—you can go out here anywhere. Why, that sand, if you put just a little bit, it's hard on your hands in turning."[20]

All of these examples clearly demonstrate that the art of improving a clay body is a complex one. They also certify that the folk potter well understood the nature of his clays. While not a scientist, he knew how to obtain the desired qualities from the materials available to him.

Due to the wide distribution of suitable clays and the costs—or more frequently, the lack—of transportation, the potters relied on local deposits, but there was still a wide range of choice. A. R. Cole recalls that, in Randolph County, "we'd get clay all around at different places. One place was up on the mountain [Needham's Mountain near Seagrove]. Jess Albright had a good clay pond. That up there [above Seagrove], that was called Auman clay, . . . made real white saltware. Then there was the Spencer clay pond; it was pond clay where water stood over it a lot. Real dark but it was good. Over at Holly Springs was a big clay deposit—it worked pretty good if you mixed it with something else. . . . There was little patches all around; I've forgot where a lot of 'em were."[21]

Sometimes the potter was fortunate enough to discover clay on his own land. Charlie Craven remembers that his father Daniel found his clay "one day possum hunting, I think. He got it where a tree'd blowed over and seen the clay in the root of this tree."[22] Another son, Braxton Craven, confirms the story and adds that it was "blue clay, nice and shiny. . . . Made pretty, white stoneware."[23] Other potters moved considerable distances to take advantage of available deposits. Hearing that "there was plenty of clay around up here in Wilkes County," B. J. Kennedy and his brother Dave traveled north to Wilkesboro from Catawba County, and they "looked around and they did find quite a bit of clay. And they went back, and he hitched up his horse and wagon, and brought—he had one child, the oldest girl—he brought her, loaded up and came up and moved in here."[24] For the most part, the valuable deposits cited above were those used for making stoneware. Earthenware clay, or "red dirt," was readily available on the surface of the ground near most shops and hence, less prized. Clyde Chrisco clearly conveys the

Figure 4-3
Alkaline-glazed stoneware milk
crock, ca. 1930, Burlon Craig, Henry,
Lincoln County. H 4¹¹/₁₆″, D 7⅛″,
½ gal. Collection of Burlon and
Irene Craig.

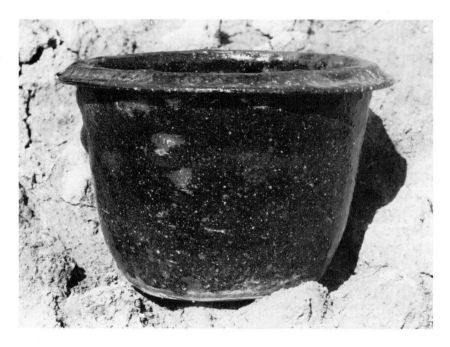

potters' relative valuation of the two clay types. "Now that redware, you know, turning that little stuff [pie dishes, flowerpots], the clay don't amount to a whole lot. And then, all the good stoneware, you've got to have *real* clay to make that stuff."[25]

Many of the clay deposits, such as the Holly Springs pond in Randolph County or the Rhodes clayhole in Lincoln County, are very old and date back to at least the middle of the nineteenth century. The properties of these clays were thus well-established by long usage, but for the newer clays the potters had to perform a number of simple tests. Having dug out a small sample, the potter might try the plasticity by rolling the clay into thin coils and then pulling or twisting it to see if it cracked too readily. He would also check for the presence of nonplastic materials. In Burl Craig's words: "Take some in your hand, through your fingers, rub it. You can tell whether it's got too much grit in it. A lot of this creek clay . . . [is] too coarse, too much sand in it to make pottery out of it."[26] Some, such as Auby Hilton, suggest an even finer test. " 'Though you may not feel any grit with the fingers in this very fine clay, yet by placing some between the teeth the presence of grit is discovered.' "[27] Taste and smell also provided clues—a sour quality could suggest excessive carbonaceous materials (such clays were also extremely sticky). Finally, the color could be important, indicating the quantity of iron and other impurities present, but it was generally difficult to predict the precise color of the fired clay body.

Such preliminary tests can give only an approximate idea of the clay's

utility. As Burl Craig warns, "You can get the clay, but there's no way to know till you've tried it. You can have an idea that it will turn, you know, on the wheel. But then you don't know whether it's going to stand the fire." Thus, the potter would take samples of a promising clay back to his shop and turn some trial pieces to put in the next burn. As Burl continues, "I'd just turn a small pitcher, small jug, just ordinary pieces. Maybe a mug or something that's easy to turn, a small piece, and glaze it and fire it. Put a piece in the lower end of the kiln, one in the middle, and one at the top. See how it looks when it comes out; see whether it'd stand the heat or not."[28] The distribution of heat in a groundhog kiln was very uneven, as the form was a long rectangle with the heat source at one end and the chimney at the other. Thus, the potter distributed the trial pieces throughout the kiln to find the proper location for the particular clay body. In fact, it was standard practice to use several clay bodies and glazes in a large kiln; those with the lowest fusion point could be positioned at a greater distance from the firebox, thereby allowing the potter to compensate for the inherent inefficiency of the kiln.

Having located and tested one or more reliable sources of clay, the folk potter made periodic visits to the local clayholes to maintain an ample stock. As illustrated in figure 4-4, digging clay was backbreaking work. Six workers—and one "supervisor" with a conspicuously clean shirt—are shown cutting a deep trench in search of a vein of stoneware clay. Armed with shovels, picks, and mattocks, the potters loaded the clay into the basket in the foreground, which was then dumped into the cart. The jugs and lunch baskets on the high ground attest to the fact that this was an all-day task.

Sedimentary stoneware clays of the type used by the North Carolina potter occur in veins of varying thickness and depth. Thus, the potter's initial task was to clear the surface of trees or bushes, if any, and then to carefully remove all of the topsoil above the clay. Just locating the vein was a major part of the operation. Howard Bass, who worked for his grandfather Lawrence Leonard during the 1930s, recalls a typical trip to the Rhodes clayhole in Lincoln County. "We still took a two-horse wagon and a pair of mules, and you got down in there. I've dug a hole in there in one day's time, me and my brother and maybe might be somebody else they'd hired for a day to help, dug a hole as big as this [living] room. . . . And you had to go down so deep, maybe you had to dig down six or eight feet deep, before you got into the clay."[29] Generally, the veins of Rhodes clay were about three feet under the surface and anywhere from eighteen to thirty inches thick. As Enoch Reinhardt recalls, "you'd get in a vein where it hadn't been worked, you know, you could dig that, and it was the prettiest stuff you ever seen—a real light gray."[30] The shift in color as the potter struck the vein was dramatic— abruptly the orange-brown soil gave way to a gleaming silver body of clay. The potters then dug out all but the bottom six inches or so, which tended to contain considerable sand and other sediment.

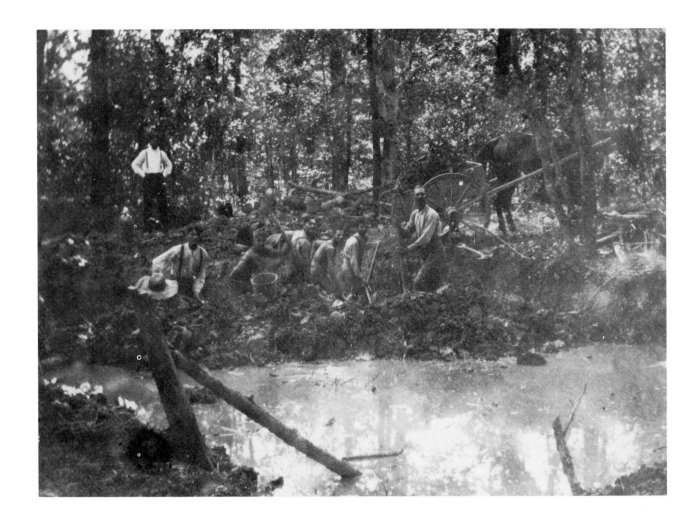

Figure 4-4
Workers from the pottery of Baxter
N. Welch digging stoneware clay
near Harper's Crossroads, Chatham
County, ca. 1900. Courtesy of Mr. and
Mrs. Gails Welch.

Today the Rhodes clayhole has the appearance of a battlefield, its surface pockmarked with the craters and ridges of at least a century of hard digging (fig. 4-5). All of the potters of the Catawba Valley drew on this source until the 1930s, by which time there were so many pits that the clay was becoming extremely difficult to locate. Enoch worked in partnership with his brother Harvey and recalls that "we just got what was left *between* holes, you know."[31] Often the earlier potters filled in an adjacent hole while digging a fresh one; thus, a potter might dig down five or six feet before realizing that a predecessor had been there before him. All he would get for his labors were a few inches of sandy clay that had once underlain a thick vein.

And there were other frustrations. As a young man Burl Craig witnessed a number of altercations over the "ownership" of a freshly dug hole. Some-

Figure 4-5
Now heavily overgrown with brush and trees, the Rhodes clayhole in Lincoln County still shows the handiwork of generations of potters from the Catawba Valley.

times, to avoid such disputes, the potter would uncover the clay, fill his wagon, and then leave a note stating that he would return shortly and bluntly warning others to stay out. On one occasion, Burl remembers seeing one of his friends return to his clayhole, only to find a second potter filling his wagon from it. But this time there was no argument: the newcomer willingly helped the original owner uncover a new vein.[32] In conjunction with the hard work and inevitable competition, the potters faced yet another problem—water. Because the sedimentary clays lay in bottom lands, usually near a stream or a river, many of the deep pits would soon fill with water. Thus, the potter would have to sink a new hole, instead of continuing to mine an earlier one, an obviously inefficient practice. The abundance of water with which the potter had to contend is all too well illustrated in figure 4-4. As Burl describes it: "Down where I work, sometimes I dip water awhile and shovel clay awhile, dip water and shovel clay."[33]

Just how much clay did the folk potter require for a single year's output? The census records from 1850 to 1880 indicate that the various individual shops turned out anywhere from 4,500 to 10,000 gallons of pottery per year. At the traditional ratio of four pounds of clay to the gallon, the larger shops would have required at least forty thousand pounds, or twenty tons, of clay. The account book of Curtis R. Hilton of Catawba County, a journeyman potter during the early years of the twentieth century, shows that in 1905 he turned 17,437 gallons of ware, which translates into more than thirty-four tons of clay, a very sizable figure.[34]

Fortunately the raw materials were not expensive, and many potters wisely purchased land containing clay deposits. Baxter Welch, for one, owned a claypit near his shop and leased another for ninety-nine years for the reasonable sum of one dollar.[35] An early photograph of one of his wagons loaded down with clay may be seen in figure 5-2. Often, however, the potter simply paid a small fee to the owner of the land each time he went to dig. Coming up the steep roadway out of the Rhodes clayhole, Burl Craig and others would stop at the owner's house and pay twenty-five cents.[36] Likewise, Enoch and Harvey Reinhardt paid $1.50 to $2.00 to fill their T-Model truck with several tons of clay at a brickyard near Morganton.[37] But the most economical arrangement was made by George Donkel, who, with his brother Dave, moved from Catawba County to Weaverville, Buncombe County, at the turn of this century. George soon married Hannah Brank, whose family owned the land he was renting. As one local resident summarized it, "they found this clay up here and liked it, and that's how come—well, then, he married into this clay!"[38]

Generally, potters would dig clay whenever their stock was low, but the ideal time was the fall. Because the roads and bottom lands were dry, Enoch and Harvey Reinhardt would spend one to two weeks at steady digging and bring back ten to twelve truckloads—perhaps twenty to thirty tons—enough to keep the pottery going for the better part of a year. The clay was then

dumped into one or more open, rectangular storage bins, which were immediately adjacent to the shop and the pug mill (fig. 4-6). A second advantage of digging in the autumn was that the ensuing winter would alternately freeze and thaw the clay, thus breaking it down into smaller, more workable lumps.[39] To supplement this natural weathering process, the potter periodically chopped or pounded the clay with a shovel or maul and then added rainwater stored in adjacent drums or barrels. This chore of pulverizing and soaking the clay was done again just before the potter was ready to grind it.

Most North Carolina potters shoveled their clay directly from the storage bin to the pug mill, but in a few areas they first mixed the clay with water and then strained it to remove the larger impurities. James A. Broome of Union County recalls that his father, "Jug Jim" Broome, would mix the clay into a "thick solution. . . . Then it was strained through a twelve-gauge screen wire—that's to get all the sticks, little rocks, everything out of it. And then boiling it was to just boil the water out of it. That was all the boiling was for—it wasn't to toughen the clay or it wasn't to change the texture of the clay or anything. It was just to boil the water back out of it." A low brick foundation measuring 3′ by 10′ still remains at the site of the Broome pottery. "The boiler was made of sheet metal in the bottom and just regular wooden sides. And that set right up on that foundation. It was only about two, two and a half feet high."

Like many other rural North Carolinians, Jug Jim also cooked his molasses in a similar type of boiler, though, as his son points out, the clay boiler was not partitioned and had 14″ sides, about twice the depth of a molasses boiler (plate 18). Normally the clay solution was boiled for about twelve hours and had to be stirred continuously with a wooden paddle tipped with the blade of an old garden hoe. Broome adds that "molasses is worked the same way; you can't get molasses too hot either. You just got to keep enough heat, enough heat just to keep it steaming to get that water out. You don't want it bubbling up like boiling potatoes in a pot." When they had achieved the desired consistency, the Broomes would allow the clay to cool and then shovel it out of the boiler and pile it near the pug mill; finally, they ground it to remove "all the lumps, air bubbles, and everything that might be formed in the clay in the boiling process."[40]

This practice of straining and boiling the clay was not widespread in North Carolina. The only other area where it may have been a standard task was southern Alamance County, but no one here can recall the technique used in any detail. In many respects, this operation resembles the English potter's use of a "sun kiln," a shallow pit into which the liquid clay was poured after it was properly blunged (mixed with water) and sieved.[41] By the early eighteenth century, the innovative Staffordshire potters had begun to dry the clay indoors in coal-fired kilns.[42] For most North Carolina potters, however, such refinement was unnecessary and only added extra time and labor to an already lengthy and arduous process.

Figure 4-6
Bryan D. Teague shaping a ball of
clay at his pottery, Moore County, ca.
1930. The clay bins are directly be-
hind him. Courtesy of the Teague
family.

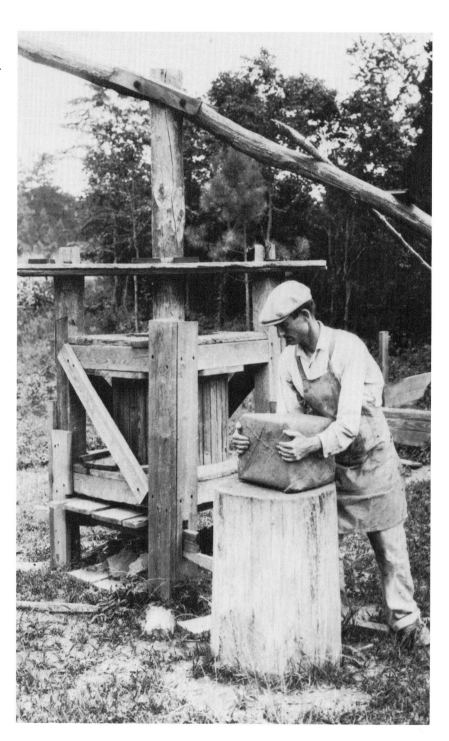

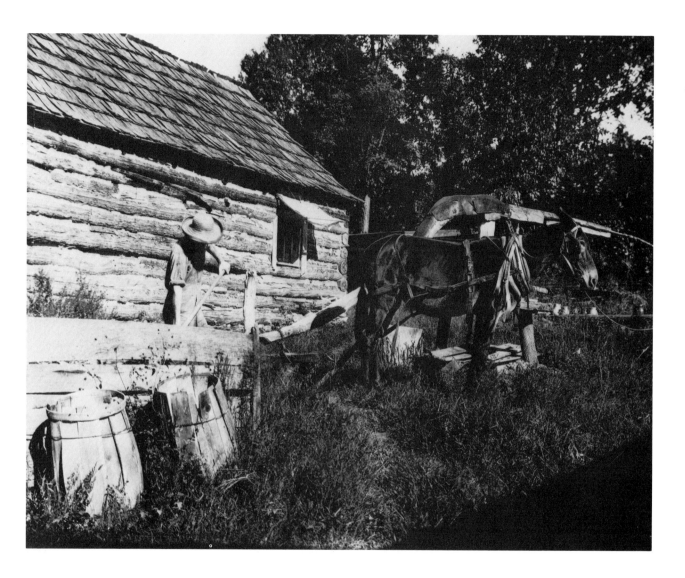

When the clay was properly conditioned, the potter shoveled it into the top of his pug mill (fig. 4-7). Essentially a barrel with a set of rotating knives or pegs inside it, the mill was a simple mechanical device designed to grind the clay into fine particles, remove the air bubbles, and bring the clay to the proper consistency for turning. It was not intended to purify the clay; invariably, the potter had to remove small stones and other impurities while wedging the clay on his bench or pulling it up on the wheel. A close inspection of the finished product reveals numerous pieces of rock or white bubbles of melted quartz embedded in the bodies of the pots. And yet given

Figure 4-7
George Donkel shoveling clay in preparation for grinding it at his shop on Reems Creek, just east of Weaverville, Buncombe County, ca. 1914. Photograph by William A. Barnhill. Courtesy of the Library of Congress.

these very simple methods of preparation, it is remarkable that the clays were not more contaminated.

In the Catawba Valley, the construction of a pug mill began with a heavy floor section of oak logs. "They just went out there and cut some three or four foot length posts. . . . And laid them down and smoothed them off on top and floored that—just took oak boards and put a floor in that thing."[43] An opening was left in the center to anchor the base of the vertical rotating shaft, and the whole unit was set about halfway into the ground for stability. Next the main cylinder, or tub, was built on top of this platform. "Harvey and Enoch [Reinhardt], they made theirs out of two-by-fours. Just made a circle, put steel bands at the bottom and at the top like you would a drum." The two-by-fours were beveled slightly on the sides with a hatchet and held together in a tight fit by hoops supplied by the local blacksmith, William Carpenter. The bands were cut from the metal strips used for wagon tires and then bolted together at the ends to complete the tub, which averaged about 2′ in diameter and 3′ in height.[44]

Next, a sturdy frame was constructed to hold the tub in place and also to support the central rotating shaft. Two large posts were set into the ground on either side of the tub and connected with a thick horizontal crossbrace. The bottom of the rotating shaft rested on a flat rock buried under the floor section, while the upper end ran through a collar in the crossbrace. The potters used axle grease to lubricate the shaft and could replace the brace if the shaft became too loose or started to wobble. The sweep to which the mule was harnessed was carefully balanced and either bolted or mortised to the top of the shaft. The size of the sweep varied considerably, but it had to be long enough to give the mule sufficient leverage to overcome the stiff clay. As shown in figure 4-8, several sets of vertical "knives" were fastened to the shaft and were designed to slice through the clay. They were also made by William Carpenter "out of something like a wagon tire, you know, went around a wagon wheel. That material came in long, straight pieces when he bought it." Burl Craig adds that the "oldtimers" were said to have used white oak pegs instead of knives in their pug mills, "but I never saw one."[45]

Normally the task of preparing the clay went to a younger member of the family or a general worker at the pottery who also helped to cut wood or burn the kiln. Figure 4-9 shows Aube Conrad putting the mule through his paces at Uncle Seth Ritchie's shop at Blackburn, Catawba County. The mule was harnessed to the long end of the sweep and his reins tied to a projecting pole to keep him on the circular path. He had to be watched carefully—if his lead line came loose, he might be tempted to head out on his own, taking the clay mill with him. A more frequent problem was just keeping the stubborn animal in motion. Burl Craig recalls that "somebody had to stay with the old mule. The way I done when I was grinding with a mule, I'd set down at the clay mill, where that sweep would pass over my head, with a

Figure 4-8
The main shaft of Robert P. Spea-
gle's pug mill, Catawba County,
showing the four sets of knives used
to grind the clay.

Figure 4-9
Aubrey E. Conrad grinding clay at the shop of Uncle Seth Ritchie, Blackburn, Catawba County, ca. 1939. Courtesy of Mr. and Mrs. Raymond A. Stahl.

good long hickory. When he stopped, I'd say, 'Get up there,' switch him a little, get him going again."[46] Because the mule moved at such a leisurely pace, it took the better part of an hour to grind a mill full of clay.

Urging the mule was often children's work, but the potter turning the wares was usually careful to supervise the operation. For example, if two types of clay were being used, a short and a tough clay, he might oversee the actual mixing. Generally, the amounts were measured by the shovelful, but as Burl Craig explains, there were too many variables involved to ensure consistent results. "Sometimes you don't do too good at mixing it. It's hard to judge just how plastic your clay's going to be. You might mix the same amount every time and then get a different clay, you know what I mean? Some of it might—your plastic clay might not be as good at some spots. You know, you dig it out and haul it here and throw it off, why, some of it might be better than others. Then you use three or four shovelfuls of that and the other, and you do it every time, but you still don't get the same clay."[47] An equally important task was to add the proper amount of water. "They might somebody else grind it, but a particular potter, . . . a real particular turner,

he'd have to run out and temper the clay. They'd grind it nearly done, and then he'd put the water in to make it as soft or as hard as he wanted it." In other words, the amount of water directly affected the plasticity and strength of the clay and thus, the types and sizes of wares being made. Burl, however, insists that he was not a "particular" potter. "If they got a millful too soft, I'd just turn it in something small, and if it got a little hard, I'd turn it in, say, five gallon jars."[48]

Because no blueprints were ever circulated on how to construct a pug mill, there were many variations. George Donkel, for example, almost completely buried the tub of his mill (fig. 4-7). This ensured greater stability, but extracting the clay must have been hard on the back. Seth Ritchie devised a simpler method of construction. "Uncle Seth, now, he just went out there and built a square box. And the corners filled up with clay, you know, naturally, as it ground; you see, well, he had a circle there. The corners filled up and . . . stayed there all the time. They'd cover it up where it wouldn't dry out, where the air couldn't get to it."[49] Thus, Uncle Seth ingeniously avoided having to fashion a tub out of two-by-fours (fig. 4-9).

The most important variation, however, concerned whether the mill was unloaded from the top or the bottom. In the Catawba Valley and the Mountains, the former type prevailed. When the potter had finished grinding the clay to his satisfaction, he reached into the top of the still-turning mill and pulled the clay out in his hands. As Burl describes it: "Most of it's got out while the knives, while it's turning. It's easier to get out. You see, it keeps it tore up and rolls it in balls. Sometimes I can reach in there and maybe get twenty-five pounds at a time."[50] Assuredly this can be a dangerous practice, particularly as he now drives the mill at higher speeds with a belt from his tractor. In fact, a Georgia potter named John S. Long was killed in 1895 when he was pulled into his water-powered mill. One variant of this local legend affirms that Long "'got up one morning and told his wife he was going down to the shop and grind a mill of mud while she's cooking breakfast.'" When Long failed to return, one of his sons went to investigate and "'found his daddy in the clay mill. They thought he had reached up there with his hand to get a piece of mud to see how it was, and one of them pins caught his hand and drug him in there.'"[51] No such grisly tales are reported for North Carolina, in part because the easygoing mule posed little danger. "With a mule," Burl muses, "You couldn't hardly get your hand fastened if you wanted to."[52]

In the eastern Piedmont a different type of pug mill predominated. The close-up of the old mill at the Jugtown Pottery in figure 4-10 reveals that the tub was raised a foot or more above ground level and supported by four sturdy 4" by 4" braces. Inside, a series of beveled wooden pegs were set every 90° into the central rotating shaft so that they forced the clay downwards (fig. 4-11) as the mule did his work. When the clay was ready, the potter simply lowered the floor of the mill by pulling out the wedges that fit

Figure 4-10
The old clay mill at the Jugtown Pottery, Moore County, which remained in use until about 1970. The central shaft (D 6⅞") is gum and was turned at a local woodworking shop. The barrel consists of a double layer of planks (W 1¾" to 2", T 1⅛"), and it is 3' in height with a 20" inner diameter. The wedging table to the right measures 29" by 26". Special thanks to Bobby Owens.

Figure 4-11
The 6" oak pegs mounted on the vertical shaft (D 6¾") of the clay mill once used by James H. Owen of Moore County. His son Jonah later moved the mill to the Log Cabin Pottery in Guilford County, which operated from 1926 to 1933. Courtesy of Howard A. Smith.

through the grooves cut into the bases of the corner posts. A much older but virtually identical mill is shown in use in figure 2-18 at the shop of Daniel Craven. This type of mill was much safer than those unloaded from the top, because the potter did not have to reach inside it to extract the clay. However, because of the added height, it was inherently less stable and required additional bracing.

As early as the 1920s, some potters began adapting cars and trucks to power their mills in place of the poky old mules. Today Burl stretches a belt from the power drum on his tractor to the large flywheel, which was once part of a generator unit powered by a stream (fig. 4-12). A Reo truck rear end, with one axle welded in place, redirects the power from the horizontal shaft to the vertical one on which the knives are mounted. The tub itself is a fifty-five-gallon drum encased in concrete. This new arrangement is more efficient—it requires only fifteen minutes to grind the clay—but the increased speed has an unexpected side effect. "The way I grind, it goes through a little heat. It [the clay] won't turn for a couple of days too good. It gets warm enough that it takes the plastic out of it. . . . [With the mule] you could take it right in and put in on your work bench and go to work as soon as you ground it."[53] For all the changes in construction, Burl's pug mill remains very similar in principle to those employed by his predecessors. In fact, the inside knives that slice the clay were made by blacksmith William Carpenter about half a century ago.

When the clay was removed from the pug mill, it was pounded into large cubes, called "balls" or "bolts." Figure 4-9 shows Aubrey Conrad about to

wheel several large balls into the shop. Olen Hartsoe describes how they were fashioned: "We had a table there. You'd just throw it on that table, just keep picking it up till you could get out about what you could carry. And then you just slam it down on there, make it flat on that side, flip it, slam it again, . . . and make it flat, then turn it to the other end, hit it and make it flat, until you get a square ball made out of that."[54] Today Burl follows the same procedure, pounding the balls of clay on an old millrock next to the clay mill (fig. 4-13). A similar rock may be seen just to the right of Uncle Seth's mill (fig. 4-9), while Bryan Teague and George Donkel appear to have used a short section of a tree trunk (figs. 4-6, 4-7).

Uncle Seth's mill held about four good-sized balls weighing seventy-five pounds each; in figure 4-9, three are already loaded on the wheelbarrow, and part of a fourth is visible on the millrock between the wheelbarrow and the mill. Burl's current mill is smaller and holds three balls weighing fifty pounds each. When his clay supply is low, he grinds about four millfuls; he repeats the process perhaps three times for each kilnful of ware. This works out to roughly 1,800 pounds of clay for each burn, the amount needed to fill his large groundhog kiln to its full capacity of four to five hundred gallons.

The large balls of clay were wheeled or simply carried into the shop and stored in a corner near the potter's working area (fig. 4-14). Olen Hartsoe remembers how "we'd carry it in on the workbench in the shop. Had a corner back in there, and you put it in that corner. When you got it all in there, then, we had old burlap, wet burlap . . . to keep the clay from drying out."[55] During the summer, it was particularly important to sprinkle water on the clay several times a week, or else it would become too hard to turn. If he neglected to do this, the potter would have to haul the clay out and regrind it in his mill, making extra work for himself or one of his coworkers. On rare occasions, the potter might construct a separate storage area to hold the ground clay. "Uncle Seth had a little corner, airtight, almost airtight corner in his shop that he kept his clay in. They could grind it up and it was never covered up there like I cover mine. It was built, just about like a little closet. . . . I think it was a little larger than about a four by four closet or something. There was plenty of room to get in there and stack clay. It had a little door on it."[56]

It is well known that some aging improves the plasticity of clay. Daniel Rhodes points out that "time is required for water to permeate each individual grain or particle." Moreover, the resulting "bacteria produce acid residues and form gels which undoubtedly affect the clay."[57] For the most part, however, the folk potter appears to have used up his clay very quickly. Curtis Hilton's account book contains numerous entries reading "no clay" or "out of clay"; in 1905, for example, there were fourteen such notations. But invariably Hilton was back at work turning on the following day.[58] With the great variety of daily, weekly, and seasonal tasks facing them, these farmer-potters had little opportunity to plan ahead in a truly efficient manner. When

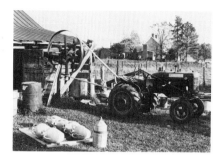

Figure 4-12
Machine replaces mule: Burl Craig's "modern" power-driven clay mill.

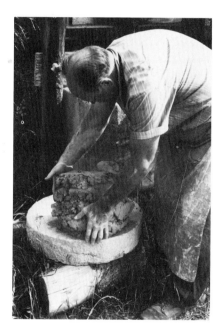

Figure 4-13
Burl Craig slapping together a ball of clay on an old millrock.

Figure 4-14
Balls of clay in the southeast corner of Burl Craig's shop. The wheel is immediately to the left, the wedging bench to the right.

asked whether all potters stocked up in the fall like the Reinhardt brothers, Burl replied: "Some of the smarter potters did. [But] some of them, they—old man Jim Lynn, I never did see him have over about enough to make a kiln full at a time." Many potters saw no need to accumulate or prepare large quantities in advance. As Burl adds, "that Rhodes clay, you didn't have—didn't need to age it, you could work it. You could go down there and dig it one day, and grind it the next and turn it the next."[59] Unlike the old Chinese potter, who is said to have prepared the clay for the next generation, the North Carolina potter consumed his raw materials just about as fast as he could ready them.

Through the work of scientists, much is known today about the physical nature and chemical composition of clay bodies. Much of this knowledge, however, is of very recent vintage. As geologist J. L. Stuckey is quick to point out, clay "is composed of minerals so fine-grained that before the use of the x-ray for mineral determination, its exact composition was unknown."[60] Thus, it is not surprising that the folk potter adopted a pragmatic approach toward his raw materials, but this does not mean that his methods were rudimentary or unscientific. Although he had no x-rays, electron microscopes, or molecular formulas at his disposal, he did have a well-formulated set of standards and procedures for judging and preparing the raw materials from his region. And he worked extremely hard to ready his clays for the wheel; it may surprise the potter of today to learn that clay does not always come in neat, clean, plastic-wrapped, twenty-five-pound packages. Finally, the folk potter relied on the abundant local resources that nature provided him. In so doing, he wisely recognized the individuality of his clays and knew how to take advantage of their strengths and weaknesses. As Auby Hilton wryly put it, " 'Working clays is like dealing with human nature—you have to work them as they are, . . . for trying to force them beyond their nature you make a failure.' "[61]

5

TURNING

Locating, assessing, and preparing the clays represent only the beginning of the folk potter's work. The true test of skill, the essential expression of the craft, is the ability to produce a variety of needed forms out of clay, and to do so at an economical pace. And the quintessential tool in this work is the wheel, a remarkably simple yet almost magical device. In the hands of an experienced potter, forms of soft, wet clay rise almost effortlessly from the spinning disk. Frequently the potter gives the impression that he is paying no attention to what he is doing, talking away to the impressed onlooker and hardly seeming to even glance at the rapidly growing cylinder in front of him. When he is finished, usually in a matter of a few minutes, he neatly slices the pot from the wheel with a thin wire, quickly lifts it off, and then resumes the process with a fresh ball of clay.

Ultimately it is impossible to describe in words how pottery is thrown on the wheel. One can only learn the technique by trying it, by getting one's hands into the damp clay and attempting to center and raise a simple form on the whirling headblock. Only a few such trials are needed to appreciate the hidden complexity of the potter's art—that apparent ease and seeming indifference are born of long hours of repetitive labor and often considerable frustration. Many would-be potters lack the concentration and patience to master this deceptively demanding instrument; they content themselves with a few small bowls or mugs and then move on to other pursuits.

A second impediment to describing the throwing of pots is that it is, necessarily, a highly individualized activity. John Dickerson, a noted potter and writer on ceramic techniques and history, asserts that

> the skilled thrower almost always has an idiosyncratic technique which he has developed as a result of such factors as his height, strength, size of hands, types of wheel and clay habitually used and the kind of form usually made. Add to this variables deriving from the technique he was originally taught and subjective tastes and predispositions in such matters as the use of tools and throwing aids and one can immediately see that the permutations are virtually infinite. These highly personal techniques are usually the result of a long process of development during which the potter has probably tried numerous solutions to each of the many problems of throwing and gradually compiled a complex of movements, hand positions, sensitivities and reflexes which work for him.[1]

Dickerson's observations are no less applicable to the folk potter. Recalling his early "lessons" at turning with his neighbor Jim Lynn, Burl Craig affirms: "That's something you got to learn yourself, actually. He could tell you, somebody could tell you, and if you didn't get your hands in the clay and learn to handle that clay, you'd never learn it. But he would help me, you know, I would get a ball of mud and try, and he would show me what I was doing wrong. . . . Of course, you can't—it's too hard to tell anybody how to hold their hands. You can show them, but still, everybody has a different way of doing it."[2] Much of the ensuing discussion is necessarily based on the work of Burl Craig, as he is the last potter in the state to use the treadle wheel and its associated equipment. Like all potters, his techniques and attitudes are partially idiosyncratic, but as the last folk potter in the Catawba Valley, his knowledge and practices are representative of a now largely vanished tradition.

Not all cultures have employed the wheel in making pottery. Native American and African potters—the majority of them women—have relied instead on pinching or coiling to construct vessels of all sizes and shapes.[3] Another widespread technique was slab-building, used, for example, by the English country potters to produce ovens, knife trays, and ornamental miniatures such as chests of drawers, rocking chairs, and cradles, "the latter being given as fertility symbols at weddings and christenings."[4] A fourth method was press-molding, widely used by American potters to form pipes and dishes by pressing the soft clay into or over molds. Nor were all these traditional ways of creating pots mutually exclusive. "Central Pennsylvania redware potters threw, molded and hand-built a wide variety of forms for use in the home, on the farm, in the tavern and in the store."[5] Even on the same piece, the potter might employ several techniques of construction. A very large jar, for example, might first be thrown and then gradually built up through the use of coils. The huge creations of slave potter Dave of the Edgefield District, South Carolina, were likely made in this manner; some have a capacity of more than thirty gallons.[6]

In North Carolina the folk potter relied almost exclusively on the wheel. The only significant exceptions were the press-molded wares of the Moravians and the manufacture of pipes, which was a sideline for many potters. Moreover, it is important to recognize the basic terminology associated with the potter's wheel. In North Carolina—and throughout the Southeast—the potter "turns" on his "lathe" (normally pronounced "lay"), and the person who does so is frequently referred to as a "turner." The verb "to throw" appears to be of recent vintage and was likely introduced by customers, contemporary potters, or ceramic historians.

To an outsider, these local expressions can prove confusing, as the "turning lathe" is a very different instrument from the wheel. In England this device was introduced near the end of the seventeenth century. "Its function was to enable the turner to scrape the surface of the ware with a sharp tool

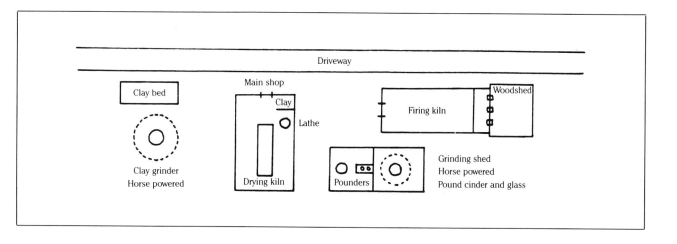

after it had been thrown or moulded and dried. The resulting surface was smoother than that obtainable by throwing only. Thus a precise appearance was given to pottery, and standardization of shapes become more possible." Undoubtedly modeled on the woodworker's lathe, the turning lathe employed a horizontal shaft and was used to trim the greenware. In widespread use by the second quarter of the eighteenth century, this tool played a critical role in the development of sophisticated English pottery.[7] Obviously it was not part of the American folk tradition, but somehow the associated terms crept into use in the Southeast. In 1870, for example, potters Alfred M. Brower and Merritt A. Sugg each reported in the Census of Manufactures for Randolph County that they employed two "turning lathes." Throughout this study, then, the verbs "turn" and "throw" and the nouns "lathe" and "wheel" will be treated as synonymous.

In working the kneaded clay on the wheel, the folk potter shared many techniques with his counterparts in studios, classrooms, and industries. Except for mechanical operations like jiggering or slip-casting, pottery is a handicraft. The clays and wheels have remained essentially unchanged for thousands of years, and thus there is a timeless and universal quality to the potter's work. What follows is not an exhaustive treatise on how the folk potter turned every form in his repertory. Rather, it is an attempt to capture the essence of his craft, to isolate the differences in equipment, processes, and attitudes that distinguish his life and work.

Few of the old shops survive today, and to the untutored eye they often have an unassuming, random appearance, perhaps because of the weathered boards or archaic equipment. However, the layout was most efficiently planned. Figure 5-1 illustrates the shop of Colin Monroe Yoder, who lived between Propst Crossroads and Blackburn, in Catawba County; the diagram is accurately reproduced from a sketch made by his son, Dr. Fred R. Yoder.

Figure 5-1
Colin M. Yoder pottery shop,
Catawba County, 1900.

Dr. Yoder notes that the plan was "rather typical" and adds that the pottery was active from 1895 to 1905.[8]

The sheer logic of this arrangement is self-evident. The clay was first weathered and ground, and then carried into the main shop where it was stored in a corner between the door and the wheel. As Burl Craig explains: "You want your clay mill close to where you put your clay, your clay bed, . . . where you can shovel it right into the mill. Then you don't want to have to carry or haul it too far from the mill to the shop." Yoder's wheel was located near the firemouth of the drying oven and probably in front of a window. The turner needed all the light he could get, as well as some warmth during cooler periods of the year. Thus, "you built your drying furnace inside, and then the lathes was set up down next to the firing end, where you could get the advantage of the heat. . . . It'd be warmer back there where you had your fire." The greenware was dried on racks over the drying oven, or else out in the yard between the shop and the kiln. Yoder ground his alkaline glaze in the adjacent shed and then loaded the glazed wares directly through the chimney into the kiln. As Burl continues: "You wanted your kiln—you couldn't put it too close to your building on account of the fire, but you wanted it as close, about as close as you could get it. That way you didn't have to carry your stuff out [so far] when you loaded your kiln."[9] Finally, after the kiln was fired, the wares were set back in the yard and then packed in straw in Colin Yoder's wagon.

Photographs of other potteries evince a like economy. Figure 5-2 illustrates the shop of Baxter N. Welch at Harper's Crossroads, Chatham County, which was active during the same period. The raw clay, clearly visible in the wagon, was processed to the left and then moved through the shop and on to the kiln at the right. No doubt the second wagon, partially hidden between the shop and the woodshed, was used to haul the finished wares to various towns and hardware stores. There are, however, two differences here, because this shop was located in the eastern Piedmont. First, there is no glazing shed; the use of the salt glaze did not require one. Second, the alignment of the groundhog kiln is reversed, because this type was loaded and unloaded through the firebox end instead of the chimney. Otherwise, Colin Yoder and Baxter Welch appear to have organized their small businesses in a strikingly similar manner.

In part, the extreme simplicity and efficiency manifested in such potteries were born of necessity. Lacking both ready cash and access to outside sources, the folk potter had to conserve his resources and adhere to the principle of self-sufficiency. Virtually all of his equipment—from the smallest stick gauge or chip to the shop and kiln—he constructed himself out of local materials. Frequently the larger buildings were erected as part of a communal effort. Charlie Craven recalls that his father Daniel's shop was built about 1915 when Charlie was only six years old (fig. 2-18). "I can remember when that shop was put up, I just can remember it. I was a little,

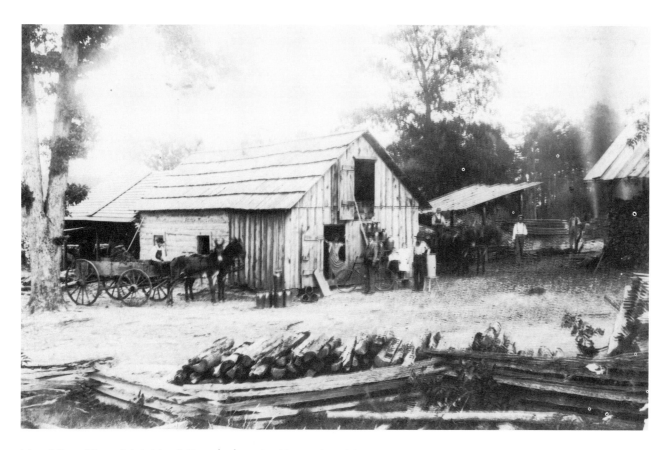

bitty fellow. They didn't hire folks to put up buildings then. They just invited the neighbors and have a log-raising, they called it, to put it up in one day."[10]

Traditionally, the shops were of log or frame construction. The Cravens' was built of hand-hewn logs, v-notched at the corners, while Baxter Welch appears to have added a frame extension to his original log shop and sheathed it with board and batten. All of these constructional features were typical of the farm buildings of Piedmont North Carolina. In fact, with ten-foot-wide, open sheds added to the sides and rear, these shops could easily be converted into the standard barns used in the region. Both photographs (figs. 5-2, 2-18) also show the loft that was used for storing the greenware; a number of unfired churns are stacked inside above Baxter Welch's head. Charlie Craven remembers that his family would "store it back up in the roof, there, . . . hand it up. Somebody get upstairs and set it all back in there till we get a kilnful dry. Then we'd put it in the kiln. Tried to make a kiln a week."[11]

Although the climate of North Carolina is relatively benign, some form of heating was essential if the potter wanted to work at all during the winter

Figure 5-2
Baxter N. Welch's pottery shop, Harper's Crossroads, Chatham County, ca. 1900. Courtesy of Mr. and Mrs. Gails Welch.

season, as most of them appear to have done. Running down the inside of all the shops was a long, low oven or furnace, usually constructed of bricks and measuring, variously, 12' to 15' in length, 2' to 3' in width, and 1½' to 2' in height (see figs. 6-1, 5-5). This is the drying kiln designated in the diagram of the Yoder shop. Daniel Craven "had one [that] reached out in the floor about middle ways in the floor, and a chimney back on that other side. You could burn four- or five-foot logs in that, sticks of wood, and it kept it good and warm."[12]

Log construction provided a natural insulation, but some potters found their frame buildings a bit chilly, even with the oven going. This seems to have been particularly true in the cooler Mountain region. At Jugtown, near Asheville, James D. Rutherford found a simple solution to his heating problem. His son Thomas recollects that "the building that we worked in there, it had a furnace in it, and you could turn winter and summer. And the way they insulated the walls on that thing, they dried sand in that furnace and then poured all those walls full of sand. And their overhead up there, they insulated it."[13] Even in subfreezing weather those shops remained warm and snug. The potter used the oven to heat his water for turning and also dried the freshly turned wares on racks built above it. Before retiring for the night, he stoked the furnace with a fresh load of wood to ensure that the temperature remained well above freezing until he returned the next morning.

A simplified diagram of Burl Craig's shop (fig. 5-3) shows a well-ordered interior, though when the shop is stacked with four to five hundred gallons of ware there is little room for extra maneuvering. Constructed shortly before World War II for Harvey Reinhardt, the building measures only 23' by 15', though the storage shed on the west side increases the overall size to 23' by 26½'. The shop earlier used by Harvey and his brother Enoch, which still stands about a quarter-mile south of Burl's, measures 25' by 19', while the Hilton shop near Propst Crossroads is a spacious 30½' by 21'. Although slightly smaller than the norm, Burl's shop is approximately the same size as those used by his former neighbors Sam Propst (fig. 3-12) and Jim Lynn. It has always been operated by a single potter, but there is a second wheel near the north window, a homemade, electric-powered unit that is now partially disassembled and covered with shelves and greenware. Conveniently Burl's wheel is adjacent to the wedging bench and the balls of clay stacked in the corner. Finished pieces are stored in the upper or north end of the shop, leaving this working area open. Glazing is done in front of the south door, where the prevailing breeze often helps to dry the wares more quickly. The glazing tub—a fifty-five-gallon drum split lengthwise—is set in place, and the alkaline glazes are ground in a stone mill just inside the shed and then carried in in five-gallon jars.

There is a sizable loft overhead, loaded or unloaded through trap doors in the ceiling at each end of the shop, but Burl does not use it today as he once did. "I have, maybe, turned a couple of kilnfuls before I burned, maybe the

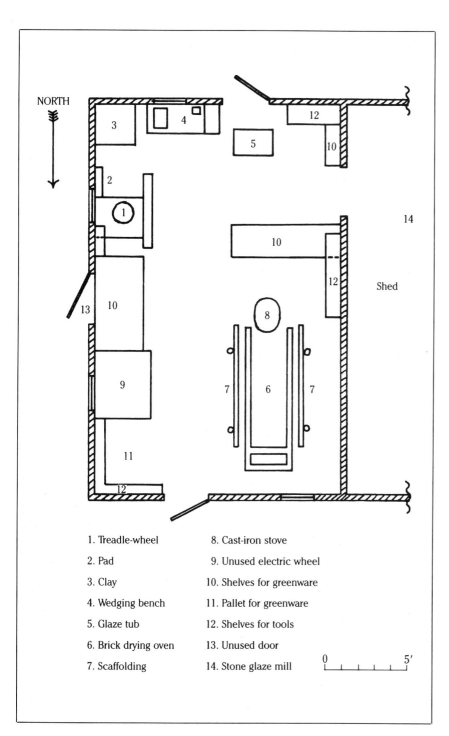

Figure 5-3
Burlon Craig's pottery shop, Henry,
Lincoln County.

NORTH

Shed

1. Treadle-wheel 8. Cast-iron stove

2. Pad 9. Unused electric wheel

3. Clay 10. Shelves for greenware

4. Wedging bench 11. Pallet for greenware

5. Glaze tub 12. Shelves for tools

6. Brick drying oven 13. Unused door

7. Scaffolding 14. Stone glaze mill

0 5'

weather'd be bad or something. I'd just keep working. . . . We was making mostly churns then, and I would set all of the five gallons together, all the three gallon, all the four gallons together. And I'd put pasteboard on top of them and then set [more] churns on top of them, green."[14] Because he now works alone, there is no one available to help put the wares up into the loft. No potter works in the north end of the shop, so he simply fills it with greenware and saves himself the trouble of passing it up to the loft, stacking it, and later handing it down (fig. 5-4). However, glazed greenwares, as fragile as they are, can last a long time when stored under a sturdy roof. In 1977 Burl burned six milk crocks that had been stacked in Enoch Reinhardt's loft since the mid-1940s; aside from a few missing patches of glaze, they emerged from the kiln in perfect condition.

A second modification is the substitution of an iron stove for the old brick drying oven, which is now partially dismantled (fig. 5-5). "It took so much wood. . . . And I didn't do that much turning back then in the wintertime, you know, I don't yet to where I need to dry on that. And in the summertime if I get behind in my drying inside, I just set it out in the sun. I can heat my shop with that stove with a third of the wood I guess it would take in that furnace."[15] The scaffolding over the oven, largely constructed of four-inch pine posts, has also been shortened, but it is still used to hold boards of smaller wares. Typically these ovens were offset from the center of the shop, both to conserve working space and to allow open passageways.

Although somewhat altered to fit a changing situation, Burl's shop well illustrates the working methods of the folk potter. With its packed earthen floor, its lack of chairs, display areas, or restrooms, and a compact, efficient design, it is clearly built for business. Most of Burl's time in his shop is spent at or near his wheel, and he always allows that turning is what gives him the greatest satisfaction. When the winters are cold and the clay is frozen, he will readily admit that he becomes a "hard man to live with."

Whatever therapy is inherent in the potter's wheel, it is a very ancient tool that "dates back to the beginnings of recorded history. No individual culture can be identified with its invention, though the general consensus of opinion, based upon archaeological evidence to date, favours the probability of the Near East. It most likely began as a simple turntable, the *slow wheel*, to aid the making of hand-built and coiled pots. It is but a short step forward to using a heavy turntable capable of retaining momentum, or the use of a separate flywheel and shaft supporting a wheel head at a more convenient height."[16] The terminology used to describe the traditional potter's wheels common to Europe and America is by no means consistent, but most often the two main types are designated as a "kick wheel" and a "treadle wheel."

The former is the simpler of the two and is illustrated in fig. 5-6. This particular example was used continuously by at least three Moravian potters for over a century, and may have been made as early as the third quarter of the eighteenth century by Gottfried Aust. A relatively simple device, it has

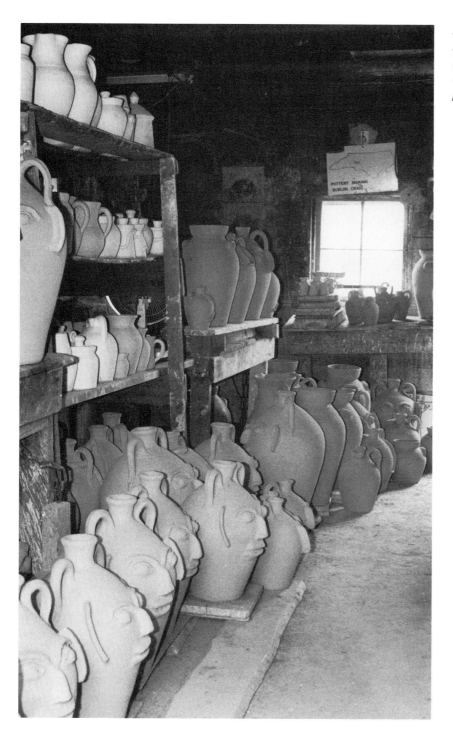

Figure 5-4
No room to work—glazed green-wares spill over onto the wheel and wedging bench as Burlon Craig pre-pares to load his kiln.

Figure 5-5
The remains of the brick drying oven inside Burlon Craig's shop and the "modern" stove now used for heating.

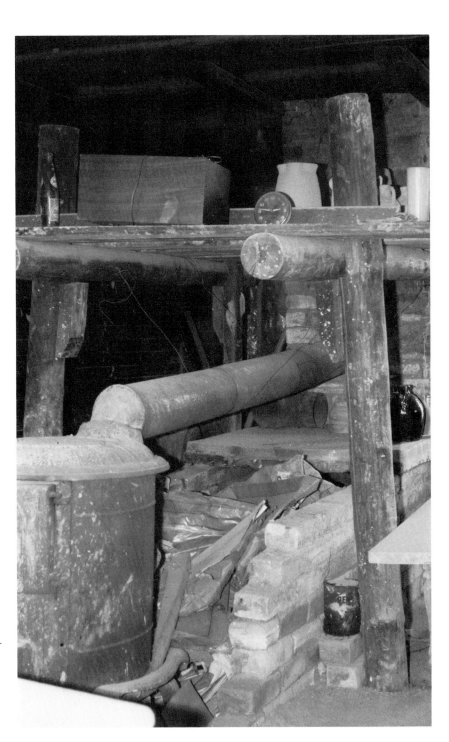

Figure 5-6
An early kick wheel used by the Moravian potters in Forsyth County, with wooden ribs (chips) hanging from the windowsill. Courtesy of Old Salem Restoration, Winston-Salem, N.C.

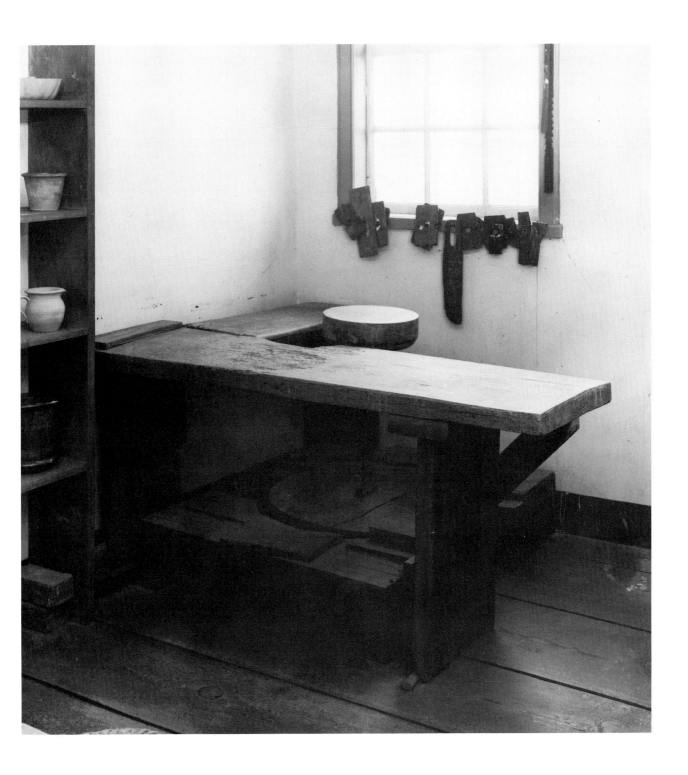

Figure 5-7
The headblock, shaft, and flywheel
of Robert Speagle's treadle wheel,
Catawba County, first quarter of the
twentieth century. Courtesy of
Thomas Childers.

four main components: (1) a thick wheelhead of some hardwood, 12″ in diameter; (2) a straight, forged iron shaft seated in a bearing on the floor; (3) an oak flywheel, 2½″ thick and 25³⁄₁₆″ in diameter; and (4) a surrounding framework. Presumably, Rudolf Christ and others had to kick the flywheel almost continuously "to maintain any speed at all because the flywheel has very little momentum due to its light weight. Most modern potters would find this wheel inconvenient to use."[17]

Perhaps this type of wheel was used throughout the Piedmont during the latter half of the eighteenth century and into the nineteenth century, but no other examples have survived. Within recent memory—which is to say, since the middle of the nineteenth century—only the treadle wheel has been employed. Local potters also refer to this type as a "kick wheel," which is in a general sense appropriate, as it is powered by the foot; but the treadle wheel works on a different principle.

Figure 5-7 shows part of the unit used at the shop of Bob Speagle in Catawba County during the early part of this century. Two important differences from the Moravian kick wheel are evident: the crank at the bottom of the forged spindle and the much heavier iron flywheel. The crank provides the leverage to turn the unit; once up to desired speed, the heavy flywheel provides sufficient momentum so that little additional force is required. A complete treadle wheel used today by Burl Craig appears in figure 5-8. The foot pedal is pinned to a crossbrace at one side of the table and suspended with an old trace chain at the opposite side. A short connecting rod, or "pitman" as Burl calls it, runs from the center of the pedal to the crank, thereby completing the linkage. Thus, the potter does not "kick" the flywheel—he pumps the foot pedal or treadle back and forth with his left foot. This wheel is only slightly more complex, though much easier to operate, than the kick wheel. And with some help from the local blacksmith, it was relatively easy to construct.

Like the Moravian example, the original headblocks and flywheels were made from wood. Burl still remembers purchasing a piece of oak for his first wheel, made while he was working with his neighbor Jim Lynn. "I went with a fellow was hauling lumber to Hickory. . . . I picked out the widest two-inch thick lumber I could find over there, and I give the bandsaw operator twenty-five cents to cut me out a round circle."[18] As shown on a late-nineteenth-century wheel used by Jacob Propst (fig. 5-9), the potter screwed a hand-forged, threaded, female fitting into the underside of the headblock to receive the top of the spindle. In this particular example, several pieces of cardboard have been added under the two upper arms of the fitting to level the headblock. Over time, of course, these wooden heads would wear down, largely from the constant pressure of the chip used to trim the pot. Periodically the potter would have to plane or sand the top to smooth it. However, the inevitable ridges or depressions that formed were not a major problem. As Burl observes, "the groove will fill up with clay, and it will ride

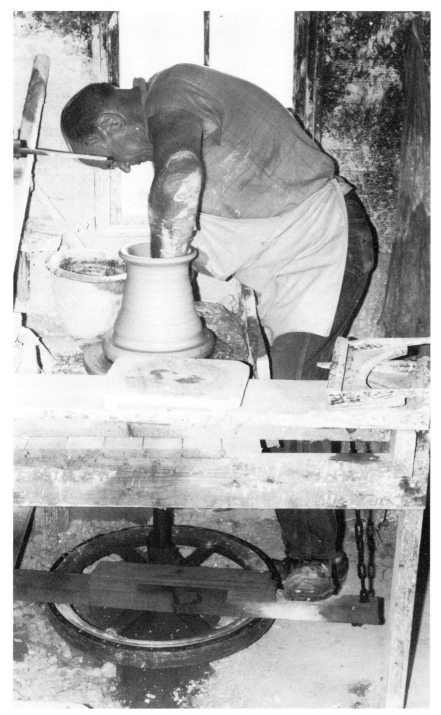

Figure 5-8
Burlon Craig at his treadle wheel,
pulling up the top of a large jar.

Figure 5-9
The underside of the wooden head-
block of Jacob Propst's treadle
wheel, Catawba County, late nine-
teenth century. Courtesy of Hazeline
Propst Rhodes and Floyd Propst.

over. Your wire won't go down in that."[19] It was also important to keep the wooden headblock wet, when not in use, by covering it with a damp cloth so it would not warp or crack.

By the beginning of this century, many of the potters had begun to adapt metal parts from textile mills and abandoned agricultural machinery. Burl recalls that "a lot of them were using the old loomheads. Along about that time, if I understood it right, they changed looms in a lot of these cotton mills, . . . and they throwed a lot of this stuff out."[20] Some still have teeth on their rims or are attached to small cogwheels, clear clues to their earlier functions. And the flywheel on Bob Speagle's wheel in figure 5-7 is said to have come from an old feedcutter used to chop corn for horses and cows.[21]

Because the potters scavenged parts where they could, the dimensions of some wheels varied considerably. Burl asserts that weight, rather than size, was the crucial criterion for the flywheel. "They always told me the heavier they were, the better they were, but you know, you seen all sizes. There wasn't two alike."[22] This variation is patently evident in the three wheels under discussion:

	Flywheel	Headblock	Connecting Rod	Treadle
Jacob Propst	24⅜″	12⅝″	13⅝″	45¼″
Burl Craig	25⅝″	15⁷⁄₁₆″	14″	42″
Bob Speagle	20⅞″	16⅞″		

Most of the headblocks were mounted about thirty inches above ground level. A large, low headblock is desirable for the big utilitarian pieces; it must support a considerable amount of clay opened out to a wide bottom, and the potter must be able to reach well down inside it. On the other hand, "in turning small stuff, if you set your lathe up right and use a smaller headblock you can get your work closer to you."[23] In other words, a higher, smaller headblock is preferable for the ornamental wares. This was not a problem in the old days when the potters turned few "toys," but since the early years of this century, tablewares and tourist items have become increasingly important. One solution was to build several wheels of different sizes. This is what James D. Rutherford of Jugtown, Buncombe County, did—the three lathes in his shop were designated "Poppa Bear," "Momma Bear," and "Baby Bear" to readily distinguish them.[24] A more flexible approach was taken by Floyd Hilton, who constructed a second headblock that was only 8″ in diameter and had a 6″ shaft or extension to raise the height. Floyd simply removed the regular headblock and screwed this unit right onto the top of his spindle to make his "fancy pottery."[25]

Having salvaged or built a proper headblock, spindle, and flywheel, the potter proceeded to assemble his wheel by constructing a "table" or framework, a socket for the base of the spindle, and a treadle mechanism. Once again, many different materials and procedures were possible. In the Catawba Valley, the potters commissioned the local blacksmith to produce the

socket. "They worked out a kind of a little cup, . . . with a little piece of steel sticking up in the center of it, pointed. Then you took a bit and you drilled out the bottom of the shaft just a little bit, and that set right on that point. . . . And that runs in oil—you keep that cup filled with oil."[26] The cup under Burl's spindle is nailed to a block of wood and buried in the ground. Other potters are said to have seated the spindles in large rocks that were also buried under the wheel.

Next Burl constructed the legs and frame for his table in preparation for plumbing the spindle. "I built the frame before I put the top on. That give me room enough to work. Then I would take a level and lay it on my headblock. Then I would put it over here, wherever it needed to be, and then I would mark it, then bore my holes for my bearing to hold it [the spindle] up here next to the table, right under the table top. I run a two-inch by four-inch across there to fasten my collar on, or bearing."[27] The earlier bearings were two curved pieces of iron fashioned by the blacksmith and bolted around the spindle to the frame of the table. The one Burl currently uses probably came from a Model T Ford. Sometimes a thick piece of leather was also used for this purpose. This upper bearing had to be carefully adjusted so that it was neither too loose nor too tight. If the former, the headblock would wobble, particularly when the potter started to pump the treadle. If the latter, the spindle would bind, and the wheel would not turn freely. Once the shaft was properly set in place, the potter could complete his table by adding boards across the top, a splashboard at his side of the headblock, the ball-opener and stick gauge opposite, and a long shelf along the side on which to rest his freshly turned wares.

The final step in the operation was to add the treadle unit—specifically, the foot pedal and the connecting rod to the crank. Figure 5-10 shows the bottom of the wheel once used by Jacob Propst; the constant wear from his left foot is clearly visible on the top of the pedal. The small holes in the center of the pedal reveal that the treadle was occasionally adjusted by repositioning the connecting rod. A leather bearing encircled by metal connected the rod to the spindle. Like the bottom socket and the upper bearing, this had to be kept well oiled or greased. Burl puts motor oil on his bearings almost daily and oils the socket cup once a week. He also adds that the treadle assembly was invariably constructed to fit the size of the potter. "You rigged that up to suit, to fit your leg, you know. Short man would have a closer kick than a long-legged man; you adjusted that to suit you. . . . I like for my leg to go out pretty well straight. It seems like it rests—my leg don't get as tired as being cramped up part of the time and not going straight out."[28]

As crude and homely as it may appear, the treadle wheel proved a highly efficient instrument, easily adapted to the needs and even the physique of the turner, and capable of turning out everything from tiny miniatures to enormous storage jars. It is not surprising that some potters were quick to

Figure 5-10
The flywheel and treadle unit of Ja-
cob Propst's wheel. Courtesy of
Hazeline Propst Rhodes and Floyd
Propst.

extol the excellence of their wheels. "They's talking about their easy-turning lathes, you know, where it would turn so easy. And they was a-bragging on them, each guy, each turner, a bunch of turners was together. And Nels [Bass], he said, 'By golly,' said, 'I could leave mine a-running and go eat dinner, and when I come back it'll still be a-turning.'" Burl is quick to add that "you know that wasn't right," but this tall tale is essentially true: the homemade treadle wheel *was* a very easy, smooth-running machine.[29]

The North Carolina folk potter used foot power to drive his wheel until the late 1920s or 1930s, when he discovered the virtues of gasoline engines and electric motors. Charlie Craven, for one, encountered his first power wheel about 1940, while working for the Royal Crown Pottery and Porcelain Company at Merry Oaks, Chatham County. He was elated. "That was really nice—I thought that about took all the work out of it!"[30] Others, however, tried the new power sources for a time and found them wanting. One such was Enoch Reinhardt, who tried an electric motor but returned to the treadle wheel because it provided better control. "I could slow it down and speed it up, what I wanted, you know." Moreover, he found the continual movement of his left leg no impediment to producing evenly turned forms. "I had my board there where I could brace my arms, and I just worked with my hands, you see. My body wasn't moving."[31] Burl Craig agrees with Enoch and continues to pump his treadle wheel today. The electric wheel that he inherited from Poley Hartsoe, rebuilt and used for several years, sits abandoned and dusty under boards of greenware. "I don't know," he explains, "I just never

was comfortable with it, some way or other. You know, I learned on a kick wheel [treadle wheel]."[32]

Like most southern potters, Burl works in a standing position. As Nancy Sweezy explains, "standing is a more efficient position for production turning: the angle of the body is at a better slant to use the whole upper torso above the wheel head, making it easier to reach down into large pots and scoop small pots off a spinning wheel. . . . In a standing position less effort is needed to pick up a ball of clay, to center it, to examine a pot's profile, to place a finished pot on a long ware board, or move to a wedging board. This greater fluency of body motion facilitates production work."[33] To take some of the weight off his feet, Burl leans his right hip against a "pad," a two-by-four nailed along the shop wall that is covered with layers of towsacks. He can also brace his arms on the splashboard on the near side of his table for additional stability.

The actual process of turning a pot does not commence at the wheel. Rather it begins with the potter's decision to make a particular form in a particular size. Partly, the choice depends on the condition of the clay available at the time. In Burl's words: "The bigger piece you turn, the harder you want the clay, so it'll stand up right. You can't turn a five gallon jar or churn out of a clay that you can turn a gallon piece out of. You want it stiffer. . . . If you're going to turn pint mugs or something, pint pitchers or pint jugs, you want it a little bit softer."[34] Assuming that the clay is of the proper consistency, the potter next weighs out the amount for each piece. As a general rule of thumb, the North Carolina potter uses about four pounds of clay per gallon capacity of the pot, though the amounts will increase at the lower end of the scale:[35]

Gallons	Pounds of Clay
10	40
6	24
5	20
4	17
3	14
2	11 (jar)
2	10 (milk crock)
1½	8
1	6
½	4
quart	2
pint	1
½ pint	½

Clearly, there is considerable room for personal preference here, particularly for the smaller pots. For the most part, the wares of the Catawba Valley are extremely light for their size. This has much to do with the qualities of

Figure 5-11
Weighing the clay.

Figure 5-12
Working the clay on the wedging bench.

the local clays, which, as noted in the previous chapter, are very short and could be turned in large sizes with unusually thin walls.

Burl's scale sits on the edge of his wedging bench near the clay; he simply reaches down to his left, tears off a handful from one of the balls in the corner (fig. 5-11), and measures it right there. No doubt his scale would qualify as an antique—it came from the shop of Uncle Seth Ritchie, who died in 1940—but the earlier potters used an even cruder instrument, a simple balance hung from the wall or ceiling joists. Burl never saw one but recalls the older men discussing their homemade scales. "They had a five-gallon weight and a three-gallon weight and a four-gallon weight, a gallon weight and all that stuff, you know, and they'd lay it on there. Then they'd balance that, lay their clay on till it balanced."[36]

Next comes the process of wedging and kneading, which Burl refers to as "working the clay." The wedging bench itself measures an ample 54″ by 20¾″. About ten inches from the right-hand edge is a taut piece of heavy wire running at a 45° angle from the wall of the shop to the front of the bench. Working the clay normally requires from two to four minutes of rapid, strenuous activity. The purpose is to remove all the air bubbles, bring the clay to uniform consistency, and pick out as many rocks and other impurities as possible—these are deposited in a small wooden box under the cutting wire.

Burl begins by splitting the clay on the wire and then slamming the two pieces together, either on the bench or in his hands if the ball is only a pound or so. Normally he repeats this task about six times, but "there's no rule on that, . . . that depends on your clay. If it's not crusted out or got hard places or dried out too much, why, probably half a dozen times 'd be as good as a dozen. And fact is, if you've got good clay, you don't have to cut it at all." Next he kneads the clay on the bench in both hands, sometimes working the halves separately when large quantities are involved. "I can tell about when the clay's even, you know, all the same. If you've still got hard places in it, it will show up in the feel of it and the turning. But there's no set rule to that."[37] Generally he uses the Oriental or spiral technique for kneading, gradually rotating the clay and working it into a shape resembling a conch shell (fig. 5-12). When finished he slaps his clay down and forms his ball for the wheel by rotating it on the bench, producing a flattened, circular loaf with a slightly conical top.

Centering is the bane of all fledgling potters, and the speed and ease with which Burl performs this critical task would dismay all but the hardiest apprentice. He slaps the ball onto the headblock; pats it into a hemispherical form; wets his hands in the adjacent milk crock of water; braces his forearms on the splashboard, with his right hand overlapping the left on the clay; gives the treadle a couple of vigorous pumps; and the job is done (fig. 5-13). The trick in "plumbing the clay" is to press down on the center of the ball with the bottoms of both palms. "The idea is when you grab that clay, is

Figure 5-13
Centering the ball on the headblock.

hold your hands—don't let your hands follow that clay. Make the clay come to your hands."[38] No time is wasted in repeatedly squeezing the clay up into a cone and then pushing it down again, as commonly taught in ceramic texts and schools. Instead, the process is almost instantaneous, even with twenty pounds or more on the wheel.

It is clearly impossible to describe how the folk potter creates all of the many forms in his repertory. Moreover, the techniques are often redundant, because most pots are generated out of the basic cylinder. Instead, the turning of a single type will be illustrated: the ubiquitous, multipurpose "churn-jar," which was used either to store a wide variety of foods or else to produce butter. The following example delineates the essential tools and methods used in turning, and because it describes a large piece—four gallons in capacity—it also shows the two-part method of construction known as "capping."

Having centered some seventeen pounds of clay on the wheel, Burl quickly opens the top of the ball with his thumbs and pulls up a rough cylinder, using perhaps one-third of the clay (fig. 5-8). He slices off this "cap" with an ice pick and sets it off on the long shelf on his table. After quickly checking to assure that the remaining clay is still properly centered and slightly concave on its surface, he lowers his "ball-opener" onto the headblock. Also known in the trade as a "bottom-maker," "ball-spreader," or "ball-buster," this useful tool consists of a long wooden arm 32″ in length that pivots freely at the far side of the table. A sourwood knob, 3¼″ long and 1½″ in diameter, is pegged into the underside of the arm near the middle, so that when the device is lowered, it comes down on the very center of the headblock. The potter holds the arm in his left hand and lowers it until it is

seated on the splashboard; this stops the peg about ½″ above the surface of the headblock. Then, firmly reinforcing the clay with his right hand, he pushes the arm to the left, opening the cylinder to the proper diameter and forming a bottom of uniform thickness (fig. 5-14). He then returns the ball-opener to the vertical rest position and packs down the bottom with his left hand. So handy is this instrument that he uses it regularly on smaller wares, even those requiring as little as half a pound of clay. As always, Burl cautions that there are no fixed rules for setting up the ball-opener. "You have to work that out and get your bottom that'll work with your clay. . . . You just have to work that out and figure that out to where it burns under your conditions."[39] However, he does allow one rule of thumb—or rule of forefinger, in this case. Potters set the height of the knob above the headblock by squeezing their forefinger under it so that there is a tight fit at the first joint.

Next Burl pulls up the walls of his jar, placing his left hand inside the cylinder and using the middle section of his bent right forefinger to bring up the clay on the outside (fig. 5-15). Then he trims the cylinder with a rectangular chip, pushing out with his left hand and gradually raising the chip to form a smooth exterior wall (fig. 5-16). By this time Burl has slowed the speed of his wheel considerably.

> I usually run, kick the wheel fast when I'm centering. That's when you got to use the most pressure. . . . Your first pull, when you pull at the start after you center it . . . is pretty hard, too, till you get your clay, begin to get it thinned out. Why, I'll usually run pretty fast, . . . but not as fast as I do when I'm centering. Then after, if you're pulling up a piece pretty high, you slow down, you know, too, while you're pulling it up. And then in finishing it, that'll depend on what you're finishing, how fast you want to run. Now like them [small] cannisters I was turning out there this morning. You can finish them fast. But now if you're turning a vase that's slim, and goes up pretty high, and not too wide a bottom, why, you have to take it sort of careful, or it'll fall. You want to run at a slower speed. So there's no set rules on that—it's just the way you feel and how you can handle the clay. That'd be up to the individual turner.[40]

While there are no absolute measurements of speed, Burl suggests three relative rates: fast for centering, medium for pulling, slow for trimming. Likewise, Burl pulls up on the walls of each pot "about three times. . . . You don't do much the first time, no more than thin it out a little, and get it up maybe about that high the first time. Then you go back there and you get ahold of a roll of clay the second time, and you pull it up. And then you get the third time; . . . sometimes I have to go another time." Yet again Burl cautions that "there's no set rules"; there are subtle variations at all stages, depending mainly on the size and shape of the pot and the condition of the clay.[41]

Figure 5-14
Opening the ball with the ball-opener.

Figure 5-15
Pulling up the wall.

Figure 5-16
Trimming the wall with a chip.

To trim the form, Burl uses a small, rectangular piece of wood or metal. In general ceramic usage this tool is called a rib, quite possible because ancient potters used animal bones for this purpose. Locally, however, it is referred to as a "chip." Originally, it was carved from wood, usually a hard type such as sourwood, dogwood, or persimmon, but metal chips have become increasingly common. Burl speculates that the name came about because "it looks like a chip of wood or something, where somebody's been cutting wood with a good sharp ax." Figure 5-17 shows four quite varied examples currently in Burl's possession. The large wooden one (7¹⁵⁄₁₆" by 2⅜") was used by Cornelius ("Nealy") Blackburn, who made only the big utilitarian forms. In the center are two once owned by Floyd Hilton: the small one at the top (3⁵⁄₁₆" by 1¹¹⁄₁₆") was used on miniatures, the other (4¹⁄₁₆" by 2½") for forming the curved surfaces of vases. The one to the right (3¹⁵⁄₁₆" by 2¹³⁄₁₆") was one of Burl's first and was cut by blacksmith William Carpenter from a cotton gin saw. "A cotton gin had a lot of little saws in there to cut that cotton off of the seed. And they'd get around those cotton gins when them saws wore out, they'd get them little saws and have somebody cut them out, blacksmith or somebody."[42] The gin saws were about 10" across and each would produce four chips. Today Burl uses an almost identical model that was cut by his son from a handsaw—he prefers it because it is even thinner. All of the chips have holes in the center for the potter's middle finger. "One without a hole would probably be all right for little stuff," Burl explains. "But I can put that finger in there . . . and put these two right behind see, one kinda on either side of the middle one, and really

put the pressure on it. On that big stuff you got to put a lot of pressure on that chip to trim it."[43]

When forming a large piece, Burl will trim the bottom section completely, because it becomes more difficult to do this when the cap is added. Potters usually only "chipped" the outside of the wares, though Burl recalls that some, such as Jim Lynn and Will Bass, also did the inside of their milk crocks; this resulted in a smoother surface that was more attractive to the housewife and easier to clean.[44] At times small stones or lumps of hard clay appear in the wall of a pot. Burl gouges them out with the corner of the chip and smoothes in a small dab of wet clay. By angling the chip he can form curved surfaces such as the shoulder, and occasionally he uses the edge to incise decorative bands. In general, the folk potter did a minimal amount of trimming, virtually all of it while the pot was on the wheel. He also wasted very little clay in the process. After a morning's turning, there were remarkably few shavings on the table, and all of these were soon recycled as handles. Burl is content to use his favorite chip for all trimming operations. By contrast, as illustrated in figure 5-6, the Moravians required a variety of ribs or "shapes" for their specialized forms and decorative applications.[45]

To clean the excess water out of the interior of the jar, Burl uses a sponge, but this now common item was not one of the folk potter's original tools. Instead, he used a small piece of sheepskin, cut about 3″ to 4″ square. "You turn the wool down and that would get the water. That's what the old-timers and what I used a long time. . . . Back then, you know, when I started, you didn't—a sponge, that was something you heard about. I don't know, I was probably grown before I seen a sponge." Burl once owned a sheepskin-lined coat, and he recalls that when it wore out, he cut the entire lining into pieces for use in the shop. For the most part, the sheepskin did not hold as much water as the sponge, but it worked well.[46] And it is important to emphasize that neither the sheepskin nor sponge were ever used to pull up or shape the walls of the pot; all that the potter employed for this purpose were his hands and his chip.

Having finished the bottom section of his jar, Burl forms a wide rim with his chip and then gingerly sets the unfinished cap on top of it (fig. 5-18). Then, rotating his wheel very slowly, he carefully "welds" the two units together. "I spread my clay out enough, if you notice, that it laps up over the crack where they go together. Then I take my hand inside and fingers like that and rub it together good and hard. . . . Take my fingers up—all the way around. Well, that welds it together better, you know."[47] Figure 5-19 illustrates the forming of the joint—a very important operation, because careless or incomplete work may leave air pockets or uneven surfaces that will cause the sections to separate after the jar is burned. Burl admits that he used to "just throw it [the cap] on there and start chipping, you know, without doing anything much else to it." The result? "I'd had them to drop apart when I took them out of the kiln."[48]

Figure 5-18
Capping the jar.

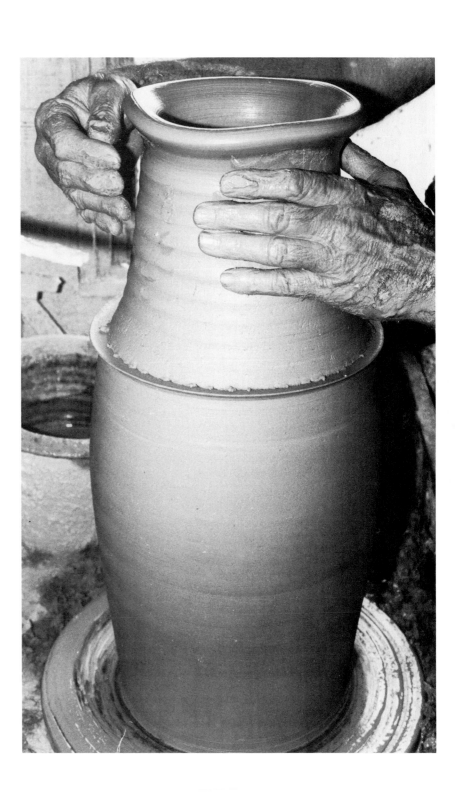

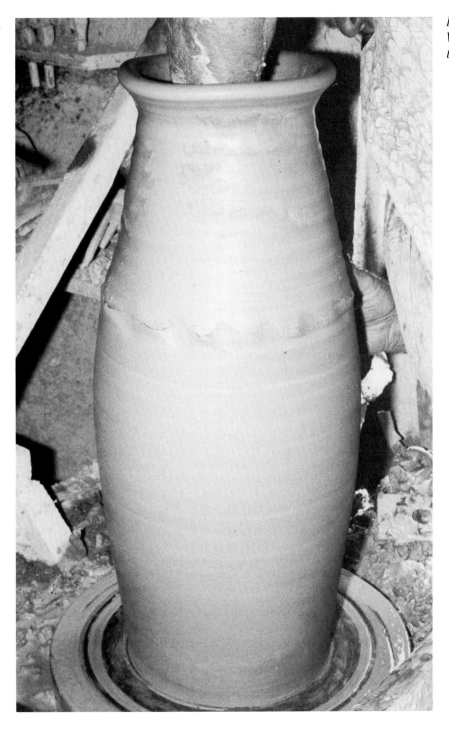

Figure 5-19
Welding the top and bottom units of
the jar together.

Once the splice is completed, Burl uses his chip to trim the upper portion of the jar. Usually the seam is not visible on the outside of the pot, but with careful inspection of the interior it is easy to locate. Burl keeps the walls of his jars very straight until he has completed most of the trimming; this is to keep the clay from shearing or collapsing. Then, applying gentle pressure with his left hand inside, he widens the shoulder and lowers the height so that the rim conforms with his stick gauge (fig. 5-20). Together with the ball-opener, the stick gauge is standard equipment on all traditional wheels. Burl has a notched stick, given to him by a predecessor named Will Bass, which he uses to set the height for different sizes of wares. Like many potters, however, he has made so many forms in all the standard sizes, that he doesn't really need it. As Enoch Reinhardt once put it, "You wouldn't have to use that. You had the amount of clay there, and you'd have every one just about the same."[49]

The technique of capping was widespread among North Carolina potters, both in the Catawba Valley and the eastern Piedmont, and it provided an efficient means of making pieces larger and more quickly. Burl now uses the method to form wares as small as two gallons in capacity. "I've never made a five in one piece. . . . The largest that I ever turned in one piece, I guess, was a three gallon, and I didn't do but a couple of them. I used to turn all my two gallons in one piece, but I don't do that anymore. I cap them because it's easier."[50] Once again, the factor of personal preference comes into play. Some potters never capped any of their wares yet regularly turned five-gallon jars and jugs. Others, like Burl, applied the technique to relatively small forms. And, for extremely large sizes of ten gallons or more, the potters sometimes made three sections. Burl recalls using two wheels for this. He first made the middle and bottom sections on one wheel, leaving the bottom on the headblock and allowing time for it to harden or "set up." Then he made the top on the second wheel and welded the units together on the first one.[51]

During the 1930s, the potters in the eastern Piedmont were making numerous large urns and vases for the tourist market, many of them requiring some sixty pounds of clay and having a capacity of fifteen gallons or more. Unlike Burl, Charlie Craven turned these giants on a single wheel and did not wait for the bottom to set up. "I'd make the middle piece first and set it off. And then I'd . . . cut my top off of the other one, and then set it off. Then I'd come on up with the other [bottom]; then I'd put it together." Charlie estimates that he used fifteen pounds of clay for each of the upper sections and thirty for the bottom. As the height of these pieces could exceed two feet, Charlie required an assistant during the assembly. "Making it on them kick wheels [treadle wheels], when I'd get up to the top there, I had to have somebody kick the wheel for me, so I could get up on top and reach down in there. I couldn't reach over far enough and kick the wheel to finish it."[52]

Having completed the cap, Burl uses his chip to shape the rim of the jar.

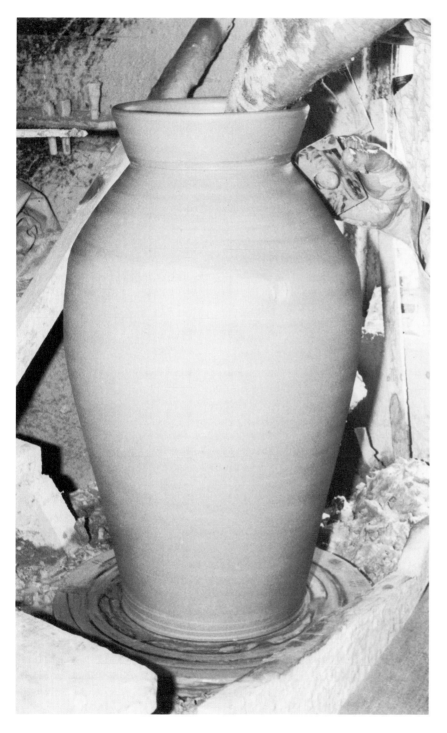

Figure 5-20
Shaping the jar into final form. The horizontal stick gauge to the left determines the final height.

To check the proper diameter of the interior of the mouth, he inserts one of the small stick measures that are kept on a shelf near the wheel with his other tools (fig. 5-21). The careful measurement will ensure a proper fit if a lid or churn collar is used. These simple gauges have the following dimensions:

4–5 gallons	6⁹⁄₁₆″
2–3 gallons	6⁵⁄₁₆″
small jars, cannisters	5⁵⁄₁₆″, 4″

The lids are also turned on the wheel and the diameters checked in the same fashion. When using a particular stick gauge, Burl keeps it floating in the milk crock of water on the table, so it is readily accessible and reasonably free of clay. By having only two sizes for his basic line of churn-jars, he can maintain a ready supply of lids with a minimum of effort.

As soon as he has shaped and trimmed his jar, Burl adds the handles, which he quickly pulls from a lump of moist clay. "You've got to have softer clay for your handles. What I do is use the scraps, like where I trim. . . . I work it in my hands, actually, you mash it up in your hands like this, slap it together. . . . It has to be perfect, too, before you can pull a nice handle."[53] Although the terminology varies, there are two basic types of handles: jars and churns usually receive "ears," "flat handles," or "jar handles," while jugs and pitchers have "strap," "round," or "jug" handles. The ear or lug handle is applied lengthwise along the upper shoulder of the jar while it is still on the wheel. The potter puts his left hand inside to support the wall; curves the handle into the shape of a shallow, upside-down "U"; and gently blends the clay along the inner edge into the body (fig. 5-22).

The second type of handle, which is mounted vertically rather than horizontally, is normally added after the pot has had some time to set up and harden a bit. The potter pulls a longer piece of clay and attaches first the upper, then the lower end, resulting in a graceful curve that complements the shape of the pot. Generally, Burl uses a slightly harder clay for this type of handle—it extends outward from the body and is only supported at the ends. Since he cannot get his hand into the narrow necks of jugs, he allows several hours for them to harden, so the walls will not collapse when he presses on the handle terminals (fig. 5-23). However, he cannot wait too long: "You don't want them to dry or it won't stick." Sometimes he does "mess up a jug," but with a small one, "a gallon or half a gallon, I can blow in it and blow it out some."[54]

Until about 1920, potters in the Catawba Valley employed the strap handle as shown on the jug in figure 5-23 but then shifted to handles that were rounder in cross section. The earlier handle is thinner and approximately rectangular in cross section, which makes it lighter and easier to grasp. Potters often added one or two ridges to the handle by grooving it with their right thumb while pulling it out. The pair illustrated on the large jug are very

Figure 5-21
An assortment of stick measures to ensure the proper fit of lids and churn collars.

similar to the powerful, deeply ribbed handles made by Daniel Seagle and other early potters, some of which are so carefully formed they almost appear to have been extruded. The precise reason for the recent shift to round handles remains unclear, but because they are thicker and more uniform, they are less apt to break. However, a loaded pot tends to twist in the hand, and they are aesthetically less attractive.

The potter's final task was to mark the pot, although he did not always do this. On the larger, utilitarian wares, from one-half gallon and up, he did invariably stamp the gallonage. This was important because most pottery was sold according to its capacity, a common rate being ten cents per gallon. In addition, a turner working for another potter was paid by the number of gallons produced—on average about two cents per gallon—and so the numbers on the wares were useful in keeping account.

Illustrated in figure 5-24 is the "stomp basket" made by Poley Hartsoe in the early 1950s, after a fire destroyed his shop. The stamps were usually metal with short wooden handles; the potter dipped them in water and impressed them on the pot before removing it from the wheel. Those who lacked a set of "stomps" just drew a large, freehand number on the side of the pot with a sharp stick or nail. In the eastern Piedmont, particularly in Moore County, a substantial number of potters made theirs with a pointed roulette wheel. Most potters underrated the capacity of their wares—a jug marked "4" may hold close to five gallons. In fact, there is an oft-told anec-

Figure 5-22
Applying a lug handle.

dote about a certain Catawba County potter who had a strong thirst for the local white lightning. It is said he would turn a five-gallon jug, stamp it with a "3," and take it to the local bootlegger to be filled, at what was surely a bargain rate.

Much less frequently, the potter impressed or inscribed his name or initials on the pot, usually with a homemade stamp of wood, metal, or even clay. In most cases he did not do so; as Carl Chrisco explains, his father Henry felt that his products were too ordinary to warrant such an additional flourish. "Nobody thought anything about ever being any value to it. When you're selling that stuff for about four or five cents a gallon, flowerpots for three cents, why nobody ever figured they'd ever be any value to it." Carl adds that his father did make up to ten cents per gallon when the market was strong![55] Ironically, today these relatively rare signed pieces fetch the highest prices from collectors and museums. Figure 10-18 shows a milk jar made by Henry Chrisco that, its cracked bottom notwithstanding, might today bring something approaching one hundred dollars per gallon—and it would never be used. In the eastern Piedmont the potters characteristically marked their full names—for example, "W.H.CRISCO," or even "J.M.YOW / ERECT.NC." In the Catawba Valley, however, the general rule was large, simple initials such as "TR" (Thomas Ritchie) or "S.L.H." (Sylvanus Leander Hartsoe). These regional differences resulted directly from the glazes used. Finer lettering shows up well under the transparent salt glaze, whereas the thick, dark alkaline glaze tends to obscure all but the most emphatic signature.

The practice of marking wares goes back at least to the first half of the nineteenth century, suggesting that the potters had definite reasons for occasionally doing this. The most obvious motive is advertising. Because of the dense concentrations of potters, wares were often wagoned long distances to find a market. Thus, future orders for a sturdy, reliable product might depend on the buyer or middleman recalling that stamped name or initials. A similar practice has been noticed among traditional gravestone carvers. Stones shipped beyond the immediate community were sometimes signed, whereas those used locally were not, because the craftsman was known personally by his clientele.[56] Sometimes, too, the buyer would request the potter's name. Burl Craig affirms that "a lot of times somebody would say, now make me so-and-so and put your name on it. Now that happened a lot of times, it did with me. What few pieces I signed over the years till I got to stomping all of mine, it was by special request. . . . Take a nail, a match-stem, or something, the way I did, just put 'B. B. Craig.'"[57] In addition to these personalized touches, it was to the buyer's advantage to know who made his jug or jar. As the late Javan Brown cautioned, "Some of them would leak, you know. You had to guarantee your stuff. If it had my name on it, I'd give them another for it. If it didn't have my name, he just had him a jar!"[58]

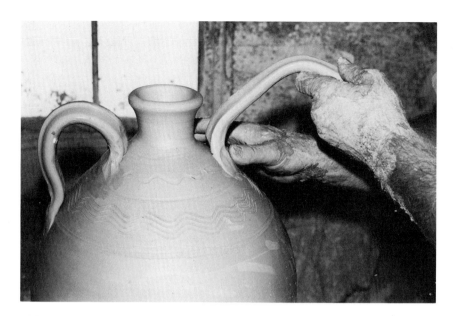

Figure 5-23
Applying a strap handle.

Figure 5-24
Alkaline-glazed stoneware stamp basket, ca. 1952, Poley Hartsoe, Catawba County. H 5¾", C 24⅝". The heads of the stamps are lead and mounted on carved wooden handles. Collection of Mr. and Mrs. Olen T. Hartsoe.

Starting in the 1920s, the potters began making increased quantities for tourists, who preferred a name or place on their purchases as a specific memento of their travels. Thus, the Propst family of Lincoln County began stamping their output with "NORTH CAROLINA," the stamp having been provided by the vendor who retailed the pottery in Hendersonville.[59] Particularly in the eastern Piedmont, where new art forms and tablewares were being introduced, it gradually became standard practice to mark the bulk of the output. But most old-time potters who specialized in utilitarian forms seem to have regarded signatures as a bothersome extra task. Still, a few must have taken pleasure in placing their name on a well-made jug or pitcher. As Javan Brown declared, "Daddy always told us, 'If you're not ashamed of your pottery,' says, 'put your name on it!' "[60]

To remove the finished jar from the wheel, Burl cuts the bottom loose from the headblock with his wire and then clamps a pair of "lifters" around the base. Numerous sets of these wooden forms hang on the wall just behind the wheel (fig. 5-25), each carefully carved to fit a different sized pot. The beveled edges wrap snugly around the bottom, and the projecting tabs lock the two halves together. Burl remembers that "the old-timers used the wooden packing boxes, you know, shipping boxes; they was thin. And they would use the corner posts that they nailed the box together with for the outside and for the hickeys [tabs] that went together. They used to whittle them out with a pocket knife."[61]

When Burl picks the jar off the wheel, he sets it on a "bat," a small wooden board with runners underneath it, so that it can be carried readily while drying (fig. 5-26). Only rarely is there an accident. "I've had 'em to fall through my lifters. Maybe not trim it enough around the bottom to where the lifters would get caught good. Pick it up, and I'd be holding the lifters, and my jar'd be laying on [the headblock]."[62] This device is particularly useful for handling large forms, but was widely used for smaller pieces as well. Burl generally picks the one-gallon jugs off with his hands, but he employs the lifters on his cannisters, because "they're wide, and they'll mash on you."[63] The lifters leave a quarter-inch indentation around the base that can be seen on many traditional wares. Often, however, Burl will invert his jars to dry them and hastily round off the still-damp clay on the bottom edge with his fingers.

Burl's churn-jar is now complete and ready to be dried, glazed, burned, and sold. The process described at length here is one that he has repeated tens of thousands of times, although always with some small variations in form or method or purpose. As such it embodies the essential qualities of the folk potter's work. Unlike certain types of traditional craftsmen like the basketmaker, tinsmith, or cobbler, the potter required a rather extensive number of buildings and large, specialized tools—one very important one, the kiln, has yet to be considered. Thus, the decision to enter the business, even on a part-time basis, was anything but a casual one. Often he was

fortunate enough to inherit his shop from a relative or neighbor, but no less frequently he had to purchase or even build his plant. However conscious the decision to become a potter, a considerable investment in materials, money, and, most of all, time and labor, was necessary.

A pervasive spirit of self-sufficiency is clearly manifest in the traditional pottery shop. Virtually all of the equipment was homemade, either from local materials or industrial discards. Much was also borrowed or passed on from one potter to the next. Burl's shop, in fact, is a living history museum for the Catawba Valley. The shop building and kiln came from Harvey Reinhardt; the wheels from the Hilton family, Poley Hartsoe, and Uncle Seth Ritchie; the glaze mill from Pinkney Reinhardt; the scale from Uncle Seth; the lifters from Jim Lynn, Harvey Reinhardt, Sam Propst, and Nealy Blackburn. All of this equipment, of course, has been repaired or modified by Burl to fit his particular needs and situation.

The principle of economy is also constantly in operation. From the overall layout of all the buildings and equipment, to the use of the shop, to the turning of a single jar, there is a powerful sense of logic that is so natural it is hardly apparent to the unobservant eye. Raw clay enters and moves inexorably through a series of transformations, heading to the final confrontation with the fire. Tools are simple in concept and minimal in number. And, pumping his treadle wheel, the potter forms his pots with admirable efficiency and dispatch. He centers the clay immediately instead of playing with it; he pulls up the walls with his bare hands; and what little clay he trims away from the finished pot he reuses almost immediately in his han-

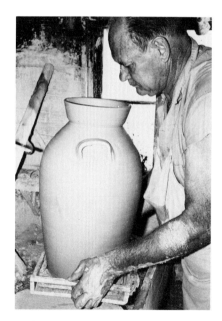

Figure 5-26
Burlon Craig shifting a freshly
turned four-gallon jar from the
wheel to a bat board.

dles. When told of the numerous scraps and tailings of clay usually seen around the studio potter's wheel, Burl responds, "well, if they had to work as hard to get it as I do, they might take a little better care of it."[64]

Burl has clearly inherited much from his predecessors: his shop, his tools, his procedures, his attitudes. But even in such a traditional craft there remains leeway for change and innovation. Burl necessarily works alone now, and so his shop has only a single wheel and wedging bench in use. An iron stove has replaced the old brick drying oven, and the loft is no longer a convenient place to store the greenware. In one sense, each of these changes embodies the same sense of efficiency the folk potter has always advocated. But as Burl continually cautions, the craft of pottery literally demands individual adaptation and idiosyncratic practice. Perhaps it is inherent in the plastic nature of clay. "There's no set rules. If you come to think about this, there's no set rules to none of this stuff when it comes to pottery. . . . You just about have to work it out to your conditions the way you want, the way it'll work best."[65]

6

GLAZES

As with his clays, the folk potter had little scientific knowledge of his glazes, but he did possess a pragmatic understanding of their formation and use. In simplest terms, "a glaze may be defined as a glassy coating melted in place on a ceramic body."[1] The functions of a glaze are many: it should make the clay body hard and more durable; smooth and easier to clean; nonporous and impermeable. Glazes also contain numerous decorative possibilities, though, as suggested, this was of little concern to the North Carolina potter. A glaze ultimately should be efficient and economical. Accordingly the folk potters relied on time-tested formulas and local materials, and they employed a very limited repertory of types, each of which possesses distinctive regional characteristics.

Before the potter could glaze his ware, he dried it as thoroughly as possible, so that it was strong enough to be carried and dipped into a tub of wet glaze. Today most pottery is bisque fired to harden the body, simplify the glazing process, and allow more elaborate decoration. Of the early North Carolina potters, however, only the "Moravian potters customarily fired their ware twice, once in the biscuit firing, when the green clay pots were fired to hard maturity, and a second time after the pots had been glazed."[2] The folk potter considered this double firing an unwarranted step that consumed additional wood, energy, and time. The size of some of the wares produced—notably the fifteen-gallon jars of Daniel Seagle—testifies to the remarkable strength of the short clays used, as well as to the skill of the potter in fully glazing such monstrosities and then maneuvering them into his cramped groundhog kiln. Surely Seagle must have broken a good number of them, either from getting them too wet when applying the glaze or by knocking their fragile bodies against some hard surface, but the surviving examples justify any frustration that he might have experienced.

Drying the greenware is a universal problem for all potters, and the folk potter was no exception. He, too, had his share of warped forms, cracked rims or bottoms, and explosions in the kiln. Burl Craig affirms that a major error was haste: "They always told me . . . the slower it dried the better it dried." In addition, he stresses the importance of constant attention to the freshly turned wares. "Anything that's open or wide at the top, you've got to attend to it pretty often or it'll warp."[3]

Generally, the potters tried to dry the pieces, at least through the leather hard state, inside the shop. The smaller pots were lined up on boards and

set across racks, the larger ones placed on individual bats on the floor or low shelves. If a breeze was blowing, the wares were rotated to promote even drying. In addition the heavier jars and churns were eventually turned upside down and the jugs set on their sides, to allow the bottoms to dry out with the walls and prevent them from cracking. In cool or moist weather, the potter stoked his drying oven. Figure 6-1, although much faded with age, shows the interior of the Kennedy Pottery in Wilkesboro, with milk crocks drying on boards across the racks and also on bricks set on the metal sheeting atop the oven. Because of the immediate heat, the potter had to be careful of using the oven top. Floyd Propst recalls that his father, Sam, covered his oven with flat rocks and a thick layer of ashes, and even then he placed only the partially dried pieces on it.[4] No doubt the moist, earthen floors of the old shops also helped to retard the drying process and were particularly beneficial for large churns and jugs such as shown in the photograph (fig. 6-1).

The origin of the drying oven remains unknown, but it certainly predates the development of pottery in North Carolina. In Staffordshire, separate, heated houses for drying pottery were in use in the very early eighteenth century and "became a common part of pottery buildings by the 1730's."[5] More recently, Peter C. D. Brears has described a type of drying oven, still in use in the traditional potteries in northern England, that is virtually identical to those in North Carolina. "It consists of a table-high stone-topped bench running down the inside of the workshop wall beneath the pottery racks, with a firebox arranged at one end of it so that a current of air can pass down through the hot coals, under the bench or 'hob,' as it is known, and out through a chimney built at the opposite end. In this way the pottery in the racks above is subjected to a gentle convected heat that dries the ware quite quickly but with little risk of cracking."[6]

While the potter generally tried to dry his wares inside his shop where he could best control the conditions, he also had to use the open air to complete the process. Burl Craig explains that "when you put out a lot of stuff, you got to dry it in the sun. Uncle Seth [Ritchie] had a rack . . . you set the boards on. And all your flowerpots and milk crocks and small stuff was set across that scaffold, set out in the sun. It was right in front of the shop door. . . . And the jars you just set down in the grass."[7] Uncle Seth's drying rack is shown in an early photograph in figure 6-2, precisely as Burl describes it. To the left the large jars rest on their sides so the bottoms will dry evenly.

Worse than excessive sun or wind, however, was a sudden rain shower, which could quickly convert the greenware back into amorphous lumps of clay. One ingenious solution to this problem was George Donkel's "drying truck" (fig. 6-3). Talman Cole, who worked with Donkel in the 1930s, explains that "it had railroad [flanged] wheels—you know what I'm talking about—and a track. And the shed was bigger than the cart. And we just

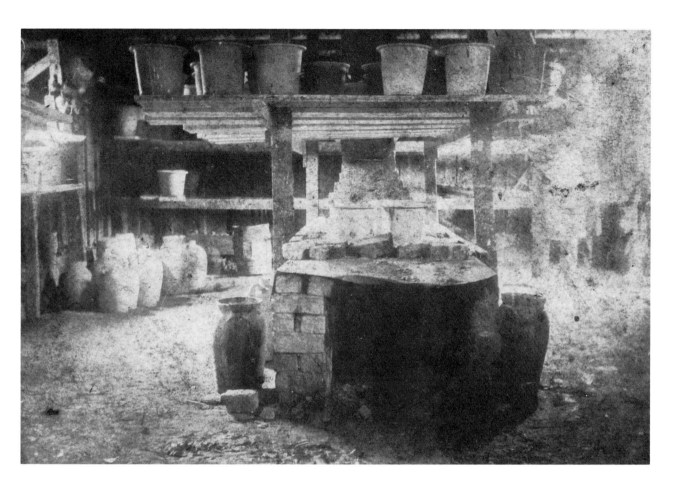

pushed it right out there in the sun, then we'd push it back of an evening. And it was as big as the kiln, . . . hold the whole kiln[ful]." Cole adds that the pots were first dried in the shop, and then put "in that shed on that track . . . [for] a week or more before you pushed them out in the sun." After several days in the sun, the ware was glazed and replaced on the truck to dry further. And this was not all. The track ran from the shed "right on out to the upper end of the kiln," where it could be quickly loaded for firing.[8] George Donkel's drying truck appears to have been a unique invention among the North Carolina potters; very likely other such innovative practices have gone unrecorded and are now lost. It suggests the importance the potters attached to preparing the greenware for the application of the glazes.

For the most part, the North Carolina folk potter employed only three major types of glazes over two centuries: the lead glaze on earthenwares, and the salt and alkaline glazes with stonewares. He occasionally used

Figure 6-1
The interior of the Kennedy Pottery in Wilkesboro, Wilkes County, ca. 1920. Courtesy of Ray A. Kennedy.

Figure 6-2
The outdoor drying racks at Seth Ritchie's pottery, Blackburn, Catawba County, ca. 1939. Courtesy of Mr. and Mrs. Raymond A. Stahl.

several lesser varieties, such as Albany slip and the Bristol glaze, as well as some hybrid forms—for example, the frogskin glaze (salt over Albany slip) or a combination of Albany slip with the alkaline glaze—but none of these was at all common.

A glaze, according to ceramist David Green, must "clearly be made to melt at a temperature suitable for the clay of the pot and the molten liquid must be runny enough to smooth over blemishes and to allow the escape of bubbles of gas erupting from the clay. . . . It must not, however, be so runny when molten that it slides off vertical surfaces, nor must its expansion, and subsequent shrinkage on cooling, be very different from that of the clay."[9] At a minimum, the glaze should contain a source of glass (silica), a stabilizer to keep the glaze from running (alumina), and sufficient flux to lower the melting point to the correct level. Generally the nomenclature used to identify glazes refers to the fluxing elements: lead, salt (sodium), and various alkaline substances (calcium, potassium, sodium) for the three primary North Carolina glazes.

The earliest glaze was, of course, the lead glaze, which predominated until the second quarter of the nineteenth century. Regrettably, there is little reliable data on the technology used during this period—other than the typically meticulous records kept by the Moravians. "The basic glaze ingredients familiar to Aust and his successors, then, were flint, red lead, and kaolin. They were combined in a formula that roughly consisted of two parts flint to one part of lead and kaolin combined; the exact formulas used by the Wachovia potters are unknown. Glaze formulas were jealously guarded."[10] The flint provided the bulk of the silica; the kaolin, additional

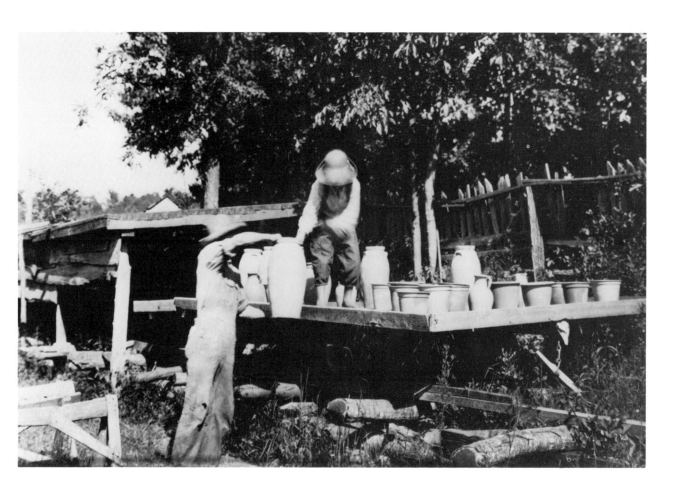

silica as well as the alumina needed to stiffen the glaze. Although flint and lead would have been available locally, records for the community store show that the potters often used preprocessed materials from Pennsylvania. Ultimately these ingredients were carefully measured out, mixed with water, and ground by hand in a stone glaze mill. The biscuit ware was then dipped in the glaze, dried, and given a second, or "glost" firing.[11]

Outside the Moravian community, there are relatively few surviving wares to provide testimony to the potters' methods. It is highly unlikely that many local potters purchased prepared ingredients as did the Moravians, and they may have used the all-important lead flux in a variety of different forms. The simplest was lead ore or galena (lead sulphide), which was crushed in a stone mill. Once ground and sifted, the powdered ore could be sprinkled on the surface of the pot; the lead then reacted with the clay body, fluxing the silica and forming a glassy coating. One obvious disadvantage to this tech-

Figure 6-3
George Donkel and his wife loading the drying truck at their pottery near Weaverville, Buncombe County, ca. 1914. Photograph by William A. Barnhill. Courtesy of the Library of Congress.

Figure 6-4
Lead-glazed earthenware jar, first
half of the nineteenth century, east-
ern Piedmont. H 9¾", C 28¹⁵/₁₆". Col-
lection of Ralph and Judy
Newsome.

nique was that "only the upper surfaces of each pot were glazed, the others being left completely raw. If, for example, a spherical bottle was to be glazed in this way the upper half of the exterior would bear a heavy coating of glaze, as would the interior of the base immediately below the mouth, but all the other surfaces would be bare, as the glaze would have fallen past them. This patchiness makes it quite easy to tell if a pot has been glazed in this way."[12]

Powdered galena was used in England until well into the seventeenth century, when a number of gradual improvements were introduced. First, the lead ore was calcined to produce two oxides, litharge (lead oxide) and red lead, the principal form used by the Moravians. Both were more soluble than the galena, and no sulphur remained to stain the ware. Second, the potters began combining the lead with water, slip, and other ingredients; this liquid glaze was much easier to apply and formed a more even coating on the pot. The lidded jar in figure 6-4 clearly reveals the liquid nature of the glaze. Such surviving examples suggest that the North Carolina potters consistently applied their glazes in a wet rather than powdered form.

No specific information is available on where the early potters obtained their lead or the additives they used to complete their glazes. No doubt there was considerable variation, as the potters made use of whatever resources were available. "In New England the powdered [litharge or red] lead was mixed with a quantity of sand or fine loam screened through a horsehair sieve, water was added, and the whole ground to a creamy consistency."[13] In Virginia, on the other hand, "it is said that after the Civil War local boys would go out into the battlefields to collect lead bullets for sale to the potters."[14] The early North Carolina potters likely used ore, metallic lead (purchased in pig form and then roasted to produce red lead), and even some preprocessed oxides. By the late nineteenth century, they were regularly purchasing red lead to glaze their baking dishes. "It was in little kegs," recalls Bascom Craven, "and just about as red as it could be. And [we] just made it up about the thickness of paint and just painted the pie dishes" with an ordinary paintbrush.[15]

Although the lead glaze was recognized as potentially poisonous to both the potter and his customers as early as the eighteenth century, no effective regulations governing its use were established until the twentieth century. One reason for this delay was that lead has always proven such an excellent flux: it is reliable and easy to use; has a low melting point and a wide firing range; and will produce an array of bright colors. On the negative side, it is soft and easily scratched or chipped; and it is highly soluble in acids, which can lead directly to lead poisoning. Today the danger of poisoning has been virtually eliminated through careful testing and research—in particular, by substituting a fritted lead silicate for the former lead oxides, and by ensuring that the glaze reaches full fusion in a properly oxidized kiln atmosphere.[16] However, these modern substitutes lack the pleasingly unpredictable colors and textures that characterize the old traditional glazes.

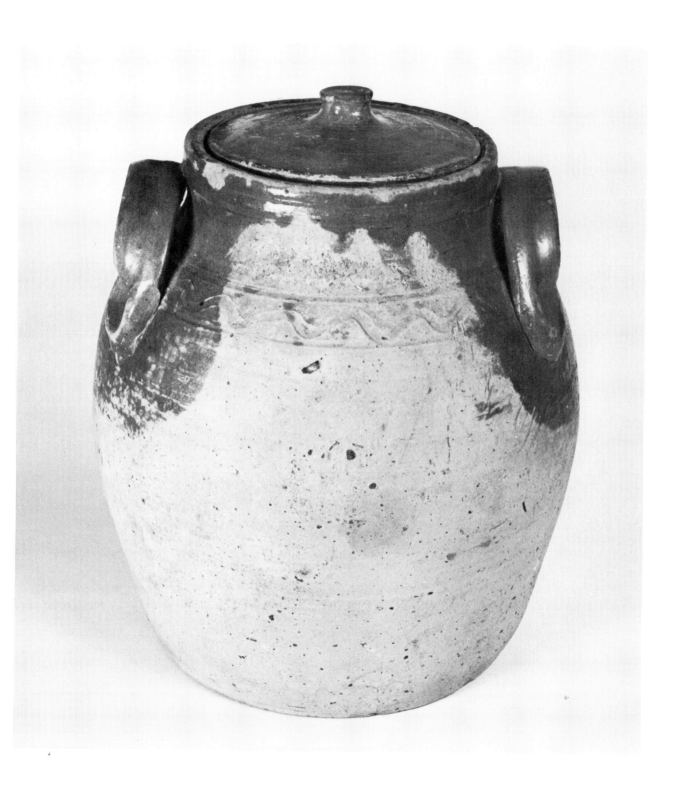

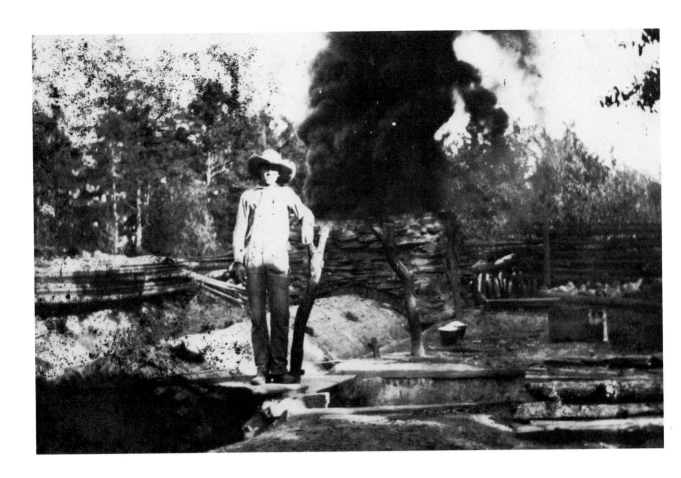

Figure 6-5
The groundhog kiln at the pottery of Baxter N. Welch, Harper's Cross-roads, Chatham County, ca. 1900. Two one-gallon milk crocks of salt are ready for use at the right side of the kiln. Courtesy of Mr. and Mrs. Gails Welch.

Stoneware largely displaced earthenware during the first half of the nineteenth century. In the eastern Piedmont, the potters adopted the salt glaze, which is unquestionably the easiest to apply and most efficient of the three major glaze types. In effect, the entire glazing process takes place in the kiln. The potter sets his greenware and "lights off" his kiln. When the temperature reaches the full stoneware heat of about 2,300°F, he introduces the salt through the firebox and the salt ports along the arch (fig. 6-5). The salt vaporizes, and the sodium functions as the flux, melting the silica on the surface of the clay to produce a hard, glassy coating. Thus, this operation eliminates two arduous tasks: mixing a glaze solution, and dipping all of the wares into it.

Herman Cole offers an interesting oral legend about the origins of the salt glaze. "Did you ever hear how come they got to using salt to glaze with? Well, they said over in the old country a potter was firing and ran out of wood for his kiln, so a neighbor give him some wood meat boxes that had

salt sticking to the sides. Well, he used these, and when he emptied his kiln the wares had a sheen on them, so then he knew that the salt had done this. He fired another kiln and put salt in the fire, and it worked. I believe things like this are just handed down to us to use. I really believe that."[17] Herman's account provides tangible evidence of the power of oral tradition within a folk craft. In effect, such a story serves to validate the salt glaze and its associated technology.

Another variant of this tale is outlined by Jack Troy in his wide-ranging study of salt-glazed ceramics. He speculates that "wood from old salt-impregnated fish-storage or sauerkraut barrels was used to fire the kilns. It seems feasible that if such fuel were employed during the late stages of firing, potters might well have concluded from the results that salt had played a part in whatever differences were apparent in the fired objects."[18] Whatever the specific facts of origin, the salt glaze appeared in the late Middle Ages in the Rhineland, and it is the one major glaze that was never employed to any extent in the Orient.

Salt was an important commodity in rural North Carolina in the nineteenth century, as it was essential for the preservation of locally produced meats and vegetables. The account book of Himer Fox and the ledger of Bartlet Craven, both of whom were potters in Randolph County, quote a standard price of 50¢ per half bushel during the mid-1850s.[19] As a ground-hog kiln requires, on average, three to four gallons of salt and a half bushel holds four, the cost of the salt for one firing would have been 37½¢ to 50¢, or roughly the price of a three-gallon jug or jar at that time. Such account books also indicate that the bartering of goods or services was very common; thus, the potter might offer one of his finished products in exchange for the glaze material.

During the early twentieth century, the "meat salt," as Joe Owen calls it, was purchased in one-hundred-pound bags; it was about the consistency of sand, not quite so fine as the table salt used today.[20] Moisture makes salt hard and lumpy, and it was not unusual for the potter to discover that his sackful had "froze." Carl Chrisco "spent many a hour beating that stuff up. . . . You'd get a sack full of salt—it was as hard as a daggone rock. We made mauls. Take a piece of oak about as big around as your thigh, I reckon, make a thing like a maul. Get that salt out there in big old blocks and just beat on it—you had to beat it up. You throw them lumps in there, why, of course, they'd go in a piece of ware."[21] The salt had to be as fine as possible to ensure that it would vaporize completely and disperse through the kiln.

The formation of the salt glaze was intimately related to the burning of the kiln—the topic of the next chapter. Here only the application of the salt will be described; this occurred near the end of the final phase of the firing cycle known as "blasting" or "blasting off." Joe Owen provides a very concise overview of the major stages of salting a kiln:

You heat up on it real slow, start off, heat up on it real slow, and when you get it [the ware] red plumb up to the chimney, then we call it blasting. We have rich pine or good dry slabs of wood, and run that blaze plumb out the chimney there for about, I believe, maybe a couple hours. And then you'd go to those holes; you take you a little salt and put it in there, and if it lay up there on the dark, it wasn't hot enough. You'd go back and fire it again. And when you get it, when you got it hot enough, you take you a little salt and try it again. When that salt drops off just like grease on a hot stove, you know she's ready to lay it in. So you get on one side, and one [potter] on the other, and you take your salt—have it in about gallon crocks, takes about, need about four gallons. . . . And you go up and down the little holes, put salt in them and that's the way you glaze. That's when it turns your smoke real white.[22]

As Joe Owen points out, the potter's first task was to get the kiln to full heat. He used a well-dried hardwood for the first twelve hours or so, but then switched to pine for the last two hours of blasting. To boost the heat, the potters used what is most often referred to as "fat pine" or "lightard," most of which came from Moore County, where there was once an extensive tar and turpentine industry (fig. 6-6). Some was cut by the potters, but much was simply gathered up from the forest floor. Carl Chrisco recalls "old, big, rich stumps all around, standing all around over these woods where the timber was cut, . . . laps, rich pine knots."[23] Gnarled and twisted in form and permeated with resin, this pine produced a long tongue of flame. With repeated stokings, the pottery changed in hue from cherry red to orange, indicating that the temperature was now high enough to introduce the salt.

When the potter was satisfied that the temperature was high enough, he salted the kiln through the salt ports in the arch and the firebox. Charlie Craven reports that his father, Daniel, built "flueholes on each side of the crown of the kiln, and I don't remember just how many there was, about twelve, I believe, twelve on each side. . . . Two rows—two or three. And you'd just get what salt you could hold in your hand good, and kind of scatter it as much as you could when it went in there. And you go over it about twice, and that was it. And Daddy'd usually throw about a quart, maybe, into the firebox to be sure the front was glazed good."[24] Figure 6-7 illustrates the right-hand side of the arch on Ben Owen's salt kiln. The configuration of the ports, or "eyes" as they are sometimes called, is similar to that recalled by Charlie Craven; there are thirteen in all, with twelve in two rows and one positioned near the center of the arch. The ports measure 2½″ to 3″ in length and are kept covered. Some of the kilns were built so that the brick could be inserted endwise to plug the port. When salting, the potter used a pair of heavy gloves to remove the brick, as the bottom was invariably red-hot. He also learned to keep his head well back while salting, as a quick rush of heat and red flame would shoot up from the open port.

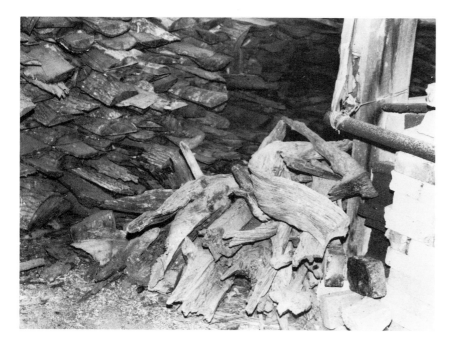

Figure 6-6
Fat pine (lightard) used to blast off
the kiln at Ben Owen's Old Plank
Road Pottery, Moore County.

Unquestionably, there was some danger involved in this operation, particularly when children were helping out. A. R. Cole reminisces about the shortcut method used by him and his brothers. "I've thought about it many a time, and it almost scared me now how us younguns would pick up a gallon of salt and go down one side of the arch putting it in. And then rather than walk around the back of the chimney to get to the other side, we'd run across the top of the kiln to salt the other side. Twenty-three hundred degree or so hot—and they'd get a little shaggy, those old kilns, just ready to fall in. Ought to have had more sense but we's just younguns then. We'd not do it if my Daddy [Ruffin] was around or he'd skin us."[25] Inside the kiln, the salt combined with water to form sodium oxide and hydrochloric acid; the former attacked the surfaces of the wares to form the coating of sodium silicate. High temperatures were necessary because "the body of the ware must be mature" so that some of the silica "is in the vitreous state and is therefore much more reactive."[26]

Most potters assert that the kiln was normally salted twice through the salt ports and at least once through the firebox, though the latter was usually a small amount. There is also general agreement that once full heat was achieved and the salting begun, no more wood was inserted.[27] Braxton ("Brac") Craven explains that "salt's the last thing you do when you glaze it. You don't fire it no more. If you did, you'd burn your glaze off. You get it hot enough to melt that salt and that's all you need."[28] Herman Cole adds that "they needed that high heat right at the last when the salt was throwed in,

Figure 6-7
The right side of the arch on Ben
Owen's groundhog kiln, showing
the configuration of the salting ports
or eyes.

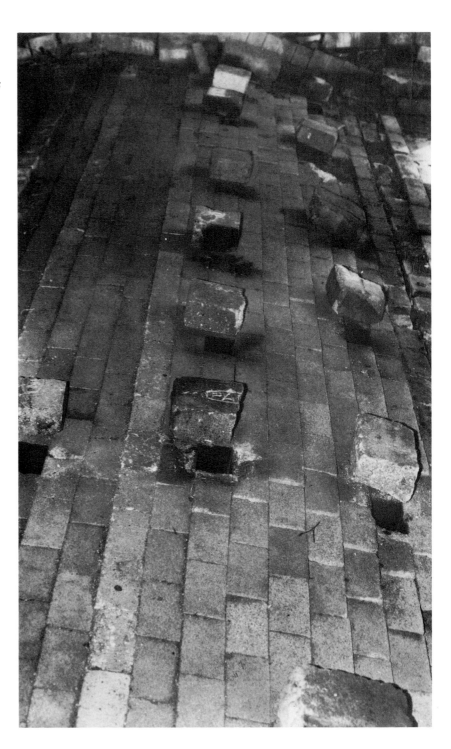

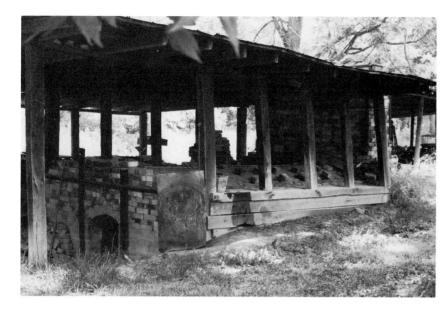

Figure 6-8
Ben Owen's groundhog kiln.

and you needed something that would get hot fast, then be done with it. If your heat lasted too long, all the vapors went out the chimney. That's how come you had to cover it up."[29]

Figure 6-8 provides a full view of Ben Owen's kiln, with the large metal door used to cover the firemouth leaning against the breast wall. Ben affirms that it is important to keep the salt vapor in the kiln where it can work on the ware. "We'd take down the iron at the front there and throw the salt in with a shovel there. And then we'd put it back up. And when the fire died down and got off of the pottery, . . . then we could put our sheet iron on the chimney. It'd take, I'd say, a half an hour or more to die down so you could put your sheet iron on the chimney."[30] In effect, the potter sealed off the kiln when the color of the ware returned to a cherry red and the temperature dropped enough so that the sheet iron on the chimney would not melt.

Because the bulk of the salt was introduced overhead through the arch, the pots directly under the salt ports sometimes received an excessive coating of glaze. This, combined with the flyash from the firebox that continually blew through the kiln, often resulted in spectacular light brown to almost black drippings along the exposed rims, handles and shoulders. This free-flowing, Oriental "decoration," well illustrated by the handsome jar in figure 6-9, is one of the quickest and surest means of identifying a piece of North Carolina salt-glazed stoneware. Also quite common was the rather even spotting seen on the side of the jar. This occurred when the sodium flux melted the iron in the clay body and pulled it up into little ridges all across the surface of the pot.

Altogether, this very simple glazing process produced a surprisingly rich variety of colors and textures and ensured that the contents of each kiln would be anything but predictable. It also proved extremely efficient, as the sodium vapors reached most of the exposed surfaces. Marvels Bascom Craven: "That smoke where it went through the ware, it even glazed it under-neath—of course, it was setting on gravel. It could go underneath of it, and it glazed it inside and out."[31] Thus, the North Carolina potters did not have to coat the interiors of their pots with Albany slip, as did the salt glaze potters in the Northeast and mid-Atlantic regions. Because the wares were rarely stacked and the kilns were hot and efficiently designed, the salt was all that was needed.

In contrast to those working with salt in the eastern Piedmont, the potters of western North Carolina labored long, extra hours to concoct and apply their rich, flowing alkaline glazes. As with the lead glaze, potters had to gather and prepare the individual ingredients and then grind and apply the resulting mixture. While the specific materials differed, many of the general methods and tools used for the alkaline glaze were similar, suggesting the now-vanished techniques of the early earthenware potters.

Perhaps the simplest form of the alkaline glaze was a mixture of equal parts of clay and wood ashes. The former provided the necessary silica and alumina, while the latter provided additional silica and alumina as well as calcium, sodium, and potassium oxides—the alkaline substances that serve to flux the compound. Pine ash, for example, contains 24.39 percent silica, 9.71 percent alumina, 39.73 percent lime, 3.77 percent sodium oxide, 8.98 percent potash, and additional oxides of iron, manganese, magnesium, and phosphorus.[32] As this analysis reveals, lime is the principal flux; thus, it is not surprising that some southern potters used calcined limestone instead of ashes in their glazes. Although it is by no means easy to tell which flux has been used in an old glaze, the lime generally produced a smoother, lighter glaze. "Lime burns nearly white," Javan Brown explains. "Ash glaze don't—it's darker and there's a running streak."[33]

For the most part, the rich variations in color and texture derived from the fluctuating content of the ash. As potter Wayne Cardinalli discovered: "Wood ash is an uncertain substance. Ash from an apple tree will not pro-duce the same results as that from a maple tree. Even two apple trees grown in different soils under different conditions will yield different ash. Further-more, the ash from the branches will differ from the yield of the trunk, roots, bark or leaves."[34] Such unpredictability may not appeal to contemporary potters, who seek to understand and control the materials they use, but to the folk potter the protean ash was another part of nature's bounty that admirably served his needs.

Lime-based glazes were used extensively in Georgia and also probably in the Edgefield District of South Carolina, but all the surviving evidence indi-cates that the North Carolina potters preferred wood ashes.[35] The ashes

Figure 6-9
Salt-glazed stoneware jar, ca. 1850, William N. Craven, Randolph County. H 9⅞", C 32". Stamped: "Wm N\.C." Collection of Mr. and Mrs. Wil-liam W. Ivey.

were sometimes pine, taken directly from the firebox of the kiln, but many potters opted for hardwoods, which were not employed as a fuel in the area. One early source of ash is recalled by Javan Brown. "Years and years ago people made their own homemade soap. After they got through making the soap, them's the best ashes you could get."[36] Today Burl Craig prefers the oak ashes from his father-in-law's woodstove. When sifted and leached in water, they contain more lye (sodium or potassium hydroxide) than an equivalent amount of pine ash. Sometimes Burl's hands are pitted or burned by the lye, but he asserts that it serves to keep the glaze particles in suspension in the glaze tub.

One problem "with glazes made from mixtures of ordinary clay and ash (from the technical, rather than the aesthetic point of view) is that they tend to be too low in silica—the combined silica from the two materials being not quite enough to achieve the 'ideal' glaze, with the result that the glazes tend to run badly if overfired." The early Chinese potters overcame this defect by employing a highly siliceous clay, or by introducing quartz or rice-hull ash (which is almost pure silica) into the glaze.[37]

In North Carolina, the potters traditionally used two silica additives, each of which defined a major subtype of the local alkaline glaze. The "cinder glaze" contained crushed iron slag, most of which was gathered at the Reinhardt (formerly Rehobeth) Furnace near Iron Station in Lincoln County. Because of the heavy iron content in the cinders, the glaze was normally a deep brown and tended to run down the sides of the pot in thick veins or rivulets. The "glass glaze," on the other hand, employed powdered glass from old windowpanes or bottles and was typically green and much smoother in texture. However, these general characteristics varied: the composition of the clay body, the addition of other substances to the glaze, and kiln conditions during the burn could radically alter both color and texture. And it is not known what the earliest potters, like Daniel Seagle or David Hartzog, may have experimented with in establishing the alkaline glaze tradition.

It is uncertain which of these two glazes is the older, but there appears to have been a general preference for the cinder. Dr. Fred Yoder advises that "iron glazed ware came out of the kiln with nice vertical stripes that people liked. Prettier than the glass but no better to hold liquid."[38] The "nice vertical stripes" that characterize the cinder glaze are typical of "glazes that are particularly high in lime and low in silica. These glazes are often unstable and where this natural patterning appears, the pots are often made with raised or deeply incised lines around them, to arrest the flowing glaze."[39]

The iron slag contained a smaller percentage of silica than the ground glass. Moreover, the high content of iron further contributed to the "unstable" but highly dramatic surface. Beyond questions of appearance, Enoch Reinhardt asserts that the cinder produced a "better glaze. It'll fill the pores of the clay, and it will hold in better. Glass is inclined—if it's burned good

Figure 6-10
Alkaline-glazed stoneware pitcher,
1897, Thomas M. Phillips pottery,
Catawba County. H 12", C 28".
Signed in script: "from [?]
Phillips / to Mrs. [?] / June 14, 1897."

and hard it's all right. But it'll seep. Put something in it like, like people use these jars and stuff for pickles; put brine and stuff in it, it'll seep out. That old cinder glaze would hold."[40]

Whether for aesthetic or practical reasons, the potters willingly made the forty-mile round trip to the Reinhardt Furnace by wagon and later by truck. Figure 6-11 shows the nearby Madison Furnace, the best-preserved of these

Figure 6-11
The Madison Furnace, Lincoln County.

Figure 6-12
Banks of slag from the iron furnaces, used by the potters for the cinder glaze.

old structures, looming up out of the dense undergrowth like some Mayan pyramid. Long banks of the honeycombed slag sill lie in the immediate vicinity of both furnaces (fig. 6-12). Burl Craig recalls making the journey armed with shovels, buckets, and fertilizer sacks, and digging the cinders out of a field above the Reinhardt Furnace near the old ironmaster's house. The best slag was said to be a green or honey-brown—these colors suppos-

edly indicated a greater iron content. In addition, the potters sought pieces that were light and porous and thus easier to crush.

By the 1930s, however, appropriate cinders were hard to find. Burl recalls that on his last trip it took five hours to fill three or four sacks. Huge mounds still lie all around the furnace, but the remaining slag is extremely hard and dense in texture and very difficult to pulverize. As Burl explains: "There's a lot of 'em, billions of tons there, but you can't beat them. Now these that they used over there, you could almost take your hand and crumble them, some of them. They was honeycombed, and you could beat them. Oh, they would beat easier than glass. . . . But you couldn't get them anymore—they was all gone."[41]

Because of this scarcity, the potters turned almost exclusively to the glass glaze, a type that also dates well back into the nineteenth century. It was almost certainly used on the gray-green jug illustrated in figure 6-13, which is inscribed "Solomon Rudisall turn this jug April the 28th day 1876." This date is corroborated by the journals of James Lee Love, who described the establishment of a pottery shop at Mount Holly (then Woodlawn), Gaston County, in the 1870s. The glaze used by the potters, two unnamed bachelor brothers from the mountains of western North Carolina, "was made of glass. Old bottles, and broken glass were ground to a fairly fine powder in a stone mill—somewhat like a corn mill; but operated by horse power. This ground glass was mixed in a large tub of water, with, perhaps, some ashes, or other ingredients which I have forgotten, so as to make a semi-liquid mass permeated throughout with ground glass."[42]

Yet another curious reference to the use of the glass glaze occurs in Alfred Nixon's history of Lincoln County. In late January 1781, General Cornwallis encamped at Ramsour's Mill on the outskirts of Lincolnton, where he discarded many of his supplies in order to pursue the American army. This event later proved fortuitous for the potters. "Where the whiskey and rum bottles were broken the fragments lay in heaps for years. They were afterwards gathered up and sold to the potters for glazing purposes."[43] It is impossible to assign a date to the use of this stockpile; certainly it was no earlier than the second quarter of the nineteenth century. However, the fact that potters like Daniel Seagle and David Hartzog used glass shards to decorate their pots suggests that glass was early recognized as a potential glazing ingredient.

Whether using cinders or glass, the potter faced the strenuous task of crushing these ingredients to a fine powder so that they would melt in the glaze. The most primitive tool was a simple iron mortar and pestle or some homemade equivalent, such as a wooden box with an iron bottom. Often the tedious work was assigned to children, who, not surprisingly, sought ways to shortcut it. Burl Craig recounts an amusing anecdote about his neighbor, Jim Lynn, who used to hire local children to prepare the glaze. "They had a piece of iron about so long. And you could set down and beat

Figure 6-13
Alkaline-glazed stoneware jug,
1876, Solomon Rudisall, Catawba
County. H 14½", 2 gal. Signed in
script: "Solomon Rudisall turn this
jug April the 28th day 1876." Collec-
tion of Milton J. Bloch.

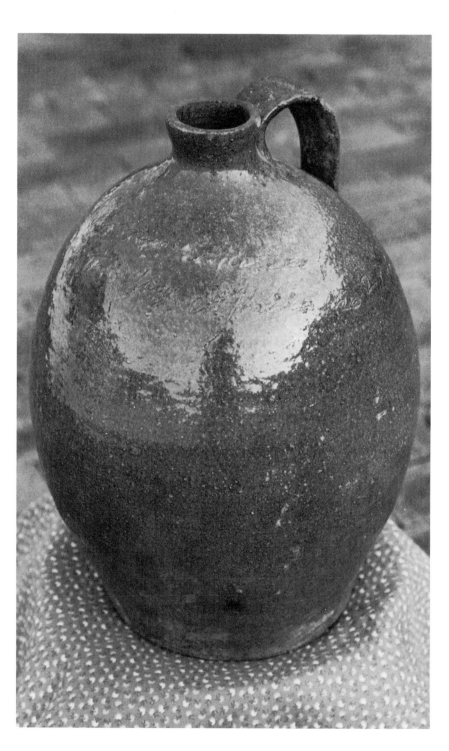

that glass. And he was [paying], I think, twenty-five cents a gallon—take you all day. And these boys was wanting to get through in time to go somewhere. . . . They didn't have their gallon finished out so they mixed the sand with it, finished it out and got their quarter apiece. And they was afraid it would ruin the whole batch. After it was over with, they got worried about it, you know. But they said that was one of the prettiest kilnfuls he ever made!"[44]

A slightly less rigorous method, involving the use of a tree-powered beater, was employed by young Olen Hartsoe, who had to assist his father Poley. "It was just a limber enough pole, tied down on one end, through the forks of a tree, and an iron weight hanging on it on the opposite end. We had a glass box with an iron bottom . . . that would stand the pressure of another iron beating on it. And you just churned it up and down. You'd have to jerk it down, you know, to make it spring, spring up and down. . . . Take a stick and rake the glass around [so it] wouldn't hit the same glass pieces every time. Beat a little bit, and then stir your glass a little, beat again. I've been doing that many a day, all day long."[45] A similar technique was used at James Rutherford's pottery in Buncombe County. In place of the box was a dug-out log with an opening in it as "big as a sink." The potter gripped a vertical "spring-pole" suspended from the ceiling; it had "handles on each side, and you stood there and picked that there glass."[46] Such a device is illustrated in a photograph taken by Margaret W. Morley about the turn of this century (fig. 6-14), probably in northwestern South Carolina, just below the North Carolina border. The use of a horizontal sapling, which is fixed at one end and serves as a power source, recalls the old pole lathe, a woodworking instrument that dates back to the Middle Ages in Europe.

Finally, there were a number of "automatic" devices, such as mill rocks or iron cones, that slowly ground the ingredients into powder. The two most common, however, were simple trip-hammer mills. One consisted of two to four sturdy, vertical posts, supported by stanchions, which were tipped with iron and alternately raised and dropped into a tub with an iron bottom. The two mule-driven "pounders" indicated on the diagram of Colin Yoder's shop (fig. 5-1) appear to have operated in this manner. Again, the children would sit nearby and deftly flick the larger cinders or glass fragments under the mauls with a stick. The machine was powered by mule or gasoline engine, and, later, a tractor, and it bears some resemblance to the flint stampers once used in Staffordshire: "wooden beams, shod with iron on the lower end, and moved vertically in a frame, so as to fall with great force down on the flint laid on a strong grate."[47]

Much simpler and more efficient, however, was the water-powered trip-hammer mill—or "glassbeater," as it is locally known—which is illustrated in figure 6-15. These were employed only in the Catawba Valley, and it is said that early in this century one could hear these metronomes marking time all over the district. They were constructed in a creek branch near the

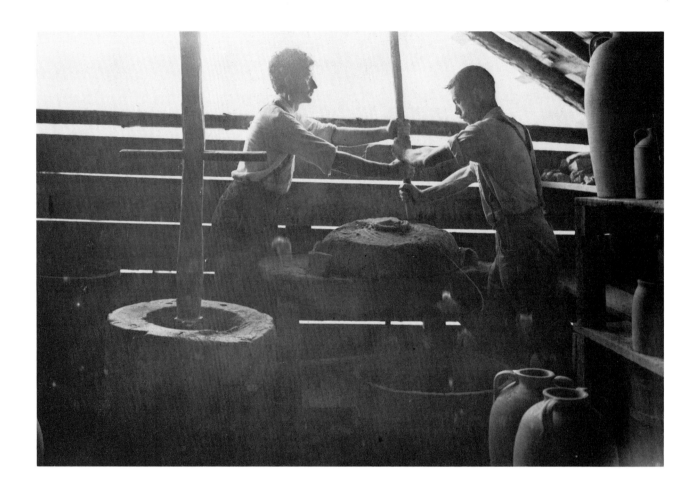

Figure 6-14
Two South Carolina potters grinding a glaze in a stone mill. To the left is a maul suspended from a spring-pole that was used to crush the glass. Photograph by Margaret W. Morley, courtesy of the North Carolina Museum of History, Raleigh, N.C.

potter's shop—but not so near that he had to listen to the thump of the iron spike striking the glazebox every thirty seconds or so. To build one, the potter began by damming the branch above the beater, so that the water flowed down a wooden spillway into the waterbox. When full, the box dropped to the creekbed, raising the iron spike at the opposite end. The box emptied on impact, and the spike crashed into the glazebox, pulverizing the iron cinders or glass fragments. The main shaft was a 4″ by 4″ beam that pivoted on a metal bolt between the two uprights, which were seated in concrete.

Burl Craig rebuilds his beater quite frequently, so the dimensions vary, but the spiked end is normally about two-thirds larger than the shorter end; the unit shown in figure 6-15 is 10′ 5″ long (47″ plus 78″). Proper balance is important: the water has to splash vigorously out of the box, and the spike must also rise high enough to strike hard against the glaze particles. Burl

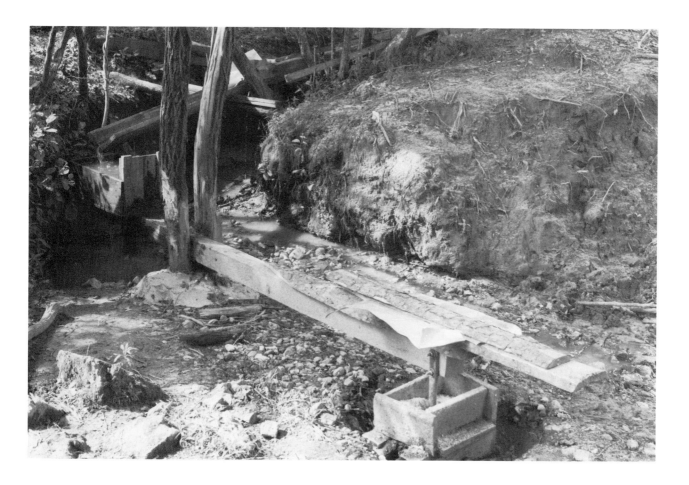

*Figure 6-15
Burlon Craig's water-powered trip-
hammer mill.*

can readily adjust the motion by drilling a new hole at the pivot or adding pine slabs at the long end (as shown). The glazebox measures 14″ by 8″ and has a section of a railroad rail running lengthwise down the middle; the wood on either side of the rail is inclined so that the glaze material continually works into the center. The iron spike shown is 12″ in length and 1¼″ in diameter.

When he is preparing to glaze, Burl runs the glassbeater continuously and checks it every evening. He removes the powdered glass and replaces it with fresh bottles that he first breaks into small pieces with an iron bar. Then he takes the pulverized glass or cinders back to his shop and sifts them through a screen purchased at a hardware store, one that is slightly finer than ordinary window screen. Burl considers his glassbeater easier to build and maintain than any of the alternatives—the only uncertainty involved is the water supply. When there is too little, the mill may run slowly or not at

all. And when there is heavy rain, the glass gets too wet and packs down in the glazebox. Burl experimented with a tin covering (shown in fig. 6-15), but this proved ineffective and has been abandoned. In extremely heavy storms, the branch may turn into a torrent and wash out the entire unit. But the glass can always be dried out in the sun on a canvas; and the dam, spillway, and beater can quickly be rebuilt.[48]

Having sifted his ashes and powdered his cinders or glass, the potter was ready to mix and grind his glaze solution. For this operation, there were no intricate calculations or scientific formulas. As Enoch Reinhardt cautions: "Well, like I told you, didn't have no written down formulas. When you were doing it, it just automatically—you just automatically *knew* how much to do it. We called things different from what you fellows would call it." What little measuring was necessary was done with a handy five-gallon jar or gallon milk crock. Enoch goes on to explain that the ingredients were blended with slip, made from "broken ware and dried ware that you'd probably pull a handle off of or knock a chunk out of. We'd break that up and put it in a five gallon jar, pour water over it. And that would soak, and it would get just as fine. And you could take that and strain it, put it through a towsack, strain all the gravel and everything out. . . . And then you'd take a gallon of that, and a gallon of cinder, and a gallon crock—we used a gallon [milk] crock—a gallon of ashes that was sifted out of the kiln firebox."[49]

This recycling of broken greenware was a standard practice; the resulting slip added silica and alumina and made the glaze more viscous. Perhaps most important, it ensured a proper fit between the glaze and the clay body. As Nigel Wood explains: "Not only do clay and ash, and clay and lime glazes make good chemical sense, they also solve the practical problem of applying the glaze to the raw pot and making it stay there as the pot shrinks, expands, and then shrinks again during the processes of drying and firing— the clay in the glaze 'keeps step' with the clay of the pot."[50]

Burl Craig uses a similar mix. If all the ware in the kiln is to be coated with the glass glaze, he requires:

> 5 gallons powdered glass
> 5 gallons oak ashes or 7½ gallons pine ashes
> 2 gallons slip
> water

Just enough water is added so that the solution will go through the glaze mill. If it is too thick, the mill is impossible to turn, but if too thin, the mill will not grind it properly. Later Burl will add more water in the glaze tub before he begins dipping the wares. And should the glaze become too thin, the potter can dip twice, though that is not the ideal. Burl always has some extra ground glaze to add if it is necessary, and on occasion he will also strain extra ash directly into the glaze tub.

Understandably, many of the potters worked to get all the mileage they

could out of their supply of powdered glass, and some, like Jim Lynn, were known for their miserly proportions. "Jim made his glaze awfully thin. He didn't have any way to beat his glass. He'd get them boys when he could to beat his glass. And he put it just as thin to try to save all the glass he could, you know. And Enoch [Reinhardt]—I know we went along out there one day, and Jim was out in the yard a-glazing. And Enoch said, 'I see you're a-giving some of it a cold water rinse!' "[51]

One other ingredient that was commonly added to the alkaline glaze produced in Buncombe County was crushed iron rock—limonite or hematite—which was gathered out of the fields. Talman Cole recalls how "the iron ore would more or less separate itself as it broke, and you'd throw the other pieces out. Then you'd just take a hammer and beat it all to pieces, into dust. And then, of course, we ground it in them old corn, them old wheat mill rocks. After you got it down as fine as you could get it, mixed it with that glass."[52] Relatively little iron was required for a batch. "For a whole kiln, I imagine a half a gallon of that was plenty, and maybe a quart. Because you know iron's pretty black when you get it melted."[53] Due to such heavy infusions of iron, many of the wares made by Talman Cole and George Donkel have an easily recognizable black, matte surface (fig. 6-16).

Other potters in this area, notably the Stones and the Penlands, also employed iron and produced an equally distinctive glaze, one which is typically orange to brown with black mottling (plate 8). Possibly they used larger granules of iron or did not grind the glaze as thoroughly as did Donkel, thus producing a more variegated pattern. In color and texture, these Mountain alkaline glazes are readily distinguishable from those of Lincoln and Catawba counties. During the 1930s, a few of the Catawba Valley potters added the same iron rock to their glass glazes. However, their purpose was different: it was done to make the glass glaze brown and "speckly" so it would resemble the preferred cinder glaze.[54]

To grind their glaze solutions, most of the potters employed a hand-powered stone mill; Burl Craig still operates the one he inherited from Harvey Reinhardt, who in turn acquired it from his father, Pinkney (fig. 6-17). Turning these mills was no easy task, as Olen Hartsoe explains:

> It was an old mill, a corn mill, . . . and it was set up for hand turning too. Had a stick up in the top up here in a four by four, and run down here in a hole in that rock out at the edge of it. And you'd stand there and turn it, great big old rock, and you'd reach out like that. It was pretty hard to turn—you had to have them close enough to grind that glass. . . . There was a hole in the middle of the [upper] rock. And you pour in a canful, keep turning that rock. And there was one place . . . it would run out in a spout there and run down into one of the big jars to catch it. And you'd just stand there and turn it and run it through, generally run it through about twice to grind it good. And then when you got it ground up good, why, you was ready to glaze with it.[55]

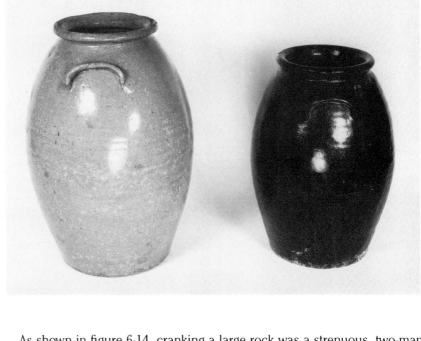

Figure 6-16
Alkaline-glazed stoneware jars, first quarter of the twentieth century, George Donkel, near Weaverville, Buncombe County. Left: H 14⅛", C 31¾", 3 gal. Stamp: impressed key. Right: H 12", C 27⅝", 2 gal. Stamp: impressed key. Both are coated with a glass glaze, but the addition of crushed iron rock has blackened the jar on the right.

Figure 6-17
Burlon Craig's hand-driven stone glaze mill.

As shown in figure 6-14, cranking a large rock was a strenuous, two-man operation. Burl recalls that "one would help a little and do the pouring, the other done the heavy work. Always kidded Jim Lynn about that was the reason he wanted me to help him, was on account of grinding that damn glazing."[56] For the younger members of the families, who no doubt wished they were elsewhere, this was no time to be daydreaming. Jeter Hilton remembers the day he was turning the mill while his father Rufus poured in the glaze. Jeter relaxed for a moment and leaned back against the board and batten wall of the shop. As he did so, the handle swung around again, his elbow jammed against a batten, and the momentum of the rock snapped his wrist.[57]

The glaze mill, as Olen Hartsoe suggests, was a diminutive version of the many gristmills that once dotted the countryside. The two rocks were centered on a heavy iron shaft that ran up through the bottom one and fit into the underside of the top one. Thus, only the top rock turned; the shaft and the bottom rock remained stationary, with the bottom of the shaft seated in a plank on the ground. While grinding a glaze, Burl can readily adjust his mill simply by raising or lowering the plank. "You pour in a cupful, and as it runs out, come out as you turn it, you take your right hand and catch some between your fingers and rub it like that. And you can tell whether it's fine or what kind of shape it's coming through. If it's too coarse, why, you let your rock down a little." Most of the potters continued using the hand rock for

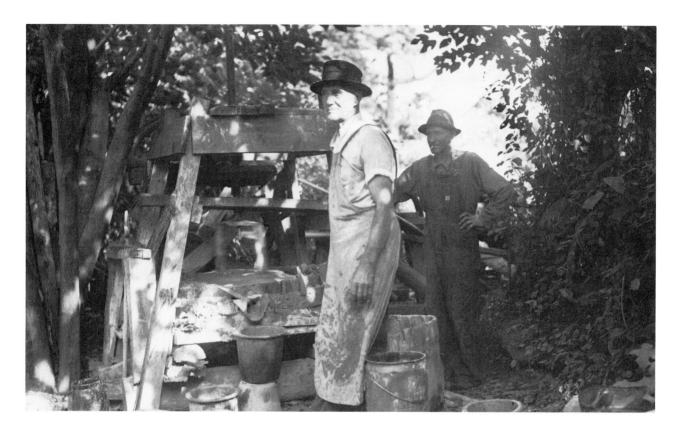

grinding their glazes, but during the 1930s a few began exploring new power sources. Enoch and Harvey Reinhardt used a wrecked Oldsmobile to drive both their glassbeater and glaze mill, while Uncle Seth Ritchie hooked his rock to a small gasoline engine.[58] From the beatific expression on Uncle Seth's face in figure 6-18, it would appear that such innovations almost converted glaze grinding into a form of recreation.

From the mill, the glaze was carried to the nearby glazing tub in milk crocks or jars. Today Burl uses a thirty-gallon drum cut in half lengthwise, but earlier potters worked with wooden containers. George Donkel had a barrel 3′ to 4′ in diameter and 3′ deep, large enough for big "home brew jars" that ran five gallons and larger.[59] Uncle Seth Ritchie used a wooden box with handles on either side that made it easy to carry (fig. 6-19). He would water the box to swell the boards before pouring in the glaze. Burl points out that metal containers were hard to come by forty to fifty years ago. He himself used to have two wooden boxes, one for cinder and one for glass glazes. After the glazing, these were left in the corner of the shop until their next use. The old glaze would dry out, but when it was needed, he would

Figure 6-18
Seth Ritchie and Aubrey Conrad posing beside their gasoline-engine-powered glaze mill, Blackburn, Catawba County, ca. 1939. Courtesy of Mr. and Mrs. Raymond A. Stahl.

Figure 6-19
Seth Ritchie dipping a churn in his
glaze box, ca. 1939. Courtesy of Mr.
and Mrs. Raymond A. Stahl.

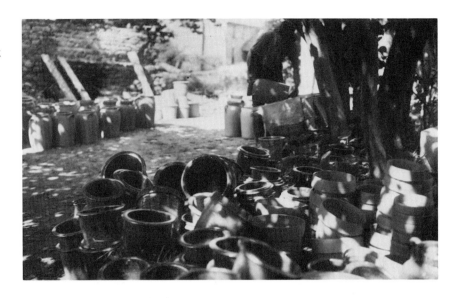

just add water, soak it for a few days, and later grind it with the newly prepared batch. One disadvantage of the drums Burl now uses is that lye persistently eats away at the metal.

When the glaze tub is filled, Burl first adds water to thin the solution. The test for proper density is a simple one. "I can feel of it with my hand. Now the [Albany] slip glaze, I thin it down to where I can pick it up like that, and it'll run off of my hand right fast. I can tell how it runs off my hand. That's the way I judge it. But the glass glaze, . . . you can't go by that."[60] With the latter, Burl uses a more viscous solution that runs off his fingers in thick driblets. Again the proper consistency is attained entirely through empirical means; there are no written formulas or exacting measurements. Burl praises his former employer, Uncle Seth Ritchie, because "he could make glazing kilnful after kilnful, and you couldn't tell one from the other. It just, you know, each kilnful looked alike. And I've never been able to do that. Some of mine'll be a little thicker, a little thinner or something."[61] When he uses a new mixture, Burl sometimes dips a test piece, allows it to dry, and then scratches through the glaze to compare it to the previous batch. If the thickness of the dried glazes on the two pieces varies significantly, he can thicken or thin his solution before dipping the rest of the wares.

Potters also took care to ensure that the glaze was well stirred at all times so that sufficient glass or cinder particles were held in suspension. Burl used to use a hoe for this purpose but now has an electric drill with a curved rod attached to it as an agitator. George Donkel employed "a paddle, about the size of a baseball bat handle, and about two inches square, . . . good and stout. And we'd glaze a while, then we'd stir it a while. We didn't

let it settle down. . . . And just every time you dipped a few, well, that is part of the job—keeping that stirred. You'd just stir all the time—dip and stir, dip and stir."[62] One other caveat was not to glaze in excessively damp or rainy weather. Greenware absorbs moisture, and Burl has had it collapse in the glaze tub. When this happens, he quickly picks out the pieces of clay; on occasion he has had to strain the entire batch. The photograph of Uncle Seth (fig. 6-18) suggests the ideal conditions: a dry, sunny day with a mild breeze blowing.

The techniques for dipping the ware in the glaze differ little from those employed by any potter, except that Burl must exercise special precaution, because his pots are not bisque fired, and many are very large. In handling a five-gallon jug, for example, he takes care to hold the piece as nearly vertical as possible, with the weight on the bottom edge, the strongest part of the pot. First, he balances the jug on the corner of the tub, while he stirs up the glaze with his left hand. Then he puts the jug on its side in the glaze and holds it steady while glaze gurgles into the spout. After about five seconds, he rotates the jug, also raising the neck slightly to coat the bottom interior (fig. 6-20). On completing the rotation, he may splash glaze with his right hand onto the neck, handles, or shoulder to cover any bare spots. He next picks up the jug vertically and shakes it about three times to spread the glaze evenly around the inner walls. Then he tilts it upside down and pours out the excess glaze, taking care to keep the jug nearly vertical and hold it by the bottom and the inside of the neck (fig. 6-21). Frequently, he will dip the neck and shoulder very quickly at the end, then invert the jug and set it on a bat. He flicks or taps the extra glaze on his right hand onto the rim to cover any thin patches made during the handling.

The final task is to clean the bottom of each piece after the glaze has dried. Burl used to use a dry rag but now brushes off the thick, gray, woolly glaze. The large pieces he gently cradles under his left arm, somehow managing not to crush the fragile walls or scrape off the soft glaze. With the numerous smaller wares and miniatures that he produces today, Burl will spend several days at glazing. But this was not always so. In the old days the task was far shorter—there were fewer pieces to put in the kiln, and a large pot takes no more time to glaze than a small one. Burl and Jim Lynn used to set the glaze tub in the yard—under a shade tree if it was hot—and glaze all the ware in a few hours. When the last piece had been dipped, they would start wiping the bottoms. And when this was finished, they set the ware in the kiln and burned it the next morning.

Virtually all of the folk pottery produced in North Carolina was coated with the standard lead, salt, and alkaline glazes. Although there were a number of other options open to the traditional potter, he rarely took advantage of them. One alternative was Albany slip, a natural clay glaze mined near Albany, New York, which was widely used in the Northeast, from the early nineteenth century on, to line the interiors of salt-glazed wares. Be-

Figure 6-20
Burlon Craig rolling a large jug in
his glaze tub.

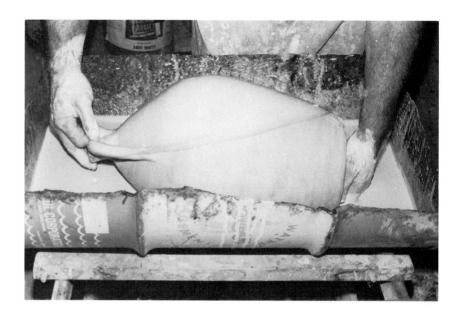

cause these pots were stacked in huge bottle kilns, the sodium vapors could not reach the inner surfaces, and so an additional glaze was required. Albany slip also served as an external glaze in the Midwest and parts of the South, and in some cases equivalent local clays were mined and sold, most notably Michigan slip and Texas slip.

The Albany slip was purchased in powdered form and shipped by rail in large barrels. It contained "roughly 38% clay substance, 13% feldspar, 28% flint, 15% magnesia, calcia, and potash, and about 6% iron."[63] In short, it was a complete glaze in itself, had a wide melting range, and required little work to prepare for application—the potter simply mixed it with water. It regularly burned to a smooth chocolate brown or black, but in a reduced kiln atmosphere it might also take on a reddish cast (plate 10).

As late as 1897, geologist Heinrich Ries lamented that "none of the North Carolina potters use Albany slip for glazing their ware. If they did the product would be far more sightly than it is now."[64] One may argue with Ries's aesthetic taste; the native stoneware glazes possess a natural, variegated beauty that many prefer to the predictable brown coating produced by the Albany slip. But he is entirely correct that the local potters stubbornly refused to accept this northern substitute. In neighboring Georgia, on the other hand, Javan Brown and most others "stopped making ash glazes and went to making Albany slip stuff. I have bought many a barrel for $1.50."[65] While fully aware that the Albany slip was easy to use, the North Carolina potters considered it inferior. Typical is Talman Cole's observation that "we just didn't care anything about it because we used glass."[66]

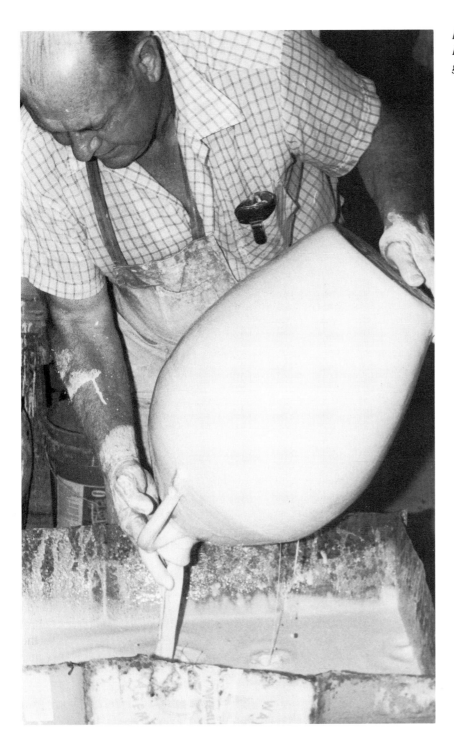

Figure 6-21
Burlon Craig draining the freshly
glazed jug.

Almost certainly Albany slip was not introduced until after the Civil War, and in most areas, not until the end of the nineteenth century. Members of the Craven family tell that William N. Craven, who moved to Missouri in the late 1850s, wrote back to his brother Dorris about 1865 and told him of this new glaze called Albany slip. The letter in question has never been found, but this story is validated by the survival of several fruit jars made by Dorris that are covered with what is locally termed "frogskin" (plate 5). This glaze is found in the eastern Piedmont and also in parts of Georgia; it is formed by coating the pot with Albany slip and then salt glazing it. The salt turns the normally brown slip rich green to mustard yellow—hence the name, which was probably coined in the 1920s by Jacques Busbee of the Jugtown Pottery. Possibly Dorris discovered this "new" glaze accidentally while following his brother's advice to try the Albany slip. Whatever the specific origins, he was almost certainly the first to use it. Albany slip is also prominent on the wares of E. A. Poe and Company of Fayetteville, which operated during the 1880s and 1890s. One of the turners there was Henry Hancock, who had worked for Craven in Moore County during the 1870s.

The glaze was equally uncommon in the Catawba Valley, where it most likely appeared about the turn of this century. One of the earliest to use it was Sylvanus Hartsoe, who employed the Albany slip alone and in combination with his glass glaze. In plate 11, the small, cylindrical jug on the left shows the smooth, even brown of the plain slip glaze, whereas the form to the right exhibits a rougher surface with large patches of black and reddish-brown, typical of a combination glaze. In addition, clearly visible in the middle of the belly is a fringe of blue and white produced by the glass in the glaze and some rutile in the clay body.

Why Sylvanus bothered to add the Albany slip to his native alkaline glaze is unclear. It is entirely possible that the mixture first occurred as an accident—the two may have blended as Sylvanus was changing over his glaze tub from one type to the other. Although this hybrid glaze was more costly because he had to pay for the slip, Sylvanus may have admired the variegated surface it produced. Whatever the motive, at least one other potter in the area, Royal M. Stallings, also deliberately combined the two glazes.[67] Most, however, persevered with cinder or glass; although they took considerable work to prepare, the old glazes cost nothing and were preferred by the customers.

In the Mountain region, Albany slip was likely used first by the Stone and Penland families near Candler. Again, the glaze appeared about the turn of this century, and by the time the Browns arrived at Arden in 1923, it had totally displaced the old alkaline glaze in the area.

The last glaze adopted by the folk potters was the Bristol glaze, which was initially developed in England during the first half of the nineteenth century as a substitute for the toxic lead glaze. Rufus Outen—whose family opened

the Matthews Pottery in Matthews, Mecklenburg County, in 1922—used a mixture of feldspar, whiting, ball clay, and zinc and tin oxides to produce the Bristol glaze shown on the churns in figure 6-22.[68] The zinc oxide is the principal flux, though the whiting (calcium carbonate) and feldspar also serve that function. The feldspar and ball clay supply the silica and alumina, and the two oxides serve as opacifiers to provide the whiteness. In actuality most of the wares were off-white to dirty gray, and the glaze tended to be rough and even pitted because it was extremely viscous.

During the late 1920s the Kennedys employed the Bristol glaze at their shop in Wilkesboro because "a lot of that Ohio pottery was white, you see. And they began to ship a lot out of Ohio in down through here. And you know, you kind of had to compete with that."[69] At the Brown Pottery in Arden, the family turned a "combination churn—white bottom and brown top, just like they shipped out of Ohio." But this is not to suggest that the local potters admired these commercial imitations. As Javan Brown observes in his usual tart manner: "That was what the public was calling for. That's what we made, what the public wanted. I didn't need none myself!"[70]

As a rule, the North Carolina folk potters were extremely conservative in their choice of glazes. Outside of the early Moravian community, where innovation was commonplace, a very limited range of glazes prevailed: the lead glaze for earthenwares; and the salt, alkaline, Albany slip, frogskin, and Bristol glazes for stoneware. And this list is deceptive, as the lead, salt, and alkaline glazes constituted virtually the entire tradition. Only small quantities of Albany slip were purchased, in most areas not until the end of the nineteenth century, and the Bristol glaze represents a last and feeble attempt to compete with the commercial whitewares coming out of Ohio and Texas. It is noteworthy that these minor glazes occurred mostly in outlying regions where only a few potteries existed. The Bristol glaze, for example, was used at the Kennedy Pottery in Wilkes County; the Matthews Pottery in Mecklenburg; the Broome Pottery in southern Union; and the Brown Pottery in Buncombe. The first three were located in that ceramic no man's land between the salt and the alkaline glaze centers, and the fourth was transplanted directly from Georgia. In the eastern Piedmont and the Catawba Valley, the Bristol glaze never appeared, and the Albany slip only infrequently.

That the old glazes were deemed entirely proper and efficacious for some two centuries by the potter and his clientele is a powerful testimony to the endurance of the folk tradition. As Burl Craig muses: "The potters in this county, you couldn't get them to try something new. It's what they learnt from the old-timers, and that's the way it was. . . . Well, they was sure of it; something they wasn't sure of, they just didn't want to try it. Like new glazes. . . . The cinders run out down there, oh, such crying and bellyaching you never heard!"[71] Change, assuredly, was gradual, but this distinctly limited stock of glazes should not lead to charges of sameness or monotony.

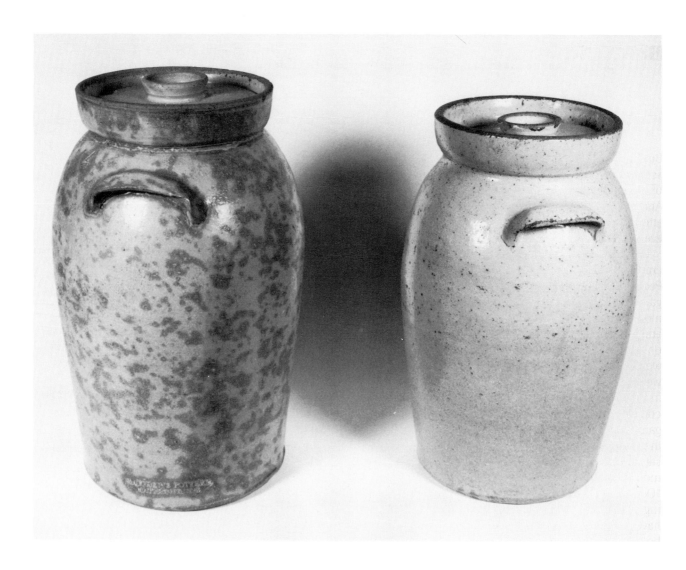

Figure 6-22
Bristol-glazed stoneware churns,
second quarter of the twentieth cen-
tury, Matthews Pottery, Matthews,
Mecklenburg County. Left: H 15⅞",
C 32¼", 4 gal. Stamp: "MATTHEWS
POTTERY. / MATTHEWS. N. C." Right:
H 14¹³/₁₆", C 30¼", 3 gal. Signed in
script on the bottom: "Matthews /
Pottery / Matthews / NC."

Folk culture is conservative but also inherently variable; each repeated act or object, though shaped by well-understood traditional guidelines, must also be unique, for these guidelines are never written down but are transmitted informally by word of mouth and example. Inevitably, each batch of glaze is a variant, containing its own particular mix of locally derived ingredients. The old-timers stubbornly adhered to glazes they were sure of, but they did so wisely, conserving their limited resources, yet producing a rich and often beautiful array of colors and textures on the surfaces of their sturdy pots.

7

BURNING

Burning the kiln is surely the most dramatic phase of the potters art. Few scenes are more stirring than the roiling black smoke and the massive sheet of orange flame erupting from the chimney of a fully heated groundhog kiln. And the sight of the potters, dripping with sweat as they stoke the firebox, attests to the human strength and endurance that lies behind this special event.

Even the local community, though thoroughly familiar with the potter's craft, regarded this task as out of the ordinary and even festive in nature. People of all ages would gather to view the spectacle and to swap tales, play games, or roast ears of corn and sweet potatoes over the hot chimney mouth. For the youngsters, this was a good opportunity "just to get together" and perhaps court a little. When George Donkel was heating up his kiln out on Reem's Creek near Weaverville, Mrs. R. L. Robinson and her friends would pass the word and then assemble at this pottery after supper. "We were out there playing games and run up every once in a while and looked in when he opened the door. . . . Most of the young people around would come in, just around in the immediate community. Oh, we'd just play little games or sing songs or play Tap Hand. . . . I think sometimes the boys if they caught the girls got to kiss them, I don't know. And sometimes we just sat around and told jokes or riddles."[1] For older participants like the young men in the community, the activities tended to be a bit more strenuous. "Out here when the Propsts burnt," recalls Burl Craig, "that was the gathering place. Well, we'd have different things. Some of them, maybe, would have a little jug of whiskey, and they'd take a few drinks. And we'd have boxing matches—we had a set of boxing gloves back then. We'd have some—after the blaze got out where they could see, why we'd have a few boxing matches, team up a couple guys together."[2]

The observers saw the burn as a pleasant social occasion, but for the potters it represented a long stretch of hard work. Like the treadle wheel, the kiln was also a precision instrument, one that the potter learned to operate through long hours of onerous, on-the-job training under one of the "masters" in the neighborhood. To the uninitiated, stoking a kiln for ten hours just looks like simple, hard work. But to build, load, and burn a kiln requires a hidden array of knowledge and skills, ranging from brick-making and masonry to an understanding of fuels and high-temperature combustion principles. Proper control of the kiln is absolutely critical. An enormous

amount of labor precedes this intense, climactic effort, from digging and preparing the clay to turning and glazing the wares. Simple errors in judgment or lack of attention, even unexpected occurrences such as a heavy rainstorm, can abruptly destroy the product of several weeks' work. While stories of kiln disasters—of warped or exploded forms and collapsed arches and burnt-out woodsheds—are occasionally told, most often the folk potter was highly successful in "slicking" his glazes and maturing his pots. For him, too, the burn was a time of excitement and anticipation, most particularly a day or so after the actual firing, when he entered the still-smoldering furnace and retrieved the fruits of his harvest.

"The ceramic kiln," writes Daniel Rhodes, "was one of man's earliest tools, the primitive form of which dates back to at least 8000 B.C., and perhaps much earlier. The earliest kilns, however, were little more than modified bonfires."[3] Over the centuries these ovens or furnaces have appeared in almost endless permutations of size, shape, fuel source, and method of operation. However, potters and ceramic historians generally divide kilns into three broad categories, based on the direction of the flow of the hot air through the body of the kiln. These are, in probable order of their development, the updraft, crossdraft, and downdraft kilns, respectively. In addition, it is convenient to analyze kilns in terms of their essential components: "a fireplace or mouth in which fuel can be burned and heat generated; a chamber in which the ware is placed and which will retain heat; and a flue or exit from which the hot gases can escape, thus creating a draft."[4]

In North Carolina, the folk potter employed only the first two types, an updraft "beehive" kiln for the early earthenware and a crossdraft groundhog kiln for stoneware (and also the later redwares). Very little is known about the operation of the former type. Not even the normally assiduous Moravians were thoughtful enough to detail a firing of Aust's or Christ's kilns for posterity, and none of their kilns has been excavated. However, the previously discussed archeological investigations of the late-eighteenth-century site at Mount Shepherd have provided valuable insights into the form and construction of one early updraft kiln.

Describing the excavation illustrated in figure 7-1, archeologist Alain C. Outlaw explains that:

> The unmortared, brick-lined flue system radiated in five directions from the center. Channels averaged 9½″ wide and the flues were at least four bricks or 1′ in height. The channels opening to the northeast and southwest went all the way through the kiln without obstruction. The remaining channels ended at the wall of the latter channel which probably acted as a baffle to distribute the initial blast more evenly. . . . The intermediate areas between the channels were filled with stones which acted as pedestals to support a perforated pot chamber floor. Ranging from 1′5″ to 2′10″ in thickness, the walls were constructed of slate mortared together with waster-tempered clay.

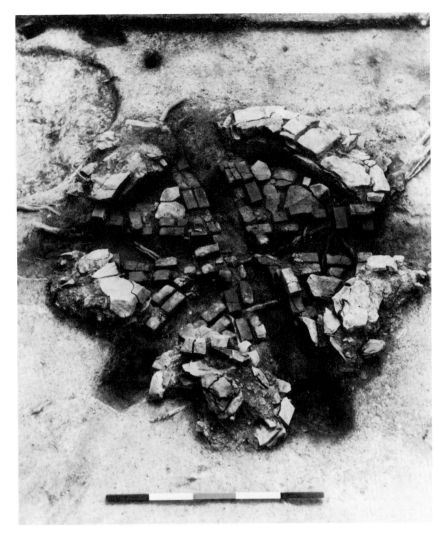

Figure 7-1
The excavated base of a beehive kiln at the Mt. Shepherd site, Randolph County, last quarter of the eighteenth century. Courtesy of Walter and Dorothy Auman.

On average the outer walls of the kiln measured 10′ in diameter and the setting floor approximately 6′. Outlaw adds that "the walls were somewhat angled towards the center of the kiln, indicating that they culminated in a dome rather than being open-topped." Moreover, he speculates that "an opening in the side of the dome was probably temporarily blocked up for each firing."[5]

Such beehive kilns were common among American earthenware potters and were used into the twentieth century.[6] Although relatively small in size, the dome could be filled with pots stacked up on top of each other, normally to a height of eight to ten feet. The potter built his fires directly under

the setting floor, so that the heat rose straight up through the wares and out through one or more flues in the top of the dome. Apparently, the Mount Shepherd kiln worked very efficiently, as "very few underfired vessels were found."[7] However, such kilns were not sturdy enough for high-temperature firing and so were displaced during the second quarter of the nineteenth century by the groundhog kiln, a distinctive form found only in the South. Because it remains in use today, it must necessarily form the basis for a study of traditional firing techniques.

The groundhog is of the crossdraft family of kilns, "which have a flame movement from the inlet flues across one side of the kiln chamber to exit flues along the opposite side."[8] Most scholars concur that this type evolved in China some two thousand years ago and that its development opened the way to high-fired stoneware and porcelain. The precise origins of the southern groundhog kiln remain unclear, but its characteristic form is a long, low rectangle, with a deep firebox spanning one end and a wide chimney at the other.[9] Frequently, but not always, it is buried in the ground or against a hillside, hence its colorful name. It takes little imagination to envision a groundhog poking his nose out of the firehole of J. B. Cole's deep-set, ramshackle kiln (fig. 7-2).

Although often dilapidated in appearance (on examining this photograph, Ben Owen shook his head and muttered, "Looks like that kiln is done for, didn't it?")[10] these homemade kilns served potters across the state for both salt- and alkaline-glazed stoneware. Because the glazes differ in their application, however, two distinct regional subtypes have emerged. To the untrained eye, a kiln from the eastern Piedmont will appear identical to one from the Catawba Valley, but they are not in fact alike. Over a span of at least 150 years, the two have gone their separate ways and embody many different regional features and practices.

The only traditional, wood-fired groundhog kiln that remains in continuous use to the present time is that of Burlon Craig in Lincoln County (plate 13). There are several salt kilns in the eastern Piedmont, but these are of comparatively recent vintage. However, with the enormous increases in the prices of oil and gas, the old groundhog may well be ready for a comeback in North Carolina. Burl's kiln was constructed in the late 1930s by Enoch and Harvey Reinhardt; a virtually identical kiln still stands just half a mile to the south, on property once owned by Enoch. In 1945 Burl returned from naval service and purchased the shop, home, and kiln from Harvey for $3,500. Except for taking one job in Long Beach, California, in 1959 and 1960, he has made pottery continuously since then. "I made some all along, I've turned, outside a year or a little over I was in California—I didn't make any out there. But I'd make some—some years there I didn't make an awful lot, but I still made it. I'd say I was going to quit, and I'd work at something else a while, and then my old hands would get itching, and I'd be back in the clay yet."[11]

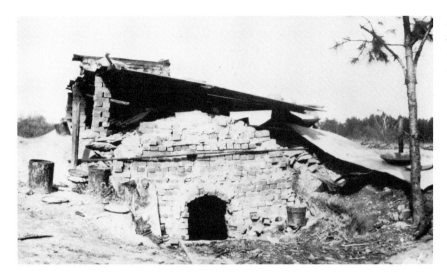

Figure 7-2
Jacon B. Cole's groundhog kiln,
Montgomery County, ca. 1925. Cour-
tesy of Walter and Dorothy Auman.

Since the war, Burl has also worked at other occupations, notably a nine-teen-year stint at the North Hickory Furniture Company. Normally he has burned about half a dozen kilns per year. With more than half a century of experience and his continued adherence to traditional tools and tech-niques, he offers a living text on the fine art of burning a groundhog kiln. The following portrait is a composite of a series of firings made over the last nine years, amplified by additional comments by others familiar with the alkaline-glazed stoneware.

As diagrammed in figure 7-3, Burl's kiln measures 24′11″ by 11′6″ overall, with an interior setting floor or ware chamber that is 20′ by 10′, large enough to contain 450 to 500 gallons of unstacked, utilitarian wares. At the lower end is the firebox, approximately 3′ deep and 10′ by 3′ in area. The dimensions given here vary somewhat over time due to constant deteriora-tion and rebuilding. Three fireholes are used to stoke the kiln, and under each is a sizable drafthole that sucks in fresh air beneath the burning wood to achieve maximum combustion. At the upper end is the chimney, which is built right over the end of the arch and supported by two massive pillars (fig. 7-4). Thus, the draft runs unobstructed through the kiln; there is no bag wall (flash wall or baffle) at the lower end of the setting floor nor any flues under the chimney. In effect, this type of kiln is simply one long chimney, and with the low arch inside—only 30″ high at the center—it creates a very powerful draft when heated.

Just as he needs to prepare his clay for turning, the potter must cut, dry, and stack his wood long before using the kiln. In earlier times, the potter had to cut and split his own wood or else hire someone else to do it for him. Olen Hartsoe recalls how "we gathered it up around in the woods—dead

Figure 7-3
Burlon Craig's groundhog kiln.

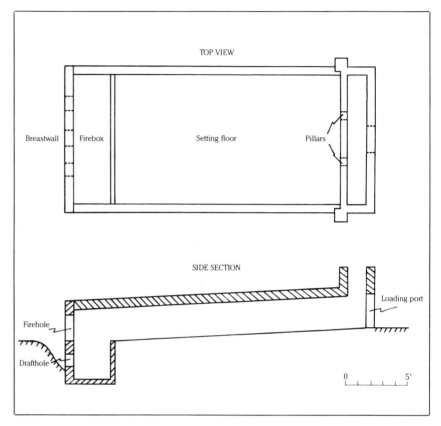

TOP VIEW

Breastwall Firebox Setting floor Pillars

SIDE SECTION

Firehole

Drafthole

Loading port

0 5'

Figure 7-4
One of two brick pillars that support the rear of the arch of Burlon Craig's kiln.

pines and such as that and old pine knots. . . . You had to burn dry wood; you couldn't burn it wet, green wood. . . . It'd steam too much."[12] Talman Cole even adds that "you had to make them cut it on the new of the moon. . . . It wouldn't dry out well enough on the old of the moon. You had to have a flashy fire; you depended on blaze, you see."[13] Talman here refers to a series of folk beliefs that assert that wood is best cut in the new of the moon or the light of the moon; for example: "Cut your pine wood in the new of the moon, if you want it to be light."[14] Dry wood was absolutely essential to prevent steaming, which might damage the wares and also keep the kiln temperature from rising fast enough.

Over the last half century or so, the potters increasingly used slabs from sawmills. Burl maintains a woodyard some three hundred yards south of the kiln, where trucks from the sawmill dump his slabs. He estimates that the 2½ cords required for a single firing cost him about fifteen dollars, a most economical figure. Of course, he has to saw the slabs into 4' lengths and then stack the proper amount in the 20' by 17' woodshed at the firebox end

of the kiln. Pine was always used in the Catawba Valley because it projects the heat and creates the long flame needed for such a large kiln. The key principle here is that softwoods release their heat much more rapidly. "The hard woods, for example, give short flames, intense local heat and good coals while the soft woods explode quickly giving an extremely long flame. This moves the heat quickly into the chamber."[15] Burl also stacks the wood under the shed with forethought: he places the thicker slabs in the middle of the pile so they can be fed directly into the center firehole, where more wood is required because of the height of the arch.

When his wood was ready and his wares glazed, the potter then waited for the weather to cooperate. If heavy rains had fallen recently, he had to allow the kiln to dry out. This could take time, because it was well insulated and had an earthen floor. Sometimes, however, to dry the kiln "they would fire it—build a fire in it, like the day before. And it would cool at night, and then they would set the next day. They would probably fire for an hour or something." This extra step required about half a cord of wood and relatively little time—the potter could raise the heat rapidly because the kiln was empty.[16] On other occasions, if the kiln was moist but did not require the preliminary heating, the potter would extend the total time of the burn, raising the temperature extra slowly during the early hours.

A far greater hazard was a heavy downpour just before or during the firing. Once the kiln was loaded, there was no turning back if it began to rain. Large quantities of greenware could not be unloaded and put back in the shop rapidly enough, yet leaving it in the wet kiln resulted in its disintegration. Burl often recalls the time he and his wife finished off the kiln in a particularly fierce thunderstorm. Irene stoked while he furiously bailed out the firebox using a tin can nailed to the end of one of the pine slabs. And the burn was a good one. Two drainage channels run along the sides of Burl's kiln, but these are easily neglected and not designed for floods. Normally the rain presents little problem once the heat is up; the only casualties will be cracked flowerpots exposed in the open chimney.

Setting the kiln was a laborious task, one that required unexpected stamina and strategy. The potter had to work in a kneeling or sitting position for several hours; he had to carefully move and place the delicate greenware; and he had to know where to locate each particular form and glaze so that it would reach proper maturity. The floor of the kiln was covered with a thick layer of sand or crushed flint rock—the latter, in fact, was often first heated in the kiln and then beaten into small particles. As a boy, Enoch Reinhardt was given the unenviable task of crawling through his father's kiln to chop the flints with an ax or a hammer.[17] And the kiln floor has to be cleaned or renewed before each burn. Particularly at the hotter end, near the firebox, Burl has to remove the patches of glaze that have run off the walls of the pots. "I stir that [sand] up every time good. Take and stir it up, and if there's any glass or anything that won't pulverize up, I throw it out, take it

Figure 7-5
Burlon Craig preparing to load his
kiln.

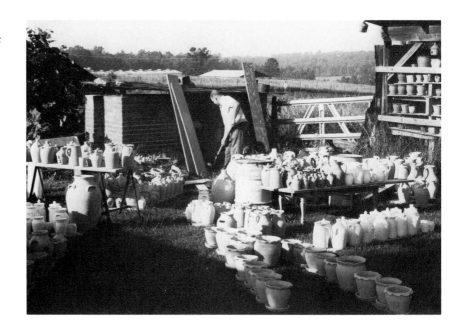

out. . . . I use a shovel and I use a trowel a lot of times, a regular mason trowel. You can shovel down and get that sand out of the bottom and put it on top. You see, that way you're using all your sand. Instead of changing it so much, you can stir that up and get new sand on top."[18] Every third or fourth burn, Burl will add several buckets of fresh sand, which he digs out of a sandbar in a nearby river. The floor ranges from 3″ to 6″ thick, being thickest at the lower end where the glazes are most likely to melt off.

When ready to start loading, Burl sets all of the greenware out in the yard and roughly sorts it out so he can call for certain shapes, sizes, and glazes (fig. 7-5). Then, not unlike a groundhog, he crawls through the loading door in the chimney into his burrow, pulling behind him several long boards that will serve as a kind of track. And here is where a large family or helpful neighbors are important. Burl begins setting the ware at the edge of the firebox, some twenty feet inside the kiln. He calls out what types he wants to those outside the kiln, and they load them on a board and slide them in on top of the boards already set in the kiln (fig. 7-6).

Another technique was to line the kiln with helpers, as the Broome family did. "With all of us kids at home, we'd start at the door and another'd pass it on to the other, and we'd just use the old bucket brigade . . . till we got it up to the front of the kiln." However, the children all married or drifted off until only James and his father remained. Because their kiln was a very long one, some 30′ in length, they had to devise a system so that the two of them could load it expeditiously. "We had a track, all of it was made out of one by

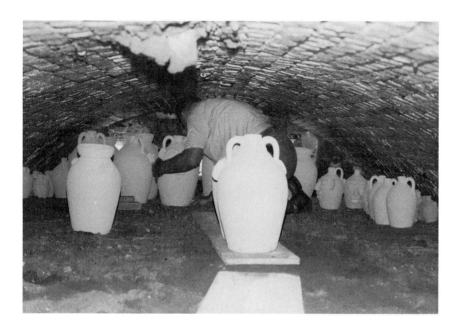

*Figure 7-6
Setting the kiln.*

fours. . . . And it reached from the door of the furnace all the way to the back. And then he had four wheels on it—had about a fourteen inch board and it had wheels on it. We'd set our churns on that, maybe six or eight, and we'd roll it—roll it through the door, roll it right up. Dad'd be there at the end of the furnace placing it, and I'd roll it up to him." The track was even built in two sections, so that when the kiln was half full, one could be disconnected and removed. The device is similar to the one used by George Donkel (fig. 6-3), though much smaller; it made setting the kiln "just like working a mine."[19]

The strategy for placing the wares in the kiln no doubt varied somewhat from potter to potter, but it mainly depended on the shapes and the glazes. Burl Craig advises: "You don't want to put your tall stuff right in the front of the kiln. That sort of cuts your draft off. . . . The way I do out here now, I try to have enough three gallon churns for the front row, then the higher stuff up in back. . . . I don't put face jugs or anything like that down there either, anything that's hard to make in the first row. They can get punched with the wood too easily down there. . . . I usually put three gallons in the middle, and then I put a two gallon on each side."[20]

Plate 12 shows the front row of churns at the lower end of the kiln across the top of the firebox. Because there is no bag wall here to protect the pottery, these pieces are occasionally "punched" if the stoker gets careless and throws his wood in horizontally, instead of angling it down into the firebox. The face jugs require much more time to make and are more valu-

Figure 7-7
Positioning the wares to conform to
the curve of the arch.

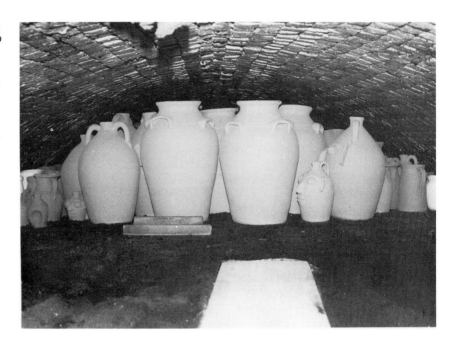

able; hence, they are set no closer than the second row. The wares then increase in size with the largest—in this case, ten-gallon jars—near the center of the kiln. Figure 7-7 illustrates the same grouping from the chimney end and demonstrates how Burl uses the configuration of the arch to full advantage. In the foreground is one of the loading boards and also Burl's tamper, a two-by-four with a handle that he uses to smooth and pack down the sand. Behind these large pieces come a succession of increasingly smaller ones, so that the draft evenly rises and falls as it traverses the kiln.

The second important consideration in loading was the type of glaze used. Because the heat source in the groundhog kiln is located at one end, the temperature falls off steadily from the firebox to the chimney. The general practice in the Catawba Valley, as outlined by Floyd Propst, was to set the cinder-glazed wares nearest to the firebox, because "that is harder than glass. We put the cinder in the lower part of our kiln, to about two-thirds of it. Then we put the glass glaze above that. Then above that . . . flowerpots."[21] If Albany slip was used, then the order was cinder-glass-Albany-unglazed. Clearly, there was an advantage to using several glazes with different melting points, and it may well be that potters like Sylvanus Hartsoe deliberately mixed Albany slip with the glass glaze in order to further extend the range of possibilities. Today Burl also coats many of his smaller pieces with what he calls a "soft glaze," which contains commercial frits, feldspar, flint, and kaolin and melts well in the "soft places" along the sides and the back of the

kiln. Unglazed flowerpots, birdhouses, urns, and strawberry planters are also set in these cooler areas as well as on the floor of the chimney.

To set each piece, Burl firmly packs the sand and then levels the pot in position. The pieces are positioned about a finger width apart, just enough so that if the glaze bubbles, it will not reach the adjacent pot. Small items like lids, pinch bottles, or pint face jugs fit neatly between their larger brethren. Because the alkaline glaze runs dramatically, the ware is not stacked, nor is it inverted, as the rims are completely glazed. However, a few potters did stack glazed pieces. Burl's erstwhile business partner, Vernon Leonard, "used to cap two milk crocks together. . . . Set one down like this and then turn one upside down on it. Put little—rub the rims, the glaze off the rim, and then he'd take little pieces of ware, about four, and lay [them] on that rim, see, so they could get air between them." Both for appearance and ease of cleaning, the potters' customers preferred glazed rims, and so Burl objected to his partner's practice. "I said, 'How do you sell them old milk crocks like that?' And he said, 'Oh, some of the women *like* 'em.' Said, 'They sharpen their knives on them!' "[22]

Normally, however, only the unglazed flowerpots were stacked, either on top of or inside each other, depending on the shape. The only kiln furniture Burl uses is a conical, pointed "setter" (or pip) that he infrequently uses for unusual forms such as ring jugs (fig. 7-8). Other potters occasionally resorted to simple spurs, stilts, or wads of clay, but these devices were generally unnecessary, because the kiln was so low and the alkaline glaze so unpredictably fluid.

Having fully loaded the kiln, Burl then bricks up the loading door in the end of the chimney, taking care to leave a header (a brick laid across the thickness of the wall so one end sticks out) near the top that he can pull out for inspections during the firing. Today, because he makes so many miniatures, tourist items, tablewares, and special orders, Burl requires three to four hours to set the kiln. Sometimes he rises at dawn on the day of the burn and finishes the task in the late morning; however, with another nine to ten hours of hard work to come, this constitutes an extremely exhausting day. More often now he sets the kiln, or most of it, on the previous evening. In the old days the demand was limited to a few utilitarian types that required much less time to set. Then, Burl knew exactly what he would be putting in his kiln each time and just where to place it; for example:

Figure 7-8
Conical setters used to support the ring jugs.

> 30 five-gallon churn-jars
> 30 four-gallon churn-jars
> 20 three-gallon churn-jars
> two-gallon milk crocks
> flowerpots

He even adds that "old man Lawrence Leonard down here, he boasted—I never did time him—but he boasted he could set a kiln full of jars and milk

Figure 7-9
Sealing the loading door in the end
of the chimney.

crocks in an hour."[23] Ironically, with the profusion of forms and sizes he makes today, Burl must work three or four times as long as he once did.

On average it requires about nine hours to burn out Burl's groundhog kiln—seven to bring the heat up and two to blast off. Of course there are many conditions that may cause him to deviate from this norm. When there is excessive moisture due to recent rains, he will heat the kiln very slowly at first, and the total time may reach ten or eleven hours. On the other hand, a heavy downpour during the burn may cause him to advance his schedule to only seven or eight hours to keep up the temperature in the kiln. This strategy, however, has its hazards, as demonstrated in figure 7-10. Rapid heating caused one large face jug to explode and lose its nose; the "tears" on the smaller model to the right were not due to the mishap but to a white clay which melts out of the eyes at high temperatures. Despite the falling rain and crackling of the flames, everyone heard the detonations. Other pieces in the kiln—including the four ten-gallon jars shown in figure 7-7—had cracked rims and sides and partially detached handles. Generally it is the larger, thicker-walled wares that suffer the most; the smaller pots in this case showed no damage at all.

Burl also spins amusing anecdotes about shortened burns caused, not by acts of God, but by human failure. Occasionally alcohol is the villain, but more often it is human fatigue or neglect. After World War II Burl was working in partnership with Vernon Leonard. "He was paying me so much for every kiln we burnt and then paying me for turning and drying. He was getting the clay and wood and doing the burning." When Vernon died in 1946, two of his sons decided that "they wanted to try it a while, same arrangement. They'd go to sleep and let the fire go out of the kiln at night. . . . The older boy went to sleep, and the younger one did too—he was supposed to have been firing. He let the fire go out, and he woke up before the older one did. And he didn't want him to know that the fire had been out, so he gets up, throws a heavy fire in there, and busted about two-thirds of the kiln. And I said, 'Boys, I believe it would pay you to get into something else.'"[24]

Normally, such mishaps were easily avoided if the potter remained attentive and built his fire slowly and steadily. Burl starts by dropping some crumpled paper and a few slabs of wood into the bottom of the firebox. Then he angles a few thin slabs through each of the three fireholes, thus creating a very gentle fire across the firebox. For the next four hours, Burl builds his fire almost imperceptibly; even at the four hour mark there are only five or six slabs slanting down to left and right in each of the fireholes (plate 12).

The essential principle—one that Burl often repeats—is to keep the flame behind the soot line in the kiln. Talman Cole explains that "when that fire started going into that furnace, the smoke and stuff turned it all black as tar. The whole chimney and everything were just soot black. Well, as you went

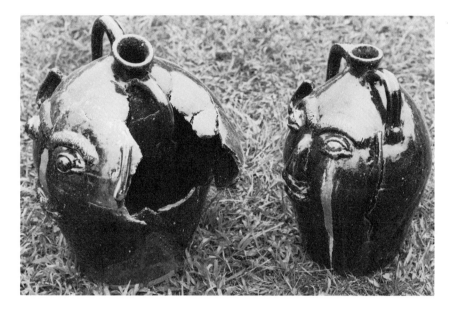

Figure 7-10
Uncommon calamities, the result of
overrapid heating of the kiln.

along through the day, why you kept firing that, and when you got that ware tempered, you see, where it wouldn't bust from the heat, you then began to really fire it. . . . The hotter you got that, you'd begin to see the smoke and soot burned off, inch at a time, going right on up through the kiln. And you had to burn on, just like you'd been a-burning, just raising your heat a little, till you got all of that soot burnt out to the upper end. And then she was ready to blast."[25] This account conforms in every detail to Burl Craig's practice. He carefully watches how the arch and, finally, the chimney turn to a gray-white color as the soot is burned away. Only when the corners and sides of the interior of the chimney have whitened, usually around the seven hour mark, does he feel it is safe to blast off the kiln.

Although it lacks a grate to suspend the fuel, the firebox of Burl's kiln is extremely efficient. Frederick Olsen points out that "solid fuels such as wood and coal/coke need a system where a maximum area of the fuel is exposed to the oxygen of the air supply, thereby allowing the largest surface area of the fuel to be ignited and give off its combustion energy quickly. Thus, wood, coal or coke need to be burned on grates, . . . with enough space below the grates to allow for proper air supply and for the ashes to fall into."[26] As shown in figure 7-11, the grate is unnecessary, because the slabs angle down through each firehole at approximately forty-five degrees and splay out to either side. Except for starting the fire, they are never thrown into a horizontal position on the bottom of the firebox. The rush of fresh air coming through the draftholes penetrates the slabs at about a ninety-degree angle and then curves immediately into the main chamber.

Figure 7-11
The firebox of Burlon Craig's kiln.

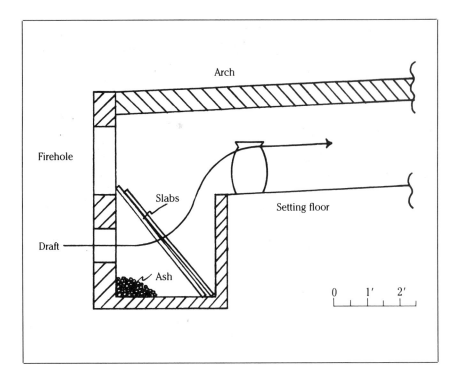

The ash, obviously, cannot be raked out during the firing, but the firebox is large enough to hold all of it without obstructing the flow of the air. As the ash pile builds underneath, moreover, it serves to preheat the incoming air before it reaches the slabs, thus further improving the combustion process. This simple firebox enhances what Olsen terms "the intimacy of the fuel with the air supply," which "solely depends upon the size and surface area exposed and whether it be hard or soft wood."[27] The traditional dimensions of the firebox are precisely designed to hold the four-foot slabs perpendicular to the draft and also to contain the ash generated by 2½ cords of fuel. And the three fireholes allow the potter to fan his wood out along the entire 10′ length of the firebox. Burl at one time experimented with just two fireholes, but he found he could not get enough wood into the firebox. Finally the thin, wide slabs of pine are superior to the old cordwood. They provide the maximum rate of combustion and ultimately produce a tongue of flame that reaches a length of some forty feet.

When the soot is burned out of the chimney and the kiln is ready to blast, the potter and his assistants fill the fireholes to their tops, literally forcing in all the slabs that space allows. This immediately puts the kiln into a reducing atmosphere, meaning that insufficient oxygen is present for complete combustion. This condition is signaled by the thick column of black smoke

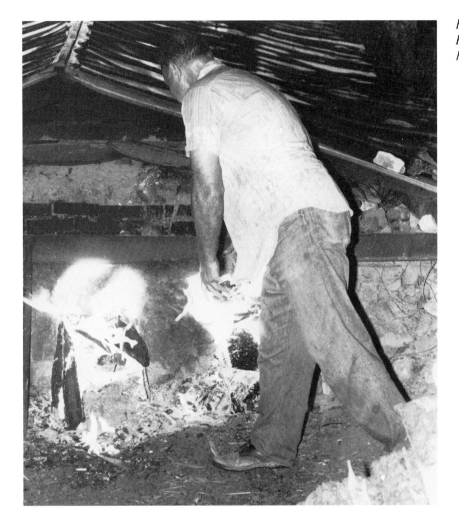

Figure 7-12
Proper form for stoking a fully heated groundhog kiln.

that billows from the chimney. Next comes a wide sheet of orange flame that, with a good south wind running through the kiln, may surge a full fifteen feet above the ground. As the fuel is rapidly consumed—the slabs "crackle like ham frying," as Burl likes to put it—the flame pulls back down into the chimney, the atmosphere clears, and the kiln is again oxidized. But just at this point—usually in cycles of four to five minutes—the men move in again and stuff the fireholes with wood. The heat is intense. In figure 7-12, Burl demonstrates the proper method of stoking—he stays upright and feeds from the side of the firehole. If he drops a slab he just kicks it in; to bend over directly in front of the firehole is to encounter a painful swell of heat, singed hair, and an intense light that is very hard on the eyes.

Just how hot does a groundhog kiln get? On the same day in August 1978 when heavy rain shortened the burn and cracked a number of the larger pieces, Burl set a series of pyrometric cones in his kiln to obtain a rough estimate of the temperature profile. Large cones (#12: 2,381°F) were embedded in clay pads and placed on the setting floor at approximately five, ten, and fifteen feet from the firebox. In addition, three small cones (#04: 2,008°F; #2: 2,154°F; #6: 2,291°F) were positioned at the front of the chimney, some twenty feet from the firebox. When the kiln was unloaded, the first two sets of large cones were found to be flattened, while the third was bent perfectly. This occurred three-quarters of the way up the setting floor, which is precisely where Burl stops his glass glaze and shifts to soft glazes or unglazed wares. Finally, at the mouth of the chimney, cones #04 and #2 were puddled, while cone #6 was bent over. Thus the temperature falls about 100°F over the final five feet, and there is likely an equivalent drop over the first fifteen feet. These results suggest that the alkaline glaze has a conveniently wide firing range and that traditional potters knew how to utilize their crossdraft kilns to the fullest advantage.

The folk potter, of course, had no such scientific pyrometric devices, but he did employ a number of effective checks to ensure that he stopped firing at the proper time. The most obvious was to look directly into the kiln, both over the firebox and through the loading door in the chimney. Some potters kept a pair of sunglasses, or even an old piece of smoked glass, for this purpose. Bird Johnson remembers that "I always wanted to look in there so bad. But my step-grandfather [Wade Johnson], he would never let me. And he always smoked a piece of glass, like you was going to look at the eclipse of the sun. And [he said not] to look in there, because he said it'll put your eyes out, that it was just like liquid fire."[28]

What the potter looked for was ware that was glowing at an orange-yellow heat with a shimmering, liquid glaze on the sides. As Talman Cole puts it, "You peeped in there, and wherever she started sweating, looked like, and that iron and glass started melting, . . . it looked just like water, like fog had hit your windshield. . . . When it started running, you had to know when to quit or you'd run it all off. So it wasn't as an unskillful job as you might think."[29] Sometimes, when the flame had died back, potters would toss in splinters of wood through the "peephole" in the chimney. As Burl explains, "I used to lay them in the hole and leave about that much sticking out, and *hit* it with something, knock it up in there." In the intense heat, the splinter would immediately ignite and "you could see the ware much better."[30]

Today Burl calls a halt when his glazes appear very liquid or "slick" and a light orange flame spurts from the chimney. Earlier, he also used trial pieces, or "try pieces," as they are often called—small rectangles of glazed clay with a hole near the top and a flat, unglazed base to keep them upright. They were usually set in or near the chimney, where the heat was lowest, so the potter could be sure that all of his glazes had matured. Poley Hartsoe

would place four or five of them at the chimney end of his kiln and periodi-
cally fish them out with a long, hooked wire. "Say at six hours you go pull
one and see how you're getting along, whether your glass is melting. . . .
Maybe seven hours you go pull another one. Then maybe eight hours you go
pull the last one and it's slick."[31]

All of these methods—the appearance of the glazes, the color of the ware
or the flame, and the use of trial pieces—may seem extremely crude, but
most of Burl's glazes emerge from the kiln in a fully mature state. Once he is
satisfied that his glazes have melted, he calls a halt to the stoking and
allows the fire to die down for about thirty minutes, until the ware has
dropped back to a cherry red hue (plate 14). Then he places barrel lids
across the fireholes; the draftholes and chimney, however, remain open. He
also pours water along the ground at the lower end of the kiln so that there
is no chance that the woodshed or remaining fuel will ignite. At this point,
the mound of glowing orange ash appears almost level with the floor of the
kiln. Twenty-four hours or so later, usually the following evening, Burl will
open the fireholes and unbrick the chimney to allow the kiln to cool further.
A day or two later the kiln is unloaded (fig. 7-13), attracting an avid crowd of
customers who purchase most of the pieces right off the yard. While Irene
collects the money, Burl performs his final task, scraping the congealed
sand and glaze off the bottoms with a handy piece of metal.

Like Burl Craig, Ben Owen learned the potter's craft as a boy and worked
at it all of his life. He first made traditional wares with his father Rufus and
others, then worked at the Jugtown Pottery, and finally opened his own
shop, the Old Plank Road Pottery, in northern Moore County. Exactly ten
years older than Burl, Ben retired in 1972. However, his salt glaze kiln still
stands in good condition and offers the best surviving example of the old
traditional form (fig. 7-14). Recently, in fact, his son and grandson reopened
the shop and are now regularly using this kiln. The specific procedures for
glazing with salt have already been covered in chapter 6. Moreover, the
basic techniques of slowly raising the temperature to dry the kiln and ware,
and then blasting off the kiln for the last hours, are essentially the same as
those practiced by Burl Craig. Of major concern here are the essential differ-
ences between the salt and alkaline glaze groundhog kilns, both in their
form and operation.

As general rule, the salt kilns appear to have been markedly smaller in
size, ranging from 16′ to 20′ in length and 6′ to 8′ in width. Joe Owen, Ben's
brother, recalls that their father Rufus's kiln was about 18′ by 6′ to 7′ over-
all.[32] Ben's kiln (fig. 6-8) measures 18′4″ by 7′8″, with a setting floor of 10′4″
by 6′1″ that holds 250 to 300 gallons—what Ben considers an average figure
for the old kilns. However, Charlie Craven asserts that his father Daniel's kiln
held up to 450 gallons, a capacity equal to that of the Craig or Reinhardt
kilns in Lincoln County.[33]

Coupled with the lesser volume was a longer burning period, usually

Figure 7-13
A potter's harvest: a profusion of
wares from Burlon Craig's kiln,
1978.

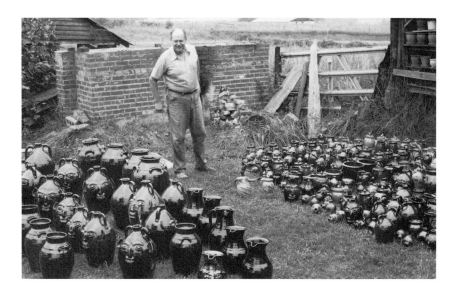

eleven to twelve hours according to Ben, but sometimes longer if a larger kiln was employed. This may partially account for the fact that the salt-glazed wares are harder and more vitreous than those of the Catawba Valley. The wood used may also have been a factor. The potters in the eastern Piedmont heated the kiln with well-seasoned hickory and oak, only using the rich pine for the blast. As noted earlier, hardwoods produce a shorter flame but provide a more intense local heat than the pine. With the shorter kiln—Ben's setting floor is only half the length of Burl's—the hardwood may actually have been a better fuel (though some potters assert that it was used only because the longleaf pine had become so scarce). Moreover, Ben adds, "hardwood like we have around here, if you split it up and let it dry for six months or more, it gives a hot fire. . . . When it goes in there, why, you run the blaze out of the chimney."[34]

The firebox is also constructed and used quite differently from that on an alkaline glaze kiln. As shown in figure 7-15, it has a single, large firehole (33″ high by 22½″ wide) with two small 4″ by 4″ draftholes near the base; only the righthand one is visible in the photograph. These "suction holes" took in fresh air along the bottom of the firebox. In addition the potters "could run an iron rod through this to stir the ashes when they'd back up. It'd be easier to do this through this hole, for you know it'd get awfully hot at the open door."[35]

The potter stands on the same level as the floor of the firebox to stoke this kiln; in effect, he works in a pit that extends out some eight feet from the kiln and is eighteen inches below ground level. This is very different from Burl's kiln, where the potter is three feet above the floor of the firebox and

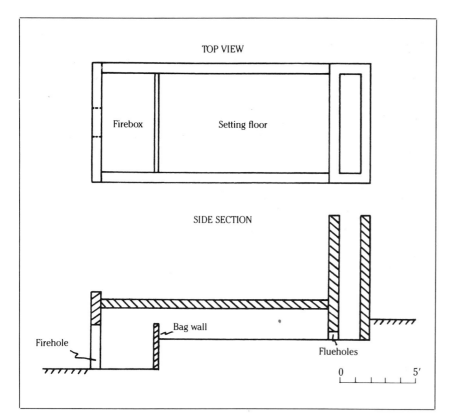

TOP VIEW

Firebox Setting floor

SIDE SECTION

Firehole

Bag wall

Flueholes

0 5′

Figure 7-14
Ben Owen's groundhog kiln, Moore County.

on the level of the setting floor. This arrangement proved most uncomfortable for the potter. The stoking pit on Daniel Z. Craven's kiln was some three feet below ground level—no doubt the kiln was buried much deeper than Ben's—and his son, Braxton, recalls his father's gyrations. "It'd be so hot he'd have to keep moving around to keep his pants from catching fire. . . . He'd keep a-twisting around every which way to keep from catching on fire."[36] Brac's brother Charlie adds, with equal amusement: "Sometimes I've seen my Daddy come out of there with his britches smoking!"[37]

While burning the kiln, the salt potters also covered the firehole with a large sheet of iron or tin. Ben Owen recounts that "we'd take that iron door down every time we put wood in there. . . . We had a wire handle in it, and you'd take gloves, have gloves, and just pick it up and set it over on one side. Then you'd fire it, pick it up and put it back, put a prop against it."[38] While this was standard practice in the eastern Piedmont, the only alkaline glaze potter known to have used such doors was George Donkel of Buncombe County (fig. 7-16). With the exception of the doors, this kiln is clearly identical to Burlon's, with large draftholes under the three fireholes. Donkel

Figure 7-15
The breastwall of Ben Owen's
groundhog kiln.

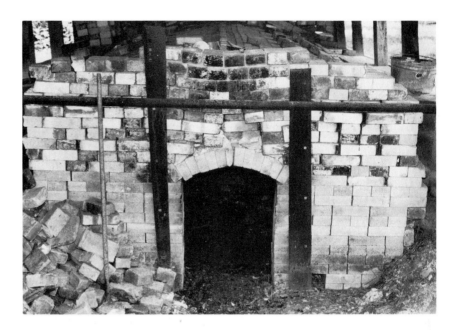

Figure 7-15
The breastwall of Ben Owen's
groundhog kiln.

apparently saw two advantages in this hybrid arrangement. First, "if you left the doors open, instead of the kiln a-drawing from underneath [through the draftholes] it'd draw through the top of the wood. Well, you wanted your draft to come up *through* the wood so you'd keep it afire, keep the fire wide open, going strong." This argument does seem to make sense for the early phases of the burn in this type of kiln, but such doors seem unnecessary during the blast, because the fireholes are plugged with wood most of the time. Second, Talman Cole adds that less wood is required. "I learned that in making molasses. You take an old evaporator furnace, you know, and we put doors on it, put a downdraft in there. And it didn't take half the wood."[39]

Whether these doors actually saved wood remains a moot point, as both the salt and alkaline kilns appear to have used two to three cords of wood per firing (though the former was burned for a longer period of time). The key to stoking the salt kiln, according to Ben Owen, was to feed in the wood at different angles. "If you just put it all in longways, it'd kind of choke up, couldn't get the air. See, if you crossed it up a little bit—this way and that way and this way—it would, it'd get more draft, more air." Figure 7-17 shows J. B. Cole angling a log into the left side of his firebox. The three rows of bricks at the base were to "keep your feet and shoes from getting so hot."[40] When ready to blast off the kiln, two stokers "would get in there, one to shoot it [the wood] this way and one this way. You just filled it up and then you'd get out and wait till that burnt down and then go back again."[41]

Clearly the wood was not exposed to the incoming air in such a regular

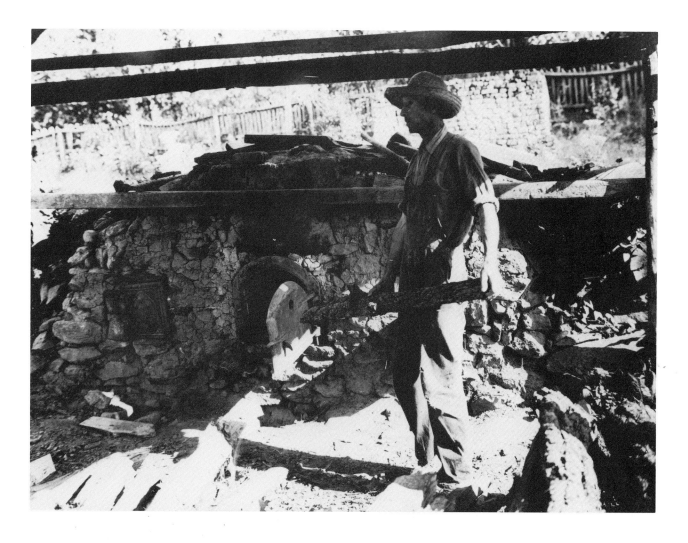

*Figure 7-16
George Donkel posing in front of
the working end of his groundhog
kiln, near Weaverville, Buncombe
County, ca. 1914. Photograph by Wil-
liam A. Barnhill. Courtesy of the
Library of Congress.*

pattern as in the alkaline kiln, nor were the draftholes as large or as low
relative to the wood. Thus, closing the door (visible to J. B. Cole's left)
helped to increase the force of the draft through the draftholes, as did the
much higher chimneys on these kilns. Ben Owen's chimney rises 7'11"
above the kiln floor, whereas Burl's is a mere 4'9". Some of the old salt kilns
had extremely tall, even tapered chimneys (fig. 7-18). The longer the chim-
ney and the more it tapers, the greater the rate of the draft through the kiln.
However, the potter had to strike a proper balance. In kiln expert Frederick
Olsen's words, "too long a chimney can cause irregular heating by pulling
the temperature out of the kiln and not allowing it to build up within the
chamber. On the other hand, too short of a chimney can protract the firing

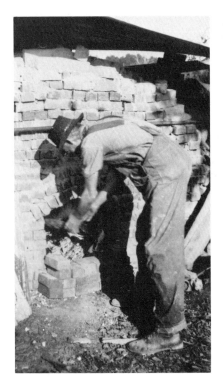

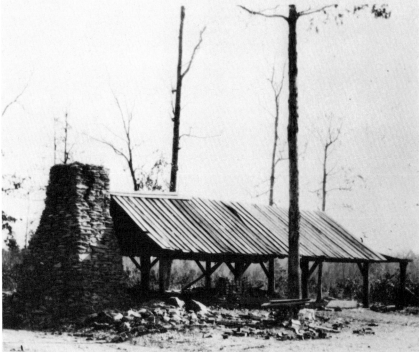

Figure 7-17
Jacon B. Cole stoking his ground-
hog kiln, Montgomery County, ca.
1925. Courtesy of Walter and Doro-
thy Auman.

Figure 7-18
An unidentified groundhog kiln with
a massive rock chimney, eastern
Piedmont. From a copy in the North
Carolina Collection, UNC Library,
Chapel Hill, N.C.

by decreasing the draft rate which allows build up in the fire box and also does not pull enough oxygen into the kiln to allow proper combustion for temperature increase."[42]

The larger chimney was also needed because the potters in the eastern Piedmont severely "choked" their kilns at the back of the setting floor. As shown in figure 7-19, the front wall of Ben Owen's chimney is almost entirely closed off. There are only six flueholes along the base, each about three courses high and perhaps 6″ in width, as well as a series of smaller openings somewhat randomly arranged across the next three courses. Ben explains that "you put that across up there to keep the blaze from pulling too fast. And it can go through these holes, you see. You leave little holes; build the brick up to the arch. . . . If it went through a big opening, it'd just pull too fast." This is in sharp contrast to Burl Craig's kiln, where the front end of the chimney simply rests on the top of the arch and is supported only by two 8″ by 8″ pillars. Ben also adds that some potters even positioned the ware to choke the draft. "I have known people to put—when they was doing stoneware and stuff—put a row of old crocks and stuff up there to keep it from going through too fast. And hold your temperature back."[43] In effect, this provides a slight downdraft, pulling the blaze down at the upper end of the kiln.

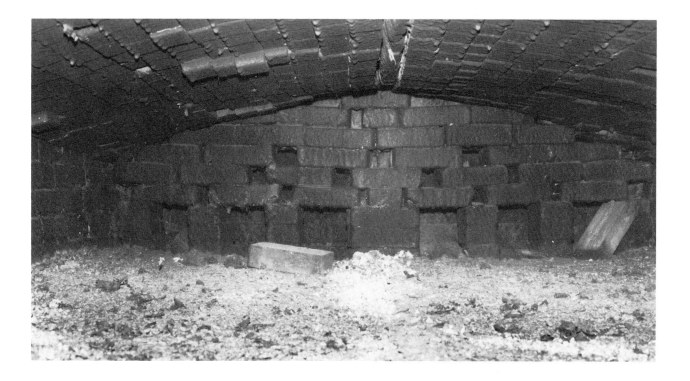

The views of the kiln interiors also reveal that the two types have different configurations. The arch of Ben Owen's kiln is much flatter—that is, it has a much smaller rise—and it is supported on side walls that are six courses high. In Burl Craig's kiln, by contrast, no vertical walls are visible; the arch slopes right down to the kiln floor. Ben Owen's design may be more efficient, in that it permits the setting of larger wares along the walls. More important, it is better suited for salt glazing, as the flatter arch will allow the salt to drop straight down on the wares. Some of the salt ports are visible along the arch, as is the flint rock or gravel on the floor. A. R. Cole attests that "we'd put white flints on the floor of this. You know, you'd have to burn these to burst them up fine enough. We got to where we'd put some in the chimney to burn for this, but before this we'd just pile 'em up on the outside—and there was plenty of wood and lightard—and we'd burn on 'em an hour or so real hot till they would burst up real good. The flints would let the ware set up so the salt would go under the bottoms."[44] Larger flint particles were more important in the salt kilns because the sodium vapors had to pass under the pots. In the alkaline kilns, the bottoms were unglazed and the wares were often set on sand.

Because the inner walls of the chimneys were choked off, the salt kilns had to be loaded and unloaded through the large firehole. This presented

Figure 7-19
The front wall of the chimney at the back of the setting floor of Ben Owen's groundhog kiln, showing the limited openings for the draft.

no particular problem in loading, but to retrieve their wares, potters such as Braxton Craven had to perform a kind of balancing act by crawling right over the still-smoldering firebox. "There'd be ashes but you'd have a plank running . . . up on the ledge where your pottery's setting. . . . I been in there when the red coals was over here on both sides of me, but I had a two by ten inch plank laid in there to crawl in there on. Crawl up there and hand it out, hand it out the door where someone could reach and get it. Yeah, it'd be hot in there, too. Second day, . . . it's so hot you can't hardly stay in there."[45] This task was much easier for the alkaline glaze potter, who entered through the chimney and worked in a much more open, better-ventilated kiln.

The fluid nature of the sodium vapors also permitted some stacking of the wares, usually the shorter, open-mouthed types. A. R. Cole recollects that "back when we used the old groundhog, it was stacked singly except when you could stack pans or crocks on one another. . . . These were stacked with a little raw clay put between them with the top one setting down inside the bottom one. This wasn't very good, for when it was packed like this the salt wouldn't go down in the bottom pan good."[46] Another common technique was to overlap the bowls or milk crocks. "When it come to crocks and things like that," observes Joe Owen, "you'd put a row of crocks and then you'd come over with another row, stacked. You didn't just stack them one on top of another; you let one go over on another."[47]

The marks from such stacking are readily visible on the rims or bottoms—small wads of clay, or circular areas that have received little glaze— and the flow of flyash or salt on the walls of the pot may indicate that it was burned upside down. Jugs and larger forms such as churns and jars were not stacked but were positioned to take full advantage of the shape of the kiln. However, potters using Albany slip, such as the Kennedy family in Wilkesboro, did stack their jars or churns by setting them mouth to mouth and bottom to bottom. They also placed the jars upside down over pitchers and small jugs, always ensuring, of course, that the bottoms and rims were free of glaze.[48] This was possible because the Albany slip did not run as precariously as the alkaline glaze, and it was not necessary that the surfaces be exposed to sodium vapors.

After loading the salt kiln, the potter normally constructed a bag wall— sometimes called a "firebreaker"—across the lower end of the setting floor. In Ben Owen's kiln, it was built to a height of three or four bricks by stacking them in an open, latticework pattern. This permitted the draft to enter the lower part of the setting floor but also deflected the flame from the front row of wares. As Ben puts it, "you didn't want the fire to hit your pottery too sudden."[49] The bag wall seems particularly necessary in this kiln, as the setting floor is only twenty-two inches above the bottom of the firebox. In Burl Craig's kiln, the distance is a full three feet; thus, there is less chance of the blaze impinging on the front row too early in the burn. For the most part, the Catawba Valley potters did not bother with a bag wall; if they made one,

it was extremely low and permanently mortared in place, as they did not enter their kiln through the firebox end.

The many differences between the kilns of the eastern Piedmont and those of the Catawba Valley stem in part from the separate developments of the two regions. Ironically old-timers from the former area will insist that Burl Craig's kiln will never work, that it won't hold the heat with such a wide-open chimney. And Burl or others will respond that there's no way you can heat a kiln with oak, or develop a full blaze with a choked-off chimney. In actuality, both types work well—each does what it was intended to do and possesses its own inner logic. For the salt glaze, a shorter, more enclosed, perhaps hotter kiln seems desirable; hence, the use of hardwoods, firebox doors, and severely choked but tall chimneys. Considerable heat is necessary to ensure that the clay on the surface of the pots is in a more or less fluid state, so that the sodium can combine with the silica to form the salt glaze. In turn, the salt vapor must be contained long enough to envelop, enter, and even pass under the wares. With the alkaline glaze, which is applied before the ware is set, a somewhat larger, more open kiln is feasible; thus the preference for pine, the lack of firebox doors, and the low, unchoked chimney. To a neutral observer, the type of firebox shown on Ben Owen's kiln seems less efficient (and comfortable) than that used by Burl Craig, but the other features that distinguish these kilns do make sense.

There may be another, more distant cause for these regional variations in the groundhog kiln. The salt kiln used in North Carolina is strikingly similar to the English Newcastle kiln, while the alkaline kiln closely resembles the German Cassel kiln. As illustrated by Daniel Rhodes (fig. 7-20), the Newcastle kiln has a single large opening in the breast wall used for both loading and firing, and also a tightly choked chimney to produce a partial downdraft effect.[50] The Cassel kiln, on the other hand, has three smaller fireholes with three draftholes beneath them; this kiln is loaded and unloaded through the chimney, which has no inner wall under the arch to restrict the draft. In short, the essential features of these two European kilns—used primarily for brick production—match closely the two distinctive groundhog types. Furthermore, the salt glaze potters in North Carolina were almost all of British origin, while those in the Catawba Valley were of German extraction. While it may never be possible to prove this European connection, the similarities are too striking to ignore and suggest that each ethnic group may have used a different type of kiln from the early nineteenth century on. Moreover, the type of kiln available may also have helped to determine or reinforce the respective preferences for the salt and alkaline glazes.

No kiln is perfect in design or totally predictable in operation, and the groundhog was no exception. To begin with, the folk potter had little control over the kiln atmosphere. Because the kiln was constructed with all the air intakes at one end, the atmosphere was normally reduced, meaning that there was insufficient oxygen available for complete combustion. This con-

Figure 7-20
The Newcastle and Cassel kilns.
From Rhodes, Kilns, *pp. 44–45.*

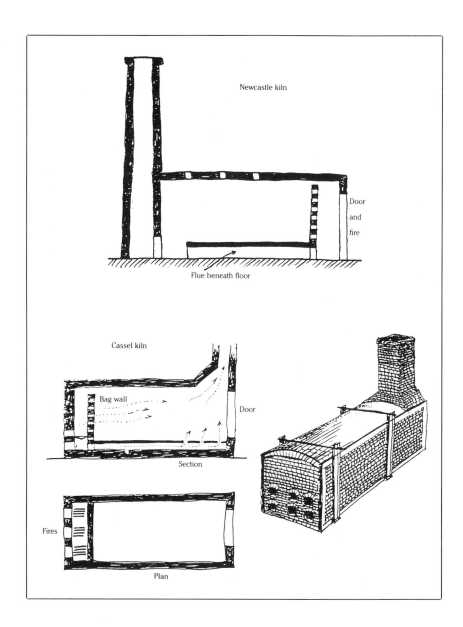

dition is not so pronounced during the early stages of heating—perhaps the first six hours or so—but during the critical blasting period reduction is extreme. Each time the potters jam the firebox with wood, they also block off much of the incoming air supply. What happens during reduction is that the clay bodies and glazes are robbed of their oxygen by the carbon compounds, and as a result their colors are altered.

The critical element is iron oxide, which in oxidation is red or brown but in reduction "gives cool colors of grey, grey-green, blue-green or olive green."[51] Thus the typical North Carolina salt glaze is gray to gray-green, because the iron is severely reduced at the time the salt is thrown into the kiln. Quite frequently, however, because the wares were placed too close together or the sodium vapor was not equally distributed, the pots show extensive patches of deep reddish purple to brown, with little evidence of the orange peel texture which typifies the salt glaze (fig. 7-21). Apparently, these surfaces received little if any glaze during the firing, and so when fresh air entered the kiln during the cooling, they reoxidized to a warm reddish brown hue. Those areas under the glaze, however, remained gray because the oxygen could not penetrate the coating of sodium silicate.

Reduction also explains the deep green that predominates in the alkaline glass glaze. It is similar to the Chinese celadon, a "color produced by adding a small amount of iron oxide to a glaze fired in reduction." Normally the Chinese employed a light clay body in order to create a pale, delicate lime green. When "used over a darker stoneware" such as that found in North Carolina, "celadon glaze will produce a dark greyed green." However, a different principle appears to be at work with the thick, brown cinder glaze. Once again the kiln is reduced, but due to the high percentage of iron in the slag, "a saturated iron effect results. In saturated iron glazes the iron, instead of yielding cool tones of grey or green, gives rich browns or red. This color results from the reoxidation of the iron on the surface of the glaze during cooling. When the iron oxide content of a glaze is high, the iron oxide has difficulty staying in the glassy solution during cooling. Some of the iron crystallizes out on the surface of the glaze. These crystals are subject to oxidation."[52] In a practical sense, the folk potter's lack of control over his kiln atmosphere was not truly a handicap. Since he was not concerned with ornamentation or even color, a mottled glaze or unusual hue mattered little as long as the pot was sturdy and impervious.

More challenging to the folk potter was the uneven heat distribution in his groundhog kiln. With the fire concentrated at one end, there was a steady falling off in temperature from the firebox to the chimney, which sometimes made it difficult to mature the glazes throughout the kiln. Burl Craig remembers seeing "Harvey and Enoch [Reinhardt] out here fire until the front row—just about all of it, usually burned three-gallon jars in the front row . . . and I saw the tops of them drop down, maybe almost hid inside, they just dropped down. Plumb ruined, you know, they get so hot. . . . What they was trying to do was run too much glass glaze and was overfiring the lower end to try to slick the upper end."[53]

Actually Harvey and Enoch knew better than to run the glazed wares too far into the upper or chimney end of the kiln. Like most potters in the Catawba Valley, they knew how to counteract the inherent heating prob-lem by using glazes with different melting ranges (cinder/glass/Albany/un-

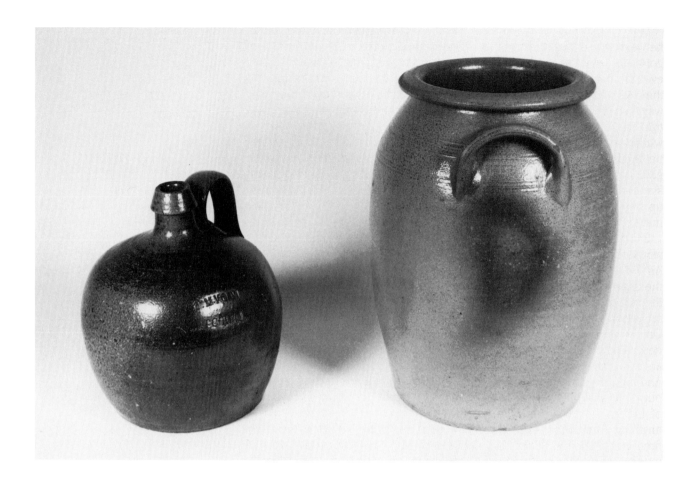

Figure 7-21
Salt-glazed stoneware jug and jar,
showing the coloring produced by
reduction (gray) and reoxidation
(brown). Jug: fourth quarter of the
nineteenth century, John M. Yow,
Erect, Randolph County. H 7⅝",
C 22". Stamped: "J.M.YOW / ERECT.
NC." Jar: third quarter of the nine-
teenth century, Paschal McCoy, Ran-
dolph County. H 11", C 26½", 2 gal.
Stamped: "P M•COY. / NC."

glazed), setting them in appropriate sections of the kiln, and burning pine as the fuel to project a long, intense blaze. Still, even in the best-executed burns, underfired glazes did appear. These were usually whitish gray and opaque on the alkaline glazes, sometimes with a rough or even blistered surface. Like the reoxidized patches on the salt-glazed stoneware, they occurred most commonly on the lower halves of bulbous forms, or the side facing away from the blaze, or on areas that were partially obscured by surrounding wares—wherever, in short, the full heat of the fire could not reach the glaze.

Yet a third recurrent concern for the folk potter was the progressive deterioration of his kiln, normally evidenced by globs of melted mortar and archbrick on the tops and sides of his vessels. And sometimes the demise of a groundhog was anything but gradual. One afternoon, a day after completing a burn, Jug Jim Broome was "in his pottery when he heard an awful

calamity. And he said—he said he couldn't say what it sounded like. It was between thunder and something else—he had a name for it, but I'm not going to repeat it. And he went out there, and he said the smoke and everything was boiling up, the shelter that was over the kiln was on fire. That there kiln had just caved in."[54] Normally a section of the arch would give way, usually after the kiln had cooled somewhat and the brick had contracted. Foister Cole remembers the day his father Arthur's kiln collapsed while the family was unloading it. " 'Once daddy was way in, my brother behind him, me in the firebox, another outside. All of a sudden that crown gave way and fell in on me and my brother right up to where daddy was and stopped. It was quite a weight, but of course it crumbled around us. I raised up through it and my brother did too. He looked at me and said, "I'm not hurt if you're not." We've laughed a lot about that.' "[55]

Salt kilns tended to have the shortest life because the sodium vapors would flux and melt the brick of the arch as well as the surface of the pots. All that a potter like Jug Jim could do when his kiln collapsed was clean out the debris (fig. 7-22), rebuild, and fire it again. Some of the brick made by the potters from local clays proved remarkably durable. Burl Craig's kiln arch remains in near perfect condition after almost forty-five years of use. On other occasions, however, the potter failed to use his normal shrewdness. Many years ago, Burl helped a group of men rebuild Lawrence Leonard's kiln near Cat Square, Lincoln County. "They bought brand new brick. And they give Big Luth Yoder the new brick, brick for brick, for the old brick out of the [Daniels] schoolhouse. Some of them said, 'Oh, they's made out of firebrick.' Now they didn't test them out; they didn't try them out or anything. They just taken somebody's word for it. We built that kiln. They fired about twice in it, and they melted—some of the milk crocks had that much [two to three inches] melted brick in them. Well, that wouldn't work. Tore that down. They went and bought some new brick. And they run into the same problem. About twice firing, and they started melting. Boy, it was pitiful!"[56] The moral to this story was clear to all. "If they'd went on and bought the firebrick to start with, why, it would have saved a lot of money there. A lot of work and a lot of aggravation! They lost a lot of stoneware and they lost their labor."[57]

Actually, such lapses in judgment appear to have been rare. And given the enormous output, the tales of woe and disaster are surprisingly few. Even the most scientific, well-schooled modern potter encounters "a lot of aggravation," and the evidence affirms that, despite his seemingly crude and simple equipment, the folk potter had no more than his share. His common sense and practicality, coupled with his deep-rooted traditional wisdom, ensured his continued success. As Burl affirms, "the old-timers like [Jim] Lynn and Lawrence Leonard and people like that, they'd been in that thing all their lives. And they *knew* what to do and how to fire and everything. . . . I never know'd any of them to make a bad burn."[58]

Figure 7-22
Three potter's nightmares: a jug fragment containing a melted brick out of the arch of the kiln (Cornelius Blackburn, Catawba County); the twisted rim, handles, and upper section of a jar (Ruffin Cole, Randolph County); and a warped and bloated jug covered with fragments of adjacent pots (Lewis O. Sugg, Randolph County). Courtesy of Walter and Dorothy Auman.

Although the kilns of the eastern Piedmont and the Catawba Valley differed in many details, the potters in both regions used very similar methods to construct them. In fact, they had little difficulty in temporarily turning brickmaker and mason, probably because the primary raw material—the local clay—was thoroughly familiar and served both for the bricks and the mortar. However, they did not use their standard stoneware clays to mold the bricks. Rather they located a clay that contained considerable sand, or if necessary they tempered it. The extra sand, or silica, not only facilitated the drying process, thereby lessening the chances of warping or cracking, but also raised the maturing temperature so that the bricks would not melt in the intense heat of the kiln. During the early 1930s, Enoch and Harvey Reinhardt made one hundred thousand bricks from a yellow clay they dug from the branch on what is now Burl Craig's property. The result was a light-colored, porous, sandy brick that breaks very easily if dropped but perfectly handles the heat and expansion during firing. These bricks were used for the Reinhardt kilns, both of which still stand today; some were also sold to Floyd Hilton.

Having located and dug a supply of the proper clay, the potter next ground it in the pug mill. Fortunately, the Reinhardts found no need to add sand to their clay; they "just put the water to it and ground it up." However, they employed a different type of pug mill. "We didn't have blades in there like we grind potter clay. We had those crosspieces, see, and that kept mixing it, and it worked it down as it ground it from the top. It was fed from the top, and when it got mixed it was all the time coming out at the bottom. We had a hole there to stand in, just about waist deep, to where it would be handy. . . . You'd just take your hand, cut off a piece and you put it in the mold. And then you had a board there; you'd strike that off in a four-brick mold." In effect the Reinhardts used a pug mill akin to that normally em-

ployed in the eastern Piedmont, with spiraled, horizontal pegs on the vertical shaft to force the clay down through a rectangular opening at the bottom. One man fed clay and water into the mill and kept the mule going; the other, standing in a waist-deep hole, cut off the bolts at the bottom, pressed them into a well-sanded mold (fig. 7-23), and then trimmed off the excess clay.[59]

A similar system was used by Daniel Craven and his family in Moore County. Charlie Craven recalls that "one man could pack them just as fast as four or five could tote them off, dump it out. We'd find a good, smooth place somewhere on the ground—just dump 'em all on the ground. And when they got hard enough, turn 'em up on the edge and stay there till they got dry." When asked about rain, Charlie laughed: "We'd always hope it wouldn't rain! I never knowed it to rain on them." Once dry, the bricks could be stacked in sheds until ready for use. When he had enough to build a kiln, Daniel Craven "didn't burn them. No, made a kiln out of 'em and let—burn 'em as he was burning pottery in there. Of course, he had it up and got it good and hot before he ever put any pottery in it. That would get 'em burnt about half enough, I'd say. That's the way they burnt them. And he kept the kiln covered up so it wouldn't rain on it."[60]

Enoch and Harvey Reinhardt, however, first burned their brick in a scove or clamp kiln. Architectural historian Harley J. McKee explains that "they were most often used when bricks were being made at the site of a building but they were also used at commercial brickyards, especially before the 19th century. . . . Several walls or *necks* were built, parallel to each other, each about three bricks in thickness. At a height of about two feet, the necks were joined by corbeling courses into a single mass. . . . Throughout the interior, open spaces were left between adjacent bricks, but the outer layers were laid together as closely as possible (*close bolted*). The tunnels near the bottoms served as fireplaces."[61]

The Reinhardts constructed a long, rectangular scove kiln, with five fireboxes or tunnels running across it. The bricks were placed in rows across the kiln, each one about a hand width apart, and then the next course was set at right angles to the ones underneath. The walls were gradually tapered in on both sides to a height of about five feet, and rocks and earth were banked against the sides for support and insulation. Enoch recalls that they fired the kiln for about one hundred hours and used close to one hundred cords of wood, estimates that could be a bit on the high side. They fired for four to five days and raised the heat very slowly. Nevertheless, much of the brick was useless, particularly the outer layers, which were burned insufficiently or too unevenly. Many years earlier, their father Pinkney had produced the bricks for his kiln in precisely the same way.[62]

When the bricks were ready, the next step was to dig out the foundations for the walls, the deep firebox, the setting floor and the chimney. "You build it," explains Burl Craig, "just like you're building a foundation. . . . You dig

Figure 7-23
An old brick mold found at the shop of Charles C. Cole, Moore County. The individual compartments measure 9" by 4¾" by 3". Courtesy of Walter and Dorothy Auman.

Figure 7-24
One of a set of four archboards now owned by Burlon Craig. The span is 9' 8½", the rise 29".

down, you want to dig down till you hit solid dirt, till you hit that old red dirt just like building a foundation for a house. If you don't why, your foundation gives way, your kiln's gonna' go. I imagine there's probably four or five [courses] anyway, rows of brick down in the ground out there, before they start the arch."[63] The walls of most kilns were 8" thick, with the bricks set in alternating courses of headers and stretchers (English or common bond). In addition, Burl's kiln floor is angled upward with a rise of approximately 12" along its 20' length in order to improve the draft. Later this pitch could be adjusted by shifting the sand or flint that covered it. For example, the draft would be increased if the potter raked more sand to the upper end of the kiln.

When the vertical side walls were completed, the potter assembled his archboards and lathing as a framework on which to raise the arch. Burl still owns the four archboards that have been used for all the kilns in his region as far back as anyone can remember (fig. 7-24). With a span of 9'8½" and a rise of 29", they are constructed of 1" pine boards with 2" by 4" braces pegged into the back and smaller boards nailed along the edges for extra support. Oral tradition asserts that they were made in the Reinhardt family, either by Enoch and Harvey's grandfather or great-grandfather. The potter placed one archboard at each end of the kiln and spaced the other two in between. Ben Owen explains that "we'd set them up on some blocks of wood like two by fours or something, all away along on the side, and maybe

Figure 7-25
Tapered wedge bricks set into the
top of the arch on Enoch Reinhardt's
kiln, Henry, Lincoln County.

tack 'em or nail 'em. And then you'd start putting your boards down at the sides to go up on; . . . you'd have to have about an inch board."

Once the archboards were completely covered with lathing—usually narrow boards no more than 2″ wide so a smooth curve was formed—the potter began laying the archbricks. the first brick was set almost horizontally with the small end against the lathing. Then the next was placed on top of it but turned slightly upward by adding extra mortar—clay, actually—underneath the outer edges. This created a smooth, tight inner arch that conformed to the curve of the lathing. Ben Owen continues: "You start on each side and come on up, and you'd meet in the middle with your brick. And that's where you had to wedge them good and tight to keep them from caving in."[64] Figure 7-25 shows the top of the arch on Enoch Reinhardt's kiln, with two narrow, tapered wedge bricks dropped into the center to hold the arch in place. A single row of wedge brick is also visible at the center of Ben Owen's arch in figure 7-19. A number of bricks near the chimney have begun to drop down, and dribbles of mortar are apparent along the seams—most of these end up on the shoulders of the wares. The arch of Burl's kiln appears much tighter, although several bricks have partially melted out about two-thirds of the way back toward the chimney (fig. 7-6).

When the arch was complete, the potter removed the archboards and lathing—the arch was still completely open at both ends—and then attended to the chimney and firebox. The chimney was also 8″ thick and

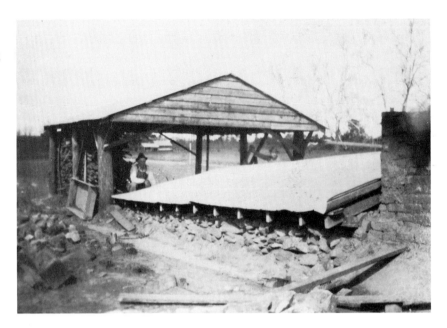

Figure 7-26
Enoch and Harvey Reinhardt burn-
ing their kiln, Henry, Lincoln County,
ca. 1935. Courtesy of James and
Irene Gates.

could be reinforced if necessary. Ben Owen would sometimes "put a row of brick through the center of the chimney back there all the way up to keep it from trying to come together. That temperature would sometimes, would pull it in."[65] Enoch Reinhardt, on the other hand, remembers that "we had the brick come apart. Well, we'd get us some heavy wire to put around it, to brace it, hold it together." At the other end, the potters constructed a relatively thin wall—usually only 2½" to 4" thick—at the back of the firebox, running from the bottom up to the level of the kiln floor. Enoch notes that this was slanted inwards, both for better support and also to give "your fire a little start over it."[66] The floor of the firebox was often also covered with brick. Finally, the "breast" or "breast wall" was finished off, with its varied combinations of fireholes and draftholes; the shafts for the draftholes were lined with a 4" wall of brick. The breast was subject to extremely high heat and was supported by heavy metal beams—Burl has bolted together two frames from a Model T to hold his in. As long as the arch bricks were well made and set, the chimney and the breast wall were the two parts of the kiln most frequently rebuilt, either to repair damage or fine tune the kiln to make it more efficient.

When the brickwork was complete, it was essential to buttress the walls, particularly when the kiln was built at or near ground level. As Enoch explains: "Well, you notice that we . . . built a wall with stones and rock, and filled it in with dirt. Dirt come up on the arch, you see. And we had weight

there—that was to hold your arch down, to keep it from spreading."[67] Figure 7-26 shows Enoch's kiln in action during the late 1930s and clearly illustrates the heavy rock retaining wall that runs along both sides.

The arch of the kiln also had to be protected from the weather, so the potter constructed a gable or shed roof over it. Burl's roof is made of a heavy wood frame covered with sheets of tin and sits only twenty-one inches above the top center of the arch. For the salt kilns, a higher roof was necessary so the potter had easy access to the salt ports; Ben Owen's is about four feet above the top of the kiln. A less common alternative was a temporary shed roof, such as used by Baxter Welch. The forked sticks set in the ground to the right of his kiln (fig. 6-5) almost certainly supported the upper end of a shed roof, which was removed during the burn.

Finally the potter also required a substantial woodshed near the firebox to keep his fuel dry. Burl Craig's overlaps the end of the kiln by about fifteen inches and is 20' by 17'; Ben Owen's roof covers both kiln and woodpile and measures 28½' by 23'. Some potters, however, saw no need to construct any covering. Jim Lynn, Burl's teacher, had only a wood frame at the end of his kiln, and would hurriedly tie up an old canvas over it when it rained. After the wood was soaked several times, Burl went to a hardware store and purchased tin roofing, paying for it with the next load of ware. But he received little thanks for his efforts—Jim only complained, because half of the pottery used for the payment was his.[68]

For the most part, the old groundhog kiln served the North Carolina potters well for over a century and a half. No plans were required to build them. All that was needed was a set of archboards and the traditional knowledge and guidance of one of the older men in the area. Even in the late 1930s, when Harvey and Enoch Reinhardt were building their kilns, "some of those old fellows was living, you know; they told us and give us information." And there is little question that the potters fully understood the limitations of their kilns. Enoch adds that he was cautioned not to make his kiln longer than 22' from the breast wall to the front of the chimney, and he followed their advice. "You get them twenty-two feet, you know, it's hard to get them hot enough to run your glaze."[69]

Most of all, the groundhog kiln was extremely economical, both to construct and operate. The real cost was time and labor, the two commodities the folk potter could best afford. As Burl Craig observes: "If you go to buy now, the firebrick the price they are—and they wouldn't be worth a damn; in a kiln like this out here, they wouldn't last long—why, it would cost you a fortune to build that kiln like that." Even today Burl can produce a large kilnful of stoneware for a total cash outlay of fifteen dollars for the pine slabs and a small amount for the gasoline used to haul and grind the clay. "Outside of the labor I'm actually no expense. A little bit of gas that I use to—probably five gallon of gas to grind enough clay or maybe more than

enough to make a kilnful. And the man he don't charge nothing for the clay. There's no expense to it!"[70]

But the ultimate sign of the groundhog kiln's efficiency was its ability to repeatedly turn out large quantities of inexpensive, durable, well-glazed pottery. Despite its low, cramped, unevenly heated interior and often dilapidated appearance, it was relatively easy to load and burn, and it proved ideally suited for the large, undecorated, utilitarian forms that constituted the bulk of the folk potter's output. Much of this stoneware survives today, often with only a few chips or cracks to suggest the generations of hard use in the kitchen or springhouse. It survives because the groundhog was a true high-fired kiln, capable of temperatures of 2,400°F and more. A few years ago, Burl was invited to inspect the small kiln erected by an eager young potter who had recently moved into the area. Once out of earshot, he shook his head in disbelief and muttered, "He couldn't bake cornbread in that thing he had out there!"[71]

Just how hot the groundhog kilns got on occasion remains a matter of speculation, but the account of Preacher Hogan's visit to Jug Jim Broome's kiln should convince any skeptics that the heat was at times almost unearthly. "He was a Baptist preacher. He used to come over to the house pretty often, and he came down there one night. Dad was burning that last two hours; in other words, he was about on his last thirty minutes, I guess. Preacher Hogan came down, and he looked in that furnace. And when you looked in that—you get down there and look in that furnace—when you looked away you didn't see anything but a spot for a few minutes. And he looked in that furnace, and he turned, walked back, got away from it. He said, 'Mr. Jim,' he said, 'My Bible tells me that hell is hotter than any fire on earth.' He said, 'If it's any hotter than that place, I'd love to know what kind of furnace he's got!' "[72]

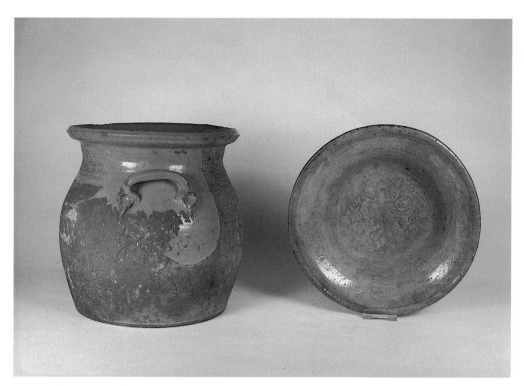

Plate 1
Lead-glazed earthenware jar and dish, first quarter of the nineteenth century, J. C. Cox, Randolph County. Jar: H 8⅜", C 27³⁄₁₆". Signed in script: "J C Cox." Collection of Mr. and Mrs. William W. Ivey. Dish: H 2⅛", D 8¹⁵⁄₁₆". Signed in script: "J C Cox." Collection of Ralph and Judy Newsome.

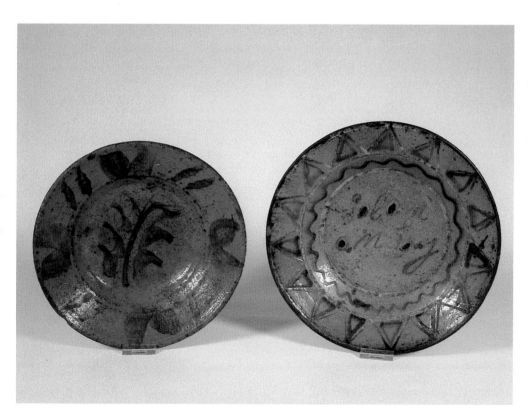

Plate 2
Decorated lead-glazed earthenware dishes. Left: ca. 1800, eastern Piedmont. H 2¼", D 9⅞". Right: second quarter of the nineteenth century, Solomon Loy, Alamance County. H 2", D 11".

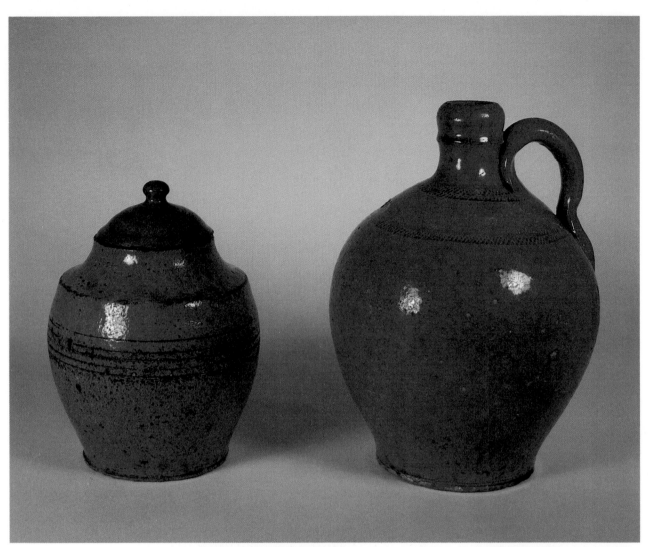

Plate 3
Lead-glazed earthenware,
Lincoln County. Jar: first
quarter of the nineteenth
century, attributed to the
Seagle family. H 6¼", C 19"
Collection of Lula Seagle
Tallent. Jug: ca. 1825, Dan-
iel Seagle. H 10", C 23¾", 1
gal. Stamped: "DS." Collec-
tion of the Southern Stars
Chapter No. 477, United
Daughters of the Confed-
eracy, Lincolnton, N.C.

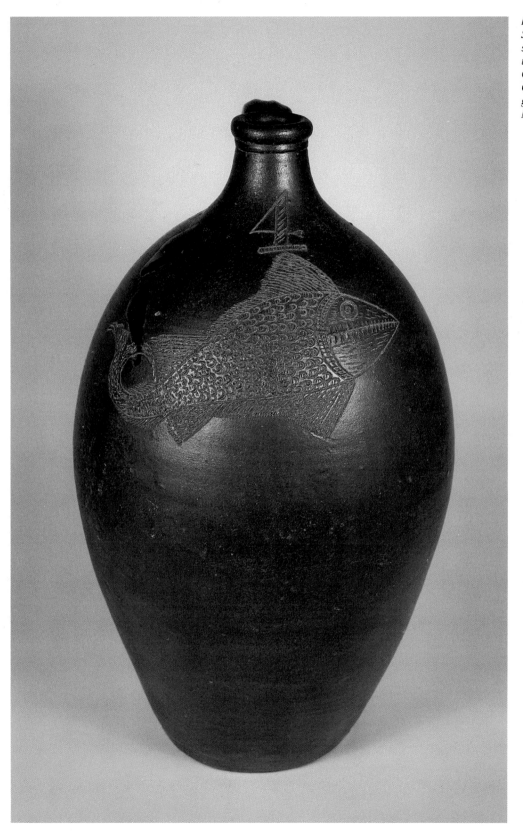

Plate 4
Salt-glazed stoneware jug,
second quarter of the nine-
teenth century, Edward or
Chester Webster, Randolph
County. H 18", C 34 ⁷⁄₁₆", 4
gal. Collection of the Mint
Museum, Charlotte, N.C.

Plate 5
Salt-glazed stoneware by the Craven family. Left: frogskin jar, ca. 1875, J. Dorris Craven, Moore County. H 11 1/4", C 19 3/16". Stamp: "J.D.CRAVEN." Collection of Cecelia Conway. Center: jug, ca. 1850, William N. Craven, Randolph County. H 16", C 32", 3 gal. Stamp: "W N CRAVEN." Right: pitcher, ca. 1850, John A. Craven, Randolph County. H 12", C 22 7/8", 1 gal. Stamp: "J.A.C."

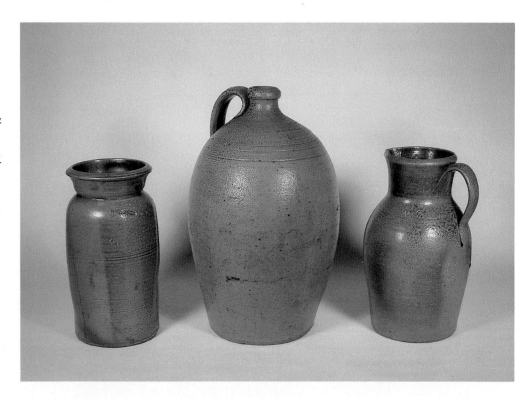

Plate 6
Salt-glazed stoneware, fourth quarter of the nineteenth century. Left: jug, James M. Hayes, Randolph County. H 14 1/4", C 27 5/8", 2 gal. Stamp: "J.M.HAYS." Center: jar, Timothy Boggs, Alamance County. H 16", C 36 1/2", 5 gal. Stamp: "T·B." Right: jar, John F. Brower, Randolph County. H 10 1/2", C 22 5/8", 1 gal. Stamp: "J. F. BROWER" with Masonic compass and square in coggled circle.

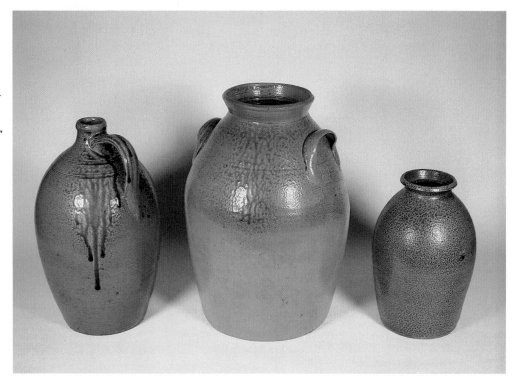

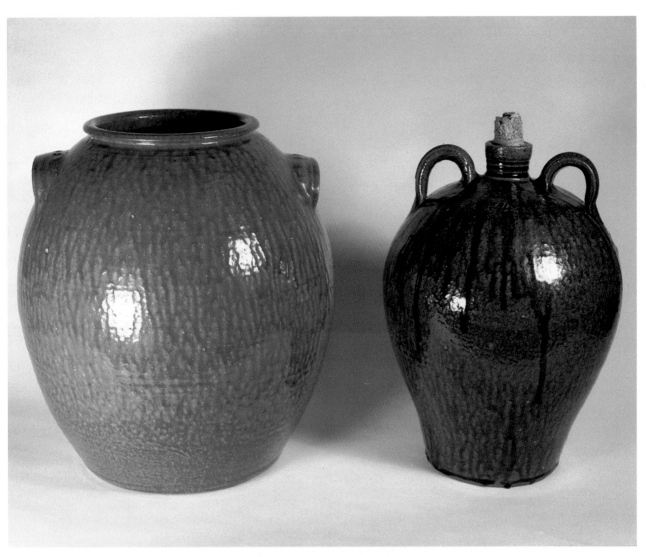

Plate 7
Alkaline-glazed stoneware,
second quarter of the nine-
teenth century, Daniel
Seagle, Vale, Lincoln
County. Jar: H 16⅝",
C 50⅛", 10 gal. Stamp:
"DS." Jug: H 16 1/16", C 37¼",
4 gal. Stamp: "DS." Both
from the collection of the
Ackland Art Museum, Uni-
versity of North Carolina at
Chapel Hill, Ackland Fund.

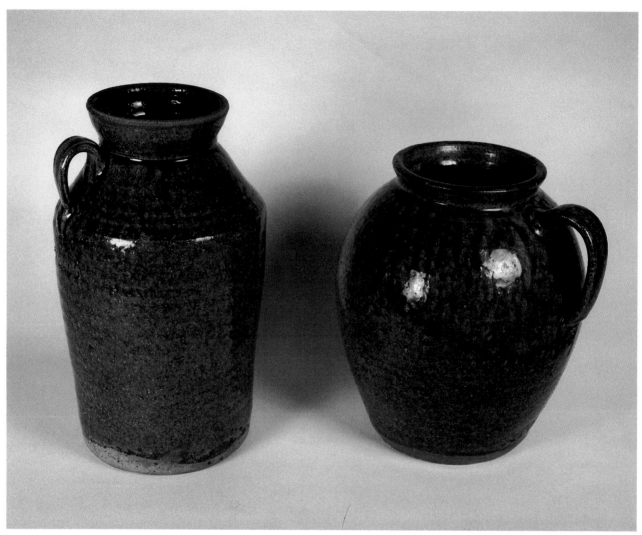

Plate 8
Alkaline-glazed stoneware
jars, Buncombe County.
Left: fourth quarter of the
nineteenth century, Joseph
S. Penland. H 10 1/2",
C 20 1/16". Stamp: "J. S.
PENLAND." Right: third
quarter of the nineteenth
century, Edward Stone.
H 8 13/16", C 24 3/8". Stamp:
"ESTOᴎE." Both from the
collection of Doug and
Jane Penland.

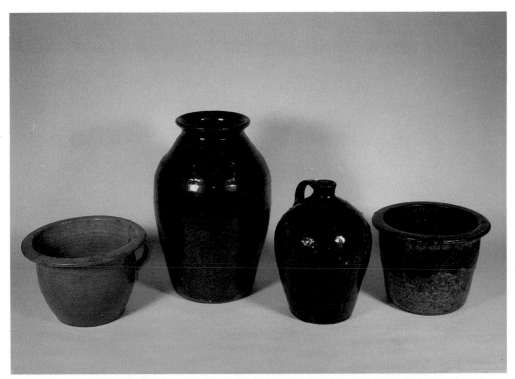

Plate 9
Alkaline-glazed stoneware, Catawba Valley. Chamber-pot: ca. 1920, attributed to the Hilton family, Catawba County. H 6¼", D 9⅝", 1 gal. Jar: 1978, Burlon B. Craig, Henry, Lincoln County. H 14⅛", C 30", 2 gal. Signed in script: "B B C." Jug: ca. 1875, Ambrose Reinhardt, Catawba County. H 10⅜", C 23⅜", 1 gal. Stamp: "AR." Milk crock: ca. 1945, shop of Enoch Reinhardt, Henry, Lincoln County. H 6¾", D 9¼", 1 gal.

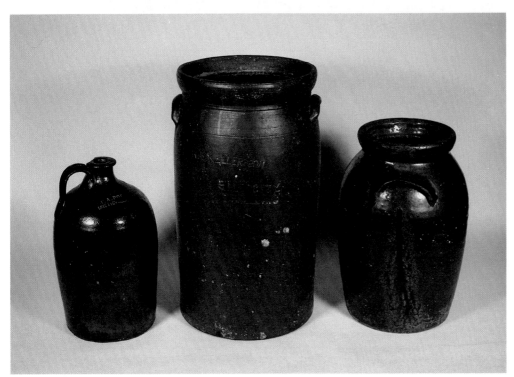

Plate 10
Albany slip-glazed stoneware. Jug: ca. 1890, E. A. Poe and Company, Fayetteville, Cumberland County. H 11¾", C 23", 1 gal. Stamp: "E. A. POE / FAYETTEVILLE.NC." Jar: ca. 1930, R. Bascom Keller, Chatham County. H 17¹¹⁄₁₆", C 32⅛", 5 gal. Stamp: "R.B.KELLER& SON / SILER CITY / N.C." Jar: first quarter of the twentieth century, William M. Penland, Buncombe County. H 13½", C 29¼", 3 gal. Stamp: "W M PENLAND."

Plate 11
Stoneware jugs, ca. 1900,
Sylvanus L. Hartsoe, Ca-
tawba County. Left: alkaline
glaze combined with Al-
bany slip. H 15½", C 35¼",
4 gal. Stamp: "S L H." Right:
Albany slip. H 8⅜", C 16⅝",
½ gal. Stamp: "S L H."

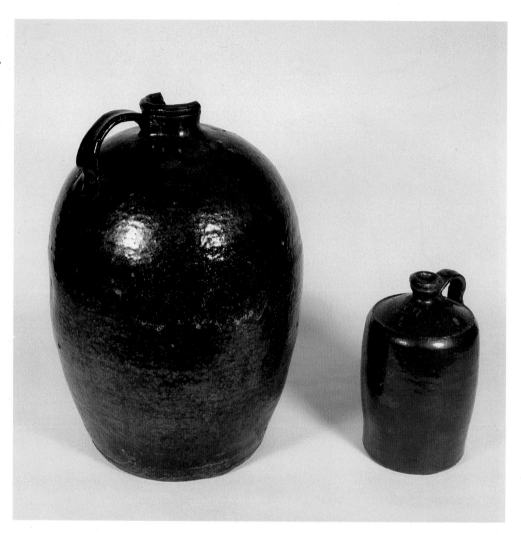

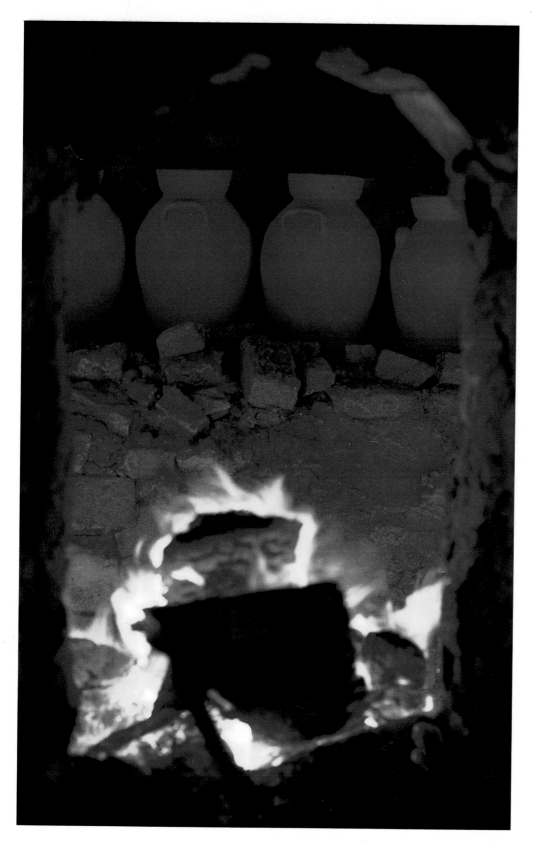

Plate 12
The view through the center firehole of Burlon Craig's kiln.

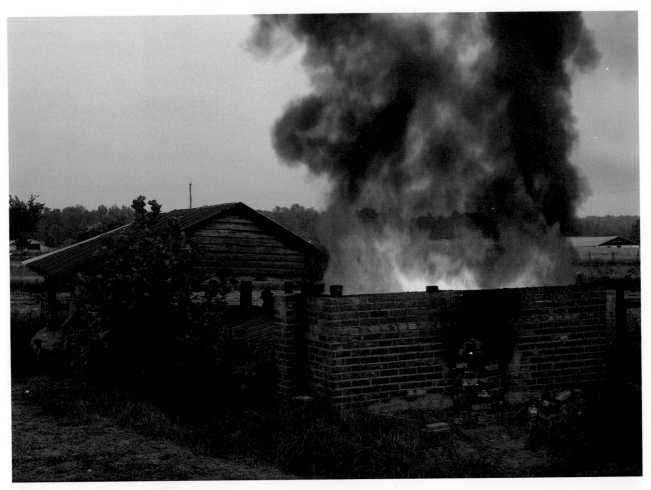

Plate 13
Blasting off Burlon Craig's
kiln.

Plate 14
The interior of Burlon
Craig's kiln as seen through
the peephole in the chim-
ney.

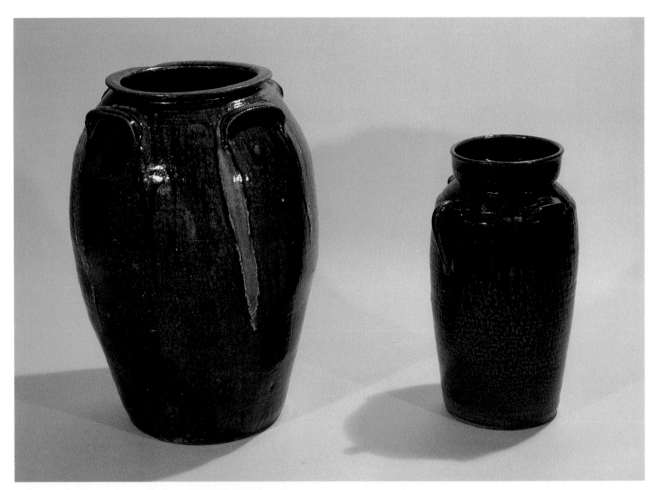

Plate 15
Left: alkaline-glazed stone-
ware jar with glass runs
from the four handles,
ca. 1900, Henry H. Heavner
and Royal P. Heavner, Ca-
tawba County. H 23½",
C 52½", approximately 20
gal. Signed in script: "H. H.
Havner's MFG Co. / The
Best / MFG. Co. / in the US /
In God we trust H. H. and
R. P. Havner / Champion."
Collection of the Ackland
Art Museum, University of

North Carolina at Chapel
Hill, Ackland Fund. Right:
alkaline-glazed stoneware
churn, ca. 1925, Samuel A.
Propst, Henry, Lincoln
County. H 18", C 30¾", 4
gal. Stamp: "NORTH CARO-
LINA." Collection of the
Ackland Art Museum, Uni-
versity of North Carolina at
Chapel Hill, gift of Mr. and
Mrs. Charles G. Zug III.
Photograph by Quentin R.
Sawyer.

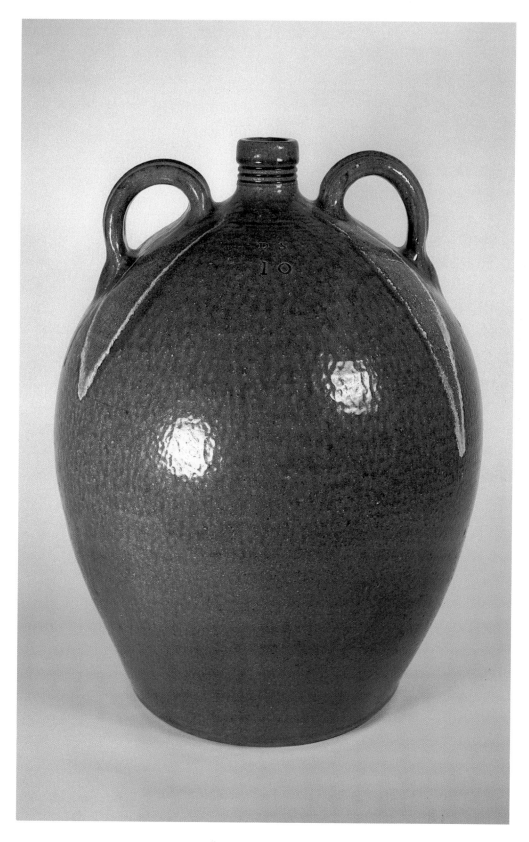

Plate 16
Alkaline-glazed stoneware
jug with glass runs from
the handles, second quarter
of the nineteenth century,
Daniel Seagle, Vale, Lincoln
County. H 21", 10 gal.
Stamp: "DS." Collection of
Mr. and Mrs. William H.
Trotter.

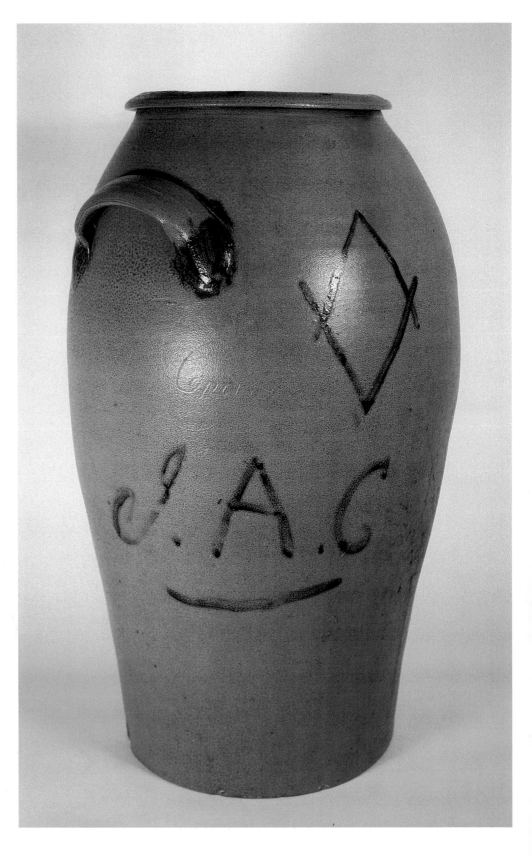

*Plate 18
"Molasses Making" by Minnie Smith Reinhardt, Catawba County, 1981. Photograph by Quentin R. Sawyer.*

*Plate 19
An array of classic forms and glazes by Ben Owen, made at the Jugtown Pottery and the Old Plank Road Pottery, Moore County. From the household of Mr. and Mrs. John V. Allcott.*

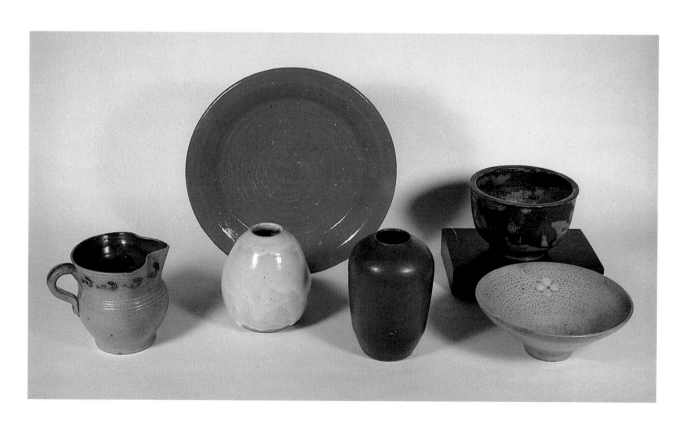

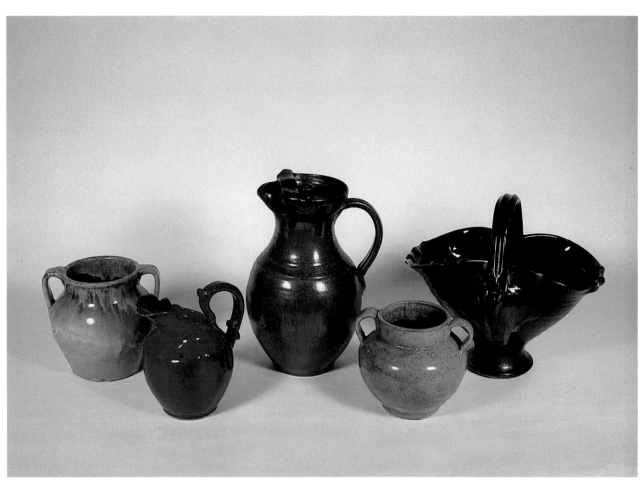

Plate 20
An array of bright colors
from the North State Pottery
Company, Lee County; Ar-
thur R. Cole, Sanford, Lee
County; and J. B. Cole's Pot-
tery, Montgomery County.

PART THREE. CULTURE

8

THE EDUCATION OF THE FOLK POTTER

The people of North Carolina have always preferred the countryside to the city. In fact North Carolina "is one of the few states that has always been predominantly rural. (By definition, rural persons are those living outside of places with 2,500 or more inhabitants.) The first official urban residents did not appear until 1820. . . . When the entire country reached an urban majority in 1920, North Carolina was still overwhelmingly rural (80.8 percent). By 1970, the state had its largest number and proportion of urban residents ever, yet with 45 percent so classified, it was still well behind the national proportion of 73.5 percent."[1] These simple yet striking statistics help to explain why the folk potter's wares remained in demand well into the first half of the twentieth century. A self-sufficient, agrarian people needed them.

These figures also account for the essential conservatism of the craft. Like the majority of his fellow Carolinians, the potter avoided cities like Wilmington, Raleigh, Greensboro, or Asheville, preferring instead the quiet villages of Coleridge, Erect, Whynot, and Seagrove in the eastern Piedmont; Blackburn, Jugtown, and Henry in the Catawba Valley; and Candler or Weaverville in the Mountain region. Such hamlets provided a reassuring, stable world, one filled with familiar people, common tasks, and shared values. Here life changed slowly. New ideas and practices were only gradually integrated into an existence attuned to the eternal cycle of the seasons and shaped by a pragmatic wisdom informally transmitted from one generation to the next.

Within these small, rural communities, pottery making was an accepted, sometimes obligatory way of life. Reflecting on earlier times in Lincoln County, Howard Bass emphasizes that "everything was pottery in here then. If anybody went out to work other than with a hoe or a plow, that's about what they had to work, was in a ware shop."[2] While there were other choices, many young men opted for this craft because it provided a reasonable supplemental income to the inevitable farm work, and for some it offered a rare outlet for self-expression.

The training of the future potter began at a very early age, and the key teaching institution was the family. All of the members worked side by side to ensure the success of their business. As Enoch Reinhardt well knew, "you had to work your wife, and if you had children, work them too. Taking the whole family. All the help you could get."[3] Sons watched their fathers kicking their treadle wheels and then imitated them by turning "toys"—miniature jars, jugs, and pitchers. Through the family the craft was perpetuated,

Figure 8-1
Mr. and Mrs. Enoch W. Reinhardt in front of their home in Henry, Lincoln County, ca. 1935. Courtesy of James and Irene Gates.

Figure 8-2
Irene and John Reinhardt, the children of Enoch and Mae Reinhardt, ca. 1934. Courtesy of James and Irene Gates.

commonly for several generations, but sometimes—in extreme cases like the Cravens or Coles—for two centuries.

At one time or another, the children had to perform virtually every task except for turning. As a boy, Enoch Reinhardt worked for his father and uncle, Pinkney and Jim. "I was hauling wood, grinding clay, beating those cinders, help putting the kiln of ware in, help taking one out, carrying it out to dry, and all that stuff, you know. They was always a job. You go around a potter's shop, you had a job. You didn't lay down under a shade tree."[4] Enoch's description of his youth suggests that he lived in a state of perpetual motion, but it is hardly an exaggeration. Children did work long, hard hours, both out in the fields as well as around the potter's shop. And Enoch's daughter Irene had to work just as hard for her father. "In the summertime they would set the pieces out on little, flat boards to dry in the sun. And if it would come up a cloud, there was quite a scurry getting all those things in. . . . Didn't want them to get wet, so we'd pitch in and help a little that way. But usually we were hoeing cotton or something, until the time came that we were needed. And then we helped out."[5] Figure 8-2 shows Irene and her younger brother, John, proudly posing with a fresh stock of jars, churns, and pitchers that they had no small part in making.

The most common children's activities were grinding the clay and making up balls for the turner, helping to prepare the glazes, cutting and hauling the

wood, and lugging the pots—both the green and finished ware—in and out of the shop and kiln. Sometimes a young worker was pushed to the very limits of his strength and ingenuity. At Brown's Pottery, Charles Brown remembers having to assist his great-uncle Javan, one of the fastest turners in the business.

> "Uncle Jay was working here, and they put me to making balls for him, twenty-five-to-thirty-pound balls. Now, Uncle Jay was a little man, five feet, four inches tall, weighed about one hundred pounds, and wore a shirt and a tie to turn in all day long. He was seventy-two or something, and my whole train of thought was, 'I'm seventeen and I'm going to work him to death. . . . I can do it.' By dinnertime I thought they were going to have to carry me out. He killed me. There's no way a man could have made balls and kept up with him. He had to wait on me. I put sticks or rocks in them to slow him down, and then he'd have to stop and pick them out of the ball. That'd give me thirty maybe forty seconds. . . . He could make all day long."[6]

Not all the tasks were so demanding as this. Far less strenuous, according to Ernestine Hilton Sigmon, was encouraging the mule or horse to walk his endless rounds and grind up the clay. "When he got this clay, they put it in a horse-drawn mill, . . . and it was our job—at least one of us; not more than one because children can't get along together—it was our job to keep it pushed down at the right spot and keep the horse going."[7] Figure 8-3 shows young Paul Leonard, son of pottery worker and salesman Vernon Leonard, supervising the mule at one of the shops near Blackburn, Catawba County, not far from Ernestine's home. The mule *does* appear to be in motion—his left front foot is slightly ahead of the right—but the attitudes of Paul and the attendant chicken hardly suggest a scene of vigorous activity. However, operating the pug mill was not just a matter of standing around and watching for an hour or so. The children had to draw the water to temper the clay and give the animal an occasional drink. Clara Ritchie Wiggs made many trips to the well—"we had a bucket and chain and a windless"—to provide water for old "Zeb," who is shown in figure 3-9. And when the pottery was not in operation, she had to draw still more water to do the family washing in the big iron clothespot.[8]

Preparing the glaze ingredients was a more arduous chore, particularly if the glass or cinders had to be pulverized by hand in a mortar or springpole beater, as described in chapter 6. More fortunate were the Hilton children, whose father, Auby, built a glassbeater in the branch below their shop. "It was our job, us kids, we had to go down, and we'd sift that glass which looked like flour. It was as fine as flour, and we'd sift it and bring the sifting back to the shop and put the larger pieces back in. And it would beat it, and it took it, I guess about, we did it about once a day. It was a continuous thing."[9] No doubt the luckiest children were those in the eastern Piedmont,

Figure 8-3
Paul Leonard at work grinding the clay, Catawba County, ca. 1939. Courtesy of Mr. and Mrs. Raymond A. Stahl.

where the salt glaze was used. At most, they had to beat up a sack of frozen salt when their father was ready to burn. But there was still plenty for them to do, such as gathering the cordwood to fuel the fire.

Burl Craig, in fact, first got into the pottery business as a boy because he had cut a load of wood that he wanted to sell. "That's how I got started. My daddy cut a yard of timber up here where we lived and sold some lumber. There was a lot—you know how it will break down some. The laps and the tree tops and all was left. I worked it up into cordwood with the idea of selling it either to Jim [Lynn] or Sam Propst or somebody. . . . One day I was down in the woods there cutting wood, and he wanted to know if I wouldn't go in with him now, as partners, in the pottery business. I said, 'How do you want to work that, Jim?' He said, 'Well,' said, 'I'll give you half the profit. . . . I'll do the turning till you learn.' And says, 'We'll use this wood!'" Jim was in his late fifties by this time and had no one to help him. Moreover, as Burl adds with a sly grin, he "didn't have no money to buy no wood with," even though a cord of wood would have cost no more than a dollar at this time.[10]

Normally the potter's sons would have cleared the new ground and split the wood, but if he had no one to help he would naturally turn to a neighboring family. Clara Ritchie Wiggs was an only child (fig. 8-4), and so her father, Bob, had to hire workers for both his farm and his pottery. "Different boys maybe in the community would help. My father always had extra help. . . . Back then a boy or man or anybody that farmed, they were anxious to get an extra day's work."[11]

Perhaps the most common job for children of all sizes was simply toting the wares through the different stages of their manufacture, from initial drying and glazing through loading and unloading the kiln. From an early age, the children had to learn how to hold the greenware properly so that it wouldn't break or lose the soft coating of glaze. Naturally there were accidents. Braxton Craven was warned that he "better not break nary a piece of it." Sometimes, however, he did, and then his father, Daniel, would "talk to you a little the first time. Don't know what he'd do the next!"[12] Jeter Hilton, however, had a better strategy. When he or his sister cracked a jar while

Figure 8-4
Robert, Emma, and Clara Ritchie in front of their hall-parlor house, Catawba County, ca. 1914. Courtesy of Clara Ritchie Wiggs.

loading the kiln, they would first check to ensure that no adults were looking, then smash it into small bits and bury it in the nearby claypile.[13] No doubt such minor disasters resulted from weariness or the desire to carry what Clara Wiggs termed a "lazy load." She adds that, "I carried a whole lot so I wouldn't have to go back the second time. Children were busy. I'd be so exhausted at the end of the day."[14]

Yet another hazard in loading the kiln was the little "drips" where "the glaze dripped down on the brick when the brick melted." Ernestine Sigmon explains that "those little things hit you on the head and it hurt. And they'd break off. But we had to carry it in, and we had to be very careful."[15] Finally, Mamie Bass Ellis recalls the agonies of unloading the kiln, caused by the sharp quartz fragments that covered the kiln floor. "I have scars on my knees right now where—when they take it out of the kiln there'd be cinders [quartz], I guess you'd call it, down on the bottom. . . . It's a wonder I didn't die—they'd put soot in those places to keep them from bleeding."[16]

For many young men this drudgery provided the stimulus to seek another occupation. But as Burl Craig recounts, options were limited. "Farm work and saw mill, that was all. You couldn't go to a town. There wasn't no factories in Hickory at that time'd amount to anything. And you couldn't buy a job in a factory or anything else. It was just either pottery or saw mill or farm." As for the numerous general stores that dotted the countryside at the time, "they didn't hire any help. They, that was a family operated thing, the stores were. And if you went into business for yourself, you had to have, back then, even then, you had to have money. A man or a boy just starting out, why, . . . there wasn't no way in the world you could get money enough."[17]

Virtually everyone was involved in farming—that is, in producing crops and animals for home consumption, along with a small surplus for sale. "That helped," affirms Burl. "If you could sell four or five bales of cotton in the fall, and get a little extra money, that bought you fall clothes, your winter clothes." Even the most successful potter farmed, because the craft did not produce enough income to sustain a family. But as Burl continues: "That farming is a gamble, gambling game. I done pretty good here—I made pottery and farmed, I raised cotton. And me and my wife picked what we could of it, gathered what we could. And then we'd hire people to help. And I made pretty good; it was a pretty good price. Then the boll weevil come along, it eat up the cotton that year." And so Burl tried a new crop. "I planted me about fifty acres of corn. And we had a [scorching] summer about like we've had this year, and didn't make nothing off of the corn. And I had enough money to buy the fertilize that I put under it when I planted it. But I went in debt for the sody [soda] that I topdressed it with later on. And I wound up over yonder at Broyhill's Furniture Plant at Newton, working out and paying for that sody. And I said, 'To hell with that!' I said, 'No, that's not for me. That farming's not for me.'"[18]

Farming was always a gamble and subject to the whims of nature, but there were innumerable small saw mills operating in the Carolina forests that offered steady wages for a strong back. Burl, however, found nothing appealing about this line of work. "No, I didn't like it. That was one reason I stuck with the pottery business. That was harder work than making pottery. You was, you could set down and rest if you got tired in working piece work. . . . [But] they wanted you to keep rolling about ten, eleven hours a day. Pay you a dollar a day, they thought they ought to work the hell out of you." Moreover, "that wasn't good money. I thought after I got into turning the pottery and could turn out a hundred gallons [a day], I thought, 'Now, man, I've made the money today.'"[19] At the normal rate of two cents per gallon, Burl could earn twice as much money in a pottery shop as he could in the forest.

The pottery business, then, was relatively stable and risk-free, and provided a better-than-average income, combined with more flexible working conditions. But another factor was the matter of individual temperament. Despite all these apparent advantages, some young men still avoided the craft. One such was Carl Chrisco, who allows that "I could turn a gallon, two gallon piece, but I never did make a turner. I didn't like it. It didn't appeal to me too much. Saw mill sounded better to me."[20] Carl's choice of sawmilling was a deliberate one—he preferred to work in the open woods rather than turning "mud" in the cramped confines of the potter's shop. For other young men, however, the many youthful tasks around the pottery—as strenuous and repetitive as they were—provided superb training for future potters. What was needed, along with the full opportunity to learn, was the proper disposition—to some extent, a creative impulse—to become fully engaged in the craft.

Although it is difficult to describe, some sense of this involvement is provided by Burl, who as a first-grader would run off to watch the potters at Lawrence Leonard's shop. "We'd run off—or I would, me and another boy. We'd run off from school and go down and watch Will Bass turn—from the old Ridge Academy schoolhouse down there. . . . We got an hour then at noon, let out an hour at school, you know, why I'd go down there. And sometimes I'd run off and go down there, watching them turn. That fascinated me. . . ." Although early absorbed in the potter's art, Burl had to wait another eight years or so to develop his interest. Then along came Jim Lynn, who coveted Burl's woodpile and proposed a partnership. "This is what I told him when we started. I said, 'Now, I want to try it this winter.' I think it was along, maybe in October, maybe the last of October. I said, 'Now I'll do this, Jim, I'll try it. And if I'm not able to turn something or make a little money out of it by next spring, cotton planting time, I'll have to stop and help my daddy farm.' And by the next spring I was turning out some saleable stuff. I wasn't the best turner in the world, but, you know, I was setting my stuff out with him, with Jim, and selling it—two gallon jars, three gallon

Figure 8-5
Burlon Craig in a pensive mood
while glazing a kilnful of ware,
1979.

churns, stuff like that." When asked why he wanted to go on after this apprenticeship, Burl conceded, "Well, I had the bug, then."[21]

The theme of economic necessity runs through Burl's account. He *had* to make money at the craft; otherwise it was back to cotton farming with his father. But it is wrong to suggest, as some have done, that southern potters were potters because they had no viable alternatives. In a brief study of the Brown family of Arden, North Carolina, and the Meaders family of Cleveland, Georgia, Robert Sayers concludes that "anyone to whom pottery had 'got' at the age of five or six was probably pretty well stuck until more glamorous occupations coupled with a decline in the craft's utility came along." Sayers sees the craft as essentially moribund—it was "held captive to a limited and poorly-championed technology, a slow inflow of new ideas, a local market which demanded a specific utilitarian ware for home use, and a unique social and cultural tradition that placed severe limits on male members of the family."[22]

While it would be foolish to take the opposite romantic extreme and argue that men like Burl were innate "artists" with pottery making "in their blood," Sayer's economic determinism is too one-sided and does not fit the facts. Clearly Carl Chrisco chose sawmilling because he liked working in the woods; he had no desire to continue as a potter, even though his father Henry's shop was readily available. Even more important, Burl's account of his beginnings reveals that he saw something more in the craft than just another job. His choice was also a deliberate one and yielded almost imme-diate satisfaction. "I never will forget the first two gallon churn I turned and set it out with Jim's. I never will forget that as long as I live. I was really proud of that."[23]

For young men like Burl, pottery provided a degree of personal pride and satisfaction that could not be found in sawmilling or raising cotton. It was no less hard work, but it was also an outlet for self-expression and, within traditional boundaries, creativity. Even today, Burl readily affirms that "I still, I still if I make a nice burn and set it out and look at it, I get a lot of pleasure out of that. I get a lot of satisfaction out of that, knowing that I made it with my hands. I enjoy it. . . . Back when I was farming and making pottery, why, . . . things wasn't going too good, it come a rainy day, I couldn't work on the farm. I'd come in here, and everything was just smooth. My nerves would just calm down, everything just lovely. Get in here on this wheel. . . . I think a lot of the old-timers felt the same way that I talked to. A lot of them done some farming, but they didn't enjoy the farming like they did the pottery."[24] Burl's eloquence on his craft serves to clarify the choices made by so many others. How else can one explain whole families like the Coles or Cravens, who have followed the potter's way through some nine genera-tions? Clearly they examined alternative occupations, but a greater number caught the same bug as Burl Craig and took on the challenge of learning to turn.

Turning is the pivotal skill of the potter; Burl frequently avers that it is his favorite task, the one he finds most pleasurable. Like the other, more general chores, this special ability was also acquired through informal, on-the-job training, usually between father and son or neighbor and neighbor. Ben Owen describes working under his father, Rufus. "I'd help him knead up his clay—weigh it out and knead it up—and help him lift his jars off. And when he'd be doing something else—putting on handles or something else—I'd be trying to make me some little jugs and pitchers to sell. . . . Oh, I must have been, before I could make a gallon piece or anything of any size much, about sixteen or seventeen. Because we used to do some farming, and then I had to go to school, you know. So—they didn't work at it steady like the potters do now."[25] As Ben makes very clear, there were no schools or formal classes, no textbooks, no fixed routines to follow. Instead, the aspiring turner stayed near his teacher, watching and helping, and taking every opportunity to try his hand when the treadle wheel was free.

The bulk of the turner's skill came from long hours of practice when no one was in the shop. Ben's brother, Joe, even maintains that "I just learnt myself. I'd just—when he [Rufus] would quit turning every evening, I'd get me some clay and fix it up and get in there, just play with it till I just learnt myself." Of course, Joe does qualify this—he allows that Rufus "was around there all right, and maybe [would] tell me things; yeah, sure, he'd do that."[26] And his experience is seconded by Burl Craig, who recalls that Jim Lynn would "be turning, maybe; he'd quit and come over, and he'd watch me. He'd tell me what I was doing wrong. . . . [But] most of the time I would work at it when he was gone. Gone to eat dinner, gone to the house for a cup of coffee or something. I'd get me a ball of clay and try it when wasn't nobody around."[27]

To those accustomed to the highly formalized patterns of learning in schools and universities, these accounts may appear to border on the incredible. But within a folk culture, knowledge and skills were transmitted through oral transmission and imitation, just as described above. Moreover, there was no set schedule for these "classes"; such training occurred when it was convenient for both potter and apprentice, and the "lesson" for the day depended entirely on the particular forms needed to fill the current orders.

Having learned to center and control the clay, most young boys began by producing miniatures of the utilitarian wares their teachers were making. Charlie Craven "studied" under his father, Daniel, in northern Moore County, not far from Ben and Joe Owen. "I started making little stuff when I was about nine or ten years old. Maybe little jugs, little pitchers and stuff like that. Just something. He made stoneware altogether, practically altogether, and I just made little, we called it 'toys,' to go in between it when we burned that."

He soon found that he could sell these toys to the local wagoners, at first

for three cents, later for five cents and sometimes more. It was a good way to "make a little change, you know; you have a little spending money, if your daddy didn't keep it." However, Daniel quickly realized the value of Charlie's work, particularly as he himself was sometimes getting as little as four cents per gallon from the wagoners for his full-sized wares. And so he kept after Charlie to make more, which created problems for a young and active boy. "I was working one day, and he wanted me to make some little stuff. And I wanted to go fishing so bad I didn't know what to do. So I started tearing them up. I finally told him, I said, 'I can't make one.' And so he said—well, I reckon he sensed what I was a-doing—well, he told me how many I had to make before I quit. He said, 'If you can tear 'em up, you can make them like you ought to. When you get that many made, you can quit.' I didn't tear up no more! I didn't get to go fishing either!"

Like many fathers, Daniel Craven actively encouraged his four sons to follow his craft. Charlie adds that his father "had an extra wheel, and I knew that he was hoping that some of us would learn. Because that's the reason he had the wheel. And so every chance I got I was on it, working."[28] And Daniel's efforts were well rewarded. Two of his sons, Charlie and Ferrell (fig. 8-6), became highly skilled turners, and a third, Braxton, remained in the pottery business until the late 1920s.

Usually somewhere around his mid-teens, the young turner graduated from toys to the larger wares. And here, too, he followed a quite standard path of development, working his way up to the more complex forms and larger sizes. Burl Craig describes this potter's progress. "A crock is about the easiest thing to start. The first—I think I've got the first piece that I ever burnt. It's a little crock about that high and so wide. A low, wide piece is about the easiest thing to turn. . . . Then you get into your jars, and then your jugs, later, you know. Jugs is a little harder to turn than a jar."[29] Burl does indeed own a half-gallon milk crock, shown in figure 4-3, that he turned very early in his career. Although once inordinately proud of it, he now recognizes that the walls are much too thick and the rim too thin; moreover, the glaze was slightly underfired, and the clay blistered badly.

Once he mastered the simpler, open forms like dishes, bowls, milk crocks, and flowerpots, the potter moved on to more closed wares such as jars, churns, and pitchers. Churns and jars required carefully molded rims, the former with a flange inside for the collar, and all three forms required strap or ear handles as well. Surprisingly, the ubiquitous jug—more than any other piece the hallmark of the folk potter's trade—was the most challenging, as considerable skill was needed to pull up the extra clay to close the shoulder and form the narrow spout.

The potter's initial attempts to produce these basic forms were modest in size, normally in the one-gallon range. Then he began to add more clay. "The way you got to do is keep going up, you know what I mean?" advises Burl. "Start with one size and then when you master that pretty good, go to

another size and keep going on up. The reason a lot of people never learn to turn larger stuff, they never try it, I think, not enough. You got to keep trying and see what you can do." Most of the utilitarian wares ran from one to five gallons, though eventually the potter might have to answer calls for ten- and even fifteen-gallon jars. As Burl continues, when "you get up to where you can make a pretty good size, then you want to start capping, you know, learn to make the two-piece stuff, the bigger stuff."[30] Generally, the turner could be said to have reached the first level of competence when he could produce all the standard wares in sizes up to five gallons. Of course, most young men felt they were "master potters" much sooner than this. Charlie Craven confides that "I got to where I could turn a churn, and so I thought I knew all about it!"[31]

Given the varied backgrounds and experiences of men like Ben and Joe Owen, Charlie Craven, and Burl Craig, it is clearly impossible to designate the specific length of time necessary to become a mature turner. As Ben Owen points out, he had to go to school and to farm; thus it took many years, perhaps six or seven, before he made the full-sized pots. Burl Craig, on the other hand, was not born into a family of potters. Instead, he started at a later age with his neighbor, Jim Lynn, skipped the making of miniatures, and was able to turn rough but functional pieces in about six months. Burl was once asked if five years would be enough time for an average person to learn to turn. He quickly responded that he could teach "an idiot" in that length of time, and a minute later added: "Make that a *retarded* idiot." In an equally facetious vein, Jack Kiser, who worked at many shops in the eastern Piedmont in the 1930s, recounts how he learned. "I didn't know it was hard to do so I just—old gentleman [Walter Lineberry] up there put up a pottery and showed me how it was turned. And he couldn't turn, so we went to turning pottery. It was always—you know, people, they told you, it's too hard to learn, it'd take you years. But if you didn't know it was so hard, you could learn in a few weeks."[32]

With considerable humor, both men provide a healthy corrective to the prevailing notions that one can only become a potter after completing a seven-year apprenticeship or a master's degree in fine arts. In the more flexible world of the folk potter, such rigid time periods have little meaning. But there were a number of important, widely recognized qualities that signalled a full mastery of the treadle wheel. And the potter only achieved these after many thousands of gallons of jars, jugs, and pitchers had been cut off his headblock.

The first mark of the mature turner was steady output. Many men, according to A. R. Cole, worked for years as journeymen. "Some folks didn't do nothing but turn on the wheel and go from one shop to another working this way. This was their job, just turning. They never helped with any of the other work like grinding clay or digging clay."[33] Their main task was to turn, and they could concentrate on producing large quantities of greenware. Enoch

Figure 8-6
Ferrell Craven finishing off a candle-stick at the Old Plank Road Pottery, Moore County, ca. 1965. Courtesy of the North Carolina Division of Archives and History, Raleigh, N.C.

Reinhardt notes that "there was a lot of them throw-turners who came through here, that could really throw that stuff out, like old man [Poley] Hartsoe. We got him over here in the wintertime one time to turn for us; he filled that thing [shop] up down there in a day or two. You couldn't walk! He'd get out two hundred gallons a day or more."[34] More commonly the turner had to help with the other tasks—and he also had to make handles and tops for many forms—so that on average his output was far below Poley's two hundred gallons a day. Most potters would agree with Ben Owen that "if a man turned a hundred gallons, he's done a big day's work. . . . A hundred gallons of ware's a lot of pottery."[35]

The most reliable evidence of what a potter could produce over a long period of time occurs in the account book of journeyman Curtis R. Hilton. An unusually meticulous man, Curtis kept a day-by-day record of his activities from 1900 through 1906. In 1905, while working for his brother George and Uncle Seth Ritchie at Houstonville, Iredell County, Curtis recorded his work as follows:

Month	Days Worked	Gallons
Jan.	16	1107
Feb.	½	35
Mar.	20	1887
Apr.	19¾	1737
May	23½	2030
Jun.	21¾	2112
Jul.	20	1837
Aug.	21	1884
Sep.	16	1622
Oct.	21½	1619
Nov.	15¼	1008
Dec.	8	559
		17,437
		8,718
		$261.55 [@1½¢]

This is merely the final tabulation. Each day of each month is dutifully entered, so there can be no question about the reliability of these figures. In 203¼ days at the pottery, Curtis thus averaged 85.8 gallons per day. The steadiness of his work is also reflected in the daily totals, which show that he rarely turned over 100 gallons and that his record for the year was but 135 on 15 March.[36]

While shopowners hired men like Poley Hartsoe or Curtis Hilton for their consistency and their ability to keep the shop filled with greenware, they also admired a turner who made economical use of his resources. As Burl Craig explains, "what they classed as a good potter around here when I was learning, the old-timers, was a man could turn it out reasonably thin and have a pretty nice shape, you know, not ridge it up and rough; smooth it out pretty smooth and turn it out reasonably thin."[37] In part, Burl's judgment appears to be aesthetic—the pot should have a "nice shape" and be "pretty smooth"—but there is a more pervasive practical concern here. A good turner uses the proper amount of clay for the size he is turning and takes care to ensure that he pulls up walls that are "reasonably thin."

The man who added an extra pound or two of clay to every jug and jar created unwarranted work for those who went to the claypits and supervised the pug mill. In effect, he lowered the efficiency of the pottery. Those who

were thus wasteful often invoked the scorn of their coworkers. Howard Bass characterizes one man at his grandfather Lawrence Leonard's pottery as "one of the roughest turners there was in the country," adding that "he just hogged it on up!"[38] Likewise, when some of the old-timers encountered the hefty, thick-walled Georgia pottery that was sometimes sold in the western Piedmont and the Mountains, they are said to have sneered, " 'Hell, that ain't pottery. That ain't a damn thing but a ball of clay with a hole punched in it.' "[39]

Certainly there were many skilled potters in Georgia, but some of the wares made early in this century do merit some criticism on the grounds of economy. Figure 8-7 shows a pair of two-gallon churn-jars by Burlon Craig and Ben S. Salter of Delray, Georgia, who was born about the middle of the nineteenth century and died in the 1930s.[40] Although virtually identical in size and capacity, Burl's pot weighs only ten pounds to Salter's fifteen. Potters from Georgia, as well as from South Carolina and Texas, turned in Buncombe, Wilkes, and Burke counties, and the Salter piece well illustrates the salient qualities of their work: heavy, straight walls; narrow but thick ear handles (often turned on the wheel as shown here, rather than pulled); and Albany slip glazes. Although turned in North Carolina shops, such vessels are readily distinguishable from those made by the native-born potters.

Together with consistency and economy, the turner was also judged on the relative neatness of his work. Even the quality of "smoothness," as cited above by Burl Craig, is primarily functional. If the walls were irregular due to finger grooves or improper use of the chip, the glaze would adhere unevenly, possibly even resulting in leakage when liquids were stored in the pot. Moreover, such rough surfaces—"rough" is frequently employed as a derogatory term—were hard to clean, making extra work for the housewife, who regularly scoured her crocks and jars. As purchasers, "the women were more particular than the men. . . . If you had to wash something every day like you did a milk crock, you'd want something pretty smooth." Thus, Burl continues, "you would see the women especially run their hands down inside a jar, to see if it had a good, smooth glaze. . . . And they always tried to get a good, slick, well-fired milk crock, and a pitcher the same. For that was something they was going to use in the house, the kitchen."[41]

Consistent output combined with prudent use of the clay and relative neatness, as opposed to roughness, in finishing off a piece were the marks of a mature turner. The folk potter was a production potter. He had to turn out the gallonage quickly and economically, and he could not spend excessive time in pulling up his forms, trimming the walls, or adding embellishments. Periodically he had to fill up that big groundhog kiln; and there were many other demands on his time as well, both from his family and his other occupations.

There were some potters who regularly exceeded the normal standards. Some men, of course, were more gifted than others and could produce

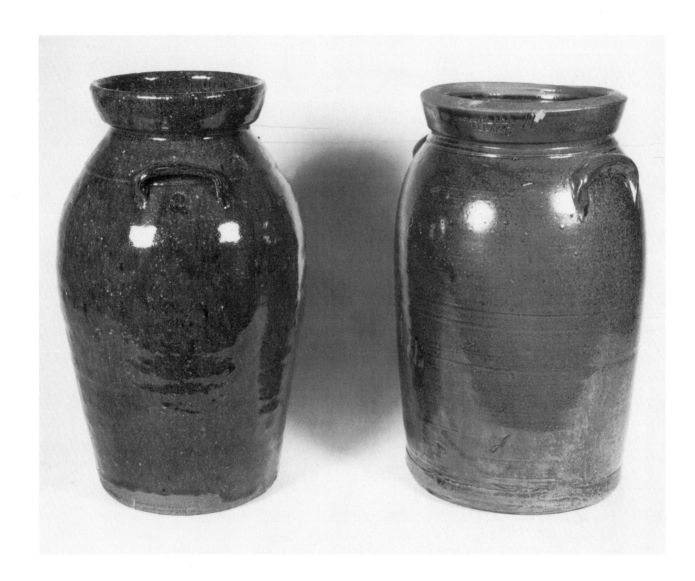

Figure 8-7
A contrast in clay usage: two two-gallon stoneware churn-jars by Burlon Craig and Benjamin Salter. Left: 1978, Henry, Lincoln County. H 14⁷/₈", C 17³/₈". Stamped: "B. B. CRAIG / VALE, N. C." Right: ca. 1900. H 14¹/₂", C 17¹/₂". Stamped: "B.S.SALTER / DELRAY, GA."

flawless masterpieces or giant jars, but these were abilities that went beyond necessity. In the eastern Piedmont, Henry Luck is said to have used his chip on the inside as well as the outside of all his forms. Herman Cole recalls that "he was the only man my Daddy said he ever knew that would put a chip on the inside and bring it up leaving the inside so smooth. He was a good turner. Nobody hardly ever used a chip on the inside—just on the outside."[42] And in like manner, Burl Craig and others in the Catawba Valley frequently extol the work of Samuel Propst (fig. 8-8). "Sam, I guess, was about the best turner of all, as far as uniform [shape] and turning it out top

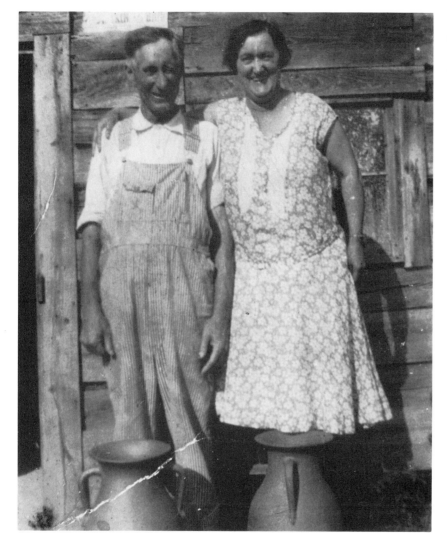

Figure 8-8
Sam and Blanche Propst, Henry, Lin-
coln County, ca. 1930. Courtesy of
Hazeline Propst Rhodes.

to bottom the same thing. I'd have to give him credit; . . . I'd class him above myself! Yes, I would, I'm not kidding. Now he didn't turn out an awful lot, but what he turned. He could turn out a board full of five gallon jugs or jars, set 'em on a long board, and I'll bet you there wouldn't be more than a matchstem difference in [height in], say, five or six."[43] Sam's son Floyd, also an outstanding turner, adds that his father "was a kind of perfectionist. Well, he was known as the best, because he had to have it perfect or it was just—he just wouldn't have it. I mean, there's that much German in him, I guess."[44]

Luck and Propst were not the only ones with a bit of "German" in them. Others whose surviving wares also consistently exhibit the hand of the "perfectionist" include the members or apprentices of the Fox and Seagle families. Virtually every extant signed piece from either group manifests a careful attention to both essential form and surface detail, a self-consciousness and precision that surpasses the work of most of their fellow potters.

One other skill that was often admired was the ability to turn abnormally large pieces. Perhaps because the craft was almost exclusively the province of men, a ten- or fifteen-gallon jar (fig. 8-9) symbolized extreme virility, a macho creation. As Burl Craig explains: "They would turn a big piece, you know, they would brag about it. Naturally, the man thought he was turning the biggest piece in the country, why he'd have to brag a little. But the old-timers, like Jim Lynn and Will Bass and them, they never did do much any bigger than a six, a six gallon size."[45] The massive jar by Henry Heavner in plate 15 illustrates the upper limits of the folk potter's aspiration and technology. Measuring nearly 2' high and 4½' in circumference, it was turned in three sections. Most likely it was a presentation piece or some sort of advertisement for the pottery, because each handle is decorated with lime-green runs of glass, and the pot bears an unusually elaborate inscription: "H. H. HAVNER'S MFG Co. / The Best / MFG. Co. / in the US / In God we trust H. H. and R. P. Havner / Champion."

To create such a huge pot required special strength and skill; it was a type of one-upmanship that a potter might use to assert his superiority over his neighbor. At the same time, as Burl makes clear, capacities over six gallons were not a common part of the folk potter's repertory. They were difficult to turn, often requiring a large headblock, a second wheel for one of the caps, and a partner to kick the treadle while the potter reached down inside to close the seams. They were also extremely precarious to glaze and then to inch through the loading port into the groundhog kiln. Finally, they were anything but portable when filled with sauerkraut or the better part of a hog.

In praise of extraordinary potters like Sam Propst, Burl Craig affirms that "he was the kind of man that took pride in his work. A little more pride than some of them did." In part he could do so because he ran his own pottery shop. "He was working for himself, too. A lot of the turning was done, was hired by the gallon. And naturally a man that was working by the gallon didn't take as much pains with it as a man that owned his own shop."[46] Thus, a perfectionist like Sam Propst or a virtuoso like Henry Heavner could take the time to produce work of great quality or stature, and thereby reap the praise and admiration of their peers. But in a very real sense, they paid for their special skills. Potters, explains Burl, "might take a whole kilnful to one place or something, and it all went for the same price. It wasn't—they wouldn't pay any more for Sam Propst's than they would mine or Jim Lynn's. People went by the gallon."[47] Because he was so meticulous, Sam necessarily worked at a slower pace than the hired journeyman who would fill the

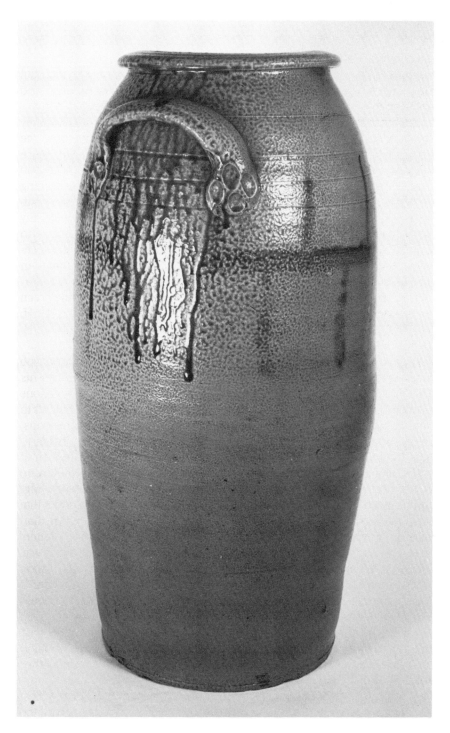

Figure 8-9
Salt-glazed stoneware jar, ca. 1850, attributed to John A. Craven, Randolph County. H 25³⁄₈", C 40¹⁄₄", about 15 gal. Collection of the Ackland Art Museum, University of North Carolina at Chapel Hill, Ackland Fund.

shop as quickly as possible. But for all his extra efforts in forming or finishing a piece, Sam received the same standard rate for his wares as did the journeyman. The simple result was that he earned less money.

Burl Craig has never forgotten the advice he received while working with Floyd Hilton. " 'Don't make any difference,' [he] said, 'Just so they hold about what they're supposed to and got a good glaze on it.' Said, 'People's gonna set 'em in the smokehouse or cellar, and nobody'll ever see 'em anyway.' "[48] The folk potter had to sell his wares, and he recognized the conditions of his marketplace. "When you took it out of here to sell it, why, that man looked at the size of it and the glaze that was on it." That was it. The aesthetics of the pot—its formal beauty or its decoration—had little relevance or meaning in this eminently practical world. In fact, Burl declares that "I never heard any of them ever say anything about the shape of a piece of ware in my life, a merchant that was buying it."[49] If twenty-five gallon jugs came out of the same kiln, they all went for the same price, provided, of course, that they would hold the proper amount of vinegar or molasses.

Probably the capacity of the pot was most important. If a prospective purchaser "thought he was getting full measure for a five gallon or a two gallon or a one gallon piece, why, he'd buy it." Generally the potters tried to ensure that their wares were slightly over the rated gallonage, but sometimes a merchant would challenge their work. Burl recalls one trip to Wilkesboro with Jim Lynn, when a storeowner threatened to measure their jars. "Old man Jim said, 'I'll guarantee you it'll hold five gallons.' Says, 'If it'—says, 'I'll tell you what I'll do.' Said, 'If you'll fill that up and if it don't hold five gallons, I'll give you a dollar for every spoonful it lacks. And if it holds, you give me a dollar for every spoonful it holds over!' The old man filled it up, and it took it up in the rim, a little, you know. It held it. But it went about half way up in the rim. And the old man said, 'It ought to hold five down here.' Jim said, 'Why the hell should it?' Said, 'That's part of the jar; it *held* it!' Old man, he just laughed and took a bunch of them, bought a bunch of them."[50]

Next to the proper volume, a smooth, even, well-fired glaze was essential. Although this particular chore was often taken for granted, Burl makes the surprising declaration that "glazing is the most important thing in making pottery, I think. A lot of people can turn, make some stuff, and don't know how to put a good glaze on it." The women who used the ware on a daily basis and the merchants who purchased it in quantity could prove sharp critics. Many of the old storeowners "could tell—they could spot a nice glazed piece, or I've seen them set some back that didn't look so good. . . . Sometimes the glazing would be real thin, and the clay would show through. And some of it didn't get slick." In Burl's opinion, "old man Seth Ritchie actually was the best glaze man I ever saw. Every kilnful was alike, I mean the glaze on it. It was just right—it wasn't too thick, it wasn't too thin. And

every kilnful was alike. He was just like, by his glazing like Sam [Propst] was by his turning."[51]

A critical part of the folk potter's education, then, was to recognize and respond to the realities of his world. His wares sold if they were useful and did what they had to do. Extra flourishes were sometimes appreciated and admired, but they possessed no practical value and usually cost the potter both time and money. And so above all, he learned to practice the cardinal virtues of consistency, economy, and neatness. Still there were exceptional potters—Nicholas Fox and John Craven and Henry Luck in the eastern Piedmont, or Daniel Seagle and Henry Heavner and Sam Propst in the Catawba Valley—men whose ambition and talent far exceeded the norm (plate 16). They were in the minority, but the quality of their work refutes the commonly held notion that folk pottery is by nature crude, heavy, repetitive, and merely utilitarian. The masterpieces of such men were true works of art, and they reveal what the folk potter *could* do—or *might* have done—in a world where "art" was expected and desired.

Reflecting on the old potters, Burl Craig once observed that "they could turn better than they really did. But I've heard this remark a lot: 'Ah, what's the use to spend a lot of time and try to make a nice shape if it sets in somebody's cellar or springbox. They don't know the difference; people don't know the difference.' Some of them looked at it like that."[52] Often adjectives such as naive or unselfconscious have been applied to folk artisans, but Burl's comments, taken with the works of a Seagle or a Fox, reveal that the potters knew exactly what they had to do and why. They were craftsmen first, not artists. In the very practical world they inhabited, they understood that perfectionism and virtuosity might sustain a potter's ego but not his purse.

Most skilled potters worked at a number of different potteries before constructing, purchasing, or inheriting a shop of their own. J. B. Cole, for example, worked for his father, Evan, at Cole and Company in southern Randolph County until the mid-1890s, and then hired out as a journeyman for the next quarter of a century. His son, Herman, recalls that "Daddy turned for a lot of different people. Sometimes he would go in partners taking half of the ware when it was finished. He turned for Little John Chrisco over at Yow's Mill and Suggs's pottery at Suggs Mill. It weren't nothing for him to walk eight miles to his job and work all day, then walk home at night. Some of the shops didn't make during the farming months, just in the fall and winter, and they'd come after my Daddy to turn for them. Then he'd fill their shop and go on to another one. He was no drifter—this is just the way he worked. This was his job—turning for other shops. He was a good turner, didn't leave thick clay in the bottoms like some did." J. B. also worked for J. D. Craven (Moore), William T. Macon (Randolph), Baxter N. Welch (Chatham), and even the Hilton family in Catawba County.[53] Finally, about 1922, he felt it was time to settle down and so built J. B. Cole's Pottery

Figure 8-10
Burlon and Irene Craig relaxing
amidst some of their progeny, 1982.

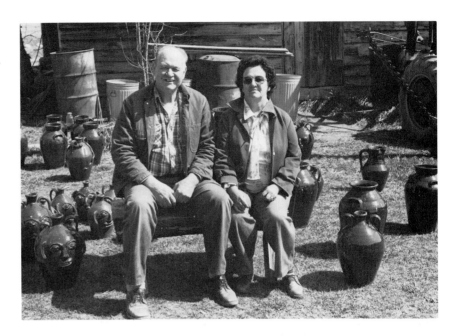

in northeastern Montgomery County, a shop that still flourishes under the direction of his children, Nell and Waymon. While J. B.'s odyssey was longer than most, it well illustrates the journeyman phase of the folk potter's education.

True to the general European and American tradition, the pottery business in North Carolina was almost exclusively a man's world. Wives and daughters were involved, certainly, and they worked hard. Hazeline Propst Rhodes allows that "I didn't turn any, but I had to work in it. Well, we would help glaze, and rub the bottoms, and help put it in the kiln. And when it come out of the kiln, of course, we had to help take it out of the kiln and knock the stuff off the bottoms."[54] Likewise, Irene Craig used to light off the kiln and stoke it by herself for the first five or six hours, until Burl got home from his job at a furniture factory (fig. 8-10). Then she would help him blast it off for the next several hours. But women never learned to turn, nor did they take a significant role in the other critical tasks. This is in sharp contrast to other cultures, such as the Native American or African, where women, not men, produced most of the pottery.

One obvious reason for the exclusion of women, according to Ben Owen, is that the work was too physically demanding. "Well, they thought it was a man's job. They done the housework and other things that had to be done. And the men worked at the pottery. See, you had to grind the clay, mix it and knead it up. And you had to turn it and you had to stack the kilns. And you had to cut a lot of wood to fire with. There's a lot of hard work. So they didn't

J. B. COLE'S POTTERY, STEEDS, N. C.

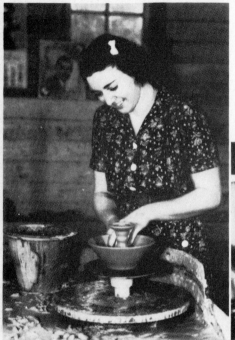

Nell Cole Graves and

Wayman Cole at

their pottery wheels.

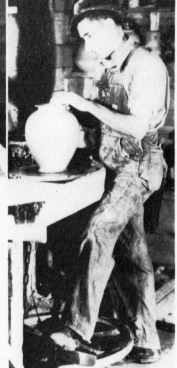

Earthenware

Boasting of our wealth and virtues rare,
What are we, but bits of earthenware?
Fashioned by the one Great Master hand,
Each one marked by that Great Maker's brand.
Some of us are fashioned tall and fair,
Vases for the mansion, Dresden ware;
Some of us as ornaments are prized,
Some of us are useful, yet despised;
Some of us are big pots lined with gold,
Some of us are mugs and bought and sold;
Some of us are broke—ah, that's a fact,
Some of us are not broke—only cracked;
Some of us are fashioned fine and true,
With every ray of sunshine gleaming through;
Some of us are coarse and chipped and stained—
Yet fragrant with the balm of love contained.

Earthenware, just earthenware, vessels of clay, just earthen-
ware;
All of us made by the one Great Potter;
Some of us as white as porcelain, some as brown as terra
cotta.
Earthenware, just earthenware, that the Master will repair
When we go to the clay that we came from, some day,
Broken earthenware. —George Wood.

2

Figure 8-11
*A page from the catalogue issued by
J. B. Cole's Pottery, ca. 1932. Cour-
tesy of Walter and Dorothy Auman.*

think it was women's work, I reckon. Well, now they use oil and electricity, see. And it's just much easier now. And then they get their clay already pulverized, mixed, ground. All they got to do is wet it up in some kind of a mill."[55] Ben's point is well taken. Indian and African women did not use the wheel, glazes, or high-fired kilns; hence, they did not have to cap ten-gallon jars, grind glazes by hand in a stone mill, or cut the wood and stoke a groundhog kiln for ten hours or more.

On the other hand, there is evidence to suggest that women could have taken on more of these tasks if permitted to do so. Irene Craig has helped Burl burn his kiln (in large part because their three sons are no longer at home). And during this century, there have been some outstanding women turners in the eastern Piedmont, among them Nell Cole Graves, Zedith Teague Garner, and Dorothy Cole Auman. Burl Craig still recalls his amazement many years ago at hearing that Nell Cole (fig. 8-11) was one of the turners at her father's shop. "I said, 'Well, I want to see her turn if I don't see nothing else.' And we went in [to J. B. Cole's Pottery]. And she was turning little sugar bowls and creamers. That's what she was making. And she was throwing them things out. She was fast!"[56]

Times have changed—the wares are smaller and the work is no longer so arduous—but an equally compelling reason for the earlier exclusion of women is that pottery was a business, and men controlled the purse strings. Traditionally, a woman's place was in and around the home. As Ben Owen put it, "they done the housework and other things that had to be done." And their tasks were many and important: tending the young children, making the clothes, preparing and preserving the food. The men also had their clearly defined duties. They worked the more distant fields and attended to the sale of cotton, corn, sweet potatoes—or pots—in outside markets.

Pottery was also entirely a white man's world. Although the black population of North Carolina has ranged between 23 and 38 percent over the last two centuries, only five black men are known to have worked at the craft.[57] The earliest was the Moravian Peter Oliver (1766–1810), a slave from Virginia who was purchased in 1786 by the Salem Single Brothers Diaconie for one hundred pounds in Virginia currency. From 1788 to 1795 Peter remained at the Bethabara pottery shop under Rudolf Christ and then Gottlob Krause. Peter was not a turner; he was one of a group of general "pottery workers," who "were neither apprentices nor journeymen, but men hired simply to do day labor in the pottery." In appreciation of his skills and character, the Diaconie set Peter free about 1795. He stayed with Christ another five years, and then retired to a small farm outside Salem.[58] During the same period, two young blacks are listed in the apprentice records: Moses Newby of Orange County and George Newby of Randolph County.[59] Like Oliver they would have worked in the earthenware tradition, but nothing more is known of their careers.

Finally, a century later, Rancy Steed was reported as a turner for Wright

Davis in Randolph County, and Eugene "Cooch" Dalton made ware along-side Curtis R. Hilton for George Hilton's shop at Houstonville in Iredell County. No identifiable pieces by either man have survived, but Curtis's account book does verify that between 27 February and 29 March 1906, Cooch Dalton turned exactly 984 gallons of ware.[60] Perhaps there were other black potters whose names are now lost, but the total would remain very small. Unlike South Carolina, where substantial numbers of slaves appear to have been potters, the North Carolina Piedmont had few large plantations where a black man might have received the training. And after the Civil War, such opportunities would not have increased; like the women, most blacks would have been denied any avenues that might lead to economic independence or success.

Primarily restricted, then, to white males, the full education of the folk potter required many years and the completion of a three-stage pattern of development: an apprenticeship with the family or a neighbor; journeyman work throughout the region; and finally, the establishment of his own pottery. There, as "master," he would set the cycle into motion again by training his children and neighbors.

From beginning to end, the theme of the family weaves through this progress. About ten years after he finally established his own shop, J. B. Cole produced a catalog to advertise his wares. In it he showed his children at work (fig. 8-11) and proudly affirmed, "I have made pottery all of my life, and so did my father before me. Then I taught my son and daughter, whom you see at their wheels. Later as business increased, extra workers were required. So I taught my two sons-in-law, making four moulders in all now."[61] Even for those who would not follow the craft, the common sense of purpose and unity of the family members proved enormously rewarding. Hazeline Propst Rhodes, daughter of the "German" turner Sam Propst, readily affirms that "I enjoyed it really. I guess it's because us kids were real close to our father that we would really want to be with him. And all of us would just—and even Momma—we were all out there helping."[62]

9

POTTERY AS A BUSINESS

When the experienced potter decided that it was time to set up his own shop, he first enlisted the aid of his family. As Ray Kennedy affirms, "Everybody worked; . . . it was a kind of family project, you know, kind of a family backyard business."[1] In North Carolina, pottery remained—in fact, remains—a true cottage industry, run out of the home and staffed by the family and neighbors. But the business often required more than the immediate family could provide; at least two men were needed to keep a shop in steady operation. Ben Owen emphasizes that when he and his brothers were young, his father, Rufus, had "another man [who] would maybe help him grind the clay and haul it and fire the kiln to get half of the pottery. You can't do it by yourself much."[2] Today Burl Craig works alone, but he does so by necessity, not by choice. "It makes it pretty hard when you have to do here like I'm doing now. It's pretty rough. About the time you get used to turning, then you got to get out and get wood, and you get your muscles all sore and stiff."[3]

Even with his wife and children to assist him, the shopowner normally sought out a journeyman—either a turner or a general worker—and established an informal agreement with him on the division of labor and profits. Like the apprenticeships, these were rarely formalized in print. However, one such document has survived, outlining the mutual responsibilities of Manley Robinson Moffitt and William Clay Routh.

> Articles of Agrement entered into this the 21 day of October 1867 betwen M. Robeson Moffit and William Routh each of the County Randolph and State of North Carolina is such that the said M. R. Moffitt doth bargain and agree to enter into Copatnership with Wm C Routh in the manufacure of Stone ware for the term two years and doth further agree to furnish Said Routh with a team to remove his family to & from the shops & furthe to furnish all the firewood & clay necessary to the business and two thirds of the glazing als Dweling House for said Rouths family with garden & potatoe patches and to keep up the kilns in good order also find a hand to help birn ware and Said Wm C Routh on his part doth bargaine and agree to perform the labor of turning burning board himself & furnish one third of the glazing for the term of two years and furthe we the Said M. R. Moffitt and Wm. C. Routh doth agree to divid the ware thus made at the kiln or Shops equual each

retain one half of the prodicts manufactured In testimomony hereof we set our hands and seals.[4]

This contract represents the simplest kind of agreement between the turner and the shopowner. Each provided certain goods and services according to their means and abilities, and so no salaries or payments were necessary. The Rouths had a place to live and could raise most of their food, and both men would receive a cash income when the pottery was sold. The 1870 Census of Manufactures for Randolph County indicates that Moffitt sold five thousand gallons of stoneware for $625. Thus the two men each grossed over $300 for their labors.

More commonly, however, the shopowner paid the turner a specific fee for the number of gallons turned. Burl Craig, who worked throughout the Catawba Valley during the 1930s and 1940s, recalls his stint with Seth Ritchie at Blackburn, Catawba County. "He furnished me a house to live in. I done some farming, too, and turned for him, . . . two cents a gallon for my turning. And . . . he got a fourth of what I raised on the farm. He had land wasn't nobody tending. . . . I set some sweet potatoes and sold them, raised some cotton, raised some corn, fattened me a hog or two, [and] I kept a milk cow." Under this arrangement, Uncle Seth kept all of the money from the sale of the pottery and shared in the harvest, while Burl gained a house, ample food, and a cash income from both the land and the pottery. Keeping track of his turning was a relatively simple task. "I had a book—I think it was advertising baking powder. . . . At the end of the day, why I'd count up what I'd turned, set it down in that book. Then when payday come, he'd add it up and pay me for the gallons I turned."[5] Burl adds that the work schedule was very flexible. He could take a day off when he wanted to, or plow when the clay was used up or on a Saturday. And he frequently asserts that Uncle Seth, who was then in his early seventies, was like a "father" to him, always ready to lend a truck or a team of mules or even some money.[6] Altogether this father-son relationship would have been quite different from that be- tween Routh and Moffitt, both of whom were forty-two when they joined forces in 1867.

After Uncle Seth died in 1940, Burl formed a different type of partnership with Vernon Leonard, a well-known pottery worker and salesman in the area. The two men rented Uncle Seth's shop—and later the nearby Hilton shop—with Burl handling the turning while Vernon took care of most of the other tasks. In particular, Burl recalls that "Vernon dug the clay, ground the clay. And I just turned—he paid me a extra penny for drying it." This was an unusual provision but one that made sense. Unlike Uncle Seth, Vernon was frequently out on the road peddling their output. As Burl continues, "You had to tend that stuff about every hour. You couldn't just set it out in the sun, or it'd warp the hell out of it. And Vernon said, 'Now I'll give you—if you'll look after it, . . .' says, 'I'll give you a extra penny.'" This meant that Burl

would receive three cents per gallon instead of the customary two, and so he willingly complied. "That was half as much as I get for turning it, so I did that."[7]

Most of the surviving account books kept by potters show clearly that an elaborate barter system was essential to their businesses. Bartlet Yancey Craven of Randolph County ran a general store as well as a pottery, and his ledger—or what remains of it—details his relationship from 1854 to 1863 with the journeyman turner Chester Webster. As customary Webster was paid by the gallon, but he is also credited for considerable farm work for Craven. For example, one entry for 1862 reads:

April 7	to turning ware 416	12.48
	By work in the corn 2 days	.80
	By binding wheat 3½ days	2.60

In turn, Bartlet provided his turner with numerous provisions,

Oct 15	[1855]	10 lbs of flour 3½ lb	.35
"	"	half gallon of brandy	.30
Nov 3	"	59 lb beef	1.77
Nov 28	"	half bu of corn	.25
Dec 17	"	one bu of potatoes	.30
"	"	half bu of meal	.30

as well as his own services:

Mar 18	[1854]	bottuming 1 chair	.12½
Sep 2	"	halling clay	.30

Even Chester's wife Elizabeth joined in the exchange; in 1858 she contributed "Cr By schooling" valued at $2.50, presumably for Bartlet's children, which was used to cancel out a large purchase of flour.[8]

Money was a scarce commodity in rural North Carolina, hence the elaborate trade-offs in these potteries. In each case the forms of payment differ, but always there is a flexible and intelligent use of the respective property and skills of those involved. These varied relationships also suggest that the term "potter" should apply to the shopowner or general worker as well as the turner, for all took an active role in most phases of the production process.

Because only a few men worked at each pottery—and they also engaged in farming and other occupations—the annual output of the North Carolina shops was relatively modest. Given the informal nature of such businesses, it is no easy task to estimate their efficiency or their profits. Paperwork was just about nonexistent. As illustrated in figure 9-1, the potter used anything handy to reckon his accounts, even the freshly turned jug on the wheel. Another potter from South Carolina "'jotted all his accounts on chips of wood and then burned them for fuel in his kiln.'"[9] The only comprehensive

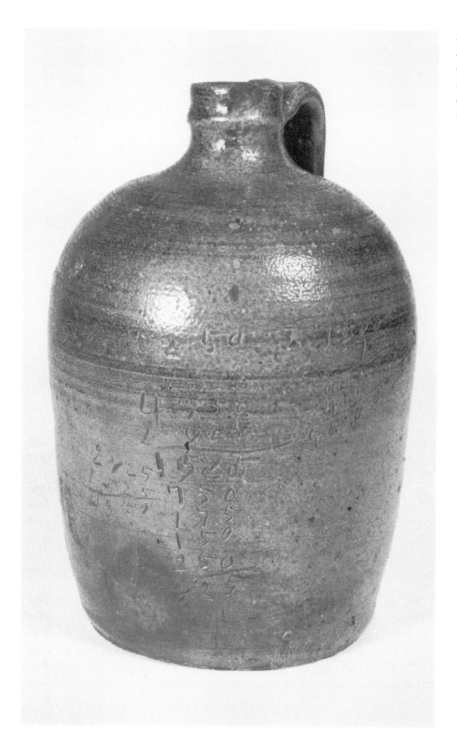

Figure 9-1
Math on clay: a jug used as an ac-
counting form. Salt-glazed stone-
ware, late nineteenth century, east-
ern Piedmont. H 8", C 17⁵/₁₆".
Collection of Mrs. Nancy C. Conover.

economic statistics occur in the Census of Manufactures, and these do provide a convenient statistical overview of the folk potter's business.

The sample in Table 3 is admittedly small in comparison to the total number of potters at work in any decade. Many simply listed their occupation as "farmer" and never mentioned their sideline. Others failed to meet the $500 minimum for the value of their product to qualify for inclusion in the census. Much also depended on the diligence and energies of the census taker, who often had considerable territory to cover and was probably content with a hasty estimate. Still the statistics remain quite consistent across the counties over the decades. They indicate that the typical shop in the latter half of the nineteenth century had a capital investment of about $200, employed two workers, operated nine months of the year, and turned out 6,000 gallons of pottery at 12½¢ per gallon for a gross of $750.

While this composite portrait may appear an impressive achievement for a rural craftsman—as indeed it was—it pales in comparison with the factories that had developed by this time in the North. For example, in 1860 James Hamilton and Company of Greensboro, Pennsylvania, used six hundred tons of clay, seven hundred cords of wood, and employed twenty-two full-time workers to produce 176,000 gallons of salt-glazed stoneware, valued at $15,500. And in 1870, the firm expanded to 200,000 gallons, worth $19,025. This was the largest pottery in southwestern Pennsylvania, but there were at least five others in the same area that marketed from 20,000 to 150,000 gallons in 1870.[10] And there were still more substantial ceramic industries in Bennington, Vermont; Trenton, New Jersey; and East Liverpool, Ohio.

In size and manner of operation such firms were very different from their counterparts in North Carolina. In 1870 James Hamilton and Company used steam engines to power its eleven wheels and then fired the ware in three huge, updraft bottle kilns, some of which stood over forty feet high.[11] The company operated all twelve months of the year—there was no competition for laborers from agriculture, sawmilling, or other occupations—and the workers pursued very specialized tasks. "Old records," writes ceramic historian Phil Schaltenbrand, "list a number of interesting job descriptions and include such titles as, burner, chopper, clay grinder, slip dryer, and teamster." Two others were the "kiln setter," a key figure who spent several days carefully stacking the jugs, jars, and other forms in tiers inside the giant kilns, and the "smoker," usually a young apprentice, who warmed the kiln for the first six to eight hours to dry it out.[12]

Finally marketing practices were much more sophisticated and included quite extensive advertising, elaborate order forms, and efficient transportation via canal, river, and railroad. The potters of southwestern Pennsylvania were located on or near the Monongahela River and shipped their wares economically by flatboat and river steamer to Pittsburgh, Cincinnati, St. Louis, and even New Orleans. Although the cobalt-decorated stoneware of

TABLE 3

North Carolina Potteries

Year	Name	County	Capital Inv. ($)	Workers	Months Open	Gallons	Value ($)
1850	David Hartzog	Lincoln	250	2			500
1850	Daniel A. Haynes	Lincoln	100	3			600
1850	David [Daniel?] Holly	Lincoln	100	1			500
1850	James M. Page	Lincoln	250	2			500
1850	Daniel Seagle	Lincoln	400	3			500
1850	William N. Craven	Randolph	500	4			1,000
1860	J. Dorris Craven	Moore	100	3		6,000	600
1860	James M. Hayes	Randolph	100	1		5,000	750
1860	Jesse H. Moffitt	Randolph	150	3		8,000	1,000
1870	J. Dorris Craven	Moore	400	4	7		800
1870	Alfred M. Brower	Randolph	75	2	8	5,000	650
1870	James and Eli Hayes	Randolph	500	2	12	10,000	2,000
1870	Elijah K. Moffitt	Randolph	75	1	12	5,000	625
1870	Jesse H. Moffitt	Randolph	75	1	6	4,500	565
1870	M. Robinson Moffitt	Randolph	100	2	9	5,000	625
1870	Merritt A. Suggs	Randolph	75	1	8	6,000	750
1880	John Leonard	Lincoln	600	1	10		750
1880	J. F. Seagle/John Goodman	Lincoln	1,000	1	12		900

Source: Census of Manufactures

such establishments (the decorator was yet another specialist) is regarded today as folk pottery, it was not. This was an industrial product, manufactured by assembly-line methods and marketed in bulk to distant parts of the country.

To the North Carolina potter, the size and complexity of the factory system would have seemed both awesome and inflexible. His modest craft, by contrast, was organized around very different principles, the most distinctive being his concept of time and his division of labor.

Traditional pottery was rarely a full-time business. In most instances it was a seasonal activity, one that dovetailed neatly with the natural cycle of planting and harvesting. Clara Ritchie Wiggs describes the pattern of the work year followed by her father Robert Ritchie. "We usually had wheat, oats, rye—the grains—and corn, cotton, and of course, garden vegetables. They planted in March, say, and April, would plant, and then they'd lay it by along the first of July. And then July and August, maybe September, they'd have the stoneware, and then they'd start gathering the crops, the cotton and corn, everything, maybe several months in the fall. And then along, I

would say, by Thanksgiving or something, they'd run [the shop] three or four months. It was about a half and half affair, I'd guess."[13] Clara's recollections are confirmed by Charlie Craven, who explains that "we quit making pottery when it got time to farm, unless we had some slack days which it rained or got too wet to farm. Well, we'd go back to the shop and work." And when the Cravens were out in the field, their neighbor, Henry Garner, would come in and use the shop and kiln.[14]

Even the wagoners who sold much of the ware were farmers and could only show up when their crops were under control. Clyde Chrisco helped his father, Henry, supply their sporadic demands. "These old fellows, all of them hauled ware about, farmed. Quick as they got the corn laid by, wanted a load of ware to go off, maybe three or four. So he always tried to be ready, and the same way after the harvest, you know. They got through throwing wheat, then they had the whole winter. I had a uncle who would sleep out in the snow under the wagon most any way."[15]

While the wagoners were free to haul during much of the winter, it was often too cold for the potters to maintain a steady output. This is well illustrated by the previously cited monthly figures on the wares turned by Curtis Hilton (chapter 5). His main period of production was from March through October, with a noticeable decline from November through February. And the entries in his account book explain why. For example, on 28 January 1904 he recorded, "Out of clay and frozen up on account of snow." Again, there is no activity from 16 December through 22 December in the same year—only the terse entry, "Snowed up and clay frozen."[16] Usually about March the weather would moderate, and the potters would get back to a full schedule of work. Enoch Reinhardt explains that "we'd store our stuff. You've seen that little loft up there—we've had it stacked on top of one another to the rafters. The spring of the year, and the weather got good, the wind blowing, wood got dry, and we'd start burning."[17]

Finally the demand for specific forms was also dependent on the flow of the seasons. In general sales would plummet during the winter months, as there was less need for all types of wares. If one's molasses, pork, kraut, and preserves were not stored away by the time the cold weather arrived, it would be a long winter indeed. The late summer and early fall proved the best time to sell storage vessels. In Burl Craig's words, "Along from August on till the frost killed everything, till October, middle of October, you sold more then." And again in the spring, "you'd sell flowerpots, and people had broke up their crocks and churns."[18] The repeated references to months and seasons in the testimonies above all attest to the fact that the folk potter responded to circadian rhythms instead of to the clock. Where large numbers of workers are engaged in specialized tasks, the clock becomes the prime organizing instrument; a factory cannot operate without it. For the older crafts, on the other hand, time revolved around the natural ebb and flow of the agricultural year.

Even when the appropriate season called him to his wheel, the folk potter approached his work in a very different manner from that of his cousins in the factory. Although some men were particularly valued for their skills in turning or glazing, few ever regarded themselves as specialists. Largely because of their traditional education, the men were competent in most phases of the craft, and this was not all. As the ensuing examples from the Craven family reveal, the potters were also farmers and were frequently active in several other trades and professions as well. Selected entries from the "True invetary of the property of John Craven Decd Sold by the Executers of Sd Craven, August 2 the 1832" provide graphic evidence of the versatility of such men.

one Horse	57.15
5 Head of cattle	13.92
7 Head of Hogs	5.00
9 Head of sheep	6.56
1 Waggon	30.00
3 Bee gums	3.86
1 Set of Blacksmith tools	15.35½
1 lot of steel	.45
set of shoetooles	.72½
1 set of turning tooles	.30
1 Poters wheel and crank	.50
1 set of Cooper tooles	.47½
1 sythe and cradle	.37½
1 plow	3.12½[19]

There are at least five occupations indicated here—farmer, potter, blacksmith, shoemaker, cooper—and there is likely a sixth, that of woodwright, depending on the precise meaning of "1 set of turning tooles." In turn, the ledger of John's nephew, Bartlet Craven, shows a similar diversity, with numerous entries such as:

Apr 17	[1854]	hooping a buckit	.05
Oct 6	[1853]	to making 1 coat	1.00
"	"	to cutting 2 coats	.20
May 30	[1854]	to shooing 1 horse	.10
"	"	to making 2 plows	.40[20]

As well as being a farmer and a potter, Bartlet ran a general store and worked as a craftsman in wood, cloth, and metal, a variety of skills certainly matching those of his uncle. Finally, John Craven's grandson, John A. Craven, was both a merchant and a sawmiller, as well as a turner. In fact, he worked at his sawmill during the 1850s with a group of highly skilled potters—his father, Anderson, his brothers, Thomas and William, and his first cousin, Himer Fox—and recorded such labors as:

```
to four days and horse to
Clearing out the Race
and sawing and giting logs
hawled                              4.80
to 8 days sawing
and working on the
house and hunting
timber                            10.00[21]
```

Despite such diverse responsibilities, John A. Craven was a talented and prolific potter who produced some of the largest pieces of salt-glazed stoneware ever made in North Carolina (plate 17; see also fig. 8-9). The massive size—the piece illustrated in plate 17 is well over 2′ tall and 4′ in circumference—and carefully controlled shape manifest his virtuoso abilities as a turner. Also he has added extensive cobalt blue decoration: a series of dots around the rim; trimming at the terminals of the powerful slab handles; a set of large initials on the opposite side; and the masonic compass and square on each wall—symbols of self-control and virtue. An additional textural beauty results from the rich flow of flyash from his groundhog kiln. Those accustomed to the elaborate flora and fauna painted or trailed in cobalt on the stoneware from the northern factories may view such a piece as lacking in finish or refinement, but they miss the point. John Craven was not merely a "decorator" or a "turner" but a total craftsman, who did everything from digging his clay to vending the finished product. Moreover, like the other members of his clan, he was competent in many other fields as well; he could not afford to be a full-time potter. When thus viewed in the proper context—as a seasonal activity, a part-time craft with little division of labor—the achievements of such men are truly laudable.

Compared to the output of a factory, the sales of a North Carolina shop appear so miniscule as to be hardly worth consideration. In 1870, for example, James Hamilton and Company of Greensboro, Pennsylvania, sold $19,025 worth of stoneware, while John Craven's brother, Dorris, valued his products at a mere $800. But once again, there are hidden factors that warrant examination. In the first place, the folk potter was far more self-sufficient than the factory worker. In addition to making pottery, he and his family raised crops and animals and produced other items such as buildings, furniture, and clothing. To him pottery represented a kind of "cash crop," not unlike the cotton or sweet potatoes or tobacco that he could also sell. It did not represent the sole income on which he depended for survival.

Moreover, the economic evidence suggests that the actual income he received from his wares compared quite favorably to the total wages of the factory worker. In 1860 James Hamilton and Company paid out $6,600 to its twenty-two full-time adult employees, an average of $300 apiece. In 1870 the figure jumped to $477 per worker (with every two "Children and Youths" counted equal to one adult), but in 1880 it dropped back to $200.[22] By

contrast the North Carolina potters worked only part-time, yet the previously cited statistical composite demonstrates that, on average, each could gross about $375 per year. Not all of this was paid in hard cash, but the equivalent goods and services were no less valuable. Because expenses were minimal—the only significant outlay was for raw materials, and this sum was normally small—most of the gross could be considered his "wage." Thus, although his shop was small and open only nine months of the year, the folk potter appears to have earned as much as his counterparts in the factory.

Like turning and burning, peddling the pottery was often a long and arduous task. Even after the coming of the automobile, haulers like Barney Chrisco of Randolph County continued to use the old covered wagon powered by a pair of horses or mules (fig. 9-2). The wagons held about 300–350 gallons of pottery, all carefully packed in wheat straw and moved along at the leisurely pace of perhaps twenty miles a day. Johnnie Scott, who drove for Baxter Welch for eight dollars per month plus board, recalls that a round trip from Harper's Crossroads in Chatham County to either Durham or Fayetteville took a full five days.[23] Before setting off, the wagoner would pack his food for the trip and also fill the feedbox at the rear of the wagon for the mules. Minnie Reinhardt's father, Wade H. Smith, would take "eggs, and Ma would bake him up sometimes a big molasses cake—he liked that with his coffee. We'd make molasses too in the fall. She'd bake a big old cake, you know, the last week. Then he'd fry him some eggs over the campfire."[24]

For safety the wagoners often drove in pairs and rested at night at campgrounds along the roadside. Johnnie Scott's partner, Atlas Brooks, even carried a pistol for protection, but they never encountered any robbers. However, on one return trip from Durham, At began firing it into the air just for fun and set the cover of his wagon on fire. Happily they were able to extinguish it before the hole got too large, but it is doubtful that Baxter Welch was very pleased with his employee's exuberance.[25]

The more common hazards were bad weather and bad roads. When it rained, the accommodations were anything but comfortable, as Carl Chrisco attests. "Worst night I ever spent was . . . above Asheboro. There was a campground on the right there. . . . Me and Frank Craven, we was a-going to Lexington and drove up there the first night; and it rained all night. And I had [milk] crocks on top of mine, just room I could crawl in under the ridgepole—you know how a covered wagon is. Them crock rims felt like they was fit between my ribs that night—didn't have room to turn over. Just twist about a little. And them mules—they rubbed and eat and messed all night. It rained, you know, and they wouldn't lie down. That was a rough night!"[26] By contrast, the trip home was almost luxurious; the wagoner could curl up in a couple of quilts in the soft packing straw without any competition from his wares.

The roads such men traveled were also narrow and poorly maintained,

Figure 9-2
Barney Chrisco's covered wagon, in which he continued to haul pottery even in the age of the automobile. Courtesy of his grandson, Alfred C. Marley.

but an audacious driver could always devise some method of clearing the way. "It is told that Little John Chrisco would meet another team head-on, and being a burly sort of fellow, would yell out quite loudly, 'If you don't move your wagon I'll do you like I did the last one I met.' At such vigorous threats as this the other wagoners reluctantly moved over and John proceeded on his way. After moving out of the mud grooves with much effort, one man cautiously asked, 'And what did you do to the other fellow?' John was far down the road when he answered, 'Well, I just moved over and let him pass.' "[27]

Despite such handicaps, there were large numbers of wagoners who purchased the pottery at the shop and then hauled it off a sufficient distance so that they could make a profit of two to three cents per gallon. Some men, like Barney Chrisco, appear to have had a wanderlust and to have enjoyed such travel for its own sake. His grandson, Alfred Curtis Marley, affirms that Barney "loved to do that. He'd just get out and ride around over the country with a load of that ware, stoneware, and just stay with it till he sold out. . . . He loved to meet new people, new faces, you know, because—I don't reckon he ever seen a stranger in his life—he'd get along with most anybody."[28]

A very similar portrait is provided by Elizabeth Leonard Stahl of her father, Vernon Leonard, a well-known trucker and pottery worker in the Catawba Valley during the 1920s and 1930s. "He did truck farming, he hauled [sweet] potatoes in the fall, and when he wasn't hauling potatoes he would haul the ware that Mr. Claude and Mr. Aubrey and Mr. Rufus Hilton made, also from Mr. Nealy Blackburn and from Mr. Seth Ritchie later on. . . . He hauled mostly potatoes for a while, but by the late twenties he was hauling a lot of ware. And he would always come back with tales about blowing his horn and people coming down from the mountains to meet him. He seemed to know all the roads."

Unlike Barney Chrisco, who never relinquished his covered wagon, Vernon purchased a 1921 Ford Model T truck and built a frame on the back so it resembled a wagon. When that wore out in the early 1930s, he replaced it with another Ford, a 1932 Model A half-ton pickup. About the same time, he encountered some problems. "The potato business wasn't so good; during the Depression the ware business was better than the potato business. And the main person making it any more then was Floyd Hilton and his father Claude. And they didn't make enough of it to suit him, so he went into business with them. And he hauled the clay and ground the clay and burned the ware. And that way Floyd and Claude could spend all their time turning." While never a turner, Vernon worked at all other phases of the craft and also involved his four young sons, Olen, Belk, Eli, and Paul (fig. 8-3). Later he formed similar partnerships with Nealy Blackburn and Burl Craig—an effective means of ensuring a steady supply of wares to sell. Even at the time of

his death from cancer in 1946, he was still in business; his sons Eli and Paul finished his final contract with Burl.[29]

An important asset for men like Barney Chrisco and Vernon Leonard was the ability to swap and barter. Buyers often lacked the money to pay for the pottery, and so some of the wagoners earned reputations as sharp traders. One such was Ben Brown of Moore County, who occasionally hauled with Carl Chrisco. "He'd have a sack full of them pipes in there to trade on, bag or two of peanuts. He'd buy coon's hides, possum hides, trade guns—Ben was a trader and a good one, too. . . . He was a fellow didn't do much talking, but he was a slick trader. You couldn't fool him much." Another wagoner from the same area, Frank Pool, "said he went off with a two-horse load of ware, never handled a dime while he was gone."[30] Such men had to know the value of many commodities as well as find the proper markets to get rid of them.

Generally the haulers preferred cash, but they knew how to use the barter system to their advantage. Vernon Leonard sold most of his pottery in the mountains, where "occasionally he would get groceries, that is, apples or something like that." His son-in-law, Raymond Stahl, accompanied him and points out that "he seemed to recognize certain ones that I guess he felt couldn't afford to do anything more than barter. And they would come down, and they would get more or less what you might call the poorer run of the ware."[31] Thus both buyer and seller benefited, the former needing no money, the latter getting rid of his culls—jars and jugs that were serviceable enough but misshapen or cracked or unevenly glazed or marred with blisters or kiln drippings. Like the bent soup cans in a supermarket, these pieces were hard to sell. Usually they were left in the potter's yard and sold at reduced prices. As Burl Craig explains: "The farmers then, they really appreciated it if they could save a nickel, you know, or a dime. That was a lot of money back then." All too ironically, many of the culls went to the potter's family or relatives. "If they wanted a pickle jar or a jar to make wine in or something, they didn't go out and pick out a first-class jar. Always the culls."[32]

Yet another common tactic was to recycle the produce received for the ware. Wade Smith of Catawba County (fig. 9-3) would set off in the fall and "go back in the mountains, back towards Blowing Rock. And he'd get apples, chestnuts, cabbage, Irish potatoes, what they raised up there, bring it back. Well, my mother would keep some of the cabbage. And she had a big sixty-gallon barrel, you know, wooden barrel. And she'd fill that full of kraut. She'd put it in the smokehouse. Well, you had to raise what you eat. Then he'd haul that down, down to Charlotte and sometimes South Carolina, where they didn't raise it, the cabbage and all."[33] Even into the 1930s bartering remained a common practice. Jug Jim Broome of Union County exchanged his wares for flour, beans, shoes, and clothes; his son, James,

Figure 9-3
Potter Wade Smith and his grand-
daughter on the lawn in front of
their home in Catawba County, ca.
1920. Courtesy of Minnie Smith Rein-
hardt.

affirms that the family always had plenty to eat and plenty to wear during those difficult years.[34]

When cash was available, the purchaser paid what seems today a ridiculously low amount. And a survey of prices from the mid-nineteenth century on shows a remarkable stability. As illustrated in Table 3, the Census of Manufactures for 1860 and 1870 indicate an average of about 12½¢ per gallon. However, the actual pricing system was somewhat more complex than this. In 1855 John A. Craven was selling his wares at 20¢ per gallon retail in his store, but for only 12½¢ to 15¢ wholesale. Moreover, unusual sizes or forms commanded different rates; for example:

quart pitcher	.10
½ gal jug	.15
½ gal jug cract or damaged	.05
½ gall jar with lid	.20[35]

At the same time Bartlet Craven was charging 15¢ and 10¢ respectively to retail and wholesale customers. However, in 1863 his prices took a quantum leap to 60¢, and he abruptly doubled his wages to Chester Webster from 3¢

to 6¢ per gallon turned. Food prices also followed suit; in one year bacon jumped from 20¢ to 50¢ per pound and flour from 4¢ to 12½¢![36]

There are no further entries in his ledger for pottery after this time, but the evidence suggests that this was a temporary aberration caused by the Civil War. By 1870 the price had settled to an average of 12½¢. At the turn of the century the rates fell off somewhat. Curtis R. Hilton's account book records the following for 1905:

1 gal	.10
50 gal 6ct	3.00
1 gal S.C.	.05
1 chicken jug	.15
2½ gal	.25[37]

Retail goods were 10¢ and wholesale 6¢, with the usual reductions for damage ("S.C." recurs quite frequently and may mean "slightly cracked") and special prices for more elaborate forms such as chicken waterers (probably a one-gallon size here). During the same decade, Baxter Welch was charging a comparable 8¢ per gallon and Colin Yoder, 6¢ to 8¢.[38] In the 1920s and 1930s the rates inched up slightly, and many potters reported receiving an average of 10¢ per gallon. Most potters closed their shops by World War II, and so the few who remained in the 1940s and 1950s—for example, the O. Henry Pottery of Valdese, Burke County, and Poley Hartsoe in the Catawba Valley—were able to hike the price up to 35¢.[39]

After Poley retired about 1957, Burl Craig carried on alone. While working full-time for a furniture factory in Hickory, he continued to burn perhaps half a dozen kilnfuls of milk crocks and churn-jars and flowerpots each year. And until the mid-1970s, the bulk of his output still went to the general stores in the nearby towns of Fallston, Forest City, and Rutherfordton. With a true monopoly on the business, Burl gradually raised his rates to one dollar per gallon, an astronomical sum when measured against past prices, but still a bargain for the buyer.[40]

Potters employed several distinct methods for disposing of their output. The more fortunate ones, like Colin Yoder, spent most of their time filling and delivering orders from stores. "He would be 'off on the road' four to six days a week at times, usually about every other week, from May to October, alternating with his farm work. . . . He sold his ware chiefly to crossroad, hamlet and small town grocery merchants, almost always for cash, at 6 to 8 cents a gallon. His profits were the equal of low wages and added materially to his low farm income and his teaching salary at 3 or 4 months a year. He built up a rather permanent trade with the little merchants and would usually receive itemized orders for the ware early in the spring, orders made up and delivered over a period of 4 or 5 months."[41] In like manner, the Kennedy Pottery developed a flourishing business with the country stores in Wilkes County, though the demand here was for one particular form. "They would

write the orders in. And these country stores, you know, we'd maybe have four or five stops—country stores here to Trap Hill. And it'd mostly be jugs because that was moonshine country. . . . They claim, now, whiskey will age in those jugs, this stoneware, as good as it will in barrels."[42]

More frequently, the potter or wagoner would set off and trust to luck or earlier experience that he could somehow find enough buyers to empty his wagon or truck. As Burl Craig explains, "sometimes you was lucky enough to get a order, but [often] you just took it out and peddled it out. . . . I've hauled it till the glazing wear off of it almost and then hauled some back home."[43] Even when a store owner wanted to buy, he would haggle over the stated price, fully aware that he might strike a profitable bargain if the potter was frustrated or eager to return home. Burl Craig recollects that "most of them would ask you what you got for it, and you said ten cents. 'Oh, I bought it from so-and-so for nine or eight.' And a lot of times I'd say, 'Well, I can't take that. I got to have ten out of mine. I make a little better ware than most of them.' Something like that. . . . It wasn't. I mean, we were all using the old glass glaze and burning these old groundhog kilns around here. Maybe wasn't as good as some of it! But I'd tell them that."[44] Usually, however, the volume buyer could force the price down at least a few cents. "Some guy would say, 'I'll take a hundred or two hundred gallons if you'll let me have it for eight cents.' Most of the time he got it. It was a lot of it being made, and you didn't know whether you was a-going to sell any at ten cents or not."[45]

Because the store owner sold the ware to his customers for about fifteen cents per gallon, every reduction in the basic rate greatly increased his profit. However, the potter was not at the total mercy of the merchant. Some, like Talman Cole of Buncombe County, knew how to play off the store against the individual buyers. "If the store would buy, I'd unload right there. If they wouldn't buy, then I'd go to the houses. . . . Well, I had a price I'd give the stores. In other words, if I could unload everything, why I had a price there. Well, that'd give them the advantage, but the biggest advantage was I wouldn't sell none around there."[46]

Many potters also sold substantial amounts of ware right off the yard of the shop, surely the most efficient way to market their product. Figure 9-4 shows Harvey Reinhardt at his shop (now operated by Burl Craig) posing with two mustachioed, rather Mephistophelean face jugs. Behind him are several kilnfuls of churns, jars, jugs, and lids, ready for sale. The Reinhardts sold a considerable amount of ware at home and on occasion had as much as 1,600 gallons of stoneware sitting in their yard (fig. 8-2).[47] Like the merchants, wagoners expected and received a discount for hauling off large quantities. But when they demanded too low a price, the potter would balk. Burl well remembers Weir Jarrett's stock answer to those who demanded too much for too little. "He said, 'Leave it a-settin' there.' Said, 'It's not eating a damned thing!' "[48]

Figure 9-4
Harvey Reinhardt and look-alikes in front of his shop at Henry, Lincoln County, late 1930s. This photograph reflects the reality of the potter's world—for every two face jugs he made hundreds of gallons of utilitarian wares. Courtesy of James and Irene Gates.

Individuals also purchased numerous pieces at the shop for domestic use. Ray Kennedy tells of "a man and his son [who] lived way back over here about five miles from town, above Moravian Falls. And every fall they'd make wine. And they would come to town, right through the summer, walk mind you, walk, the old man and the boy. And they would buy four jugs apiece. And they'd have a rope, and they would tie them through the handle—put one across this way and other across this way, have two in front and two behind—and they'd carry those jugs back home."[49]

Sales off the yard were a distinct convenience, but Irene Reinhardt Gates cautions that "if we weren't there, I think they just helped themselves."[50] Usually it was a piece or two at a time, but on some occasions there was large-scale thievery. Just up the road from the Reinhardts was the pottery of Sam Propst, whose daughter Hazeline recalls how "one night in summer-

time my Daddy had just taken a kiln of ware out. And you know, we just had it setting in the yard. And somebody stole every jug he had that night. They'd taken every one of them! And my Dad said, 'Well, I guess somebody had a run of whiskey coming off.'"[51] Heists of this proportion were unusual, but Sam took the loss philosophically, with full appreciation of the need for his jugs. Normally, in the rural communities in which the potters worked, there was little need for security measures or locks or storage buildings, and so the potter's wares sat out beside the kiln until, one way or another, they disappeared.

It is a commonplace that the folk craftsman produced goods for a local market, but in the case of the potter, nothing could be farther from the truth. For a variety of reasons—the abundance of clay, family connections, the difficulty of passing on a highly complex craft—potters tended to cluster together in substantial numbers, hence the several Jugtowns found across the state. As a result, the local markets were saturated—a housewife could readily purchase a jar or a churn off the yard of one of her neighbors, if not from her own family—and so the wares had to be hauled for often considerable distances. Although they were concentrated in the Piedmont, the North Carolina potters marketed their pottery throughout the Coastal Plain and the Mountains, as well as into most of the surrounding states.

Appropriately, the potters from the eastern Piedmont and the Catawba Valley appear to have divided the state between them, roughly along an imaginary boundary stretching from Charlotte to Winston-Salem. Even before the Civil War, Bartlet Craven of Randolph County was regularly sending his wagon to Raleigh and Fayetteville, a not inconsiderable round trip of 130 miles.[52] With the construction of better roads and even railroads in the second half of the nineteenth century, the eastern potters further extended their range. Herman Cole recalls that "wagoners would haul the wares way down in South Carolina and down east too at least two hundred miles. Be gone a good while. They'd buy hides as they were coming home and bring these back to the tanyard around here, making their trips pay both ways. Sometimes they would stay a long time, having the folks back home ship them more wares by train, and they'd sell that too before they'd come home."[53]

Herman is referring specifically to the practice of his grandfather, Evan Cole, who died near Wilmington while marketing wares for Cole and Company. "The sons packaged and shipped the ware by railroad to depots such as Ivanhoe, a small community near Wilmington. Evan picked it up and peddled it from his wagon; by 1885 he had developed a network of regular customers in this region. In fact, family tradition relates that it was here that he died in 1895. His loaded wagon had become stuck while he was crossing a creek, and in trying to dislodge it, he became chilled. He went to a nearby farm and asked for assistance but died of pneumonia before a doctor could see him. It was nearly a month before the family received the bad news;

Evan, Jr., and Will Garner had to 'hitchhike' down to the coast by catching rides on wagons to retrieve Evan's wagon, horses and bag of money."[54]

The potters of the Catawba Valley never appear to have used the railroad, but they roved widely throughout the western half of North Carolina and into Virginia, Tennessee, and South Carolina. Some, like Colin Yoder of Catawba County, stayed relatively close to home and worked the counties in the western Piedmont. Colin "sold his ware chiefly in northern Iredell County, occasionally as far away as western Davie County and Mocksville, all over Alexander County (90 percent of his ware) and southern Wilkes County as far as Wilkesboro and North Wilkesboro."[55] Most of the potters, however, headed west. Typically, Lawrence Leonard hauled to Asheville and even across the Blue Ridge into the edges of Tennessee and Virginia.[56]

The Mountain region proved a fertile market well into the twentieth century; the people remained isolated and continued a self-sufficient way of life. Even as late as 1950, A. M. Church was selling plenty of Albany slip-glazed jars from his O. Henry Pottery in Valdese. While he also marketed them in Charlotte, Wilkesboro, and Lenoir, he affirmed that "anywhere in these mountains is a good jar business. You can sell them off from Asheville, by God, all back through there everywhere!"[57] Other potters traveled directly south to peddle their wares. Robert Ritchie would make day trips to Lincolnton and Shelby, but his daughter Clara particularly remembers a journey into South Carolina. "One time when I was ten years old [1919], I remember going with my father and Uncle Seth Ritchie. We went to Cherryville, Blacksburg, and to Gaffney, South Carolina, back to Boiling Springs where Gardner-Webb [College] is now, and back to Shelby and Fallston." For young Clara this epic journey was cause for bragging to her classmates at the small, two-teacher school she attended. "I never got through telling I'd been all the way to another state—I'd been all the way down to Gaffney, South Carolina!"[58]

As late as the 1930s, the last decade in which a substantial number of traditional shops remained in operation, pottery proved a viable occupation where many other failed. Irene Gates was only ten in 1933 when her father, Enoch Reinhardt, moved the family from the town of Shelby back to the little village of Henry. "Daddy had a barber shop in Shelby and then everything just went flat. So we came back to the farm, and I guess it was more or less as a necessity to make a living, to make a little money, that they turned to the pottery again. There was pottery being made all around at that time. So it just came sort of natural to them, I guess, as an interest. So they made the kiln, and they put the shop up, and they worked together very well."[59] Enoch went into partnership with his brother Harvey, farmed, and continued barbering one or two days a week (at fifteen cents a haircut). He comments that "I don't call them hard days because we went through them and never missed a meal. But we worked and raised our living."[60]

At almost exactly the same time, Talman Cole (fig. 9-5) joined potter

Figure 9-5
Talman K. Cole, who worked as a young man with the aging George Donkel near Weaverville, Buncombe County.

George Donkel out on Reem's Creek just east of Weaverville in Buncombe County. "I was a young man then, just scouting around during the Depression, and there wasn't much to do, only farming. . . . Of course, we always had plenty to do in the fall, putting up corn, cutting tobacco, things like that. Sometimes we'd get jobs [at] sawmills and one thing and another. But a lot of times you'd just be scouting around, and it didn't take much to live on. You could live for five dollars a week—board, room, and everything." Talman worked with Donkel until about 1940 and adds that "we made a run of pottery about every three weeks." Their kiln held about four hundred gallons, and Talman was able to sell most of it in the mountains at twenty cents per gallon, meaning that the two could have grossed eighty dollars every three weeks, a very tidy sum for the Depression years, when a man could live on five dollars a week.[61]

Altogether the evidence suggests that, from 1850 to 1940, pottery represented a worthwhile economic undertaking for all involved, from the shop owner and journeyman turner to the smallest members of the family. There are no census records or account books to provide a portrait of the craft in the previous hundred years, from 1750 to 1850, but there is little reason to expect that conditions were appreciably different. These rather positive findings contrast sharply to anthropological studies of peasant potters, in which the craft is normally viewed as a mark of low social status.

In a wide-ranging article on the sociology of pottery, George M. Foster characterizes the situation of the Mexican potter as one of degradation and hopelessness. "Wherever pottery is made, potters appear to deprecate themselves, and they are looked down upon by non-potters. Time after time Tzintzuntzan potters have remarked to me, half by way of apology and half by way of stating an obvious fact, 'Here you find us in all this dirt.' *Es nuestro destino*' ('it's our destiny') is the way they refer to their work. Opportunities for giving up pottery are slim, . . . and almost everyone agrees that farming or storekeeping is preferable to the traditional craft." In reviewing additional evidence from other parts of the world, Foster hypothesizes that "more intensive fieldwork will indicate that the position of potters in peasant society generally is not high, and that given reasonable alternatives, a majority of potters will try to abandon the profession. The explanation for low status probably is found in the combination of average low income and the feeling that the work is 'dirty.'"[62]

Such appraisals of so-called "peasant societies"—usually third-world or underdeveloped countries—do not apply to the folk potters of North Carolina or of the United States, for that matter. Here there was no such stigma concerning the dirtiness of the craft. In fact potters did often refer to their raw material as "mud" or "red dirt," but certainly without any pejorative connotations. Moreover, they deliberately integrated pottery with farming and storekeeping and myriad other occupations, and there is no evidence to suggest that one line of work was superior to another. In recalling the impor-

tance of his grandfather, J. Dorris Craven, to the pottery industry in Moore County in the latter nineteenth century, Braxton Craven observes that "way back in them days if you had something like that, you had a gold mine, almost. Other people didn't have—wasn't making nothing."[63] Perhaps pottery was no gold mine—no one was likely to strike it rich—but it usually ensured a more comfortable way of life and constituted a familiar, well-regarded occupation.

Burl Craig readily allows that some potters weren't "too highly thought of," but quickly adds that "they brung a lot of that on themselves. A lot of them didn't do as well as they could have done with what they had. . . . A lot of them just worked enough to get by, and that was all. The farmer, he went out here, and he planted a crop. He *had* to work that—he got out there and worked that stuff. But a potter, if he wanted to take off a day, why, there wasn't nothing to hurt. It'd be there the next day." In short, the potential was always there to earn a living, but not all were equally energetic and prepared to take advantage of the opportunities the craft offered. With a deep laugh, Burl recalls the minimal effort expended by his old neighbor and teacher, Jim Lynn: "He set the pottery business back a hundred years!"[64]

Among the potters of this century, the prevailing attitude was one of pride toward the traditional craft and its long heritage. Typical are the comments of octogenarian Javan Brown, who died in 1980 after working all over the Southeast. At one stage in his long career, Javan operated a jigger wheel at the Bowers Pottery, a factory in Atlanta.[65] With intense dislike for the mechanical, assembly-line nature of this operation, he snorted: "They called themselves potters! I told them there one day, I says, 'Any potter can jigger, but,' I says, 'Any jigger can't pot.'" If possible, Javan had even less respect for the hobbyist or studio potter who dabbled in the craft. "Now, everybody's a potter. Like I tell you, the woods is full of them. You can go over here around Burnsville, I'll bet you can find fifty potters over there, and ain't a cockeyed one of them a potter!"[66]

Javan understood the difference between his way and that of the manufacturer or studio potter, but many do not. Too often the work of the folk potter is hastily dismissed because it lacks a cobalt blue bird or flower to attract the viewer's eye, or because the walls are not always smoothly trimmed or the glaze carefully controlled. The problem with this attitude is its failure to appreciate the remarkable versatility of the folk potter and the context in which he worked. He was not a specialist—he was a true jack-of-all-trades who had mastered the knowledge and abilities to execute all phases of his craft. And this was not all that he had to learn. In most instances, he was also a farmer and might be active in one or more other occupations as well.

Thus, it is misleading to compare his wares to the assembly-line products of the northern factory or to the carefully wrought forms of the art potter. To do so is to equate the proverbial apples and oranges. The folk potter possessed a very broad competence, which enabled him to tackle a wide range

of tasks. For him, there was little opportunity to hone a particular skill to the point where he could call himself a "slip dryer" or "kiln setter" or "burner"—or even an "artist." Of necessity he had to perform all of these roles and many more. His sturdy pots may lack the decoration or finish or attention to detail that the specialist might demand. But the folk potter was a generalist—he had to be—and his work reflects this simple fact.

Although small and essentially local, the folk pottery was a more complex operation than has often been assumed. As a business, it made extremely efficient use of the available resources and the varied skills of the workers. It turned out a cheap, much-needed product, whose stable price for the better part of a century seems a miracle when viewed from the perspective of today's inflation rates. And it sold its output through a variety of marketing methods over a surprisingly wide geographic range. In effect, it was a true "export industry," and thus very different from most folk crafts. Finally, in purely human terms, the folk pottery provided the extra income that could raise the quality of life for an ambitious man and his family. Although the profits were modest, they provided a significant increase to what the potter produced on his farm or earned in other trades. In an eloquent testimony to the craft, Clara Wiggs explains that her father, Robert Ritchie, "wasn't a full-time potter, but we always had a little bit [extra], we always seemed to have enough to carry us through. Back then you didn't have a lot of money, but they were able to carry through. Of course, most farmers would charge [borrow], or someone would rent them some fertilizer, things like that. This shop and kiln making stoneware helped to balance the budget."[67]

10

STORAGE VESSELS

On 17 May 1876, a resident of Randolph County wrote to her niece describing a buggy excursion to the pottery of Evan Cole, located about four miles east of Whynot, just above the Moore County line:

> Dear Niece Anne,
>
> This leaves us well ecept Paw. Winter has been rough on him and we are all joyed for the warm spring to get crops in. . . .
>
> I went with Rossinah to the Cole pottery shop past week to get somethings for setting in her house making. They are distant kin to us by Aunt Rach that you never knew but herd us talk of was Marks wife. Sallie was airing beding and shewed us one of old Aunt Rach covers that was so fine work but old and worn and not in use for it covered Rafe when he passed. Rossinah got a stone churn and milk pans and pie dishes and saw a teapot but did not buy that. I got you a cake mole with blue decorate since you admired mine so long. Hope you do like it well.
>
> Coming home the buggy wheel ran into a mudrut and stuck but John came by and moved it out fortunately we was not damaged just muddy. We laughed heartily for John told we had more mud on us than it took to make our ware. We look for you in June. Write when you can.
>
> Your loving Aunt Rebecca W[1]

Clearly an intimate friend of Evan's wife Sallie, Aunt Rebecca accurately identifies Raphard and Mark, Evan's father and grandfather, both of whom were potters as well. Above all, her letter provides rare, firsthand evidence of the critical role of the folk potter in the lives of rural North Carolinians more than a century ago.

Of the wares that Rossinah purchased for "setting in her house making," the milk pans would have been filled daily with fresh milk and placed in a springhouse or other cool place. When the cream had risen, it was poured off into the stoneware churn and worked into fresh butter and buttermilk. In turn, these ingredients might be used in the fruit pies or other concoctions baked in the lead-glazed earthenware dishes. Other wares that might have tempted Rossinah included pitchers to serve the buttermilk or bowls for her mixing. And in the fall of the year, she might have chosen several large jugs to hold vinegar or molasses, or jars in various sizes and shapes for preserving her meats, fruits, and vegetables through the long winter. While Evan's

products were essentially utilitarian, Aunt Rebecca's remarks leave no doubt that some of them also appealed to a woman's eye for beauty. The cake mold with cobalt blue flourishes and the teapot—possibly with a bright orange lead glaze (fig. 11-20)—would have added strong touches of color to enliven the home. Very likely Rossinah deferred purchasing her teapot to another visit, because she had already spent her allowance and knew that the essentials came first.

Today it is virtually impossible to appreciate the importance of this pottery in the homes and on the farms of earlier generations. Now every town has at least one large market that is open at all hours and offers an enormous variety of foods. Refrigerators and freezers make preservation a quick and simple matter, and commercial dairies supply ample quantities of fresh milk and butter on a daily basis. The old milk crocks and jars and jugs survive in considerable numbers, but they are rarely used anymore. Instead their owners keep them for their historical associations or aesthetic qualities, or just out of sheer nostalgia. As Burl Craig well understands, "they want them because Granny had one."[2] Ironically, old churns and chamberpots have become objets d'art; today they are venerated on remote shelves or mantles or even in china cabinets. As "art" they are too valuable to use for filling or carrying or pouring; a five-gallon jug that once cost fifty cents now commands one hundred dollars. But even if a collector wished to use one of these forms, it is unlikely that he or she would know how.

For Aunt Rebecca and Rossinah, however, the old wares were inexpensive, familiar, and ultimately essential to the self-sufficient life adhered to by many North Carolinians until well into the first half of the twentieth century. Dr. Fred R. Yoder, whose father, Colin, operated a farm and a pottery shop in Catawba County at the turn of this century, catalogs the various uses of pottery by the thirteen members of his family. "In our own household and about the farm buildings, we used jugs (for vinegar, wine, 'remedial' brandy, molasses, oils), crocks (for spring milk house, different kinds of foods, etc.) and jars (for a dozen different kinds of canned fruits and vegetables, large jars for kraut, pickles, clothes-washing soap, beef, in spring house). Almost all orders for ware included a few 2 to 5 gallon churns for making home-made butter. We always had three or four around our house and kitchen."[3]

Large families like the Yoders raised ample crops and animals to feed themselves and used most of the pottery to store and prepare their foods. Small surpluses—for example, butter or molasses—could then be sold or bartered for items not produced at home. Most farmers also usually raised one or two "money crops"—cotton, sweet potatoes, or tobacco, depending on the particular region. These generated the additional income to purchase coffee, tea, salt, sugar, and soda (all of which were normally stored in small jars) as well as various types of clothing.

The potter played a critical role in sustaining this independent way of life,

and the range of forms he produced is far greater than many assume. Too often the old potter is simply regarded as a supplier for illicit stills or Snuffy Smith types who were never without a jug of corn liquor balanced on their shoulders. In fact, the jug was not his most common form; it ranks well behind the jar in terms of frequency of production. Contrary to this popular stereotype, the potter possessed a varied repertory of containers, tools, pipes, flowerpots, and even gravemarkers.

Underlying all these possibilities is the essential relationship between pottery and food. In his wide-ranging study, *Ceramics*, Philip Rawson rightly points out that "pottery has always been one of the necessary attributes of civilized life. We still take it for granted, and even if we ourselves use plastic tableware, the odds are on its being made in modifications of shapes which are original to pottery techniques, even though plastic is formed by totally different processes. Pottery has, of course, been used to make a wide variety of other things. . . . But far and away its most important function, underlying all the historical evolutions of separate traditions, has been to contain food or drink."[4] Within a folk tradition, this bond between pottery and foodways is clear and extensive, in fact so obvious that it is often overlooked. In North Carolina most pottery was produced for the storage, preparation, and consumption of food. It would be impossible to quantify precisely the proportions involved, but a conservative estimate is that at least 75 percent of all the pottery ever made falls into these three categories.

The discussion of form and function in chapters 10, 11, and 12 is segmented for convenience as follows:

1. Food Preservation
2. Food Preparation
3. Food Consumption
4. Pipes
5. Implements
6. Grave Markers
7. Horticulture
8. Whimseys

Each of these categories will be further subdivided for easy reference, and wherever possible, the local names—or folk taxonomy—will be used to identify the forms.

No mode of classification is perfect. In the first place, the nomenclature is anything but systematic. In discussions of pottery, such terms as "pot," "crock," and "jar" are often used interchangeably, with the result that none of them retains a very specific meaning. Second, the owner of a pot may choose not to use it in the intended manner. The simple milk crock was designed as a cream riser but is also employed for storage, cooking, and even growing flowers. Third, some five hundred potters have worked in earthenware and stoneware in North Carolina over the last 225 years, producing millions of pieces of pottery. The full extent of their achievement is simply too great to be summarized in three chapters or even an entire book. Ultimately the very fluid nature of clay defies efforts to invoke comprehen-

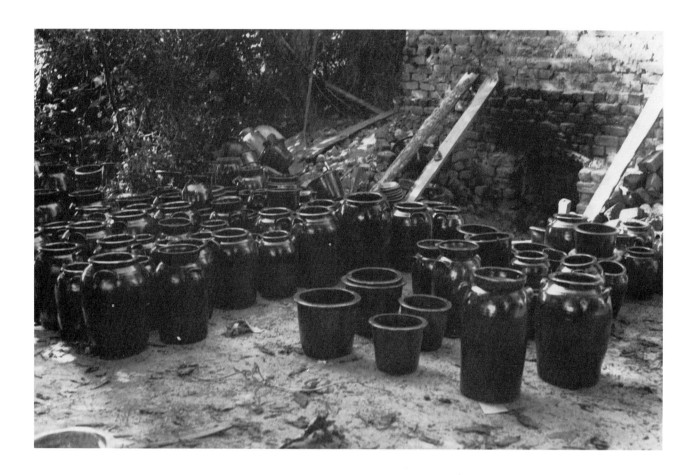

Figure 10-1
A typical assemblage of traditional wares at the kiln of Seth Ritchie, Blackburn, Catawba County, ca. 1939. Courtesy of Mr. and Mrs. Raymond A. Stahl.

sive order. With all these reservations, the following plan nevertheless has the virtues of being relatively compact and emphasizing the primary contexts and uses of the individual items.

FOOD PRESERVATION

The preservation of food was the essential function of pottery made in North Carolina; well over half of all the pieces ever made were intended for this purpose. In this category there were four essential forms: the jar, jug, milk crock, and churn. Figure 10-1 illustrates the typical contents of a kilnful of lustrous, alkaline-glazed stoneware made at Uncle Seth Ritchie's shop at Blackburn, Catawba County, about 1939. Most of these pieces were turned by journeyman potter Burlon Craig, who recalls that what Uncle Seth "wanted was jars, milk crocks, and churns. That was it. That's all. Some-

times he'd get a order for a jug—a gallon jug or two gallon or three gallon jug."[5] By this late date there was no longer an active demand for jugs, but the other forms are present in abundance. To the undiscerning eye, these essential pots appear monotonously similar, but in fact the North Carolina potters produced them in an almost endless variety of shapes and sizes, depending on such factors as clay body, regional preference, and specific function.

JAR

The jar is the ultimate pottery form, the fundamental container that has served mankind since his beginnings. Perhaps because its open mouth makes it easier to turn than the jug, it runs the full gamut of capacities, from one pint to the great fifteen- and even twenty-gallon storage jars made in the Catawba Valley. At the lower end of the scale is a series of small jars, normally holding from a pint to a quart and used for jams, salt, soda, sugar, tobacco, and coffee.

A "jam jar" from Buncombe County is illustrated in figure 10-2; the knobbed lid rests firmly on a flange inside the mouth, thereby protecting the contents. The tiny "handles" on the shoulders are not truly functional or necessary. Most likely they were added for decoration or to echo the lug handles on the larger cousins of this diminutive piece. Figure 1-6 shows an earthenware sugar jar with bulbous form, incised bands, and opposed strap handles. Clearly more delicate and graceful than many of its counterparts, this jar was intended to be seen and used at the table. Yet another variant is the yellow, lead-glazed tobacco jar (fig. 10-3), which is inscribed

> Jo'han Jo'han
> Jo'han Worth
> Run Run For all Your Worth
> Hurrah Hurrah
> For Jo'han Worth

The object of this humorous effusion was Jonathan Worth, a prominent politician from Randolph County who served as governor of the state from 28 December 1865 to 1 July 1868. Worth is said to have been a good friend of the Coles and Cravens,[6] and he may have been presented with this jar during one of his campaigns. Such inscriptions are decidedly rare but have always been a part of the potter's art in both Europe and the United States. Very likely Worth also owned some clay pipes and could dip them into his jar for a relaxing smoke during the heat of a convention.

Another and more common type is the so-called "preserve jar" that was normally made in half-gallon and one-gallon sizes for a wide variety of fruits and vegetables. Unlike the jam, sugar, or tobacco jars, this one was normally sealed and designed for long-term storage rather than daily use. Be-

Figure 10-2
Left: alkaline-glazed stoneware jar, ca. 1900, Buncombe County. H 5⅜", C 12⅛". Right: salt-glazed stoneware preserve jar, fourth quarter of the nineteenth century, Alamance County. H 10⅝", C 19¹³⁄₁₆". Collection of Robert and Jimmie Hodgins.

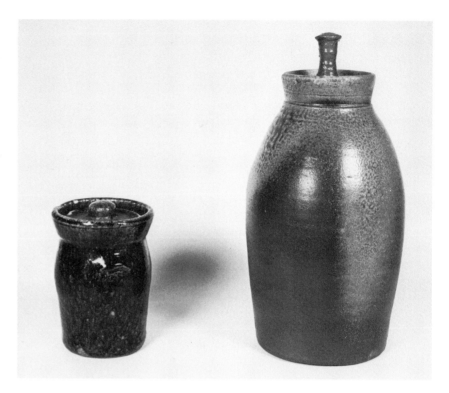

cause they were put away out of sight, they rarely exhibit any decoration or inscriptions. Mrs. Alvah Hinshaw of Snow Camp explains that

> we canned apples and blackberries and peaches—things that we raised. We didn't go anywhere to buy that because you couldn't buy it. You didn't have the money to buy it. No, we'd pick blackberries, and my daddy had a lot of apple trees and some peach trees. . . . You'd just cut 'em up and cook 'em till they got done and put 'em in those jars while they's hot. . . . They might have put a little sugar in them to make them keep better. Then you sealed them with some sort of rosin. They would get—they would put a cloth on top of the jar, and they'd smear that rosin over the top of that. And then they'd put a thick paper on top of that to keep it from bursting through, and just cover it all over with that rosin or whatever you call it to seal the jar.[7]

Figure 10-2 illustrates a preserve jar made in Mrs. Hinshaw's immediate neighborhood, with the characteristic tapered shoulder, extended neck, and long finial attached to the lid.

In like manner, Mrs. J. W. Gentry of Propst Crossroads, Catawba County, would put up her Kiefer pears each fall. When the weather turned cool, she

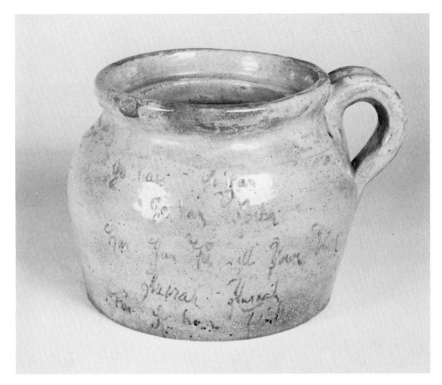

Figure 10-3
Lead-glazed earthenware jar, third
quarter of the nineteenth century,
Randolph County. H 4⅜", C 18⅜".
Collection of the Mint Museum,
Charlotte, N.C.

would pick the pears and quarter them, then add about an equal amount of sugar, which functioned as both preservative and sweetener. "You'd let that stand overnight and then you would cook them pears until you cooked them down, until your syrup got—until the water run out of the pears and it got to be a syrup. And you'd just put it in them jars. . . . You'd just tie a cloth on them to keep dirt and mice and everything out."[8] During the winter she enjoyed these preserves as a dessert with her hot, buttered biscuits.

Figure 10-4 shows two preserve jars made a short distance south of Mrs. Gentry's home by Daniel Seagle and his son, Frank. The smaller jar has a turned rim and indented shoulder to facilitate tying down a cloth cover as described above. The larger one, however, has a pottery lid that rests on a flange inside the neck; it could more quickly be sealed with wax or rosin. Georgeanna Greer points out that "the very earliest types had tie down rims or were made with mouths small enough to close with corks. In later jars the lid ledges receiving simple flat lids which could be sealed with grease, wax, or sealing wax were common."[9] In North Carolina the majority of preserve jars made after the middle of the nineteenth century were designed for lids, but the lidless type was also made into the twentieth century.

Far to the west, in Buncombe County, the Stone and Penland families

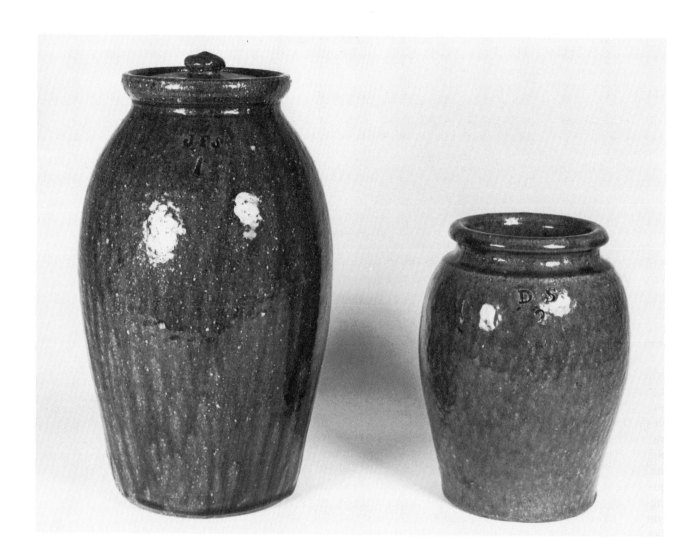

Figure 10-4
Alkaline-glazed stoneware preserve jars. Left: third quarter of the nine-teenth century, J. Frank Seagle, Vale, Lincoln County. H 11⁷/₁₆″, C 22⁵/₈″, 1 gal. Stamped: "JFS." Right: second quarter of the nineteenth century, Daniel Seagle, Vale, Lincoln County. H 7⁵/₈″, C 18½″, ½ gal. Stamped: "DS." Collection of Roddy Cline.

often added a single strap handle to their small jars, a feature not encoun-tered elsewhere (plate 8). This additional touch does not seem necessary but the handle may have been useful in pouring out liquid contents. Edward Stone was one of the pioneer potters in this region and may have brought this particular form from South Carolina. Greer illustrates a virtually identi-cal jar by Collin Rhodes of the Edgefield District and adds that "early stoneware preserve jars are sometimes cylindrical, although most are ovoid or globular in form, particularly those made before the mid-nineteenth cen-tury."[10] Apparently, J. S. Penland retained the handle on the later, more cylindrical, shape.

The preserve jar remained an important part of the potter's repertory until the beginning of the twentieth century, when the glass canning jar began to offer serious competition. The newer "fruit jars" were airtight and easier to clean, and so increasing numbers began to buy them to put up their fruits and vegetables. Predictably many potters across the country began to duplicate these commercial products. "During the later half of the nineteenth century, the imitation of glass fruit jars began and a number of these stoneware jars were manufactured with a specially tooled groove into which the same simple metal dome cap used on glass fruit jars could be fit. . . . By the last quarter of the nineteenth century various patented stoneware fruit jars were being manufactured."[11] In North Carolina, only a few potters took up the challenge and attempted to replicate the work of the factory. Perhaps the most flamboyant was J. J. Owen of Moore County, who produced a tall preserve jar with lug handles and the standard double rim, all boldly stamped "J.J.OWEN / PATENT / JAR." Himer Fox turned a virtually identical form, and a few unsigned cylindrical jars with rather crudely tooled rim grooves have been found in the alkaline glaze of the Catawba Valley. Ultimately the glass fruit jar did displace the old preserve jar, but the process was a very gradual one. As Mrs. Gentry knew all too well, "till later years, people just didn't have that many glass jars; they's too expensive."[12]

Along with the once ubiquitous preserve jar, two other medium-sized jars deserve notice: the "medicine jar" and the "butter jar," both of which were made in the eastern Piedmont (fig. 10-6). Normally ranging from one-half to one gallon in capacity, the former type was most commonly produced by the Foxes but also by the Cravens, Browers, and others. With its cylindrical walls, short, pinched neck, and wide, nearly horizontal rim, it does resemble the European alboretto or apothecary jar (which was normally made of majolica). This form may have been used during the Civil War; it is frequently asserted that the Foxes and others avoided conscription by making "bowls, mugs, medicine jars, and telegraph insulators for the Confederacy."[13] However, there is no hard evidence for this, and it seems more likely that these medicine jars were primarily for storing foods. In the North, stoneware "drug jars" were "used by apothecaries for storing their balsams, barks, extracts, flowers, oils, roots, seeds, salts, and elixirs."[14]

The second type of medium-sized jar common to the eastern Piedmont is the butter jar, another straight-walled container, which commonly occurs in one- and two-gallon capacities. Unlike the medicine jar, it has opposed lug handles, no rim, and a large, flat lid with an interior flange. These vessels bear a general similarity to the usually squat, cylindrical butter pots made in the North, though of course the North Carolina wares lack the Albany slip-glazed interior as well as cobalt decoration. "Butter for household use was packed in small, covered crocks and stored in the cellar or springhouse. If the butter was carefully prepared and well salted it could be used for six months or more."[15] In particular, with their wide, thin handles and plain,

Figure 10-5
Salt-glazed stoneware preserve jar,
second half of the nineteenth cen-
tury, James J. Owen, Moore County.
H 9½", C 17⁵/₁₆". Collection of Mrs.
Nancy C. Conover.

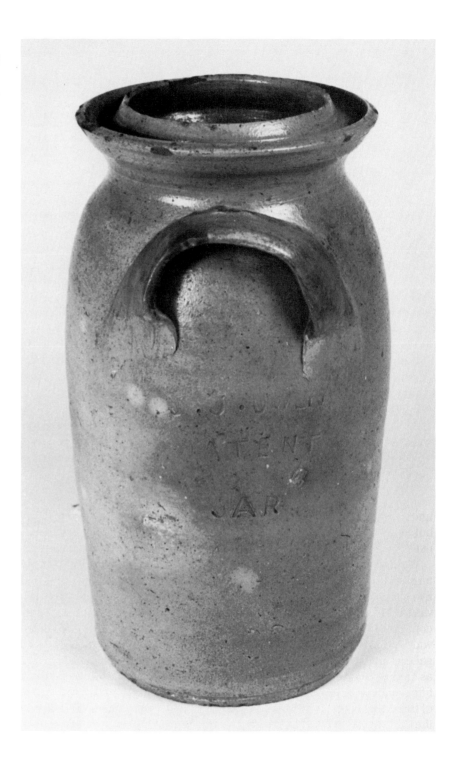

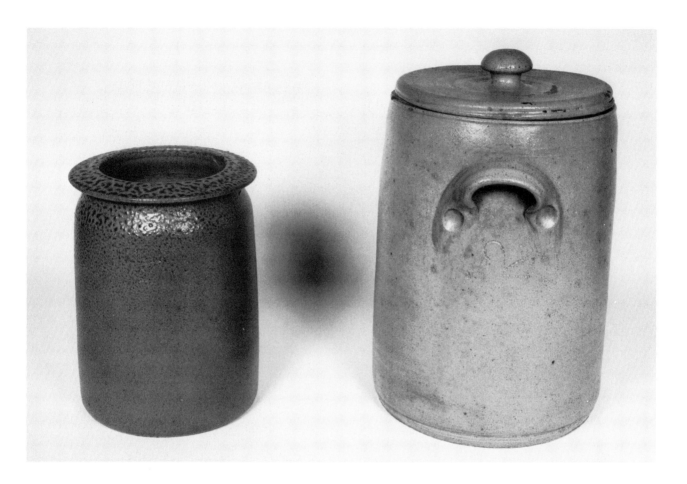

undecorated surfaces, the North Carolina examples strikingly resemble the butter pots of seventeenth- and eighteenth-century Staffordshire, which were used locally and also "filled with butter, for sale to dealers from London."[16]

While most of these lesser jar forms were no longer being made by the turn of this century, the large storage jar sold well through the Depression. Even today Burl Craig still provides them for his neighbors to put up a variety of vegetables or wine. Across the state, the storage jar was most commonly made with a capacity of from two to five gallons, with small and wide mouths, turned rims, and opposed lug handles. Large sizes up to ten gallons are not uncommon, and during the nineteenth century, potters such as Daniel Seagle and John A. Craven produced virtuoso pieces that held fifteen gallons and more. Based on the surviving pottery, a great many more of these "superjars" appear to have been made in the Catawba Valley than in the eastern Piedmont. More than a dozen by Daniel Seagle, marked in ca-

Figure 10-6
Left: salt-glazed stoneware medicine jar, ca. 1850, Himer Fox, Chatham County. H 7⅞″, C 18¾″. Stamped: "H FOX." Right: salt-glazed stoneware butter jar, ca. 1875, Manley R. Moffitt, Randolph County. H 10″, C 24½″, 2 gal. Stamped: "M. R. MOFFITT."

pacities of ten, twelve, and fifteen gallons, are known today (fig. 4-1). They may well have survived *because* of their size. Tremendously heavy when filled, they would have been moved only infrequently, and thus were less liable to breakage than the smaller wares.

Storage jars were primarily used for preserving large quantities of salted meats and pickled vegetables. During the fall, for example, farmers would butcher a few hogs. Mrs. Hinshaw recalls packing their jars with ground sausage and lard. "It was hard to get ahold of lard them days. You had to raise your own meat to get your meat and lard." In addition to serving as a sealant, the lard was important for cooking many foods and also as an ingredient in breads and pie dough.[17]

Perhaps the most common pickled vegetables were beans, cucumbers, corn, and cabbage (sauerkraut), all of which were immersed in a brine. Mrs. Gentry reveals how convenient it was to fill the jar as the crop came in and then later use the contents as needed. "People up here, they like cucumber pickles, you know, and you see, they would just put a layer of their cucumbers in and a layer of salt. And then, when they gathered some more cucumbers, they put them in. But you see, the cucumbers—the water run out and it covered the cucumbers. You wouldn't have to put water [in], but you'd have to put a weight to hold your cucumbers down. . . . They used a piece of plank that was cut to go in the jar, and then they'd put a rock or weight on it." For extra flavoring, some added layers of fox grape leaves with the cucumbers. When the jar was full, "they'd tie several layers of cloth over it, and then they'd just take out those cucumbers, however many they wanted, and soak them overnight."[18] Vegetables like beans were usually parboiled first, but otherwise the procedure was the same.

Figure 10-7 shows a typical four-gallon, alkaline-glazed jar from Mrs. Gentry's region, dating from the late nineteenth century. The sturdy turned rim facilitated tying down the cover and also assisted "in keeping the form in the round during drying and firing."[19] A very different form from the same area, one which resembles an oversized preserve jar, is the slender, small-mouthed jar by Sylvanus Hartsoe in figure 10-8. Although only half the capacity of the Bass jar, it is almost the same height and has a flaring rim to hold a pottery or wooden lid. In general, the wide-mouthed jar was the more popular, as it was easier to clean and the contents more accessible. However, it had one disadvantage. Greer notes that "in the storage of lard, meat covered by lard, and any form of sugared preserve, the large opening and subsequently large exposed surface allowed more rapid oxidation and contamination of the contents."[20]

Figure 10-9 illustrates two storage jars from the eastern Piedmont in three- and four-gallon capacities. The smaller one by Enoch S. Craven typifies the classic Randolph County style of the second half of the nineteenth century. The bold, protruding rim; wide shoulder; neatly applied, thumb-printed handles; and carefully trimmed body characterize the work of most of the Cra-

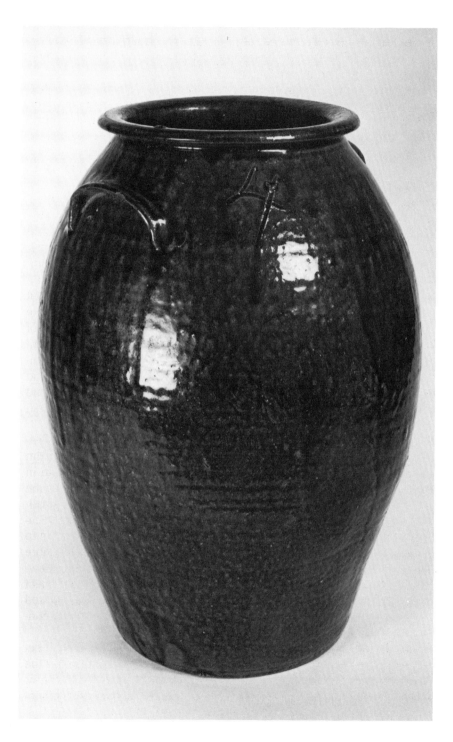

Figure 10-7
Alkaline-glazed storage jar, fourth
quarter of the nineteenth century,
Nelson Bass, Lincoln County.
H 15¼", C 35¼", 4 gal. Stamped:
"N B."

Figure 10-8
Alkaline-glazed stoneware storage jar, fourth quarter of the nineteenth century, Sylvanus L. Hartsoe, Catawba County. H 14³/₁₆″, C 24⁷/₈″, 2 gal. Stamped: "SLH." Collection of Mr. and Mrs. Hurdle Lea.

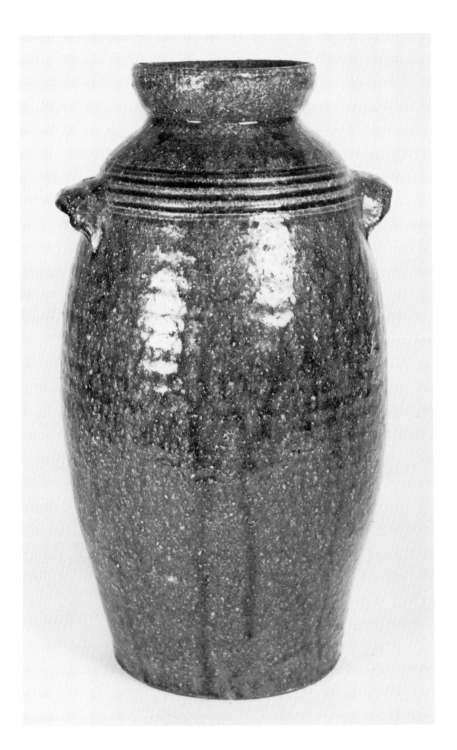

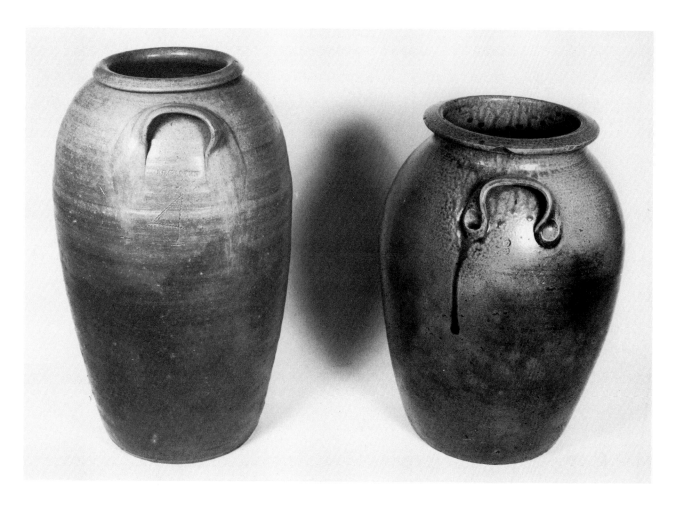

vens, their relatives the Foxes, and J. F. Brower, among others. Although made by Enoch's nephew, Dorris, the larger jar is quite different in form and finish. The thin, wide handles with flattened terminals, the coggled "4," and the rougher surface all represent the Moore County tradition, in which Dorris Craven played the seminal role.

Over the years the shape of the jar gradually evolved from the globular creations of Daniel Seagle through various ovoid forms and ultimately to the perfect cylinder (fig. 10-10). During the second quarter of this century, potters in the Catawba Valley produced a substantial number of large, straight-walled containers in imitation of the commercial wares coming in from Texas and the Midwest. Burl Craig remembers the growing popularity of "that straight jar, open-topped jar. People got to seeing that Ohio pottery, you know; they'd hauled some in here. People got to seeing them, and they

Figure 10-9
Salt-glazed stoneware storage jars.
Left: third quarter of the nineteenth century, J. Dorris Craven, Moore County. H 16½", C 31½", 4 gal. Stamped: "J.D.CRAVEN." Right: ca. 1850, Enoch S. Craven, Randolph County. H 14⅜", C 33⅜", 3 gal. Stamped: "E.S.CRAVEN."

Figure 10-10
Alkaline-glazed stoneware storage jar, ca. 1930, Catawba Valley. H 22", C 41¾", 10 gal. Collection of Mary Frances Berrier.

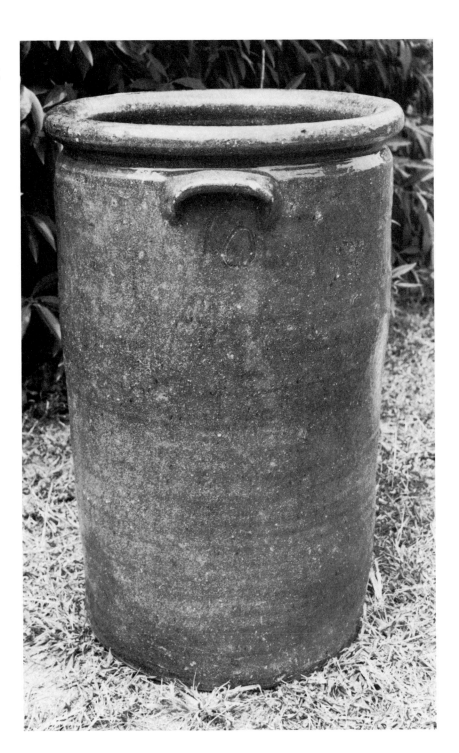

wanted them that shape." The local jars, of course, were hand-turned and coated with an alkaline glaze; the factory products, on the other hand, were often jiggered or molded and covered with Albany slip or the white Bristol glaze. Burl adds that he "made a lot of ten gallon, eight and ten gallon jars. . . . The big ones went back up in the mountains, around Spruce Pine, back, you know, Big Toe River, Little Toe River. People used them to put up beans, pickled beans, pickled corn. . . . You didn't have money to go to the store and buy it like you do now. People, mountain people back then, they didn't buy [much]: a little bit of salt and sugar and coffee, that's all they ever bought."[21] Such cylindrical jars are not found in the salt glaze of the eastern Piedmont, as by this time the remaining potters had begun producing the new artistic and domestic wares. In the more isolated Catawba Valley, however, the folk tradition persisted, in part because of the strong demand for the old wares in the not-so-distant mountains.

In all, the evolution of the jar form in North Carolina was neither a clearcut nor a uniform process, and the move to the cylinder came very late. Georgeanna Greer finds that "wide-mouthed jars became more or less cylindrical in form after the mid-nineteenth century in all parts of this country. They remained more or less the same in form from that period onward. Some are short, but most are relatively tall, full cylinders. They have little grace of form."[22] Greer's comments hold for the North and Midwest, where large factories were operating in the second half of the nineteenth century, but not for the Southeast, where the folk potter—free of the regulations and constraints of industry—continued to turn highly variable ovoid jars and jugs into the twentieth century. Even today Burl Craig continues to produce the swelling forms that reflect a now largely vanished heritage.

Greer's comment on the declining "grace of form" echoes the feelings of many collectors who have lamented the shift to the cylinder. However this gradual transformation was not a matter of taste or aesthetics on the part of the potter. As Enoch Reinhardt observed, the bulbous forms required considerable skill to turn, as well as a "short" clay that would not collapse or shear on the wheel. In addition, they were easier to break in handling—that is, while drying, glazing, loading, or unloading. And in the kiln—or later, the covered wagon or truck—their form proved truly inefficient, as they required far more space than an equivalent cylinder.[23]

As the jar inched inward and upward, potters began producing what they sometimes called a "churn-jar," a combination form that sold well because of its versatility. Exactly when this type appeared in significant numbers would be difficult to ascertain, but it was almost certainly early in this century. Burl Craig recalls that "back when I started [1930], they was making a lot of jars, regular jars. . . . They was wider and wasn't quite as tall as your churn, and they had a different top on them—they didn't have a high top for a lid."[24] Gradually, however, he and others began making fewer jars, because "the churn was a little taller and a little narrower; it didn't take up as much—

saved some space in the kiln. And then people found out that they could use them, maybe, to put up pickles in. And if they broke their churn you was using, they could turn around and after they used their sauerkraut or their pickles, they could use that. Wash it out and use it as a churn." The logic of this development is indisputable—the new hybrid was a boon to both the potter and his customer. As embodied in Burl Craig's two-gallon churn-jar (fig. 8-7), the form incorporates characteristics of the old jar (the wide shoulder) as well as the churn (the relatively vertical form and the flaring rim with an internal flange for the lid). As Burl concludes, "After I quit making jars and went to making mostly churn types, I made them just a little bit wider than . . . regular churns."[25]

A parallel development occurred in the eastern Piedmont. Carl Chrisco explains that his family made no "jars" as such. "They call them churns. You could use them for milk churns. Made two styles of lids—one with a hole in it for a dasher if you wanted to use it for a milk churn, the other with a knob on it."[26] The contrast in figure 10-11 illustrates the evolution that took place, from the tall, slender cylinder to a shorter, moderately ovoid, multipurpose container.

JUG

Perhaps because it is a more specific form than the jar, with its pulled-in shoulder and narrow spout, the jug is somewhat easier to recognize and classify. In North Carolina, the usual capacities were ½ gallon and whole sizes from 1 to 5, with the 3 and 4 being somewhat less common. Occasionally, odd sizes, such as 1½ gallons, were also made and marked as such. Relatively few are found above five gallons, and the record appears to be ten—shared, not surprisingly, by Daniel Seagle (plate 16) and Thomas W. Craven (fig. 2-16). Pulling up sufficient clay to close the shoulder and form the neck was no easy task, and only a truly seasoned potter could produce a jug in such mammoth dimensions. Spouts were normally quite small, about 1″ to 1½″ in diameter, but for viscous liquids like molasses a diameter of 3″ to 4″, usually with a simple, turned-out rim, was employed.

Smaller jugs received a single strap handle. In North Carolina, one terminal was normally pressed into the base and against the side of the spout, and then the soft, wet clay strip was shaped into a smooth arch that curved downward onto the shoulder or upper belly. In the neighboring states, the upper terminal was more commonly applied to the top of the shoulder rather than against the spout itself, a subtle but important stylistic difference that makes the local wares easier to identify (fig. 10-12). Opposed strap handles were applied to the larger sizes from about four gallons up, so that they could be lifted safely when full.

Jugs are designed to contain and pour all sorts of liquids—vinegar, cider, wine, beer, brandy, molasses, oils, even water—but the popular mind al-

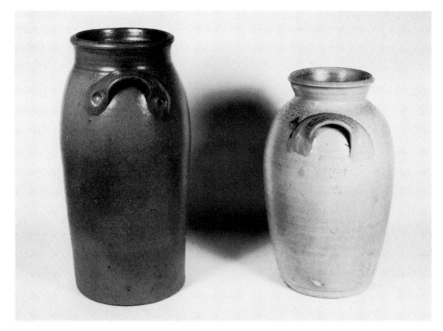

Figure 10-11
Salt-glazed stoneware churn and churn-jar. Left: third quarter of the nineteenth century, Himer Fox, Chatham County. H 16¾", C 27⅜", 3 gal. Stamped: "H FOX." Right: fourth quarter of the nineteenth century, John M. Yow, Erect, Randolph County. H 14³/₁₆", C 27¾", 2 gal. Stamped: "J. M. YOW / ERECT.NC."

ways fills them with a single product: whiskey. And there is some truth in this assertion. In his history of prohibition in North Carolina, Daniel Jay Whitener sketches the growing popularity of this potent drink:

> The most important intoxicating beverage of the colonial period was rum, usually imported from New England and the West Indies. Not until near the middle of the eighteenth century did corn whiskey come into common use. As the rise of the use of whiskey parallels the settlement of the Piedmont, the Scotch-Irish, German, English, and other immigrants there doubtless contributed to its popularity. Without ready means of transportation, corn and other bulky commodities could not be economically marketed. Because a profit could be made from distilled liquors, home-made whiskey quickly rivaled in volume and in popular favor imported rum. After the Revolutionary War the former supplanted rum almost entirely.[27]

Thus the taste for "mountain dew" (originally a term for Scotch whiskey) and other, less potent, homemade beverages was both inherited and necessary. With abundant crops and poor transportation, farmers in the Piedmont and later the mountains distilled their fruits and grains as the best way to preserve them.

The great age of the jug was probably the final third of the nineteenth century. Although they are not totally reliable or comprehensive, official

Figure 10-12
A trio of typical one-gallon stone-ware jugs from Georgia, North Carolina, and Virginia. Left: alkaline glaze, third quarter of the nineteenth century, eastern Crawford County. H 11¼", C 21⅜". Center: salt glaze, fourth quarter of the nineteenth century, William H. Hancock, Moore County. H 10⅛", C 23¼". Stamped: "WHHANCOCK." Right: salt glaze, fourth quarter of the nineteenth century, William H. Lehew, Strassburg. H 11", C 21". Stamped: "W. H. LEHEW & Co. / STRASSBURG VA."

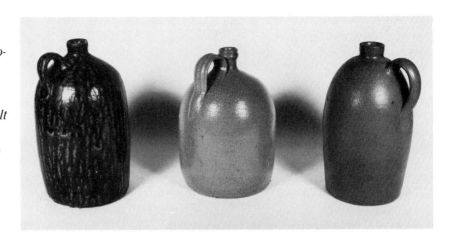

statistics indicate that the manufacture of liquor in North Carolina peaked in the early to middle 1890s and then went into a steady decline. "In 1892 the United States tax was collected on 851,219 gallons" of corn whiskey, and in 1895 the number of licensed manufacturers in the state reached 733.[28] Such demand must have brightened the day of many a potter. Enoch Reinhardt recalls how his father, Pinkney, and others "made just absolutely jugs, maybe burn a whole kilnful, five hundred in the kiln, of gallon jugs. And they was selling them to these here government distilleries; they shipped whiskey in them, you see. That was a business!"[29] And just a mile or so away, appropriately enough near Jugtown, Catawba County, Jacob Propst and his family were also "making a lot of jugs: half gallon, gallon, two, three, four, five gallon jugs. And they was hauling most of that stuff to the saloons in Charlotte. That was before Prohibition."[30]

By the late nineteenth century, the temperance forces were gaining considerable strength and were even putting pressure on some of the potters. James Broome of Union County remembers how his father, Jug Jim, had to stand up for his profession. "I'll never forget the preacher of the Mt. Pleasant Church at that time brought the subject up. And he told Dad, he says, 'You're committing a sin, making jugs for a whiskey still.' Dad said, 'I'm not making them for whiskey. . . . I'm not going to tell him to put liquor in those jugs. I don't care what he puts in them.' He said, 'He can dip water out of Rich's Creek and fill them up if he wants to. But all he's ordering from me is jugs, he's not buying *whiskey* jugs.' The preacher didn't say any more about it."[31]

In the early years of the twentieth century, two developments crippled the market for whiskey jugs: Prohibition and the fruit jar. In North Carolina, temperance groups passed effective legislation long before the Volstead Act of 1919. The Watts Bill of 1903 "prohibited both the sale and the manufacture of liquor outside of incorporated towns," and this was followed by still

more restrictive measures in 1905 and 1908.[32] However, illegal stills contin-
ued to flourish; even as late as 1940, 1,143 distilleries were seized and 2,456
persons arrested.[33] As a young man, Burl Craig served as a lookout for the
local moonshiners. "Back then, you know, they had stills on these branches
around here making it, a lot of the people did, moonshine." Burl's task was
to "set up on the hill and watch for the law to come in. . . . I had an old
shotgun; I'd blast that thing off if I saw the law or anybody that I didn't know
coming in towards the still." And of course he was paid in kind: "they would
give me a half gallon jar."[34]

Such was the local trade that in 1919, the very year of the Volstead Act,
one revenue commissioner lamented in the *Biblical Recorder*: " 'We have
more illicit distilleries than any other State in the Union or any other portion
of the earth; and the number is increasing.' "[35] Under the new conditions
demand shifted away from the old one-gallon jug to the larger sizes. As Burl
explains, "They would use the five gallon jugs to hide it in the hedgerows
and bury it in the ground. They'd go get a jug full at a time, bring it down to
the house and pour—most of it was sold in pints, you know, or half a
gallon."[36]

With their natural, earthy hues of green and brown, the alkaline-glazed
stoneware jugs of Burl's region were well camouflaged and provided a par-
ticularly reliable form of outdoor storage. But increasingly the actual sales
were made in glass containers. "What hurt the stoneware along the whiskey
trade was the short fruit jars: half gallons—they didn't hold a half gallon—
and the quarts and pints. And the bottles the same way, they got to mak-
ing them, a lot of them." Unlike the old jugs, which often held more than
their stated capacities, these new pints were "short," holding only fourteen
ounces. But the customers generally knew the difference. As Burl con-
cludes, "We always tried to take a bottle that held sixteen ounces—we didn't
take no short bottles."[37]

Still the smaller-sized stoneware jug continued to have its adherents.
"That's the best thing in the world to keep whiskey in," Burl affirms, "if you
want it to age. It won't age in glass. You've got to have the old oak barrel or
either a jug. A lot of them would get 'em a little whiskey and put it away,
maybe for Christmas or something like that. And keep it hid out in the barn
if they didn't want their wife to know it, you know, sip on it a little." Burl's
mentor, Jim Lynn, kept such a jug and was always surprised at how quickly
he emptied it. What Jim didn't know was that his wife, Leola, was sipping on
it too.[38]

Along with his jugs, the potter also made a more direct contribution
toward local whiskey production. His very large jars could be used for
fermenting the mash (though wooden barrels were most common) and
occasionally he produced a still cap such as shown in figure 10-13. This was
fitted on the top of the still so that the alcohol vapors collected inside and
then ran down through the arm into the condenser. This particular example

Figure 10-13
*Alkaline-glazed still cap, second
half of the nineteenth century, Lin-
coln County. H 9¾", C 29⁷⁄₁₆", L of
arm 13½".*

was turned in two parts, a jar and a pipe, which were then connected together after each had hardened somewhat.

While the whiskey trade declined early in this century, there remained a consistent demand for other types of jugs, in particular to hold vinegar and molasses. Like salt, the former was an important preservative (and also a widely used condiment for greens). Farmers could take their apples to the local press and leave a percentage of the cider as payment. The cider was strained through a cloth into large jugs; loosely stoppered, often with a corncob wrapped in a cloth; and allowed to ferment and run over until the contents were clear. Selling the vinegar was a good way for some people to raise extra cash. Irene Gates, daughter of potter Enoch Reinhardt, recalls that "my grandmother had a cider mill, and we'd make cider for her. And she had these great big, old, earthen [stoneware] jugs full of vinegar. And anybody wanted to buy vinegar, they'd go to her house. . . . She didn't sell the jug, too; she would just pour that out into their container. That was her storage—she had a lot of jugs of vinegar."[39]

No less important was molasses—also called "surp" or "sogrum"—which was made from sorghum during the fall and served as an economical substitute for sugar. Mrs. Gentry's father owned a cane mill in South Carolina and "made molasses for the public. They'd bring their cane there and bring their jugs or whatever, and he'd grind it. Look to me like it'd make a mule drunk just to go around and around. But it didn't. My father—we had two mules, and he'd use one in the morning and he'd put that one up at lunchtime. And he'd get the other one, and he'd go on to the evening."[40] The painting in plate 18 is by Minnie Reinhardt, also of Catawba County, whose father, Wade Smith, was both a potter and a molasses maker. It shows the full production process: on the right a boy and a man are grinding the green cane that is stacked under the tree; to the left a couple is stoking the boiler and skimming the thick, bubbling syrup. The containers shown include wide-mouthed jars, a one-handled molasses jug, and two barrels. During the fall, Wade carried several full barrels while peddling his pottery and sold the molasses for forty cents per gallon.[41]

Sugar was expensive and often unavailable, and so molasses (and sometimes honey) served as the common sweetener. Mrs. R. L. Robinson of Weaverville recollects that "in my grandfather's day they used molasses for nearly everything for sweetening. My mother-in-law said she had never seen a cake baked with sugar and icing and things like that. They had them made with molasses until she was—well, in the early 1900s when she moved to Buncombe County. . . . And they would make what they called sweet bread with the molasses. And then they would put apple sauce between it and make what they called stack cakes. The older men was very fond of it."[42] Molasses jugs normally ranged from two to five gallons, with the threes and fives being most common. The decorated jug from the Catawba Valley in figure 10-14 illustrates the characteristic wide mouth on these vessels,

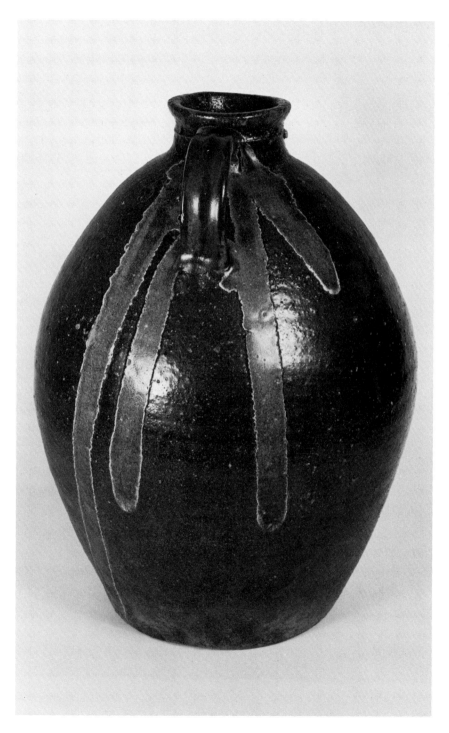

Figure 10-14
Alkaline-glazed stoneware molasses jug, fourth quarter of the nineteenth century, Catawba Valley.
H 16⅞", C 41⅛", 5 gal. Glass streaks around the handles.

though molasses was also kept in regular jugs, jars, and pitchers. In cold weather, it often had to be warmed near the fire to get it to pour, so occasionally the potters made smaller (one to two gallon) jugs with wide spouts for immediate use in the house.

It should never be forgotten that a jug can hold water. Burl Craig points out that "a lot of people would fill it up with water and take it to the field. . . . They would take a, wet a tow sack and put it in something like a half bushel measure, and wrap this sack around it and set it in there. And your water would stay cool. Set it in the shade, you know, when you got where you was going to work."[43] The usual size was one gallon, and the cool stoneware must have helped slake many a thirst in the humid southern heat. There was no particular container made just for this purpose, however. By contrast potters in England produced a wide range of "harvest wares"—jugs, costrels, flasks, kegs—that were often decorated and appropriately inscribed:

In harvest time when work is hard
Into the field I must be Carr:d
Full of Good Cyder or Strong Beer
your thirsty work folks for to cheer.[44]

Only infrequently do a number of special forms of the jug appear in North Carolina. One such is the salt-glazed stoneware bottle in figure 2-21, which, were it not for the stamp "COLE & Co," would appear to be a northern product. Only one other is known and stamped "JFH," presumably for John F. Hancock, who worked in Moore County. The use of initials to mark ware is highly unusual in the eastern Piedmont; consequently this attribution may be erroneous. What these two bottles were used for is not known, but in the North and Midwest they commonly held ink, cider, beer, catsup, or soft drinks.[45] A second rarity is the pinch jug, usually very small in size and formed by pressing in the wet clay walls to flatten the sides. This appears to be the local variant of the hip flask, usually made without a handle and designed "for carrying small amounts of liquor in the pocket or saddlebag."[46] Several other jug types also occur—notably the face, monkey, and ring jugs—but these do not seem to have been made for utilitarian purposes, and so will be considered in the section on whimseys.

Like the jar, and for the same reasons, the jug gradually tended toward a more cylindrical form. However it is very rare to find the straight-walled, shouldered type in figure 10-15. The potter has imitated the commercial whiskey jug of the late nineteenth and early twentieth centuries, which was often produced by jiggering or molding and then coated with a Bristol or slip glaze. He has even added the horizontal shoulder rim, which would have supported a "jug sagger or stacker," a truncated cylinder placed over the top of the jug to support another jug directly above it.[47] That this example was not covered or stacked is shown by the abundant flyash on the shoulder.

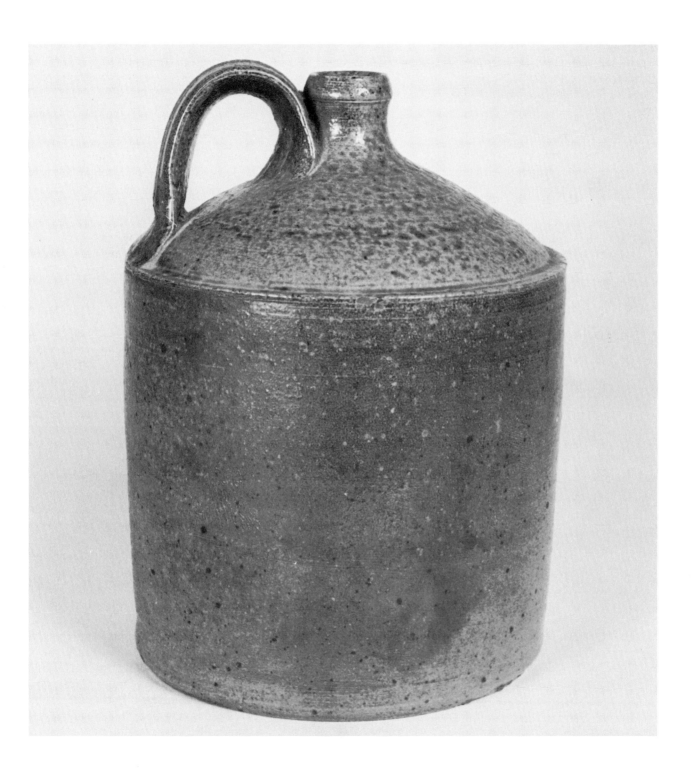

Figure 10-16
Salt-glazed stoneware jug, ca. 1900,
Millard F. Wrenn, Randolph County.
H 6¾", C 28⅛". Signed in script:
"M. F. WRENN." Collection of the
Mint Museum, Charlotte, N.C.

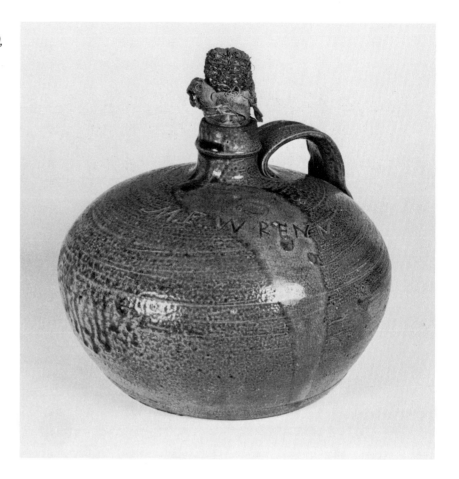

Even in the twentieth century, the North Carolina potters continued to produce jugs with at least a mild ovoid shape. And in the eastern Piedmont a very squat, globular form that would seem to suggest a much earlier era (fig. 10-16) was popular during the late stages of the folk tradition. In fact, there may have been a very practical use for these forms. As Burl Craig reminisces.

We had what they call the buggy jugs too. You know, where you put your feet in the buggies, those sides wasn't built up too high, so we made a one-gallon jug that was just a regular jug with the small mouth and handle—just a regular jug, only it was squashed down low and wide. People could put their liquor in that and hide it in the buggy between their feet, you know what I mean. If you had a big tall jug and was riding along the road and the sheriff come along, he could see

Figure 10-17
Alkaline-glazed stoneware milk
crock, ca. 1925, Samuel A. Propst,
Henry, Lincoln County. H 9″, D 11⅞″,
2 gal. Stamped: "NORTH CARO-
LINA." Collection of Mary Frances
Berrier.

your jug. So they wanted them low so they could put it between their feet and then put a lap robe over their legs to hide it from the law.[48]

Like the flattened decanters used by sea captains for the same product, the buggy jugs also proved more stable than the taller, cylindrical forms.

MILK CROCK

In most contexts, the term "crock" has been used as a catchall—like "pot"— to describe any type of ceramic container, particularly a jar. But in North Carolina, at least in this century, crock has meant "milk crock": a rather deep, flaring, straight-walled form with a wide, horizontal rim (fig. 10-17). Ordinarily it was filled with fresh milk and stored in a cool place such as a springhouse or cellar. As Mrs. Gentry explains: "That's what you usually

strained your night's milk in. You wanted it in something that's pretty big at the top so the cream'd rise to the top. And you could just skim off that cream—just tilt your crock and use a spoon or something and guide that cream off into your churn."[49] Milk crocks were produced in four basic sizes from one-half to two gallons that were, because they lacked handles, easily stacked inside each other in nests by the wagoners who hauled them off to sell. And unlike the jar or jug, the milk crock showed little variation across the pottery-making areas of the state.

The North Carolina milk crock is a regional derivative of a widespread form elsewhere called a "milk pan" or a "cream riser."[50] In the North, the pan was relatively wide and shallow, with a pouring spout and two lug handles on the upper sides. The hotter climate of the South, however, necessitated a deeper container that could be partially submerged in water. Interestingly the term "pan" appears to have been used in North Carolina during the nineteenth century. It occurs in Aunt Rebecca's letter at the beginning of this chapter and also, albeit infrequently, in the ledgers of Himer Fox and John A. Craven, both of whom were active at mid-century. Along with the jar and the churn, the milk crock remained a staple of the potter's repertory right through the Depression. Bascom Craven of Randolph County recounts that "there was a big demand then for gallon milk crocks. . . . I don't know whether they had any electricity then or not. We didn't have any here in the country, not by a long shot. We had a milk house down there on the branch below the spring, and we kept our milk setting in the water there."[51]

Refrigeration was a problem for the rural family, but North Carolinians were familiar with a range of traditional, homebuilt methods for chilling the contents of their crocks and jars, jugs and pitchers. Water was the cheapest, easiest coolant at hand, and many, like A. C. Marley of Alamance County, used the "regular old spring run box. You just go in there and dig down in that, in that spring run, and put your box in, however wide you want it. And you leave the ends—well, what you really do, is put a end in the box but cut a hole out in it. Both ends, so the water runs straight on through it. And you put a top over it, so a dog or nothing couldn't get in it."[52]

The spring box was simple and convenient, but many constructed a small "springhouse" or "milk house" over the spring for better protection. The crocks and jars were set so that the water came about halfway up or up to the handles; they were then covered with plates or pieces of plank, often with a rock weight on top for extra stability. Some of the springhouses, like the one used by Mrs. Robinson's family, were large enough to work in. "We kept it nice and clean in there, and we had a table or a shelf or something where we strained your milk up, and you set your things out onto it. And then you churned over there, and you set your butter there and worked it and molded it. . . . Get it out in a ball and get all the water out of it. And then you put it in that mold. put it down into, maybe, a pottery crock . . . [and] set it

in the upper part where it [the water] wasn't too deep and put it—cover it all over nicely." Mrs. Robinson adds that watermelons were particularly tasty after they were submerged in the spring run. "Anything we wanted to keep cold, that's all we had. And we had to run to the spring when we got ready to eat a meal."[53]

Sometimes, however, the spring was a considerable distance from the house. And as Minnie Reinhardt cautions, another disadvantage was rain. "You know if it come up a big rain it would sometimes wash your milk—drown it! Once it would get up, a washpot would wash away."[54] For these reasons, some preferred a dry storage facility, which could be located in or near the house. Enoch Reinhardt's family used "just a hole dug out in the ground, sort of like a cellar. And that's where we kept our milk in those milk crocks, we called them, with the little flat edge around the top. . . . That's what everybody kept their milk in. Of course, there was an enormous market for those."[55]

A more elaborate solution was to dig a "milk well" about twenty feet deep, often under the back or side porch for easy access. The crocks were then placed on the shelves of a cylindrical cage or frame that was raised and lowered with "a rope and windlass. You'd let that thing down fifteen or twenty feet, far enough till it got cool, you know. And then when you wanted your butter or your milk—whatever you had you wanted to keep cool—well, you'd draw it up like drawing a bucket of water." Later on, Mrs. Gentry concludes, "when we got a little money, we had the icebox made." Constructed of wood by a local carpenter, it was lined with tin and filled with cottonseed hulls for insulation. Unlike sawdust the hulls would not run out when the box leaked. The icebox was also located on the porch and easy to use, but when filled with two blocks of ice, "it didn't leave you much room for your stuff."[56]

Eventually electricity and the refrigerator solved all these problems—and eliminated the need for the milk crock in the process. One interesting transitional form made in the Catawba Valley that was designed for cramped quarters was the "refrigerator jar" (fig. 10-18). By all accounts it evolved from the milk crock, but with its straight sides and thin, wide collar it occupied less space. Two other somewhat related forms were also seen occasionally. One was the "milk jar" of the eastern Piedmont (fig. 10-18), which, by Carl Chrisco's definition, "is straight up, got a rim on it. A milk crock is flared."[57] Much rarer were the squat butter tubs made by George Donkel. As shown in figure 10-19, these were very low and wide, with a horizontal rim for tying down a cloth cover. "Butter for household use was sometimes 'put down' in crocks without lids by placing a cloth sack partially filled with salt on top of the butter."[58] Donkel's family came from Pennsylvania, and he may have been inspired by northern examples to make this unusual alkaline-glazed form.

The milk crock may be regarded as a subtype of the jar, but its distinctive

Figure 10-18
Left: salt-glazed stoneware milk jar,
ca. 1900, W. Henry Chrisco, Moore
County. H 10", C 23¼", 1½ gal.
Stamped: "W.H.CRISCO." Right: alka-
line-glazed stoneware refrigerator
jar, ca. 1925, Catawba Valley.
H 8³⁄₁₆", C 22⅞".

Figure 10-19
Alkaline-glazed stoneware butter
tub, first quarter of the nineteenth
century, George Donkel, near
Weaverville, Buncombe County.
H 5⅛", D 13⅞". Collection of Mr.
and Mrs. James W. Robertson.

form and association with dairy products necessitate its special consider-
ation. In fact during the twentieth century, as the preserve jar and other
lesser types were being phased out, it often served as a convenient, small
container for various types of foods. And occasionally it appeared at meal-
time. Burl Craig recalls that "they would just set the milk on the table in
the crock it was in. Just set it, and they would dip it out and fill up the

glasses. . . . Then, everybody eat cornbread and milk, and crumble their cornbread in their milk. . . . Oh, man, that's good. Take you some good cornbread and crumble it up."[59] Although milk crocks remain easy to find today, few people recognize them as such. Most assume they are flowerpots, and in fact, a fair number of the survivors have holes punched through their bottoms, indicative of their new function in the age of electricity.

CHURN

The churn could be classified under the heading of Food Preparation, but ultimately its true functions have more to do with preservation. In the first place, the churn—often in the modified churn-jar form—was widely employed in North Carolina and throughout the Southeast for storing pickled vegetables. Second, its most common use was to preserve milk in the form of butter. According to Georgeanna Greer: "Ceramic churns seem, strangely, to be a form of pottery vessel used mainly during the nineteenth century. Prior to that period this form seldom appears, and most churning of milk was done in a staved wooden churn. Some churns were manufactured in earthenware, but the majority were produced in stoneware."[60] Indeed in North Carolina no earthenware churns appear to have survived outside the Moravian tradition. And the fact that "churns are not listed on the pottery inventories" of the meticulous Moravians suggests that few were made.[61] Very likely, as Greer suggests, "the forceful action of the dasher against the interior bottom of the vessel made the more durable stoneware a distinctly better medium."[62]

The common sizes in North Carolina ranged from two to five gallons, with occasional orders for a one or a six. A small churn, such as the one by Enoch Reinhardt in figure 10-20, would have been used by women who like to provide fresh butter every day. On the other hand, many churned only when a substantial amount of cream was ready. Alvah Hinshaw's mother would "skim it into what she called her cream jar. And when we got that thing full and let the milk thicken, we'd churn it."[63] The frequent churnings must have proved tedious, but Mrs. Gentry's mother knew how to make the time pass. "She liked to read. And she'd set there with a book in her hand and she'd churn. And once in a while she'd raise up the lid to see if she had butter. And if she did, well, she'd put her book down, and go and take up the butter. It'd just be in wads. . . . And we had a little paddle that was made out of cedar that you worked your butter with, and worked the milk kind of out of it. And then my mother always washed it through several waters. . . . Then you put your salt in and put your butter—molded it if you wanted to or however you wanted to use it at the table." The cream had to be warm for the butter to form, and so many women worked in a comfortable spot near the fireplace (fig. 10-21). Mrs. Gentry adds that "sometimes people'd get in a hurry, and they'd pour hot water in their churn to make it come quicker."

Figure 10-20
Alkaline-glazed stoneware swirl
beanpot and churn, Enoch Rein-
hardt, Henry, Lincoln County. Left:
ca. 1935. H 4⅝", C 25¹¹⁄₁₆". Stamped:
"Reinhardt Bros. / Vale, N.C." Collec-
tion of James and Irene Gates.
Right: ca. 1940. H 10½", C 24".
Stamped: "E. W. REINHARDT'S /
POTTERY / VALE, NO. CAR." Collec-
tion of Roddy Cline.

However, that made the buttermilk thinner and the butter very "puffy and white." While not as good to eat, "it made awful good cakes 'cause it was light and fluffy."[64]

Most of the butter was consumed at home, but some families produced enough to sell. As a child, Mrs. Robinson would help wrap their butter in clean cloths—and later, "butter paper"—and pack it in baskets. While the butter was often stored in pottery containers at home, they were not used for transportation because they were too heavy. Then her father would rise early the next morning to make the twelve-mile trip into Asheville in his buggy to peddle it to his customers, whom he called his "butter women." Sometimes the buttermilk was also sold at ten cents per gallon, but the excess usually went to the hogs.[65] The milk was used in several forms. Some drank the whole milk, but others, like Mrs. Gentry's family, preferred "skimmed milk because that whole milk was too creamy. I never liked it; it'd make you too

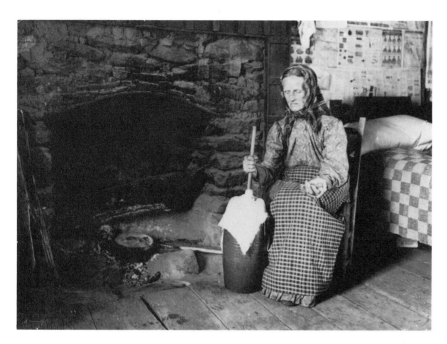

Figure 10-21
A mountain woman churning in front of her fireplace. Photograph by Margaret W. Morley. Courtesy of the North Carolina Museum of History, Raleigh, N.C.

fat."[66] Inevitably, North Carolinians praise fresh buttermilk, both as an ingredient in cornbread or biscuits and as a refreshing drink. In A. C. Marley's view, "That's the only kind of buttermilk that's fit to drink as far as I'm concerned. Can't get it no more. I don't like this old chemical stuff."[67]

Most of the churns made in North Carolina were relatively tall and straight-sided, with a flaring neck, 1″ to 2″ in length, that breaks sharply away from the shoulder. In the eastern Piedmont, two lug handles were applied (fig. 10-22), but in the Catawba Valley and the Mountains, at least within this century, it was more common to use both lug and strap handles. Two combinations appear: opposed strap and lug handles (fig. 10-20) and, less frequently, opposed lug handles with a strap handle between them (plate 15). The employment of the strap handle on churns is a distinctly southern feature and was no doubt intended to facilitate pouring out the contents.

Two types of lids were used, the "jug lid" and "saucer lid," as Burl Craig refers to them (fig. 10-22). The former is flat with a short neck or spout, while the latter is concave. And each had its advocates. "You know, when you make something like that," Burl explains, "why, it's always the best. Harvey and Enoch [Reinhardt] argued that people liked them [jug lids] the best, because you could take ahold of it and pick it up. . . . And old man Seth [Ritchie] said the people liked his [saucer lids] the best, because the cream didn't run out over the lid. On the other one, when you churned, the

Figure 10-22
Salt-glazed stoneware churn,
ca. 1925, Auman Pottery, Ran-
dolph County. H 20", C 33 1/4", 6
gal. Stamped: "Auman Pottery /
Seagrove N.C."

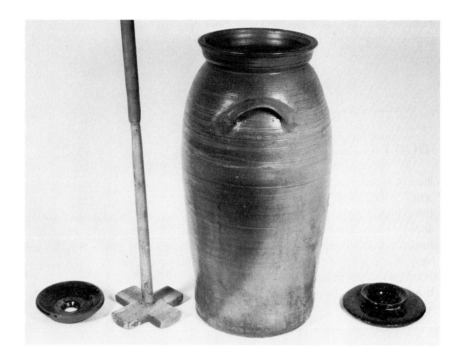

cream would come up a lot of times with the stick—you know, the dasher part—and run down over the lid, where it wouldn't do it with the saucer lid." Early on, Burl opted for the saucer lid, but when he went to work for the Reinhardts, Enoch objected, "'Ah, you ain't gonna' make them old kind of churn lids, are you? They ain't no good!' "[68] Personal preferences notwithstanding, both lids were easily broken and often replaced with a homemade wooden disk with a hole drilled through the center.

The demand for churns remained strong in this century, largely because of their increasing role as storage vessels. Their original function steadily became less important, both because of the availability of commercial dairy products and competition from factory-made churns. Mrs. Gentry's husband eventually bought her a fancy, new, crank-driven wooden model, but she soon found that she preferred the old, traditional pottery churn. "It didn't tire my hands just to churn with the dasher, you know; it didn't tire me like it did to crank *that* thing!"[69]

11

PITCHERS, PIPES, AND IMPLEMENTS

FOOD PREPARATION

Numerous lead-glazed earthenware baking dishes survive today, but other forms designed for food preparation are very rare. No doubt the scarcity stems in part from the more fragile earthenware bodies of most of these pieces or the common breakage incurred during daily use in the kitchen. However, inventories, estate sales, and account books confirm that relatively little pottery was ever made for food preparation. For convenience this group of wares is subdivided into those used for general preparations (bowls, strainers, funnels) and those for cooking (dishes, pans, and bean pots).

GENERAL PREPARATIONS

Like the jar, the bowl is an ancient, open-mouthed form that has an almost limitless number of shapes, sizes, and uses. Truly all-purpose vessels, bowls were "used in the kitchen for food preparation. They were used to carry vegetables and fruit from the garden, to collect eggs, and to store food temporarily in the house."[1] However, despite their obvious utility, they were not a common item in the North Carolina potter's repertory. Surviving examples are rare, and they are only infrequently encountered in early historical records. Most bowls for kitchen use appear to have been made in lead-glazed earthenware. The sturdy, unpretentious example in figure 11-1 was turned by Albert Loy of Snow Camp, one of the last earthenware potters. Occasionally a bowl was ornamented with incised rings or sine waves on the belly, or a fluted rim, or even bands of trailed slip on the interior wall. Although very restrained, such decoration suggests that these bowls were made to be seen and admired as well as used. Most undoubtedly received very hard service and were eventually broken and discarded by the housewife; Loy's survives, perhaps, because it was made only half a century ago.

Estate inventories from the nineteenth century show that pottery bowls were in use, but they also list alternative vessels. When he died in 1832, potter John Craven left his wife "5 boles" and "2 puter basins."[2] Likewise, in 1854 the property of Mary Beard, wife of potter Benjamin, included "4 Bowls & 2 Pitchers" and "2 Tin Pans & 2 Baking Dishes." Eleven years earlier, at the death of her husband, she was allotted "2 Earthen pans" as well as "1 puter

Figure 11-1
Lead-glazed earthenware bowl, first quarter of the twentieth century, Albert Loy, Snow Camp, Alamance County. H 5⅜", D 11⅝". Collection of Robert and Jimmie Hodgins.

Bason."[3] While very important, these records present obvious problems in interpretation. Were the nine bowls made of earthenware or stoneware, or were they even of local manufacture? And exactly what type of form is implied by the terms "pan" and "basin"? The uncertainties here are further compounded by the early potters' account books, which, amidst the numerous entries for jars, jugs, crocks, churns, and pitchers, also occasionally record a pan or a basin. During the mid-1850s, Bartlet Y. Craven of Randolph County listed:

2 one gall crocks & pan .35
1 pan .30
1 gal pan .60[4]

Figure 11-2
Lead-glazed earthenware bowl, ca.
1900, eastern Piedmont. H 4¾",
D 13¼".

At the same time, Himer Fox was retailing items such as a "Stone pan .30," "one bason .20," and a "stone Bason .50."[5] Neither potter ever records selling a bowl.

Several inferences may be drawn from this apparent confusion. First, while "basin" was used in some areas on "broadside price lists" to desig-

Figure 11-3
Lead-glazed earthenware colander,
first half of the nineteenth century,
eastern Piedmont. H 3¾", D 9⅞".
Collection of Ralph and Judy
Newsome.

nate "mixing bowls," in North Carolina it apparently had other meanings.[6] The pewter basins in the inventories are invariably listed with other pewter tablewares and were used as serving dishes at meals. The stoneware basins made by Himer Fox, on the other hand, were almost certainly washbowls, which were located, along with a large pitcher, both in the house and on the back porch before the era of sinks and plumbing. In short, it is unlikely that either type applies to food preparation.

The evidence for the second term, the pan, is less conclusive. As John Bivins explains: "Differentiating between pans and bowls can often be confusing. The basic difference often was purely in the form of the cross-section, the pan having straight sides, and the bowl having curved, usually convex sides."[7] Thus, on the basis of form, some of the entries above may refer to a straight-sided bowl. In terms of function, however, these may be milk pans, used for storing fresh milk in a cool springhouse. And, as will be seen shortly, the pan may also refer to a vessel used for baking; the specific combination of "2 Tin Pans & 2 Baking Dishes" cited above reinforces this possibility. Altogether, then, the potters did turn earthenware and stoneware bowls for general kitchen use, but their numbers were probably never large.

Two other useful devices for preparing foods were the colander and the funnel. Earthenware strainers, often bearing handles and mounted on short legs, were common in the North and were used for draining foods and making cheese.[8] A well-formed, orange and green colander from North Carolina is shown in figure 11-3; it is turned in the straight-sided pan form with symmetrical rings of small holes punched through the bottom. Displayed at the Seagrove Potters Museum is a salt-glazed stoneware container that is shaped like a squat milk crock and has eight larger holes in the base. Southerners made little cheese, but they loved their hogs. During the late fall this was used to strain the hot lard and to separate the cracklings.

No less rare are pottery funnels, though they must have been required for pouring liquids into narrow-mouthed containers such as jugs. None appears in any potter's account book, but Daniel Seagle's estate sale in 1867 included "one gallon Measure & Funnel" that sold for twenty cents.[9] Most likely, however, it was made of tin, copper, or pewter rather than clay.

COOKING

Early inventories make it very apparent that there was little need for pottery cooking vessels. At their deaths in 1832 and 1841, respectively, John Craven and Benjamin Beard left to their wives the following cast iron implements:

Craven (Randolph)[10]		*Beard (Guilford)*[11]	
2 ovens	1 pot rack	2 ovens and lids	all the pot
3 pots	2 frying pans	3 pots	trammels on the
2 pare of pot hooks	1 grid iron	1 skillet	Crain and the Crain

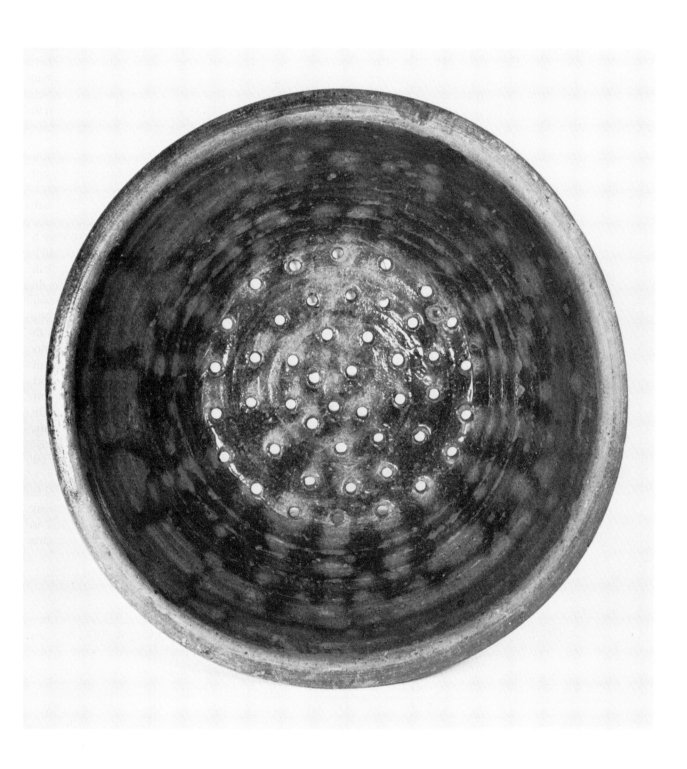

Occasionally the kettle or "kittle" also appears, normally a larger form of the pot with mildly concave sides and a wide mouth. Iron vessels were made in large quantities both at home and abroad from the eighteenth century on; they were used in open fireplaces for boiling, broiling, roasting, and baking. "With the advent of the cookstove in the 1850's the classic iron pot became outmoded. . . . [However] farmers continued to use the larger varieties in hog butchering or in making apple butter."[12] Only rarely are large pottery forms encountered that seem to have been intended to duplicate these containers. The huge alkaline-glazed pot from the Catawba Valley in figure 11-4 is a good copy of the "classic iron pot"—albeit without the usual tripod legs—and was apparently employed for rendering lard.

The one cooking vessel that was produced in considerable numbers for close to two centuries was the earthenware baking dish. As suggested in chapter 1, those made before the middle of the nineteenth century were more elaborate in form and were sometimes decorated. The dish in figure 11-5 shows a carefully articulated rim and concave well, with three manganese or iron "fingers" daubed around the rim (a fourth one in the center remains only slightly visible). As the potters across the state turned to stoneware, the dirt dish became a sideline and its quality declined. Potters in the Catawba Valley dropped earthenware altogether but produced a few alkaline-glazed baking dishes. Burl Craig affirms that "I made some pie dishes on special order. [But] I've never made any just to set out to sell."[13] In the eastern Piedmont, on the other hand, earthenware dishes glazed with red lead were made into the twentieth century. These are usually heavy and hastily turned, with flat bottoms and thick, straight, flaring walls. However they still worked well. Bascom Craven helped his father, Frank, make them and attests that "they'd use them for baking pies for corn shuckings. They'd bake a sliced potato pie in there, and boy, you never eat one any better!"[14]

Although Aunt Rebecca purchased a "cake mole with blue decorate" at Evan Cole's pottery in 1876 (chapter 10), no examples of this form appear to have survived. The cobalt decoration indicates that this was most likely in stoneware, with straight rather than fluted walls and possibly a hollow conical projection in the center. Such molds were quite common in the North. In his survey of early American folk pottery, Harold Guilland illustrates one that might have been similar to Evan Cole's—it even has the "blue decorate"— and he points out that "pottery cake molds were more popular than those made of tin and cast iron. They were inexpensive, light in weight, easy to clean, and did not rust."[15] It is also possible that Evan's "cake mole" is simply another term for the previously cited "pan." As Georgeanna Greer explains: "Large circular baking molds, with or without a central cone, were a second variation of the pan form. Cake and pudding molds are much less common in stoneware than in earthenware."[16] Thus, some of the "Earthen" and "Stone" pans cited earlier may have served as cooking vessels. All of

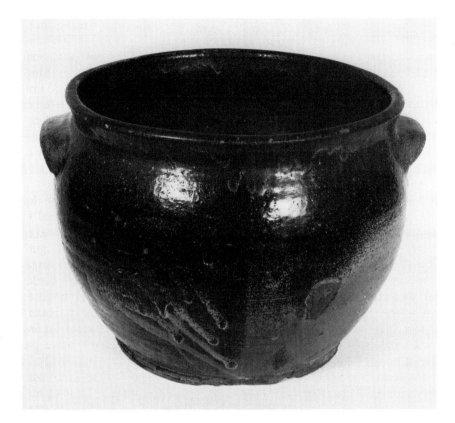

Figure 11-4
Alkaline-glazed stoneware jar, second half of the nineteenth century, Catawba Valley. H 11⅛", C 47".

these were turned by hand. Only the Moravians press-molded them, producing large numbers of the familiar "Turk's-head" or Bundt pan forms.[17]

Along with the dish and the cake pan, North Carolinians also cooked with the lowly bean pot. As Guilland describes them: "Bean pots were made in both earthenware and stoneware and ranged in size from 2 to 4½ quarts. Early bean pots, 'old style,' were deep, cylindrical earthenware shapes which were used to bake beans in beds of hot coals. Later 'stone' bean pots for oven use were low-handled forms with a lid."[18] Undoubtedly the early earthenware potters must have produced such a general cooking pot, probably with a wide lid and a single strap handle.[19] However, the only area for which there is any evidence of extensive production is the Catawba Valley in the early twentieth century. Here potters like Enoch Reinhardt made alkaline-glazed bean pots somewhat in the "stone" style described above—usually squat and turned in at the shoulders with opposed lug handles (fig. 10-20). Burl Craig adds that his mentor Jim Lynn also "made a lot straight up, open at the top with a wide lid."[20] And these were generally used on top

Figure 11-5
Lead-glazed earthenware dish, last
quarter of the eighteenth century,
eastern Piedmont. H 2¹/₁₆″, D 10½″.
Painted iron or manganese brown
design. Collection of Mr. and Mrs.
William W. Ivey.

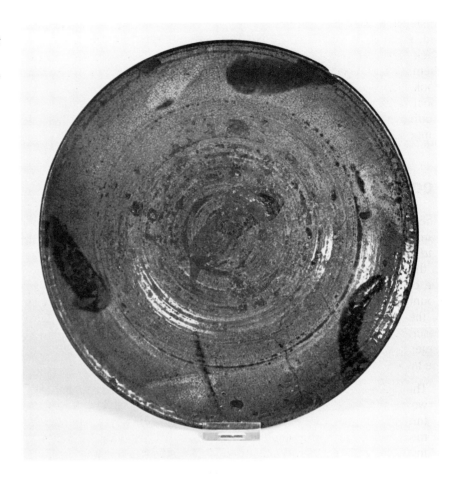

of the stove rather than in an oven. "Say if you was going to cook pinto beans or something like that, you'd put your beans in your pot and put your water in, have 'em all cold. And you'd set 'em on the stove and it'd heat together."[21] This was the only cooking vessel Burl recalls seeing made in any quantity, and it commonly held one gallon.

Altogether only a small part of the North Carolina potter's output was intended for food preparation, and most such pieces were turned in earthenware. Because this clay body is less tight and vitreous than the higher-fired stoneware, it is more suitable for cooking purposes. In like manner, the stoneware of the Catawba Valley is more porous and open than that of the eastern Piedmont. Hence the tradition of stoneware bean pots, one for which there is no equivalent in the salt glaze areas. Most important, the competition from iron, pewter, tin, and other materials reduced the overall demand for these vessels. But the available evidence could be somewhat

misleading. Howard Bass, who worked for his grandfather, Lawrence Leonard, in Lincoln County during the 1930s, recalls that "the mountain folks back then even bought these gallon pots, [milk] crocks; they kept milk in them. And a lot of them even used them to cook in on stoves. I've seen them cook beans in them."[22] Thus function does not always follow form. The local pottery was sometimes used in unexpected but efficient ways, and North Carolinians may well have done more cooking with it than hitherto supposed.

FOOD CONSUMPTION

One of the most delightful, informative, yet neglected books on life in North Carolina is Harden Taliaferro's *Fisher's River (North Carolina) Scenes and Characters*, first published in 1859. Typical of the local color writing of the time, this series of sketches offers a rich and humorous portrait of the customs and characters, tales and language, that characterized Surry County during the 1820s. It also provides valuable insights into the foodways of the region. In a section on "COOKING, BIG EATING, ETC.," Taliaferro describes a close-knit, cooperative way of life, which extended from the larger tasks on the farm to the very manner in which food was consumed at the table:

> Their gatherings were frequent, as previously intimated. One neighbor would help another harvest his grain, taking it in turn till they were all through. Corn-shuckings were conducted in the same way; nor could a man clear a piece of ground without inviting his neighbors, and having a "clearin'." They "swopped work." They were pre-eminently social. At such gatherings and workings, all hands would sit down to a long table, and the first dish they "moseyed into" was soup. Larger pewter basins full of soup were placed along the table at a convenient distance, and several pewter spoons were placed in each basin. They "waded inter it"—never dipped it out—all that could reach in the same basin.

Under such a communal regimen, fewer tablewares would have been required, even for the large families typical of the time. And Taliaferro lovingly details the particular utensils available at the time:

> Pewter cupboard ware was all the go. The tinker made it his business once a year to visit every family to remould their broken pewter ware. We had pewter basins, dishes, plates, spoons, etc. Our cups were tin mostly; some were pewter; but few men had plain delft-ware; china was unknown. Of "yethen-ware" there were crocks, jugs, and jars, which are essential every where. Major Oglesby, a man of some

wealth, "one of the quality," had the finest delft known. It was a great curiosity to the "natives," and much talked of every where. When his plain neighbors visited him they were much embarrased to know how to use it.[23]

Taliaferro's accounts closely match the more extensive inventories of tablewares left to their wives by potters John Craven and Benjamin Beard:

Craven (Randolph)[24]	*Beard (Guilford)*[25]
3 bottles	6 puter plates
1 set of tea ware	1 puter dish
7 delph plates & tea pot	1 puter Bason
1 cream pitcher	2 Coffe pots
2 puter Dishes	Delph plates Cups and Saucers
2 puter Basins	Bottles
5 puter plates	1 tea kettle
6 glass tumblers	2 tin cups
1 vinegar cruit	
1 Lot of stoneware	
1 Lot of earthen ware	

The Cravens and Beards, like Major Oglesby, were no doubt "'one of the quality,'" for they possessed substantial amounts of Delftware as well as some glass.[26] For the rural Piedmont in the early nineteenth century, this range of utensils is somewhat surprising. Even the poorer families must have had sufficient tin or pewter articles for their purposes, particularly if they shared or ate from the same vessels. Thus the potters produced little for the table, instead specializing in "crocks, jugs, and jars, which are essential every where."

PITCHER

The pitcher was by far the most common type of pottery tableware, in part because it was such a versatile form and could be used for storage or washing, as well as for food consumption. Mrs. J. W. Gentry recalls that "we had pitchers of different sizes that we used for . . . our milk or tea or whatever at the table, because it poured easy out of a pitcher. . . . [And] when we churned, we'd keep the buttermilk in crocks or pitchers."[27] In essence the pitcher combines the virtues of the jug and the jar, and as Burl Craig explains, it could be found in many different locations. "They used some of them in the springhouse, but you see, you wanted your milk—most of the people wanted their milk sour, that they made the bread with. Most, a lot of the pitchers, was kept in the house so the milk would clabber, sour."[28]

In North Carolina, pitchers ranged in size from one pint to two gallons; anything larger would have been extremely difficult to handle and pour. The classic pitcher shape, according to Georgeanna Greer, is the baluster, which

"has a full rounded bottom with a cylindrical top section. The top section is usually about one-half to one-third of the total height. There are hundreds of minor variations of this basic form."[29] The two pitchers in figure 11-6 well illustrate Greer's point on variation. In fact, they are both by the same potter, William L. Hutson of Randolph County, yet they show few similarities. The one on the left has a low belly with an extended, gently curving top section and an unusually long pouring spout to match. In contrast to this sinuous piece, the other seems more dramatic and angular, with its high, turned-in belly, abrupt cylindrical top section, and short handle. Of all the major utilitarian wares, the pitcher offered the potter the greatest leeway for individual creativity. Greer also notes two less common forms, the globular (fig. 11-7), which is "full and rounded," often with "a very short collar or neckband," and the cylindrical pitcher.[30]

The smaller pitchers were frequently used at the table and were sometimes decorated. Hannah Craven's inventory, listed above, includes "1 cream pitcher," which may have looked like the earthenware example with the small sugar shown in figure 1-6. Conceivably, they could have been turned as a local imitation of an imported "set of tea ware" such as was owned by the John Cravens. In the early twentieth century, perhaps in an attempt to appeal to a wider market, potters began to market greater numbers of sugar and creamer sets. A handsome pair in swirl by Enoch Reinhardt is shown in figure 13-5.

Medium-sized pitchers, most frequently in one-gallon capacities, were employed for milk and buttermilk and are frequently referred to as "buttermilk pitchers." The large, two-gallon form was probably used more for washing up, in combination with a wash bowl or basin (fig. 11-23), and for storage. Burl Craig still makes an occasional "Jim Lynn pitcher" (fig. 11-7), a very squat, open form named for the potter who taught him to turn. "It had a larger mouth on it; it was more open at the top. And you could still pour out of it. . . . They could get their hands in them, clean them out better." In effect, this pitcher has almost become a storage jar, and it is not surprising to find that "some people used them to put up pickles in."[31] An almost identical form was used in White County, Georgia, as a cream riser.[32]

CUP, MUG, PLATE

While the pitcher occurs in considerable quantity, commonplace drinking and eating utensils such as cups, mugs, and plates are surprisingly scarce. As suggested by the Craven and Beard inventories, ceramic, glass, pewter, and tin wares were readily available even during the first half of the nineteenth century. The competition certainly increased as time passed, and U.S. factories began marketing inexpensive jiggered or molded wares. Burl Craig began turning pottery about 1930 and remembers "some of the turners that were old when I started talk about making plates, saucers, teacups. . . .

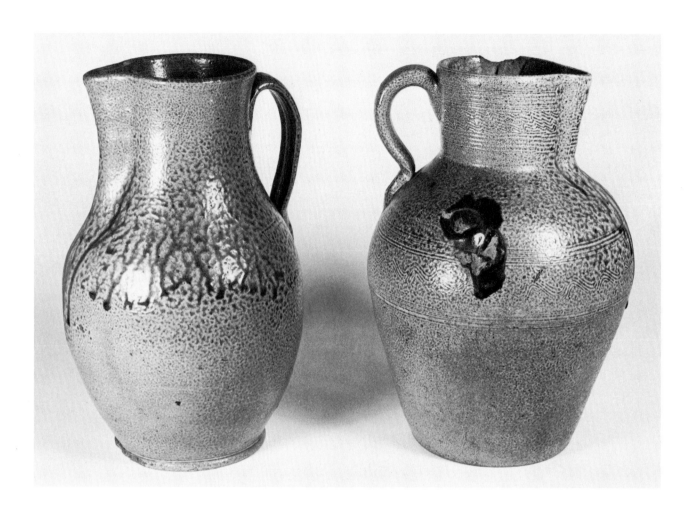

Figure 11-6
Salt-glazed stoneware pitchers,
second half of the nineteenth
century, William Hutson, Randolph
County. Left: H 11⅞", C 23³⁄₁₆",
1 gal. Stamped: "W Hutson / REED
CREEK." Collection of Ralph
and Judy Newsome. Right: H 11¾",
C 26⅛", 1 gal. Stamped:
"W HUTSON." Collection of Mrs.
Nancy C. Conover.

[Then] they begin to ship in that old whiteware in here from Ohio—plates and teacups and saucers—and it was awfully cheap, you know. People could buy it cheaper than they could buy what you made."[33]

Durability was another factor. The Craig family "used to buy them metal cups that held about a pint with a handle on them, straight up cups. . . . They used to buy them for us to eat out of—you couldn't break them, you know. If you knocked it off the table, all you'd do is mess up the floor. But if it was in a earthenware or ceramic cup, why, it'd break. Them old tin cups, you could throw them around any way."[34] Tableware often received pretty rough treatment, particularly in a large family with one daughter and ten strapping sons like the Craigs. Locally made pottery vessels were unlikely to survive for long, but occasionally a mug or a cup or a plate does turn up to prove that the potters did try their hands at them.

One extremely venerable survivor, illustrated in figure 11-8, is a sturdy

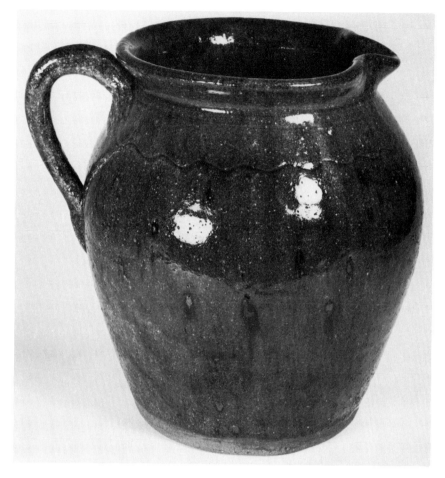

Figure 11-7
Alkaline-glazed stoneware pitcher, 1980, Burlon Craig, Henry, Lincoln County. H 10⅞", C 31¼", 2 gal. Stamped: "B. B. CRAIG / VALE, N. C." Collection of the Ackland Art Museum, University of North Carolina at Chapel Hill, gift of Mr. and Mrs. Charles G. Zug III.

earthenware mug made in the eastern Piedmont, perhaps about 1800. The Moravians, of course, produced a variety of mugs, ranging in capacity from one quart to one gill (½ pint), and it is possible that this potter may have seen some of their work. However, this example lacks the precise architectural form and delicate extruded handles that characterize the finest productions of Gottfried Aust or Rudolf Christ.[35] The potter apparently decorated the mug by flicking on blobs of white and manganese slip as it turned on his wheel. Perhaps this was his way of emulating the mottled English Whieldon glaze that was so popular in the eighteenth century.

The stoneware potters also produced some small tablewares. Figure 11-9 shows a teacup and cream pitcher, both marked by J. S. Penland, as well as a small plate with a similar alkaline glaze that typifies the Buncombe County tradition. As well formed as they are, these wares embody some of the problems the potters faced in attempting them. The cup is thin-walled and

Figure 11-8
Lead-glazed earthenware mug, ca.
1800, eastern Piedmont. H 6⅜".
White and manganese slip decora-
tion. Courtesy of the Museum of
Early Southern Decorative Arts, Win-
ston-Salem, N.C.

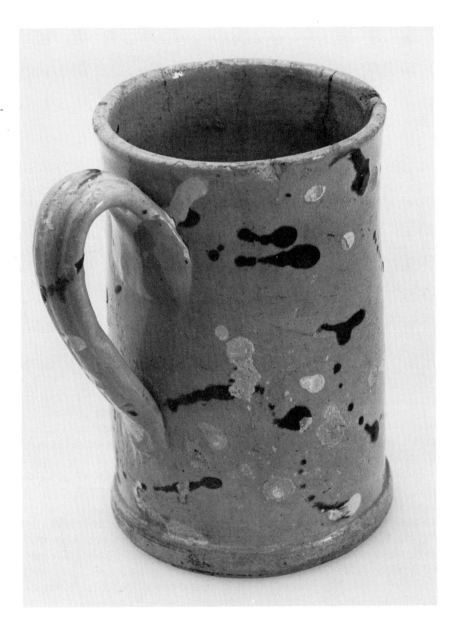

evenly turned, but the alkaline glaze ran excessively, so that a considerable amount of quartz from the kiln floor adhered to the bottom. On a large jar or jug it would be no problem to chip this off with a file or metal bar, but to do so here would have risked damaging the cup. Thus this cup was never used; it rests at a severe angle due to the deposit on its bottom. The plate, on the other hand, is clean, but the glaze has pooled and crazed in the bottom and

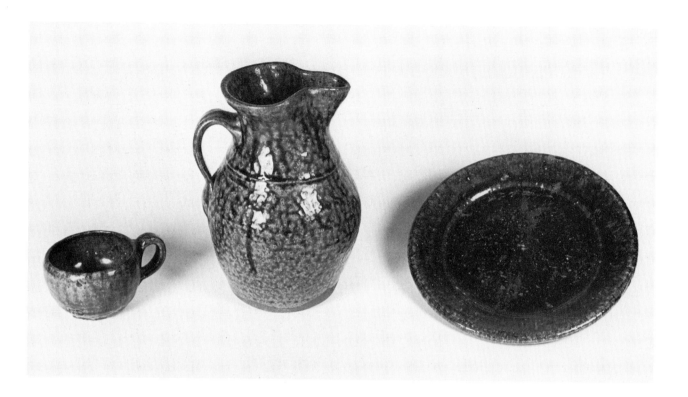

would likely chip off under the action of a knife and fork. In addition, such plates frequently warped during the firing and took up more space in the kiln than they were worth.

Finally, the grouping of cups and mugs in figure 11-10 illustrates a variety of forms and glazes from the first half of the twentieth century, when the old potters began to produce more tablewares as the demand for storage vessels was falling off. With the exception of the cup and saucer by Bascom Keller, all are rather heavy, with thick handles or a protruding foot. In short, they are eminently serviceable but hardly comparable to the commercial whitewares alluded to by Burl Craig.

The one period in which the folk potter may have produced substantial quantities of such tablewares was during the Civil War. Harold Guilland speculates that "the only time country potters made any amount of tableware or 'dirt dishes' as they were called was during the Civil War. The Union blocade of the South and general lack of foreign trade in domestic articles in the North caused a severe shortage of cups, saucers, plates, teapots and other tablewares."[36] This is an often repeated assertion that is never fully substantiated, but several entries in Bartlet Craven's ledger do offer some support for it:

Figure 11-9
Alkaline-glazed stoneware, fourth quarter of the nineteenth century, Buncombe County. Teacup: John S. Penland. H 2". Stamped: "J. S. PENLAND." Pitcher: John S. Penland. H 7⅝", C 16¾". Stamped: "J. S. PENLAND." Plate: D 8¹/₁₆". All from the collection of Carl and Deeta Pace.

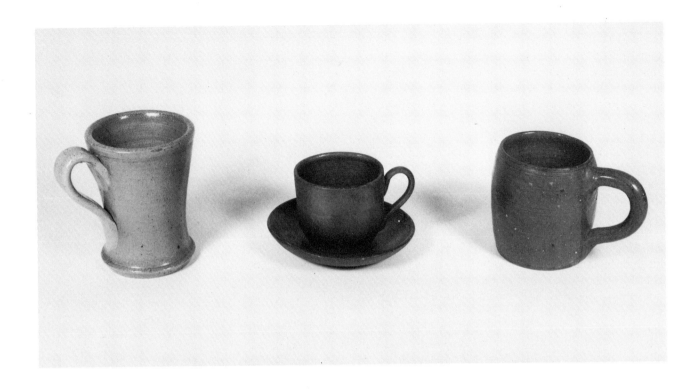

Figure 11-10
Drinking vessels, first half of the twentieth century. Left: salt-glazed stoneware mug, eastern Piedmont. H 5 1/16". Center: Albany slip-glazed teacup and saucer, R. Bascom Keller, Chatham County. H 3". Right: alkaline-glazed stoneware mug, Enoch Reinhardt, Henry, Lincoln County. H 4 1/16". Stamped: "REINHARDT BROS. / VALE, N.C."

August 26 1864 took out of the shop
2 gal ware and 1 set cups & saucer
4 plates
1863 J. H. Faust Dr [debtor]
 to 67 gal ware 75 cts per gal 49.50
 to one doz cups 2.00

A third, undated entry, but one that probably dates to the early 1860s, records "60 cups," as well as crocks, pans, and pitchers, for his family and friends.[37] No other references to cups or plates occur in this or any of the other potters' account books. Thus while the evidence is limited, it appears that the North Carolina potters were called upon to produce tablewares during the Civil War, and that they willingly did so.

COFFEEPOT, TEAPOT

Most of the early inventories indicate that North Carolinians enjoyed their coffee or tea. On her husband's death, Hannah Craven inherited "1 Coffee mill" and "10 lb of coffee" in addition to the previously cited "tea ware" and

"tea pot."[38] And perhaps Mary Beard did even better, receiving "2 Coffe pots," "1 Coffe Mill," "1 tea kettle," and a whopping "36 lbs of Coffe."[39] The price of coffee at mid-century was high but not unreasonable. Entries for 1855 in John A. Craven's ledger show that it sold for 16⅔¢ per pound. For comparison, a gallon of molasses brought 40¢, bacon 13½¢ per pound, a plug of tobacco 15¢, a pair of shoes $1.50, and a day's work at the sawmill 75¢.[40] Those who could not afford such prices developed other strategies. "Tea and coffee were often cut with local herbs to make them go farther, until their flavor was hardly recognizable. Substitutes for tea and coffee were used in many households. Tea was made from thyme, sage, pennyroyal, and catnip, and coffee from sassafras, roasted chestnuts, and barley, rye, and wheat which was boiled and roasted."[41]

Given the demand for such beverages, it is not surprising that the local potters attempted to replicate imported metal and ceramic forms. As early as 1820, Georgia potters were advertising a "coffee boiler," a tall pot with a lid and spout that was normally coated inside and out with an alkaline glaze.[42] No equivalent term appears to have been used by the North Carolina potters, but figure 11-11 shows a handsome coffeepot, glazed with Albany slip, that was made in 1900 by Poley Hartsoe for his mother-in-law. The top is fastened to the body with a wire hinge, and a thin clay strip supports the long spout. Next to it is an alkaline-glazed teapot made by Poley's son, Albert, around 1950. The beige color typifies the later wares from the Catawba Valley as made by the Hiltons, Hartsoes, and others. To complete the work of the Hartsoe family, a globular teapot attributed to Poley's father, Sylvanus, is illustrated in figure 11-12. The glaze is a rich black with occasional patches of rust red (where the glaze is thin) and sky blue (from rutile in the clay). In the eastern Piedmont teapots were also made in earthenware (fig. 11-20) and possibly even stoneware. It will be recalled that Rossinah almost purchased a teapot from Evan Cole in 1876 (chapter 10).

KEG

More common in North Carolina than the coffeepot or teapot was the pottery keg—or barrel or rundlet, as it is variously called. These were made in two distinct sizes. The smaller varied from approximately one quart to one gallon and was found in the lead, salt, and alkaline glazes. The larger model, however, survives only from the Catawba Valley, where Sylvanus Hartsoe produced sturdy three- to five-gallon kegs in alkaline-glazed stoneware. In general, this ceramic form derives from the wooden barrels used for similar purposes. In his study of coopers, Kenneth Kilby observes that "a common item of equipment for farmers, and people working on the land in this country [England], was the bever barrel, sometimes called a costrel, and holding anything from 2 pints to a gallon of beer. It could be slung

Figure 11-11
Left: Albany slip-glazed stoneware
coffeepot, 1900, Poley Hartsoe, Ca-
tawba County. H 12⁷⁄₁₆″, C 23″.
Signed in script: "granie bulinger /
august 23 1899" and "P.C.Hartsoe /
August the 14 1900." Right: alkaline-
glazed stoneware teapot, ca. 1950,
attributed to Albert Hartsoe, Ca-
tawba County. H 8³⁄₈″, C 21⁵⁄₁₆″. Col-
lection of Roddy Cline.

over the shoulder to carry into the fields, and it had a protruding mouth-piece. . . . The word 'bever' comes from the Old French word *beivre*, meaning drinking."[43]

At some point potters began to copy these early containers. Within the English tradition, Peter Brears finds that "the majority of the harvest wares made in Sussex were neither jugs nor bottles, but instead took the form of smaller kegs or flasks. The most usual ones to have survived are the kegs which closely copied the shape and proportions of the rather elongated cane-bound casks of oak. . . . Round each end of these kegs an appropriate number of raised bands was thrown to represent the cane bindings."[44]

The earliest keg extant in North Carolina is, appropriately, of lead-glazed earthenware and was made by David Hartzog in Lincoln County, probably early in the second quarter of the nineteenth century (fig. 1-11). Figure 11-13 shows two small salt-glazed kegs, also diminutive in size, with separately

Figure 11-12
Left: Albany slip-glazed monkey jug, ca. 1900, attributed to Sylvanus L. Hartsoe, Catawba County. H 7", C 14⅜". Right: Alkaline-glazed stoneware teapot, ca. 1900, attributed to Sylvanus L. Hartsoe, Catawba County. H 7", C 24". Collection of Georgeanna Greer.

turned, jug-type spouts and lug and strap handles. The smaller one is incised at appropriate intervals to suggest the hoops that would have held the staves securely in place. A lavishly decorated example dated 1846 (fig. 11-14) illustrates the raised bands referred to by Brears. Characteristic of the work of the Webster family are the carefully inscribed bird and fish on either side of the keg, as well as the elaborate cartouche surrounding the spout.

The larger kegs by Sylvanus Hartsoe, David's son, were also made with the spout in the center of the belly (fig. 3-3). In some respects, these appear to be North Carolina's version of the "cooler," a large container used for serving water, cider, wine, and stronger potions such as gin. The typical stoneware cooler, as made elsewhere, occurs in the jug, jar, or keg form, sometimes with a lidded rather than a closed top, and invariably with a bunghole set slightly above the base. Such vessels "were commonly used in taverns for storing drinks behind the bar. They were convenient containers for carrying small amounts of cider or wine from barrels stored in the basement or back room. The bungs were often placed a little above the base to allow sediment to settle below the spigot."[45] The Hartsoe kegs were almost certainly intended to be used resting horizontally in a wooden rack, as the spout and airhole are centrally located. The only true cooler form yet found in North Carolina is the jar with the small spout at the base made by Thomas Ritchie (fig. 3-8). There is some argument that this unusual piece may have been intended for moonshining operations. However, like the Hartsoe barrel, it was also decorated with glass runs, which suggests that it was meant to be seen on public occasions.

In general it appears that the kegs made in North Carolina were neither harvest wares nor storage vessels, but tablewares for dispensing homemade

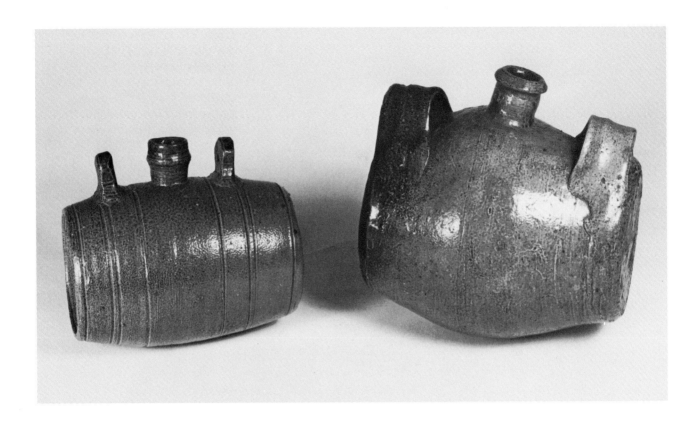

Figure 11-13
Salt-glazed stoneware kegs, second
half of the nineteenth century, east-
ern Piedmont. Left: L 5⅞", C 13½".
Right: L 6⅞", C 19". Collection of
Ralph and Judy Newsome.

cider, brandy, or whiskey. Most are ornamented in some way—either with incising or glass runs—and some were clearly presentation pieces. The keg shown by Sylvanus Hartsoe was specifically made for his son, Finley; yet another by him bears the date 25 August 1898, implying some sort of anniversary. Thus, because of their ornamental qualities and personal associations, these kegs may well have survived in proportionally larger numbers than other types of wares.

PIPES

By all accounts, North Carolinians enjoyed their tobacco no less than their whiskey, and so the production of molded clay pipe heads remained an important sideline for the potters for some two centuries. Predictably, the Moravians provided the earliest references to pipe making. In December 1755, only a month after his arrival at Bethabara, Gottfried Aust "dug clay and made pottery, for which the people were eager; he also began to make clay pipes."[46] Over the years Aust and his successors made tremendous numbers of them; in 1808, for example, the inventories show "3,000 doz.

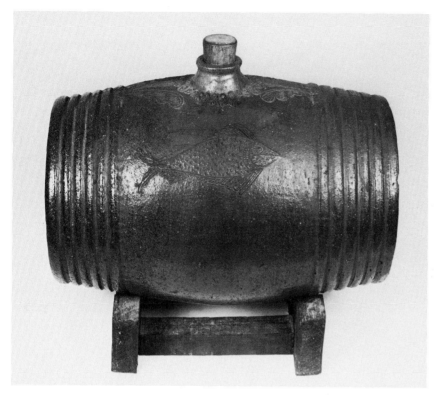

Figure 11-14
Salt-glazed stoneware keg, 1846, Edward or Chester Webster, Randolph County. L 9¹⁵/₁₆", C 21½". Incised bird, fish, and date with swags and floral decoration around the bunghole. Collection of the Mint Museum, Charlotte, N.C.

white pipes @ 8d per doz." and "200 doz. glazed do. @ 2/." John Bivins explains that "they were made of both red clay and kaolin; most pipes were left unglazed, but some were offered also with both green and brown [lead] glazes." The pipe heads were pressed in brass or pewter molds, some in anthropomorphic designs and others with simple fluting.[47] The only other eighteenth-century reference comes from the Mount Shepherd excavation, just west of Asheboro in Randolph County. Here archeologist Alain C. Outlaw discovered "anthropomorphic smoking pipe forms" that were "similar to those that were found by Stanley South at Bethabara," evidence that suggests at least one of the potters here had migrated from the Salem area.[48]

Outside the Moravian tradition, the evidence is more recent, but it indicates that pipes were being made from Fayetteville in the east to the very western reaches of the Piedmont. It also appears that women frequently took over the task of producing the pipes. One highly romanticized (and totally unsubstantiated) account describes Sally Michael of southwestern Burke County, a "widowed little woman" who molded and burned pipes in her "two-room cabin, built of hickory logs and chinked with clay," during the mid-nineteenth century. Sally is said to have dug kaolin along the banks of nearby Silver Creek. The clay was "washed and kneaded like dough until all

the foreign matter disappeared" (a trick all potters would like to master); then it was pressed in a soapstone mold. The pipe heads were burned "through a night and part of a day" with hickory wood "in the huge fireplace." Finally Sally peddled her pipes herself, often on Saturdays at Morganton, "where she found ready sale for them at 25 cents a dozen." Soldiers in both the Confederate and Union armies took them off to war and "commenced a distribution which ultimately became nationwide."[49]

Even with the obvious inaccuracies and exaggerations, there is substantial truth here. For example, Elizabeth Johnson Dixon, wife of potter N. H. Dixon, made pipes almost up to the time of her death.[50] One of her products is illustrated in *Chatham County 1771-1971*, which shows a neighbor, Matilda Smith Pascal, contentedly puffing away while sitting in a slatback rocker on her front porch.[51] And Sarah Cole of Randolph County regularly made pipes to be sold with her husband Ruffin's wares. Her son, A. R. Cole, recalls that "we'd take 'em off and sell 'em when they'd take a wagonload of ware. But this was hers; this was her money."[52] Because the men turned the larger forms, it is not surprising that the task of molding the pipe heads often went to their wives.

Figure 11-15 shows a series of pipe heads made at the shop of E. A. Poe in Fayetteville during the late nineteenth century. They represent the two major forms of decoration: simple grooves or fluting, and an anthropomorphic design that often suggests the head of an Indian.[53] Although the white kaolin or "pipe clay" was preferred, potters used whatever was at hand, including earthenware and stoneware clays. A ball of clay was placed in a small, two-part mold, most commonly a block of wood lined with lead or pewter or else carved entirely out of soapstone. The mold illustrated in figure 11-16 was owned by Jim Reinhardt and probably came originally from his father, Ambrose. It produces a fluted pipe head that is 2″ long and 2″ high; the outer diameters of the bowl and stem are 13/16″ and 1″ respectively. To lock the mold, the potter used a screw press such as the one owned by the Hartsoe family (fig. 11-17), or, more commonly, a larger frame press (fig. 11-18). In either case, two separate plungers were required: the potter first pushed in and twisted the larger one to form the bowl, and then he inserted the smaller one to make the opening for the stem.

Only the Moravians appear to have glazed any of their pipe heads. To do so, they devised several types of cylindrical pipe saggers, which supported the inverted heads on pins so they could be burned in the kiln.[54] Other potters left them unglazed and so the firing procedure was simpler. As they did not require high temperatures, the pipe heads could be set in the kiln around the larger pieces or in the cooler spots along the sides and near the chimney. At least one potter used a separate kiln. A. R. Cole recalls that his mother, Sarah, "had a little kiln of her own to fire them. . . . She just sort of piled them in, no set pattern, just piled them on top of one another. They weren't glazed or anything. The fire went up through them and out the top.

Figure 11-15
Unglazed pipe heads, ca. 1890, E. A. Poe and Company, Fayetteville, Cumberland County. Courtesy of Old Salem Restoration, Winston-Salem, N.C.

Figure 11-16
Lead and wood pipe mold, second half of the nineteenth century, attributed to Ambrose Reinhardt, Catawba County. Each half measures L 3 1/2", H 2 15/16", W 1 7/16". Courtesy of Burlon Craig.

Figure 11-17
Wooden screw press and pipe mold with lead interior, nineteenth century, Hartsoe family, Catawba Valley. L 23 3/8", H 10 1/2", W 3". Collection of the Catawba County Historical Museum, Newton.

Weren't no chimney—it was just a little, square, box-like thing. And when she'd make enough to fill it, she'd cover it with old, broken pottery, and then she'd fire it."[55] In effect, Sarah Cole used a simple updraft kiln, with the fire underneath the pipes and shards from the waster pile on the top to hold in the heat.

Despite the rapidly growing competition from cigarettes and cigars during the late nineteenth century, the potters continued to make clay pipes into the first quarter of this century. In southeastern Randolph County, not far from Sarah Cole's home, Frank Craven made pipes "by the barrel" out of local "red dirt."[56] No doubt demand remained steady because the heads were quite fragile, both women and men smoked them, and they were very inexpensive. However by the 1930s, when Burl Craig was working as a potter, there was little call for the old ceramic pipe. Although "some of the old women [still] smoked a pipe of tobacco," he adds that "after I got into it,

people begin to get a little money; they bought them a cheap pipe. You know, you could buy a pipe, maybe, for fifteen or twenty cents. . . . The first pipes that I remember seeing is what they called the corncob pipe."[57] And so Burl made very few pipes, and eventually lost his soapstone mold and hand-whittled plungers.

IMPLEMENTS

While the bulk of their work was intimately related to the local foodways, the North Carolina potters also turned out a variety of useful implements for daily life in the home, farm, and community. Today, few of these ceramic tools remain in use, having long since been superseded by more efficient forms or superior materials. Still, there was a time when the local potter turned out chamberpots and chicken waterers, grease lamps and spittoons, because they were cheap and served his neighbors' needs well. This broad category of objects can, for simplicity, be divided into the following subsections: lighting, hygiene, animal husbandry, and construction.

LIGHTING

Before the age of electricity, which for many North Carolinians did not arrive until the twentieth century was well under way, lighting in the home was supplied by the open fire, candles, and various types of simple, fuel-burning lamps. Once again, Mary Beard's 1841 allotment is highly revealing:

> 1 Candle Stand
> 1 Candle Stick
> 1 lamp
> 1 pare of Candle moles
> 1 Candle Box
> all the tallow on hand

At her death in 1854, "1 Tin Lamp & Candlestick" were sold for ten cents and are presumably the two items listed above.[58] Thus it appears that she relied primarily on candles, and that her two lighting devices were made of tin. However, this seems a very small number, and she might also have owned some pottery forms that were not deemed worth reporting.

One such item might have been a grease or fat lamp as illustrated in figure 11-19. This delicately turned earthenware form was purchased by the Museum of Early Southern Decorative Arts with two other pieces (figs. 1-5, 1-9) and probably came from northern Randolph County, not far from Mary Beard's home. The shaft is hollow, no doubt to ensure that it would not crack during drying and firing, and the cup at the top has a spout to hold the wick. Such "fat lamps burned grease, scraps of fat, fish oil and whale oil."[59]

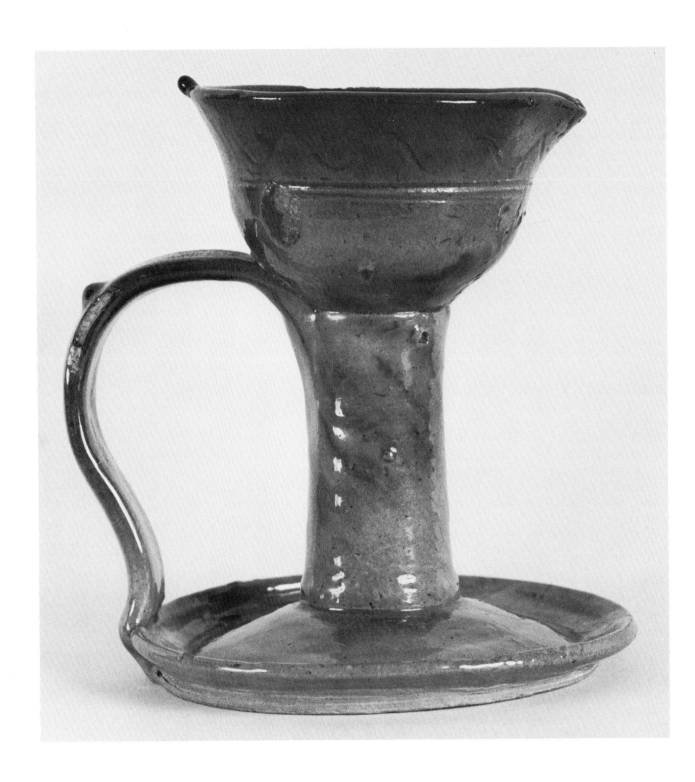

Most of the surviving examples in this country are made from earthenware and predate the Civil War.

As Mary Beard's inventory suggests, housewives made their own candles. Presumably the local potters must have produced some candlesticks, both the taller form and the squat chamber-stick with a handle. Gottfried Aust made both types at his first shop at Bethabara, but none exist outside the Moravian tradition that can be reliably dated earlier than the twentieth century.[60] A simple yet graceful pair of orange lead-glazed candlesticks is shown in figure 11-20. The shaft is completely hollow, and the potter pulled up a wide drip-pan around the socket to catch the overflow of wax.

The salt-glazed stoneware candlestick on the left in figure 11-21 appears to be a combination form. It is quite tall but possesses the strap handle and wide base to catch the wax that are associated with the chamber-stick. The rather hasty application of cobalt to the rim, shaft, and handle suggests that this was made very late in the folk tradition, when the potters were beginning to make fancy wares for the growing tourist trade. On the right is a virtuoso production, one of a pair, which sports a fluted rim, a corded shaft and base, and impressed asterisk and gearwheel designs. The potter also applied a cobalt wash under the lead glaze, which produces a blue-green coloration that contrasts to the natural orange.

Overall the stoneware potters of the later nineteenth and early twentieth centuries may have had few calls for candlesticks, not only because other metal or ceramic types were available, but also because of "the discovery and use of petroleum for lighting. Kerosene lamps were invented about 1859 and by 1865 were the most common means of producing artificial light."[61] As demand grew for a more decorative pottery after World War I, the potters responded with more elaborate forms and glazes. And potters in the eastern Piedmont such as Ben Owen, Farrell Craven, and, today, Vernon Owens, have continued to produce a tall, elegant candlestick (fig. 8-6) that remains extremely popular.

HYGIENE

Far more lucrative for the potter were wares used for personal hygiene in the days before indoor plumbing. Perhaps the best seller was the lowly chamberpot, or simply "chamber," as it is often called. As Burl Craig explains: "I could see where they come in good then; with indoor plumbing you don't need them. Back then you didn't have nothing but a path, you know, went right out to the johnny house. Well, a real cold night, if you had to get up, why you didn't want to get dressed and go down. [And] they didn't want a building right at the house; they always set back a good ways from the house. They used the pots. And they'd take them out, clean them out the next morning. Put them back under the bed—they was there for the next night. Everybody back then had them!"[62]

Figure 11-19
Lead-glazed earthenware fat lamp,
first half of the nineteenth century,
Guilford or Randolph County. H 6".
Courtesy of Old Salem Restoration,
Winston-Salem, N.C.

Figure 11-20
Lead-glazed earthenware candle-
sticks, first quarter of the twentieth
century, eastern Piedmont. H 10¼".
Lead-glazed earthenware teapot,
first quarter of the twentieth century,
attributed to James H. Owen, Moore
County. H 6¼".

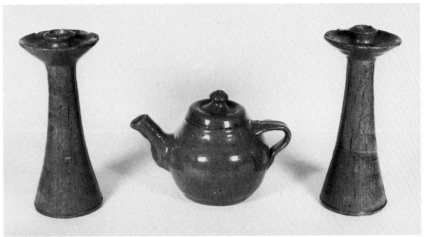

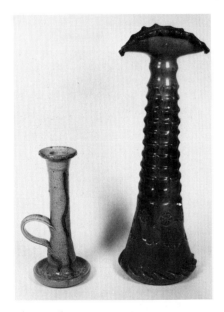

Figure 11-21
Left: salt-glazed stoneware candle-
stick, first quarter of the twentieth
century, eastern Piedmont. H 8½".
Cobalt trim on the shaft, handle,
and rim. Right: lead-glazed earthen-
ware candlestick, first quarter of
the twentieth century, attributed to
Daniel Z. Craven, Moore County.
H 16⅛". Stamped on bottom: "CRA-
VEN POTTERY / STEEDS / N.C." Im-
pressed asterisk and gear wheel de-
signs. Cobalt wash on rim and
shaft.

In essence the chamberpot is simply a bowl with a fairly wide, turned-out rim and a single strap handle (fig. 11-22). Most were made in the "adult" size with a one-gallon capacity, but occasionally the potters produced a half-gallon model for the children. Even in the twentieth century, potters continued to produce them in quantity. Burl Craig avows that "man, I made a lot of them. You wouldn't believe it. This neighbor woman over here give me an order, I don't know how many it was. She sent her children over here one day; they come with three fertilizer sacks to pick them up, carry them home."[63] Ironically, potters still make them today, not for their original function but as soup tureens or serving dishes for use at the table.

As suggested earlier, the "bason," or washbowl, was also a common fixture in the home and was located either in the house or on the back porch, where workers coming in from the fields could clean themselves off. When Daniel Seagle died in 1867, he left to his wife, Sarah, "one wash Bowl Stan & pitcher" valued at exactly one dollar.[64] The Seagle family's set might have resembled the one in figure 11-23, except that the glaze would have been alkaline rather than salt. Such simple pine washstands were a common article of furniture and as shown could hold chunks of homemade soap along with the ubiquitous chamberpot. In other areas such as Pennsylvania and Virginia, such basins, particularly the earthenware examples, were often highly decorated with ornamental trim, handles, and even a soapdish, but the North Carolina examples are always plain and functional.[65]

Finally there is the once familiar spittoon, probably better known in its shiny brass manifestation that often graces courthouses and other public places, but which was also once common in earthenware and stoneware. These were produced both in a closed, cylindrical form (fig. 11-24) and a bowl shape with a broad, flaring rim (fig. 11-25). Either was probably

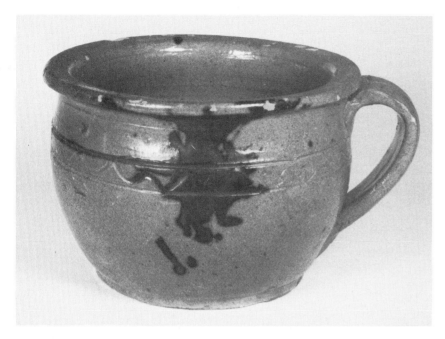

Figure 11-22
Lead-glazed earthenware chamberpot, first half of the nineteenth century, eastern Piedmont. H 5⅜", C 24⅝". The dark manganese or iron slip splotch on the side was doubtless a potter's joke on the user. Collection of Mr. and Mrs. William W. Ivey.

equally difficult to hit, but the latter with its wide, open mouth was certainly easier to clean. Salt-glazed stoneware spittoons, many with cobalt decoration, are relatively common in the North, but few have survived in North Carolina.[66] As Burl Craig explains: "Some of these barber shops and places like that, general stores, they would maybe have one. One man I heard him say, he didn't want any more of them. They'd get kicked over and get broke, and you'd have to clean up the mess in the store."[67]

ANIMAL HUSBANDRY

The potters fashioned implements for the benefit of animals as well as people, notably birdhouses and waterers and feeders for both chickens and rabbits. The ceramic birdhouse can be traced back at least to colonial Virginia, where the lead-glazed earthenware "bird bottle" or "martin pot" was in common use. Archeologist Audrey Noël Hume points out that "for centuries, wise gardeners have known that the best and cheapest way to control insects lies in the encouragement of their natural enemies, of which birds are the most responsive. In Virginia, where mosquitoes could sharply diminish the pleasures of colonial gardening, the martin was a welcome visitor. In order to encourage them to remain close to a garden, the provision of a suitable nesting place was essential, and for this pottery bottles were hung beneath the eaves of houses and outbuildings."[68]

Figure 11-23
Pine washstand with salt-glazed stoneware pitcher, basin, and chamberpot. Collection of the Mint Museum, Charlotte, N.C.

Figure 11-24
Albany slip-glazed soneware spit-
toon, ca. 1890, E. A. Poe and Com-
pany, Fayetteville, Cumberland
County. H 3⅜", D 8⅛". Stamped:
"POE & CO." Collection of Elizabeth
A. Poe.

Figure 11-25
Alkaline-glazed stoneware spittoon
and chicken waterer, 1978, Burlon
Craig, Henry, Lincoln County. Spit-
toon: H 6⅝", C 21¾". Chicken
waterer: H 12½", C 24½". Stamped:
"B. B. CRAIG / VALE, N. C."

No early earthenware examples have survived in North Carolina, but as illustrated in figure 11-26, potters produced stoneware birdhouses in a closed jug form. The knobs or finials at the top were pierced so the bird-house could be hung, and some had protective hoods over the opening, as well as small holes underneath to hold a perch for the occupants. And when a true birdhouse was unavailable, it was easy enough to knock a hole in the lower side of a one-gallon jug (fig. 11-26). Bascom Craven recalls recycling numerous jugs in this fashion to keep the insects away.[69] Today dried gourds and Chlorox bottles are most commonly used for this purpose, and in rural areas they can be seen hanging in rows from horizontal poles mounted on a tall post.

Another bird once common around the home and farm was the chicken, but, unlike the martin, this one had to be watered and fed. There was always a steady demand for "chicken waterers" or "poultry fountains," because, as Burl Craig recalls, "everybody had a gang of chickens running out around the house."[70] This very simple and efficient device was made in two models. The simplest was a closed jug with a small trough pulled out near the base (fig. 11-27). The potter turned a jug, closed the top, and then slit the wall about 1½″ above the base. The key was to ensure that the outer lip of the trough was pulled up slightly higher than the inner wall. Thus the vacuum inside kept the water constantly at the level of the inner wall and the trough would remain full. When the chickens lowered the water level below the inner wall, a bubble of air entered the container and an equivalent amount of water filled the trough. All the farmer needed to do was to periodically fill the waterer and then quickly stand it up to form the vacuum.

The second type of waterer worked on the same principle but was made in two pieces so that the waterer rested inside a dish (fig. 11-25). The potter punched a hole just above the base, taking care that the top of the hole was slightly lower than the rim of the dish. This was probably a more recent form and may have been confined to the Catawba Valley. Burl Craig explains that "the people around here wanted the two-piece. They raised a lot of small chickens. You take a hen and a gang, maybe, of fifteen or twenty chickens, why, it's hard for all of them to get round and drink, you know, just one opening in the jug."[71]

Not only was this type more efficient, but it was easier to clean. Often the potter cut a large hole in the bottom "where you could get your fist up in there. You could just turn it upside down, run some water, throw some water in it, and take your hand and wash it out." Obviously, this was impossible to do with the single unit: "chickens'd eat and eat the feed and stuff and then drink the water. The jug would get messed up; the feed and crumbs and stuff would get in your water. . . . They was hard to clean, keep sanitary." Of course, the two-piece waterer offered more opportunity for breakage and was somewhat harder to fill—"sometimes you'd get your britches wet by turning them back up"—but increasingly customers seemed to prefer it.[72]

Figure 11-26
For the birds: salt-glazed stoneware
birdhouse and jug. Left: fourth quar-
ter of the nineteenth century, eastern
Piedmont. H 9½″, C 20½″. Collec-
tion of Luke Beckerdite. Right: sec-
ond half of the nineteenth century,
E. J. V. Craven, Randolph County.
H 11⅝″, C 22⅝″, 1 gal. Stamped:
"E.J.V. CRAVEN." Collection of Ralph
and Judy Newsome.

Today chickenhouses contain large tin waterers that still operate on the vacuum principle.

During the first half of this century, potters like "Jug Jim" Broome of Union County also benefitted from a rabbit boom. "Back several years ago, every-body got in the rabbit business. Tame rabbits, raising tame rabbits. Well, it kept him busy making rabbit feeders and waterers for a long time. . . . Lots and lots of times he wouldn't have anything [else] in his furnace, a whole furnace full of them."[73] As illustrated in figure 11-28, the feeder and waterer were similar in form, except that the former had a pronounced lip. As Burl Craig describes it, "the feeders had a rim turned in about a inch, I guess, or wide as my finger, maybe a little wider. It was turned down level. . . . See, if you made them straight without the rim, like you would the waterers, why,

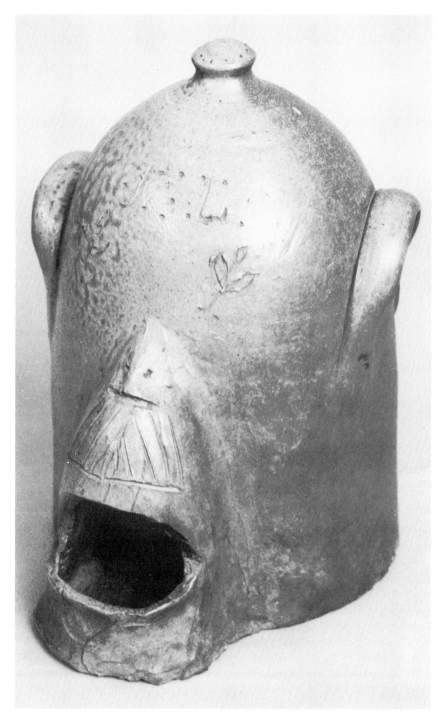

Figure 11-27
Salt-glazed stoneware chicken wa-
terer, fourth quarter of the nine-
teenth century, eastern Piedmont.
H 9¾", D 6¾". Signed in script:
"J. L." The potter humanized his
waterer with lug handles as ears,
incised flowers as eyes, an incised
nose and moustache, and a gaping
"mouth." Collection of the Greens-
boro Historical Museum, Greens-
boro, N.C.

Figure 11-28
Rabbit pots. Left: alkaline-glazed
stoneware rabbit feeder, 1977, Bur-
lon Craig, Henry, Lincoln County.
H 3⅛", D 6¼". Stamped: "B B C."
Right: Albany slip-glazed stoneware
rabbit waterer, ca. 1950, O. Henry
Pottery, Valdese, Burke County.
H 4⅜", D 5⅝".

they would get in there with their feet and drag the feed out."[74] These vessels were also very heavy, with unusually thick walls and bottoms. A. M. Church, former owner of the O. Henry Pottery at Valdese, cautions that "you have to make it heavy, or the old rabbit'll turn it over if you don't. You can set that down in front of him, and he'll clean it out, but he won't turn it over."[75]

CONSTRUCTION

Construction or building materials were never a significant part of the local potter's repertory, though in other ceramic traditions such items were produced in large numbers. In England, for example, beginning about the second quarter of the nineteenth century, "a number of redware potteries, sensing the coming decline in their sales, began to make bricks, tiles, chimney-pots and field drain-pipes in addition to their normal product. This was a wise decision, for as the century progressed the building trade and the improvement of land through drainage both flourished, whereas the demand for coarse redwares waned."[76] Such items were necessary to the survival of the English country potter and marked the final phase of his craft before it was replaced by modern industry.

In North Carolina, however, construction materials were never more than a minor sideline. The earliest evidence comes, once again, from the Moravians, who produced stoneware water pipes and earthenware drain pipes for use in Salem.[77] Elsewhere, potters in the eastern Piedmont made salt-glazed

stoneware pipes to line the walls of wells, which were normally dug out to a depth of about twenty feet. These were usually referred to as "tiles." And as illustrated in figure 11-29, they also turned some water pipes. This was one of sixteen sections discovered by potter Lucien Koonce near the Deep River in northern Moore County. They may have been used to drain bottom land or to carry water from a spring to a springhouse. No bonding agent was necessary; the pipes were simply fitted together and held in place by the surrounding earth.

The only other implement made in large numbers was the stove thimble or stove collar, which, in Burl Craig's words, was "just a cylinder with a rim, a kind of a rim on one end" (fig. 11-29). These were unglazed and served as a simple form of insulation around the metal stovepipe where it ran through the wall of the house. Burl continues: "Way back when I was growing up, we didn't have nothing but a fireplace. But then later on, the people began to get the wood heaters, and some of them had flues built, beside of the house. . . . And they put a thimble in to put the pipe in, run their stovepipe through the wall."[78] The thimble appears to have been a twentieth-century product; even as late as 1950 the O. Henry Pottery was wholesaling "a world of those thimbles" in three different sizes. The 6″ sold for thirty-one cents per dozen, the 9″ for forty-one cents per dozen, and the 12″ for fifty-one cents per dozen.

Finally there were some special orders. A. M. Church recalls one chimneypot made for a woman in nearby Hickory. Javan Brown turned it, and the

Figure 11-29
Building materials. Left: unglazed stoneware thimble, 1985, Burlon Craig, Henry, Lincoln County. L 8 1/8″, D 7 3/4″. Right: salt-glazed stoneware water pipe, fourth quarter of the nineteenth century, found in northern Moore County. L 14″, D (top) 4 3/4″, D (bottom) 7 1/8″. Collection of Lucien Koonce.

two men installed it, all for the rather stiff price of twenty-five dollars.[79] Occasionally, the potter made implements for his own use. A small, salt-glazed stoneware doorknob was found on the house of J. Thomas Boggs in southern Alamance County. It is the only one of its kind from North Carolina, although lead-glazed knobs were made for chests in Pennsylvania during the nineteenth century.[80] Perhaps one final, inadvertent contribution by the potters to the building trade deserves mention. When an old groundhog kiln was replaced or demolished, the homemade bricks were often recycled. Today the brickwork on the homes of Bascom Craven in Randolph County and Forrest Brackett in Lincoln County sports numerous black, well-burned reminders of their fathers' once extensive businesses.

12

GRAVE MARKERS, FLOWERPOTS, AND FACE JUGS

GRAVE MARKERS

The cemetery seems an unlikely home for the works of the potter, but in Alamance, Buncombe, Moore, Randolph, and Union counties, there remains solid evidence that he produced a variety of grave markers. Not that the potter ever threatened to put the stonecarver out of business. The number of ceramic markers was modest, and the surviving examples are found within easy walking distance of the old shops. Probably the heaviest concentration occurred at the Union Grove Baptist Church in the southeast corner of Randolph County, right in the heart of the old salt glaze region (fig. 12-1). Once there were dozens of clay markers here, but by 1961 Jean Crawford could locate but eight, "dated 1838, 1895, 1896, 1897, 1898, 1918, 1932, and 1938."[1] And today only one fragment remains, a testimony to the ravages of time, lawnmowers, and man himself.

The production of ceramic grave markers was by no means limited to North Carolina. Potters made them in many sections of the eastern United States, from the hyperborean climes of Grand Ledge, Michigan, all the way south to Florida and west to Texas.[2] Although all the evidence is not yet in, the rural Southeast may have possessed one of the richest traditions. As Georgeanna Greer explains: "In a number of areas, particularly in the South, where small pottery shops were present, stoneware head markers as well as foot and corner markers for graves may be found. This was an inexpensive, but relatively permanent method of marking a grave. Many of these markers were made for members of potters' families. They were generally cylindrical in form with an open base and a closed top."[3] Perhaps the clay markers were not so durable as those in stone, but they certainly would have been much cheaper. In North Carolina they normally occurred in one- to four-gallon sizes, which, at the going rate, would indicate a total price of only ten to forty cents. And it appears that most of the extant examples were made for members of the potter's family, meaning that no money would have changed hands.

The predominant form in North Carolina was the "jug marker," which was turned like the common jug but closed at the top and surmounted with a decorative finial or knob. Figure 12-2 shows a head and foot marker from the Laney family cemetery in southern Union County; another, very similar salt-glazed form also survives and is marked "L.C. LANEY / Born / DEC

Figure 12-1
Salt-glazed stoneware grave marker, 1896, Union Grove Church, Randolph County. H 12⅛", *C 24¹¹/₁₆". Top finial broken off. Collection of the Ackland Art Museum, University of North Carolina at Chapel Hill, gift of Charles G. Zug III.*

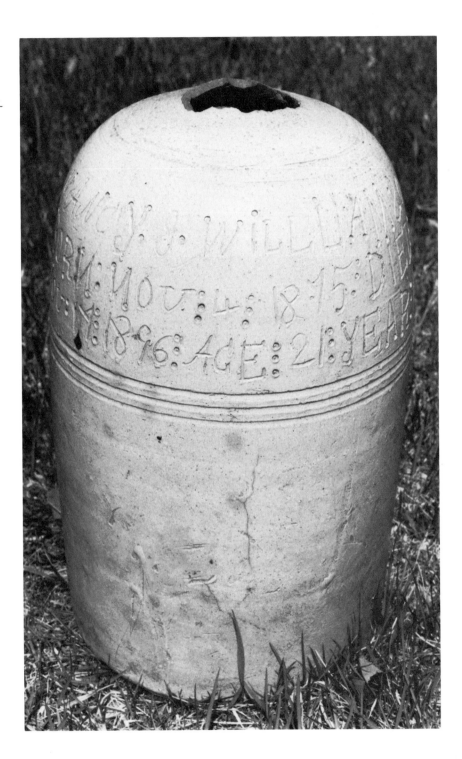

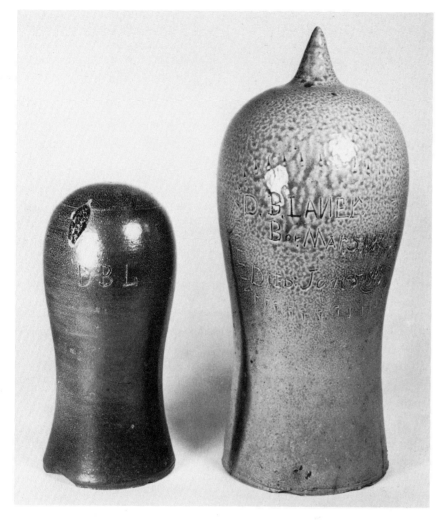

Figure 12-2
Salt-glazed stoneware foot and head marker, 1885, Laney Family Cemetery, Union County. Left: H 10⅞″, C 16½″. Signed in script: "D B L." Right: H 16″, C 23³/₁₆″. Signed in script: "D. B. LAN EY / Bor. Mar. 5, 1871 / DIED Jan. 5 1885." Courtesy of the Laney Family Cemetery Committee, Altan, N.C.

2 & 1821 / Died July 18 / 1890." These were likely made by a member of the Gay family, which lived nearby and intermarried with the Laneys. Foot markers were typically smaller and plainer. Around the inscriptions, the potter impressed a circle of exclamation points to heighten the decorative effect. Finally, he also cut much of the clay out of the bottom when it was in a leather hard state, to ensure constant drainage and prevent cracking. With their tucked-in waists, sharp pinnacles, and heavy coatings of flyash on the shoulders, these head markers have a graceful, soaring quality and rich texture that mark them as outstanding examples of the folk potter's art.

In Randolph and Moore counties, the jug form also predominated, though there were three distinct subtypes. The Williamson marker in figure 12-1

most closely resembles the classic jug, except that it once had a finial on the end of a long neck to close off the top. Three incised bands frame an elaborate inscription embellished with a veritable epidemic of dots:

"NANCY· J· WILLAMƧON
BORИ:ИOV:4:1875:DIED:
NOV:17:1896: AGE:21:YEAR:13:DAY

Very close by in the same cemetery was a second type of marker, a tall cylinder (fig. 12-3) set some seven inches into the ground and inscribed on the slightly concave top:

JAMES. R. TEAGUE.
BORN.APR. 20TH.1884.
DECEASED.OCT.13TH.1938.
AGE.54.YRS.5MO.24DAYS.

Until a few years ago a smaller but very similar marker stood nearby, with the initials "L.A.T." in the top. All three were likely made by the Teague family, who until recently operated a shop at Robbins and had earlier intermarried with the Williamsons.

Yet a third variation appears in figure 12-4. The side walls were squeezed in to create a series of rolls, and the marker was topped with a squat knob covered with a greenish slip (possibly the frogskin glaze). In addition, there is a barely discernible coggled cross on the roll below the shoulder. While the potter obviously took extra pains with the form, his inscription almost appears an afterthought, a hasty, cursive scrawl near the base: "Matson Cagle / was born March 25 1856 / Dide December 2 1861 / The Son of Landry / and Eeliza Cagle." This piece, together with four unmarked, smaller, but similar corner markers, was rescued by Dorothy and Walter Auman when one of the Cagle cemeteries in Moore County was bulldozed about thirty years ago.

In addition to these five, the *Guide to Moore County Cemeteries* records three other graves with "jug markers" in another Cagle family cemetery in northwest Moore County, just off Route 705. These are dated 1883, 1889, and 1892, and a photograph of one of them shows a general similarity to the Matson Cagle marker.[4] Dan Cagle was a prominent potter in the area who signed his ware "D. CAGLE/ WHY NOT N.C." and could have turned these three. Finally, an exhibition in Washington, D.C., in 1982, entitled "Celebration: A World of Art and Ritual," included a "tombstone fragment" from Moore County inscribed "MONROE BROWN / DIED OCT THE [broken] 1918."[5] Both Hardy Brown and his son Ben were potters in this region, and this may have been the work of the latter.

Much more rare is the slab or tablet marker, which was produced, not by turning, but by rolling out and trimming a thick, flat piece of clay. In the Valley of Virginia, at least three potters made them, in sizes and shapes that

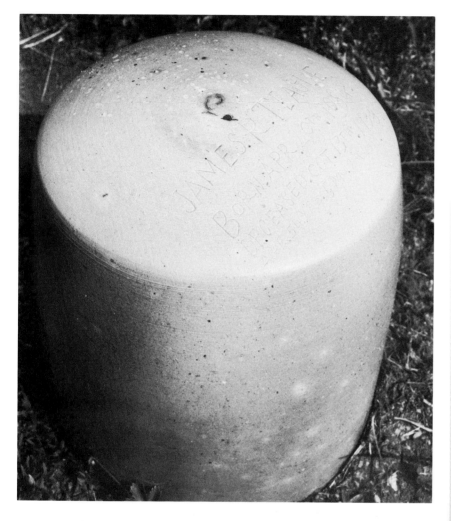

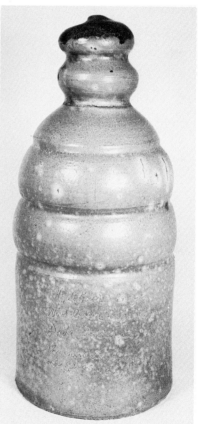

Figure 12-3
Salt-glazed stoneware grave marker, 1938, Union Grove Church, Randolph County. H 17½", C 30¾". Collection of the Ackland Art Museum, University of North Carolina at Chapel Hill, gift of Charles G. Zug III.

Figure 12-4
Salt-glazed stoneware grave marker, 1861, Moore County. H 17¾", C 25¼". Collection of the Mint Museum, Charlotte, N.C.

closely resemble the typical gravestone.[6] Smaller ones appear to have been relatively common in Mississippi and Alabama, where, as in Virginia, the potters used cobalt to accent the lettering and designs.[7]

In North Carolina, on the other hand, only two slab markers are known, both from the Cane Creek Friends Cemetery in Snow Camp, Alamance County. The only one still standing is dated 1834 and is cut in a simple discoid form that closely resembles the stones surrounding it. In fact, from any distance its gray-brown color, weathered surface, and familiar shape all belie that it was made of salt-glazed stoneware (fig. 12-5). The lettering was done very carefully, with three different sizes of type, and shows the standard Quaker execution of the date. And, in a rather un-Quakerlike manner,

Figure 12-5
Salt-glazed stoneware grave
marker, 1834, Cane Creek Friends
Cemetery, Snow Camp, Alamance
County. H 21¾", W 9", T 1".

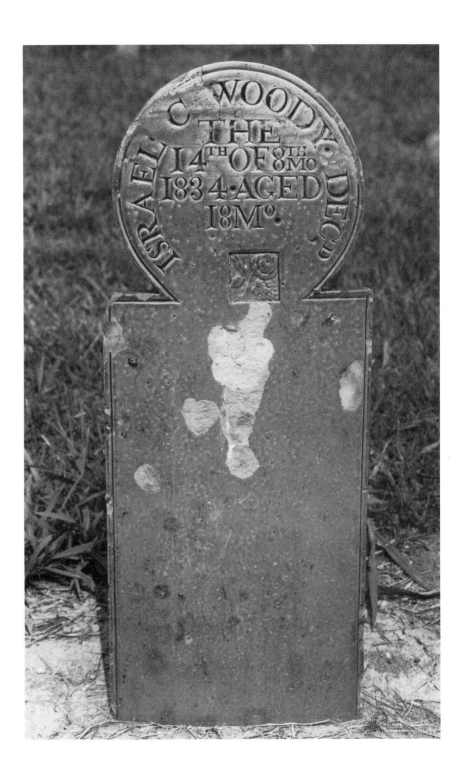

the potter impressed a small mold (1⅝″ square) with a flower design, once on the front, under the inscription, and then four more times in a strip across the back. The second marker is much plainer and smaller, with a semicircular tympanum and slightly curved shoulders. It measures only 11¾″ by 5⁹⁄₁₆″ by ¾″, and is inscribed:

> T ▲ BOGGS
> BORND ◄ 14
> AUGUST ► 1861
> DC ◄ JULλ ◄ 14
> AD ▲ 1862.

Most likely this was a relative of potter J. Thomas Boggs, who lived several miles to the south, just above the present Chatham County line. Some years ago this marker broke off from its base, and recently it has disappeared altogether.

The continuing loss of the few remaining ceramic grave markers is cause for concern, but the attrition rate does suggest that these all too fragile (and unfortunately, collectible) items may once have been a common sight in cemeteries near pottery-making centers in the eastern half of the Piedmont. Most were turned; slab construction was never a familiar technique. It likely required more time and effort, and the thick tablets would have been difficult to dry thoroughly and then to burn without some cracking or warping. Moreover, most of the North Carolina markers were made of salt-glazed stoneware. Earthenware would have proved too fragile and impermanent, and the thick, often dark alkaline glaze would have obscured most of the inscription. Thus there is no evidence that they were ever produced in the Catawba Valley.

Elsewhere, however, southern potters did use the native alkaline glaze on these forms. In Washington County, Georgia, members of the Redfern family made "cylindrical, uninscribed grave markers . . . with closed dome- or cone-shaped tops and only the bottoms dipped in a smooth green glaze."[8] And in Alabama, the markers "show every major glaze type including salt, alkaline, Albany and Bristol."[9]

Ultimately the potter's decorative impulse appears to have been quite restrained. No cobalt or applied ornaments were employed, and, when present, the incised or impressed designs were simple and were quickly stamped into the soft clay. Only on the level of form does the potter appear to have given some play to his imagination—and he could afford to do so, because the markers were not functional in the same sense as a whiskey jug. But most do not vary greatly from the utilitarian shapes, and even the finials or knobs had their purpose: to seal the top so that water could not get in. All of these tendencies seem entirely in keeping with the practical nature of the folk potter, whose purpose was to produce an inexpensive, relatively durable memorial to his family or neighbors. And perhaps the potter's asso-

ciation with the graveyard is closer than one might expect, as the epitaph of an eighteenth-century potter from Maryland suggests:

> Beneath this Stone, lies Katharine Gray,
> Chang'd from a busy Life, to lifeless Clay,
> By Earth and Clay she got her Pelf,
> and now she's turn'd to Earth herself.
> Ye weeping Friends, let me advise,
> Abate your Grief, and dry your Eyes:
> For what avails a Flood of Tears!
> Who knows but in a run of Years,
> In some tall Pitcher, or broad Pan,
> She in her Shop may be again.[10]

HORTICULTURE

While the folk potter's customers required vessels for foods and assorted implements, they also demanded a surprising range of horticultural wares, including flowerpots and, later, vases and urns. The flowerpot was by far the most common of these forms. Its essential function was to add a dimension of beauty to temper the austerity and hard physical labor so common to rural life. In particular, Clara Wiggs recollects that "many women back then, they'd have a whole shelf—they'd build shelves out in the yard. Maybe they'd have forty or fifty different plants. Sometimes they'd be old buckets and different things, but those that cared more, they used flowerpots."[11] Mrs. R. L. Robinson offers an identical account—the plants were set "something like steps out in the yard"—and adds that "some people had a shelf all along their porch, and they'd set it full of plants."[12] Traditionally the house and surrounding yard—including the flower and kitchen gardens—fell into the province of the women in the family. Thus it appears that these arrangements of plants, often in elaborate numbers on stepped shelving, constituted an unrecognized form of folk art (fig. 12-6).

FLOWERPOTS

Within the very practical, down-to-earth context of folk culture, the flowerpot may seem a rather frivolous production, but all evidence suggests that it is a very old and common form. In England "the use of earthenware vessels for the growth and display of flowers is of considerable antiquity, having provided an important source of the country potter's trade since the mid-sixteenth century at least." Initially the bulk of the output was "for the wealthier households which possessed large formal gardens," but by the mid-eighteenth century, the flowerpot was "being made in the majority of the smaller potteries scattered throughout the country," and had become "a semi-orna-

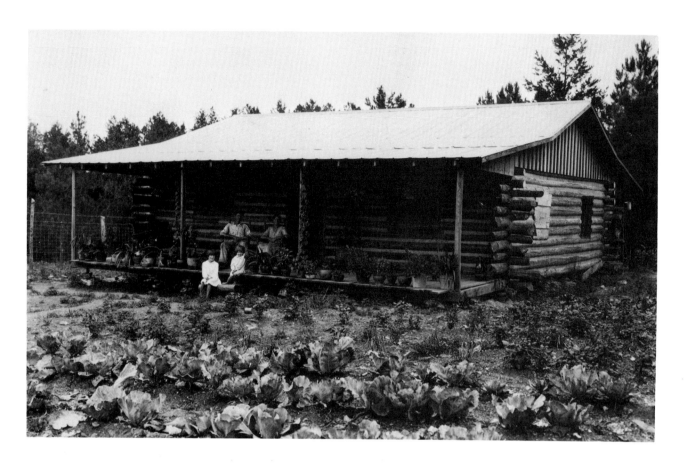

mental item in the home of the working man."[13] As for the New World, there is solid archeological and historical evidence to show that flowerpots were in use in Virginia in the seventeenth century, and extensive excavations at Williamsburg reveal a wide variety of eighteenth- and nineteenth-century forms, with the familiar straight, flaring walls, turned or rolled rims, and occasional decorative cordons or incising.[14]

In North Carolina the earliest known examples are, again, from the Moravian inventories. "Flowerpots had become a popular earthenware item in the Salem pottery by the early nineteenth century; in 1819, they are listed at a price of one shilling, and in 1821 at prices of ten pence and ¼." John Bivins illustrates three pots, all of them lead-glazed and one with an attached saucer.[15]

The rural potters were never so meticulous as the Moravians, and thus it remains impossible to establish a precise date for the earliest production of flowerpots in the North Carolina countryside. However, given the general interest in flowers and horticulture, it would seem reasonable to assume

Figure 12-6
Mr. and Mrs. Bryan D. Teague relaxing with their daughters Avis (l.) and Zedith on the front porch of their home in Moore County, ca. 1930. Courtesy of the Teague family.

Figure 12-7
Unglazed stoneware flowerpot, first half of the twentieth century, Poley Hartsoe, Catawba County. The homemade coggle wheel used to form the decorative banding rests in the foreground. Collection of Mr. and Mrs. Olen T. Hartsoe.

that flowerpots were being produced in small numbers in the nineteenth century, and that they constituted an important sideline by the early twentieth. Some were turned in the familiar broad-rimmed form of the commercial stamped flowerpot (fig. 12-7). This type boasted one particular advantage. If evenly turned, the pots would fit inside each other, both in the kiln and, later, the potter's wagon or truck. However, economy of space was not a major concern to the local potter, as he rarely stacked the wares in his long, low groundhog kiln. Thus, at least in this century, he appears to have produced a greater number of more graceful, curved forms, often with flaring, fluted, or serrated rims and combed or coggled designs (fig. 12-8).

There were very practical reasons for making flowerpots. In the eastern Piedmont, they could be burned in a low temperature firing, along with the popular lead-glazed pie dishes (only rarely were the flowerpots salt-glazed). In the Catawba Valley and the Mountains, on the other hand, they could be set in the cooler areas of the kiln—along the sides and toward the chimney—where the alkaline glazes would not mature properly. In short the flowerpot increased the efficiency of the potter's operation.

As illustrated in figure 12-8, the flowerpots varied in size, the most common capacities being ½, 1, 1½, and 2 gallons. Because the function of the flowerpot was to provide beauty, the folk potter spent an uncharacteristic amount of time decorating them. While these ornamental touches were usually accomplished quite quickly, much greater time and effort were needed for the overall "tree trunk" design such as made by William M. Penland (fig. 12-9). This style was widespread in nineteenth-century America and also in England, where "by the 1850s an almost universal technique of producing 'rustic wares' had been adopted in most potteries. This normally consisted of making the wares in a common red-firing fabric, the surface of which was scratched with a fork to give a bark-like finish. For additional reality clay 'knots' were frequently applied."[16] Indeed, other Penland pots have the applied knots as well, and represent a very late folk adaptation of a popular taste.

Applied designs are rare, but occasionally a potter such as Wade Johnson took the extra time to hand-build a cluster of grapes hanging amidst vines and leaves (fig. 12-10). This particular motif appears to have been a minor tradition in the Catawba Valley; Burl Craig recalls that Jim Lynn's wife, Leola, "put grapes and grape leaves" on his "fern pots," the local term for the large, curved flowerpots that Burl still makes today.[17] "She just rolled the grapes in her hand, one at a time, you know. And she had a little piece of wood, a roller, maybe a small rolling pin, and she rolled out the leaves and cut 'em, just by guess." Leola did not make many of them, but she sold all she made right out of their yard. Generally, she decorated the two-gallon pots and charged about thirty cents for them, a mere ten cents premium over the normal rate.[18]

One particular form of the flowerpot is the familiar strawberry planter,

Figure 12-8
An assortment of birdhouses, flow-erpots, and strawberry planters from Burlon Craig's kiln, 1978.

which provided an additional income for potters like Jug Jim Broome during the early years of this century. His son, James, recalls that "there was a fad for those things one time, and it kept him busy for a long time making those things. And he made them to hold up [to] six, six, gallons."[19] These were easy work for the folk potter, as they are nothing more than tall storage jars with two or three rows of open pockets in the sides. Burl Craig forms his by piercing the walls with a Prince Albert tobacco can and then pulling out the lower lip with his moistened finger (fig. 12-11). To form a fuller pocket, some potters turned a series of small cups, sliced them in half with a wire, and then applied them to the outer walls around the holes.

VASES AND URNS

Decorative vessels for cut flowers and large ornamental urns for the home did not enter the North Carolina potter's repertory until the early years of this century. In general, vases "were not particularly common in stoneware until the late nineteenth and twentieth centuries, when most potteries began making a larger range of forms to compete with industrialized pottery products in both stoneware and earthenware. The Art Nouveau decorative period and the beginnings of the Studio Pottery Movement also spurred this additional range of forms."[20] Although of relatively recent date and subject to outside influences, the forms produced by the local potters were extremely varied and often quite graceful. Figure 12-12 illustrates a slender vase,

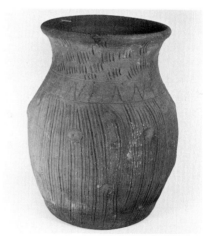

Figure 12-9
Unglazed stoneware flowerpot, ca. 1925, William M. Penland, Buncombe County. H 12 13/16", C 33 1/2". Signed in script: "W M PENLAND & sons." Incised rustic or tree trunk style. Collection of Doug and Jane Penland.

Figure 12-10
Unglazed stoneware flowerpot, first
quarter of the twentieth century,
Wade Johnson, Jugtown, Catawba
County. H 8⅞", C 29⅞". Applied
hand-molded grapes and leaves;
painted white by a former owner.
Collection of James and Irene
Gates.

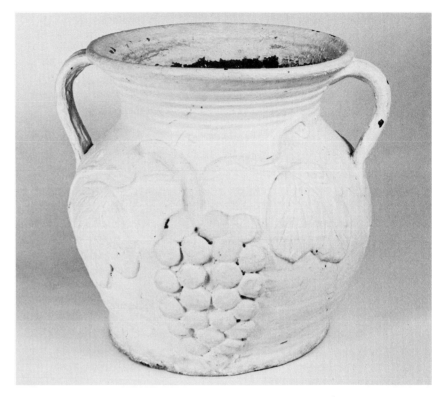

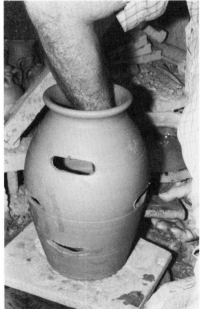

Figure 12-11
Burlon Craig opening the pockets in
a strawberry planter with his Prince
Albert tobacco can.

glazed in Albany slip, made at the Penland Pottery about 1925. Like most folk pottery, this piece has rather thick walls and handles reflecting the hard use to which such ware was put. However, the baluster shape, balanced foot and rim, and opposing handles combine to produce a pleasing lightness and symmetry.

Because the potters rarely decorated the surfaces of vases, it was not unusual for others to paint designs on them—or simply to paint them in solid colors—red, green, gold, and white being common choices. The Kennedy Pottery at Wilkesboro turned out a line of unglazed vases that a local woman decorated with birds and flowers. In the example in figure 12-13, the background is Carolina blue and the dogwood flowers pink and white, with a heavy use of gold on the peacock and the rim. Ray Kennedy recalls that the artist paid for the vases by giving back a certain number of painted ones, which the Kennedys then sold in their display room. The Kennedys also produced "florist vases" on special order; these were designed "for florists to put flowers to set in their refrigerator." Two of these tall, straight-walled containers, designed to make efficient use of space rather than for beauty, can be seen in front of Bulo Kennedy in figure 2-35.[21]

Among the more specialized types of vases is the flower jug or quintal, a somewhat variable form, but one characterized by a central mouth or spout with a number of additional spouts evenly spaced around the shoulder (fig. 12-14). This vase form is very old; it occurs in the ancient Near East and later in China and the Netherlands.[22] Most likely it was reinvented by potters in different times and cultures. Ash-glazed flower jugs were also made in the Mossy Creek District of White County, Georgia; John Burrison illustrates one made there about 1870 by Isaac H. Craven, a great-great-grandson of North Carolina's Peter Craven.[23] To produce it, the potter made a normal jug with the spout on the top and then applied a series of extra spouts that he turned individually on his wheel.

A similar form substitutes several rings of holes in the shoulder for the applied spouts (fig. 12-15). These were locally referred to as "pansy pots" or again, just "flower jugs," and as Burl Craig affirms, "they made a pretty nice flowerpot. Back then people didn't have the artificial flowers like they got now. You could take, fill it up with water up to the holes, and put cut flowers in them, and they would stay fresh for several days."[24] Finally there is the "wall pocket," in effect a hanging vase, which was usually conical and flattened at the back so that it could be suspended on a nail. These also held cut flowers or perhaps a potato, which would put forth some welcome greenery in the middle of winter. The large wall pocket in figure 12-15 was made by the Brown family in the late 1920s and is said to have been part of a set of eight for a theater in Asheville. The North Carolina potters made this form in both earthenware and stoneware, but, aside from the finial at the base, they rarely attempted any decoration. In the Shenandoah Valley, on the other hand, the Virginia potters used brightly colored glazes over applied birds, flowers, and other designs.[25]

Urns are not always easy to distinguish from vases, but in general they are larger, more ornate, and frequently mounted on a pedestal or base. Originally intended to preserve the ashes of the dead, they are now simply decorative vessels, though they may also contain liquids or even pots full of flowers. For the folk potter, urns represented an even greater concession to fashionable tastes than vases. They were never a significant part of his output, and virtually all of them were produced between the World Wars, during the final stages of the folk tradition. Figure 12-16 illustrates a handsome urn made by Jug Jim Broome of Union County, one of a pair sold to a neighbor during the 1920s. It was made in two sections that were then bolted together; this procedure ensured that the bottom would not collapse due to the weight of the top during the turning or firing. Moreover the base appears to have been inspired by the many stove thimbles that Jug Jim was producing at the time. No glaze was used on either component, but the owner later painted the cordons black to provide a contrast to the orange clay body.

Even more monumental were the large urns turned by George Donkel of

Figure 12-12
Albany slip-glazed stoneware vase, ca. 1925, William M. Penland, Buncombe County. H 11¹⁵⁄₁₆", C 18½". Collection of Doug and Jane Penland.

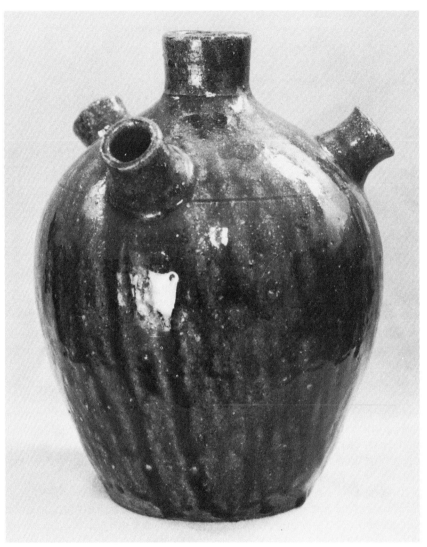

Figure 12-13
Unglazed stoneware vase, ca. 1925,
Kennedy Pottery, Wilkesboro, Wilkes
County. H 15⅜", C 29½". Painted
decoration. Collection of Ray A. Ken-
nedy.

Figure 12-14
Alkaline-glazed stoneware quintal,
second half of the nineteenth cen-
tury, Catawba Valley. H 9½". Photo-
graph by Daisy Wade Bridges.

Weaverville during approximately the same period (fig. 12-17). Apparently inspired by a German artist who had a summer home nearby and encouraged him to try his hand at art ware, Donkel hand-sculpted roses, laurels, or rhododendrons on the walls of these large jar forms and then added ring handles and a small, molded Indian head.[26] The final product was expensive for the time—they sold for three to five dollars to "outsiders," but were marked down for the local residents.[27] However the urn illustrated was free—one of the handles fell off during the burn, and so Donkel gave it to

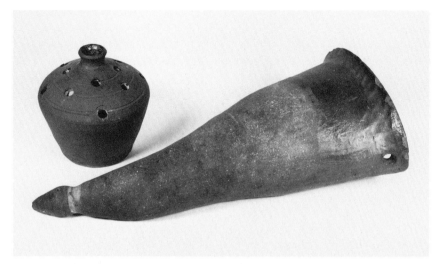

Figure 12-15
Two flower containers. Left: flower
jug, alkaline-glazed interior, ca.
1930, Floyd or Samuel Propst, Henry,
Lincoln County. H 4⁷/₁₆″, C 14³/₈″.
Stamped: "NORTH CAROLINA."
Right: wall pocket, interior glazed
with Albany slip and Spanish whit-
ing, ca. 1930, Brown's Pottery, Arden,
Buncombe County. L 14″. Stamped:
"BROWN / BROS."

Ruth Hannah Brank, a member of his wife's family, who as a girl used to help out around the pottery.[28]

Although most of these so-called horticultural wares were used around the home, a small number also went to the cemetery to honor the dead. Figure 12-18 shows the Broome family cemetery in southern Union County, with the graves of Nimrod and his son, Jim, prominent at the center rear. As might be expected of such a family of potters, the cemetery is full of pots. Two recycled milk crocks are readily visible, as well as two vases that once held fresh flowers. While these are not marked in any way to suggest a particular funerary function, potters in Georgia did produce elaborately decorated grave planters that were sometimes inscribed with the names and dates of the deceased.[29]

A much rarer cemetery pot—if that is what it is—is the salt-glazed stoneware jug in figure 12-19, which is embellished with seashells, beads, dolls, and various glass, ceramic, and plastic fragments. Although most of the jug is coated with plaster to hold the ornaments, the shape and glazing on the bottom reveal that it is from the eastern Piedmont and probably of late nineteenth-century vintage. All the evidence suggests that this may be an Afro-American grave pot; a small jar with similar decoration was recently shown at an exhibition of southern folk art.[30] As folklorist John Michael Vlach explains, the use of shells at black gravesites is very common, because "they create an image of a river bottom, the environment in African belief under which the realm of the dead is located." Also prevalent are numerous broken objects—particularly "pottery or pressed-glass containers"—which were once part of the life of the deceased. These are set on or near the grave and constitute "a statement of homage": they are "material

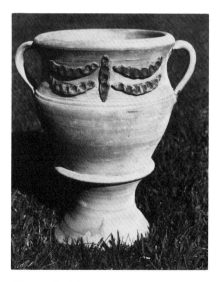

Figure 12-16
Unglazed stoneware urn, ca. 1925,
James C. Broome, Union County.
H 16″, D 10½″. Collection of James
A. Broome.

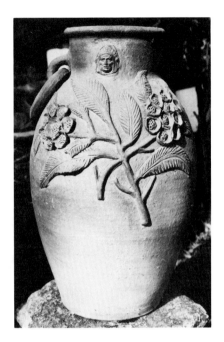

Figure 12-17
Unglazed stoneware urn, ca. 1920,
George Donkel, near Weaverville,
Buncombe County. H 18½", C 36⅞".
Collection of Ruth H. Brank.

Figure 12-18
A potter's cemetery: the Broome
Family Cemetery in southern Union
County.

messages of the living intended to placate the potential fury of the deceased."[31] While few such pots are known, their symbolism allows the possibility—and this remains speculative—that they relate to Afro-American attitudes toward death and the dead. Most likely others exist—glass fruit jars coated with similar ornaments have turned up in black families in eastern North Carolina—but have been ignored or discarded due to a lack of knowledge about their meanings.

WHIMSEYS

The old adage that "all work and no play makes Jack a dull boy" applies to folk potters too. While their world abounded in long hours and exhausting, repetitive labor, they still found time to exercize their sense of play and concoct fanciful forms out of the malleable clay. Because these whimseys were out of the ordinary and did not have to be particularly useful, they occurred in a variety of shapes and sizes. Sometimes the potter received a request for some bizarre, one-of-a-kind oddity. As Joe Owen reminisces, "I've made a lot of different kinds of shapes. . . . I've had people come in wants you to make them a left-handed pitcher and a right-handed pitcher, you know. Somebody come along one time, wanted me to make 'em a jug. Said, 'I want you to make me a jug just like a man is when he's drunk.' I says,

Figure 12-19
Salt-glazed stoneware jug, second half of the nineteenth century, eastern Piedmont. H 13".

Figure 12-20
Alkaline-glazed stoneware doll's
head, ca. 1950, Poley Hartsoe, Ca-
tawba County. H 3¼". Collection of
Mr. and Mrs. Olen T. Hartsoe.

'Never did make one like that.' So I said, 'I'll make you one.' And I made him one. And when I turned it, I struck my hand [slaps], just slashed down on it like that. And I glazed that thing. He come back, he said, 'That's just what I wanted!' "[32]

Aside from the occasional unique piece that defies any attempts at classification or sheer reason for being, the more common whimseys included miniatures, puzzle jugs, ring jugs, monkey jugs, and face vessels. Often these were made at the end of the day, or during slack moments when the turner was not filling his shelves with jars and jugs. Frequently they were intended for a particular person—a member of the family or a neighbor—or to commemorate a special occasion, perhaps a holiday or an anniversary. It is important to stress that all of these forms were rare. Too often collectors and curators overemphasize them, precisely because they are scarce and unusual, thus providing a very distorted overview of the folk potter's achievement. One book that does precisely this is *Folk Pottery of the Shenandoah Valley* by William E. Wiltshire, III. The large, attractive color photographs are full of banks, animals, log cabins, human figures, and other elaborately decorated pieces, giving the impression that the Virginia potters were primarily painters and sculptors rather than craftsmen. Only a few of the sixty plates illustrate the simple, everyday, utilitarian wares that constituted the essence of the tradition.

MINIATURES

Miniature ceramic vessels included toys for children, the apprentice work of young turners, samples used to advertise the full-sized pots, and more recently, tourist items. Potters have always catered to children—in part, because children have always been drawn to their shops to witness the magical growth of a jug on the wheel or to take part in the excitement of a kiln burning. And in a world lacking plastic and cheap, mass-produced toys, the potters could fashion relatively durable playthings to exercise the young imaginations of both sexes. "Toys made for girls were usually miniatures of standard production items such as bean pots, crocks, jugs, jars, pitchers, pipkins and teapots. Occasionally a potter modeled dolls' heads, chairs and other toy furniture. Pottery and toys for boys were marbles, banks and whistles."[33]

Because these diminutive forms were rarely marked and have usually passed out of the hands of their original owners, it is virtually impossible to ascertain that a particular little jug or pitcher was once used by a girl to practice her homemaking. However, a few dolls have survived. Figure 12-20 shows an alkaline-glazed head made by Poley Hartsoe for his granddaughter, Nancy Fay Hartsoe, in about 1950. Alkaline-glazed dolls are also reported from the pottery of James R. Cheek at Weaverville, Buncombe County, and today one member of the Hilton family, Ernestine Hilton Sig-

Figure 12-21
Salt-glazed stoneware miniatures and puzzle jugs, ca. 1900, Baxter N. Welch pottery, Harper's Crossroads, Chatham County. Left: H 10⅝", C 19⁷/₁₆". Signed in script: "G. W. BriGht his jug 1900." Bright was a wagoner for the pottery. Right: H 8¼", C 17⅜". Miniatures: H ⅝" to 3³/₁₆". All from the collection of Mr. and Mrs. Gails Welch.

mon, still produces elaborate porcelain dolls in the style of her mother, Clara Maude Hilton.[34]

The boys were perhaps more involved with miniature pots, because as apprentice turners they were often given the opportunity to make them. And as mentioned in chapter 8, they were even able to earn some money by selling them. Burl Craig recalls his neighbor, Floyd Propst, "picking up a little extra money that way. He was turning and going to school too when he first started. He would turn in the afternoon and through the summertime. They could burn a lot of that miniature [ware] . . . between the large stuff—it didn't take up any room." And with the growing tourist market for small pieces, Floyd was able to make a substantial contribution to the family income. Burl adds that his father, Sam, "would give him a certain percent of what they got out of it. Of course, Sam had to have some money out of it."[35] Boys also fashioned their own marbles. James G. Teague recalls placing them in his father's kiln among the full-sized wares; they emerged so hard and glassy that he insists he never saw one break.[36] Banks appear to have been much less common, and as yet no whistles have been found locally, though these were quite common among the earthenware potters of Pennsylvania.

While many of the miniature wares were intended for children, others had a more practical purpose. The samples shown in figure 12-21—a milk crock, flowerpot, butter jar, dish, and preserve jar, respectively—were car-

Figure 12-22
Alkaline-glazed stoneware jugs, ca.
1925, Catawba County. H 3⅞", 4",
C 11⅝", 12". Signed in script: "Huf-
fery Hotel." Collection of Paul Lloyd.

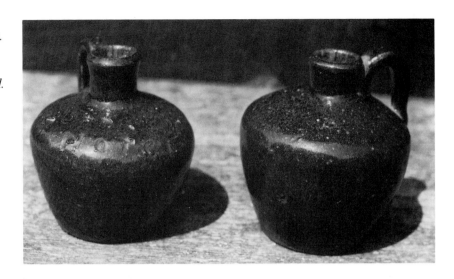

ried by Baxter Welch to surrounding hardware stores to encourage orders. Perhaps the most remarkable feature of his salesmanship is that he rode on a bicycle; figure 5-2 shows him standing proudly in front of his shop, bicycle at the ready and satchel over his shoulder. Baxter must have been extremely fit, because his son, Gails, points out that he sold pottery as far away as Raleigh, Fayetteville, and even Goldsboro (a round trip of about two hundred miles!). After the storeowners had examined the samples and placed their orders, the wagoners would follow with the real article.[37]

From the beginning of this century, miniatures were also produced as souvenirs. Figure 12-22 contains two stubby alkaline-glazed jugs inscribed "Huffery Hotel," which once stood in Hickory. Most likely made by members of the Hilton family, who operated several shops near the city, they were either used at the hotel or given away as advertisements. Ironically the production of full-sized jugs dropped sharply during the first quarter of this century because of the growing Prohibition movement. However in its diminutive form the jug continues to excite the imagination of tourists and the general public, no doubt because it is small and thus harmless, yet still conjures up images of illicit stills bubbling over in dark mountain coves.

PUZZLE JUG AND RING JUG

One very ancient practical joke on the part of European potters was the puzzle jug, a drinking vessel variously constructed with a perforated neck, hollow handle and rim, and assorted mouthpieces, all designed to embarrass anyone attempting to drink its contents. In England these trick vessels were used at least six hundred years ago (appropriately enough in a tavern at Oxford), though the major period of output was the eighteenth and nine-

teenth centuries.[38] Relatively few were produced in this country, however, with the greatest number probably coming from the potters of the mid-Atlantic region.[39]

Technically the two salt-glazed jugs in figure 12-21 are not true puzzle jugs; the contents can only be poured out of the canted spouts to the right, and there are no piercings or hidden tubes to deceive the user. But with the miniatures mounted at the top and around the shoulder, these decorative forms have the *appearance* of the traditional puzzle jug, though in a decidedly southern interpretation. At least three other jugs like the one on the right are known, one of which is glazed in Albany slip. All were probably turned at the Welch shop, most likely by Wrenn or J. B. Cole, but their specific inspiration and purpose remain unknown. The jug on the left is inscribed "G. W. BriGht his jug 1900." Bright was a wagoner and perhaps carried this jug with him on trips; it was found by one of Baxter Welch's great-granddaughters in an old building near the now-vanished pottery. Most likely, then, these "puzzle jugs" were presentation pieces for close friends, but they may also have served, albeit indirectly, to advertise the fine wares of the Welch pottery.

No less striking, but much more common in North Carolina, was the ring jug (fig. 12-23), which was produced in both the eastern Piedmont and the Catawba Valley. An old European form that was particularly favored by the German stoneware potters, it was known elsewhere in this country as a ring bottle, harvest bottle, or mower's bottle.[40] There is considerable debate among potters as to whether it served any useful purpose. In defense of its utility, Javan Brown explains that "the people in the rural district farmed, would put water in them. But they didn't want them glazed, because the evaporation of the water kept it cool, you know. They'd hang it up, and when they wanted a drink of water, go get that ring jug."[41] Javan qualifies his account by referring to it as an old potter's tale, but terms such as harvest or mower's bottle suggest that it may have functioned in this manner. Recently, a number of mail-order firms have featured large, unglazed ring jugs as wine coolers. In their catalog for the spring of 1981, Hammacher Schlemmer offered a "Dual System Wine Keeper" for $19.95, "a wine chiller as functional as it is graceful."

The general consensus among local potters, however, is that the ring jug was primarily a novelty to amuse customers and display the virtuosity of the turner. Herman Cole recalls that his father, J. B., "mostly made churns and crocks and jugs and pitchers back then. [He] made some ring jugs, not often. This was done mostly when people came to see pottery being made. And maybe he wasn't on the wheel right then so he'd take a small piece of clay and show them how it was done. This is what he would usually make because it was so odd. They couldn't figure out how he'd get the hole in the middle."[42]

One solution to this perplexing problem is demonstrated by Burl Craig. He first forms a shallow bowl on the wheel, opening it to the outer diameter

Figure 12-23
Salt-glazed stoneware ring jug,
last quarter of the nineteenth
century, William H. Hancock, Moore
County. D 8", T 2". Stamped:
"W.H.HANCOCK."

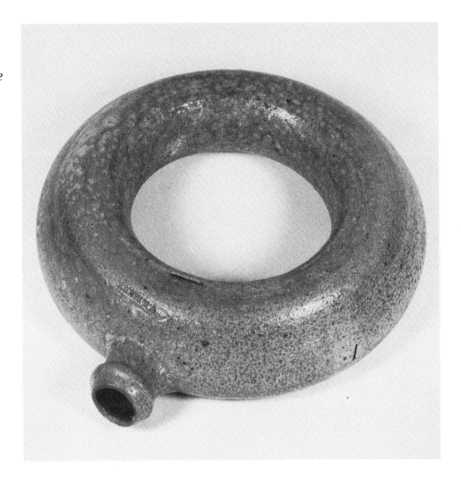

of the ring jug. Next, he pulls up the bottom of the bowl and works it out to the side to form the inner wall (fig. 12-24). All that remains is to carefully fold over and fuse the tops of the two walls (fig. 12-25). After the piece has hardened for several hours on a bat board, Burl turns it over and trims off the excess clay to round off the bottom. Finally, he turns a small jug spout on the wheel, welds it to the ring, and cuts a hole through it to open the interior. All this is much easier said than done: indeed, a well-formed ring jug is an appropriate emblem of the potter's skill.

On balance it would appear that the ring jug is best classified as a whimsey. The majority of the surviving examples are glazed, thus preventing the evaporation needed to cool the contents, and the capacities are rarely sufficient to slake the thirst of a field hand who has been broiling under the Carolina sun. Most farmers knew better and carried a regular water jug with them.

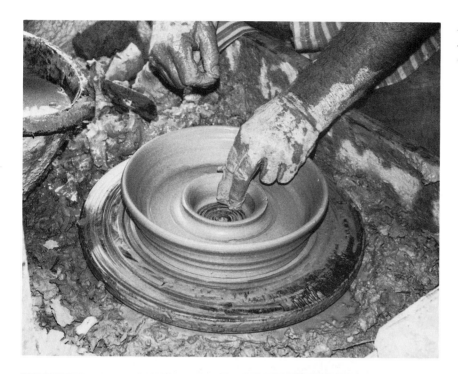

Figure 12-24
Burlon Craig pulling up the walls of a ring jug.

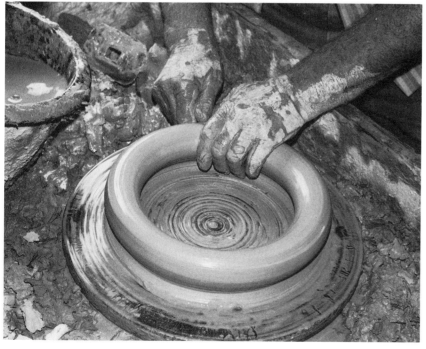

Figure 12-25
Closing the wall to form the ring.

MONKEY JUG

Equally curious to most observers is the so-called monkey jug, which appeared in North Carolina in two distinct forms. The first type consisted of a single container, which normally had two opposed, canted spouts with a transverse strap handle running between them. The carefully turned example in figure 12-26 has also been decorated with runs of melted glass, a very rare practice in the eastern Piedmont. For variation the potter could manipulate the handle or spouts. The alkaline-glazed jug in figure 12-27 exhibits the classic large and small spouts, but the potter rotated the handle 90° and added a finial—possibly for support as well as decoration—beneath it. Actually, the longitudinal handle is better designed for pouring, particularly if the pourer has only one free hand. On the salt-glazed example, the potter has retained the transverse handle but omitted one of the spouts. In effect, the monkey jug reverses the normal alignment of the common southern jug by placing the handle on the top and the spouts on the side. While the top handle makes the jug easier to carry because the load is equally balanced, the form requires more work for the potter. He must fashion the spouts separately and attach them, rather than turning the single spout as an integral part of the body of the jug.

The precise origin of this vessel remains something of a mystery. It is very common throughout Spain, where it is generally called a *botijo*, and it also occurs in Africa and in the Caribbean, where at least one black potter is still making them. John Burrison reports that "they are unknown in Britain and I have so far failed to find them in Germany, the two most logical sources of our American pottery tradition."[43] As for the colorful name, John Vlach points to "the 1797 phrase, 'to suck the monkey,' a slang expression used to describe someone who drinks directly from the bottle and therefore drinks too much. Some Blacks in South Carolina still use the word 'monkey' to mean a strong thirst caused by physical exertion."[44] In addition the term "monkey" has been used as a racial epithet. Roger D. Abrahams explains that "the words 'monkey' and 'ape' have been used as derogatory words in relation to the Negro, and have achieved a meaning and notoriety not very different from 'nigger.'"[45]

Occasionally one hears that the extra spout was added so that a master and slave could each drink from the jug, hence the possible racial overtones in the word "monkey." However, for two reasons, this explanation seems less satisfying. First, the double spouts do have a practical purpose. The larger one is often designed for filling, the smaller for emptying the jug. Moreover the extra spout serves as a vent, readily allowing the air to escape or reenter the jug when it is being used. Second, the connection with work in the fields is supported by potter Javan Brown. "Now we make a water jug we don't glaze. Hold about a gallon. Put two spouts and a handle across the top. One spout bigger than the other, that's where you fill it. And the other

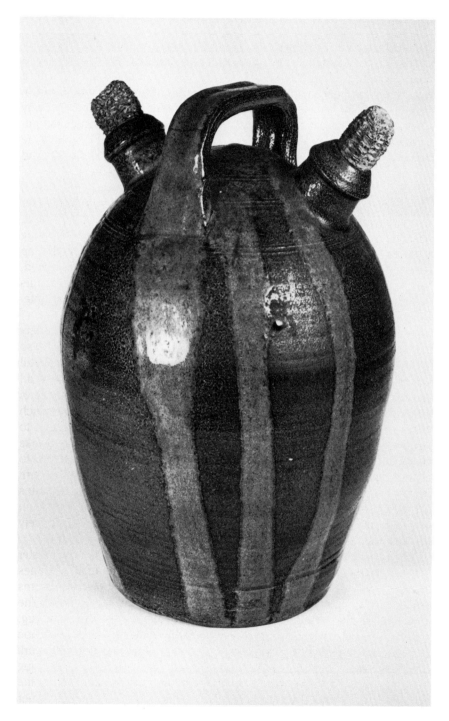

Figure 12-26
Salt-glazed stoneware monkey jug, second half of the nineteenth century, eastern Piedmont. H 12",
C 25⅝". Glass streaks around handle and spouts. Collection of Mary Frances Berrier.

Figure 12-27
A pair of stoneware monkey jugs.
Left: alkaline glaze, second half of
the nineteenth century, Catawba
Valley. H 11″, C 25″. Right: salt glaze,
second half of the nineteenth cen-
tury, eastern Piedmont. H 9″, C
18⅝″.

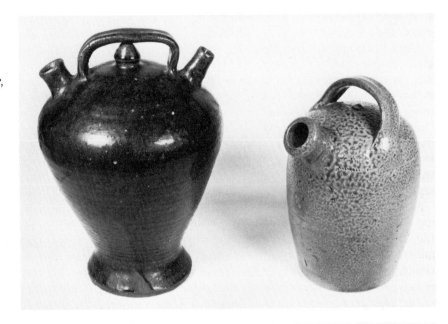

Figure 12-28
A pair of alkaline-glazed stoneware
monkey jugs, Lincoln County. Left:
swirl ware, ca. 1940, Enoch W. Rein-
hardt. H 9⅝″, C 16¼″. Stamped:
"E.W. REINHARDT'S / POTTERY /
VALE, NO. CAR." Right: ca. 1930, at-
tributed to William Bass. H 9⅝″,
C 16¹³/₁₆″.

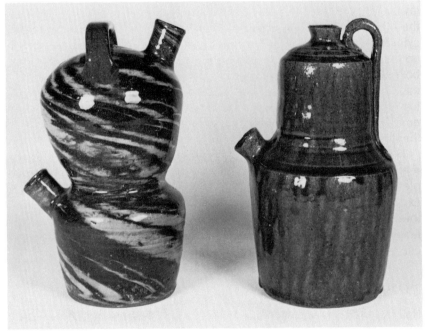

smaller spout, why, you drink out of that. You can set that out and the evaporation keeps it cool."[46]

Thus it appears that this form originated in either the Mediterranean region or Africa and may have been introduced into American ceramics by Afro-Americans, who used it in the fields. It is quite rare in North Carolina, though Clyda Rutherford Coyne asserts that her father, James D. Rutherford, produced many such monkey jugs at his shop near Candler, Buncombe County, during the early twentieth century.[47] And the Hiltons appear to have made alkaline-glazed monkey jugs as part of their "Catawba Indian Pottery" line (fig. 13-4). But as the three pieces illustrated here are all glazed and variously decorated, it would appear that these forms were made as whimseys rather than utilitarian production items.

The second type of monkey jug is found only in the Catawba Valley; it is much smaller and consists of two separate chambers with individual spouts (fig. 12-28; another example is shown in fig. 11-12). Elsewhere double containers called "gemels" or "gemel bottles" were "used for storing oil and vinegar or two kinds of wine." One Connecticut example from around 1800 is formed by attaching two small bottles together, while another from Pennsylvania is in the shape of a sweet potato.[48] While these two are similar in principle, they are markedly different in form from monkey jugs in the Catawba Valley, where the potter skillfully turns one chamber right on top of the other. As Burl Craig explains: "You turn the top first. Just turn you a cylinder, you know, with no bottom. Close it up a little—you leave your lip up there like you're going to make a jug. And set it off. Then you turn your bottom; close it up like you're going to make a, them closed-up jugs like I make. And then you set that [top cylinder] back on it, get it in the center on top of this bottom jug. Then you finish the top." All of this can be done very quickly, though Burl warns that "you got to leave the bottom a little bit thicker than the top so it'll stand, hold the weight."[49]

Thus it appears that this double-chambered monkey jug was a unique regional creation. And it is a rather late one, as the oldest surviving examples date from the 1920s or 1930s, a time when the folk potter was rapidly expanding his repertory in order to attract new customers. Burl readily allows that "they were tourist things—they didn't have no practical use. Just a novelty. They always said, one was to put your whiskey in, one to keep your chaser in. . . . Fact is, I've never seen one with liquor and chaser in it."[50]

FACE VESSELS

Nothing excites a contemporary collector of ceramics more than a face vessel—or "face jug," "ugly jug," or "voodoo jug," as they are variously called. Scarcity alone cannot explain this interest. While the older ones (those made before World War II) are not common, they are no less plentiful than many other forms, like the ring jug or monkey jug. Rather it is the

public imagination, the ability to envision, perhaps, voodoo rites or burial ceremonies behind these humanoid creations, that seems to spur such enthusiasm for them. Appropriately, the prime beneficiaries of this ardor have been Burl Craig and Lanier Meaders of Georgia, the two most active folk potters remaining in the South. Between them, they have produced thousands of face vessels over the last decade, many of which have been transported north and sold at substantial markups as "old" pottery.

At the same time, scholars have been debating the problem of origins, with some, notably John Vlach, emphasizing the African contribution to the tradition. Drawing particular attention to face vessels made by blacks in the Edgefield District of South Carolina during the second half of the nineteenth century, Vlach posits "a complex amalgam—a more-or-less direct retention of basic African decorative preferences and pottery traditions plus indirect influences from Afro-American ceramic forms and newly learned Euro-American pottery forms and techniques."[51] Clearly there is a need to recognize African contributions to American material culture—the previously discussed monkey jug is a likely possibility. But the Africanist position as presented by Vlach and others too often lacks full evidence, disregards other possible sources for the face vessel, and uses doubtful formal and stylistic analogies to prove intercultural relationships.

A more comprehensive approach has been developed by John Burrison, who explores the potential European and white American contributions as well, and who offers a balanced, if less specific, conclusion. "Based on admittedly limited comparative data, then, it appears that neither England nor Africa is directly responsible for the American face vessels. Again, as with the spiritual [song], one can point to Old World analogues, but the phenomenon, as fully developed, is a uniquely American and biracial folk expression."[52]

Ultimately the controversy over origins has little bearing on the situation in North Carolina. Here there is presently no evidence that black potters turned face vessels, or, in fact, that anyone made them before the twentieth century. The largest number appears to have come from the Catawba Valley, where Auby Hilton and Harvey Reinhardt produced them during the 1920s and 1930s (fig. 12-29). Despite the almost infinite range of possibilities in sculpting a face, most potters tended to repeat the same form and features. Harvey's face jugs, for example, are immediately recognizable for their pointy ears, prominent moustaches, and long, narrow, toothy grins (see also figs. 3-14, 9-4). True to the general southern tradition, Harvey turned an ordinary jug and then applied a popeyed, somewhat grotesque visage to the exterior.

Auby Hilton's face pitcher is another matter. It has a conspicuous foot, shows much less work on facial features, sports a small chin or goatee, and is trimmed in cobalt around the eyes and rim. During the 1920s, he was increasingly turning to art pottery; in many respects his work seems closer

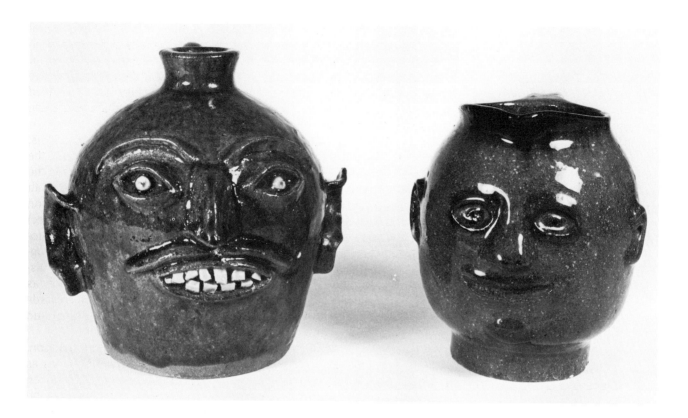

to an English Toby jug (to an English potter the term "jug" means pitcher). Specifically Auby appears to have been imitating a Zachary Taylor "Rough and Ready" Toby pitcher, as made in the mid-nineteenth century at Christopher Webber Fenton's well-known pottery at Bennington, Vermont.[53] Where the prototype was molded and covered with a brownish, mottled Rockingham glaze, Auby's is hand-turned and finished with the local alkaline glaze. But the prominent rim, rather benign features, flattened ears, jutting jaw, and coat collar base on the original are all reflected in the North Carolina copy.

Almost certainly, Auby obtained his model—whether a photograph or an actual Toby pitcher—from Mrs. M. G. Canfield, a pottery collector from Woodstock, Vermont, who had visited and assisted him.[54] Perhaps it was this curious hybrid form—a ceramic blend from England, Vermont, and North Carolina—that led archeologist Stanley South to identify a similar Hilton face pitcher as a nineteenth-century "alkaline glazed 'voodoo head' jug . . . thought to be a South Carolina piece."[55]

Altogether relatively few face vessels were produced in the Catawba Valley. Other than Reinhardt and Hilton, journeyman Will Bass is said to have turned some, and Burl Craig adds that "after I got to where I could turn a

Figure 12-29
A pair of alkaline-glazed stoneware face vessels. Jug: ca. 1935, Harvey Reinhardt, Henry, Lincoln County. H 8". Collection of James and Irene Gates. Pitcher: ca. 1920, Ernest Auburn Hilton, Catawba County. H 6½", C 18⅛". Cobalt trim on rim and eyes. Collection of the Mint Museum, Charlotte, N.C.

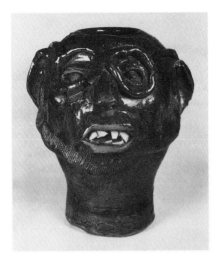

Figure 12-30
Slip-glazed face vessel, ca. 1900,
Randolph County. H 11¾". Collec-
tion of the Mint Museum, Charlotte,
N.C.

little jug, I put faces on a few."[56] However, no face vessels have been located that appear to date before 1920, which suggests that these late pieces were part of a growing tourist business.

Even more unexpected is the lack of salt-glazed face vessels from the eastern Piedmont. The only pot that falls into this class is the brown, slip-glazed curiosity in figure 12-30, surely a unique creation if there ever was one. Perhaps some sort of vase, if it has any utilitarian purpose at all, it features an applied, combed beard, combed hair on the back, and even a pair of spectacles. Such individual touches suggest that it may bave been a deliberate parody of the potter's neighbor.

For all the speculations about the ritual functions of face vessels, it is often forgotten that they could serve as a good practical joke on a friend or enemy. As Louis Brown observes, "I don't think they really meant anything. The public takes it as a joke. I've seen people get mad. One would accuse the other that he looks like that. But I guess that's what sells them."[57] Louis should know what he is talking about, as it is likely the Browns made more face vessels in the South than any other family. When they moved north and established a shop at Arden in 1923, they brought with them a well-established Georgia practice. John Burrison has found that "at least seven white pottery families" have made face vessels in Georgia, and he even speculates that this tradition may extend well back into the nineteenth century, possibly even to the Edgefield District of South Carolina.[58]

A characteristic devil jug by Javan Brown, Louis's uncle, is illustrated in figure 12-31. Made for a hardware store in Bakersville, the county seat of Mitchell County, it would have been an eyecatcher in the front window. This one is unglazed, but sometimes the Browns painted them in lurid black, white, and red. As Louis explains, with some understatement, "lots of places they would like to attract attention and draw crowds and so they'd order a bunch of them to be made 'cause everybody'll stop in front of a place to look at them."[59]

Today Louis's sons, Charles and Robert, still turn well-crafted face jugs at the family shop at Arden. And of course, Burl Craig produces whole families of them, from the economy-sized pint model right on up to five gallons (fig. 12-32). In addition he continually receives requests for face wall pockets, face chicken waterers, face birdhouses, face spittoons, and so on. But this modern mania should not obscure the historical evidence. Very few face vessels were made in North Carolina; all the extant "older" examples date from no earlier than the 1920s; and the most productive single family in this line, the Browns, only emigrated from Georgia in 1923, when the folk tradition in North Carolina was waning.

Other than general historical considerations, such as the diffusion of ideas, there appear to be at least two reasons for this lack. First, making face jugs is extremely tedious work. Turning the jug is only the prelude to the potter's main task. After allowing it to dry for a few hours, he must then form

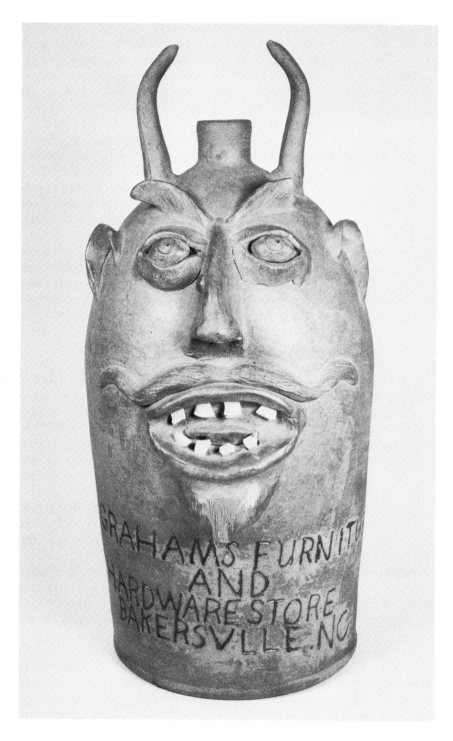

Figure 12-31
Unglazed stoneware devil jug, ca.
1930, Javan Brown, Arden, Bun-
combe County. H 20", C 19¾".
Signed in script: "GRAHAM'S
FURNITURE / AND / HARDWARE
STORE / BAKERSVILLE.NC." Collec-
tion of Doug and Jane Penland.

Figure 12-32
Several generations of face jugs
fresh from Burlon Craig's kiln, 1978.
The "tears" are produced by packing
the eye sockets with a white-burn-
ing clay.

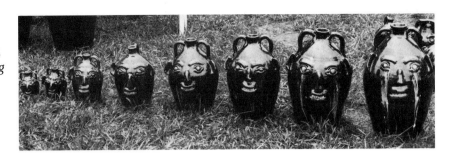

and apply at least thirteen pieces of clay to create the typical face: ears (2), eyebrows (2), eyes (6), nose (1), lips (2). Optional features such as a moustache (2), tongue (1), beard (1), or horns (2) raise the total to nineteen (plus one more for the wart on the nose of Javan Brown's devil jug). Finally he must insert the teeth, which are jagged pieces of commercial whitewares in the illustrations above (older vessels from other areas employed white-burning clays or fragments of rock). Burl Craig readily allows that he has no love for this lengthy decorating process; he much prefers turning the jug itself. But he also knows that he must answer to current tastes, and he recognizes the modern efficiency of a face vessel. It takes up no more room in the kiln than a plain jug but commands a far higher price. As Burl admits, making face vessels "is getting old, but what I like is the money I get out of it."[60]

In the past, however, there was very little money in the face jug. "There wasn't no sale for it, that was the trouble. There wasn't no sale. You maybe take a face jug and let it set around a long time before somebody come around and wanted to buy it. What everybody was trying to do then is to get a buck as quick as they could. . . . They made something they was sure they could sell right off."[61] The extra flourishes described above more than double the time needed to finish the pot, but they add nothing to its ultimate function of storing vinegar, molasses, or some "medicinal" beverage. And few people were willing to pay more than the standard rate of ten cents per gallon just to have ears, eyes, and teeth on their water jug.

This same rational, down-to-earth attitude applies to all of the forms grouped under Horticultural Wares and Whimseys, and it was certainly shared by the potters themselves, who frequently voiced their disdain for all toys, miniatures, and other such frivolities. Burl Craig reinforces this no-nonsense attitude with the following anecdote about the day the journey-man potter Will Bass quit working for the Reinhardts. "When they made the flowerpots, they had a comb. And they wanted him to put a comb design, jiggle it up and down on the rim of the flowerpot. . . . It wasn't very hard—he could do it all right. But old man Will said it took up extra time, and it wasn't worth a damn, and he wasn't going to do it. And he didn't! He *quit*!"[62]

13

THE DECLINE AND RENEWAL OF THE FOLK TRADITION

From the middle of the eighteenth century to the opening of the twentieth, folk pottery in North Carolina changed little, evolving very slowly over decades and generations in response to the needs of a rural, self-sufficient people. The major alteration during this period was the shift from earthenware to stoneware, which took place largely during the second quarter of the nineteenth century. As significant as it was, this acceptance of new clays, glazes, and associated technologies was gradual and natural, and it had little effect on the potter's role as a craftsman essential to his community.

Beginning about 1900, however, a new set of social and economic forces combined to transform and threaten this long-established traditional industry. As demand for their products fell off, the old shops closed their doors, and the groundhog kilns crumbled into useless piles of brick and rock. Many of the potters headed for new careers in "public work," a common term for jobs outside the family farm and local community. But a surprising number remained at their wheels, and with perseverance, ingenuity, and attentiveness to changing tastes, they managed to survive by creating a whole new range of elaborately formed, brightly colored art, tourist, and domestic wares. Their story is an important one, because it illustrates the renewal of a folk tradition, and it explains why so many of the early families continue today to prosper as potters.[1]

To measure the varied transformations that have taken place since the early years of this century, it is useful to review the essential qualities of folk pottery. What are the inherent meanings of the adjective "folk," as developed in the preceding chapters? In the first place, the term denotes conservatism. As John Burrison characterizes the north Georgia heritage, "what makes this ware *folk* pottery is that the production techniques, forms, and glazes were handed down from one generation of potters to the next, maintaining a continuity of tradition relatively unresponsive to change. Although there was some leeway for individual variation and development, replication, or conservative fidelity to the inherited tradition, governed the folk potter rather than innovation or the desire to create a unique product."[2] Such conservatism is not inherent in modern approaches to technology or art, but it was central to the work of the folk potter. His world was governed by inherited ideas—not restrictive forces, as some might assume, but a positive, reinforcing set of attitudes and practices that served to guide each new genera-

tion. Young men followed their fathers' methods of locating clay, turning on the wheel, concocting glazes, burning the kiln, and selling the ware because they were right and they worked.

Closely related to this pervasive stability was the intensely regional flavor of the pottery. In part this resulted from the use of local materials—most particularly the clays, glazing ingredients, and fuels—which were available for the taking in the nearby river bottoms, fields, and forests. The early earthenwares are not so easy to differentiate, but even a novice can quickly distinguish the salt from the alkaline glazes, while a more seasoned observer can detect far more subtle clues to the local origins of a piece, such as the particular shade of the clay body on the bottom of the pot.

Beyond such direct environmental distinctions are the more intangible preferences that developed because the various pottery-making communities remained largely separate and self-contained. As John Burrison explains, "the pottery designs, . . . determined largely by function, were slowly refined as they were transmitted through the generations, becoming the shared property of families, communities, even regions of potters."[3] Take, for example, that most fundamental of all forms, the jar. Although used in a similar manner all across the state to store foods and other materials, it varied considerably in shape and design depending on the region in which it was produced. In the eastern Piedmont, the Cravens and Foxes turned distinctive medicine jars, and butter jars with flat lids. These are never found in the Catawba Valley, a mere hundred miles to the west, but there the Seagles and others produced massive, bulbous storage jars—forms that are not seen to the east. And in the Mountains, the Stones and Penlands affixed handles to their preserve jars, a practice that Edward Stone brought with him from South Carolina.

Clearly there are many reasons for these divergent developments: the raw materials available, the training and habits of the potters, the needs and tastes of their customers. In fact such variations often appear arbitrary, but that is precisely the point. Over time the separate "families, communities, even regions of potters" developed their own ways and means, and thus the sense of place is deeply embedded in every pot. Perhaps the potters sensed how redundant it would be to mark every piece; their "signatures" were there even without their names.

The third characteristic of folk pottery is its oft-mentioned utility. Because most of the pots had to perform some useful function, such as producing butter or storing beans, there was little reason to alter an obviously efficient form or glaze. There was also little point in adding superfluous decoration, in creating "art," when the churn or jar already did what it had to. Only infrequently did the potter incise a design or model a face on his jug, and when he did so it was usually for some special occasion or person. In this eminently practical world, such flourishes represented wasted motions, a squandering of time and labor, the potter's most valuable assets. Art, as

Kenneth Ames has interpreted the term, connotes a "canon of aesthetic values, . . . an ineradicable association . . . with wealth, power, and status," and a "celebration of innovation," all concepts that are foreign to the world of the folk potter.[4] If he created art—and he rarely did so in any self-conscious sense—it was an adjunct to the practical need for the pot.

Folk pottery, then, is conservative, regional, and utilitarian; these are the innate qualities that underlay the craft in North Carolina for at least a century and a half. But starting about 1900, the potters began to find it increasingly difficult to sell their wares. By World War I, the folk tradition was virtually at an end in the eastern Piedmont; however it continued with surprising vigor in the more isolated Catawba Valley and the Mountains until World War II. The reasons for this rather precipitous decline are varied. Some have been suggested in the preceding chapters on specific forms, but the most succinct explanation came from the late Enoch Reinhardt. When asked what crippled his business, he responded: "Prosperity, I guess."[5]

Prosperity is indeed an excellent term to cover the economic and social changes that the Reinhardt family and others experienced. Enoch's daughter, Irene, worked in the pottery as a young girl during the 1930s and thus can elaborate on her father's observation. "The younger generation did not stay in Henry. Soon as they got through high school, away they'd go to the nearest town and get a job. And maybe they kept a cow for the family, but as far as selling cream or milk as my grandmother did—she kept a drove of cows, and she would sell cream; she did that for years, you know, to make money. And she needed a lot of churns and jars and things. When people didn't use so many more, well, naturally they just didn't sell." The decline of the small, independent farm and the allure of steady wages in towns and cities dispersed the rural family and lowered demand for the old wares. Irene herself went to work in Hickory and, later, Charlotte, and her brother John soon followed. As a result, her father "couldn't do all that by himself as well; . . . you see, he was short-handed."[6]

What happened in North Carolina is neither a unique nor an isolated phenomenon. Similar events had occurred in the northeastern United States during the nineteenth century and also in many foreign lands—as, for example, in north Germany at the end of the nineteenth century. "Changes in the household, the availability of cheap industrial wares in enamel, stoneware and porcelain, and the taking over of milk processing by creameries had all robbed the potter of his means of existence. The few pottery workshops which survived adapted their wares to meet changing production and marketing conditions of artistic ceramics. Traditional earthenware survived in only a few southern regions of Germany, where it is now flourishing once more due to the tourist trade."[7] Add to this account the effects of the various Prohibition laws, the increasing popularity of the glass fruit jar, and the growth of large food marketing chains, and it serves as an accurate summary of developments in North Carolina. At the same time, the references to

Figure 13-1
A sample page from the catalog issued by J. B. Cole's Pottery, ca. 1932. Courtesy of Walter and Dorothy Auman.

"artistic ceramics" and the "tourist trade" point to the new directions in which the folk craft was heading.

During the first two decades of this century, the North Carolina potters were on the defensive; they could do little more than watch their businesses rapidly deteriorate. However during the 1920s and 1930s, most particularly in the eastern Piedmont, they became active innovators, and, with the assistance of a number of farsighted, sympathetic individuals from other backgrounds, they rapidly transformed and renewed their craft. In retrospect, a consistent pattern of transition is apparent, one that is probably applicable in principle to other folk crafts as well. It is convenient to examine, first, the more tangible signs of change as embodied in the new products, technologies, and marketing strategies. But no less important are the catalytic agents behind these developments—specifically, the outsiders who brought in new ideas and the younger potters who actualized them.

Unquestionably the most visible evidence of the new order was a radically altered product line, a veritable explosion of fresh forms and glazes. The folk potter's repertory of forms was rather limited. Most were directly associated with the preservation and preparation of foods; the remaining categories—food consumption, implements, horticultural wares, whimseys —constituted a relatively small percentage of his output. Moreover most of his energies went into jars, jugs, milk crocks, and churns, with pitchers, dishes, and flowerpots an important secondary line. Although he concentrated on a small number of types, the folk potter still had options for variation in the size and shape of his pieces. Jars, for example, could run from one pint to fifteen gallons, and they might emerge from the wheel as tall and cylindrical or squat and bulbous.

To counteract the decline in demand for their utilitarian wares, the remaining North Carolina potters both expanded the range and shifted the functions of their forms. About 1932 J. B. Cole of Montgomery County published a catalog in which he offered no less than 524 different forms, ranging from tiny pitchers and candlesticks to massive urns several feet in height. A typical page from the Cole catalog, shown in figure 13-1, only hints at the variety now available.[8] Many of the pieces listed are still associated with food, but the emphasis is on consumption rather than preservation. This clear shift in function reveals that the pottery was now designed to be seen and not merely used.

These new forms posed two problems for the older turners. First, the pieces illustrated here are diminutive, ranging from only 1¾″ to 4¾″ in height. Burl Craig explains that "some of them old potters, they couldn't turn it. They made big stuff all their lives, and it'd be hard to get down to turn a good, nice vase." Although as boys the potters often began by turning "toys," once they mastered the craft they produced only the large utilitarian pieces. And thus, as Burl continues, it proved extremely difficult to return to such miniatures. "Do you believe that I was a-turning maybe five, six years before

I was able to turn a pint jug? That's the truth. Well, you see, when I was a-working for other people, I turned what they wanted. They'd bring in a bill, say, 'Here, turn me twenty fives or twenty fours, twenty threes, and so many milk crocks, you know, to go in a kilnful. Well, I turned it; I didn't try—that was all they made. And then, I never will forget the first time I really, I tried to make a few little jugs, and I made a few. But they wasn't decent looking." Just a young man in his early twenties, Burl responded to the challenge. "I sort of got mad at myself then. And I thinks, 'Well, a man's a turner; he might be able to turn about anything he wants to.' About every day after that I would try a pint jug. Start off with the pints before I tried anything smaller. And it wasn't long until I was turning them, . . . a pretty decent jug."[9]

Most veterans, however, were not so flexible. Ben Owen recalls how his father, Rufus, refused to adapt to the changing tastes. "He'd always been used to making churns and jugs and crocks and pitchers, different things like that. And he never did get up on that [fancy ware], trying that. He tried some one time—he was the first one that tried it for Mr. Busbee, years ago when he first come in this part of the country, up here a few miles back up. Anyway, he said he wasn't used to those little things. He wanted to make bigger things."[10] In part such recalcitrance was a matter of skill, but it was also attitude. For Rufus, normal pots measured from 12″ (one gallon) up to 18″ (five gallons), and that was the proper work of a real potter.

Size was not the only impediment for the traditional turner. Because the new wares were intended for display in the home rather than storage in the springhouse or smokehouse, they had to be more carefully finished than their predecessors. "When you get into that art line," notes Burl Craig, "you're more particular with it than you are with the stoneware. You could sell an old stoneware jar if it's a cull or cracked or something, but when you get into that [art] stuff, why, people want it to be pretty well perfect."[11] When he went to work for the Jugtown Pottery, Ben Owen gradually learned to turn small and delicate forms such as Chinese rice and tea bowls. And so the owner, Jacques Busbee, taught him "to cut these little bases on them. Yeah, I had a little [trimming] tool I done that with. Then I had a lot of other bowls that I cut bases on."[12] Because such pieces were intended to be admired as well as used, Ben had to learn to handle new tools to ensure smooth, even, unblemished surfaces or neatly formed bottoms. For the older generation like his father Rufus, several quick passes with the chip were all that was necessary to ensure a serviceable jug or jar. The folk potter was concerned with the overt function of the pot, not the appearance. Thus he was far less meticulous in trimming or finishing, and frequently he had little patience for "that art line."

Together with the domestic forms and tablewares came a greatly expanded class of art pottery, including bowls, jars, vases, urns, baskets, and Rebekah pitchers. Unlike the limited horticultural productions of earlier generations, these were turned in elaborate shapes, with sinuous curves,

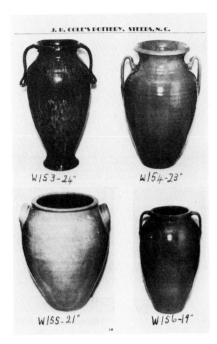

J. B. COLE'S POTTERY, STEEDS, N. C.

W153-24" W154-23"

W155-21" W156-19"

Figure 13-2
From jar to urn: the larger forms in
J. B. Cole's catalog, ca. 1932. Cour-
tesy of Walter and Dorothy Auman.

decorative (if not practical) handles, and bright colors. The designs were readily borrowed from other cultures and traditions. The potters in the eastern Piedmont were discovered by tourists from Pinehurst, a resort area in lower Moore County. Waymon Cole explains that " 'these northern people came down after Christmas and spent the winter in Pinehurst. They would come and draw for us what they wanted. Then we could change the shape a little, make it more ours. People didn't want the old jugs for syrup. When they'd go back north, we'd have enough orders for the summer.' " Bryan "Duck" Teague concurs and specifies some of the new forms that were made at the Teague Pottery. " 'Now we used to copy two jars. One was a Greek amphora and the other was the Portland vase, discovered by the Duke of York way back. And several Asian shapes—some of those biblical pictures, you know, like Rebecca's pitcher. Then there's those big oil jars from Egypt.' "[13]

As Waymon Cole suggests, the potters were not slavish copyists, and in some cases the old local wares served as starting points for new, more decorative forms. Figure 13-2 depicts four large urns from J. B. Cole's pottery; the one at the lower left is a perfect copy of the old storage jar, even to the ear handles and the flat rim for tying down a cloth cover. The remaining three, examined counterclockwise, show a steady progression toward more ornate treatment of the form, handles, rim, and foot; they aptly illustrate the new direction in which the North Carolina potter was heading. A page from the catalog of the Royal Crown Pottery and Porcelain Company (fig. 13-3) located at Merry Oaks, Chatham County, shows still more drastic revisions, perhaps reflecting a very late and generalized influence of the American art pottery movement.

A third source of inspiration was the Native American. In Catawba County, the Hiltons produced a line of "Catawba Indian Pottery," which is shown in figure 13-4. Neither the forms nor the technology employed had anything to do with the Catawba Indians, but the rough, unglazed, buff to orange clay body must have been sufficient to make the buyers *think* they were acquiring a piece of Native Americana. Fittingly the interiors were glazed with a smooth, clear alkaline (glass) glaze, thus firmly linking these new tourist items to the old ways of the Catawba Valley.

Unquestionably the most creative and harmonious integration of exotic forms occurred at the Jugtown Pottery in northern Moore County, where Jacques and Juliana Busbee introduced potters Charlie Teague and Ben Owen to oriental ceramics. Initially Jugtown had relied on the old regional earthenware and stoneware forms. However, as Jacques Busbee explains:

We operated on our earnings and the market soon demanded more variety of form and color than pickle jars in salt glaze or slip, however various the sizes might be. Something more had to be done. And this brings us to the point of Jugtown translations.

After a careful survey of the ceramic field, the primitive and early

periods of Chinese pottery stand out as the classic periods of the world's pottery. And I think the reason will be clear to all who consider the facts. The early Chinese potter had discovered only a very few glazes so that his whole interest lay in form—form that was the perfect expression of the technique that produced it. Centrifugal force was made concrete. Later, as one after another color was added to the potter's knowledge, he lost his prime importance and was made to serve the decorator.[14]

In retrospect Jacques Busbee's decision appears eminently correct. Recognizing the economic necessity of diversification, he focused on the wares of the Han, Tang, and Sung Dynasties, which are best noted for their powerful forms, monochromatic glazes, and lack of elaborate surface decoration. These very general qualities also applied to the existing folk tradition in North Carolina, and thus young men like Ben Owen were able to comprehend the oriental models that Busbee presented to them.

Closely coupled to the innovations in form was a dramatic expansion of the range of glazes. The folk potter, of course, had a very limited palette, one that was severely restricted by the local materials available to him. In the eastern Piedmont, he relied on the salt and lead glazes, and to the west, the alkaline; only rarely did he employ a slip or Bristol glaze. Thus his primary colors were gray, orange, green, and brown, though the tone and texture could vary greatly (and unpredictably), depending on the clay body, glaze ingredients, and kiln conditions.

By the mid-1920s, however, the potters of the eastern Piedmont had begun to experiment extensively with commercial oxides of iron, cobalt, tin, copper, manganese, and other metals. The result was a veritable rainbow of colors. In his catalog, J. B. Cole declared that "any article shown herein may be supplied in any of the following colors: yellow, white, rose, dark blue, Alice blue, periwinkle blue, turquoise, blue-green, enamel green, peacock blue, blue and white, orange, rust and antique." Not to be outdone, the North State Pottery Company at Sanford advertised "Copper red, Chinese red, moss green, tampa green, brown, yellow, turquoise blue, dark blue, black, bronze black, and white." And still other subtle hues such as "Spanish Moss" and "Colonial Cream" were promised by the Royal Crown Pottery and Porcelain Company. One can easily imagine one of the oldtime potters contemplating this dazzling array of possibilities and puzzling over whether to glaze his kraut jars Alice blue or tampa green. And, if this multitude of choices were not enough, at some shops the wares were dipped into several brightly colored glazes. Ceramic historian Stuart C. Schwartz explains that "the combination of several glazes on one piece, tastefully applied in layer or bands, is an 'identifier' of North State Pottery. In particular the double-dipping of a single glaze color to produce two or even three (triple-dipped) bands of color was never copied with any success by other potteries. . . . Experimental pieces can exhibit anything imaginable."[15]

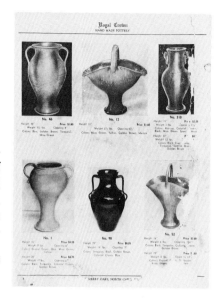

Figure 13-3
The new art forms as depicted in the catalog of the Royal Crown Pottery and Porcelain Company, ca. 1940. Courtesy of the North Carolina Division of Archives and History, Raleigh, N.C.

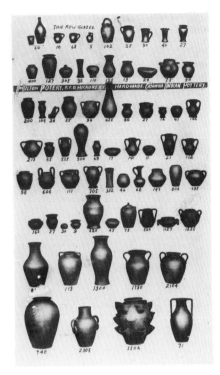

Figure 13-4
"Indian" pottery as envisioned and advertised by the Hilton family, ca. 1920. Courtesy of the North Carolina Division of Archives and History, Raleigh, N.C.

With such double- and triple-dipping and often wild experimentation with new colorants, it is hardly surprising that the resulting glazes were often improperly fired or extremely bright and gaudy. Under Jacques Busbee's guidance, however, the Jugtown Pottery pursued a more restrained course, adhering to oriental principles by employing, for the most part, monochromatic glazes.[16] As he himself claimed, Busbee had no intention of sacrificing essential form in order "to serve the decorator." Thus he directed his potters to use just six primary glazes (S = stoneware; E = earthenware):

Traditional	New
Lead (E)	Mirror Black (E)
Salt (S)	White (E/S)
Frogskin (S)	Chinese Blue (S)

The familiar lead and salt glazes were used on the tablewares; Busbee's only innovations in this area were to popularize the "tobacco spit" glaze (a traditional combination of lead and manganese granules) and to decorate some of the salt-glazed stoneware with cobalt oxide (which was rarely used by the North Carolina folk potters). The "frogskin" and mirror black glazes were applied to both utilitarian and artistic forms, while the white and Chinese blue were reserved for the oriental translations.[17] The Chinese blue is a thick, lustrous turquoise with random patches of oxblood where the copper oxide has been reduced. When successfully fired to achieve proper texture and colors, this glaze represents the highest artistic achievement by any of the modern, transitional potteries.

In part, Busbee's success in exercising restraint in the use of his glazes during several decades of experiment—and often, excess—is due to the fact that he continued to use a stoneware clay body. During the 1920s and 1930s, most of the other potteries gradually shifted to earthenware clays. The lower maturation temperature required less fuel and, most important, allowed a far greater range of coloring oxides, which were readily combined with the lead flux. Most of the potteries today continue to employ an earthenware clay body, burning it to a temperature of about 2,000°F. At Jugtown, however, the potters persisted in their emulation of the ancient Chinese. The high-fired wares were more challenging and offered fewer options for surface decoration, but the potential rewards were far greater.[18]

Most of the experimentation occurred in the eastern Piedmont. In the more secluded Catawba Valley, the old ways persisted, and what few innovations the potters attempted were entirely within the context of the alkaline glaze. Certainly the most widespread type of fancy pottery was the "swirl ware" or "striped ware," a local variant of agate or scroddle ware (fig. 13-5). The blending of contrasting clay bodies is an old technique. It was used in the late seventeenth century by John Dwight of Fulham (London), one of England's first stoneware potters, as well as in eighteenth-century Staffordshire and a number of later American potteries.[19] Some swirl ware was also

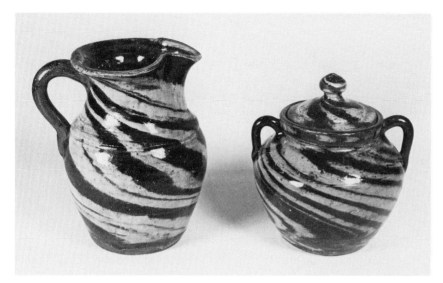

Figure 13-5
Alkaline-glazed stoneware swirl creamer and sugar, ca. 1935, Enoch W. Reinhardt, Henry, Lincoln County. H 6⅞", 6", C 15¾", 16⅝". Collection of James and Irene Gates.

produced in the eastern Piedmont—the North State Pottery made some imitations of a piece obtained from the Niloak Pottery in Benton, Arkansas—but these are very rare.[20]

According to general oral tradition, the first swirl was made in Lincoln County during the early 1930s, probably by Sam Propst. Perhaps he also saw a piece from one of the art potteries, but his daughter recollects that he simply invented (or reinvented) this combination. "My Daddy decided—he'd found some white clay somewhere. And he decided, well, he would see what it would do. So he made a piece [of swirl] or two, and it really sold good. So then he just started making it."[21] Others who also took to it include Sam's son Floyd Propst, Will Bass, Enoch Reinhardt, members of the Hilton family, and Burl Craig, who sells large quantities of it today.

Producing a piece of swirl involves considerable extra labor. In fact, Burl Craig estimates that "you could make probably three or four pieces the same size while you was making one swirl." To begin with, "if you was going to make a gallon, say, a gallon piece, you used six pounds. You took three pounds of dark, three pounds of light. Well, you had to work that clay separate. That took twice as long to work it. Then you had to put it in a little square block, the way they did. And then they sliced it and laid the layer one way or the other. Then they just took that and rolled it up just enough to get it on the lathe, enough of a ball. You didn't work it—you couldn't work it or it'd blend together."[22] Next the potter must pull the walls in an expeditious manner. Enoch Reinhardt, who probably made more swirl than anyone, warns that "the more you turn that and the more you keep your hands in it, the more blurred it's going to be. . . . That's the secret—when you get it

finished, quit. The more you mess with it, the more blurred you get it."[23] When finished, the potter used his chip on the surface to clean and accentuate the stripes.

Both clay bodies had to have the same rate of shrinkage or else they tended to crack and separate after the firing, particularly on the bottoms. Enoch, however, devised a simple solution. "Well, I taken some of just the one kind of clay, mostly the dark clay, and put it on the headblock and spread it, and then put my ball on it, you see. And plumb [center] your ball good then and then take your bottom-maker . . . and make your bottom. Well, you got your bottom's in all of that one clay."[24]

One other area of concern was the alkaline glaze, which had to be as clear as possible. Obviously the very murky cinder glaze was out of the question, so Enoch concocted a glass glaze containing window panes and even kaolin if it was available, to ensure relatively few impurities. "We'd fix that glaze and it would be kind of special, you know. We'd grind that, maybe run it through the mill two or three times, to get it just as fine and mixed as thoroughly as we could. We'd have a separate tub to put that in."[25] Apart from the basic concept of combining light and dark clays, the swirl ware of the Catawba Valley was thoroughly traditional in materials and techniques. It simply required more time and precaution than the regular stoneware. Burl Craig speculates that "I don't think any of them really liked to make it. But it would sell, and that was the main thing. I don't think actually for the time they put in on it that they made any more money off it than they did the regular pottery. But it was something that would sell and was different."[26]

Ranging from thimble size up to two gallons, the swirl ware was used for miniatures, tablewares, and art forms like vases, baskets, or pinch bottles. But it was also turned in traditional shapes such as pitchers, churns, and beanpots. It was fancy ware, made to be seen, but it was also used. "Some of them cooked in it. Set it on them old wood stoves and cooked beans and potatoes in it." Because of the extra labor involved, the swirl ware sold for around forty to fifty cents per gallon, or four to five times the standard rate. Thus while the local people admired it, "a lot of them wouldn't pay the difference in the price. They wanted a beanpot or a pitcher, why, they'd take the other [ware]. . . . It was the necessity of it. If they would have had the money, they would have bought it, I think, a lot of the swirl. But if you didn't go through them times," Burl concludes, "you just can't imagine what it was like."[27] And so the bulk of the swirl went to tourists and others who purchased it primarily for its decorative qualities. While the patterns formed were never so fine or delicate as those of Staffordshire or some nineteenth-century American potteries, they still possess a sturdy beauty and embody the folk potter's innovative response to a changing market.[28]

Beyond the swirl, there was little attempt in the Catawba Valley to produce novel effects. A few families such as the Propsts and Reinhardts made limited experiments with commercial ingredients, but the process was trial

and error, as there were no outsiders like the Busbees to direct them. A small notebook discovered in the papers of the late Enoch Reinhardt contains five rather basic glaze recipes using, primarily, combinations of red lead, Albany slip, feldspar, flint, and whiting. For example, the first entry reads:

> for stone ware
> Soft glaze:
> 22 lb red lead
> 22 lb albany slip
> 4 lb manganease
> 1 lb borax

Because of its lower maturation temperature, such a "soft glaze" would have been of practical use in the cooler areas of the kiln, where the alkaline glaze would not mature. But this glaze, like the other four listed, had no decorative possibilities. Only the recipe for a "white glaze" (Bristol glaze) has Enoch's added notation, "can add colors."[29]

One amusing anecdote concerning the folk potter's search for new colors is related by Burl Craig, who, during the 1930s, set out on his own to discover the secret ingredient for a blue glaze. His initial solution to the problem was a Pepsi Cola sign—"they had a lot of blue in them, them signs, them old Pepsi Cola signs. Had a lot of blue in them. I knew it would have to be something." And so Burl scaled the blue paint off a sign, "beat it up and put it in some glaze." The results were not entirely satisfactory, but "there was a little trace of blue in it. . . . Then I got to trying to find out what was in that sign, what they used. Come up with cobalt." Actually two elderly ladies in Burl's area who had "fooled with pottery some" came to his assistance by supplying him with some glazing formulas that indicated cobalt oxide as the source of the blue color.[30]

Burl's experiments with local materials vividly illustrate the plight of the folk potter who desires to experiment. Many admired the new art ware, but "a lot of them didn't fool with it because they didn't have a suitable glaze. You know, if you come down to it, . . . a regular glass glaze is a poor glaze for art ware, you know that. You got to have something to dress it up a little or change the color."[31] Because he frequently lived in a somewhat isolated, rural area and relied on traditional ideas and techniques, the folk potter rarely had access to new materials or the knowledge of modern practices. Often it was luck or the intervention of some outsider that provided the impetus for significant change.

The one innovative clan in this inherently conservative region was the Hiltons, particularly Ernest Auburn and his wife, Clara Maude. Auby learned to turn traditional stoneware by working for his father, John Wesley, and then as a journeyman at many different potteries; finally, about 1918, he formed a partnership with his brothers, Claude and Shufford, and established the

Figure 13-6
*Ernest A. ("Auby") Hilton taking a
smoking break in front of the Hilton
Pottery Company, Propst Cross-
roads, Catawba County. Courtesy of
the North Carolina Division of Ar-
chives and History, Raleigh, N.C.*

Hilton Pottery Company at Propst Crossroads, Catawba County.[32] Figure 13-6
shows the weary potter taking a smoking break in front of his business; the
small tourist wares on the display rack behind him reveal the new direction
in which he was heading.

Shortly after he established his company, Auby received a visit from a
"Mrs. M. G. Canfield of Woodstock, Vt., who collected old pottery as a
hobby" and was hoping to locate some early slip-decorated earthenware
made by Jacob Weaver. "In the course of conversation with Mrs. Canfield the
North Carolina potter mentioned his own experimenting with color. For four
years he had been trying and trying to get just the right mixture but had
never found one that satisfied him. The Vermont woman knew a chemist
who might help him. Her advice proved to be valuable."[33] The precise bene-
fits that accrued from this fortuitous friendship are not known, but it would
appear that Mrs. Canfield provided the Hiltons with an access to commer-
cial glazes and, if not the actual materials, at least some knowledge on how
to obtain and use them. And the Hiltons took care to guard their newfound
secrets. Even as late as the 1930s, Burl Craig recalls that Auby's nephew,
Floyd, would tear the labels off the containers of oxides so the other pot-
ters would not know what he was using or where he was purchasing his
supplies.[34]

Mrs. Canfield's contribution was quite limited when compared to the per-
vasive influence exerted by others such as the Busbees, but it was important
to Auby and Maude. Particularly at their later locations at Oyama (1927),
near Hickory, and Pleasant Gardens (1935), in McDowell County, they
achieved a substantial reputation as art potters. Among their most charac-
teristic creations were wares colored or fringed in a deep cobalt blue, or
ornamented with hand-molded dogwood flowers in white, green, and black
(fig. 13-7). Maude appears to have taken a prominent role in this work and,
together with several of her children, painted the wares with idyllic rural
scenes depicting homes, fields, forests, and rivers (fig. 13-8).

Back in Catawba County, both Shufford and Floyd continued this orna-
mental impulse. Burl Craig recalls seeing Floyd make a tree trunk with
branches, on which perched brightly colored birds modeled by his wife,
Annie Mae. "Floyd would turn a little, like a little tree, and put limbs on it,
well, like a hollow tree, up so high. She'd put birds on the limbs, the
beautifulest blue birds when they come out of the kiln." None have survived,
which makes Burl agonize over his lack of foresight in not keeping one. "I
would give anything if I could get one. . . . I could have been worth a for-
tune!"[35] Floyd's father, Shufford, specialized in the large utilitarian forms but
he also made a substantial quantity of swirl and cobalt blue tableware. In
all, a considerable body of decorated Hilton ware is extant today. But other
than a few molded pieces, these were turned on treadle wheels, coated with
the alkaline glaze, and burned in wood-fired kilns. For all their willingness

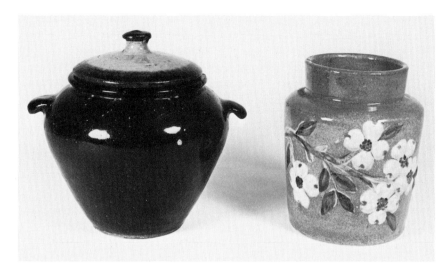

Figure 13-7
Alkaline-glazed stoneware cookie jar and vase, ca. 1930, Ernest Auburn Hilton, Catawba County. Jar: H 7⅜", C 22⅜". Vase: H 6½", C 17¼". Stamped: "HILTON." Collection of Ernestine Sigmon Hilton.

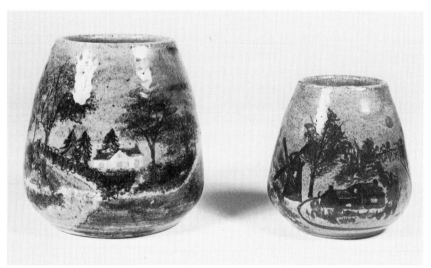

Figure 13-8
Alkaline-glazed stoneware vases, ca. 1930, Ernest Auburn Hilton, Catawba County. H 3⅞", 3¼". Rural scenes painted by Clara Maud Hilton, the potter's wife. Collection of Ernestine Sigmon Hilton.

to experiment, even the Hiltons never strayed far from their traditional heritage.

As the potters expanded their repertory of forms and glazes, they also began updating the folk technology that had served their ancestors so well for almost two centuries. As inexpensive as they were, the treadle wheel, the mule-powered mill, and the groundhog kiln were often slow and inefficient and required extensive muscle to operate. Thus it is hardly surprising that the potters consciously sought out or constructed new devices to alleviate

Figure 13-9
Electricity replaces foot power: A. R.
Cole's wheel, Sanford, Lee County.

the physical labor and increase output and quality. One of the first casualties was the treadle wheel; many were pleased to discover a new means of avoiding the continuous legwork.

Charlie Craven, for one, encountered his first electric wheel at the Royal Crown Pottery and Porcelain Company about 1940. "That was really nice," he reflects; "I thought that about took all the work out of it!"[36] But few potters simply went out and bought a commercial wheel; many purchased a power source and then combined it with their old unit. Burl Craig recollects that during the 1930s "Poley Hartsoe had the first one that I saw. Pulled it with a little gasoline, horse-and-a-half gasoline engine. . . . Set it outside and run the pulley or shaft to his lathe."[37] Others, such as A. R. Cole of Sanford, ordered an electric motor and wheel from Ohio in the late 1930s and then built it into his traditional wooden crib, complete with the ubiquitous ball-opener and stick gauge (fig. 13-9). Such hybrid assemblies are still in use today, though most now turn on the small electric wheels favored by studio potters.

Other shops went further and replaced the wheel with industrial devices that could stamp or mold part of their output. As early as January 1918, the resourceful Auby Hilton had acquired a "flour pot machine" for the Hilton Pottery Company. His time book indicates that his one-third interest was worth $93.43 and lists the various shafts, belts, pulleys, piping, and cement required to install it.[38] About 1925 the Kennedy Pottery of Wilkesboro, where Auby had earlier worked as a journeyman, purchased their first machine. "Flower pot production was started around 1920 and gradually increased until 1925, when 50,000 to 60,000 flower pots were being produced. Other items were dropped and flower pots became the exclusive product, reaching 500,000 a year a few years ago. In 1946 the plant produced 600,000 flower pots."[39] Two other shops that molded large quantities of flowerpots were the Matthews Pottery at Matthews, Mecklenburg County, and the O. Henry Pottery at Valdese, Burke County. As late as 1977, the former plant was still producing thirty thousand flowerpots per week, partly on machinery obtained from the Kennedys.[40]

Finally, during the late 1930s, Davis Brown of Arden, Buncombe County, "remodeled his machinery and introduced to his pottery the new manufacturing techniques of jiggering and slip-casting." These processes require little skill and permit the rapid production of identical forms. A few years later the Browns applied these methods to a line of French-style casseroles called "Valorware," and by 1942, Davis "had as many as twenty-six persons working for him making Valorware at the shop."[41] Today the Browns still produce large quantities of molded cooking wares, but Davis's sons, Charles and Robert, are also skilled turners, just like the previous six generations of the family.

The wheel is perhaps the strongest symbol of the potter's craft, but it was not the only tool to be modified or updated. In fact the changes in the

methods of processing the clays and glazes appear to have been much more extensive. Always accustomed to building their own equipment, the traditional potters were skilled mechanics; Evan J. Brown, Jr., of Skyland, Buncombe County, even admits that " 'I've always heard that a potter was a mechanic with his brains knocked out.' "[42] With such talents, then, they quickly discovered ingenious ways of recycling that most American of all machines, the automobile. In Burl Craig's area, "Enoch [Reinhardt] built the first clay mill pulled with power. I think he'd wrecked an old Oldsmobile car he had and he . . . put a belt on the rear tire. . . . Just like you would a tractor, you know—backed it up to the clay mill. Jack up the wheels. . . . I used an old Chevrolet to saw wood and beat glass and grind clay too."[43]

Figure 13-11 illustrates exactly the sort of arrangement described by Burl—in this case a 1948 truck used by Walter Owen at his Pine State Pottery near Sanford. Where sufficient capital was available, some were able to purchase commercial equipment. Mr. and Mrs. Henry Cooper incorporated their North State Pottery in 1926 and sold stock to raise ten thousand dollars for machinery. "Mr. Cooper installed a 'disintegrator' for breaking up the clay; a 'plunger' for mixing water with the clay; a mesh screen for removing gravel; a mixer to stir the clay before it is passed to the slip pump for filtering; and a 'squeezer' to press out excess water. For production of uniform glazes Cooper bought a machine to mix the metallic oxides and water prior to glazing. A frit kiln was also built."[44] This was a far cry from the old pug and glaze mills, but few shops possessed the resources of North State. For most the solution lay in a highly variable combination of homemade and commercial devices.

For at least a century in North Carolina, the groundhog kiln served admirably for burning utilitarian pots. Because they were thoroughly familiar with it, the potters continued to use it for their new forms and glazes, but they quickly encountered problems. Although easy to construct and operate, in important respects the groundhog kiln is not well suited for the production of artistic pottery. Essentially a crossdraft kiln with the heat source at one end, it is difficult to regulate, and the temperature distribution from firebox to chimney is very uneven. Furthermore the arch is extremely low, usually about 2½' to 3' at the center, so that stacking the pottery in an economic manner is virtually impossible. While it worked well for large pieces of stoneware, the groundhog kiln proved a poor choice for the more numerous and smaller decorative pots that required a more carefully controlled firing to attain proper texture and color.

The solution was to radically alter the shape of the old kilns, primarily by shortening and raising them. A typical series of changes occurred at the Kennedy Pottery, where the groundhog kiln was replaced by a rectangular one measuring 20' by 10' by 5' inside; this, in turn, was followed by two round kilns with interior diameters of 21' and 19'.[45] In 1939 or 1940, Davis Brown also built a large circular kiln, with some 6' of headroom inside.

Figure 13-10
A jigger wheel for high-speed production, Brown's Pottery, Arden, Buncombe County.

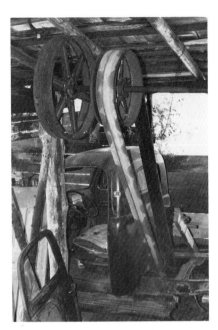

Figure 13-11
The new form of horsepower used
by Walter Owen at his Pine State
Pottery, Lee County.

Moreover, he spaced the four burners around the perimeter and employed a downdraft: the heat rises to the top of the dome, moves down evenly through the ware, and then exits through vents in the floor and out through the flue.[46]

Such innovations yielded two major benefits. First, the increased height permitted the potter to stack large quantities of pottery (fig. 13-12). And with intelligent use of the kiln furniture—shelves, stilts, saggers, and the like—he could combine varied shapes and sizes and also protect the individual pieces. The Hiltons constructed higher kilns both at Propst Crossroads and Oyama, and they stacked their artware in homemade saggers made of local clay and sawdust (fig. 13-13). This combination ensured a very porous body, one that would shrink very little and could withstand repeated firings. Floyd Hilton "would set one full, then cap one over the top; . . . and then he would set the top of that full."[47]

Second, by employing a more nearly square or, better, circular cross section, as well as a downdraft, the potter achieved a more even flow of heat and, hence, more predictable results (fig. 13-14). Journeyman Jack Kiser built a downdraft kiln at the Royal Crown Pottery and Porcelain Company and affirms that "there wouldn't be, oh, maybe one cone difference in the bottom and the top."[48] His use of the term "cone"—meaning a small, ceramic, heat-measuring device used by virtually all modern potters—attests to the growing sophistication of the North Carolina tradition. Jack also worked for Herman Cole at Smithfield, Johnston County, who constructed a huge bottle kiln, perhaps the largest ever employed in the state (fig. 13-15). However, this giant proved Herman's downfall. "It never did work for us, and it just broke us. Cost five thousand dollars to build it, then another five thousand trying to make it work."[49]

With these numerous modifications in the forms of the kilns came a variety of new fuels. At first the potters continued using wood, but as good pine became more scarce, they began to shift to commercial fuels, most of which were relatively cheap and required considerably less labor. The Kennedys progressed from wood to coal to oil; the Browns did likewise and then went to gas and electricity as well.[50] And some used combinations of fuels. At the Jugtown Pottery, the potters heat their stoneware with oil and then blast off with pine, largely to emulate the rich, flowing surface texture of the older salt-glazed wares.

In the last decade, however, the potters have had to confront the accelerating costs of power, a problem that never concerned the folk potter. Some, such as Neolia and Celia Cole of the Cole Pottery in Sanford, no longer light off the oil kiln that their father, Arthur, constructed. Instead, they are using two small commercial electric kilns, firing one every day. Their fuel bills have dropped, probably because there is no heat loss through a chimney. Moreover the new schedule ensures a steadier supply of wares for sale. But perhaps M. L. Owens, who with his son, Boyd, runs the family pottery in

Moore County, has come up with the most original solution. Some years ago he built a wood-fired groundhog kiln just like the ones he and his father, Jim, had once used.

After burning his kiln, the potter still had to find buyers for his wares. Because the folk potters tended to cluster together in relatively isolated and rural areas, little of their output was sold at the shop. Most of it was carried off by the wagoners—who were frequently neighbors or relatives—or by the potter himself to distant communities and stores. But with the decline in demand for their utilitarian products, the potters had to cultivate a new clientele and develop a totally new marketing strategy.

For many potters, the first step was to relocate, which usually involved moving from the backcountry onto a major highway. A. R. Cole (fig. 13-16) opened his first shop in southeastern Randolph County near his father Ruffin's property, where, in the old way, he both farmed and turned wares. But by the early 1930s, he recognized that there was little future for him in this remote, rural location, and so in January 1934 he moved east to Sanford and put up a shop on Route 1. The move was well calculated: years later he recalled: " 'When I came down from Seagrove 37 years ago, I drove up and down this road from Wake Forest to Southern Pines looking for a good spot. . . . I knew they'd be building up Fort Bragg and all and that a lot of traffic would have to come by here.' "[51] Route 1 was a major road used by tourists heading for Florida, and so was Highway 301 to the east, where A. R.'s first cousin, Herman, had set up his Smithfield Art Pottery some seven years earlier. Herman knew there was good clay in the vicinity, but, more important, there was "a whole lot of travelers going north and south. We made some down there and sold really good. Mrs. Cole would some days sell as much as one hundred dollars right there on the road, and this was in them Hoover Days too."[52]

Like E. A. Hilton, who left the old Jugtown region in the Catawba Valley to settle on Route 70, first near Hickory and later at Pleasant Gardens, or the Brown family, who opened shop on Route 25 just below Asheville and the Biltmore Estate, the Coles recognized that they had to reach out for a new kind of customer to keep their craft alive. For those potteries that were not so well located, like the North State some eight miles west of Sanford, a ready solution was to build roadside sales stands (fig. 13-17). Increasingly the buyers—tourists and owners of retail outlets—came right to the shop of the potter.

One rather subtle consequence of these changes was a new rhythm of work. The production of the folk wares had been based on seasonal considerations, with the major demand occurring in the spring and fall. But for the tourists, the peak periods were Sundays and summers. A. M. Church, owner of the O. Henry Pottery on Route 70 near Valdese during the late 1940s and early 1950s, recalls that "I worked there every Sunday. I'd line that place [with pottery] up and down there, and people going to the mountains in the

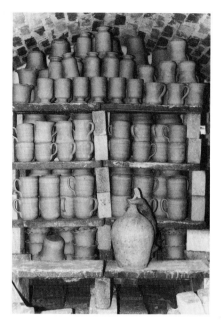

Figure 13-12
A carefully stacked rectangular, upright, downdraft oil kiln at the Owens Pottery, Moore County.

Figure 13-13
Two saggers used for the smaller art wares by the Hiltons at Propst Crossroads, Catawba County.

Figure 13-14
A round downdraft kiln operated by Herman Cole (extreme right) and his crew at the Smithfield Art Pottery, Johnston County, ca. 1930. A display of huge urns surrounds the men. Courtesy of Walter and Dorothy Auman.

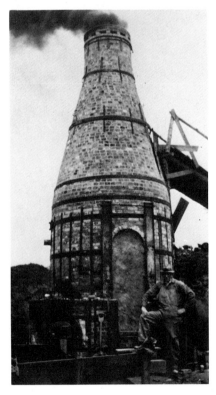

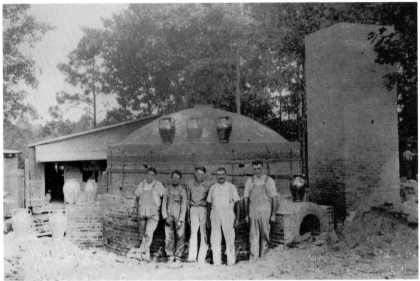

Figure 13-15
The coal-fired, updraft, bottle kiln in action at the Smithfield Art Pottery, ca. 1935. Courtesy of Walter and Dorothy Auman.

summertime, coming back by there—I'd sell lots of stuff, lots of stuff!"[53] Tourists even found their way out into the quiet fields around the hamlet of Henry, where young Floyd Propst and his family were happy to supply them with "little jugs, little pitchers, little vases, little baskets, and stuff like that." And they came in numbers. "They come from Ohio and come from Illinois and Pennsylvania and all those places. . . . They would come to the mountains there around Hendersonville and through there and stayed during the summer. You know, there are a lot of hotels and stuff; I guess they're still in there. And then they started roaming around the country. They'd heard of Jugtown and all that stuff, and they'd come down in there. And the summer-

time—they got coming pretty often all summer."[54] Not only were the hours and seasons changed, but the potters were now becoming full-time craftsmen. Particularly for those who had left their native region and family-owned lands, the old link with farming and other local occupations was irrevocably broken.

Floyd Propst's ready enumeration of distant states only begins to suggest the new sales range for the pottery. Where the folk potters had reached into the adjacent states, their successors sent their wares across the continent. To a large extent, this was accomplished through aggressive wholesaling and shipping. Victor Obler, who founded the Royal Crown Pottery and Porcelain Company in 1939, probably chose the little village of Merry Oaks in southeastern Chatham County because it was "an important stop in the Seaboard Railroad." Moreover, it was located on Route 1, so that "truck lines supplemented the railroad and provided Obler with an additional avenue to the sales rooms he supplied. His main office and show rooms were listed at 225 Fifth Avenue, New York."[55] His major product, according to Jack Kiser, was a black florist's vase, "shaped just like a ice cream cone with a base" and made "in three heights. And the florists in New York were taking every damn bit of it. Some way he sold it through the Florist's Association. . . . And there was money in it."[56]

Assuredly Royal Crown operated on a larger scale than most, but the other shops were also actively shipping pottery north to New York, south to Florida, and even west to California. For those located off the main routes, like the Jugtown Pottery, the transportation facilities were still a bit old-fashioned. "The roads was so bad," reminisces Ben Owen, that "they had to take it on a wagon to the train depot, Seagrove or Robbins—it was Hemp then. So they'd pack it in barrels. See, used to, coffee, sugar, candy, apples—all these different things—come in barrels at the stores. And you'd go around and get these barrels for ten or fifteen cents in all these country stores and towns around. And you'd pack it in those barrels. And head it up and pack it in straw and paper. And they'd take it on a wagon."[57] Little pottery was shipped out of the remote Catawba Valley, but Enoch Reinhardt did send substantial quantities of miniatures to California. Lacking the facilities of Victor Obler, he improvised—he sent them in discarded egg crates, thirty dozen at a time.[58]

The potters developed this extended sales network by resorting to a number of novel advertising techniques. In place of the old reliance on word of mouth, many of them printed modest catalogs. These followed a fairly standardized format that usually included a brief history of the pottery, pictures of the shop and workers, photographs of and detailed specifications on the pottery, and a map to guide the interstate traveler to the location. The North State Pottery even printed a separate wholesale catalog, complete with prices by the dozen at "a packing charge of 50¢ per barrel. A barrel holds from $20.00 to $35.00 worth of pottery, depending on size of pottery."[59] Some

Figure 13-16
Mr. and Mrs. Arthur Ray Cole on the porch of their home in Sanford, Lee County, ca. 1940. Courtesy of the North Carolina Division of Archives and History, Raleigh, N.C.

Figure 13-17
A roadside stand offering wares
from the North State Pottery Com-
pany, location unknown, second
quarter of the twentieth century.
Courtesy of the North Carolina Divi-
sion of Archives and History, Ra-
leigh, N.C.

added business cards as well. During the early 1920s, the Hilton Pottery Company issued an elaborate brochure featuring a photograph of four pieces of their Catawba Indian Pottery, their address, and the statement, "Makers of HAND MADE/ 'CATAWBA INDIAN POTTERY'/ Special Designs/ Made to Order."[60]

A few of the potteries also discovered more unusual means of promoting their wares. In 1925 the Coopers took some five thousand pieces from their North State Pottery to the state fair at Raleigh and sold almost every one of them (fig. 13-18). Even more impressive, in the following year they gained national attention by exhibiting at the Sesqui-Centennial International Exposition at Philadelphia. "With old logs trucked from North Carolina, Mr. Cooper and Jonie Owen erected a log cabin similar to the one which housed the first sales office. Within it the Coopers mounted a display duplicating the one at their sales cabin. The Jury of Awards honored their effort with a medal and a certificate for 'a Silver Medal conferred upon North State Pottery Company for Old Fashioned Pottery.'"[61] Old-fashioned pottery to Northerners, perhaps, but certainly not to most North Carolinians.

The Coopers' promotional efforts make it clear that the pottery shop itself had become a part of the advertising strategy. Because the pottery was "old-fashioned" in the eyes of outsiders who purchased most of it, the shop had to possess a similar aura. Hence the log cabin—or pseudo-cabin—used as a setting in Philadelphia. Similar "folky" qualities are apparent in the Busbees' dining room at the Jugtown Pottery (fig. 13-19): the log walls and joists, the bare pine floor, the slatback chairs, the coverlet-style curtains.

Figure 13-18
An attractive display by the North State Pottery Company at the State Fair in Raleigh, 1925. Courtesy of the North Carolina Division of Archives and History, Raleigh, N.C.

With the display shelves along the wall and the several fresh flower arrangements, the room possesses a self-conscious neatness and attention to detail that suggest the work of a decorator. In no way was this scene like the dwelling of one of the earlier folk potters, yet many of the customers probably saw it as exactly that. In fact, the whole concept of a display room or "sales cabin" would have been totally foreign to the old craftsman, but it became an essential part of the modern business.

The new potteries also needed a formal name, one usually incorporating the terms "Pottery" or "Company." Some of these names had romantic or historical connotations (Jugtown, North State, O. Henry, Log Cabin, Carolina); others pointed to the new types of ware being sold (Smithfield Art Pottery, Rainbow Pottery, Glen Art Pottery). Many, however, simply proclaimed the old family names like Auman, Brown, Hilton, Cole, Owen, and Teague.

Each of these labels, in their various ways, conveyed a special meaning or identity to the purchaser, and it became important to mark it on every piece of pottery. Hazeline Propst Rhodes recalls that her father, Sam, never stamped his wares, though occasionally, on special request, he might incise his name on a jug with a nail or a sharp stick. But a retailer from Hendersonville, who sold large quantities of Propst pottery to summer visitors, insisted on some sort of signature and even supplied the family with their first stamp, which said, appropriately, "NORTH CAROLINA." Then, as the tourist business increased, Sam's son, Floyd, designed a second one: "PROPST POTTERY / VALE, / NORTH CAROLINA."[62] The addition of a simple address

Figure 13-19
The rustic dining room in the home of Jacques and Juliana Busbee at the Jugtown Pottery, Moore County, ca. 1935. Courtesy of the North Carolina Division of Archives and History, Raleigh, N.C.

Figure 13-20
The modern facade of Victor Obler's Royal Crown Pottery and Porcelain Company, Merry Oaks, Chatham County, ca. 1940. Courtesy of the North Carolina Division of Archives and History, Raleigh, N.C.

was also an important feature, particularly in areas like the Catawba Valley, where the shops were by no means easy to find.

One rather humorous exception to this careful choosing of names was supplied by Victor Obler. As Jack Kiser tells it, "Now how he run into that name, . . . we'd just started, and he rode up the road somewhere. And he

saw a Royal Crown sign, drink. Says, 'There's the name, that's what we'll call it: Royal Crown Pottery and Porcelain!' "[63] Obler, of course, was a businessman from New York City, where he sold most of his output. Moreover by 1939, when he established his plant, the new art pottery was well known and widely accepted. Thus he scarcely had to worry about developing a rustic or regional image (fig. 13-20). And yet he still managed to pick a name with a special resonance for Southerners.

Directly behind all of these extensive changes in product, technology, and marketing were two groups of individuals whose attitudes and abilities were essential to the success of the new pottery. First, there was a small number of individuals—such as Jacques and Juliana Busbee, Henry and Rebecca Cooper, and Victor Obler—who, for varied personal reasons, injected new ideas about ceramics into the old folk community. In a cultural sense, those persons were outsiders, foreigners, mediators with the larger world. And not surprisingly, they were greeted with curiosity and suspicion when they began their quests. Braxton Craven recalls Jacques Busbee's arrival in Seagrove in 1917. "He wanted to go in with several people. And during wartime they was afraid he was some kind of a spy or something [laughs]. They wouldn't do it. No, my Daddy [Daniel] said he didn't need nobody going by himself. He was just a little old, one-horse concern and just kept him busy all he wanted to do."[64] Such resistance was gradually overcome, however, and the newcomers were able to supply needed capital, inspire new forms, introduce exotic glazes, and promote the sales. But they were not craftsmen. And thus they had to rely on the second group, the still-active potters, to give their visions tangible form. Only the old families knew how to prepare the clay, turn it on the wheel, and burn it into a real pot.

Even before the beginning of this century, there were a number of exciting new developments in the field of American ceramics. Perhaps most important to eventual developments in North Carolina were, first, an enthusiasm for oriental pottery, and second, a widespread acceptance of the ideals of the Arts and Crafts Movement. Without question it was the Philadelphia Centennial Exhibition in 1876 that served as the major catalyst for change. One potter who later worked in North Carolina, Oscar Louis Bachelder, journeyed to Philadelphia and "'inspected vases and other ceramics, ancient ware and beautiful specimens of ceramic art. I was so impressed with the exhibits that I decided to take a thorough course of training and learn the artistic side of clay working, modeling and molding. I came in contact with an English potter who taught me all he knew in this line, even to handmade dishes.' "[65] Bachelder's spirited reaction typifies that of many American potters at this time, but necessity forced him to continue working as a journeyman producing utilitarian wares. Not until he established his Omar Khayyam Pottery at Luther, Buncombe County, some four decades later, was he able to realize this new artistic impulse.

Above all the Centennial Exhibition whetted American tastes for things

foreign, and, most particularly, for Far Eastern ceramics. "In addition to the porcelain of Sèvres and the Royal Porcelain Works of Berlin, the public could marvel at fine Chinese porcelains. Moreover, German, Egyptian, French, Indian, Turkish, Russian, and British pottery provided a kaleidoscopic range of styles of ornamentation that foreshadowed American eclectic design of the following decades. It was the Japanese pavilion, however, that was the most impressive."[66] Within a few years, American art potters had begun to employ oriental motifs for ornamentation. Some, however, went much further. One was Hugh Cornwall Robertson, who devoted much of his life to "the rediscovery of many of the lost processes of ancient Chinese ceramics," and who "advanced beyond the ornate Victorian style to explore the aesthetic value of simple glazed forms." At his Chelsea Keramic Art Works at Chelsea, Massachusetts, "the glazes were applied to simple shapes derived from Chinese prototypes. No other ornamentation was added; the sole decorations were the brilliant glazes."[67]

Precisely the same description might be applied to Jacques Busbee's work at Jugtown. Trained in art and active as a painter, Busbee understood the growing interest in oriental aesthetics and used it to revitalize the moribund folk tradition in North Carolina. In fact it was the oriental simplicity and earthiness of the folk pottery that first drew him to Seagrove. "My attention was first focussed on the country pottery of my native state by some extraordinary similarities in certain shapes of primitive Chinese pottery in the Metropolitan Museum at New York, and this North Carolina folkcraft. And so my interest and collection began."[68] One has to wonder what might have happened had the Busbees settled in the Catawba Valley, where a true oriental glaze was yet in widespread use.

Behind specific admiration for oriental ceramics lay the general philosophy of the Arts and Crafts Movement, which had originated in England during the third quarter of the nineteenth century and spread to the United States by the 1890s. Speaking out against the dehumanizing tendencies of an ever-enlarging industrial system, adherents like John Ruskin proclaimed the dignity of "handiwork," which "gave the individual an opportunity to express his artistic and moral integrity." And in order to escape the debilitating effects of mass production and specialization, English artists looked back beyond the Industrial Revolution and "turned to the arts of the Middle Ages for both stylistic and philosophical inspiration, hoping to reforge the link between art and life."[69] America, unfortunately, lacked a medieval past, but there were yet two old and integrated ceramic traditions that could provide appropriate guidance and inspiration for contemporary American potters. For some, like the Rookwood, Weller, and Niloak Potteries, Native American wares were sufficiently "medieval" to provide a source for forms and designs.[70] Quite possibly the Hilton family sensed this interest when they introduced their line of "Catawba Indian Pottery." But in North Carolina,

there was a far more immediate and obvious alternative: the living folk tradition.

Both the Busbees and the Coopers embraced the local folk craft as the nucleus for a unified and organic art form. And both couples were quick to enunciate their ideas to any who would listen. Very typical is Rebecca Cooper's speech at the Sesqui-Centennial International Exposition at Philadelphia in 1926, which opened with the following "history":

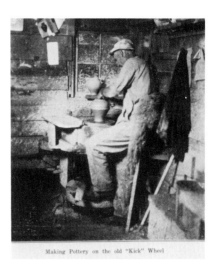

Making Pottery on the old "Kick" Wheel

Figure 13-21
Jonah Owen at work on the treadle wheel at the North State Pottery Company, Lee County. From a catalog, ca. 1930. Courtesy of Walter and Dorothy Auman.

> The exhibit of the North State Pottery Company, of Sanford, N.C., picturesquely housed in a primitive log cabin in Building No. 2, has a romantic story connected with it that is quite as interesting as the marvellous hand-made pottery itself.
>
> Over a century ago a famous English potter, Peter Craven by name, emigrated from the celebrated Staffordshire district of England, a locality notable as the heart and center of the remarkable renaissance of English pottery in the Eighteenth Century where Josiah Wedgewood and the Mintons had produced their beautiful ware. Craven settled in an out-of-the-way spot in central North Carolina and spent the remainder of his life teaching the ancient art of the potter to the natives in the neighborhood. Generation after generation ever since, these simple, primitive folk, isolated in large measure from the world about them, have continued to produce work which though intended purely for utility, was distinguished by a beauty of form and an excellence of finish that challenge comparison with the finest work of the great European potteries. Although possessed of only the most primitive of kick-wheels and the crudest of kilns—identical with those in use among the Chinese thousands of years ago—these people, nevertheless . . . were making a cultural and artistic contribution to our national life that is nothing less than amazing, when their limitations are considered.[71]

Precisely the same themes were echoed by the Busbees (see chapter 2): the direct European heritage, the "hand-made" pottery, the Chinese connection, the integrated tradition blending "utility" with "beauty." And these leitmotifs were reinforced in other ways. In one of their catalogs, the Coopers pointedly featured a photograph of Jonie Owen turning a vase on a traditional treadle wheel (fig. 13-21) and concluded their text: "No amount of money or expensive machinery . . . could produce results obtained with the super quality ware made by hand and by which process each color is applied by hand and burned in." In like manner, the Busbees insisted that Ben Owen use a treadle wheel at the Jugtown Pottery. As Ben explains, "They wanted it old-timey." However, he found it "hard on your knees, legs," and promptly purchased a variable speed wheel from Denver, Colorado, when he opened his own shop.[72] In both cases the Coopers and the Bus-

bees deliberately promoted the image of the "old-timey" craftsman working with traditional technology, even when some of the potters were beginning to hunger for a power wheel. And if the customer still missed the point, North State (as well as the Browns) incorporated the phrase "Hand Made" in their characteristic stamp on the bottoms of the wares.

By thus fusing the contemporary American admiration for oriental ceramics and the ideals of the Arts and Crafts Movement with the folk tradition, the Busbees and the Coopers stimulated a new hybrid pottery that still flourishes today and appeals to diverse customers because it is a blend of the old and the new. But it should not be assumed that all of these outsiders were precisely alike in character and influence. The Busbees are best viewed as the classicists of the new movement. Jacques, in particular, closely adhered to the forms and glazes of the folk and oriental traditions, and he always advocated both restraint and simplicity as his cardinal rules. As Ben Owen affirms: "We didn't go in for so many glazes like a lot of the potters. We had very few glazes. . . . It was more form or shape, you know."[73] He took Ben to museums in New York and Washington and provided sketches, pictures, even actual pieces of oriental pottery to imitate. Ben adds, "Well, it didn't take me long to get on to it. But it had to be just right or he wouldn't have it. . . . He wanted it to be just like the picture or the model."[74]

The Coopers, on the other hand, seem to have been much more practical and businesslike, and more open to a broad range of popular tastes. Stuart Schwartz has found that "a comprehensive exhibition of Cooper's wares would be almost impossible to attempt. The variety of forms and the number of glaze combinations available is somewhat staggering." Moreover, Henry Cooper took a large role in "the day-to-day operations. He studied the science of glaze chemistry and became an expert in the preparation of glazes. In each kiln load Cooper would place clay and glaze tests; these experiments helped him formulate clay bodies and glaze colors. When formulating new glazes, Henry Cooper worked closely with the Ceramic Engineering Department of North Carolina State College (now University) at Raleigh, North Carolina."[75]

Finally, at the opposite end of the scale from the Busbees, is Victor Obler, businessman par excellence. Obler first encountered the local pottery at A. R. Cole's in Sanford, where Jack Kiser was working as a turner. "He would come down and stop at Arthur's pottery and come in. Seemed like he was fascinated with this turning. And he'd go on to Florida, spend two or three months, and come back by. It was on Number One—they all traveled it back then. And he did that for a couple of years. Finally, he got to talking to me about building him a pottery." Whatever the causes for his initial fascination, Obler had little interest in traditional forms—folk or oriental—and he left the daily operation of the Royal Crown to Jack Kiser. Most of his energies were spent in marketing a huge volume of highly specialized wares in New

York City, where he also operated a silver company. Perhaps his major interest in the Royal Crown is best revealed on the occasion he confided to Jack, "We get this thing going good, we'll incorporate. We'll sell stock. And we'll take off the cream and give the stockholders the milk!" But his business skills are undeniable, and it took a wartime shortage of fuel and metallic oxides to shut down his highly profitable operation.[76]

The majority of the potteries in the eastern Piedmont followed the middle-of-the-road course set by the Coopers, turning out a wide variety of forms and bright glazes that appealed to popular tastes. The strict artistic emphasis at Jugtown and the highly commercial orientation of the Royal Crown represent the extremes between which most of the potters eventually worked. But the new ideas on art, technology, and commerce, as advanced by the Busbees, Coopers, and Obler, would never have been realized were it not for a group of younger craftsmen who were willing to try them. Old ways change slowly in a folk community, and it is the older members who are most responsible for perpetuating them. Thus, the generation of potters born around 1870 showed little inclination to test the new ideas that were in the air. Typical was the experience of Talman Cole (b. 1908) who went to work for the aging George Donkel (b. 1870) in the 1930s. Talman began making all sorts of tourist wares, like three-legged miniature washpots covered with an iron-saturated black alkaline glaze. Although these sold very well and brought a good price, old George stubbornly informed the customers, "'I never made none of them, and,' he says, 'I ain't a-going to,' he says. 'You talk to him over there.' And he says, 'I ain't going to fool with that stuff.'"[77]

George Donkel's remark is echoed by Rufus Owen (b. 1872), who, when queried about "turning small pieces of pottery for the New York clientele," responded, "'I didn't want to fool with them little toys.'"[78] In short, Jacques Busbee faced a real problem when he landed at Seagrove in 1917: "to get the three or four old potters in this section who had stuck to their wheels, though the price had dropped to three or four cents a gallon, to produce pottery with sufficient finish and color to make it generally saleable. After five years of effort with these hard-baked old men, we realized that just so much time had been wasted."[79] Perhaps Rufus, his brother, Jim (b. 1866), and Daniel Craven (b. 1873) were not about to change their ways, but their numerous children and grandchildren became the prime agents for implementing the new order.

Recognizing the need for more open-minded, tractable workers, Jacques Busbee wisely turned to the generation born around the turn of the century, hiring first Charles Teague (b. 1901) and then Ben Owen (b. 1904), one of Rufus's sons. Ben was only eighteen when he went to Jugtown in 1923; like the others of his generation he had been thoroughly trained within his family in all phases of the manufacture of traditional wares. In fact, he had even done a brief stint as a journeyman. "I made a couple of kilns for a

Figure 13-22
Veteran potter Ben Owen at ease
outside of his shop in Moore
County, 1971. Courtesy of Walter and
Dorothy Auman.

fellow [Dalton Garner] one time, of stoneware—jars and churns and stuff." Then came the visit from Jacques Busbee. "He came to my house and wanted to know if I'd come down and try. He wanted some young potters that he could show and tell. The older ones, he said, was harder to, you know, get it in their heads what he wanted. . . . Well, they get set in their ways when they get, I'd say, forty-five or fifty. So he wanted somebody young so he could show him what he wanted."[80] Ben stayed for thirty-six years and then, in 1959, founded his own shop, the Old Plank Road Pottery. Jugtown was reorganized, and the following year two of Jim Owen's grandsons, Vernon and Bobby, took over the operation, together with Charles Moore.

The results of the collaboration between Jacques Busbee and Ben Owen are now history, but it should not obscure similar arrangements made with other young men. Charles Craven (b. 1909), for example, was also offered a position at Jugtown. "He tried to get me one time, when I was a little fellow. He knew I could turn. And so he tried to get my Dad to let me go down there and work for him, and my Daddy wouldn't agree to it." Charlie was five years Ben's junior and was probably too young at the time, but by 1928, at the ripe

age of nineteen, he decided that "I was going to work for myself." And so he wrote to Henry Cooper, asking if he needed an extra hand. "Instead of writing me back he sent a telegram! [laughs] He was interested right then! And he told me what he'd pay me—of course, everything was cheap then— told me he'd give me twenty-five dollars a week and board. . . . That sounded big to me then. And so I went down there and worked a good long while."[81] Charlie's brother, Braxton (b. 1901), also worked at the North State for a time, helping to glaze and burn the kilns. However he confides that he "didn't learn much down there—only learned how to work hard!"[82] Two other prominent turners for the Coopers were Jonah (b. 1895) and Walter Owen (b. 1904), both sons of Jim. The latter, in fact, worked there from 1925 to 1959 and then, at the death of Henry Cooper, rechristened the operation the Pine State Pottery and ran it until the late 1970s.[83] His career in many respects parallels that of his first cousin, Ben.

All of these young men—and there were many others who could be cited—were taught within their families to make traditional earthenware and stoneware, and thus they possessed all the requisite skills of the craft. At the same time they were very young—many were yet teenagers—when the Busbees and Coopers appeared on the scene. Not yet so "hard-baked"—a more apt epithet might be "high-fired"—as their fathers, they were far more receptive to the new ideas coursing through American ceramics. Moreover, most reached maturity at the time the old folk community was disintegrating and the demand for the utilitarian products was falling off rapidly. A new world was taking shape that depended on cash and consumers rather than barter and self-sufficiency, but the new generation of potters responded to these often bewildering events with surprising ease and inventiveness.

Change is a constant process in all societies. At times it occurs so rapidly that it rends the earlier cultural fabric; yet just as frequently, at least in retrospect, it seems to proceed in a sane and orderly fashion, creating new principles and procedures out of the old. Surely the latter alternative applied in the North Carolina pottery industry, where the innovations in product, technology, and marketing flowed naturally out of the folk tradition. To be sure, a certain amount of good fortune obtained. The folk craft happened to dovetail with modern ideas and tastes in ceramics: it was old if not "medieval"; it relied on handwork and an integrated system of production; and it yielded an often earthy, unpretentious pottery worthy of an oriental master. Moreover a relatively small number of shrewd idealists and skilled craftsmen were present to direct this inexorable modernization.

Ultimately what evolved was a whole new set of operating principles. Innovation gradually replaced conservatism; eclectic inspiration, the old regionalism; and conscious artistry, the once pervasive utilitarianism. And yet, elements of earlier days remain. The potters dig and process their own clays, and they retain long-established forms and glazes. Most learned to turn and burn at an early age by working alongside their parents or neigh-

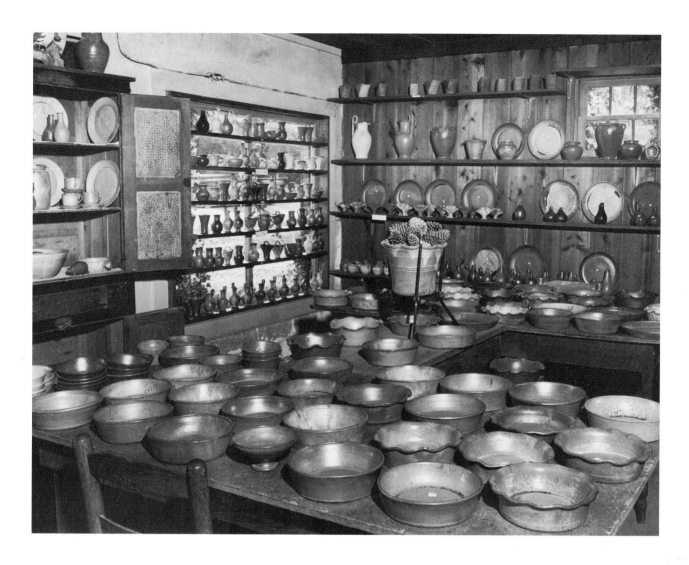

Figure 13-23
The contemporary scene: the sales room at the Seagrove Pottery, Randolph County, 1969. Courtesy of Walter and Dorothy Auman.

bors. They remain, primarily, craftsmen—production potters who replicate large numbers of useful (if no longer necessary) forms at extremely reasonable prices. And most important, the informal, cluttered shops remain firmly under the control of the same families, the Aumans, Browns, Coles, Owens, and Teagues. Folklorists and others may lament the passing of the old ways; so did some of the potters. But they did what they had to do in order to survive, and they did it very well. And thus, over the last two-thirds of a century, they built a healthy new hybrid tradition, one that remains deeply rooted in the old folk pottery but is also infused with contemporary American ceramic tastes and needs.

NOTES

PREFACE

1. Shaw, *Staffordshire Potteries*, pp. v–vi.

2. A full appreciation of the vitality of today's potteries is provided by Sweezy, *Raised in Clay*, which appeared after my research and manuscript were virtually completed. Sweezy offers a lively survey of thirty-five contemporary southern potteries (seventeen of them in North Carolina), together with superb drawings and insights into the varied technologies currently employed.

CHAPTER 1

1. Watkins, "Ceramics in the English Colonies," pp. 277–80.

2. Ries, *Clay Deposits*, pp. 46–47, 110–11.

3. Lefler and Newsome, *North Carolina*, pp. 108–9.

4. Ibid., p. 176.

5. Bivins, *Moravian Potters*, p. 7.

6. Fries, *Records of the Moravians* 1:159.

7. Ibid., 1:237, 250, 412.

8. Ibid., 2:770.

9. Bivins, *Moravian Potters*, p. 15.

10. Ibid., pp. 114, 215.

11. Ibid., pp. 77, 86, 88–89. I am indebted to Georgeanna Greer for pointing out the possibility that the Moravians were using a rectangular kiln.

12. Ibid., p. 17.

13. Ibid., p. 74.

14. Ibid., pp. 50–51.

15. Ramsay, *Carolina Cradle*, pp. 158, 169–70.

16. Newsome, "Records of Emigrants," p. 45. I am indebted to Walter and Dorothy Auman for this reference.

17. Thomas Andrews, will.

18. Philip Miller, will.

19. David Flough, estate records. Both of these references to potter Philip Miller were given to me by Bradford L. Rauschenberg of the Museum of Early Southern Decorative Arts.

20. Weatherill, *Pottery Trade*, pp. 96–98.

21. Outlaw, "Preliminary Excavations."

22. Whatley, "Mount Shepherd."

23. Ibid., pp. 40–43.

24. Outlaw, "Preliminary Excavations," p. 2.

25. Whatley, "Mount Shepherd," pp. 25–37.

26. Bivins, *Moravian Potters*, pp. 56–57.

27. William Watkins, will.

28. Hinshaw, *American Quaker Genealogy* 1:691. Watkins is listed as a potter in the 1850 Population Census of Guilford County.

29. Craig, *Arts and Crafts*, p. 93.

30. Guilland, *Early American Folk Pottery*, pp. 14–15.

31. Myers, "Survey of Pottery Manufacture," p. 2.

32. Watkins, *Early New England Potters*, p. 80.

33. "For the *Clarion*," pp. 3–5. This reference was kindly supplied by Bradford L. Rauschenberg of the Museum of Early Southern Decorative Arts, Winston-Salem, N.C.

34. Ibid.

35. Fries, *Records of the Moravians* 5:2,283.

CHAPTER 2

1. Myers, "Survey of Pottery Manufacture," p. 3. See also Barka, "'Poor Potter' of Yorktown."

2. Bivins, *Moravian Potters*, p. 26.

3. Ibid., pp. 36, 123, 133, 142, 143.

4. Craig, *Arts and Crafts*, p. 93.

5. Scarborough, "Connecticut Influence," pp. 16–17.

6. Ibid., p. 28.

7. Webster, *Decorated Stoneware*, pp. 97, 225.

8. Scarborough, "Connecticut Influence," pp. 40, 35.

9. Ibid., pp. 21, 30–34.

10. Rauschenberg, "'Success to the Tuley,'" pp. 1–26.

11. Treasurer's and Comptroller's Papers, *Ports*.

12. Craig, *Arts and Crafts*, p. 93.

13. Lawson, *New Voyage*, pp. 88–89.

14. Blount, *Blount Papers* 3:58–59.

15. *Fayetteville Observer*, 28 Nov. 1889.

16. Rose, *Resources and Industries*, p. 27.

17. Interview, Elizabeth Poe. See also Johnson, "Poe Pottery."

18. Webster, *Decorated Stoneware*, p. 103. See, in particular, chapter 7, "Birds," and chapter 8, "Animals, Land and Water."

19. Crawford, *Jugtown Pottery*, p. 7.

20. Scarborough, "Connecticut Influence," pp. 27, 36–40.

21. Ibid., p. 69.

22. Genealogical information on the Beards and other Quaker families comes from Hinshaw, *American Quaker Genealogy*, vol. 1.

23. Powell, *North Carolina Gazetteer*, p. 403.

24. Haworth, *Springfield*, p. 16.

25. Busbee, "Jugtown Pottery," p. 127.

26. Sweezy, "Tradition in Clay," p. 20.

27. Mildred Galloway, letters to author, 25 May, 1 June, 6 Nov. 1979.

28. Lefler and Newsome, *North Carolina*, p. 85.

29. Powell et al., *The Regulators*, pp. 261, 367. Peter's sons Thomas, Peter, and Joseph were also involved.

30. Thomas Craven, estate records.

31. John Craven, estate records.

32. Smith and Rogers, *Pottery Making in Tennessee*, p. 110.

33. Burrison, *Brothers in Clay*, pp. 246–49, 236–37.

34. Mildred Galloway, letter to author, 25 May 1979.

35. Creech, "Information"; Creech, "More Information."

36. Interview, Carl Chrisco.

37. Auman and Zug, "Nine Generations."

38. Arnold Mountford, letter to Dorothy Auman.

39. Grant-Davidson, "Early Swansea Pottery," pp. 59–65.

40. Kingsbury, *Records of the Virginia Company* 3:230.

41. Smith and Rogers, *Pottery Making in Tennessee*, pp. 83, 85–86, 94–95. At the present time it is not possible to verify that these were descendants of Michael Cole.

42. Much of the genealogical information on the Foxes (and later generations of the Cravens) comes from Vallentine, *Fox Family History*.

43. Interview, W. A. Dixon. Mr. Dixon is a great-nephew of the potter and lives on the site of the shop, just south of Siler City.

44. Interview, James Teague.

45. Interview, Melvin Owens.

46. Crawford, *Jugtown Pottery*, p. 12.

47. Schwartz, *North State Pottery*.

48. Due to a longstanding boundary dispute, part of lower Alamance belonged to Chatham County until the southern dividing line was adjusted in 1897. Thus, some of the potters cited above are actually listed in the Chatham County censuses.

49. I am indebted to Howard Hinshaw of Snow Camp for sharing his extensive knowledge of the history and potters of Alamance County.

50. Smith and Rogers, *Pottery Making in Tennessee*, p. 104.

51. Interview, Samuel Sebastian.

52. Ibid.

53. Interview, Ray Kennedy, 10 May 1979. It was a common practice to bury jugs full of whiskey to hide them from the revenue agents.

54. Gay, *Gay Family*, p. 13.

55. Sherrill, *Annals of Lincoln County*, p. 445.

56. Willett and Brackner, *Traditional Pottery of Alabama*, p. 31.

57. Interview, James Broome, 13 Aug. 1977.

58. Interview, Rufus Outen.

CHAPTER 3

1. Rhodes, *Stoneware and Porcelain*, p. 8.

2. Greer, "Preliminary Information."

3. Burrison, "Alkaline-Glazed Stoneware," p. 386.

4. Greer, "Preliminary Information," p. 156.

5. Penderill-Church, *William Cookworthy*, p. 49.

6. Greer, "Preliminary Information," pp. 156–57.

7. Bivins, *Moravian Potters*, p. 24.

8. Ibid., pp. 24–27.

9. South, "Comment," pp. 172–75.

10. Bivins, *Moravian Potters*, p. 166.

11. Burrison, "Alkaline-Glazed Stoneware," p. 387.

12. Ibid., p. 381.

13. Bordley, *Essays and Notes*, p. 457. This reference was very kindly supplied by Susan Myers, associate curator, Division of Ceramics and Glass, National Museum of American History, Smithsonian Institution.

14. *Baltimore American and Daily Advertiser*, 25 Mar. 1801, pp. 2–5. Bradford L. Rauschenberg supplied this reference from the files of the Museum of Early Southern Decorative Arts, Winston-Salem, N.C.

15. Polack, *Glass*, pp. 11–18, 162–64.

16. Greer, "Preliminary Information," p. 157.

17. No full-length study of this pottery has been written, but see Ferrell and Ferrell, *Early Decorated Stoneware*, and Burrison, "Georgia Jug Makers," pp. 221–34.

18. Shedd, *Landrum Family*, p. 6.

19. Ferrell and Ferrell, *Early Decorated Stoneware*.

20. Burrison, "Georgia Jug Makers," p. 226.

21. Vlach, *Afro-American Tradition*, pp. 81–87.

22. Ferrell and Ferrell, *Early Decorated Stoneware*.

23. Ibid.

24. Ibid.

25. Ibid.

26. Burrison, *Brothers in Clay*, p. 75.

27. Shedd, *Landrum Family*, pp. 61–62.

28. Saunders, *Colonial Records* 7:733–36.

29. Ibid., pp. 844–45, 864.

30. Ibid. 8:530–32.

31. Shedd, *Landrum Family*, p. 61.

32. Ibid., p. 73.

33. Ferrell and Ferrell, *Early Decorated Stoneware*.

34. Burrison, "Carolina Clay," pp. 2–3.

35. "Famous Pottery," p. 8.

36. Ibid.

37. Jacob Weaver, will.

38. Jacob Weaver, inventory.

39. Ramsay, *American Potters*, p. 170; Lasansky, *Redware Pottery*, p. 16; Smith and Rogers, *Pottery Making in Tennessee*, pp. 46–47.

40. Strassburger, *Pennsylvania German Pioneers* 1:761.

41. Franklin Seagle, estate records.

42. Interview, Lula Tallant.

43. He is listed in Branson's *North Carolina Business Directory*, vol. 2 (1867–68) through vol. 8 (1896) at Seagle's Store, Lincoln County, N.C.

44. I am greatly indebted to Poley's son Olen, who lives near the old site in Little Mountain, N.C., for supplying valuable information on the family.

45. Interview, Floyd Propst.

46. For a fuller account of the Reinhardt family, see Schwartz, "Reinhardt Potteries."

47. Hahn, *Catawba Soldier*, p. 332.

48. For a fuller account of the Hiltons, see Danielson, "Hilton Potteries."

49. Hahn, *Catawba Soldier*, pp. 337–38.

50. Tesh, "Penland Pottery."

51. Terrell, "Two Families."

52. The 1850 census for Buncombe County shows a daughter Frances, born in South Carolina in about 1842, and a daughter Sarah, born in North Carolina about 1845.

53. *Edgefield Advertiser*, 12 Aug. 1841. This reference was kindly supplied by Cinda Baldwin of the McKissick Museum, University of South Carolina.

54. Ferrell and Ferrell, *Early Decorated Stoneware*.

55. Interview, Clyda Coyne.

56. Interview, Thomas Rutherford.

57. For an excellent account of Bachelder's career, see Johnston and Bridges, *O. L. Bachelder*.

58. Interview, Lester Cheek.

59. N.C. State Board of Agriculture, *North Carolina*, p. 203.

60. For additional information on the Brown family, see Burrison, *Brothers in Clay*, pp. 166–68, 190–98; Sayers, "Potters in a Changing South"; and "Southern Folk Pottery," pp. 288–90, 345–84.

CHAPTER 4

1. Rhodes, *Clay and Glazes*, p. xvii.

2. Ibid., p. 11.

3. Stuckey, *North Carolina*, p. 379.

4. Ibid., p. 373.

5. The term apparently derives from the word *unega*, which means "white."

6. Finer and Savage, *Josiah Wedgwood*, p. 53.

7. Ibid., p. 180.

8. Ibid., p. 272.

9. Ibid., p. 211.

10. Stuckey, *North Carolina*, p. 371.

11. Interview, Clyde Chrisco.

12. Interview, Burlon Craig, 16 Aug. 1979.

13. Henderson, "Finest Pottery Clays."

14. Interview, Enoch Reinhardt, 19 Dec. 1978.

15. Rhodes, *Clay and Glazes*, p. 14.

16. Interview, Bascom Craven, 31 May 1978.

17. Auman and Zug, "Nine Generations," p. 171.

18. Rhodes, *Clay and Glazes*, p. 17.

19. Interview, Enoch Reinhardt, 19 Dec. 1978.

20. Interview, Burlon Craig, 6 Aug. 1980.

21. Interview, Arthur Cole.

22. Interview, Charles Craven.

23. Interview, Braxton Craven.

24. Interview, Ray Kennedy, 15 Dec. 1978.

25. Interview, Clyde Chrisco.

26. Interview, Burlon Craig, 16 Aug. 1979.

27. Henderson, "Finest Pottery Clays."

28. Interview, Burlon Craig, 16 Aug. 1979.

29. Interview, Howard Bass.

30. Interview, Enoch Reinhardt, 19 Dec. 1978.

31. Ibid.

32. Interview, Burlon Craig, 5 Aug. 1980.

33. Ibid., 3 Jan. 1981.

34. Curtis Hilton, account book. This book was generously loaned to me by Curtis's son Boyd, who is also a potter.

35. Auman and Zug, "Nine Generations," p. 169.

36. Interview, Burlon Craig, 5 Aug. 1980.

37. Interview, Enoch Reinhardt, 19 Dec. 1978.

38. Interview, Talman Cole, 7 Jan. 1978.

39. Interview, Enoch Reinhardt, 16 May 1977.

40. Interview, James Broome, 22 Aug. 1980.

41. Shaw, *Staffordshire Potteries*, p. 98.

42. Weatherill, *Pottery Trade*, p. 20.

43. Interview, Burlon Craig, 3 Jan. 1981.

44. Ibid., 16 Aug. 1979.

45. Ibid., 3 Jan. 1981.

46. Ibid., 16 Aug. 1979.

47. Ibid., 6 Aug. 1980.

48. Ibid., 16 Aug. 1979.

49. Ibid.

50. Ibid., 3 Jan. 1981.

51. Burrison, *Brothers in Clay*, p. 143.

52. Interview, Burlon Craig, 3 Jan. 1981.

53. Ibid., 16 Aug. 1979.

54. Interview, Olen Hartsoe.

55. Ibid.

56. Interview, Burlon Craig, 3 Jan.

1981.

57. Rhodes, *Clay and Glazes*, p. 70.
58. Curtis Hilton, account book.
59. Interview, Burlon Craig, 3 Jan. 1981.
60. Stuckey, *North Carolina*, p. 371.
61. Henderson, "Finest Pottery Clays."

CHAPTER 5

1. Dickerson, *Pottery Making*, p. 60.
2. Interview, Burlon Craig, 16 Dec. 1978.
3. See, for example, Leftwich, *Arts and Crafts*, pp. 62–86.
4. Brears, *English Country Pottery*, pp. 112–13.
5. Lasansky, *Redware Pottery*, p. 5.
6. Ferrell and Ferrell, *Early Decorated Stoneware*.
7. Weatherill, *Pottery Trade*, p. 33.
8. Fred Yoder, letter to author, 27 Sept. 1976.
9. Interview, Burlon Craig, 11 Mar. 1983.
10. Interview, Charles Craven.
11. Ibid.
12. Ibid.
13. Interview, Thomas Rutherford.
14. Interview, Burlon Craig, 9 July 1981.
15. Ibid., 10 July 1981.
16. Charles, *Pottery and Porcelain*, pp. 277–78.
17. Bivins, *Moravian Potters*, pp. 89–90.
18. Interview, Burlon Craig, 9 July 1981.
19. Ibid.
20. Ibid.
21. Interview, Thomas Childers.
22. Interview, Burlon Craig, 9 July 1981.
23. Ibid.
24. Interview, Thomas Rutherford.
25. Interview, Burlon Craig, 9 July 1981.

26. Ibid.
27. Ibid.
28. Ibid.
29. Ibid., 10 July 1981.
30. Interview, Charles Craven.
31. Interview, Enoch Reinhardt, 23 Aug. 1978.
32. Interview, Burlon Craig, 16 Dec. 1978.
33. Sweezy, *Raised in Clay*, p. 30.
34. Interview, Burlon Craig, 16 Aug. 1979.
35. Ibid., 15 Nov. 1977.
36. Ibid., 10 July 1981. For a description of the old balance scales used by Joe Owen and his family, see Sweezy, *Raised in Clay*, p. 223.
37. Interview, Burlon Craig, 9 July 1981.
38. Ibid.
39. Ibid.
40. Ibid.
41. Ibid., 10 June 1982.
42. Ibid., 9 July 1981.
43. Ibid., 10 July 1981.
44. Ibid.
45. Bivins, *Moravian Potters*, pp. 91–94.
46. Interview, Burlon Craig, 10 July 1981.
47. Ibid., 6 Aug. 1980.
48. Ibid.
49. Interview, Enoch Reinhardt, 4 Jan. 1978.
50. Interview, Burlon Craig, 6 Aug. 1980.
51. Ibid.
52. Interview, Charles Craven.
53. Interview, Burlon Craig, 9 July 1981.
54. Ibid.
55. Interview, Carl Chrisco.
56. Benes, *Masks of Orthodoxy*, pp. 6–7.
57. Interview, Burlon Craig, 2 Jan. 1980.
58. Interview, Javan Brown, 4 Jan. 1980.

59. Interview, Hazeline Rhodes, 19 July 1980.
60. Interview, Javan Brown, 4 Jan. 1980.
61. Interview, Burlon Craig, 9 July 1981.
62. Ibid., 6 Aug. 1980.
63. Ibid., 10 July 1981.
64. Ibid.
65. Ibid., 9 July 1981.

CHAPTER 6

1. Rhodes, *Clay and Glazes*, p. 80.
2. Bivins, *Moravian Potters*, p. 19.
3. Interview, Burlon Craig, 10 July 1981.
4. Interview, Floyd Propst.
5. Weatherill, *Pottery Trade*, p. 40.
6. Brears, *English Country Pottery*, p. 114.
7. Interview, Burlon Craig, 9 July 1981.
8. Interview, Talman Cole, 10 June 1978.
9. Green, *Pottery Glazes*, p. 24.
10. Bivins, *Moravian Potters*, p. 79.
11. Ibid., pp. 79–82.
12. Brears, *English Country Pottery*, p. 125.
13. Watkins, *Early New England Potters*, p. 6.
14. Wiltshire, *Folk Pottery*, p. 18.
15. Interview, Bascom Craven, 31 July 1978.
16. For a succinct discussion of the lead glaze problem, see Green, *Pottery Glazes*, pp. 71–80, 242–43.
17. Interview, Herman Cole.
18. Troy, *Salt-Glazed Ceramics*, p. 14.
19. Himer Fox, account book; Bartlet Craven, ledger.
20. Interview, Joe Owen.
21. Interview, Carl Chrisco.
22. Interview, Joe Owen.
23. Interview, Carl Chrisco.
24. Interview, Charles Craven.
25. Interview, Arthur Cole.

26. Rhodes, *Clay and Glazes*, p. 285.

27. As always there are exceptions to ʟe rule. A. R. Cole insists that "you'd ᴀlt it and then blast again—about three ᴍes'd get a good coating" (Interview, ʟrthur Cole).

28. Interview, Braxton Craven.

29. Interview, Herman Cole.

30. Interview, Benjamin Owen, 3 Aug. ⁇978.

31. Interview, Bascom Craven, 31 May ⁇978.

32. Sanders, *Japanese Ceramics*, ⁇p. 232–33.

33. Interview, Javan Brown, 4 Jan. ⁇980.

34. Cardinalli, "Wood-Ash Glazes," ⁇. 58.

35. Burrison, "Alkaline-Glazed Stoneware," p. 382; Ferrell and Ferrell, *Early Decorated Stoneware*.

36. Interview, Javan Brown, 4 Jan. 1980.

37. Wood, *Oriental Glazes*, pp. 8–9.

38. Fred Yoder, letter to author, 31 Dec. 1976.

39. Wood, *Oriental Glazes*, p. 10.

40. Interview, Enoch Reinhardt, 4 Jan. 1978.

41. Interview, Burlon Craig, 21 Aug. 1981.

42. James Love, journals, pp. 41–43.

43. Nixon, "Lincoln County," p. 128.

44. Interview, Burlon Craig, 10 July 1981.

45. Interview, Olen Hartsoe.

46. Interview, Clyda Coyne.

47. Shaw, *Staffordshire Potteries*, p. 142.

48. Interviews, Burlon Craig, 29 June 1977, 24 Aug. 1979, 21 Aug. 1980.

49. Interview, Enoch Reinhardt, 4 Jan. 1978.

50. Wood, *Oriental Glazes*, pp. 9–10.

51. Interview, Burlon Craig, 10 July 1981.

52. Interview, Talman Cole, 10 June 1978.

53. Ibid., 7 Jan. 1979.

54. Interview, Enoch Reinhardt, 16 May 1977.

55. Interview, Olen Hartsoe.

56. Interview, Burlon Craig, 10 June 1982.

57. Interview, Jeter Hilton.

58. Interview, Burlon Craig, 10 June 1982.

59. Interview, Talman Cole, 10 June 1978.

60. Interview, Burlon Craig, 21 Aug. 1981.

61. Ibid., 10 June 1982.

62. Interview, Talman Cole, 10 June 1978.

63. Troy, *Salt-Glazed Ceramics*, p. 68.

64. Ries, *Clay Deposits*, p. 73.

65. Interview, Javan Brown, 22 July 1973.

66. Interview, Talman Cole, 7 Jan. 1978.

67. Interview, Elma Stallings.

68. Interview, Rufus Outen.

69. Interview, Ray Kennedy, 15 Dec. 1978.

70. Interview, Javan Brown, 4 Jan. 1980.

71. Interview, Burlon Craig, 21 Aug. 1981.

CHAPTER 7

1. Interview, Mrs. R. L. Robinson.

2. Interview, Burlon Craig, 6 Jan. 1982.

3. Rhodes, *Kilns*, p. 3.

4. Ibid., p. 13.

5. Outlaw, "Preliminary Excavations," pp. 4–5, 10.

6. A photograph and drawing of Jessiah Diehl's beehive kiln, which was still standing near Quakertown, Pennsylvania, in 1968, may be found in Powell, *Pennsylvania Pottery*, pp. 16–17.

7. Outlaw, "Preliminary Excavations," p. 10.

8. Olsen, *Kiln Book*, p. 41.

9. For a thorough description of the groundhog kiln, see Greer, "Groundhog Kilns."

10. Interview, Benjamin Owen, 24 July 1982.

11. Interview, Burlon Craig, 2 Jan. 1980.

12. Interview, Olen Hartsoe.

13. Interview, Talman Cole, 7 Jan. 1978.

14. White, *Brown Collection*, vol. 7, no. 8441.

15. Olsen, *Kiln Book*, p. 85.

16. Interview, Burlon Craig, 16 Dec. 1978.

17. Interview, Enoch Reinhardt, 4 Jan. 1978.

18. Interview, Burlon Craig, 21 Aug. 1981.

19. Interview, James Broome, 22 Aug. 1980.

20. Interview, Burlon Craig, 16 Aug. 1979.

21. Interview, Floyd Propst.

22. Interview, Burlon Craig, 21 Aug. 1981.

23. Ibid., 16 Aug. 1979.

24. Ibid., 16 Dec. 1978.

25. Interview, Talman Cole, 7 Jan. 1978.

26. Olsen, *Kiln Book*, p. 94.

27. Ibid., p. 96.

28. Interview, Bird Johnson.

29. Interview, Talman Cole, 7 Jan. 1978.

30. Interview, Burlon Craig, 10 June 1982.

31. Interview, Olen Hartsoe.

32. Interview, Joe Owen.

33. Interview, Charles Craven.

34. Interview, Benjamin Owen, 3 Aug. 1978.

35. Interview, Arthur Cole.

36. Interview, Braxton Craven.

37. Interview, Charles Craven.

38. Interview, Benjamin Owen, 3 Aug. 1978.

39. Interviews, Talman Cole, 10 June,

7 Jan. 1978.

40. Interview, Benjamin Owen, 24 July 1982.

41. Interview, Joe Owen.

42. Olsen, *Kiln Book*, pp. 37–38.

43. Interview, Benjamin Owen, 3 Aug. 1978.

44. Interview, Arthur Cole.

45. Interview, Braxton Craven.

46. Interview, Arthur Cole.

47. Interview, Joe Owen.

48. Interview, Ray Kennedy, 15 Dec. 1978.

49. Interview, Benjamin Owen, 3 Aug. 1978.

50. Rhodes, *Kilns*, pp. 44–45.

51. Rhodes, *Clay and Glazes*, p. 266.

52. Ibid., pp. 266, 267.

53. Interview, Burlon Craig, 6 Aug. 1980.

54. Interview, James Broome, 22 Aug. 1980.

55. Sweezy, *Raised in Clay*, p. 188.

56. Interview, Burlon Craig, 2 Jan. 1980.

57. Ibid., 21 Aug. 1981.

58. Ibid., 4 Jan. 1981.

59. Interview, Enoch Reinhardt, 4 Jan. 1978.

60. Interview, Charles Craven. Ben Owen also recalls making a kiln of raw brick in the early days of the Jugtown Pottery, under the direction of William Henry Chrisco, but adds that "it didn't last too long" (Interview, Benjamin Owen, 3 Aug. 1978).

61. McKee, *Early American Masonry*, p. 43.

62. Interview, Enoch Reinhardt, 15 Aug. 1977.

63. Interview, Burlon Craig, 21 Aug. 1977.

64. Interview, Benjamin Owen, 3 Aug. 1978.

65. Ibid.

66. Interview, Enoch Reinhardt, 19 Dec. 1978.

67. Ibid.

68. Interview, Burlon Craig, 9 Aug. 1978.

69. Interviews, Enoch Reinhardt, 19 Dec., 4 Jan. 1978.

70. Interview, Burlon Craig, 21 Aug. 1981.

71. Ibid., 19 Aug. 1983.

72. Interview, James Broome, 22 Aug. 1980.

CHAPTER 8

1. Clay, Orr, and Stuart, *North Carolina Atlas*, p. 34.

2. Interview, Howard Bass.

3. Interview, Enoch Reinhardt, 4 Jan. 1978.

4. Ibid.

5. Interview, Irene Gates.

6. Sweezy, *Raised in Clay*, pp. 164–65.

7. Interview, Ernestine Sigmon.

8. Interview, Clara Wiggs.

9. Interview, Ernestine Sigmon.

10. Interview, Burlon Craig, 21 Aug. 1981.

11. Interview, Clara Wiggs.

12. Interview, Braxton Craven.

13. Interview, Jeter Hilton.

14. Interview, Clara Wiggs.

15. Interview, Ernestine Sigmon.

16. Interview, Mamie Ellis.

17. Interview, Burlon Craig, 19 Aug. 1983.

18. Ibid.

19. Ibid.

20. Interview, Carl Chrisco.

21. Interview, Burlon Craig, 16 Dec. 1978.

22. Sayers, "Potters in a Changing South," p. 104.

23. Interview, Burlon Craig, 21 Aug. 1981.

24. Ibid., 22 Apr. 1981.

25. Interview, Benjamin Owen, 3 Aug. 1978.

26. Interview, Joe Owen.

27. Interview, Burlon Craig, 16 Dec. 1978.

28. Interview, Charles Craven.

29. Interview, Burlon Craig, 16 Dec. 1978.

30. Ibid., 6 Aug. 1980.

31. Interview, Charles Craven.

32. Interview, Jack Kiser.

33. Interview, Arthur Cole.

34. Interview, Enoch Reinhardt, 4 Jan. 1978.

35. Interview, Benjamin Owen, 3 Aug. 1978.

36. Curtis Hilton, account book.

37. Interview, Burlon Craig, 16 Dec. 1978.

38. Interview, Howard Bass.

39. Interview, Burlon Craig, 10 June 1982.

40. Burrison, *Brothers in Clay*, pp. 164–65, 319.

41. Interview, Burlon Craig, 11 Nov. 1983.

42. Interview, Herman Cole.

43. Interview, Burlon Craig, 6 Aug. 1980.

44. Interview, Floyd Propst.

45. Interview, Burlon Craig, 16 Dec. 1978.

46. Ibid., 19 Aug. 1983.

47. Ibid., 11 Nov. 1983.

48. Ibid., 10 July 1981.

49. Ibid., 19 Aug. 1983.

50. Ibid.

51. Ibid.

52. Ibid., 11 Nov. 1983.

53. Interview, Herman Cole.

54. Interview, Hazeline Rhodes, 19 July 1980.

55. Interview, Benjamin Owen, 24 July 1982.

56. Interview, Burlon Craig, 19 Aug. 1983.

57. Clay, Orr, and Stuart, *North Carolina Atlas*, p. 37.

58. Bivins, *Moravian Potters*, pp. 54, 68–69.

59. See chapter 1, p. 00.

60. Curtis Hilton, account book.

61. Jacon Cole, catalog. This catalog is in the files of the Seagrove Potters Museum and was kindly loaned to me by Dorothy and Walter Auman.

62. Interview, Hazeline Rhodes, 19 July 1980.

CHAPTER 9

1. Interview, Ray Kennedy, 10 May 1979.

2. Interview, Benjamin Owen, 3 Aug. 1978.

3. Interview, Burlon Craig, 2 Jan. 1980.

4. Moffitt and Routh, Articles of Agrement. A copy of this document was kindly sent to me, by Carolyn Hager and Charlesanna Fox, from the research files of the Randolph County Public Library, Asheboro, N.C.

5. Interview, Burlon Craig, 10 June 1982.

6. Ibid., 2 Jan. 1980.

7. Ibid., 19 Aug. 1983.

8. Bartlet Craven, ledger.

9. Burrison, *Brothers in Clay*, p. xviii.

10. Schaltenbrand, *Old Pots*, p. 75

11. Ibid., pp. 75, 58.

12. Ibid., pp. 83, 58, 60.

13. Interview, Clara Wiggs.

14. Interview, Charles Craven.

15. Interview, Clyde Chrisco.

16. Curtis Hilton, account book.

17. Interview, Enoch Reinhardt, 4 Jan. 1978.

18. Interview, Burlon Craig, 6 Jan. 1982.

19. John Craven, estate records.

20. Bartlet Craven, ledger.

21. John A. Craven, ledger.

22. Schaltenbrand, *Old Pots*, p. 75.

23. Interview, Johnnie Scott.

24. Interview, Minnie Reinhardt, 12 Sept. 1980.

25. Interview, Johnnie Scott.

26. Interview, Carl Chrisco.

27. Auman and Auman, *Seagrove Area*, p. 104.

28. Interview, Alfred Marley.

29. Interview, Elizabeth Stahl.

30. Interview, Carl Chrisco.

31. Interview, Raymond Stahl.

32. Interview, Burlon Craig, 19 Aug. 1983.

33. Interview, Minnie Reinhardt, 12 Sept. 1980.

34. Interview, James Broome, 13 Aug. 1977.

35. John A. Craven, ledger.

36. Bartlet Craven, ledger.

37. Curtis Hilton, account book.

38. Interview, Johnnie Scott; Fred Yoder, letter to author, 27 Sept. 1976.

39. Interview, Anderson Church; interview, Olen Hartsoe.

40. Interview, Burlon Craig, 11 Nov. 1983.

41. Fred Yoder, letter to author, 27 Sept. 1976.

42. Interview, Ray Kennedy, 10 May 1979.

43. Interview, Burlon Craig, 2 Jan. 1980.

44. Ibid., 19 Aug. 1983.

45. Ibid., 11 Nov. 1983.

46. Interview, Talman Cole, 7 Jan. 1978.

47. Interview, Burlon Craig, 6 Jan. 1982.

48. Ibid.

49. Interview, Ray Kennedy, 10 May 1979.

50. Interview, Irene Gates.

51. Interview, Hazeline Rhodes, 19 July 1980.

52. Bartlet Craven, ledger.

53. Interview, Herman Cole.

54. Auman and Zug, "Nine Generations," p. 169.

55. Fred Yoder, letter to author, 27 Sept. 1976.

56. Interview, Howard Bass.

57. Interview, Anderson Church.

58. Interview, Clara Wiggs.

59. Interview, Irene Gates.

60. Interview, Enoch Reinhardt, 4 Jan. 1978.

61. Interview, Talman Cole, 7 Jan. 1978.

62. George Foster, "Sociology of Pottery," pp. 46, 47.

63. Interview, Braxton Craven.

64. Interview, Burlon Craig, 19 Aug. 1983.

65. The jigger wheel provides a semi-automated means of turning. A worker places the proper amount of clay in a plaster mold mounted on the headblock and then mechanically shapes the pot by lowering a template that is fitted to a lever arm.

66. Interview, Javan Brown, 4 Jan. 1980.

67. Interview, Clara Wiggs.

CHAPTER 10

1. The identity of the writer is not known, though she claims kin to the Coles. This letter was discovered among papers at an auction in Randolph County and is the property of the Seagrove Potters Museum.

2. Interview, Burlon Craig, 21 Aug. 1981.

3. Fred Yoder, letter to author, 27 Sept. 1976.

4. Rawson, *Ceramics*, p. 16.

5. Interview, Burlon Craig, 6 Jan. 1982.

6. In March of 1858, John A. Craven sold Jonathan Worth 8,055 feet of planking for the plank road, then under construction in Randolph County (John A. Craven, ledger).

7. Interview, Alvah Hinshaw.

8. Interview, Mrs. J. W. Gentry.

9. Greer, *American Stonewares*, p. 91.

10. Ibid., pp. 90, 91.

11. Ibid., p. 91.

12. Interview, Mrs. J. W. Gentry.

13. Crawford, *Jugtown Pottery*, p. 7.

14. Guilland, *Early American Folk Pot-*

tery, p. 287.

15. Ibid., pp. 122, 108, 110.

16. See Weatherill, *Pottery Trade*, pp. 14 (plate 1a), 77.

17. Interview, Alvah Hinshaw.

18. Interview, Mrs. J. W. Gentry.

19. Greer, *American Stonewares*, p. 83.

20. Ibid.

21. Interview, Burlon Craig, 6 Jan. 1982.

22. Greer, *American Stonewares*, p. 83.

23. Interview, Enoch Reinhardt, 10 Feb. 1977.

24. Interview, Burlon Craig, 16 Dec. 1978.

25. Ibid., 6 Jan. 1982.

26. Interview, Carl Chrisco.

27. Whitener, *Prohibition*, pp. 7–8.

28. Ibid., p. 130.

29. Interview, Enoch Reinhardt, 4 Jan. 1978.

30. Interview, Floyd Propst.

31. Interview, James Broome, 22 Aug. 1980.

32. Whitener, *Prohibition*, pp. 140, 150, 162.

33. Ibid., p. 189.

34. Interview, Burlon Craig, 22 Apr. 1981.

35. Whitener, *Prohibition*, p. 190.

36. Interview, Burlon Craig, 2 Jan. 1980.

37. Ibid.

38. Ibid., 6 Jan. 1982.

39. Interview, Irene Gates.

40. Interview, Mrs. J. W. Gentry.

41. Interview, Minnie Reinhardt, 2 Jan. 1981.

42. Interview, Mrs. R. L. Robinson.

43. Interview, Burlon Craig, 6 Jan. 1982.

44. Brears, *Collector's Book*, pp. 66–91.

45. Guilland, *Early American Folk Pottery*, pp. 198, 201.

46. Ibid., p. 122.

47. Greer, *American Stonewares*, p. 218.

48. "Southern Folk Pottery," pp. 212–13.

49. Interview, Mrs. J. W. Gentry.

50. For an illustrated comparison of the regional forms, see Greer, *American Stonewares*, p. 96.

51. Interview, Bascom Craven, 31 May 1978.

52. Interview, Alfred Marley.

53. Interview, Mrs. R. L. Robinson.

54. Interview, Minnie Reinhardt, 12 Sept. 1980.

55. Interview, Irene Gates.

56. Interview, Mrs. J. W. Gentry.

57. Interview, Carl Chrisco.

58. Guilland, *Early American Folk Pottery*, p. 110.

59. Interview, Burlon Craig, 11 Nov. 1983.

60. Greer, *American Stonewares*, p. 93.

61. Bivins, *Moravian Potters*, pp. 162–63.

62. Greer, *American Stonewares*, p. 93.

63. Interview, Alvah Hinshaw.

64. Interview, Mrs. J. W. Gentry.

65. Interview, Mrs. R. L. Robinson.

66. Interview, Mrs. J. W. Gentry.

67. Interview, Alfred Marley.

68. Interview, Burlon Craig, 10 July 1981.

69. Interview, Mrs. J. W. Gentry.

CHAPTER 11

1. Guilland, *Early American Folk Pottery*, p. 170.

2. John Craven, estate records.

3. Mary Beard, estate records; Benjamin Beard, estate records.

4. Bartlet Craven, ledger.

5. Himer Fox, account book.

6. Guilland, *Early American Folk Pottery*, p. 202.

7. Bivins, *Moravian Potters*, p. 140.

8. Guilland, *Early American Folk Pottery*, pp. 276–77.

9. Daniel Seagle, estate records.

10. John Craven, estate records.

11. Benjamin Beard, estate records.

12. Tyler, "Cast-Iron Cooking Vessels," p. 224.

13. Interview, Burlon Craig, 6 Jan. 1982.

14. Interview, Bascom Craven, 31 May 1978.

15. Guilland, *Early American Folk Pottery*, p. 173.

16. Greer, *American Stonewares*, p. 101.

17. Bivins, *Moravian Potters*, pp. 190–93.

18. Guilland, *Early American Folk Pottery*, p. 104.

19. Note the Moravian "cook pot" (Bivins, *Moravian Potters*, pp. 144–45).

20. Interview, Burlon Craig, 6 Jan. 1982.

21. Ibid., 16 Dec. 1978.

22. Interview, Howard Bass.

23. Taliaferro, *Fisher's River*, pp. 218, 220–21.

24. John Craven, estate records.

25. Benjamin Beard, estate records.

26. The term "Delft" occurs frequently in these records, but it may be a misnomer. Very likely, the pottery was the white earthenware of Staffordshire.

27. Interview, Mrs. J. W. Gentry.

28. Interview, Burlon Craig, 6 Jan. 1982.

29. Greer, *American Stonewares*, p. 103.

30. Ibid.

31. Interview, Burlon Craig, 6 Jan. 1982.

32. Burrison, *Brothers in Clay*, p. 64 (fig. 33).

33. Interview, Burlon Craig, 6 Jan. 1982.

34. Ibid., 11 Nov. 1983.

35. Bivins, *Moravian Potters*, pp. 128–

33.

36. Guilland, *Early American Folk Pottery*, p. 209.

37. Bartlet Craven, ledger.

38. John Craven, estate records.

39. Benjamin Beard, estate records.

40. John A. Craven, ledger.

41. Guilland, *Early American Folk Pottery*, p. 206.

42. Greer, *American Stonewares*, p. 108.

43. Kilby, *The Cooper*, p. 174, plate 98. This reference was kindly supplied by Stuart C. Schwartz.

44. Brears, *Collector's Book*, p. 68.

45. Guilland, *Early American Folk Pottery*, p. 91.

46. Fries, *Records of the Moravians* 1:149.

47. Bivins, *Moravian Potters*, pp. 174–75. See also pp. 96–98.

48. Outlaw, "Preliminary Excavations," p. 5; Whatley, "Mount Shepherd."

49. Butler, "Sally Michael's Pipes," pp. 3, 22.

50. Interview, W. A. Dixon.

51. Hadley et al., *Chatham County*, photographs between pp. 168 and 169.

52. Interview, Arthur Cole.

53. For a broad survey of pipemaking in the United States, see Sudbury, "Tobacco Pipemakers."

54. Bivins, *Moravian Potters*, p. 103.

55. Interview, Arthur Cole.

56. Interview, Bascom Craven, 31 May 1978.

57. Interview, Burlon Craig, 6 Jan. 1982.

58. Benjamin Beard, estate records; Mary Beard, estate records.

59. Guilland, *Early American Folk Pottery*, p. 218.

60. Bivins, *Moravian Potters*, pp. 157–59.

61. Guilland, *Early American Folk Pottery*, p. 71.

62. Interview, Burlon Craig, 6 Jan. 1982.

63. Ibid., 16 Dec. 1978.

64. Daniel Seagle, estate records.

65. See Lasansky, *Redware Pottery*, p. 50; Wiltshire, *Folk Pottery*, p. 76.

66. See Guilland, *Early American Folk Pottery*, p. 275.

67. Interview, Burlon Craig, 16 Dec. 1978.

68. Hume, *Colonial Gardener*, pp. 83–84.

69. Interview, Bascom Craven, 31 May 1978.

70. Interview, Burlon Craig, 16 Dec. 1978.

71. Ibid., 6 Jan. 1982.

72. Ibid., 16 Dec. 1978.

73. Interview, James Broome, 22 Aug. 1980.

74. Interview, Burlon Craig, 6 Jan. 1982.

75. Interview, Anderson Church.

76. Brears, *English Country Pottery*, p. 79.

77. Bivins, *Moravian Potters*, pp. 164–65.

78. Interview, Burlon Craig, 6 Jan. 1982.

79. Interview, Anderson Church. A photograph of a T-shaped chimneypot, topped with a finial made by Javan Brown, can be found in "Southern Folk Pottery," p. 300.

80. Lasansky, *Redware Pottery*, p. 49.

CHAPTER 12

1. Crawford, *Jugtown Pottery*, p. 8. For a color photograph of some of these early grave markers, complete with their finials, see Moose, "Frogskin and Tobacco Spit," p. 47.

2. Dewhurst and MacDowell, *Cast in Clay*, p. 61; Guilland, *Early American Folk Pottery*, p. 190. Greer, *American Stonewares*, p. 125.

3. Greer, *American Stonewares*, p. 125.

4. Parker, *Moore County Cemeteries*, cemetery #110.

5. *Celebration*, item 195, p. 144.

6. Smith, *Pottery*, p. 26.

7. *Made by Hand*, p. 66; Willett and Brackner, *Traditional Pottery of Alabama*, p. 40.

8. Burrison, *Brothers in Clay*, pp. 125–26.

9. Willett and Brackner, *Traditional Pottery of Alabama*, pp. 18–20.

10. *Annapolis Maryland Gazette*, p. 6.

11. Interview, Clara Wiggs.

12. Interview, Mrs. R. L. Robinson.

13. Brears, *Collector's Book*, pp. 94–95.

14. Hume, *Colonial Gardener*, pp. 39–54.

15. Bivins, *Moravian Potters*, pp. 148–49.

16. Brears, *Collector's Book*, p. 96.

17. Interview, Burlon Craig, 21 Aug. 1980.

18. Ibid., 11 Nov. 1983.

19. Interview, James Broome, 22 Aug. 1980.

20. Greer, *American Stonewares*, p. 114.

21. Interview, Ray Kennedy, 10 May 1979.

22. Cox, *Book of Pottery* 1:33; see also the color plate facing p. 302.

23. Burrison, *Brothers in Clay*, p. 66.

24. Interview, Burlon Craig, 6 Jan. 1982.

25. Wiltshire, *Folk Pottery*, pp. 72, 98, 104.

26. Interview, Mr. and Mrs. James Robertson.

27. Interview, Talman Cole, 10 June 1978.

28. Interview, Ruth Brank.

29. Burrison, *Brothers in Clay*, p. 209.

30. Terry and Myers, *Southern Make*, pp. 29, 42.

31. Vlach, *Afro-American Tradition*, pp. 143, 139. The jar referred to above is illustrated here in color in plate 8.

32. Interview, Joe Owen.

33. Guilland, *Early American Folk Pottery*, p. 282.

34. Danielson, "Hilton Potteries," pp. 28–31.

35. Interview, Burlon Craig, 2 Jan. 1980.

36. Interview, James Teague.

37. Interview, Gails Welch.

38. Brears, *Collector's Book*, pp. 106–18.

39. Guilland, *Early American Folk Pottery*, p. 136; Lasansky, *Redware Pottery*, p. 47.

40. Troy, *Salt-Glazed Ceramics*, p. 67; Guilland, *Early American Folk Pottery*, p. 200.

41. Interview, Javan Brown, 4 Jan. 1980.

42. Interview, Herman Cole.

43. Burrison, "Afro-American Folk Pottery," p. 196 (n. 40).

44. Vlach, *Afro-American Tradition*, p. 86.

45. Abrahams, *Deep Down*, p. 144.

46. Interview, Javan Brown, 4 Jan. 1980.

47. Interview, Clyda Coyne.

48. Guilland, *Early American Folk Pottery*, p. 200; Watkins, *Early New England Potters*, fig. 98; Lasansky, *Redware Pottery*, p. 43.

49. Interview, Burlon Craig, 6 Jan. 1982.

50. Ibid.

51. Vlach, *Afro-American Tradition*, p. 90.

52. Burrison, "Afro-American Folk Pottery," p. 193.

53. Barret, *Bennington Pottery*, plate 8.

54. "Famous Pottery," p. 8.

55. South, "Comment," p. 173.

56. Interview, Burlon Craig, 16 Dec. 1978.

57. Interview, Louis Brown.

58. Burrison, "Afro-American Folk Pottery," pp. 186–87.

59. Interview, Louis Brown.

60. Interview, Burlon Craig, 19 Aug. 1983.

61. Ibid.

62. Ibid., 10 July 1981.

CHAPTER 13

1. For a preliminary, highly condensed version of the ideas in this chapter, see Zug, "Jugtown Reborn."

2. Burrison, *Meaders Family*, p. 3.

3. Ibid.

4. Ames, *Beyond Necessity*, p. 15.

5. Interview, Enoch Reinhardt, 4 Jan. 1978.

6. Interview, Irene Gates.

7. Kaufmann, *North German Folk Pottery*, p. 23.

8. I am indebted to Dorothy and Walter Auman of Seagrove for sharing with me their valuable collection of early catalogs.

9. Interview, Burlon Craig, 19 Aug. 1983.

10. Interview, Benjamin Owen, 24 July 1982.

11. Interview, Burlon Craig, 19 Aug. 1983.

12. Interview, Benjamin Owen, 24 July 1982.

13. Sweezy, *Raised in Clay*, pp. 177–78, 260.

14. Busbee, "Jugtown Pottery," p. 129.

15. Schwartz, *North State Pottery*.

16. The full range of Jugtown glazes is illustrated in the color plates in Crawford, *Jugtown Pottery*.

17. The name "frogskin" (as well as "tobacco spit") was probably coined by Jacques Busbee; the glaze itself dates back to the nineteenth century.

18. For an excellent discussion of the Jugtown translations of other traditions, see Hertzman, *Jugtown Pottery*.

19. Oswald, *English Brown Stoneware*, colour plate A.

20. Schwartz, *North State Pottery*.

21. Interview, Hazeline Rhodes, 19 July 1980.

22. Interview, Burlon Craig, 11 Nov. 1983.

23. Interview, Enoch Reinhardt, 4 Jan. 1978.

24. Ibid., 19 Dec. 1978.

25. Ibid., 4 Jan. 1978.

26. Interview, Burlon Craig, 11 Nov. 1983.

27. Ibid.

28. Spargo, *Early American Pottery*, pp. 317–20; plates 44, 45.

29. Printed about 1940 by the F. S. Royster Guano Company of Norfolk, Va., the notebook was discovered and very thoughtfully brought to my attention by Enoch's daughter, Irene Gates, of Hickory, N.C.

30. Interview, Burlon Craig, 10 June 1982.

31. Ibid., 19 Aug. 1983.

32. For a more detailed account of Hilton's meanderings, see Danielson, "Hilton Potteries."

33. "Famous Pottery," p. 8.

34. Interview, Burlon Craig, 11 May 1979.

35. Ibid., 19 Aug. 1983.

36. Interview, Charles Craven.

37. Interview, Burlon Craig, 16 Aug. 1979.

38. Ernest Hilton, time book, p. 41. This book was loaned to me by Mildred Hilton Shufford, Pleasant Gardens, N.C.

39. Dunnagan, "Pottery Making," p. 59.

40. Interview, Kenneth Outen.

41. Sayers, "Potters in a Changing South," pp. 98–99.

42. Burton, "All the Browns."

43. Interview, Burlon Craig, 16 Aug. 1979.

44. Schwartz, *North State Pottery*.

45. Interview, Ray Kennedy, 15 Dec. 1978.

46. Interview, Louis Brown. This was the forty-seventh out of fifty-three kilns

that Davis Brown constructed.

47. Interview, Burlon Craig, 21 Aug. 1981.

48. Interview, Jack Kiser.

49. Interview, Herman Cole.

50. Interview, Ray Kennedy, 15 Dec. 1978; Interview, Louis Brown.

51. Nichols, "Being Sorry," p. 6.

52. Interview, Herman Cole.

53. Interview, Anderson Church.

54. Interview, Floyd Propst.

55. Schwartz, "Royal Crown Pottery," p. 60.

56. Interview, Jack Kiser.

57. Interview, Benjamin Owen, 3 Aug. 1978.

58. Interview, Enoch Reinhardt, 28 Jan. 1977.

59. Schwartz, *North State Pottery*.

60. For an illustration, see Danielson, "Hilton Potteries," p. 26.

61. Schwartz, *North State Pottery*.

62. Interview, Hazeline Rhodes, 19 July 1980.

63. Interview, Jack Kiser. No porcelain was ever produced, however.

64. Interview, Braxton Craven. See also Crawford, *Jugtown Pottery*, pp. 13, 15.

65. Johnston and Bridges, *O. L. Bachelder*, p. 12.

66. Keen, *American Art Pottery*, p. 6.

67. Ibid., pp. 22–23.

68. Busbee, "Jugtown Pottery," p. 128.

69. Keen, *American Art Pottery*, pp. 4, 53.

70. Ibid., pp. 58, 64–65.

71. Typescript copy kindly loaned by Dorothy and Walter Auman of Seagrove, N.C.

72. Interview, Benjamin Owen, 24 July 1982.

73. Ibid.

74. Ibid., 3 Aug. 1978.

75. Schwartz, *North State Pottery*.

76. Interview, Jack Kiser.

77. Interview, Talman Cole, 7 Jan. 1978.

78. Crawford, *Jugtown Pottery*, p. 23.

79. Busbee, "Jugtown Pottery," p. 129.

80. Interview, Benjamin Owen, 3 Aug. 1978.

81. Interview, Charles Craven.

82. Interview, Braxton Craven.

83. Schwartz, *North State Pottery*.

BIBLIOGRAPHY

INTERVIEWS

Unless otherwise noted, all interviews were conducted by the author.

Bass, Howard. Henry, N.C., 4 Mar. 1977.

Brank, Ruth. Weaverville, N.C., 7 Jan. 1978.

Broome, James A. Monroe, N.C., 13 Aug. 1977, 22 Aug. 1980.

Brown, E. Javan. Interview by Dorothy Cole Auman. Connelly Springs, N.C., 22 July 1973.

Brown, E. Javan. Connelly Springs, N.C., 1 July 1977, 4 Jan. 1980.

Brown, Louis. Interview by Robert Sayers. Arden, N.C., 22 July 1968.

Brown, Louis. Arden, N.C., 4 May 1977.

Cheek, Lester. Weaverville, N.C., 9 Mar. 1978.

Childers, Thomas. Propst Crossroads, N.C., 17 Aug. 1977.

Chrisco, Carl. Moore County, N.C., 17 July 1978.

Chrisco, Clyde. Moore County, N.C., 16 Aug. 1978.

Church, Anderson M. Valdese, N.C., 4 Jan. 1980.

Cole, Arthur R. Interview by Dorothy Cole Auman. Sanford, N.C., 15 July 1973.

Cole, Herman. Interview by Dorothy Cole Auman. Seagrove, N.C., 28 July 1973.

Cole, Talman R. Weaverville, N.C., 7 Jan., 10 June 1978.

Coyne, Clyda Rutherford. Buncombe County, N.C., 10 Mar. 1978.

Craig, Burlon B. Henry, N.C., 29 June, 15 Nov. 1977; 9 Aug., 16 Dec. 1978; 11 May, 16, 24 Aug. 1979; 2 Jan., 5, 6, 21 Aug. 1980; 3 Jan., 22 Apr., 9, 10 July, 21 Aug. 1981; 6 Jan., 10 June 1982; 11 Mar., 19 Aug., 11 Nov. 1983.

Craven, Charles B. Raleigh, N.C., 23 Aug. 1978.

Craven, L. Bascom. Randolph County, N.C., 31 May, 31 July 1978.

Craven, W. Braxton. Moore County, N.C., 8 July 1978.

Dixon, W. A. Siler City, N.C., 27 Sept. 1975.

Ellis, Mamie Bass. Henry, N.C., 4 Mar. 1977.

Gates, Irene Reinhardt. Hickory, N.C., 17 May 1977.

Gentry, Mrs. J. W. Propst Crossroads, N.C., 8 Mar. 1978.

Hartsoe, Olen T. Maiden, N.C., 30 Mar. 1977.

Hilton, Boyd. Blackburn, N.C., 11 May 1979.

Hilton, Jeter. Propst Crossroads, N.C., 15 Aug. 1977.

Hinshaw, Alvah. Alamance County, N.C., 15 Sept. 1979.

Johnson, Bird. Corinth, N.C., 21 Mar. 1977.

Kennedy, Ray A. Wilkesboro, N.C., 15 Dec. 1978, 10 May 1979.

Kiser, Jack. Montgomery County, N.C., 3 Aug. 1978.

Marley, Alfred C. Alamance County, N.C., 20 Aug. 1981.

Outen, Kenneth. Matthews, N.C., 5 July 1977.

Outen, Rufus F. Matthews, N.C., 13 Aug. 1977.

Owen, Benjamin W. Moore County, N.C., 3 Aug. 1978, 24 July 1982.

Owen, Joseph T. Moore County, N.C., 26 Sept. 1978.

Owens, Melvin L. Moore County, N.C., 12 Sept. 1978.

Poe, Elizabeth. Fayetteville, N.C., 25 Aug. 1983.

Propst, Floyd D. Hickory, N.C., 2 Jan. 1981.

Reinhardt, Enoch W. Henry, N.C., 28 Jan., 10 Feb., 16 May, 15 Aug. 1977; 4 Jan., 19 Dec. 1978.

Reinhardt, Minnie Smith. Catawba County, N.C., 12 Sept. 1980, 2 Jan. 1981.

Rhodes, Hazeline Propst. Hickory, N.C., 19 July 1980, 2 Jan. 1981.

Robertson, Mr. and Mrs. James W. Weaverville, N.C., 7 Jan. 1978.

Robinson, Mrs. R. L. Weaverville, N.C., 9 June 1978.

Rutherford, Thomas. Buncombe County, N.C., 11 Aug. 1978.

Scott, Johnnie. Chatham County, N.C., 18 May 1978.

Sebastian, Samuel E. North Wilkesboro, N.C., 8 Aug. 1978.

Sigmon, Ernestine Hilton. Hickory, N.C., 4 Mar. 1977.

Stahl, Elizabeth Leonard. Blackburn, N.C., 11 June 1982.

Stahl, Raymond A. Blackburn, N.C., 11 June 1982.

Stallings, Elma. Catawba County, N.C., 31 Mar. 1977.

Tallent, Lula Seagle. Lawndale, N.C., 5 Jan. 1977.

Teague, James G. Moore County, N.C.,

12 July 1978.

Welch, Gails. Harpers Crossroads, N.C., 9 Mar. 1977.

Wiggs, Clara Ritchie. Corinth, N.C., 21 Apr. 1977.

MANUSCRIPT SOURCES

References to records in the North Carolina State Archives, Raleigh, North Carolina, are abbreviated as NCSA.

Andrews, Thomas. Will, 13 Apr. 1779, Chatham County, N.C. NCSA.

Beard, Benjamin. Estate Records, 29 Nov. 1841, Guilford County, N.C. NCSA.

Beard, Mary. Estate Records, 31 Mar. 1854, Guilford County, N.C. NCSA.

Cole, Jacon B. Catalog, ca. 1932. In the possession of Dorothy and Walter Auman, Seagrove Potters Museum, Seagrove, N.C.

Cooper, Rebecca Palmer. Speech, delivered at the Sesqui-Centennial International Exposition, Philadelphia, Pa. Typescript in the possession of Dorothy and Walter Auman, Seagrove Potters Museum, Seagrove, N.C.

Craven, Bartlet Yancy. Ledger, 1853–69, Randolph County, N.C. Manuscript Department, William R. Perkins Library, Duke University, Durham, N.C.

Craven, John. Estate Records, 2 Aug. 1832, Randolph County, N.C. NCSA.

Craven, John A. Ledger, 1855–80, Randolph County, N.C. Manuscript Department, William R. Perkins Library, Duke University, Durham, N.C.

Craven, Thomas. Estate Records, 21 Jan. 1825, Randolph County, N.C. NCSA.

Flough, David. Estate Records, 3 May 1792, Mecklenburg County, N.C. NCSA.

Fox, Himer. Account Book, 1844–75, Randolph County, N.C. Manuscript Department, William R. Perkins Library, Duke University, Durham, N.C.

Galloway, Mildred Craven. Letters to author, 25 May, 1 June, 6 Nov. 1979.

Hilton, Curtis. Account Book, 1900–1906. In the possession of the Boyd S. Hilton family, Blackburn, N.C.

Hilton, Ernest Auburn. Time Book, 1908–20. In the possession of Mildred Hilton Shuford, Pleasant Gardens, N.C.

Love, James Lee. Journals. Vol. 5, 1921. Southern Historical Collection, University of North Carolina, Chapel Hill, N.C.

Miller, Philip. Will, 28 Mar. 1797, Mecklenburg County, N.C. NCSA.

Moffitt, Manley Robinson, and William Clay Routh. Articles of Agrement, 21 Oct. 1867, Randolph County, N.C. Randolph County Public Library, Asheboro, N.C.

Mountford, Arnold R. Letter to Dorothy Cole Auman, 18 Jan. 1972. In the possession of Dorothy Cole Auman, Seagrove, N.C.

Seagle, Daniel. Estate Records, 30, 31 May 1867, Lincoln County, N.C. NCSA.

Seagle, James Franklin. Estate Records, 12, 14 Nov. 1892, Lincoln County, N.C. NCSA.

Treasurer's and Comptroller's Papers. *Ports*, Port Brunswick, Vessels Entered 1784–1789, Box #9. NCSA.

Watkins, William. Will, 13 Sept. 1816, Randolph County, N.C. NCSA.

Weaver, Jacob. Inventory, 3 Aug. 1789, Lincoln County, N.C. NCSA.

Weaver, Jacob. Will, 5 Apr. 1788, Lincoln County, N.C. NCSA.

Yoder, Fred R. Letters to author, 27 Sept., 31 Dec. 1976.

PUBLISHED SOURCES

Abrahams, Roger D. *Deep Down in the Jungle . . . : Negro Narrative Folklore from the Streets of Philadelphia*. Chicago: Aldine Publishing Company, 1970.

Ames, Kenneth L. *Beyond Necessity: Art in the Folk Tradition*. Winterthur, Del.: The Henry Francis du Pont Winterthur Museum, 1977. Exhibition Catalog.

Annapolis Maryland Gazette, 27 Dec. 1764. Excerpt reprinted in *The Luminary*, Museum of Early Southern Decorative Arts (Winter 1984): 6.

Auman, Dorothy, and Walter Auman. *Seagrove Area*. Asheboro, N.C.: Village Printing Company, 1976.

Auman, Dorothy, and Charles G. Zug, III. "Nine Generations of Potters: The Cole Family." *Southern Exposure* 5, nos. 2–3 (1977): 166–74.

Barber, Edwin Atlee. *Pottery and Porcelain of the United States*. 1893. Reprint. Watkins Glen, N.Y.: Century House Americana, 1971.

Barka, Norman F. "The Kiln and Ceramics of the 'Poor Potter' of Yorktown: A Preliminary Report." In *Ceramics in America*, edited by Ian M. G. Quimby, 291–318. Winterthur Conference Report, 1972. Charlottesville: University Press of Virginia, 1973.

Barret, Richard Carter. *A Color Guide to Bennington Pottery*. Manchester, Vt.: Forward's Color Productions, 1966.

Benes, Peter. *The Masks of Orthodoxy: Folk Gravestone Carving in Plymouth County, Massachusetts, 1689–1805*. Amherst: University of Massachusetts Press, 1977.

Bivins, John, Jr. *The Moravian Potters in North Carolina*. Chapel Hill: University of North Carolina Press, 1972.

Blount, John Gray. *The John Gray Blount Papers*. Edited by William H. Masterson. Vol. 3. Raleigh, N.C.: State Department of Archives and History, 1965.

Bordley, John Beale. *Essays and Notes on Husbandry and Rural Affairs*. Philadelphia, Pa.: Budd and Bartram, 1801.

Branson, Levi. *Branson's North Carolina Business Directory*. 8 vols. Raleigh, N.C.: Levi Branson, 1866–96.

Brears, Peter C. D. *The Collector's Book of English Country Pottery*. North Pomfret: David and Charles, 1974.

————. *The English Country Pottery: Its History and Techniques*. Rutland, Vt.: Charles E. Tuttle Company, 1971.

Bridges, Daisy Wade, ed. *Potters of the Catawba Valley, North Carolina*. Journal of Studies, Ceramic Circle of Charlotte, vol. 4. Charlotte, N.C.: Mint Museum, 1980. Exhibition Catalog.

Burrison, John A. "Afro-American Folk Pottery in the South." *Southern Folklore Quarterly* 42 (1978): 175–99.

————. "Alkaline-Glazed Stoneware: A Deep-South Pottery Tradition." *Southern Folklore Quarterly* 39 (1975): 377–403.

————. *Brothers in Clay: The Story of Georgia Folk Pottery*. Athens: University of Georgia Press, 1983.

————. "Carolina Clay: The Rise of a Regional Pottery Tradition." In *Carolina Folk: The Cradle of a Southern Tradition*, edited by George D. Terry and Lynn Robertson Myers, 1–9. Columbia, S.C.: McKissick Museum, University of South Carolina, 1984. Exhibition Catalog.

————. "Georgia Jug Makers: A History of Southern Folk Pottery." Ph.D. diss., University of Pennsylvania, 1973.

————. *The Meaders Family of Mossy Creek: Eighty Years of North Georgia Folk Pottery*. Atlanta: Georgia State University Art Gallery, 1976. Exhibition Catalog.

Busbee, Jacques. "Jugtown Pottery: Its Origin and Development—An Intimate Touch of the Local Color That is Molded into This Historic American Ware." *The Ceramic Age* 14, no. 4 (Oct. 1929): 127–30.

Burton, W. C. "All the Browns of Arden Are Birthright Potters." *Greensboro Daily News*, 26 Sept. 1973.

Butler, George. "Sally Michael's Pipes." *The State*, 1 Mar. 1947.

Cardinalli, Wayne. "Wood-Ash Glazes in Oxidation." *Ceramics Monthly* 31, no. 1 (1983): 58–59.

Celebration: A World of Art and Ritual. Washington, D.C.: Smithsonian Institution Press, 1982. Exhibition Catalog.

Charles, Bernard H. *Pottery and Porcelain: A Glossary of Terms*. New York: Hippocrene Books, 1974.

Clay, James W., Douglas M. Orr, Jr., and Alfred W. Stuart, eds. *North Carolina Atlas: Portrait of a Changing Southern State*. Chapel Hill: University of North Carolina Press, 1975.

Cox, Warren E. *The Book of Pottery and Porcelain*. 2 vols. New York: Crown Publishers, 1970.

Craig, James H. *The Arts and Crafts in North Carolina 1699–1840*. Winston-Salem, N.C.: Old Salem, 1965.

Crawford, Jean. *Jugtown Pottery: History and Design*. Winston-Salem, N.C.: John F. Blair, 1964.

Creech, James Bryan. "Information on a Potter from Near Four Oaks." *The Four Oaks News*, 15 Sept. 1982.

————. "More Information on a Potter from Four Oaks." Ibid., 22 Sept. 1982.

Danielson, Leon E. "The Hilton Potteries of the Catawba Valley, North Carolina." In *Potters of the Catawba Valley, North Carolina*, edited by Daisy Wade Bridges, 21–32. Journal of Studies, Ceramic Circle of Charlotte, vol. 4. Charlotte, N.C.: Mint Museum, 1980. Exhibition Catalog.

Dewhurst, C. Kurt, and Marsha MacDowell. *Cast in Clay: The Folk Pottery of Grand Ledge, Michigan*. Publications of the Museum, Folk Culture Series, vol. 1, no. 2. East Lansing: Michigan State University, 1980.

Dickerson, John. *Pottery Making: A Complete Guide*. New York: Viking Press, 1974.

Dunnagan, M. R. "Pottery Making, Ancient Art, Increasing in the State." *The E.S.C. Quarterly* 5 (1947): 53–59.

"Famous Pottery First Made at Johnson Place." *Hickory Daily Record*, 26 Feb. 1938, sec. 3.

Ferrell, Stephen T., and Terry M. Ferrell. *Early Decorated Stoneware of the Edgefield District, South Carolina*. Greenville, S.C.: Greenville County Museum of Art, 1976. Exhibition Catalog.

Finer, Ann, and George Savage, eds. *The Selected Letters of Josiah Wedgwood*. London: Cory, Adams and MacKay, 1965.

"For the *Clarion*. On Pottery." *Nashville Clarion and Tennessee State Gazette*, 26 Aug. 1817, sec. 2.

Foster, George M. "The Sociology of Pottery: Questions and Hypotheses Arising from Contemporary Mexican Work." In *Ceramics and Man*, edited by Frederick R. Matson, 43–61. Viking Fund Publications in Anthropology, no. 41. New York: Wenner-Gren Foundation for Anthropological Research, 1965.

Fries, Adelaide L., ed. *Records of the Moravians in North Carolina*. Vol. 1, 1752–1771. Raleigh, N.C.: Edwards and Broughton Printing Company, 1922. Vol. 2, 1752–1775. Raleigh, N.C.: Edwards and Broughton Printing Company, 1925. Vol. 3, 1784–1792. Raleigh, N.C.: State Department of Archives and History, 1970.

Gay, Walter E., Sr. *History and Genealogy of the Gay Family*. n.p., 1978.

Grant-Davidson, W. J. "Early Swansea Pottery, 1764–1810." *English Ceramic Circle Transactions* (1968): 59–82.

Green, David. *A Handbook of Pottery Glazes*. New York: Watson-Guptill Publications, 1979.

Greer, Georgeanna H. *American Stonewares: The Art and Craft of Utilitarian Potters*. Exton, Pa.: Schiffer Publishing, 1981.

————. "Groundhog Kilns—Rectangular American Kilns of the Nineteenth and Early Twentieth Centuries." *Northeast Historical Archeology* 6 (1977): 42–54.

————. "Preliminary Information on the

Use of the Alkaline Glaze for Stone-ware in the South 1800–1970." In *The Conference on Historic Site Archeology Papers 1970*, edited by Stanley South, vol. 5, 155–70. Columbia, S.C.: Institute of Archeology and Anthropology, University of South Carolina, 1971.

Guilland, Harold F. *Early American Folk Pottery*. Philadelphia, Pa.: Chilton Book Company, 1971.

Hadley, Wade Hampton, Doris Goerch Horton, and Nell Craig Strowd, eds. *Chatham County, 1771–1971*. Durham, N.C.: Moore Publishing Company, 1976.

Hahn, George W. *The Catawba Soldier of the Civil War*. Hickory, N.C.: Clay Printing Company, 1911.

Haworth, Sara Richardson. *Springfield, 1773–1940: A History of the Establishment and Growth of the Springfield Monthly Meeting of Friends*. High Point, N.C.: Barber-Hall Printing Company, 1940.

Henderson, Ida Briggs. "Finest Pottery Clays are Found in Western Section of This State." *Asheville Citizen*, 5 Nov. 1933.

Hertzman, Gay Mahaffey. *Jugtown Pottery: The Busbee Vision*. Raleigh, N.C.: North Carolina Museum of Art, 1984. Exhibition Catalog.

Hinshaw, William Wade. *Encyclopedia of American Quaker Genealogy*. Vol. 1. Baltimore, Md.: Genealogical Publishing Company, 1969.

Hume, Audrey Noel. *Archeology and the Colonial Gardener*. Colonial Williamsburg Archeological Series, no. 7. Williamsburg, Va.: Colonial Williamsburg Foundation, 1974.

Johnson, Lucille. "Poe Pottery." *Pottery Collectors Newsletter* 7, no. 5 (1978): 41–43. (First published in *Fayetteville Observer*, 4 Sept. 1977.)

Johnston, Pat H., and Daisy Wade Bridges. *O. L. Bachelder and his Omar Khayyam Pottery*. Journal of Studies, Ceramic Circle of Charlotte, vol. 5. Charlotte, N.C.: Mint Museum, 1984. Exhibition Catalog.

Kaufmann, Gerhard. *North German Folk Pottery of the Seventeenth to the Twentieth Centuries*. Richmond, Va.: International Exhibitions Foundation, 1979. Exhibition Catalog.

Keen, Kirsten Hoving. *American Art Pottery, 1875–1930*. Wilmington, Del.: Delaware Art Museum, 1978. Exhibition Catalog.

Kilby, Kenneth. *The Cooper and his Trade*. London: John Baker, 1971.

Kingsbury, Susan Myre, ed. *The Records of the Virginia Company of London*. Vol. 3. Washington, D.C.: U.S. Government Printing Office, 1933.

Lasansky, Jeannette. *Central Pennsylvania Redware Pottery, 1780–1904*. Lewisburg, Pa.: Oral Traditions Projects, 1979.

Lawson, John. *A New Voyage to Carolina*. Edited by Hugh Talmadge Lefler. Chapel Hill: University of North Carolina Press, 1967.

Lefler, Hugh Talmage, and Albert Ray Newsome. *North Carolina: The History of a Southern State*. Chapel Hill: University of North Carolina Press, 1973.

Leftwich, Rodney L. *Arts and Crafts of the Cherokee*. Cullowhee, N.C.: Land-of-the-Sky Press, 1970.

McKee, Harley J. *Introduction to Early American Masonry: Stone, Brick, Mortar and Plaster*. National Trust/Columbia University Series on the Technology of Early American Building, no. 1. Washington, D.C.: National Trust for Historic Preservation in the United States, 1973.

Made By Hand: Mississippi Folk Art. Jackson: Mississippi Department of Archives and History, 1980. Exhibition Catalog.

Moose, Ruth. "Frogskin and Tobacco Spit." *Tar Heel* 7, no. 1 (1979): 45–47.

Myers, Susan M. "A Survey of Pottery Manufacture in the Mid-Atlantic and Northeastern United States." *Northeast Historical Archeology* 6 (1977): 1–13.

Newsome, Albert Ray, ed. "Records of Emigrants from England and Scotland to North Carolina, 1774–1775." *The North Carolina Historical Review* 11, no. 1 (1934): 39–54.

Nichols, Rick. "Being Sorry Doesn't Help Sanford Potter A. R. Cole." *Raleigh News and Observer*, 21 Jan. 1972.

Nixon, Alfred. "The History of Lincoln County." *The North Carolina Booklet* 9, no. 3 (1910): 111–78.

N.C. State Board of Agriculture. *North Carolina and Its Resources*. Raleigh, N.C.: M. I. and J. C. Stewart, 1896.

Olsen, Frederick L. *The Kiln Book*. 2d ed. Bassett, Calif.: Keramos Books, 1973.

Osgood, Cornelius. *The Jug and Related Stoneware of Bennington*. Rutland, Vt.: Charles E. Tuttle Company, 1971.

Oswald, Adrian. *English Brown Stoneware 1670–1900*. London: Faber and Faber, 1982.

Outlaw, Alain C. "Preliminary Excavations at the Mount Shepherd Pottery Site." In *The Conference on Historic Site Archeology Papers 1974*, edited by Stanley South, 2–12. Columbia, S.C.: Institute of Archeology and Anthropology, University of South Carolina, 1975.

Parker, Anthony E. *A Guide to Moore County Cemeteries*. Moore County Historical Association, n.p., n.d.

Penderill-Church, John. *William Cookworthy, 1705–1780: A Study of the Pioneer of True Porcelain Manufacture in England*. Truro, Cornwall: D. Bradford Barton, 1972.

Polack, Ada. *Glass: Its Tradition and Its Makers*. New York: G. P. Putnam's Sons, 1975.

Powell, Elizabeth A. *Pennsylvania Pottery: Tools and Processes*. Doylestown, Pa.: Bucks County Historical Society, 1972.

Powell, William S. *The North Carolina Gazetteer: A Dictionary of Tar Heel Places*. Chapel Hill: University of North Carolina Press, 1968.

Powell, William S., Thomas J. Farnham, and James K. Huhta, eds. *The Regulators in North Carolina: A Documentary History*. Raleigh, N.C.: State Department of Archives and History, 1971.

Purdy, Ross Coffin. "The Craft Potters of North Carolina." *The Bulletin of the American Ceramic Society* 21, no. 6 (1942): 79–87.

Ramsay, John. *American Potters and Pottery*. 1939. Reprint. Ann Arbor, Mich.: Ars Ceramica, 1976.

Ramsay, Robert W. *Carolina Cradle: Settlement of the Northwest Carolina Frontier, 1747–1762*. Chapel Hill: University of North Carolina Press, 1964.

Rauschenberg, Bradford L. "'Success to the Tuley' et al. via Liverpool." *Journal of Early Southern Decorative Arts* 2, no. 1 (1976): 1–26.

Rawson, Philip. *Ceramics*. The Appreciation of the Arts, 6. London: Oxford University Press, 1971.

Rhodes, Daniel. *Clay and Glazes for the Potter*. Radnor, Pa.: Chilton Book Company, 1973.

———. *Kilns: Design, Construction, and Operation*. Radnor, Pa.: Chilton Book Company, 1968.

———. *Stoneware and Porcelain: The Art of High-Fired Pottery*. Philadelphia, Pa.: Chilton Book Company, 1959.

Ries, Heinrich. *Clay Deposits and the Clay Industry in North Carolina*. North Carolina Geological Survey, bulletin no. 13. Raleigh, N.C.: Guy V. Barnes, 1897.

Ries, Heinrich; William S. Bayley; et al. *High-Grade Clays of the Eastern United States, with Notes on Some Western Clays*. U.S. Geological Survey, bulletin no. 708. Washington, D.C.: U.S. Government Printing Office, 1922.

Rose, Duncan. *The Resources and Industries of Cumberland County and Fayetteville, North Carolina*. n.p.: Commissioners of Cumberland County and the Mayor and Aldermen of Fayetteville, [1897].

Sanders, Herbert H. *The World of Japanese Ceramics*. Tokyo: Kodansha International, 1969.

Saunders, William L., ed. *The Colonial Records of North Carolina*. Vols. 7 and 8. Raleigh, N.C.: Josephus Daniels, 1890.

Sayers, Robert. "Potters in a Changing South." In *The Not So Solid South: Anthropological Studies in a Regional Subculture*, edited by J. Kenneth Moreland, 93–107. Athens: University of Georgia Press, 1971.

Scarborough, Quincy. "Connecticut Influence on North Carolina Stoneware: The Webster School of Potters." *Journal of Early Southern Decorative Arts* 10, no. 1 (1984): 14–74.

Schaltenbrand, Phil. *Old Pots: Salt-Glazed Stoneware of the Greensboro-New Geneva Region*. Hanover, Pa.: Everybody's Press, 1977.

Schwartz, Stuart C. *The North State Pottery Company, Sanford, North Carolina, 1924–1959*. Charlotte, N.C.: Mint Museum, 1977. Exhibition Catalog.

———. "The Reinhardt Potteries." In *Potters of the Catawba Valley, North Carolina*, edited by Daisy Wade Bridges, 33–38. Journal of Studies, Ceramic Circle of Charlotte, vol. 4. Charlotte: Mint Museum, 1980. Exhibition Catalog.

———. "The Royal Crown Pottery and Porcelain Company, Merry Oaks, North Carolina." *Pottery Collectors Newsletter* 3 (1974): 57–62.

Shaw, Simeon. *History of the Staffordshire Potteries*. 1829. Reprint. Great Neck, N.Y.: Beatrice C. Weinstock, 1968.

Shedd, Joel P. *The Landrum Family of Fayette County, Georgia*. Washington, D.C.: Moore and Moore, 1972.

Sherrill, William L. *Annals of Lincoln County, North Carolina*. 1937. Reprint. Baltimore, Md.: Regional Publishing Company, 1972.

Smith, Elmer L. *Pottery: A Utilitarian Folk Craft*. Lebanon, Pa.: Applied Arts Publishers, 1972.

Smith, Samuel D., and Stephen T. Rogers. *A Survey of Historic Pottery Making in Tennessee*. Research Series, no. 3. Nashville: Division of Archeology, Tennessee Department of Conservation, 1979.

South, Stanley. "A Comment on Alkaline Glazed Stoneware." In *The Conference on Historic Site Archeology Papers 1970*, edited by Stanley South, 171–85. Columbia, S.C.: Institute of Archeology and Anthropology, University of South Carolina, 1971.

"Southern Folk Pottery." In *Foxfire 8*, edited by Eliot Wigginton and Margie Bennett, 71–384. Garden City, N.Y.: Anchor Press, 1984.

Spargo, John. *Early American Pottery and China*. Rutland, Vt.: Charles E. Tuttle Company, 1974.

Strassburger, Ralph Beaver. *Pennsylvania German Pioneers*. Vol. 1. Norristown, Pa.: Pennsylvania German Society, 1934.

Stuckey, Jasper Leonidas. *North Carolina: Its Geology and Mineral Resources*. Raleigh, N.C.: Department of Conservation and Development, 1965.

Sudbury, Byron. "Historic Clay Tobacco Pipemakers in the United States of America." In *The Archeology of the Clay Tobacco Pipe: II. The United States of America*, edited by Peter Davey, 151–341. BAR International Se-

ries, no. 60. N.p., 1979.

Sweezy, Nancy. *Raised in Clay: The Southern Pottery Tradition*. Washington, D.C.: Smithsonian Institution Press, 1984.

———. "Tradition in Clay: Piedmont Pottery." *Historic Preservation* 27, no. 4 (1975): 20–23.

Taliaferro, Harden. *Fisher's River (North Carolina) Scenes and Characters*. New York: Harper and Brothers, 1859.

Terrell, Virginia. "Two Families Hand Down Trade Secrets Learned in England." *Asheville Citizen*, 19 Dec. 1926.

Terry, George, and Lynn Robertson Myers. *Southern Make: The Southern Folk Heritage*. Columbia, S.C.: McKissick Museums, University of South Carolina, 1981. Exhibition Catalog.

Tesh, Bessie. "Penland Pottery is 99 Years Old." *Asheville Citizen*, 1 June 1930.

Troy, Jack. *Salt-Glazed Ceramics*. New York: Watson-Guptill Publications, 1977.

Tyler, John D. "Cast-Iron Cooking Vessels." In *Antique Metalware: Brass, Bronze, Copper, Tin, Wrought and Cast Iron*, edited by James R. Mitch-ell, 220–24. New York: Universe Books, 1977.

Vallentine, John Franklin. *Fox Family History (1703–1976)*. Ashland, Kans.: Fox Family Reunion, 1976.

Vlach, John Michael. *The Afro-American Tradition in Decorative Arts*. Cleveland, Ohio: The Cleveland Museum of Art, 1978. Exhibition Catalog.

Watkins, C. Malcolm. "Ceramics in the Seventeenth-Century English Colonies." In *Arts of the Anglo-American Community in the Seventeenth Century*, edited by Ian M. G. Quimby, 275–99. Winterthur Conference Report, 1974. Charlottesville: University Press of Virginia, 1975.

Watkins, Lura Woodside. *Early New England Potters and Their Wares*. 1950. Reprint. Hamden, Conn.: Archon Books, 1968.

Weatherill, Lorna. *The Pottery Trade and North Staffordshire 1660–1760*. New York: Augustus M. Kelley, 1971.

Webster, Donald Blake. *Decorated Stoneware Pottery of North America*. Rutland, Vt.: Charles E. Tuttle Company, 1971.

Whatley, L. McKay. "The Mount Shepherd Pottery: Correlating Archeology and History." *Journal of Early Southern Decorative Arts* 6, no. 1 (1980): 21–57.

White, Newman I., ed. *The Frank C. Brown Collection of North Carolina Folklore*. Vol. 7, *Popular Beliefs and Superstitions*. Edited by Wayland Hand. Durham, N.C.: Duke University Press, 1964.

Whitener, Daniel Jay. *Prohibition in North Carolina, 1714–1945*. Chapel Hill: University of North Carolina Press, 1945.

Willett, E. Henry, and Joey Brackner. *The Traditional Pottery of Alabama*. Montgomery, Ala.: Montgomery Museum of Fine Arts, 1983. Exhibition Catalog.

Wiltshire, William E., III. *Folk Pottery of the Shenandoah Valley*. New York: E. P. Dutton and Company, 1975.

Wood, Nigel. *Oriental Glazes*. London: Pitman Publishing, 1978.

Zug, Charles G., III. "Jugtown Reborn: The Folk Potter in Transition." *Pioneer America Society Transactions* 3 (1980): 1–24.

———. *The Traditional Pottery of North Carolina*. Chapel Hill: Ackland Art Museum, 1980. Exhibition Catalog.

Index of North Carolina Potters

The following index is adapted from the one used by John Burrison in *Brothers in Clay: The Story of Georgia Folk Pottery*. It includes those firmly identified as potters by the census and other written records, or marked pots, or recurrent mention in oral tradition. All members of a potter's family had their hands in the clay, but many did so under duress and sought another occupation as soon as they could. Only those who made a substantial commitment to the craft are included here. In addition, this index omits the Moravian potters studied by John Bivins in *The Moravian Potters in North Carolina*.

Information on the potters occurs in the following order:
(1) Name
(2) Dates of birth and death (based largely on census records, tombstone inscriptions, and genealogies. There is considerable variation here, and I have made liberal use of "circa")
(3) Areas of operation (where county names have changed or borders shifted, I use the most recent one)
(4) Documentation (based on the census, apprentice indentures, industrial surveys such as the works of Levi Branson, county histories, and dated wares. I have listed the dates of such documentation and the actual terms applied to the potter. Where dates or other temporal references are missing altogether, I occasionally give a general period of operation, e.g. "late 19th century" or "1930s")

(5) Kinship (with other potters)
(6) Marks (the major variants or the most complete mark. Potter's marks are subject to all sorts of mutations in size, spacing, lettering, and orthography)
(7) Page references (not all the potters listed in this index were referred to in the text)

At the end of the index is a listing of the modern or transitional potteries that have evolved out of the utilitarian tradition during this century. The format here is similar to that used for the potters: name, dates, areas, principal workers, marks, and page references.

North Carolina Potters

GENERAL INDEX